LIVING WITH ART

ELEVENTH EDITION

Mark Getlein

Editorial Manager: Kara Hattersley-Smith Senior Editor: Felicity Maunder Production Controller: Simon Walsh

Designer: Ian Hunt

Picture Researcher: Julia Ruxton Copy-editor: Carolyn Jones

LIVING WITH ART, ELEVENTH EDITION

Published by McGraw-Hill Education, 2 Penn Plaza, New York, NY 10121. Copyright © 2016 by McGraw-Hill Education. All rights reserved. Printed in the United States of America. Previous editions © 2013, 2010, and 2008. No part of this publication may be reproduced or distributed in any form or by any means, or stored in a database or retrieval system, without the prior written consent of McGraw-Hill Education, including, but not limited to, in any network or other electronic storage or transmission, or broadcast for distance learning.

Some ancillaries, including electronic and print components, may not be available to customers outside the United States.

This book is printed on acid-free paper.

4 5 6 7 8 9 LWI 21 20 19 18

ISBN 978-0-07-337931-9

MHID 0-07-337931-X

Senior Vice President, Products & Markets: Kurt L. Strand

Vice President, General Manager, Products & Markets: Michael Ryan Vice President, Content Design & Delivery: Kimberly Meriwether David

Managing Director: William Glass Brand Manager: Sarah Remington

Director, Product Development: Dawn Groundwater

Product Developer: Betty Chen Marketing Manager: Kelly Odom

Director, Content Design & Delivery: Terri Schiesl

Project Manager: Debra Hash

Content Project Managers: Sheila M. Frank, Jodi Banowetz

Buyer: Susan K. Culbertson Design: Keith McPherson

Content Licensing Specialists: Carrie Burger, Ann Marie Jannette

Printer: LSC Communications

Cover Image: Markus Linnenbrink, Wasserscheide (Desire All Pull Together), installation view,

Kunsthalle Nürnberg, Nuremberg, 2014. Acrylic, pigments, epoxy resin on walls, floors, and ceilings.

© Markus Linnenbrink

All credits appearing on page or at the end of the book are considered to be an extension of the copyright page.

Library of Congress Cataloging-in-Publication Data

Getlein, Mark.

Living with art / Mark Getlein. - Eleventh Edition.

pages cm

Includes bibliographical references and index.

ISBN: 978-0-07-337931-9 - ISBN: 0-07-337931-X

1. Art appreciation. I. Title.

N7477.G55 2016

701'.-dc23

2015019438

The Internet addresses listed in the text were accurate at the time of publication. The inclusion of a website does not indicate an endorsement by the authors or McGraw-Hill, and McGraw-Hill does not guarantee the accuracy of the information presented at these sites.

mheducation.com/highered

BRIEF CONTENTS

About Living with Art x

PART ONE INTRODUCTION 2

- 1 Living with Art 3
- 2 What Is Art? 19
- 3 Themes of Art 51

PART TWO THE VOCABULARY OF ART 76

- 4 The Visual Elements 77
- 5 Principles of Design 115

PART THREE TWO-DIMENSIONAL MEDIA 140

- 6 Drawing 141
- 7 Painting 158
- 8 Prints 178
- 9 Camera and Computer Arts 199
- 10 Graphic Design 226

PART FOUR THREE-DIMENSIONAL MEDIA 240

- 11 Sculpture and Installation 241
- 12 Arts of Ritual and Daily Life 265
- 13 Architecture 284

PART FIVE ARTS IN TIME 320

- 14 Ancient Mediterranean Worlds 321
- 15 Christianity and the Formation of Europe 349
- 16 The Renaissance 365
- 17 The 17th and 18th Centuries 388
- 18 Arts of Islam and of Africa 411
- 19 Arts of Asia: India, China, and Japan 426
- 20 Arts of the Pacific and of the Americas 453
- 21 The Modern World: 1800–1945 471
- 22 From Modern to Postmodern 500
- 23 Opening Up to the World 528

CONTENTS

About Living with Art x Acknowledgments xix Letter from the Author 1

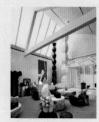

PART ONE INTRODUCTION 2

1 Living with Art 3

The Impulse for Art 4
What Do Artists Do? 7
Creating and Creativity 12
Looking and Responding 15

ARTISTS: Maya Lin 8
ARTISTS: Vincent van Gogh 11

2 What Is Art? 19

Artist and Audience 22
Art and Beauty 25
Art and Appearances 29
Representational and Abstract Art 30
Nonrepresentational Art 34
Style 36
Art and Meaning 38
Form and Content 39
Materials and Techniques 39
Iconography 40
Context 43

Art and Objects 46

THINKING ABOUT ART: Insiders and
Outsiders 26
ARTISTS: Louise Bourgeois 31
THINKING ABOUT ART: Aesthetics 47

3 Themes of Art 51

The Sacred Realm 51
Politics and the Social Order 55
Stories and Histories 59
Looking Outward: The Here and Now 61
Looking Inward: The Human
Experience 65
Invention and Fantasy 67
The Natural World 71
Art and Art 73
THINKING ABOUT ART: Iconoclasm 54
ARTISTS: Robert Rauschenberg 64
ARTISTS: Yayoi Kusama 70

PART TWO THE VOCABULARY OF ART 76

4 The Visual Elements 77

Line 77
Contour and Outline 79
Direction and
Movement 80
Implied Lines 82
Shape and Mass 83
Implied Shapes 85

Light 86
Implied Light: Modeling Mass in
Two Dimensions 87
Color 89
Color Theory 90
Color Properties 92
Light and Pigment 92
Color Harmonies 93

Optical Effects of Color 94
Emotional Effects of Color 96
Texture and Pattern 98
Actual Texture 98
Visual Texture 100
Pattern 101
Space 101
Three-Dimensional Space 102
Implied Space: Suggesting Depth in
Two Dimensions 103
Linear Perspective 104
Foreshortening 108
Atmospheric Perspective 109
Isometric Perspective 110
Time and Motion 111

CROSSING CULTURES: Japanese Prints 99
THINKING ABOUT ART: Conservation 107

5 Principles of Design 115

Unity and Variety 116
Balance 118
Symmetrical Balance 118
Asymmetrical Balance 122
Emphasis and Subordination 126
Scale and Proportion 129
Rhythm 133
Elements and Principles: A Summary 136
ARTISTS: Georgia O'Keeffe 120
THINKING ABOUT ART: Points of View 125

PART THREE TWO-DIMENSIONAL MEDIA 140

6 Drawing 141

Materials for Drawing 146
Dry Media 146
Graphite 146
Metalpoint 147
Charcoal 148
Crayon, Pastel, and Chalk 149
Liquid Media 151
Pen and Ink 151
Brush and Ink 153
Drawing and Beyond:
Paper as a Medium 154

ARTISTS: Leonardo da Vinci 143 CROSSING CULTURES: Paper 145

7 Painting 158

Encaustic 159
Fresco 159
Tempera 161
Oil 164
Watercolor, Gouache,
and Similar Media 166
Acrylic 169
Painting and Beyond:
Off the Wall! 170

The Idea of Painting: Painting
without Paint 172
Sumptuous Images: Mosaic and
Tapestry 174
ARTISTS: Jacob Lawrence 163

8 Prints 178

Relief 179 Woodcut 179 Wood Engraving 182 Linocut 183 Intaglio 184 Engraving 184 Drypoint 185 Mezzotint 187 Etching 188 Aquatint 188 Photogravure 190 Lithography 190 Screenprinting 192 Monotype 194 Inkjet 195 **Recent Directions:** Printing on the World 196 ARTISTS: Käthe Kollwitz 181 ARTISTS: Albrecht Dürer 186

9 Camera and Computer Arts 199

Photography 200
The Still Camera and Its Beginnings 201
Bearing Witness and Documenting 204
Photography and Art 205
Film 213
The Origins of Motion Pictures 214

Exploring the Possibilities 214

Film and Art 218

The Internet 223
THINKING ABOUT ART: Censorship 211

Video 220

10 Graphic Design 226

Signs and Symbols 227
Typography and Layout 230
Word and Image 232
Motion and Interactivity 234
Graphic Design and Art 236

PART FOUR THREE-DIMENSIONAL MEDIA 240

11 Sculpture and Installation 241

Methods and Materials of Sculpture 243
Modeling 243
Casting 244
Carving 248
Assembling 248
The Human Figure in Sculpture 252
Working with Time and Place 258

CROSSING CULTURES: Primitivism 256
ARTISTS: Christo and Jeanne-Claude 264

12 Arts of Ritual and Daily Life 265

Clay 265
Glass 268
Metal 270
Wood 271
Fiber 274
Ivory, Jade, and Lacquer 275
Art, Craft, Design 278
ARTISTS: María Martínez 267
ARTISTS: Olowe of Ise 273
CROSSING CULTURES: Export Arts 277

13 Architecture 284

Structural Systems in Architecture 284

Load-Bearing Construction 285
Post-and-Lintel 286
Round Arch and Vault 290
Pointed Arch and Vault 292
Dome 293
Corbelling 298
Cast-Iron Construction 299
Balloon-Frame Construction 300
Steel-Frame Construction 301
Suspension and Cable-Stayed Structures 304
Reinforced Concrete 305
Geodesic Domes 306

New Technologies, New Materials, Current Concerns 308 Digital Design and Fabrication 309 Fabric Architecture 310 Architecture and Community 313 Sustainability: Green Architecture 316

ARTISTS: Frank Lloyd Wright 307 ARTISTS: Zaha Hadid 312

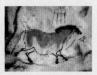

14 Ancient Mediterranean Worlds 321

The Oldest Art 321
Mesopotamia 324
Egypt 328
The Aegean 335
The Classical World: Greece
and Rome 336
Greece 336
Rome 344

THINKING ABOUT ART: Whose
Grave? 334
THINKING ABOUT ART: The Marbles and
the Museums 341

15 Christianity and the Formation of Europe 349

The Rise of Christianity 349
Byzantium 353
The Middle Ages in Europe 355
The Early Middle Ages 355
The High Middle Ages 357
Toward the Renaissance 363

16 The Renaissance 365

The Early and High Renaissance in Italy 367
The Renaissance in the North 378
The Late Renaissance in Italy 385
ARTISTS: Michelangelo 375

17 The 17th and 18th Centuries 388

The Baroque Era 388
The 18th Century 401
Revolution 407
ARTISTS: Artemisia Gentileschi 392
ARTISTS: Rembrandt van Rijn 399
THINKING ABOUT ART:

Academies 405

ARTISTS: Elisabeth Vigée-Lebrun 408

18 Arts of Islam and of Africa 411

Arts of Islam 411
Architecture: Mosques and Palaces 412
Book Arts 415
Arts of Daily Life 416
Arts of Africa 417
CROSSING CULTURES: Africa Looks Back 420

19 Arts of Asia: India, China, and Japan 426

Arts of India 427 Indus Valley Civilization 427 Buddhism and Its Art 428 Hinduism and Its Art 432 Jain Art 435 Mughal Art and Influence 435 Arts of China 436 The Formative Period: Shang to Qin 436 Confucianism and Daoism: Han and Six Dynasties 437 The Age of Buddhism: Tang 439 The Rise of Landscape Painting: Song 440 Scholars and Others: Yuan and Ming Arts of Japan 444 New Ideas and Influences: Asuka 446 Refinements of the Court: Heian 446 Samurai Culture: Kamakura and

Samurai Culture: Kamakura and
Muromachi 448
Splendor and Silence: Momoyama 450
Art for Everyone: Edo 451

CROSSING CULTURES: The Early Buddha Image 431 ARTISTS: Katsushika Hokusai 452

20 Arts of the Pacific and of the Americas 453

Pacific Cultures 453
The Americas 458
Mesoamerica 458
South and Central America 464
North America 466

21 The Modern World: 1800–1945 471

Neoclassicism and Romanticism 472
Realism 474
Manet and Impressionism 475
Post-Impressionism 478
Bridging the Atlantic: America in the
19th Century 481

19th Century 481 Into the 20th Century: The Avant-Garde 483

Freeing Color: Fauvism and Expressionism 483

Shattering Form: Cubism 487

Futurism and Metaphysical Painting 490

World War I and After: Dada and

Surrealism 492

Between the Wars: Building New

Societies 495

THINKING ABOUT ART: Presenting the Past 479

ARTISTS: *Henri Matisse* 485 ARTISTS: *Pablo Picasso* 488

22 From Modern to Postmodern 500

The New York School 501
Into the Sixties: Assemblage and
Happenings 504
Art of the Sixties and Seventies 507

Pop Art 507

Abstraction and Photorealism 509

Minimalism and After 511

Process Art 512

Installation 513

Body Art and Performance 513

Land Art 514

Conceptual Art 514

New Media: Video 516

Reconsidering Craft 517

Feminism and Feminist Art 517

Art of the Eighties and Nineties:

Postmodernism 519

The Painterly Image 520

Words and Images, Issues and Identities 522

New Media: The Digital

Realm 524

ARTISTS: Jackson Pollock 502

ARTISTS: Andy Warhol 508

THINKING ABOUT ART: The Guerrilla Girls 525

23 Opening Up to the World 528

THINKING ABOUT ART: *Is It Over?* 535

Pronunciation Guide 540 Suggested Readings 543 Notes to the Text 546 Glossary 549 Photographic Credits 557 Index 562

LIST OF ESSAYS

Artists

Maya Lin 8
Vincent van Gogh 11
Louise Bourgeois 31
Robert Rauschenberg 64
Yayoi Kusama 70
Georgia O'Keeffe 120
Leonardo da Vinci 143
Jacob Lawrence 163
Käthe Kollwitz 181
Albrecht Dürer 186
Christo and Jeanne-Claude 264
María Martínez 267

Olowe of Ise 273
Frank Lloyd Wright 307
Zaha Hadid 312
Michelangelo 375
Artemisia Gentileschi 392
Rembrandt van Rijn 399
Elisabeth Vigée-Lebrun 408
Katsushika Hokusai 452
Henri Matisse 485
Pablo Picasso 488
Jackson Pollock 502
Andy Warhol 508

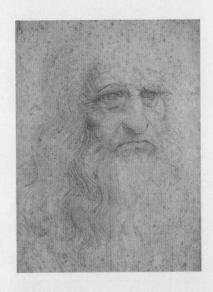

Crossing Cultures

Japanese Prints 99 Paper 145 Primitivism 256 Export Arts 277 Africa Looks Back 420 The Early Buddha Image 431

Thinking About Art

Insiders and
Outsiders 26
Aesthetics 47
Iconoclasm 54
Conservation 107
Points of View 125
Censorship 211

Whose Grave? 334
The Marbles and the
Museums 341
Academies 405
Presenting the Past 479
The Guerrilla Girls 525
Is It Over? 535

Move beyond first impressions. See art in everyday life.

ART is part of our lives.

From the monuments in our communities, to the fashions we wear and media images we take in, to the exhibits on display in museums and galleries. It permeates our daily lives.

But why do we study art? How do we talk about art?

Living with Art helps students see art in everyday life by fostering a greater understanding and appreciation of art and by equipping them with the tools to analyze and talk about art.

Understand ART

SmartBook with **NEW** learning resources is the first and only adaptive reading and study experience that contextualizes the contents of *Living with Art* based on what the individual student knows and doesn't know. Enhanced by LearnSmart, SmartBook is a proven resource in the Art Appreciation course, having been used by over 11,000 students nationwide since it first launched with the tenth edition of *Living with Art*. SmartBook helps students understand art and optimizes student study time by creating a personalized learning path for improved course performance and overall student success in four stages:

Preview – Students start with a preview of each chapter and the corresponding key learning objectives. This preview establishes a framework of the material in a student's brain to help retain knowledge over time.

Read - While students read the material, they are guided to core topics where they should spend the most time studying.

Practice - As students read the material, SmartBook presents them with questions to help identify what content they know and what they don't know.

Recharge – To ensure concept mastery and retention, students complete the Read and Practice steps until SmartBook directs them to Recharge the important material they're likely to forget.

■SMARTBOOK[™]

Analyze ART

Connect Art delivers assessments, analytics, and resources—including SmartBook—that make *Living with Art* a rich digital experience. Featured activities that help students analyze art include:.

Guided Viewing Assignments, which feature links to Google Art Project. Questions guide students through learning the process of describing what they see, providing formal analysis of various works of art, discussing their meanings, and ultimately developing informed opinions.

Animations on Elements and Techniques and Art Technique Videos with comprehension and analytical questions that provide an engaging introduction to core concepts from each chapter to bring students into the creative process.

Interactive Activities to challenge students to apply their newly acquired vocabulary to new works of art, and to prepare them to describe the art they encounter in their lives.

Appreciate ART

Living with Art fosters each student's unique path to "appreciation."

Featured essays, such as *Thinking about Art* and *Crossing Cultures*, focus on **social, historical, and global context**, introducing issues of art in society over time—how art has been appreciated, interpreted, destroyed, categorized, displayed, fought over, preserved, censored, owned, and studied.

Chapter 3 of *Living with Art* helps students appreciate some of the **common themes of art**. The following themes will be explored in SmartBook's learning resources, and can be incorporated into lectures and class discussion as appropriate:

Community and Politics in Art Spirituality in Art The Natural World in Art Stories and Histories in Art Life and Death in Art Self-Expression in Art The Human Figure in Art

NEW thematic worksheets help students to build their appreciation skills, individually or as a group, as they explore a gallery or museum collection in person or online. The worksheets guide them in making connections between works of art by choosing a theme, looking for works that reflect this theme, and supporting their selections with formal and contextual details.

The Eleventh Edition

Small but significant changes appear in almost every chapter, refreshing the illustration program and clarifying and enlivening the text.

Highlights of the Eleventh Edition

Chapter 7, Painting, features a new topic called **Painting without Paint**, which looks at contemporary works that inscribe themselves in the tradition of painting but do not use paint as a medium.

Yayoi Kusama is the subject of a new biographical **Artists** essay in Chapter 3, Themes of Art. In the final chapter, Opening Up to the World, a new **Thinking about Art** essay titled "Is It Over?" invites readers to ponder the ideas put forth by Hans Belting and Arthur Danto about the beginning and possible end of the era of art.

In Chapter 13, Architecture, the section on **Sustainability** takes note of the current interest in massive timber construction and organic building materials.

Sustained attention to **contemporary art** continues to be a hallmark of the text. Artists appearing for the first time in this edition include Tara Donovan, Mark Grotjahn, Amy Sillman, Channing Hansen, Nicole Eisenman, Dario Robleto, Swoon, Olia Lialina, Aram Bartholl, Ilya and Emilia Kabakov, Tomás Saraceno, Jeroen Verhoeven, Merete Rasmussen, Marcus Amerman, Glenn Ligon, Nermine Hammam, Imran Qureshi, Sopheap Pich, Kohei Nawa, Damián Ortega, and Thomas Demand.

A number of **historical artists** appear for the first time as well, including Sultan Muhammad, Sonia Delaunay, Willem Kalf, Kaikei, John Frederick Kensett, Shen Zhou, Petrus Christus, Lü Ji, and Edward Steichen.

The Revision in Detail

Chapter 2, What Is Art? The discussion of Leonardo's Mona Lisa now clarifies why scholars long suspected that the panel had been cut down. An endnote updates the tale with the results of the 2004-05 examination of the painting at the Louvre. The discussion of stylization has been expanded to juxtapose a Chinese porcelain bowl and a Persian miniature painting, showing how the conventions for depicting clouds and flames passed from one culture to the other. The painting, Sultan Muhammad's The Ascent of the Prophet Muhammad, also serves as an example of the slender but important tradition within Islam of depicting the Prophet, a timely topic widely ignored or misunderstood. Works by Sonia Delaunay and Tara Donovan refresh the introduction to nonrepresentational art. Kara Walker's much talked-about 2014 work A Subtlety provides a spectacular introduction to installation. The topics in the section "Art and Meaning" have been lightly revised and reorganized for pedagogical clarity: the role of materials and techniques in suggesting meaning, formerly subsumed into the discussion of form and content, is now presented as a separate topic. The terms content and context have been fitted with more straightforward definitions that can be committed to memory. Form and content are reinforced as paired terms.

Chapter 3, Themes of Art. *Love Is Calling,* a recent *Infinity Mirrored Room* by Yayoi Kusama, is a new presence here, complemented by a biographical "Artists" essay that introduces readers to Kusama's life and work.

Chapter 4, The Visual Elements. The discussion of texture has been refreshed with a still life by the 17th-century Dutch painter Willem Kalf and new works by Mona Hatoum and Constantin Brancusi. John Frederick Kensett's hushed, luminous *Lake George* illustrates atmospheric perspective, answered by a section of Shen Zhou's handscroll *Autumn Colors among Streams and Mountains*. Richard Serra now authorizes only black-and-white photographs of his work for reproduction. His *Inside Out*, a monumental work from 2013, is illustrated with an image by his chosen photographer, Lorenz Kienzle.

Chapter 5, Principles of Design. A recent *Infinity Net* painting by Yayoi Kusama introduces readers to one of her most famous recurring motifs.

Chapter 6, Drawing. New to the chapter are a radiant drawing in colored pencil by Mark Grotjahn and a chilling work in cut paper by Mona Hatoum.

Chapter 7, Painting. Oil paint is now represented in its first decades of popularity by *A Goldsmith in His Shop*, a richly detailed Early Netherlandish painting by Petrus Christus. Amy Sillman's *Nut* newly illustrates a contemporary approach to the medium. A new section called "Painting Without Paint" brings together Mark Bradford, shifted here from Chapter 6, and Channing Hansen, whose knit paintings were a highlight of the recent "Made in LA" exhibition at the Hammer Museum.

Chapter 8, Prints. Sumida River, Late Autumn, by Motosugu Sugiyama, updates the coverage of woodblock prints. Sugiyama uses traditional Japanese polychrome woodblock techniques to depict aerial views of contemporary Tokyo. Other new presences include Nicole Eisenman, Dario Robleto, and Caledonia Curry, better known as the street artist Swoon, whose wheat-paste prints appear unexpectedly on urban walls.

Chapter 9, Camera and Computer Arts. One of the most celebrated images of the Pictorialist movement, Edward Steichen's *Flatiron*, is newly featured. The discussion of Internet art has been updated with a recent work by Olia Lialina, one of the pioneers of the medium. The term post-Internet art is introduced, illustrated by *Map*, a thoughtful and accessible project by Aram Bartholl.

Chapter 10, Graphic Design. Universal Everything's crowd-sourced installation 1000 *Hands* illustrates how today's digital designers can be equally adept at working for corporate clients and creating their own art for the public.

Chapter 11, Sculpture and Installation. Bas-relief is now illustrated by a substantial detail from *The Churning of the Sea of Milk* at Angkor Wat. Kaikei's carving of the Shinto deity Hachiman introduces the idea of polychrome sculpture and illustrates Japanese realism. The discussion of installation has been updated with recent works by Ilya and Emilia Kabakov and Tomás Saraceno.

Chapter 12, Arts of Ritual and Daily Life. Jade is now illustrated by a *cong*, a characteristic (though still mysterious) ritual object from the Neolithic Liangzhu culture in China. An additional example of lacquer allows the chapter to present both the Chinese tradition of carving and the Japanese tradition of inlay, illustrated in this edition by a writing box decorated with motifs that allude to the *Tale of Genji*. The section "Art, Craft, Design" has been updated with recent works in wood, ceramic, glass, and resin by Jeroen Verhoeven, Merete Rasmussen, Marcus Amerman, and WertelOberfell.

Chapter 13, Architecture. The opening of the chapter has been revised to introduce the basic concepts of loads, tension, compression, tensile strength, and compressive strength, allowing for more satisfactory explanations of the structural systems that follow. J. Mayer H. und Partner's Metropol Parasol is a new presence in "Architecture and Community," providing as well an additional example of the possibilities opened up by CAD/CAM technology. "Sustainability: Green Architecture" continues to track recent directions. New to this edition are: LISI House, Team Austria's winning entry in the 2013 Solar Decathlon; Michael Green's Wood Innovation and Design Center, a showcase for the structural potential of mass timber; and The Living's *Hy-Fi*, a temporary structure made of lightweight, organic bricks.

Chapter 14, Ancient Mediterranean Worlds. Changes to this chapter are textual: the discussion of the wall painting from the tomb of Nebamun has been enlivened with details drawn from Richard Parkinson's monograph *The Painted Tomb Chapel of Nebamun*. A review of the literature on the Parthenon laid to rest the popular claim that the facade takes the proportions of a golden rectangle and points instead to an organizing ratio of 9:4. Particularly helpful were Susan Woodford's *The Parthenon* and *The Parthenon and Its Impact in Modern Times*, edited by Panayotis Tournikiotis. A lightly revised discussion of the equestrian statue of Marcus Aurelius is indebted to Raimund Wünsche's "Der Kaiser zu Pferd," in *Marc Aurel; der Reiter auf dem Kapitol*.

Chapter 15, Christianity and the Formation of Europe. The discussion of the mosaic fragment depicting Christ as the Sun refers now to the Greek god Helios, worshiped in Rome as Sol Invictus. Revisions to the discussion of Charlemagne and his chapel at Aachen are indebted to Charles McClendon's *The Origins of Medieval Architecture: Building in Europe, A.D. 600–900.* A new image of Giotto's *Lamentation*, taken after the recent restoration, includes the decorative bands that Giotto devised to define picture spaces on the chapel walls, enabling students to understand something of the visual context of the scene and the larger organization of the fresco cycle.

Chapter 16, The Renaissance. The discussion of the Sistine ceiling has been revised to touch on the earlier decoration under Sixtus IV and Michelangelo's use of assistants to accomplish his Herculean task, explicitly countering the "lone genius" model still prevalent in popular culture. William Wallace's essay "Michelangelo's Assistants in the Sistine Chapel" informed the changes.

Chapter 17, The 17th and 18th Centuries. The Palace of Versailles is now illustrated with a view by Pierre-Denis Martin. Painted in 1722, it represents the palace as Louis XIV left it after the completion of his fourth and final building campaign. A new photograph of the Hall of Mirrors shows its appearance after the recent restoration (especially noticeable in the ceiling paintings).

Chapter 19, Arts of Asia: India, China, and Japan. Lü Ji's monumental bird-and-flower painting Mandarin Ducks and Hollyhocks is a new presence here, exemplifying the closely observed, decorative style favored by the Ming court. The shrine complex at Ise is now illustrated by a stunning aerial photograph that captures both the latest rebuilding nearing completion and the previous rebuilding still standing next to it, not yet dismantled. A new illustration from the 12th-century Tale of Genji scrolls is paired with a detail of the text, showing the exquisite decorated paper and liquid calligraphy that distinguish this aristocratic production. The chapter now ends with Hokusai's beloved Great Wave at Kanagawa, one of Japan's most enduring contributions to world visual culture.

Chapter 20, Arts of the Pacific and of the Americas. The survey of North America now begins with an effigy pipe depicting a beaver. Carved from stone and set with pearl eyes and bone teeth, it is one of the finest works to have come down to us from the early cultures of the Eastern Woodlands. The chapter closes with a spectacular four-headed Cannibal Bird mask from the Pacific Northwest.

Chapter 22, From Modern to Postmodern. Small changes complete this chapter's transformation to a historical chapter that follows art from the postwar years through the 1990s. New to the chapter are Walter De Maria's Lightning Field, Joseph Kosuth's Five Words in White Neon, Glenn Ligon's Untitled (I Do Not Always Feel Colored), and Olia Lialina's iconic My Boyfriend Came Back from the War, a pioneer work of Internet art from 1996. Bill Viola is now represented by The Greeting, perhaps his most famous work of the 1990s. Jean-Michel Basquiat is now represented by Hollywood Africans and David Wojnarowicz by Americans can't deal with death.

Chapter 23, Opening Up to the World. This chapter has been thoroughly updated with new artists and works. Artists appearing for the first time are Nermine Hammam (Egypt), Imran Qureshi (Pakistan), Sopheap Pich (Cambodia), Kohei Nawa (Japan), Damián Ortega (Mexico) and Thomas Demand (Germany). Yinka Shonibare and Subodh Gupta are represented by more recent works. A new Thinking About Art essay called "Is It Over?" invites students to ponder the ideas put forth by Arthur Danto and Hans Belting about the era of art and the possible end of its unfolding in history.

Supporting Resources

Instructors can access a database of images from select McGraw-Hill Education art and humanities titles, including *Living with Art*. **Connect Image Bank** includes all images for which McGraw-Hill Education has secured electronic permissions. Instructors can access a text's images by browsing its chapters, style/period, medium, and culture, or by searching on key terms.

Instructors can also search for images from other McGraw-Hill Education titles included in the database. Images can be easily downloaded for use in presentations and in PowerPoints. The download includes a text file with image captions and information.

You can access Connect Image Bank under the library tab on Connect Art.

Connect Insight

The first and only analytics tools of its kind, Connect InsightTM is a series of visual data displays—each framed by an intuitive question—to provide at-a-glance information regarding how a class is doing: *How are my students doing? How is this student doing? How is this assignment doing? How are my assignments doing? How is my section doing?*

Instructors receive instant student performance matched with student activity, view real-time analytics so instructors can take action early and keep struggling students from falling behind, and are empowered with a more valuable and productive connection between themselves and their students with the transparency Connect InsightTM provides in the learning process.

Tegrity

Capture lessons and lectures in a searchable format for use in traditional, hybrid, "flipped classes," and online courses by using Tegrity. Its personalized learning features make study time efficient, and its affordability brings this benefit to every student on campus. Patented search technology and real-time Learning Management System (LMS) integrations make Tegrity the market-leading solution and service.

McGraw-Hill Education's Campus

MHE Campus (http://mhcampus.mhhe.com) provides faculty with true single signon access to all of our McGraw-Hill Education's course content, digital tools, and other high-quality learning resources from any LMS. This innovative offering allows for secure and deep integration, enabling seamless access for faculty and students to any of McGraw-Hill Education's course solutions, such as Connect® (all-digital teaching and learning platform), Create (state-of-the-art custom-publishing tool), and Tegrity (fully searchable lecture-capture service).

McGraw-Hill Education's Create

Easily rearrange chapters, combine materials from other content sources, and quickly upload content you have written, such as your course syllabus or teaching notes, using McGraw-Hill Education's Create. Find the content you need by searching through thousands of leading McGraw-Hill Education's textbooks. Arrange your book to fit your teaching style. Create even allows you to personalize your book's appearance by selecting the cover and adding your name, school, and course information. Order a Create book, and you will receive a complimentary print review copy in 3 to 5 business days or a complimentary electronic review copy via email in about an hour. Experience how McGraw-Hill Education empowers you to teach *your* students *your* way. http://create.mheducation.com

Instructor Resources include an Instructor's Manual, test banks, and lecture Power-Point slides that can be accessed through Connect Art.

Acknowledgments

Connect Art, LearnSmart Suite, and Instructor Resources Contributors and Subject-Matter Experts

Alex Scott Baine Susan E. Dodge Diana Lurz Vicki Mayhan Chris Narozny Sarah Van Anden Paige Wideman Evan Wilson

Numerous reviewers have contributed to the growth and development of *Living with Art* through various editions. We want to express our gratitude to those who have offered valuable feedback on the eleventh edition and *Connect Art*:

Living with Art and Connect Art Reviewers

Alex Scott Baine, East Mississippi Community College Rachel Bomze, Passaic County Community College Stephen Cappelli, Alabama State University John Caputo, University of Tampa Joanne Carrubba, MiraCosta College Cat Crotchett, Western Michigan University Heea Crownfield, Beaufort County Community College Kathleen Desmond, University of Central Missouri Susan E. Dodge, Frostburg State University Dustin Farmer, Seward County Community College Melissa Hebert-Johnson, Black Hawk College John Hope, South Plains College Carolyn Jacobs, Central Piedmont Community College Melissa Lovingood, North Iowa Area Community College, Mason City Diana Lurz, Rogers State University Jan Mainzer, Marist College Vicki Mayhan, Richland College Julie McArdle, Greenville Technical College Robert Millard-Mendez, University of Southern Indiana Cynthia Persinger, California University of Pennsylvania Sylvia Ramachandran Skeen, University of Utah, Salt Lake City Susan Ramos, Central Arizona College Gilbert Rocha, Richland Community College Lisa Rockford, Broward College Sean Russell, College of Southern Nevada Patti Shanks, University of Missouri, Columbia Mary E. Shira, James Madison University Lisa Spinks, East Mississippi Community College Ivanhoe Tejeda, Harold Washington College Paige Wideman, Northern Kentucky University

Kimberly Winkle, Tennessee Technological University

Author Acknowledgments

An edition of Living with Art is the work of many hands, and even more so now that the text has taken its place as an element of a larger online learning environment. At McGraw-Hill Education, it has been a pleasure to find myself in the care of two old acquaintances wearing new hats, Sarah Remington and Betty Chen, Brand Manager and Senior Product Developer, respectively. They know the book well, having worked on previous editions in other capacities, and are uniquely qualified to shepherd its latest incarnation into the world. The vast digital offerings have taken shape under the exacting attentions of Content Project Manager Sheila Frank and Assessment Content Project Manager Jodi Banowetz. In editions past, gratitude has flowed from New York to points west. With this edition, I gaze eastward across the Atlantic to London, where the genial staff of Laurence King Publishing made light work of the numerous and complex tasks of production. I'm grateful to Kara Hattersley-Smith, the Editorial Manager there, and to Senior Editor Felicity Maunder, unfailingly cheerful and seemingly unflappable. Images were gathered by Picture Manager Julia Ruxton, who generously began fielding questions and dispensing excellent advice even before our work had officially begun. She was assisted by Picture Researcher Peter Kent. I'm grateful to, and also slightly in awe of, copyeditor Carolyn Jones, who flagged small errors and inconsistencies in text now many editions old and more than once sent me into the stacks to track down definitive information about things I thought I knew. Ian Hunt is responsible for refreshing the book's design and for introducing me to the term colorways. Production Manager Simon Walsh oversaw the transformation of hundreds of digital files into a printed book.

Researching new images and artists brought me into contact with numerous people and often occasioned pleasant exchanges. It's nice to feel a human tug at the other end of an email inquiry. I'm grateful to Kristine Virsis and Karmimadeebora McMillan at Swoon Studio, photographer Jaime Rojo at Brooklyn Street Art, photographer Jason Wyche, Liz Wall at the Denver Art Museum, Sindhu Mahadevan at Michael Green Architecture in Vancouver, Sara at Plantagon in Stockholm, Daisuke Ota at Kyodo News, and Anna Marcum at P.P.O.W. in New York for their help and good humor.

This edition of *Living with Art* has profited greatly from privileges enjoyed at Avery Library at Columbia University, thanks to whose magnificent collection, helpful librarians, blissful open stacks, and late hours I was finally able to investigate a number of small questions that had long been gnawing at me. Debts carried over from previous editions include those to Monica Visonà, Herbert Cole, Marylin Rhie, David Damrosch, John Christ, Virginia Budney, and Terry Hobbs for matters African, South Asian, Mesoamerican, American, sculptural, geometric, nautical, and zoological, and to Stephen Shipps and Kathleen Desmond, who hover over Chapter 2, friendly spirits and wise.

-Mark Getlein

Letter from the Author

To the reader,

I'm about to disappear. There I am, below, walking off the page and into the book. When next we meet, in the first chapter, you won't recognize me, for "I" will not appear. An impersonal authority will seem to be speaking, explaining ideas and concepts, imparting information, directing your attention here and there, narrating a history: first this happened, and then that. But you should know that there is someone in particular behind the words, just as there is someone in particular reading them.

I'm walking by a painting of dancers by Matisse. Before that, I've stopped to look at a group of sculptures by Brancusi. Often it's the other way around: I linger for a long time before the painting and walk right by the sculptures without thinking much about them. The works are in the same museum, and I've known them for most of my life. In a way, I think of them as mine—they belong to me because of the hours I have spent looking at them, thinking about them, reading about the artists who made them. Other works in the museum are not mine, at least not yet. Oh, I recognize them on sight, and I know the names of the artists who made them. But I haven't given them the kind of sustained attention it takes to make them a part of my inner world.

Is it perhaps that I don't like them? Like anyone, I am attracted to some works more than others, and I find myself in greater sympathy with some artists more than others. Some works have a deeply personal meaning for me. Others do not, however much I may admire them. But in truth, when looking at a work of art for the first time, I no longer ask whether I like it or not. Instead, I try to understand what it is. These are deep pleasures for me, and I would wish them for you: that through this book you may learn to respond to art in ways that set like and dislike aside, and that you may encounter works you find so compelling that you take the time to make them your own.

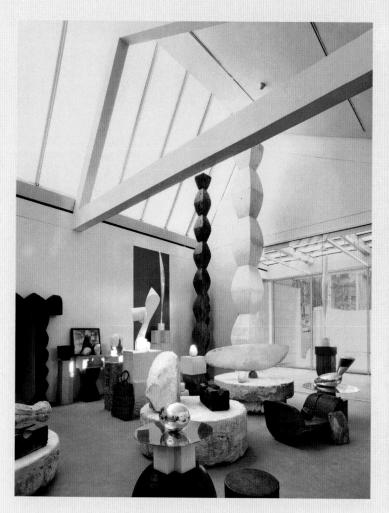

1.1 Brancusi's studio. Reconstruction at the Musée National d'Art Moderne, Centre Georges Pompidou, by the Renzo Piano Building Workshop. 1992–96.

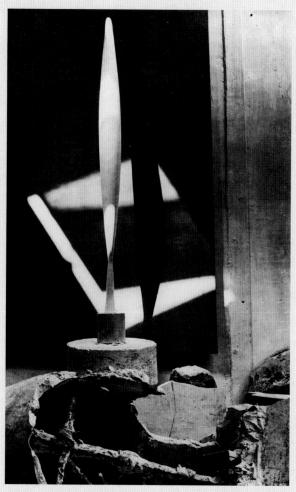

1.2 Constantin Brancusi. *Bird in Space*. c. 1928–30. Gelatin silver print, $11\frac{3}{4} \times 9\frac{3}{6}$ ". Musée National d'Art Moderne, Centre Georges Pompidou, Paris

PART ONE

Introduction

Living with Art

ur simplest words are often the deepest in meaning: birth, kiss, flight, dream. The sculptor Constantin Brancusi spent his life searching for forms as simple and pure as those words—forms that seem to have existed forever, outside of time. Born a peasant in a remote village in Romania, he spent most of his adult life in Paris, where he lived in a single small room adjoining a skylit studio. Upon his death in 1957, Brancusi willed the contents of his studio to the French government, which eventually re-created the studio itself in a museum (1.1).

Near the center of the photograph are two versions of an idea Brancusi called *Endless Column*. Pulsing upward with great energy, the columns seem as though they could go on forever. Perhaps they *do* go on forever, and we can see only part of them. Directly in front of the white column, a sleek, horizontal marble form looking something like a slender submarine seems to hover over a disk-shaped base. Brancusi called it simply *Fish*. It does not depict any particular fish but, rather, shows us the idea of something that moves swiftly and freely through the water, the essence of a fish. To the left of the dark column, arching up in front of a patch of wall painted red, is a version of one of Brancusi's most famous works, *Bird in Space*. Here again the artist portrays not a particular bird but, rather, the idea of flight, the feeling of soaring upward. Brancusi said that the work represents "the soul liberated from matter."

A photograph by Brancusi shows another, more mysterious view of *Bird in Space* (1.2). Light from a source we cannot see cuts across the work and falls in a sharp diamond shape on the wall behind. The sculpture casts a shadow so strong it seems to have a dark twin. Before it, lies a broken, discarded work. The photograph might make you think of the birth of a bird from its shell, or of a perfected work of art arising from numerous failed attempts, or indeed of a soul newly liberated from its material prison.

Brancusi took many photographs of his work, and through them we can see how his sculptures lived in his imagination even after they were finished. He photographed them in varying conditions of light, in multiple locations and combinations, from close up and far away. With each photograph they seem to reveal a different mood, the way people we know reveal different sides of themselves over time.

Living with art, Brancusi's photographs show us, is making art live by letting it engage our attention, our imagination, our intelligence. Few of us, of course, can live with art the way Brancusi did. Yet we can choose to seek out encounters with art, to make it a matter for thought and enjoyment, and to let it live in our imagination.

You probably live already with more art than you think you do. Very likely the walls of your home are decorated with posters, photographs, or even paintings you chose because you find them beautiful or meaningful. Walking around your community you probably pass by buildings that were designed for visual appeal as well as to serve practical ends. If you ever pause for a moment just to look at one of them, to take pleasure, for example, in its silhouette against the sky, you have made the architect's work live for a moment by appreciating an effect that he or she prepared for you. We call such an experience an *aesthetic* experience. Aesthetics is the branch of philosophy concerned with the feelings aroused in us by sensory experiences—experiences we have through sight, hearing, taste, touch, and smell. Aesthetics concerns itself with our responses to the natural world and to the world we make, especially the world of art. What art is, how and why it affects us—these are some of the issues that aesthetics addresses.

This book hopes to deepen your pleasure in the aesthetic experience by broadening your understanding of one of the most basic and universal of human activities, making art. Its subject is visual art, which is art that addresses the sense of sight, as opposed to music or poetry, which are arts that appeal to the ear. It focuses on the Western tradition, by which we mean art as it has been understood and practiced in Europe and in cultures with their roots in European thought, such as the United States. But it also reaches back to consider works created well before Western ideas about art were in place and across to other cultures that have very different traditions of art.

The Impulse for Art

No society that we know of, for as far back in human history as we have been able to penetrate, has lived without some form of art. The impulse to make and respond to art appears to be as deeply ingrained in us as the ability to learn language, part of what sets us apart as humans. Where does the urge to make art come from? What purposes does it serve? For answers, we might begin by looking at some of the oldest works yet discovered, images and artifacts dating from the Stone Age, near the beginning of the human experience.

Named for one of the explorers who discovered it in 1994, the Chauvet cave is one of hundreds of caves in Europe whose walls are decorated with images created during the Upper Paleolithic era, the latter part of the Old Stone Age (1.3). A number of these caves were already known when the marvels of Chauvet came to light, but the Chauvet cave created a sensation when radiocarbon dating confirmed that at least some of the images on its walls had been painted 32,000 years ago, thousands of years earlier than their accomplished style suggested.

The galleries and chambers of Chauvet teem with over three hundred depictions of animals-lions, mammoths, rhinoceroses, cave bears, horses, reindeer, red deer, aurochs, musk-oxen, bison, and others-as well as palm prints and stenciled silhouettes of human hands. Evidence from this and other Paleolithic sites tells us something of how the paintings were made. Charcoal, naturally tinted red and yellow clays (ochres), and a black mineral called manganese dioxide served as pigments. They were ground to a powder with stone mortars, then mixed with a liquid that bound them into paint-blood, animal fat, and calcium-rich cave water were some of the binders used. Paint was applied to the cave walls with fingers and animal-hair brushes, or sprayed from the mouth or through a hollow reed. Some images were engraved, or scratched, into the rock; others were drawn with a chunk of rock or charcoal held like a pencil. Deep in the interior of the caves, far from any natural light or living areas, the images would have been created and viewed by the flickering light of torches, or of stone lamps that may have burned animal fat using moss wicks.

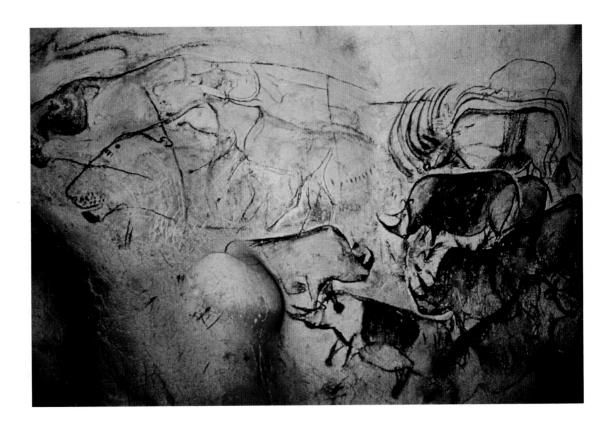

When Paleolithic cave paintings were first discovered, during the late 19th century, scholars suggested that they had been made purely for pleasure during times of rest from hunting or other occupations. But their presence in deep and difficult-to-reach areas seemed to work against that notion. For Stone Age image-makers to have gone to such lengths, their work must have been meaningful. One influential early theory held that the images were a form of magic to ensure success in hunting. Other scholars began to look past individual images to consider each cave as a purposefully structured whole, carefully noting the placement of every image and symbolic marking within it. A related branch of research examines how Paleolithic artists responded to the unique characteristics of each underground space, including the spaces' acoustics. Most recently, it has been suggested that the images were used in rituals conducted by shamans—religious specialists who communicate with a parallel spirit world, often through animal spirit go-betweens.

Fascinating as those theories are, they pass over perhaps the most amazing thing of all, which is that there should be images in the first place. The ability to make images is uniquely human. Anthropologists speak of an "explosion" of images during the Upper Paleolithic period, when anatomically modern humans arrived in Europe and began to displace the Neanderthal human population that had been living there for several hundred thousand years. Along with musical instruments, personal ornaments, and portable sculptures, cave paintings were part of a cultural toolkit that must have given our ancestors an advantage over their now-extinct Neanderthal competitors, helping communities to form and thrive in a new environment. If images had not been useful to us, we would have stopped making them. As it is, we have been making them ever since. All images may not be art, but our ability to make them is one place where art begins.

The contemporary British sculptor Anthony Caro has said that "all art is basically Paleolithic or Neolithic: either the urge to smear soot and grease on cave walls or pile stone on stone." By "soot and grease" Caro means the cave paintings. With "the urge to pile stone on stone" he has in mind one of the most impressive and haunting works to survive from the Stone Ages, the

1.3 Left section of the "Lion Panel," Chauvet cave, Ardèche Valley, France. c. 30,000 B.C.E.

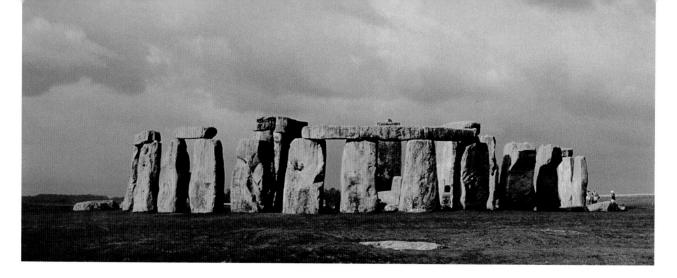

1.4 Stonehenge. Salisbury Plain, England, c. 3000–1500 B.C.E. Height of stones 13'6".

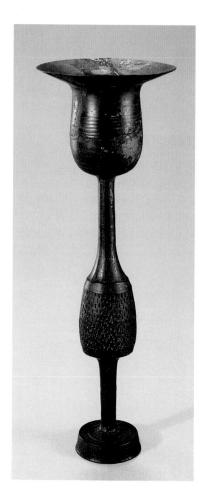

1.5 Stemmed vessel, from Weifang, Shandong, China. Neolithic period, Longshan, c. 2000 B.C.E. Black pottery, thin biscuit, height 10½".

structure in the south of England known as Stonehenge (1.4). Today much ruined through time and vandalism, Stonehenge at its height consisted of several concentric circles of **megaliths**, very large stones, surrounded in turn by a circular ditch. It was built in several phases over many centuries, beginning around 3000 B.C.E. The tallest circle, visible in the photograph here, originally consisted of thirty gigantic upright stones capped with a continuous ring of horizontal stones. Weighing some 50 tons each, the stones were quarried many miles away, hauled to the site, and laboriously shaped by blows from stone hammers until they fit together.

Many theories have been advanced about why Stonehenge was built and what purpose it served. Recent archaeological research has confirmed that the monument marks a graveyard, perhaps that of a ruling dynasty. The cremated remains of up to 240 people appear to have been buried there over a span of some five hundred years, from the earliest development of the site until the time when the great stones were erected. Other findings show that the monument did not stand alone but was part of a larger complex, perhaps a religious complex used for funerary rituals. What is certain is that Stonehenge held meaning for the Neolithic community that built it. For us, it stands as a compelling example of how old and how basic is our urge to create meaningful order and form, to structure our world so that it reflects our ideas. This is another place where art begins.

Stonehenge was erected in the Neolithic era, or New Stone Age. The Neolithic era is named for the new kinds of stone tools that were invented, but it also saw such important advances as the domestication of animals and crops and the development of the technology of pottery, as people discovered that fire could harden certain kinds of clay. With pottery, storage jars, food bowls, and all sorts of other practical objects came into being. Yet much of the world's oldest pottery seems to go far beyond purely practical needs (1.5). This elegant stemmed cup was formed around 2000 B.C.E. in what is now eastern China. Eggshell-thin and exceedingly fragile, it could not have held much of anything and would have tipped over easily. In other words, it isn't practical. Instead, great care and skill have gone into making it pleasing to the eye. Here is a third place we might turn to for the origins of art—the urge to explore the aesthetic possibilities of new technologies. What are the limits of clay, the early potters must have wondered. What can be done with it? Scholars believe such vessels were created for ceremonial use. They were probably made in limited quantity for members of a social elite.

To construct meaningful images and forms, to create order and structure, to explore aesthetic possibilities—these characteristics seem to be part of our nature as human beings. From them, art has grown, nurtured by each culture in its own way.

What Do Artists Do?

In our society, we tend to think of art as something created by specialists, people we call artists, just as medicine is practiced by doctors and bridges are designed by engineers. In other societies, virtually everyone contributes to art in some way. Yet no matter how a society organizes itself, it calls on its art-makers to fulfill similar roles.

First, artists create places for some human purpose. Stonehenge, for example, was probably created as a place where a community could gather for rituals. Closer to our own time, Maya Lin created the Vietnam Veterans Memorial as a place for contemplation and remembrance (1.6). One of our most painful national memories, the Vietnam War saw thousands of young men and women lose their lives in a distant conflict that was increasingly questioned and protested at home. By the war's end, the nation was so bitterly divided that returning veterans received virtually no recognition for their services. In this atmosphere of continuing controversy, Lin's task was to create a memorial that honored the human sacrifice of the war while neither glorifying nor condemning the war itself.

At the heart of the memorial is a long, tapering, V-shaped wall of black granite, inscribed with the names of the missing, the captured, and the dead—some 58,000 names in all. Set into the earth exposed by slicing a great wedge from a gently sloping hill, it suggests perhaps a modern entrance to an ancient burial mound, though in fact there is no entrance. Instead, the highly polished surface acts as a mirror, reflecting the surrounding trees, the nearby Washington Monument, and the visitors themselves as they pass by.

Entering along a walkway from either end, visitors are barely aware at first of the low wall at their feet. The monument begins just as the war itself did, almost unnoticed, a few support troops sent to a small and distant country, a few deaths in the nightly news. As visitors continue their descent along the downward-sloping path, the wall grows taller and taller until it towers overhead, names upon names upon names. Often, people reach out to touch the letters, and as they do, they touch their own reflections reaching back. At the walkway's lowest point, with the wall at its highest, a corner is turned. The path begins to climb upward, and the wall begins to fall away. Drawn by a view of either the Washington Monument (as in the photograph here) or the Lincoln Memorial (along the other axis), visitors leave the war behind.

In a quiet, unobtrusive way, the place that Maya Lin created encourages a kind of ritual, a journey downward into a valley of death, then upward toward hope, healing, and reconciliation. Like Stonehenge, it has served to bring a community together.

1.6 Maya Lin. Vietnam Veterans Memorial, Washington, D.C. 1982. Black granite, length 492'.

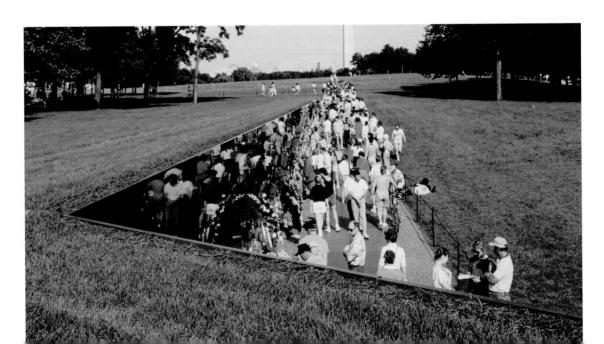

ARTISTS Maya Lin (b. 1959)

How do Lin's works provide a space for contemplation? Is she an architect or a sculptor? What kind of an artist is Lin?

ach of my works originates from a simple desire to make people aware of their surroundings, not just the physical world but also the psychological world we live in," Maya Lin has written. "I create places in which to think, without trying to dictate what to think."

The most famous of Maya Lin's places for thought was also her first, the Vietnam Veterans Memorial in Washington, D.C. Lin created the design in response to an open call for proposals for the memorial, and it was selected unanimously from the more than 14,000 entries that flooded in. We can imagine the judges' surprise when they dialed the winner's telephone number and found themselves connected to a dormitory at Yale University, where Lin was a twenty-two-year-old undergraduate student in architecture. Like much of Lin's work, the memorial's powerful form was the product of a long period of reading and thinking followed by a moment of intuition. On a trip to Washington to look at the site, she writes, "I had a simple impulse to cut into the earth. I imagined taking a knife and cutting into the earth, opening it up, an initial

violence and pain that in time would heal. The grass would grow back, but the initial cut would remain a pure flat surface in the earth with a polished, mirrored surface, much like the surface on a geode when you cut it and polish the edge." Engraved with the names of the dead, the surface "would be an interface, between our world and the quieter, darker, more peaceful world beyond. . . . I never looked at the memorial as a wall, an object, but as an edge to the earth, an opened side." Back at school, Lin gave her idea form in the university dining hall with two decisive cuts in a mound of mashed potatoes.

Maya Lin was born and grew up in Athens, Ohio. Her father, a ceramist, was chair of the fine arts department at Ohio University, while her mother, a poet, taught in the department of English there. Both parents had immigrated to the United States from China before Maya was born. Lin readily credits the academic atmosphere and her family's everyday involvement with art for the direction her life has taken. Of her father, she writes simply that "his aesthetic sensibility ran throughout our lives." She and her brother spent countless hours after school watching him work with clay in his studio.

Lin admits that it took a long time to put the experience of constructing the Vietnam Veterans Memorial behind her. Although the design had initially met with widespread public approval, it soon sparked an angry backlash that led to verbal, sometimes racist, attacks on her personally. They took a toll. For the next several years, she worked quietly for an architectural firm before returning to Yale to finish her doctoral studies. Since setting up her studio in 1987, she has created such compelling works as the Civil Rights Memorial in Montgomery, Alabama; *Wave Field*, an earthwork at the University of Michigan in Ann Arbor; and the Langston Hughes Library in Clinton, Tennessee.

Critics are often puzzled about whether to classify Lin as an architect or a sculptor. Lin herself insists that one flows into the other. "The best advice I was given was from Frank Gehry (the only architect who has successfully merged sculpture and architecture), who said I shouldn't worry about the distinctions and just make the work," Lin recalls. That is just what she continues to do.

Maya Lin discussing an upcoming project, 2006.

A second task artists perform is to *create extraordinary versions of ordinary objects*. Just as the Neolithic vessel we looked at earlier is more than an ordinary drinking cup, so the textile here is more than an ordinary garment (1.7). Woven in West Africa by artists of the Asante people, it is a spectacular example of a type of textile known as *kente*. *Kente* is woven in hundreds of patterns, each with its own name, history, and symbolism. Traditionally, a newly invented pattern was shown first to the king, who had the right to claim it for his own exclusive use. Like the Neolithic vessel, royal *kente* was reserved for ceremonial occasions. Rich, costly, and elaborate, the cloth distinguished its wearer as special as well, an extraordinary version of an ordinary human being.

A third important task for artists has been to *record and commemorate*. Artists create images that help us remember the present after it slips into the past, that keep us in mind of our history, and that will speak of our times to the future. Illustrated here is a painting created in the early 17th century by an artist named Manohar, one of several painters employed in the royal workshops of the emperor Jahangir, a ruler of the Mughal dynasty in India (1.8). At the center of the painting we see Jahangir himself, seated beneath a sumptuous canopy. His son Khusrau, dressed in a yellow robe, offers him the precious gift of a golden cup. The painting commemorates a moment of reconciliation between father and son, who had had a violent falling out. The moment did not last, however. Khusrau would soon stage an armed rebellion that cost him

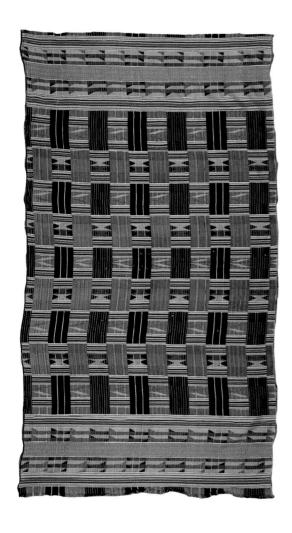

1.7 Kente cloth, from Ghana. Asante, mid-20th century. Cotton, 6'5¼" × 3'9".
The Newark Museum, New Jersey

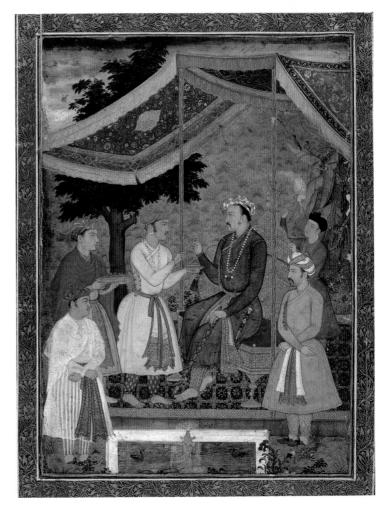

1.8 Manohar. Jahangir Receives a Cup from Khusrau. 1605–06. Opaque watercolor on paper, $8\% \times 6$ ". The British Museum, London

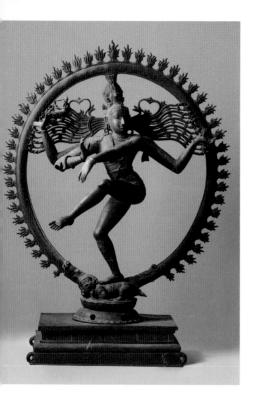

1.9 Shiva Nataraja. India, 10th century C.E. Bronze, height 511/41". Rijksmuseum, Amsterdam

the throne. Although the intricate details of Mughal history may be lost on us today, this enchanting painting gives us a vivid glimpse into their vanished world as they wanted it to be remembered.

A fourth task for artists is to *give tangible form to the unknown*. They portray what cannot be seen with the eyes or events that can only be imagined. An anonymous Indian sculptor of the 10th century gave tangible form to the Hindu god Shiva in his guise as Nataraja, Lord of the Dance (1.9). Encircled by flames, his long hair flying outward, Shiva dances the destruction and rebirth of the world, the end of one cycle of time and the beginning of another. The figure's four arms communicate the complexity of this cosmic moment. In one hand, Shiva holds the small drum whose beat summons up creation; in another hand, he holds the flame of destruction. A third hand points at his raised foot, beneath which worshipers may seek refuge, while a fourth hand is raised with its palm toward the viewer, a gesture that means "fear not."

A fifth function artists perform is to give tangible form to feelings and ideas. The statue of Shiva we just looked at, for example, gives tangible form to ideas about the cyclical nature of time that are part of the religious culture of Hinduism. In The Starry Night (1.10), Vincent van Gogh labored to express his personal feelings as he stood on the outskirts of a small village in France and looked up at the night sky. Van Gogh had become intrigued by the belief that people journeyed to a star after their death, and that there they continued their lives. "Just as we take the train to get to Tarascon or Rouen," he wrote in a letter, "we take death to reach a star." Seen through the prism of that idea, the night landscape inspired in him a vision of great intensity. Surrounded by halos of radiating light, the stars have an exaggerated, urgent presence, as though each one were a brilliant sun. A great wave or whirlpool rolls across the sky-a cloud, perhaps, or some kind of cosmic energy. The landscape, too, seems to roll on in waves like an ocean. A tree in the foreground writhes upward toward the stars as though answering their call. In the distance, a church spire points upward as well. Everything is in turbulent motion. Nature seems alive, communicating in its own language while the village sleeps.

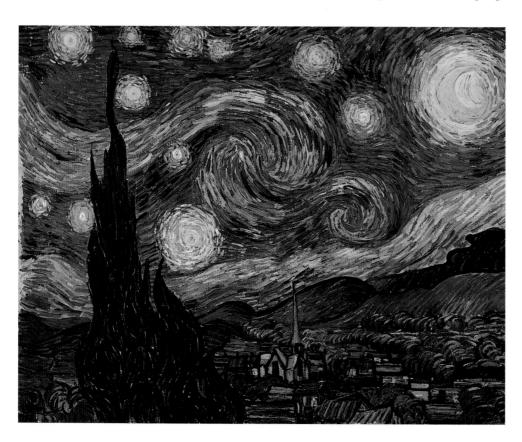

1.10 Vincent van Gogh. *The Starry Night*. 1889. Oil on canvas, $29 \times 36\%$ ". The Museum of Modern Art, New York

ARTISTS Vincent van Gogh (1853–1890)

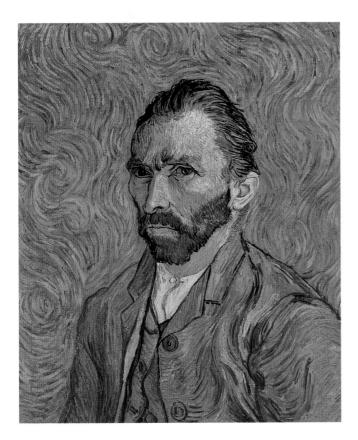

Why do Van Gogh's life and works appeal to us? How does his style reflect his emotional suffering and his response to it?

he appeal of Van Gogh for today's art lovers is easy to understand. A painfully disturbed, tormented man who, in spite of his great anguish, managed to create extraordinary art. An intensely private, introspective man who wrote eloquently about art and about life. An erratic, impulsive man who had the self-discipline to construct an enormous body of work in a career that lasted only a decade.

Vincent van Gogh was born in the town of Groot-Zundert, in the Netherlands, the son of a Dutch Protestant minister. His early life was spent in various roles, including those of theological student and lay preacher among the miners of the region. Not until the age of twenty-seven did he begin to take a serious interest in art, and then he had but ten years to live. In 1886 he went to stay in Paris with his brother Theo, an art dealer,

who was always his closest emotional connection. In Paris, Vincent became aware of new art movements such as Impressionism and incorporated aspects of them into his own style, especially by introducing light, brilliant colors into his palette.

Two years later, Van Gogh left Paris for the southern city of Arles. There he was joined briefly by the painter Paul Gauguin, with whom Van Gogh hoped to work closely, creating perfect art in a pure atmosphere of self-expression. However, the two artists quarreled, and, apparently in the aftermath of one intense argument, Van Gogh cut off a portion of his ear and had it

delivered to a prostitute.

Soon after that bizarre incident, Van Gogh realized that his instability had got out of hand, and he committed himself to an asylum, where—true to form—he continued to work prolifically at his painting. Most of the work we admire so much was done in the last two and a half years of his life. Vincent (as he always signed himself) received much sympathetic encouragement during those years, both from his brother and from an unusually perceptive doctor and art connoisseur, Dr. Gachet, whom he painted several times. Nevertheless, his despair deepened, and in July of 1890 he shot himself to death.

Vincent's letters to his brother Theo represent a unique document in the history of art. They reveal a sensitive, intelligent artist pouring out his thoughts to someone uniquely capable of understanding them. In 1883, while still in the Netherlands, he wrote to Theo: "In my opinion, I am often rich as Croesus, not in money, but (though it doesn't happen every day) rich, because I have found in my work something to which I can devote myself heart and soul, and which gives inspiration and significance to life. Of course my moods vary, but there is an average of serenity. I have a sure faith in art, a sure confidence that it is a powerful stream, which bears a man to harbor, though he himself must do his bit too; and at all events I think it such a great blessing, when a man has found his work, that I cannot count myself among the unfortunate. I mean, I may be in certain relatively great difficulties, and there may be gloomy days in my life, but I shouldn't want to be counted among the unfortunate nor would it be correct."

Vincent van Gogh. Self-Portrait. 1889. Oil on canvas, $25\% \times 21\%$ ". Musée d'Orsay, Paris

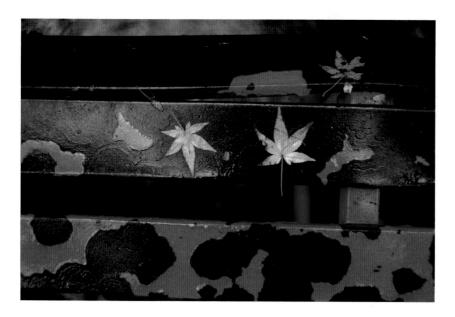

1.11 Ernst Haas. *Peeling Paint on Iron Bench, Kyoto*. 1981. Kodachrome print.

Finally, artists refresh our vision and help us see the world in new ways. Habit dulls our senses. What we see every day we no longer marvel at, because it has become familiar. Through art we can see the world through someone else's eyes and recover the intensity of looking for the first time. Ernst Haas' photograph Peeling Paint on Iron Bench, Kyoto (1.11) singles out a small detail of an ordinary day and asks us to notice how rich it is if we really take the time to look. Rain has made the colors shine with fresh intensity, brilliant red against deep black, and the star-shaped leaves could almost be made of gold. After seeing through Haas' eyes, we may find ourselves—if only for a few hours—more attentive to the world around us, which is stranger, more mysterious, more various, and more beautiful than we usually realize.

Creating and Creativity

Out walking on a rainy day in Kyoto, Ernst Haas could have noticed the park bench, smiled with pleasure, and continued on his way. Standing in a field over a century ago, Van Gogh could have had his vision of the night sky, then returned to his lodgings—and we would never have known about it. We all experience the moments of insight that put us where art begins. For most of us, such moments are an end in themselves. For artists, they are a beginning, a kind of raw material that sets a creative process in motion.

Creativity is a word that comes up often when talking about art, but what is creativity exactly? Are we born with it? Can it be learned? Can it be lost? Are artists more creative than other people? If so, how did they get that way? Creativity has been broadly defined as the ability to produce something that is both innovative and useful within a given social context. Although the exact nature of creativity remains elusive—there is no definitive test for it—psychologists agree that creative people tend to possess certain traits: Creative people have the ability to generate numerous ideas, many of them quite original, then to analyze their ideas, selecting the most promising ones to develop. They redefine problems and seek connections between seemingly unrelated ideas. They tend to have a playful side, but they are also capable of long periods of intense, concentrated work. They take risks, remain open to experience, and do not feel restricted by existing knowledge or conventional solutions.

Recently, advances in brain monitoring and imaging technologies have allowed neuroscientists to investigate creativity from their own point of view,

with fascinating, though inconclusive, results. Using Magnetic Resonance Imaging (MRI) to monitor white matter—the tissue that transmits signals from one area of the brain to another—one group of researchers discovered that nerve traffic (i.e., signal transmission) in a creative brain is slower and more meandering in key areas, perhaps allowing more novel and varied ideas to be linked up (1.12). Another study compared the brain activity of trained musicians and nonmusicians as they improvised on a keyboard. Researchers found that, when improvising, the trained musicians shut down the part of the brain that reads and sorts through incoming stimuli. By doing this, they blocked out potential distractions, allowing themselves to focus exclusively on the music they were making. Years of training had made an extra level of concentration available to them.

Looking at a work of art, we know we are seeing the end result of a creative process, but we rarely have access to the process itself. Occasionally, sketches of initial ideas for a work survive, or photographs that document its progress. In the case of Mike Kelley's *Kandors Full Set* (1.13), we are lucky enough to have a text from the artist that relates how the work came to have the form we see, and through it we can witness something of the creative process in action.

A fictional city on the fictional planet of Krypton, Kandor is the place where Superman, the comic-book hero, was born. In the Superman story, we learn that Krypton was destroyed. Kandor, however, was miniaturized and stolen before the disaster. It eventually ended up in Superman's possession; he keeps it under a glass bell jar in his Fortress of Solitude. The subject of Kandor first occurred to Kelley when he was asked to participate in a museum exhibit that took place at the turn of the millennium, 1999–2000. Taking the beginning of a new century as its theme, the exhibition was to include historical objects from past "turns of the century," with an emphasis on "new media of the past." Several contemporary artists were asked to create work responding to these themes.

Kelley was drawn to Kandor because the Superman artists of the past had imagined it as a "city of the future," much like cities in old science-fiction films. His initial idea was to use the Internet, a new medium just then coming into popular use, to reach out to Superman fans, asking them to contribute information and ideas about Kandor to a Web site. From their input, models of the city would be created for exhibit in the museum. Web site participants would be flown to the opening of the exhibition, showing that the project had created a community, and that fears that the Internet would isolate people and disconnect them from reality were unfounded.

Kelley's initial idea had to be modified almost immediately: The museum's budget could not cover setting up a Web site, much less travel expenses for the participants. Another idea took shape. During his research for the project, Kelley had received from a collector photocopies of every image of Kandor that

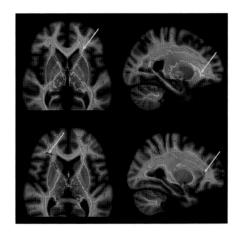

1.12 Scans showing nerve traffic pathways through white matter in the brain. Arrows point to regions where nerve traffic slows in individuals identified as creative. Courtesy Rex Jung, Brain & Behavioral Associates, PC

1.13 Mike Kelley. Kandors Full Set, detail. 2005–09. Cast resin, blown glass, illuminated pedestals; dimensions variable.
Punta della Dogana, François Pinault Foundation, Venice.
Courtesy Gagosian Gallery

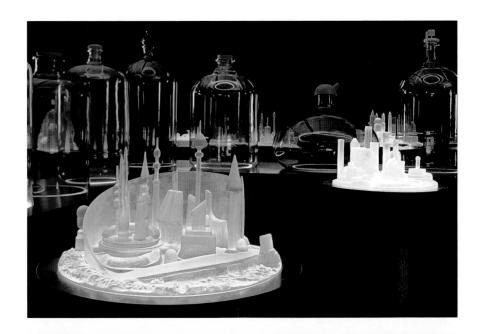

had appeared in the Superman series. He was intrigued to find that the city had never been drawn the same way twice. There had never been a standardized image for the artists to follow. In the unstable image of Superman's childhood home, Kelley found a link to one of his own artistic preoccupations: the partial and unrecoverable nature of childhood memories, including memories of the spaces in which childhood unfolded.

Kelley asked a digital animator to create a video of Kandor's constantly shifting shape, and he commissioned architects to begin a scale model of Kandor that drew freely on the photocopied images. The architects worked continuously as part of the exhibition, which included signage that advertised Kandor as though it were a housing development in progress. Kandor would be completed in the year 419500, one billboard announced—Kelley's estimate of how long it would take to build a model of every building in every version of the city. The project had shifted in meaning from Kelley's original concept, becoming a work about failure—failure to recapture the past, and the failure of so many optimistic visions of the future to come true.

The theme of Kandor was so rich that Kelley continued with it, this time focusing on the bell jar that kept the miniature city alive. He decided to have twenty jars blown of colored glass, reproducing designs that appeared in the Superman images. Using the figures from the cartoon panels as a guide to scale, the largest jars were to be over 40 inches in height. One famous glass center after another told him that it was physically impossible to blow a vessel that large, but Kelley persevered, finally locating a glass blower who agreed to take on the challenge.

Kelley wanted to create a sense of motion and atmosphere inside the jars. He experimented with a number of methods to achieve this, including having particles of various substances blown around inside each jar by a compressor. This solution proved too noisy, but videos made of the swirling particles were captivating. Kelley worked with a composer to develop a sound track for the whirling, atmospheric patterns of each video. He had hoped to project the videos onto the bottles, but he found the results disappointing. Still, the videos were so compelling that he decided to include them in the exhibition, projected onto the walls. The jars, he decided, would now house models of twenty versions of Kandor cast in colored, translucent resin. Set on bases that Kelley designed after the Superman images and lit from below, the models seem to glow from within. Only ten of the models were completed in time for the projected exhibit in 2007, but Kelley eventually finished all twenty, showing the complete set for the first time in 2010 as illustrated on page 13. Visitors wandered in a darkened room amid a display of luminous, jewel-like cities, empty bell jars, and haunting videos. Kelley had created an enchanted space, a prolonged meditation on memory, loss, and desire.

We can see many of the traits of creativity at work in Kelley's narrative of his Kandor projects: the leap of imagination that led him to link Kandor to the museum's proposal, the flexibility with which he responded to setbacks by generating new ideas, the way continued reflection on the theme deepened its meaning for him and suggested new forms, his willingness to experiment and take risks, and, not least, the persistence and concentration that allowed him to see the project through to completion.

The profession of artist is not the only one that requires creativity. Scientists, mathematicians, teachers, business executives, doctors, librarians, computer programmers—people in every line of work, if they are any good, look for ways to be creative. Artists occupy a special place in that they have devoted their lives to opening the channels of *visual* creativity.

Can a person learn to be more creative? Absolutely, say researchers. The key to creativity is the ability to alternate quickly between two modes of thinking, generating ideas and analyzing them, and this ability can be consciously cultivated. Furthermore, by regularly practicing a creative activity, people can learn to tap into the brain's creative network more rapidly and effectively. Creativity may not bring happiness, but it promotes a richer, more engaged life, and it is as essential to looking at art as it is to making it. We close this chapter with a look at what creative looking might entail.

Looking and Responding

Science tells us that seeing is a mode of perception, which is the recognition and interpretation of sensory data—in other words, how information comes into our eyes (ears, nose, taste buds, fingertips) and what we make of it. In visual perception, our eyes take in information in the form of light patterns; the brain processes these patterns to give them meaning. The role of the eyes in vision is purely mechanical. Barring some physical disorder, it functions the same way for everyone. The mind's role in making sense of the information, however, is highly subjective and belongs to the realm of psychology. Simply put, given the same situation, we do not all notice the same things, nor do we interpret what we see in the same way.

One reason for differences in perception is the immense amount of detail available for our attention at any given moment. To navigate efficiently through daily life, we practice what is called selective perception, focusing on the visual information we need for the task at hand and relegating everything else to the background. But other factors are in play as well. Our mood influences what we notice and how we interpret it, as does the whole of our prior experience—the culture we grew up in, relationships we have had, places we have seen, knowledge we have accumulated.

The subjective nature of perception explains why a work of art may mean different things to different people and how it is that we may return to a favorite work again and again, noticing new aspects of it each time. It explains why the more we know, the richer each new encounter with art will be, for we will have more experience to bring to it. It explains why we should make every effort to experience as much art in person as possible, for physical dimensions also influence perception. The works reproduced in this book are miniaturized. Many other details escape reproduction as well.

Above all, the nature of perception suggests that the most important key to looking at art is to become aware of the process of looking itself—to notice details and visual relationships, to explore the associations and feelings they inspire, to search for knowledge we can bring to bear, and to try to put what we see into words. A quick glance at Juan de Valdés Leal's *Vanitas* (1.14) reveals a

1.14 Juan de Valdés Leal. *Vanitas*. 1660. Oil on canvas, $51\frac{3}{4} \times 39\frac{5}{6}$ ". Wadsworth Atheneum, Hartford

careless jumble of objects with a cherub looking over them. In the background, a man looks out at us from the shadows. But what are the objects? And what are the cherub and the man doing? Only if we begin to ask and answer such questions does the message of the painting emerge.

In the foreground to the left is a timepiece. Next to it are three flowers, each one marking a stage in the brief life of a flower across time: budding, then blossoming, then dying as its petals fall away. Then come dice and playing cards, suggesting games of chance. Further on, a cascade of medals, money, and jewelry leads up to an elaborate crown, suggesting honors, wealth, and power. At the center, books and scientific instruments evoke knowledge. Finally, back where we began, a skull crowned with a laurel wreath lies on its side. Laurel traditionally crowns those who have become famous through their achievements, especially artistic achievements.

Over this display the cherub blows a bubble, as though making a comment on the riches before him. A bubble's existence is even shorter than a flower's—a few seconds of iridescent beauty, and then nothing. When we meet the man's gaze, we catch a glimpse of a wing: He is an angel, a messenger. He has drawn back a heavy curtain with one hand and is pointing at a painting he has thus revealed with the other. "Look at this," he all but speaks. The painting depicts the Last Judgment. In Christian belief, the Last Judgment is the moment when Christ will appear again. He will judge both the living and the dead, accepting some into Paradise and condemning others to Hell. The universe will end, and with it time itself.

We might paraphrase the basic message of the painting something like this: "Life is fleeting, and everything that we prize and strive for during it is ultimately meaningless. Neither wealth nor beauty nor good fortune nor power nor knowledge nor fame will save us when we stand before God at the end of the world." Without taking the time to perceive and reflect on the many details of the image, we would miss its message completely.

Vanitas is Latin for "vanity." It alludes to the biblical Book of Ecclesiastes, a meditation on the fleeting nature of earthly life and happiness in which we read that in the end, "all is vanity." The title wasn't invented or bestowed by the

artist, however. Rather, it is a generic name for a subject that was popular during his lifetime. Numerous *vanitas* paintings have come down to us from the 17th century, and together they show the many ways that artists treated its themes.

Closer to our own time, the painter Audrey Flack became fascinated by the *vanitas* tradition, and she created a series of her own, including *Wheel of Fortune (Vanitas)* (1.15). Knowing something of the tradition Flack is building on, we can more easily appreciate her updated interpretation. As ever, a skull puts us in mind of death. An hourglass, a calendar page, and a guttering candle speak of time and its passing. The necklace, mirrors, powder puff, and lipstick are contemporary symbols of personal vanity, while a die and a tarot card evoke the roles of chance and fate in our lives. As in the painting by Valdés, a visual echo encourages us to think about a connection, in this case between the framed oval photograph of a young woman and the framed oval reflection of the skull just below.

Flack may be painting with one eye on the past, but the other is firmly on our society as we are now. For example, she includes modern inventions such as a photograph and a lipstick tube, and she shuns symbols that no longer speak to us directly such as laurels and a crown. The specifically Christian context is gone as well, resulting in a more general message that applies to us all, regardless of faith: time passes quickly, beauty fades, chance plays a bigger role in our lives than we like to think, death awaits.

Despite their differences, both Flack and Valdés provide us with many clues to direct our thoughts. They depict objects that have common associations and then trust us to add up the evidence. At first glance, a contemporary work such as Jim Hodges' Every Touch seems very different (1.16). Every Touch is made of artificial silk flowers, taken apart petal by petal. The petals were ironed flat, intermingled, then stitched together to form a large curtain or veil. Yet although Every Touch may not direct our thoughts as firmly as the other works, we approach it in the same way. We look, and we try to become aware of our looking. We ask questions and explore associations. We bring our experience and knowledge to bear. We interrogate our feelings.

1.16 Jim Hodges. *Every Touch*. 1995. Silk flowers, thread, 16 × 14'. Philadelphia Museum of Art. Image courtesy the artist and Gladstone Gallery, New York and Brussels

We might think of spring. We might be put in mind of other art, such as the flowered backgrounds of medieval tapestries (see 15.24) or the role of flowers in the *vanitas* tradition. We might think about flowers and the occasions on which we offer them. We might think about the flowers we know from poetry, where they are often linked to beauty and youth, for all three fade quickly. We might think about petals, which fall from dying flowers. We might think about veils and when we wear them, such as at weddings and funerals. We might notice how delicately the work is stitched together and how fragile it seems. We might think about looking not only *at* it but also *through* it, and about how a curtain separates one realm from another. The angel in Valdés' painting, for example, draws back a curtain to reveal the future.

Every Touch is not as easily put into words as the vanitas paintings, but it can inspire thoughts about many of the same ideas: seasons that come and go, how beauty and sadness are intertwined, the ceremonies that mark life's passing, the idea of one realm opening onto another, the fragility of things. In the end, what we see in Every Touch depends on what we bring to it, and

if we approach the task sincerely, there are no wrong answers.

Every Touch will never mean for any of us exactly what it means for Hodges, nor should it. An artist's work grows from a lifetime of experiences, thoughts, and emotions; no one else can duplicate them exactly. Works of art hold many meanings. The greatest of them seem to speak anew to each generation and to each attentive observer. The most important thing is that some works of art come to mean something for you, that your own experiences, thoughts, and emotions find a place in them, for then you will have made them live.

What Is Art?

rt is something that has great value in our society. Across the country, art museums are as much a point of civic pride as new sports stadiums, pleasant shopping districts, public libraries, and well-maintained parks. From daring structures designed by famous architects to abandoned industrial buildings reclaimed as exhibition spaces, new museums are encouraged by city governments eager to revitalize neighborhoods and attract tourists. Inside our museums, art is made available in many ways, not only in the galleries themselves, but also in shops that offer illustrated books, exhibition catalogs, and photographs of famous artworks reproduced on posters, calendars, coffee mugs, and other merchandise. The prestige of art is such that many of us visit museums because we feel it is something we ought to do, even if we're not exactly sure why.

Many artists from the past have left moving accounts of just how much they, too, valued art. For Vincent van Gogh, to be an artist was a great and noble calling, even if the price to be paid for it in life was high. In a letter written to keep up his brother Theo's flagging spirits, he admitted that the two of them were "paying a hard price to be a link in the chain of artists, in health, in youth, in liberty, none of which we enjoy. . . ." And yet, he continued, "there is an art of the future, and it is going to be so lovely and so young that even if we give up our youth for it, we must gain in serenity by it." Here as elsewhere he speaks of art in a way that makes it seem greater than any single painting or sculpture, something that exists in an ideal realm.

Van Gogh's world was not so far removed from ours. He bought his paints and brushes at an art supply store, just as we could. He walked out into the nearby countryside and set up his easel at the edge of a field, just as we could. He painted *Wheat Field and Cypress Trees* (2.1, next page) . . . and here we feel the comparison ends. Van Gogh was an artistic genius. His vision of the world was so strong, so uniquely individual, that the force of it seems present in every brush stroke. The world itself bends to his intense way of seeing, its colors heightened, its forms undulating and alive: the golden grain, the writhing olive tree, the tumbling blue hills, the ecstatic, cloud-filled sky.

In another letter to his brother, Vincent sounds both prickly and confident. "I cannot help it that my pictures do not sell," he writes. "Nevertheless the time will come when people will see that they are worth more than the price of the paint and my own living, very meager after all, that is put into them." After his death, that prediction came true. Even Van Gogh, however, could not have imagined that in 1990 one of his paintings would sell for 82.5 million dollars, at that time the highest price ever paid for a work of art. We are a long way from the cost of paint, lodgings, and food.

2.1 Vincent van Gogh. Wheat Field and Cypress Trees. 1889. Oil on canvas, $28\frac{1}{2} \times 36$ ". The National Gallery, London

2.2 Robert Watts. *Rembrandt Signature*. 1965/1975. Neon, glass tubing, Plexiglas, wiring, and transformer; 13½ × 44 × 9½". Courtesy Robert Watts Estate, New York

Money, of course, is one way in which we express value. Part of the value today of a painting by Van Gogh lies in the fact that his work had a major influence on artists of the next generation, and so when we tell the story of Western art, he plays an important role. Part of the value also comes from the fact that there are a limited number of paintings from his hand, and there will be no more. But much of the value seems to lie elsewhere, in the connection that the painting allows us to feel with the artist himself, who has become a cultural hero for us, both for his accomplishments and for the story of his life.

We value not only art but also artists. We are interested in their lives. A handful of artists are so well known that even people who know nothing about art can recite their names. Van Gogh is one. Picasso, Michelangelo, and Rembrandt are others. In casual speech, we use them almost as brand names, saying "That's a Picasso" in the same way we might say "That's a BMW." Robert Watts created a work about this phenomenon in *Rembrandt Signature*, which is nothing more or less than the great painter's signature reproduced in neon as a work of art in its own right (2.2).

Certain works of art, too, have become as famous generally as they are among art lovers. Van Gogh's own *Starry Night* is one of these (see 1.10). Another is the *Aphrodite of Melos*, popularly known as the *Venus de Milo* (see 14.28). But by far the most famous work of Western art in the world is the portrait known as *Mona Lisa*. Andy Warhol paid tribute to her renown in his slyly titled *Thirty Are Better than One* (2.3). Warhol portrays the painting as a celebrity, someone whose instantly recognizable image circulates in endless multiples through our

mass media. He depicted stars such as Marilyn Monroe and Elvis Presley in the same way, repeating their publicity photos again and again.

Warhol was fascinated by how celebrities have a separate existence as images of themselves. But just as Marilyn Monroe and Elvis Presley were also private individuals with private lives, so of course the *Mona Lisa* is an actual painting with a physical existence and a history (2.4). It was painted by Leonardo da Vinci during the early years of the 16th century. The sitter was a woman named Lisa Gherardini del Giocondo. Leonardo portrays her seated on a balcony that overlooks a landscape of rock and water. Her left forearm rests on the arm of her chair; her right hand settles gently over her left wrist. She turns her head to look at us with a hint of a smile.

The portrait dazzled Leonardo's contemporaries, to whom it appeared almost miraculously lifelike. The *Mona Lisa*'s current fame, however, is a product of our own modern era. The painting first went on view to the public in 1797, when it was placed in the newly created Louvre Museum in Paris. Writers and poets of the 19th century became mesmerized by what they took to be the mystery and mockery of the sitter's smile. They described her as a dangerous beauty, a fatal attraction, a mysterious sphinx, a vampire, and all manner of fanciful things. The public flocked to gaze. When the painting was stolen from the museum in 1911, people stood in line to see the empty space where it had been. When the painting was recovered two years later, its fame was greater than ever.

Today, still in the Louvre, the *Mona Lisa* attracts millions of visitors every year. Crowds gather. People standing toward the back raise their cameras over their heads to get a photograph of the famous masterpiece in the distance.

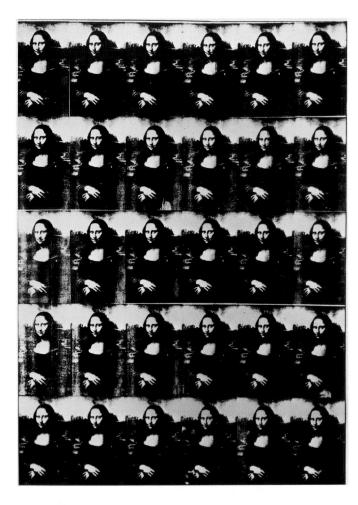

2.3 Andy Warhol. *Thirty Are Better than One.* 1963. Silkscreen ink, acrylic paint on canvas, $9'2'' \times 7'10\%''$.

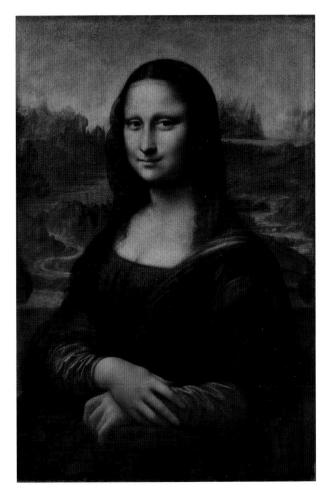

2.4 Leonardo da Vinci. *Mona Lisa*. c. 1503–05. Oil on panel, $30\% \times 21$ ". Musée du Louvre, Paris

Those patient enough to make their way to the front find their view obscured by glare from the bulletproof-glass box in which the priceless painting is encased. The layer of protective varnish covering the paint surface has crackled and yellowed with age. Cleaning techniques exist, but who would take the risk?

Obviously, we do not see the *Mona Lisa* as Leonardo's contemporaries did, before the crowds, before the glass, and when its colors were fresh. Few people know, however, that scholars long suspected we do not see as much of it, either. If you follow the balcony ledge out to the left and right edges of the painting, you will notice two small, curved forms—the bases of two columns. Early copies of the painting include these columns, which frame the sitter. Based on the evidence of these presumably faithful copies, scholars assumed that at some point in its history the *Mona Lisa* had been trimmed down, its columns cut away. Today, with our regard for art and for the genius of Leonardo, that seems unimaginable. Yet it was not so unusual for its time. Paintings might be trimmed down or enlarged, often to fit a favorite frame.³ Elaborate frames were luxury items as well, and highly prized.

The ideas we have about art today have not always been in place. Like the fame of the *Mona Lisa*, they are a development of our modern era, the period that began a little over two hundred years ago. Even our use of the word *art* has a history. During the Middle Ages, the formative period of European culture, *art* was used in roughly the same sense as *craft*. Both words had to do with skill in making something. Forging a sword, weaving cloth, carving a cabinet—all of these were spoken of as arts, for they involved specialized skills.

Beginning around 1500, during the period known as the Renaissance, painting, sculpture, and architecture came to be thought of as more elevated forms of art, but it was not until the 18th century that the division became formalized. It was then, during the period we know as the Enlightenment, that philosophers grouped painting, sculpture, and architecture together with music and poetry as the *fine arts* on the principle that they were similar kinds of activities—activities that required not just skill but also genius and imagination, and whose results gave pleasure as opposed to being useful. As the 19th century began, the word "fine" tended to drop away, leaving only art, often capitalized to distinguish it from earlier uses and underscore its new prestige. Also during the Enlightenment, the philosophical field of aesthetics came into being and began to ask questions: What is the nature of art? Is there a correct way to appreciate art? Are there objective criteria for judging art? Can we apply our concept of art to other cultures? Can we apply it backward to earlier eras in our own culture?

Many answers have been proposed, but the fact that philosophers still debate them should tell us that the questions are not easy. This chapter will not give any definitive answers. Rather, we will explore topics that touch on some common assumptions many of us have about art. We will look at where our ideas come from and compare them with ideas that were current earlier and elsewhere. Our goal is to arrive at an understanding of art as we find it today, in the first decades of the 21st century.

Artist and Audience

Claude Monet's Fisherman's Cottage on the Cliffs at Varengeville is the kind of painting that almost everyone finds easy to like (2.5). The colors are clear and bright. There is no difficult subject matter that needs explaining. We can imagine ourselves on vacation, taking a walk along the cliffs high over a beach below. We've stopped to appreciate the view near a quaint fisherman's cottage. How pretty the orange tile roof looks against the deep blue waters!

Monet belonged to a group of painters we know as the Impressionists. Most of them met as art students in Paris, and they banded together because they shared certain ideas about what art could be. Like Van Gogh, his junior

2.5 Claude Monet. Fisherman's Cottage on the Cliffs at Varengeville. 1882. Oil on canvas, 235/8 × 3113/16".

Museum of Fine Arts, Boston

by fifteen years, Monet spent his early adult years in poverty, painting pictures that few people wanted to buy. Unlike Van Gogh, however, he lived long enough to see his art triumph, eventually finding galleries willing to display his paintings to the public, critics able to write insightfully about them, and collectors eager to buy them. Museums accepted his work into their collections. When he died at age eighty-six, his reputation as a great and influential painter was secure. All along he had been faithful to his personal artistic vision, working to express the quality of light on the landscape at different times of day, under various weather conditions, and across the seasons.

Monet's world of art schools, galleries, critics, collectors, and museums is still with us, and artists still struggle to make their way in it. We may think of it as the way things have always been, but to the 15th-century Italian artist Andrea del Verrocchio, it would have seemed strange indeed. One of the foremost artists of the early Renaissance, Verrocchio did not create what he wanted to but what his clients asked him for. He did not work alone but ran a workshop staffed with assistants and apprentices—a small business, essentially, that produced paintings, altarpieces, sculptures, banners, objects in precious metals, and architecture. He did not hope to have his art enshrined in museums, for there were no museums. Instead, displayed in public spaces, private residences, civic buildings, churches, and monasteries, the products of his workshop became part of the fabric of daily life in Florence, the town where he lived and worked.

One of Verrocchio's best-known works is a statue of the biblical hero David (2.6). The work was commissioned by Piero de' Medici, the head of a wealthy and powerful Florentine family, for display in the Medici family palace. Piero's sons later sold it to the City of Florence, which had adopted the story of David and his victory over Goliath as an emblem of its own determination to stand up to larger powers. Thereafter, the statue was displayed in the city hall.

Verrocchio had learned his skills as all artists of the time did, by serving as an apprentice in the workshop of a master. Boys (the opportunity was available only to males) began their apprenticeship between the ages of seven and fifteen. In exchange for their labor they received room and board and sometimes a small salary. Menial tasks came first, together with drawing lessons. Gradually apprentices learned such essential skills as preparing surfaces for painting and casting statues in bronze. Eventually, they were allowed to collaborate with the master on important commissions. When business was

2.6 Andrea del Verrocchio. David. c. 1465. Bronze with gold details, height 3'11¼".
Museo Nazionale del Bargello, Florence

slow, they might make copies of the master's works for sale over the counter. Verrocchio trained many apprentices in his turn, including a gifted teenager named Leonardo da Vinci. The *David* may actually be a portrait of him.

Our next three artists had yet another working arrangement and audience. Dasavanta, Madhava Khurd, and Shravana were employed in the royal workshops of Akbar, a 16th-century emperor of the Mughal dynasty in India. Their job, for which they were paid a monthly salary, was to produce lavishly illustrated books for the delight of the emperor and his court. Akbar ascended to the throne at the age of thirteen, and one of his first requests was for an illustrated copy of the *Hamzanama*, or *Tales of Hamza*. Hamza was an uncle of the Prophet Muhammad, the founder of Islam. The stories of his colorful adventures were (and still are) beloved throughout the Islamic world.

Illustrating the 360 tales of the *Hamzanama* occupied dozens of artists for almost fifteen years. The painting here portrays the episode in which *Badi'uzzaman Fights Iraj to a Draw* (2.7). Prince Badi'uzzaman (in orange) is one of Hamza's sons. Iraj (in green) is a warrior who fights him just to see if he is as brave as he is reputed to be. Looming up in the background is Landhaur, a friend of Hamza's. He is portrayed as a giant on a giant elephant, perhaps because of his role as an important presence behind the scenes.

A single artist would sometimes be responsible for an entire illustration, but more often the paintings were the result of collaboration, with each artist contributing what he did best. Here, Dasavanta created the overall design and painted the lavender rock formation with its billowing miniature mountain. Madhava Khurd was called on to paint Landhaur and his elephant, while Shravana was responsible for the rest of the figures. Like Verrocchio, these artists would have learned their skills as apprentices.

Our fourth and final artist takes us out of the realm of professional training, career paths, and intended audiences altogether. James Hampton had no particular training in art, and the only audience he ever sought during his lifetime was himself. Hampton worked for most of his adult life as a janitor for the

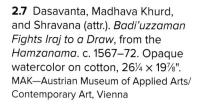

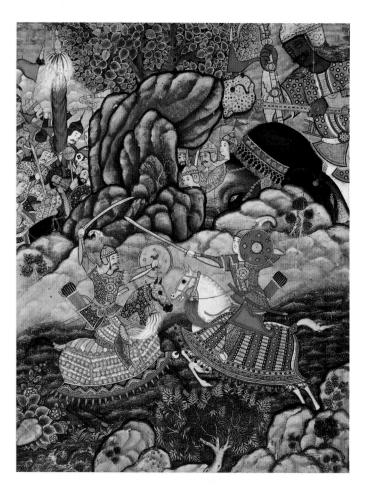

federal government in Washington, D.C., but for many years he labored secretly on an extraordinary work called *Throne of the Third Heaven of the Nations' Millennium General Assembly* (2.8). Discovered after his death in a garage that he had rented, the work represents Hampton's vision of the preparation for the Second Coming as described in the biblical Book of Revelation. Humble objects and cast-off furniture are here transformed by silver and gold foil to create a dazzling setting ready to receive those who will sit in judgment at the end of the world.

We do not know whether Hampton considered himself an artist or whether he intended his work to be seen as art. He may have thought only about realizing a spiritual vision. The people who opened Hampton's garage after his death might easily have discarded *Throne of the Third Heaven of the Nations' Millennium General Assembly* as a curiosity. Instead, they recognized it as art, and today it is in a museum collection and on view to the public.

Our modern ideas about art carry with them ideas about the person who makes it, the artist, and the people it is for, the audience. We take it for granted that the artist's task is to pursue his or her own vision of art; to express his or her own ideas, insights, and feelings; and to create as inner necessity dictates. We believe these things so strongly that we recognize people such as James Hampton as artists and accept a broad range of creations as art. We assume that art is for anyone who takes an interest in it, and through museums, galleries, books, magazines, and academic courses we make it available to a wide public. Other times and places did not necessarily share these ideas, and most visual creators across history have worked under very different assumptions about the nature of their task, the purpose it served, and the audience it was for.

2.8 James Hampton. Throne of the Third Heaven of the Nations' Millennium General Assembly. c. 1950–64. Gold and silver aluminum foil, colored kraft paper and plastic sheets over wood, paperboard, and glass; 180 pieces, 105 × 27 × 14½'. National Museum of American Art,

National Museum of American Art, Smithsonian Institution, Washington, D.C.

Art and Beauty

Beauty is deeply linked to our thinking about art. Aesthetics, the branch of philosophy that studies art, also studies the nature of beauty. Many of us assume that a work of art should be beautiful, and even that art's entire purpose is to be beautiful. Why should we think that way, and is what we think true?

During the 18th century, when our category of art came into being, beauty and art were discussed together because both were felt to provide pleasure. When philosophers asked themselves what the character of this pleasure was and how it was perceived, their answer was that it was an intellectual pleasure and that we perceived it through a special kind of attention called disinterested contemplation. By "disinterested" they meant that we set aside any personal,

THINKING ABOUT ART Insiders and Outsiders

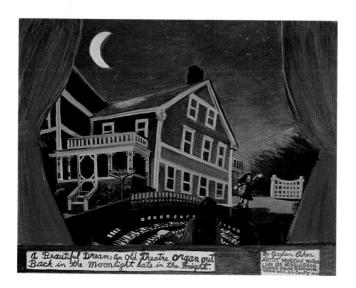

What makes an individual an artist? Do we and are we continuing to label art on the basis of an individual's training and style? How are we blurring the lines between insider and outsider today?

rom her girlhood during the 1940s until her unexpected death in March 2005, Gayleen Aiken made and exhibited puppets, drawings, and paintings such as the one illustrated here. Like many contemporary artists, she drew inspiration from popular culture, comic books, music, and local life—in this case the life of her hometown in Vermont. Aiken became well known, but not simply as an artist. She became known as an outsider artist.

Over the past several decades, there has been a great deal of interest in outsider art, art by so-called self-taught artists. These artists have little or no formal training in the visual arts and often live far from the urban centers traditionally associated with artistic creativity. With this interest, there has been an unprecedented growth in the number of venues that exhibit and sell outsider art. Many outsider artists maintain highly visible careers and have gained impressive followings among collectors and critics. There are even a number of magazines, such as *Raw Vision*, devoted to outsider art, and a museum, the American Visionary Art Museum.

The term *outsider* has come into common use only recently. Folk, naive, intuitive, primitive, and art brut (French for "raw art") have also been used over the past century to categorize work by nonprofessional artists. Interest in such work can be traced to the efforts of psychiatrist Hans Prinzhorn, who beginning in 1919 amassed thousands of pieces by patients in psychiatric hospitals around Europe. Prinzhorn's book Artistry of the Mentally Ill, published in 1922, greatly inspired many artists and writers. Leading figures of the Surrealist movement, for example, celebrated the art of the "insane," attributing to these artists the most exemplary works of Surrealism. Later, some of these same paintings would be used by the Nazis in their infamous Degenerate Art exhibition of 1937 to support their thesis that modern art was "pathological," for it resembled the art of the mentally ill. Many Prinzhorn artists were murdered in Nazi death camps.

Unlike such terms as Surrealism and Impressionism, outsider does not label a recognizable style or artistic movement. Rather, it attempts to define a group of people and their work as somehow "apart." Questions about what these artists are apart from, where the boundaries are drawn, and what social forces are at work in drawing them have placed outsider art at the center of a hotly contested debate over art's role in reinforcing society's attitudes about such topics as class, race, gender, and human difference. Indeed, the very notion of an artistic "outsider" has been called into question. Since the 19th century at least, critics point out, artists have tended to see themselves as visionaries and outsiders, even as outlaws. Hence, the line between insider and outsider has long been somewhat fuzzy. Paul Gauguin, for example, took great pride in his selfimposed "outsider" status (see 21.8).

The popularity of outsider art today is a result of the most progressive aspect of our modernity. The emergence and validation of difference within culture, the collapse of the distinction between an elite "high" culture and a popular "low" culture, the great proliferation of the popular arts—these are all part of the democratization of culture brought about by modernity, which has broadened our ideas about what we recognize as art and whom we consider to be an artist.

Gayleen Aiken. A Beautiful Dream. 1982. Oil on canvasboard, 12×16 ". Private Collection. Courtesy Grass Roots Art and Community Effort (GRACE), Hardwick, Vermont

practical stake we might have in what we are looking at. For example, if we are examining a peach to see whether it is ripe enough to eat, we are contemplating it with a direct personal interest. If we step back to admire its color, its texture, its roundness, with no thought of eating it, then we are contemplating it disinterestedly. If we take pleasure in what we see, we say the peach is beautiful.

Edward Weston's photograph Cabbage Leaf embodies this form of cool, distanced attention (2.9). Gazing at the way the light caresses the gracefully arching leaf, we can almost feel our vision detaching itself from practical concerns (good for coleslaw? or is it too wilted?). As we look, we become conscious of the curved object as a pure form, and not a thing called "cabbage leaf" at all. It looks perhaps like a wave crashing on the shore, or a ball gown trailing across a lawn. Letting our imagination play in this way was part of the pleasure that philosophers described.

But is pleasure what we always feel in looking at art? For a painting such as Giovanni Bellini's Pietà, "sadness" might be a more appropriate word (2.10). Italian for "pity," pietà is the name for a standard subject in Christian art, that of Mary, the mother of Jesus, holding her son after he was taken down from the cross on which he suffered death. Bellini intended the work as a devotional image, which is an image meant to focus and inspire religious meditation. Although the subject matter is both sad and moving, as opposed to pleasurable, many people may still find the painting to be beautiful.

2.9 Edward Weston. Cabbage Leaf. 1931. Gelatin silver print, $7\%6 \times 9\%6$ ".

The Museum of Modern Art, New York

2.10 Giovanni Bellini. Pietà. c. 1500-05. Oil on wood, $25\% \times 35\%$ ". Gallerie dell'Accademia, Venice

2.11 Francisco de Goya. *Saturn Devouring One of His Children*. c. 1820–22. Wall painting in oil on plaster (since detached and transferred to canvas), $57\% \times 32\%$ ". Museo del Prado, Madrid

Some theories link beauty to formal qualities such as symmetry, simple geometrical shapes, and pure colors. Here, for example, Bellini has arranged Mary's robes so that they form a symmetrical triangular shape. The white of Christ's loincloth is continued in Mary's head covering. The curve of the head covering is echoed by the curves of the roads in the background. The pure blue and violet of her robes are echoed by the paler blue of the sky and matched by the intense green of the vegetation behind her, while the rest of the painting is in subdued but glowing earth colors. If we find Bellini's *Pietà* beautiful, perhaps those are the qualities we are reacting to.

To contemplate the formal beauty of Bellini's painting, we detached ourselves from the pitiable subject matter in somewhat the same way that Edward Weston detached himself from any feelings he might have had about cabbages to create his photograph. But not all art makes this sort of detachment so easy. An image such as Francisco de Goya's Saturn Devouring One of His Children seems to shut down any possibility for aesthetic distance (2.11). It grabs us by the throat and shows us a vision of pure horror.

A Spanish painter working during the decades around the turn of the 19th century, Goya lived through tumultuous times and witnessed terrible acts of cruelty, stupidity, warfare, and slaughter. As an official painter to the Spanish court, he painted lighthearted scenes, tranquil landscapes, and dignified portraits, as asked. In works he created for his own reasons, he expressed his increasingly pessimistic view of human nature. Saturn Devouring One of His Children is one of a series of nightmarish images that Goya painted on the walls of his own house. By their compelling visual power and urgent message, we recognize them as extraordinary art. But we must admit that they leave notions of pleasure and beauty far behind.

Art can indeed produce pleasure, as the first philosophers of aesthetics noted. But it can also inspire sadness, horror, pity, awe, and a full range of other emotions. The common thread is that in each case we find the experience

of looking to be valuable for its own sake. Art makes looking worthwhile. Similarly, art can be beautiful, but not all art tries to be beautiful, and beauty is not a requirement for art. Beauty remains a mysterious concept, something that everyone senses, many disagree about, and no one has yet defined. Artists are as fascinated by beauty as any of us and return to it again and again, though not always in the form we expect. Often, they seek out beauty in new places—in a cabbage leaf, for example.

Art and Appearances

The son of a painter who taught drawing, Pablo Picasso showed talent as a child and was surrounded by people who knew how to nurture it. Like a Renaissance apprentice, he grew up so immersed in art that he mastered traditional techniques while still a teenager. He completed *First Communion* in 1896 at the age of fifteen, the year he was accepted into art school (2.12). After graduation, Picasso moved from Barcelona to Paris, then the center of new directions in art. There he experimented with style after style. The one that launched him on his mature path would become known as Cubism, and it began to take form in paintings such as *Seated Woman Holding a Fan* (2.13).

Picasso was part of a courageous generation of artists who opened up new territory for Western art to explore. These artists had been trained in traditional skills, and yet they set off on paths where those skills were not

2.12 Pablo Picasso. First Communion. 1895–96. Oil on canvas, 5'5%" \times 3'10%". Museo Picasso, Barcelona

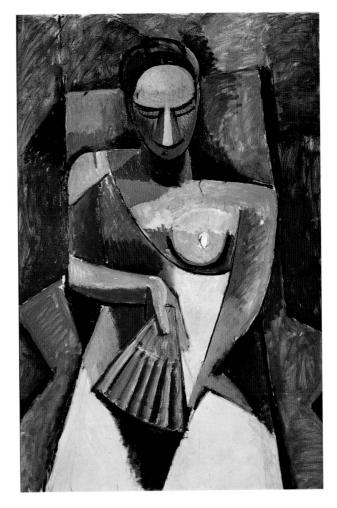

2.13 Pablo Picasso. Seated Woman Holding a Fan. 1908. Oil on canvas, $4'11'' \times 3'3\%''$. State Hermitage Museum, St. Petersburg

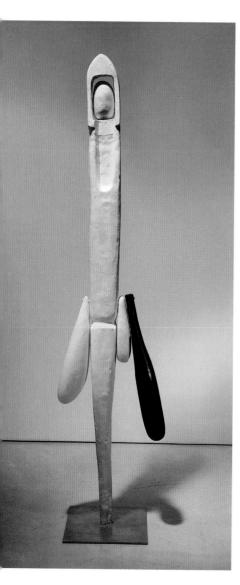

2.14 Louise Bourgeois. *Woman with Packages*. 1949. Bronze, polychromed, 65 × 18 × 12". Collection the Easton Foundation

required. Many people wish they hadn't. Many people feel that art should aim at representing appearances as faithfully as possible, that artists who do not do this are not good artists, and that paintings such as *Seated Woman Holding a Fan* are not good art, or perhaps not even art at all.

Where do we get these ideas? The simple answer is that we get them from our own artistic heritage. For hundreds of years, Western art was distinguished among the artistic traditions of the world by precisely the concerns that Picasso and others turned their backs on. The elevation of painting and sculpture to higher status during the Renaissance had gone hand in hand with the discovery of new methods for making optically convincing representations. From that time until almost the end of the 19th century, a period of about five hundred years, techniques for representing the observable world of light and shadow and color and space—the techniques evident in *First Communion*—formed the foundation upon which Western art was built.

Why did art change all of a sudden? There are many reasons, but Picasso, when asked, pointed to one in particular: photography. "Why should the artist persist in treating subjects that can be established so clearly with the lens of a camera?" he asked. Photography had been developed not long before the artists of Picasso's generation were born. They were the first generation to grow up taking it for granted. Photography is now so pervasive that we need to take a moment to realize how revolutionary that change was. From the Paleolithic cave paintings until about 160 years ago, images had to be made by hand. Suddenly, there was a mechanical way based on chemical reactions to light. For some artists, photography meant the end of painting, for manual skills were no longer needed to create a visual record. For Picasso, it meant liberation from a lifetime spent copying nature. "Now we know at least everything that painting isn't," he said.

If the essence of art was not visual fidelity, however, what was it? The adventure of the 20th century began.

Representational and Abstract Art

Both paintings by Picasso refer clearly to the visible world, yet each has a different relationship to it. *First Communion* is **representational**. Picasso set out to represent—that is, to present again—the visible world in such a way that we recognize a likeness. The word *representational* covers a broad range of approaches. *First Communion* is very faithful to visual experience, recording how forms are revealed by light and shadow, how bodies reflect an inner structure of bone and muscle, how fabric drapes over bodies and objects, and how gravity makes weight felt. We call this approach **naturalistic**.

Seated Woman Holding a Fan is abstract. Picasso used the appearances of the world only as a starting point, much as a jazz musician begins with a standard tune. He selected certain aspects of what he saw, then simplified or exaggerated them to make his painting. In this instance, Picasso took his cue from the fan. The lower edge of the fan is a simple curve. Picasso used this curve-idea to form the woman's brow, her nose, her breast, and the line of her dress as it swings up to her shoulder. The top part of the fan is an angle or a wedge. Picasso used the angle/wedge idea almost everywhere else: the shadow below the fan, the woman's left hand and the shadow it casts, the arms of the chair and gray space they cut out of the background, and so on.

Like representation, abstraction embraces a broad range of approaches. Most of us would be able to decipher the subject of *Seated Woman Holding a Fan* without the help of the title, but the process of abstraction can continue much further, until the starting point is no longer recognizable. In *Woman with Packages* (2.14), Louise Bourgeois abstracted the visual impact of a standing woman all the way to a slender vertical column topped by an egg-shaped element. *Woman with Packages* belongs to a series of sculptures that the artist called *Personages*. A personage is a fictional character, as in a novel or a play.

ARTISTS Louise Bourgeois (1911–2010)

How do Bourgeois' works bring about magic and mystery? What emotions do they conjure, and what do they reveal about the artist's childhood?

ell into her ninth decade, Louise Bourgeois made art whose unsparing emotional honesty and restless formal inventiveness left far younger artists in awe. At an exhibition in 1992 at New York's Museum of Modern Art, the video and installation artist Bruce Nauman, some thirty years her junior and himself on the cutting edge of aggressive new art, paid her the ultimate compliment. Standing before Bourgeois' monstrous, mechanical, copulating *Twosome* (1991), he said simply, "You've gotta watch that woman."

Louise Bourgeois was born in Paris in 1911. Her parents were restorers of antique tapestries, and as a teenager Louise helped out by drawing missing parts so that they could be rewoven. After earning an undergraduate degree in philosophy, she studied art history at the Ecole du Louvre (a school attached to the famous museum) and studio art at the Ecole des Beaux Arts (the School of Fine Arts, France's most prestigious art school). Bourgeois was a restless student, however, and her dissatisfaction with official art education led her to explore alternative paths, most valuably a period of study with the painter Fernand Léger. In 1938 she married Robert Goldwater, a young American art historian who was in Paris doing research. The couple moved to New York that same year.

It was in America that Bourgeois discovered herself as an artist. "When I arrived in the United States from France I found an atmosphere that allowed me to do as I wanted," she told an interviewer. The young couple quickly established themselves in the New York art world. Robert published his groundbreaking work *Primitivism in Modern Art* and began a distinguished scholarly career. Louise exhibited frequently, culminating with her first solo show of paintings in 1945. She exhibited her first sculptures four years later.

Louise Bourgeois' art is deeply rooted in memories of her childhood and adolescence. "My childhood," she wrote, "has never lost its magic, it has never lost its mystery, and it has never lost its drama." The drama was not a happy one. When Bourgeois was eleven years old, her father brought a woman to live with them. She was to teach the children English and serve as a chauffeur to their mother. In fact, the woman soon became her father's mistress and lived with them as such for ten years. Bourgeois' fury at her father for this betrayal and her uncomprehending anger at her mother for putting up with it remained at the troubled core of her own adult emotional life. Periods of depression often crippled her, and for several decades she featured only intermittently on the New York art scene.

In 1982 the Museum of Modern Art held a retrospective exhibit of Bourgeois' work, only the second such show it had ever devoted to a female artist. The attention the exhibition generated fueled an astonishing late flowering of creativity, and masterpieces poured forth from Bourgeois' studio to worldwide acclaim. Through her art, Louise Bourgeois tried to come to terms with a past that she could not let go of. "My goal is to re-live a past emotion," she once said. "My sculpture allows me to re-experience fear, to give it a physical form so that I am able to hack away at it. I am saying in my sculpture today what I could not make out in the past."

Louise Bourgeois in 1997. Portrait © Sylvia Plachy

Like a writer, Bourgeois created a cast of characters in an imagined world. She often displayed her *Personages* in pairs or groupings, implying a story for them.

At the opposite end of the spectrum from Bourgeois' radically simplified forms are representational works so convincingly lifelike that we can be fooled for a moment into thinking that they are real. The word for this extreme optical fidelity is *trompe l'oeil* (pronounced tromp-loy), French for "fool the eye," and one of its modern masters was Duane Hanson. Hanson's sculptures portray ordinary people in ordinary activities—cleaning ladies and tourists, museum guards and housepainters (2.15). Like a film director searching for an actor with just the right look for a role, Hanson looked around for the perfect person to "play" the type he had in mind. Once he had found his model (and, we may imagine, talked him or her into cooperating), he set the pose and made a mold directly from the model's body. Painted in lifelike skin tones and outfitted with hair, clothing, and props, the resulting sculptures can make us wonder how much distance we actually desire between art and life.

By opening Western art up to a full range of relationships to the visible world, artists of the 20th century created a bridge of understanding to other artistic traditions. For example, sculptors working many centuries ago in the Yoruba kingdom of Ife, in present-day Nigeria, also employed both naturalistic and abstract styles. Naturalistic portrait sculptures in brass were created to commemorate the kingdom's rulers (2.16). Displayed on altars dedicated to royal ancestors, each head was accompanied by a smaller, abstract version (2.17).

2.15 Duane Hanson. *Housepainter III*. 1984/1988. Autobody filler, polychromed, mixed media, with accessories; life-size. Hanson Collection, Davie, Florida

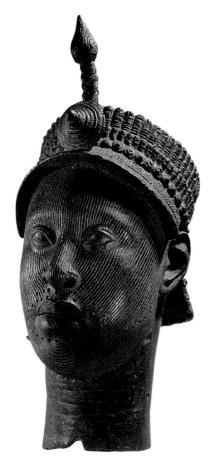

2.16 Head of a king, from Ife. Yoruba, c. 13th century. Brass, life-size. The British Museum, London

2.17 Cylindrical head, from Ife. Yoruba, c. 13th—14th century. Terra cotta, height 6%". National Commission for Museums and Monuments, Nigeria

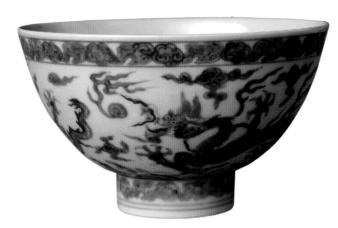

The two heads relate to concepts that are still current in Yoruba thought today. The naturalistic head represents the outer, physical reality that can be perceived by the senses, and the abstract head represents the inner, spiritual reality that can be perceived only by the imagination. Similarly, Louise Bourgeois' *Woman with Packages* could be said to portray the inner essence of the subject, whereas Duane Hanson's *Housepainter* is about how abstract concepts such as "housepainter" are rooted in the particular details of an individual.

Somewhere between naturalism and abstraction lies stylization. **Stylized** describes representational art that conforms to a preset style or set of conventions for depicting the world. The Chinese porcelain bowl illustrated in Figure **2.18**, for example, is decorated with a depiction of a dragon flying through clouds in pursuit of a motif known as the flaming pearl. A band of clouds rings the rim of the bowl as well. The clouds are stylized, defined by lines that spiral inward like a snail shell or a scroll. The individual clouds near the dragon are each formed from a bouquet of four scrolls and three trailing elements that wave like silk scarves in the breeze. The band of clouds around the rim is made of symmetrical, mushrooming scroll forms linked by waves of trailing scrolls.

Scrolling clouds were a convention in Chinese art for many centuries, appearing on embroidered robes, porcelain decoration, and paintings. They are especially associated with apparitions of divine beings, including dragons. If you look ahead to the Chinese Buddhist painting illustrated in Figure 19.17,

2.18 Bowl. China, 1506–21. Porcelain painted in underglaze blue and overglaze enamels, diameter 63%".

The Metropolitan Museum of Art, New York

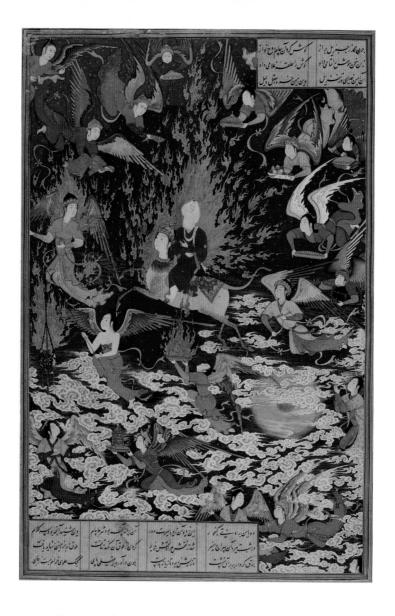

2.19 Sultan Muhammad (attr.). *The Ascent of the Prophet Muhammad.* 1539–43. Opaque watercolor, gold, and ink on paper; $11\frac{5}{6} \times 7^{5}$ %". The British Library, London

you will see at the upper left a depiction of paradise set on a bank of scrolling clouds. They were painted over six hundred years before the clouds on the porcelain bowl, but they are stylized in the same way.

Chinese culture was highly influential, and scrolling clouds were adopted by artists in Korea, Vietnam, and Japan. To the West, they were taken up by Persian artists, as in this illustration of *The Ascent of the Prophet Muhammad* (2.19). Persian artists also adopted the Chinese convention of depicting radiating light as stylized flames. The single stylized flame that issues from the flaming pearl on the porcelain bowl—a writhing, branching form—is multiplied many times to indicate the light radiating from Muhammad, his miraculous mount, and the archangel Gabriel, who according to tradition guided him on his nighttime journey through the heavens.

Nonrepresentational Art

Even as Picasso and others experimented with abstraction, seeing how far art could go without severing its ties to the visible world, other artists at the beginning of the 20th century came to believe that only by abandoning these ties could art progress and realize its true nature. Instead of imitating or interpreting appearances, they found meaning and expressive power in the elements of art itself—in line, shape, form, and color. They referred to their art variously as abstract, nonrepresentational, or nonobjective. In this book, we reserve the

term abstract for works such as Picasso's Seated Woman Holding a Fan (2.13) and Louise Bourgeois' Woman with Packages (2.14), which retain cues to their origins in the visible world. Art that does not represent or refer to the world outside of itself we call **nonrepresentational** or **nonobjective**.

Russian-born French artist Sonia Delaunay was one of the pioneers of nonrepresentational art. In paintings such as *Electric Prisms*, she realized symphonic compositions of pure color arranged in a loose geometry of arcs and grids (2.20). Although *Electric Prisms* contains no references to the visible world, it had its roots in visual experience. Out walking one evening in Paris in 1913, Delaunay and her husband were fascinated by the halos of light surrounding the bulbs of the electric streetlamps that had just replaced gas lighting on the boulevard. She returned often to sketch this new kind of light and the effects it produced, and from her observations she composed *Electric Prisms*. "Up to the present, painting has been nothing but photography in color," Delaunay wrote, "but the color was always used as a means of describing something. Abstract art is a beginning towards freeing the old pictorial formula. But the real new painting will begin when people understand that color has a life of its own. . . ."

A century later, nonrepresentational art is no longer a revolutionary idea, nor has it supplanted representational approaches, as some of its early practitioners predicted. Instead, it has taken its place as one of the possibilities available to contemporary artists, who continue to find ways to enliven it. Tara Donovan, for example, makes large-scale installations from accumulations of ordinary objects. She has stacked transparent plastic buttons until they resemble groups of stalagmites, covered a ceiling with an undulating blanket of Styrofoam cups, and stacked wooden toothpicks into a 3-foot-tall cube. Here, her chosen material is Mylar, scrolled and gathered into spheres, the spheres joined in a way that suggests that the sculpture grew by itself, and might grow still more as we watch (2.21).

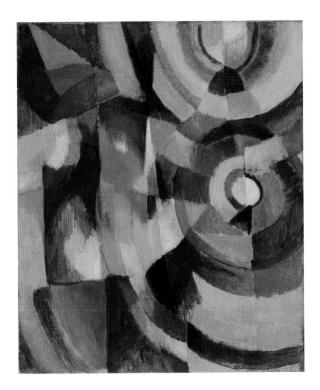

2.20 Sonia Delaunay. *Electric Prisms*. 1913. Oil on canvas, $22\% \times 18\%$ ". Davis Museum at Wellesley College, Wellesley, MA

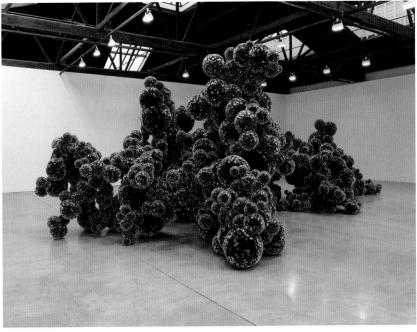

2.21 Tara Donovan. *Untitled (Mylar)*. 2011. Mylar and hot glue, site specific, dimensions variable.

© Tara Donovan, courtesy Pace Gallery

Style

Terms such as *naturalistic* and *abstract* categorize art by how it relates to the appearances of the visible world. A work of art, of course, has a place in the visible world itself. It has its own appearance, which is the result of the artist's efforts. A term that helps us categorize art by its own appearance is *style*. **Style** refers to a distinctive, recognizable ensemble of recurring characteristics. If a person we know always wears jeans and cowboy boots, we identify that person with a certain style of dress. If a family has furnished their living room entirely in antiques except for one very modern chair, we would recognize a mix of styles. But if they do this in every room of their house, and in every house they live in, then we would say that mixing styles is their style, and we would call it eclectic, meaning drawing on many sources.

In the visual arts as in other areas of life, style is the result of a series of choices, in this case choices an artist makes in creating a work of art. As we grow more familiar with a particular artist's work, we begin to see a recurring pattern to these choices—characteristic subject matter or materials, distinctive ways of drawing or of applying paint, preferences for certain colors or color combinations. For example, now that you have seen three paintings by Van Gogh (1.10, the self-portrait on page 11, and 2.1), you can see certain traits they have in common, such as heightened color, thickly applied paint, distinct brush strokes, distorted and exaggerated forms, and flamelike or writhing passages. Each subsequent work by Van Gogh that you come across will fine-tune what you already know about his style, just as what you already know will provide a framework for considering each new work.

One theory of art maintains that style is what distinguishes artists from other skillful makers. Not all people who set out to make art eventually develop an individual style, but all artists do. An enjoyable way to get a sense of the great range of individual styles is to compare works that treat similar subjects, as in these three depictions of a woman having her hair combed (2.22, 2.23, 2.24).

2.22 Kitagawa Utamaro. Hairdressing, from Twelve Types of Women's Handicraft. c. 1798–99. Polychrome woodblock print, 153/6 × 10".

Library of Congress, Washington, D.C.

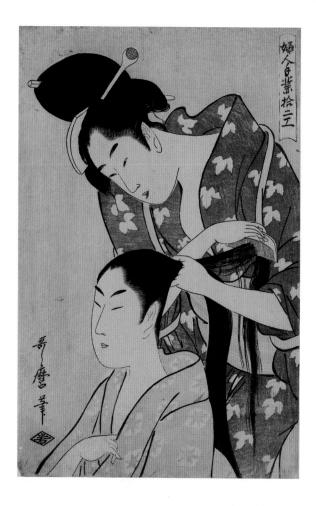

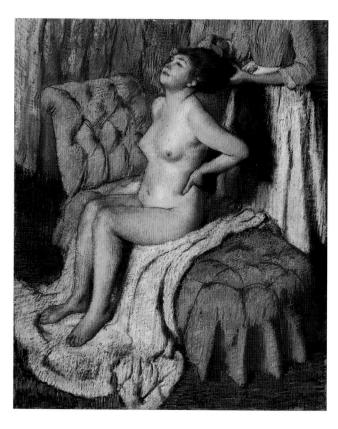

2.23 Edgar Degas. *Nude Woman Having Her Hair Combed.* c. 1886–88. Pastel on paper, $29\% \times 23\%$ ". The Metropolitan Museum of Art, New York

The first is a woodcut by the 18th-century Japanese artist Kitagawa Utamaro (2.22), the second a drawing in pastel by 19th-century French artist Edgar Degas (2.23), and the third an oil painting by the 20th-century American artist Susan Rothenberg (2.24).

Utamaro's women are slightly stylized. They do not strike us as particular people drawn from life but as types of women drawn from the imagination—the beauty and her hairdresser. Their robes, too, are stylized into a series of sinuous curves. Slender black lines describe the faces and features, the robes and their folds, even the individual strands of hair. We could take away the color altogether, and the lines would still tell us everything we need to know. Color is applied evenly, with no lighter or darker variations. This makes the robes seem flat, as though they were cut out of patterned paper. The background is blank, and gives no hint of where the scene is set.

Edgar Degas works in a naturalistic style. The woman seems like a particular person, probably a model who posed for him in his studio. Faint lines describe the contours of her body and the chair she sits on, but these lines do not have a life of their own, as in the Japanese work. Colors are applied in individual strokes that remain distinct even as they build up in layers. Variations in color depict light and shadow, showing us the roundness and weight of the woman's body and sculpting the deep folds of the ruffles on the upholstered chair. Not all forms are depicted with equal attention to detail. The woman's body is very finely observed, whereas the outer areas of the image are treated more freely. The background is suggested rather than really described, yet the scene is clearly set in an interior. The composition is quite daring, with the servant's body cropped suddenly at the upper torso.

Susan Rothenberg's style is a unique combination of representational and nonrepresentational traditions. She portrays not complete figures but fragments, bits of representation that seem to surface like memories in a nonrepresentational painting. Here, two arms detach themselves from the red. Their hands grasp a dark mass—we understand it as hair only when we notice the small ear to the right that indicates a human head. A hand at the lower right offers a ring to secure the ponytail.

2.24 Susan Rothenberg. *Maggie's Ponytail.* 1993–94.

Oil on canvas, 5'5¼" × 4'5¼".

Private Collection. Courtesy Sperone
Westwater, New York

Each of these artists formed his or her style within a particular culture during a particular historical moment. Artists working in the same culture during the same time often have stylistic features in common, and in this way individual styles contribute to our perception of larger, general styles. General styles fall into several categories. There are cultural styles (Aztec style in Mesoamerica), period or historical styles (Gothic style in Europe), and school styles, which are styles shared by a particular group of like-minded artists (Impressionist style). General styles provide a useful framework for organizing the history of art, and familiarity with them can help us situate art and artists that are new to us in a historical or cultural context, which often helps understanding. But it is important to remember that general styles are constructed after the fact, as scholars discern broad trends by comparing the work of numerous individual artists. Cultures, historical periods, and schools do not create art. Individuals create art, working with (and sometimes pushing against) the possibilities that their time and place hold out to them.

Art and Meaning

"What is the artist trying to say?" is a question many people ask when looking at a work of art, as though the artist were trying to tell us in images what he or she could have said more clearly in a few words. As we saw in Chapter 1, meaning in art is rarely so simple and straightforward. Rather than a definitive meaning that can be found once and for all, art inspires interpretations that are many and changeable.

According to some theories of art, meaning is what distinguishes art from other kinds of skilled making. Art is always *about* something. One brief definition of art, in fact, is "embodied meaning." Viewers who wonder what the artist is trying to say are thus right to expect their experience of art to be meaningful, but they may misunderstand where meaning can be found or underestimate

2.25 Henri Matisse. *Piano Lesson*. 1916. Oil on canvas, $8\frac{1}{2}$ " \times $6\frac{11}{4}$ ".

The Museum of Modern Art, New York

2.26 Henri Matisse. *Music Lesson*. 1917. Oil on canvas, $8'\%'' \times 6'7''$.

The Barnes Foundation, Philadelphia

their own role in making it. Understanding art is a cultural skill and, like any cultural skill, must be learned.

Key terms related to meaning are form and content; materials and techniques; iconography; and context. We look at them in turn.

Form and Content

In thinking about art, philosophers have found it useful to distinguish two aspects, form and content. **Form** is the physical appearance of the work, everything the eye registers about it, such as colors, shapes, and internal organization. **Content** is what the work of art is about, its meaning. For representational and abstract works, content begins with the objects or events the work depicts, its **subject matter**.

Two paintings by Henri Matisse allow us to explore the intimate relationship of form and content in art (2.25, 2.26). The two begin with the same subject matter, a piano lesson. They are the same large size. They even depict the same young student, Matisse's son Pierre, and are set in the same place, the Matisse family home, with the piano placed in front of a window looking out onto a garden. Yet their form clearly differs, and thus their content diverges as well.

Piano Lesson (2.25) is abstract. Matisse takes his cue from the metronome, the pyramidal form that sits on the piano. A metronome is a device that disciplines musicians as they practice by beating steady time. The wind-up type Matisse depicts has a slender wand that ticks as it sways back and forth like a windshield wiper. The boy is concentrating so hard that his face is disappearing into this ticking. He is concentrating so hard that almost everything around him is vanishing into grayness. Outdoors, the garden has been abstracted into a green wedge—even nature obeys the metronome! On the piano a candle burns low, suggesting that many hours have passed. In the background a woman sits on a stool, her head turned toward the boy. She seems to be a teacher, and a severe one at that. Actually, she is a painting by Matisse hanging on the far wall. Nestled in the lower left corner is another work by Matisse, a small bronze figure of a nude woman. The boy's muse and inspiration, perhaps, but also another work of art.

Music Lesson (2.26) sets music in a social realm of family togetherness. Again Pierre practices, but he is not alone. His sister stands over his shoulder, watching him play. His older brother sits in a chair, reading, while out in the garden his mother works on a piece of sewing. Instead of a metronome on the piano there is an open violin case with a violin inside. Matisse played the violin, and this is his way of saying "I'm here too." The painting in the background is once again just a painting, its gold frame visible, and the bronze statue has moved outdoors into the garden, where it reclines by a little pond. The austere abstraction of *Piano Lesson* has blossomed here into a relaxed representational style of luscious colors and curves.

We could summarize the difference in content by saying that *Piano Lesson* is about the discipline of music, its solitary and intellectual side; *Music Lesson* is about the pleasure of music, its social and sensuous side. Matisse has expressed each message through a different form; we in turn have interpreted the form to arrive at the content.

Materials and Techniques

Matisse's paintings are made of oil paint applied with brushes to canvas stretched over a wooden frame. Oil paint, brushes, and canvas had been the standard materials of European painting for centuries, and Matisse took them for granted—they don't represent significant choices he made. Similarly, Rodin probably took white marble and the technique of carving for granted when he created *The Kiss*, one of his most famous works (2.27). White marble had long been a standard material for sculpture in Europe, and carving was the standard way to shape it.

2.27 Auguste Rodin. *The Kiss*. 1886–98. Marble, height 5'11¼". Musée Rodin, Paris

2.28 Janine Antoni.
Gnaw. 1992. Installation
view and details.

Solution Janine Antoni. Courtesy
of the artist and Luhring
Augustine, New York

With Janine Antoni's *Gnaw*, in contrast, what it is made of and how it was made are the first things that grab our attention (2.28). The artist has reached far outside traditional art materials and techniques, and her choices are fundamental to the work's content. Gnaw consists of a 600-pound cube of chocolate and a similar one of lard, each gnawed at by the artist herself. The chewed portions of lard were made into lipsticks, and the chocolate was made into heart-shaped, partitioned boxes for fancy gift chocolates. These are displayed in a nearby showcase, as though in an upscale boutique. Chocolate has strong associations with love, as both a token of affection and a substitute for it. Lard summons up obsessions with fat and self-image, which in turn are linked to culturally imposed ideals of female beauty, as is lipstick. Gnaw is about the gap between the prettified, commercial world of romance and the private, more desperate cravings it both feeds on and causes. The gnawed blocks of chocolate and lard resemble the base of Rodin's statue after the couple has gone, and perhaps that is part of the message as well. The Kiss wants to convince us that love is beautiful, and that we are beautiful when we are in love. Not always, Gnaw replies, and the romantic illusions that works such as *The Kiss* inspire are part of the problem.

Iconography

In talking about form and content in Matisse's *Piano Lesson*, we relied on something so basic you may not even have noticed it. In fact, it was our very first step: we recognized the subject matter. We know what a piano looks like, and what lessons are. We expect to see a piano, a student, a teacher. Other objects depicted in the painting required some research to identify. Who was the first viewer to notice that the teacher in the background is actually another painting by Matisse? Today that information is standard knowledge, and almost any description of *Piano Lesson* will include it. But at some point it was newly discovered. One object depicted in *Piano Lesson* even carried a traditional meaning of its own: the candle burning low, which has a long history in Western art of symbolizing the passing of time.

This kind of background information about subject matter is the domain of iconography. **Iconography**, literally "describing images," involves identifying, describing, and interpreting subject matter in art. Iconography is an important activity of scholars who study art, and their work helps us understand meanings that we might not be able to see for ourselves. For example, unless you are schooled in Japanese Buddhism, you would not recognize the subject matter of *Amida Nyorai* (2.29). An important work of Japanese art, the statue was created

during the 11th century by the sculptor Jocho for a temple called Byodo-in, where it still resides. Its intended audience—Buddhists who come to worship at the temple—understands the statue easily. The rest of us need some help.

Our investigation begins with the most basic question of all, Who is Amida Nyorai? Amida Nyorai is a buddha, a fully enlightened being. The historical Buddha was a spiritual leader who lived in India perhaps as early as the 6th century B.C.E. His insights into the human condition form the basis of the Buddhist religion. As Buddhism developed, it occurred to believers that if there had been one fully enlightened being, there must have been others. In Japan, where Buddhism quickly spread, the most popular buddha has been Amida, the Buddha of the Western Paradise.

The iconography of the historical Buddha image was established early on and has remained constant through the centuries. Amida is portrayed following its conventions. A buddha wears a monk's robe, a single length of cloth that drapes over the left shoulder. His ears are elongated, for in his earthly life, before his spiritual awakening, he wore the customary heavy earrings of an Indian prince. The form resembling a bun on the top of his head is a protuberance called *ushnisha*. It symbolizes his enlightenment. Sculptors developed a repertoire of hand gestures for the Buddha image, and each gesture has its own meaning. Here, Amida's hands form the gesture of meditation and balance, which symbolizes the path toward enlightenment. He sits in the cross-legged position of meditation on a lotus throne. The lotus flower is a symbol of purity. Rising up behind Amida is his halo, radiant spiritual energy envisioned as a screen of stylized flames.

The iconography of this statue is readily available to us because it forms part of a tradition that has continued unbroken since it first developed almost two thousand years ago. Often, however, traditions change and meanings are forgotten. We cannot always tell with certainty what images from the past portray, or what they meant to their original viewers. Such is the case with one of the most famous images in Western art, the *Arnolfini Double Portrait* by

2.29 Jocho. *Amida Nyorai*, in the Hoodo (Phoenix Hall), Byodo-in Temple. c. 1053. Gilded wood, height 9'2".

2.30 Jan van Eyck. *Arnolfini Double Portrait*. 1434. Oil on wood, 33 × 22½". The National Gallery, London

2.31 Arnolfini Double Portrait, detail of mirror and rosary.

Jan van Eyck (2.30). Painted with entrancing clarity and mesmerizing detail, the work portrays a man and a woman, their hands joined. He has taken off his shoes, which lie on the floor next to him; hers can be seen on the floor in the background. Seemingly pregnant, she stands next to a bed draped in rich red fabric. Overhead is a chandelier with but one candle. On the floor between the couple stands an alert little dog. A mirror on the far wall (2.31) reflects not only the couple but also two men standing in the doorway to the room and looking in—standing, that is, where we are standing as we look at the painting. Over the mirror the painter's signature reads "Jan van Eyck was here."

By the time the painting ended up in the National Gallery in London in 1842, it had changed hands so many times that even the identity of the couple had been forgotten. Researchers working from old documents soon identified them as Giovanni di Arrigo Arnolfini, a rich merchant capitalist, and his wife, Giovanna Cenami, also from a socially prominent family. But what was the purpose of the painting? What, exactly, does it depict? One influential theory claims that the painting records a private marriage ceremony and served as a sort of marriage certificate. The men reflected in the mirror are none other than Jan van Eyck and a friend, who had served as witnesses. Moreover, almost every detail of the painting has a symbolic value related to the sacrament of marriage. The bride's seemingly pregnant state alludes to fertility, as does the red bed of the nuptial chamber. The single candle signifies the presence of God at the ceremony, and the dog is a symbol of marital fidelity and love. The couple have cast off their shoes as a sign that they stand on sacred ground.

Another, more recent theory claims that the painting does not depict a marriage but a ceremony of betrothal, an engagement. It commemorates the alliance of two prominent and well-off families. In this view, the details do not carry specific symbolism, although many of them serve to underscore the couple's affluence. Canopied beds, for example, were status symbols and as such were commonly displayed in the principal room of the house. Candles were enormously expensive, and burning one at a time was common thrift.

The shoes were of a style worn by the upper class and were probably taken off routinely upon going indoors. The dog is simply a pet: everyone had dogs.

Still more recent research questions the identity of the sitters and leads to further possible interpretations. The man may not be Giovanni di Arrigo Arnolfini but, rather, his cousin, Giovanni di Nicolao Arnolfini. The woman would presumably be Giovanni di Nicolao's second wife, his first wife having died before the painting was made. The painting portrays neither a marriage nor a betrothal but is a straightforward portrait of a prosperous couple. A fourth theory points out that we have no direct evidence that Giovanni di Nicolao remarried and maintains that the woman is indeed his first wife, Costanza Trenta. She may have died in childbirth, perhaps even as the painting was in progress. We are looking at a commemorative image: the man is alive, the woman is not. He turns his raised right hand toward her to bid her farewell; her right hand slips from his left, for she is no longer of this world.⁸

All these theories are supported by impressive research and reasoning. Some scholars believe one, some another. Viewers will continue to find their own meanings in this magical painting, but we may never know just what it signified for its original audience.

Context

Art does not happen in a vacuum. Strong ties bind a work of art to the life of its creator, to the tradition it grows from and responds to, to the audience it was made for, and to the society in which it circulated. These circumstances form the **context** of art, the personal, social, cultural, and historical setting in which it was created, received, and interpreted.

This chapter has already made use of the kind of insights that context can provide. Near the beginning, passages from the letters of Vincent van Gogh helped set his painting in the context of his life and thought. In the discussion of Picasso's *Seated Woman Holding a Fan*, the challenge posed by photography was mentioned to set the painting in the context of the development of European art.

The type of context that especially concerns us here is the social context of art, including the physical setting in which art is experienced. Figure 2.32 portrays a work of African art as we might see it today in a museum. Isolated against a dark background and dramatically lit, the gilded carving gleams like a rare and precious object. We can admire the harmony of the sculpture's gently rounded forms in much the same way that we contemplated the light flowing over Edward Weston's cabbage leaf earlier in the chapter (see 2.9). Yet the sculpture was not made primarily to be looked at in this way. In fact, it was not made to be seen in a museum at all.

Figure 2.33 shows similar sculptures in their original context, as they were made to be seen and used by the Akan peoples of West Africa. The men in the photograph are officials known as linguists. Linguists serve Akan rulers as

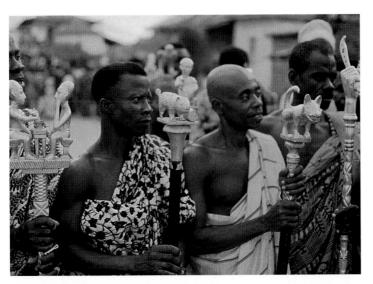

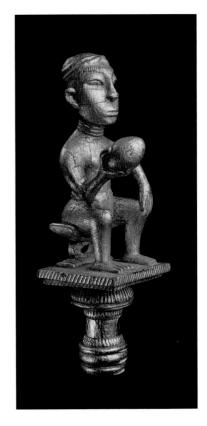

2.32 Finial of a linguist's staff, from Ghana. Asante, 20th century. Wood and gold, height 11/4".

Musée Barbier-Mueller, Geneva

2.33 Akan (Fante) linguists at Enyan Abaasa, Ghana, 1974.

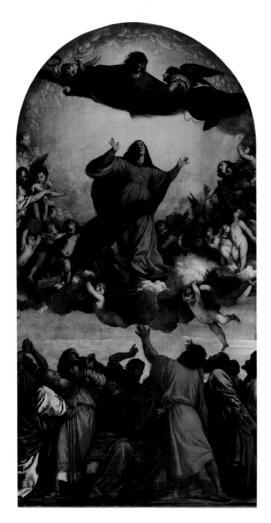

2.34 Titian. *Assumption*. 1518. Oil on wood, 22'7³/₄" × 11'11⁵/₁₂". Church of the Frari, Venice

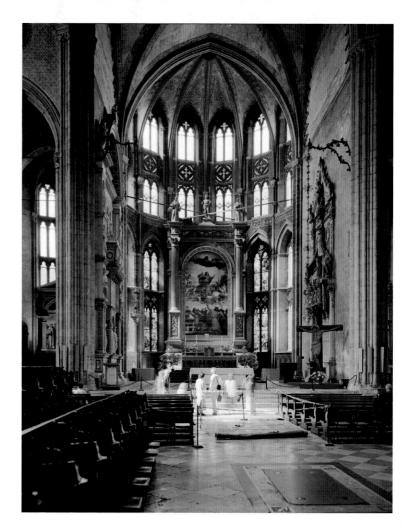

2.35 Thomas Struth. *Church of the Frari, Venice*. 1995. Chromogenic print, edition of 10, $7'7\%" \times 6'\%"$. © Thomas Struth

translators, spokespersons, advisers, historians, and orators. Every local chief employs at least one linguist, and more powerful chiefs and kings may be attended by many. As a symbol of office, a linguist carries a staff topped with a wooden sculpture covered in gold leaf. Each sculptural motif is associated with one or more proverbs, often about the nature of leadership or the just use of power. In the photograph here, for example, the staff at the far left portraying two men seated at a table calls forth the proverb "Food is for its owner, not for the one who is hungry," meaning that the chieftaincy belongs to the man who has the right to it, not just to anyone who wants it.

In an Akan community, the aesthetic attention that we directed at the sculpture (2.32) would have been the unique privilege of the artist who carved the work and the linguist who owned it. Other members of the community would have glimpsed the figure only during public occasions of state. More meaningful to them would have been the authority that the staffs symbolized and the pageantry they contributed to—a lavish visual display that reaffirmed the social order of the Akan world.

Museums are the principal setting our society offers for encounters with art. Yet the vast majority of humankind's artistic heritage was not created with museums in mind. It was not made to be set aside from life in a special place but, rather, to be part of life—both the lives of individuals and the lives of communities. Its meaning, like that of the Akan linguist staff, was united with its use. This is as true for Western art as it is for the art of other cultures. Figure 2.34 shows Titian's *Assumption* in isolation, as we might expect to find it in a museum or an art book. "Assumption" names another standard subject

of Christian art, that of Mary, the mother of Jesus, being accepted bodily into heaven at her death. Titian has imagined Mary being borne upward amid a crowd of angels, her garments swirling about her, into a golden glory. Above, God appears to welcome her; below, witnesses marvel at the miracle.

Titian's masterpiece does not reside in a museum, however, or on the white pages of an art book. It towers up behind the main altar of the Church of the Frari in Venice, in the exact location the artist painted it for. Thomas Struth's photograph *Church of the Frari, Venice* captures something of the experience of seeing Titian's work in context (2.35). Now we understand that the painting is part of a richly worked, massive stone altarpiece, with fluted columns, marble inlay, and gilded carving. A statue of Christ crowns the ensemble, flanked by two monks. We can see how the tall, arched shape of the painting repeats the pointed arches of the church itself, and we can appreciate how the painting's bold composition projects clearly into the cavernous interior.

But all these ways of looking are still ways of looking at art. At its unveiling in 1518, the painting was seen through the eyes of faith. We need to imagine the effect it produced when Christianity was the central cultural force of Venetian life. Citizens filling the Church of the Frari would have felt the truth of their beliefs through the splendor of the architecture echoing with music, the pageantry of the rituals, and the glorious vision of a miracle made present through Titian's skill and imagination. In Struth's photograph, light falls on a small group of tourists who have paused to look at the famous painting. They have come to look at art, as though the church were a museum. And yet for a moment they seem transfigured.

The museum as we know it today—a building housing a collection of art and open to the public—developed in Europe during the decades leading into the 19th century, the same decades that witnessed the social upheavals that inaugurated our modern era, including the American and French revolutions. Viewed as repositories of the past, newly created museums were filled with objects that used to belong to the aristocracy or the Church, or to vanished civilizations such as ancient Rome and Egypt. All those objects were removed from the contexts that originally gave them meaning. Placed in a museum, their new function was to be works of art.

Whereas the first museums were concerned only with the art of the past, many museums now exhibit the work of living artists. Along with galleries that display (and usually sell) art, and a circuit of international exhibitions that survey current artistic trends, they are the principal context for the art of our time. Our artists work with these institutions and spaces in mind, and as viewers we expect to see their work in these settings.

There is a long tradition of artists who have protested this separation of art from the fabric of everyday life. Often, they make art that tries to reach outside this specialized context or to question it. We will look at some of their ideas next. But there is an equally long tradition of artists who have explored what could be done *within* such a context. One such artist is Tom Friedman, whose inventive, labor-intensive works defy categorization. Here, we illustrate a cereal box he made by cutting nine boxes into small squares and then piecing them back together as one (2.36). Elsewhere, he has exhibited a pencil processed through a sharpener into one continuous coil of shaving and a life-size statue of himself made of sugar cubes.

Friedman not only intends his art specifically for the quiet, empty, white spaces of contemporary galleries and museums, but even suggests that the things he makes are not quite art outside such spaces. "I think that after I make it and it goes into the gallery it's in its sort of original context within a body of work," he explains. If a collector buys an individual work from the exhibition, "it becomes historical, more of an artifact, as opposed to the same conveyor of meaning it was originally."

Friedman's remarks underscore the importance of context to meaning, just as his work illustrates how our modern context of galleries and museums opened up new possibilities for what could be seen as art.

2.36 Tom Friedman. *Untitled*. 1999. Cereal boxes, $31\frac{1}{4} \times 21\frac{1}{4} \times 6\frac{5}{8}$ ". Courtesy the artist

Art and Objects

During the 20th century, many artists began to feel that something important had been lost when art was separated from life and placed in a separate, privileged realm. Seen in the larger context of consumer culture, where shopping and window-shopping are favorite leisure activities, were museums and galleries really so different from department stores and boutiques? Despite the talk of meaning and spiritual value, did the role of the artist in modern society come down in the end to making objects for display and sale?

Sometimes a slight shift in perspective is all it takes to open up new ways of thinking. A painting, for example, is indeed an object. But it is also the result of a process, the activity of painting. In questioning the purpose of art and the role of the artist in contemporary culture, many artists began to shift their focus away from the products of art to its processes, considering how they might be meaningful in themselves.

Looking beyond the West to other cultures often provided guidance and inspiration. The Navajo practice of sand painting, for example, is one of the most famous instances of an art where product and process cannot be separated, for the painting, its making, and its unmaking are all equally important. Sand painting is part of a ceremony in which a religious specialist known as a singer, hataali, calls upon spirit powers to heal and bless someone who is ill. The ceremony begins as the singer chants a Navajo legend. At a certain point, he begins making the painting by sifting colored sand through his fingers onto the earthen floor. The photograph illustrated here depicts two Navajo men demonstrating the technique of sand painting for the public (2.37). Actual sand painting is viewed as a sacred activity, and photography is not usually permitted. The painting acts as an altar, a zone of contact between earthly and spirit realms, and together with the chanting it attracts the spirits, the Holy People. When the painting is completed, the patient is instructed to sit at its center. The singer begins to touch first a portion of the painting and then the patient, gradually transferring the powers of healing. When the ceremony is over, the painting is unmade-swept with a feather staff into a blanket, then carried outside and deposited safely so that it does not harm anyone with the sickness it has taken on.

2.37 Navajo men creating a sand painting. Photograph c. 1939.

THINKING ABOUT ART Aesthetics

What is our definition of *aesthetics*? What do the aesthetics of various cultures encountered so far tell us about their creative expression and values? What commonalities can be deduced about aesthetics across time and culture?

he word *aesthetics* was coined in the early 18th century by a German philosopher named Alexander Baumgarten. He derived his word from the Greek word for perception, *aisthanomai*, and he used it to name what he considered to be a field of knowledge, the knowledge gained by sensory experience combined with feelings. Like art, aesthetics existed before we named it and outside our naming it: just as cultures around the world and across time have created what we now call art, so they have thought about the nature and purpose of their creations and focused on certain words for evaluating and appreciating them.

Exploring the aesthetics of other cultures can help us understand what expressive forms they value and why. For example, the illustration here depicts a tea bowl formed by hand in the Japanese province of Shigaraki during the early 17th century. Although we may find the bowl pleasing to look at (or not, depending on our taste), we have no way of talking about it as art. A tea bowl holds no meaning for us. In Japan,

however, this small vessel would be the focus of intense appreciation centered on two key terms, *wabi* and *sabi*. *Wabi* embraces such concepts as naturalness, simplicity, understatement, and impermanence. *Sabi* adds overtones of loneliness, old age, and tranquility. The two terms are central to the aesthetics that developed around the austere variety of Buddhism known as Zen. They are especially connected with the Zen-inspired practice we know as the tea ceremony. Through its connection with the tea ceremony and with Zen Buddhist spiritual ideals, this simple bowl partakes in a rich network of meanings and associations.

The closest traditional Japanese equivalent to the word art (in the sense of visual art) is katachi. Translated as "form and design," it applies to ceramics and furniture as much as it does to paintings and sculpture. The Navajo people of the American Southwest, in contrast, do not have a word that separates made things from the rest of the world, for in the Navajo view the two are deeply intertwined. According to Navajo philosophy, the world is constantly becoming, constantly being created and renewed. Its natural state is one of beauty, harmony, and happiness, conditions summed up in the word hozho. Yet all things contain their opposites, and thus hozho is countered by forces of ugliness, evil, and disorder. The interplay between opposites is what allows creation to perpetuate itself. Day and night, for example, are opposite aspects of an ongoing process. One shades into the other; together they keep creation in motion. Humans do not stand apart from this natural world but, rather, have a vital role to play: through harmonious thoughts and actions, they radiate beauty into the world, maintaining and restoring hozho against the threat of dangerous spirit forces. Many of these actions we would call art-singing, painting, weaving. Yet beauty for the Navajo does not lie in the finished product but in the process of making it. The most famous example of this is sand painting, discussed on the facing page (see 2.37).

In their different ways, Japanese and Navajo aesthetics challenge and expand traditional Western ideas about art, one by erasing our boundary between fine art and other kinds of skilled making such as ceramics, the other by valuing process over product and by not recognizing a border between art and life.

Hon'ami Koetsu. Teabowl. Momoyama—Edo period, late 16th—early 17th century. Raku ware, height 3½". Freer Gallery of Art, Smithsonian Institution, Washington, D.C.

2.38 Standing figure holding supernatural effigy. Olmec, 800–500 B.C.E. Jade, height 85%".
The Brooklyn Museum

The Navajo *hataali* is a shaman, a type of religious specialist common to many cultures. A shaman is a person who acts as a medium between the human and spirit worlds. A jade carving from the ancient Mesoamerican Olmec culture gives visual form to ideas about the power of shamans (2.38). Standing in a pose of meditation, the shaman holds up a small creature whose fierce, animated expression contrasts vividly with his own trancelike gaze. The creature's headband, catlike eyes, snub nose, and large downturned mouth identify him as the infant man-jaguar, a supernatural being mingling animal and human traits. The navels of the creature and the shaman are aligned, as on an axis linking the cosmic and earthly realms. In Olmec belief, the creature probably served as the shaman's contact in the supernatural world.

The person who most directly adopted the idea of the artist as a kind of shaman and art as a tool of spiritual healing was Joseph Beuys. In his 1965 work *How to Explain Pictures to a Dead Hare*, he covered his head in honey and gold leaf and appeared in a gallery cradling a dead hare in his arms (2.39). Walking about the room, he spoke quietly and tenderly to the animal as he brought it close to the pictures on display. On the floor in the middle of the gallery was a withered fir tree that Beuys stepped over from time to time, still cradling the hare. Beuys' performances—he called them Actions—did not result in an object at all. They were ritual-like events that, for those who chose to reflect on them, touched on issues of art, society, and nature. Beuys believed that an artist's role in a materialistic society was to remind people of human and spiritual values. He also thought that artists should be concerned with how these values point to the need for social and political change.

As with other developments in Western art during the 20th century, accepting the idea that art could embrace process and performance helped build bridges of understanding to other cultures. The masquerades of Africa, for example, constitute one of the most varied and compelling world traditions of art in performance (2.40). Masquerades serve to make otherworld spirits physically present in the human community. The photograph here shows a

2.39 Joseph Beuys performing *How to Explain Pictures to a Dead Hare.* 1965.

2.40 Bwa masqueraders, Burkina Faso.

procession of nature spirits entering a community of the Bwa people of West Africa. Raffia costumes and carved and painted masks completely disguise the performers' human identities, which are believed to be subsumed into the spirit identities of the masks. Masks are called upon during times when the cooperation of spirits and the natural forces they control is especially needed. For example, masks may appear at festivals surrounding the planting and harvesting of crops, or during the initiation of young people into adulthood, or at funerals when their help is needed to ensure that the spirit of the deceased leaves the human community and takes its place in the spirit world of ancestors. When Western scholars first became interested in African masks, they tended to discuss them formally as sculptures, for this was the standard Western category of art that masks most resembled. Today our broader understanding of art encourages us to see masks as an element in a larger art form, the masquerade, which is based in performance.

Viewers, too, have a process related to art, the process of experiencing and reflecting upon a work. Artists looking for new directions thought about this process as well. They realized that being in a gallery or a museum is itself an experience, and they began to take this into account in various ways. One result was a new art form called installation, in which a space is presented as a work of art that can be entered, explored, experienced, and reflected upon.

Kara Walker's installation A Subtlety was created for a space that was already intensely evocative on its own, the cavernous raw sugar warehouse of the Domino Sugar Refinery in Brooklyn, New York (2.41). At its height, the Domino Factory had been the largest sugar refinery in the world. It was shuttered in 2004 after 148 years of continuous operation, all but one of its buildings slated for demolition. Sponsored by an arts organization, Walker's installation allowed the general public to enter the warehouse for the first and last time before it disappeared.

The past was still present in the warehouse. The sweet and acrid odor of burnt sugar still hung in the air. Molasses still oozed from the blackened walls and puddled on the floor. A Subtlety brought another aspect of sugar's past into the mix, its historical reliance on slavery: the vast sugar plantations founded by European colonists in Brazil and the Caribbean were worked by African slaves.

2.41 Kara Walker. At the behest of Creative Time Kara E. Walker has confected: A Subtlety, or the Marvelous Sugar Baby, an Homage to the unpaid and overworked Artisans who have refined our Sweet tastes from the cane fields to the Kitchens of the New World on the Occasion of the demolition of the Domino Sugar Refining Plant. Installation view: A project of Creative Time, Domino Sugar Refinery, Brooklyn, NY, May 10-July 6, 2014. Styrofoam, resin, sugar, and molasses; height of sphinx figure 35'. Photo: Jason Wyche. Artwork © 2014

Kara Walker

2.42 Felix Gonzalez-Torres.

"Untitled." 1995. Billboard,
dimensions vary with installation.
Billboard location: 1633 Lexington
Avenue at East 103 St., Harlem,
NYC. As installed for Solomon R.
Guggenheim Museum, New York,
"Felix Gonzales-Torres," March
3—May 10, 1995 in six outdoor
locations throughout New York City.

© The Felix Gonzalez-Torres
Foundation, courtesy of Andrea Rosen
Gallery, New York. Photo: Paul Jeramias,
The Solomon R. Guggenheim
Foundation, New York

The most imposing element of Walker's installation was a monumental sphinx with distinctly African features and a kerchief tied around her head. Blindingly white, she seemed to be made of solid sugar. (In fact, the sculpture was built from blocks of Styrofoam, then coated with 30 tons of sugar.) Scattered around the warehouse were her attendants, fifteen life-size sculptures of African children carrying large baskets or lugging bunches of bananas. Some were made of caramel-colored sugar and gradually disintegrated over the course of the exhibition. Others, cast in resin and coated with molasses, remained, mute witnesses to their companions' end.

Walker brought art into a specialized space, evoking a connection between what took place there and larger social and historical issues. Other artists have worked in the opposite direction, slipping works of art into the everyday visual world. In 1995 Felix Gonzalez-Torres had a black-and-white photograph of a single bird in flight placed in six outdoor locations around New York City (2.42). Nothing told passersby that it was art. No words tried to explain it or take credit for it. The artist presented the image anonymously, hoping only that people might notice, might wonder, might bring their own meanings to this unexpected encounter.

Gonzalez-Torres took the photograph himself, but his art consisted in having it reprinted at billboard size, renting the billboard locations, and slipping the image into the clamor of signs, symbols, and advertisements that surrounds us. The collector who bought the work bought both the right and the responsibility to perpetuate this gesture, manifesting the work as often as desired on outdoor billboards. The collector, in essence, bought an idea. Insisting that art could reside in an idea was the most radical of 20th-century artists' many moves away from making objects. During the 1960s, idea-based art became known as Conceptual art—a very intimidating name for so gentle, generous, and hopeful a gesture as Gonzalez-Torres' billboard of a bird in flight.

The questions that artists of the 20th century posed about the nature of their task, and the great formal variety of their responses to those questions, served to map the territory of the word "art." We now understand that art can manifest itself in many more ways than the 18th-century philosophers who invented the category ever dreamed. A painting, a sculpture, a video, an installation, a Web site, a computer program, a concept, a performance, an action—all of these and more may be presented and understood as art.

Themes of Art

n extending our modern concept of art outward to other cultures and backward in time, we observe that peoples throughout history have created visually meaningful forms. Whether those forms be paintings or textiles, buildings or ceramics, they have in common that they are *about* something. This "aboutness" is what allows us to experience them as art. But what sorts of things are they about?

One way to begin exploring the elusive concept of "aboutness" is to consider some broad areas of meaning that have been reflected in the arts of many cultures throughout human history. We can call these areas of meaning *themes*. No doubt, every person setting out to name the most important themes in art would produce a different list. This chapter proposes eight themes, from the sacred realm to art about art. Each one allows us to range widely over the world's artistic heritage, setting works drawn from different times and places in dialogue by showing how their meanings begin in a shared theme.

Just as a work of art can hold many meanings and inspire multiple interpretations, so it may reflect more than one theme. As you read this chapter, you may find yourself considering works discussed earlier in the light of the new theme at hand, or thinking about how a newly encountered work also reflects themes discussed earlier. This is as it should be. Themes are not intended to reduce art to a set of neat categories. Rather, they provide a framework for exploring how complex a form of expression it can be.

The Sacred Realm

Who made the universe? How did life begin, and what is its purpose? What happens to us after we die? For answers to those and other fundamental questions, people throughout history have turned to a world we cannot see except through faith, the sacred realm of the spirit. Gods and goddesses, spirits of ancestors, spirits of nature, one God and one alone—each society has formed its own view of the sacred realm and how it interacts with our own. Some forms of faith have disappeared into history, others have remained small and local, while still others such as Christianity and Islam have become major religions that draw believers from all over the world. From earliest times, art has played an important role in our relationship to the sacred, helping us to envision it, to honor it, and to communicate with it.

Many works of architecture have been created to provide settings for rituals of worship and prayer, rituals that formalize contact between the earthly

and the divine realms. One such work is the small marvel known as the Sainte-Chapelle, or holy chapel (3.1). Located in Paris, the chapel was commissioned in 1239 by the French king Louis IX to house an important collection of relics that he had just acquired, relics he believed to include pieces of the True Cross, the Crown of Thorns, and other instruments of Christ's Passion. The king's architects created a soaring vertical space whose walls seem to be made of stained glass. Light passing through the glass creates a dazzling effect, transforming the interior into a radiant, otherworldly space in which the glory of heaven seems close at hand.

The Sainte-Chapelle is a relatively intimate space, for it was intended as a private chapel for the king and his court. In contrast, the Great Mosque at Córdoba, Spain, was built to serve the needs of an entire community (3.2). A mosque is an Islamic house of worship. Begun during the 8th century, the Great Mosque at Córdoba grew to be the largest place of prayer in western Islam. The interior of the prayer hall is a vast horizontal space measured out by a virtual forest of columns. Daylight enters through doorways placed around the perimeter of the hall. Filtered through the myriad columns and arches, it creates a complex play of shadows that makes the extent and shape of the interior hard to grasp. Alternating red and white sections break up the visual continuity of the arch forms. Oil lamps hanging in front of the focal point of worship would have created still more shadows.

In both the Sainte-Chapelle and the Great Mosque at Córdoba, architects strove to create a place where worshipers might approach the sacred realm. The builders of the Sainte-Chapelle envisioned a radiant vertical space transformed by colored light, whereas the architects of the Great Mosque at Córdoba envisioned a disorienting horizontal space fractured by columns and shadows. In both buildings, the everyday world is shut out, and light and space are used to create a heightened sense of mystery and wonder.

The sacred realm cannot be seen with human eyes, yet artists throughout the ages have been asked to create images of gods, goddesses, angels,

3.1 Interior, upper chapel, Sainte-Chapelle, Paris. 1243–48.

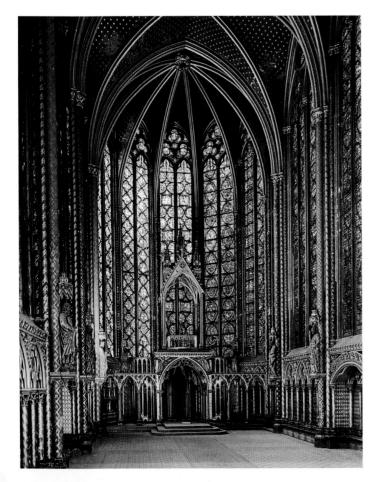

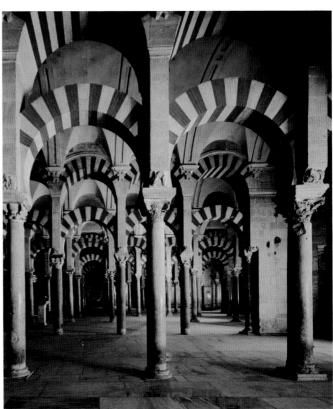

3.2 Prayer hall of Abd al-Rahman I, Great Mosque, Córdoba, Spain. Begun 786 C.E.

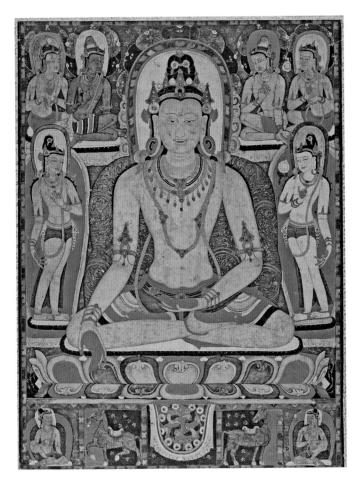

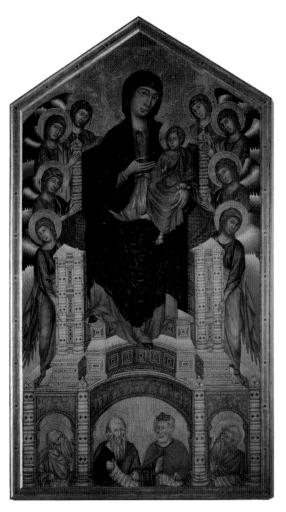

3.4 Cimabue. *Madonna Enthroned*. c. 1280–90. Tempera on wood, 12'7½" × 7'4". Galleria degli Uffizi, Florence

demons, and all manner of spirit beings. Religious images may serve to focus the thoughts of the faithful by giving concrete form to abstract ideas. Often, however, their role has been more complex and mysterious. For example, in some cultures, images have been understood as a sort of conduit through which sacred power flows; in others, they serve as a dwelling place for a deity, who is called upon through ritual to take up residence within.

Our next two images, one Buddhist and one Christian, were made at approximately the same time but some four thousand miles apart, the Buddhist image in Tibet, the Christian one in Italy. The Buddhist painting portrays Rathnasambhava, one of the Five Transcendent Buddhas, seated in a pose of meditation on a stylized lotus throne (3.3). His right hand makes the gesture of bestowing vows; his left, the gesture of meditation. Unlike other buddhas, the Five Transcendent Buddhas are typically portrayed in the bejeweled garb of Indian princes. Arranged around Rathnasambhava are bodhisattvas, also in princely attire. Bodhisattvas are enlightened beings who have deferred their ultimate goal of nirvana—freedom from the cycle of birth, death, and rebirth—in order to help others attain that goal. All wear halos signifying their holiness. The buddha, being the most important of the personages depicted, dominates the painting as the largest figure. He faces straight front, in a pose of tranquility, while the others around him stand or sit in relaxed postures.

The second example, painted by the 13th-century Italian master Cimabue, depicts Mary, mother of Christ, with her son (3.4). Mary sits tranquilly on her throne, her right hand indicating the Christ child, who raises his right hand in a gesture of benediction. On both sides of her are figures of angels, heavenly

THINKING ABOUT ART | Iconoclasm

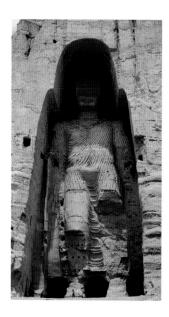

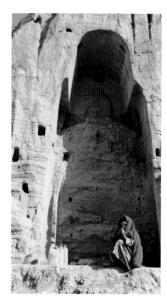

In arguments for iconoclasm, why is worshiping artworks themselves not the same as worshiping what they represent? On the other hand, how can art communicate religious beliefs, practices, and values?

n February 26, 2001, the Islamic fundamentalist rulers of Afghanistan, the Taliban, issued an edict that stunned the world: all statues in the country must be destroyed, for they were being worshiped and venerated by unbelievers. The order targeted statues large and small, those housed in museums and those on view in public places. But the statues that caught the public's attention were a pair of monumental buddhas. Carved into the living rock of a cliff face sometime between the 3rd and 7th centuries, they were originally cared for by Buddhist monks and visited by pilgrims during religious festivals. The monks and pilgrims left centuries ago, but the statues had survived. It seemed scarcely credible that they were about to be blown up, but that is exactly what happened. In early March, despite international diplomatic efforts, the statues were destroyed.

Why would statues be destroyed in the name of religion? Like many other religions, Islam has at its core a set of texts that invite interpretation. One of these, the Traditions of the Prophet, contains two objections

to representational images. The first objection is that making images usurps the creative power of God; the second is that images can lead to idolatry, the worship of the images themselves. Historically, the warnings have led Muslims generally to avoid representational images in religious contexts such as mosques or manuscripts of the Qur'an, their holy book. Interpreted more radically, they have sometimes been used to forbid all representational images, no matter what their context. Our word for the destruction of images does not come from Islam, however, but from Christianity, which also has a history of destroying images in the name of spiritual purity. The word is iconoclasm.

Iconoclasm is derived from the Greek for "image breaking." It was coined to describe one side of a debate that raged for over a century in the Christian empire of Byzantium (see page 353). Byzantine churches, monasteries, books, and homes were decorated with depictions of Christ, of the saints, and of biblical stories and personages. Yet during the 8th century, a movement arose against such depictions, and a series of emperors ordered the destruction of images throughout the realm. Again, the objection was idolatry. Christianity too has at its core a set of texts. The most important of these is the Bible, which contains a very clear warning against making images. The warning comes directly from God as the second of the Ten Commandments.

Centuries after the Byzantine episode, iconoclasm arose in western Europe when newly forming Protestant movements of the 16th century accused Catholics of idolatry. Protestant mobs ransacked churches, smashing stained glass, destroying paintings, breaking statues, whitewashing over frescoes, and melting down metal shrines and vessels. To this day, Protestant churches are comparatively bare.

Images have played an important role in almost every religion in the world. Many religions embrace them wholeheartedly. In Buddhism, for example, making religious images is viewed as a form of prayer. In Hinduism they may provide a dwelling place for a deity. The modern Western invention of "art" has seen many of these images moved to museums, and in the end this may have been part of the Taliban's point. We may not worship images for the deities they represent, but do we worship art?

⁽left) Large Buddha, Bamiyan, Afghanistan. 3rd–7th century C.E. Stone, height 175'.

⁽right) The empty niche after the statue was destroyed. March 2001.

spirit-messengers. Again, all wear halos signifying their holiness. As in the Buddhist painting, the most important personage dominates the composition, is the largest, and holds a serenely frontal pose.

We should not conclude from the remarkable formal similarity of these works that any communication or influence took place between Italy and Central Asia. A safer assumption is that two artists of different faiths independently found a format that satisfied their pictorial needs. Both the Buddha and the Virgin are important, serene holy figures. Bodhisattvas and angels, who are always more active, attend them. Therefore, the artists, from their separate points of view, devised similar compositions.

Politics and the Social Order

Of the many things we create as human beings, the most basic and important may be societies. How can a stable, just, and productive society best be organized? Who will rule, and how? What freedoms will rulers have? What freedoms will citizens have? How is wealth to be distributed? How is authority to be maintained? Many answers to those questions have been posed throughout history, and throughout history the resulting order has been reflected in art.

In many early societies, earthly order and cosmic order were viewed as interrelated and mutually dependent. Such was the case in ancient Egypt, where the pharaoh (king) was viewed as a link between the divine and the earthly realms. The pharaoh was considered a "junior god," a personification of the god Horus and the son of the sun god, Ra. As a ruler, his role was to maintain the divinely established order of the universe, which included the social order of Egypt. He communed with the gods in temples only he could enter, and he wielded theoretically unlimited power over a country that literally belonged to him.

When a pharaoh died, it was believed that he rejoined the gods and became fully divine. Preparations for this journey began even during his lifetime, as vast tombs were constructed and outfitted with everything he would need to maintain his royal lifestyle in eternity. The most famous of these monuments are the three pyramids at Giza (3.5), which served as the tombs of the pharaohs Menkaure, Khafre, and Khufu. Thousands of years later, the scale of these structures is still awe-inspiring. The largest pyramid, that of Khufu, originally reached a height of about 480 feet, roughly the height of a fifty-story skyscraper. Its base covers over 13 acres. Over two million blocks of stone,

3.5 The Great Pyramids, Giza, Egypt. Pyramid of Menkaure (left), c. 2500 B.C.E.; Pyramid of Khafre (center), c. 2530 B.C.E.; Pyramid of Khufu (right), c. 2570 B.C.E.

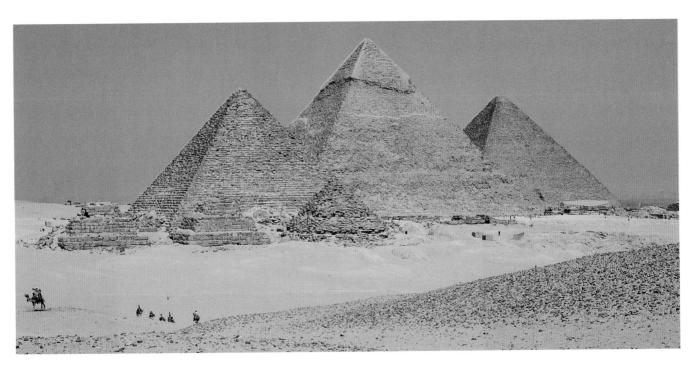

each weighing over 2 tons, went into building it. Each block had to be quarried with hand tools, transported to the site, and set in place without mortar. Tens of thousands of workers labored for years to build such a tomb and fill its chambers with treasures.

The pyramids reflect the immense power of the pharaohs who could command such forces, but they also reflect the beliefs underlying the social order that granted its rulers such power in the first place. In the Egyptian view, the well-being of Egypt depended on the goodwill of the gods, whose representative on earth was the pharaoh. His safe passage to the afterlife and his worship thereafter as a god himself were essential for the prosperity of the country and the continuity of the universe. No amount of labor or spending seemed too great to achieve those ends.

Visitors to the pyramids at Giza originally arrived by water, disembarking first at one of the temples that sat on the riverbank (each pyramid had its own). From there, they would have walked along a long, raised causeway to a second temple at the base of the pyramid, which itself could not be entered. The temples contained numerous shrines to the dead pharaoh, each with its own life-size statue of him. Statues lined the causeways as well, and still more were inside the pyramid itself. Before our modern mass media, it was art that served to project the presence and authority of rulers to the people throughout their lands. During the days of the Roman Empire, in the first centuries of our era, an official likeness of a new emperor was circulated throughout the realm so that local sculptors could get busy making statues for public places and civic buildings.

One of the finest of these ancient Roman works to come down to us is a bronze statue of the emperor Marcus Aurelius (3.6). Seated on his mount, he extends his arm in an oratorical gesture, as if delivering a speech. His calm in victory contrasts with the spirited motions of his horse, which was originally shown raising its hoof over a fallen enemy, now lost. The Roman fashion for beards came and went, like all fashions. But the emperor's beard in the statue is significant, and part of the way he wanted to be portrayed. Beards were associated with Greek philosophers, and Marcus Aurelius' beard signals his desire to be seen as a philosopher-king, an ideal he genuinely tried to live up to.

3.6 Equestrian statue of Marcus Aurelius. 161–80 c.E. Gilded bronze, height 11'6". Musei Capitolini, Rome

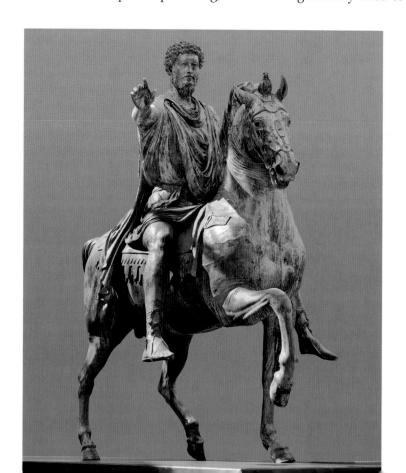

During the often violent transition into our modern era, art remained deeply involved with politics and the social order. The perspective of the artist changed profoundly, however. Instead of exclusively serving those in power, the artist was now a citizen among other citizens and free to make art that took sides in the debates of the day. Eugène Delacroix's *Liberty Leading the People* leaves no doubt about the artist's support for the Revolution of 1830, a popular uprising in Paris that toppled one government and installed another (3.7). Delacroix completed the painting in the very same year, and it retains the passion of his idealized view of the insurrection and the hopes he had for the future it would bring. At the center is Liberty herself, personified as a Greek statue come to life. Holding the French flag high, she rallies the citizens of Paris, who surge toward us brandishing pistols and sabers as though about to burst out of the painting. Before them lie the bodies of slain government troops.

When the painting was displayed to the public in 1831, it was bought by none other than Louis-Philippe, the "citizen-king" that the revolution had put in power. But perhaps the image was a little *too* revolutionary, for the new king returned the painting to Delacroix after a few months. In fact, *Liberty Leading the People* did not go on permanent public display until 1863, after a vast urban renewal program had minimized the possibility of angry citizens

again taking control of the streets.

Where Delacroix glorifies violence in the service of democracy in *Liberty Leading the People*, Pablo Picasso condemns the violence that fascism unleashed against ordinary citizens in *Guernica*, one of the most famous paintings of the 20th century (3.8). *Guernica* depicts an event that took place during the Spanish

3.7 Eugène Delacroix. *Liberty Leading the People, 1830.* 1830. Oil on canvas, 8'6" × 10'10". Musée du Louvre, Paris

3.8 Pablo Picasso. *Guernica*. 1937. Oil on canvas, 11'5½" × 25'5¾". Museo Nacional Centro de Arte Reina Sofia, Madrid

Civil War, when a coalition of conservative, traditional, and fascist forces led by General Francisco Franco were trying to topple the liberal government of the fledgling Spanish Republic. In Germany and Italy, the fascist governments of Hitler and Mussolini were already in power. Franco willingly accepted their aid, and in exchange he allowed the Nazis to test their developing air power. On April 28, 1937, the Germans bombed the town of Guernica, the old Basque capital in northern Spain. There was no real military reason for the raid; it was simply an experiment to see whether aerial bombing could wipe out a whole city. Being totally defenseless, Guernica was devastated and its civilian population massacred.

At the time, Picasso, himself a Spaniard, was working in Paris and had been commissioned by his government to paint a mural for the Spanish Pavilion of the Paris World's Fair of 1937. For some time, he had procrastinated about fulfilling the commission; then, within days after news of the bombing reached Paris, he started *Guernica* and completed it in little over a month. The finished mural shocked those who saw it; it remains today a chillingly dramatic protest against the brutality of war.

At first encounter with *Guernica*, the viewer is overwhelmed by its presence. The painting is huge—more than 25 feet long and nearly 12 feet high—and its stark, powerful imagery seems to reach out and engulf the observer. Picasso used no colors; the whole painting is done in white and black and shades of gray, possibly to echo the visual impact of news photography. (Newspapers at the time were illustrated with black-and-white photographs; newsreels shown in cinemas were also in black-and-white. Television did not yet exist.) Although the artist's symbolism is very personal (and he declined to explain it in detail), we cannot misunderstand the scenes of extreme pain and anguish throughout the canvas. At far left, a shrieking mother holds her dead child, and at far right, another woman, in a burning house, screams in agony. The gaping mouths and clenched hands speak of disbelief at such mindless cruelty.

Like Liberty Leading the People, Guernica has had an interesting political afterlife. Franco's forces were triumphant. Picasso refused to allow Guernica to reside in Spain while Franco was in power, and so for years it was displayed at the Museum of Modern Art in New York. When Franco died in 1975, the painting was returned to Spain, but there another debate ensued: Where in Spain should it stay? The town of Guernica wanted it. So did the town where Picasso was born. Madrid, the Spanish capital, won out in the end. The Basque

Nationalist Movement, which would like to see the Basque territories secede from Spain, considers that Madrid kidnapped their rightful cultural property. *Guernica* is now displayed under bulletproof glass.

Stories and Histories

Deeds of heroes, lives of saints, folktales passed down through generations, episodes of television shows that everyone knows by heart—shared stories are one of the ways we create a sense of community. Artists have often turned to stories for subject matter, especially stories whose roots reach deep into their culture's collective memory.

In Christian Europe of the early 15th century, stories of the lives of the saints were a common reference point. One of the best-loved saints was Francis of Assisi, who had lived only about two centuries earlier. The son of a wealthy merchant in the Italian town of Assisi, Francis as a young man renounced his inheritance for a life of extreme poverty in the service of God. He preached to all who would listen (including birds and animals) and cared for the poor and the sick. With the disciples who gathered around him, he founded a religious community that was eventually formalized as the Franciscan Order of monks.

The painting here by the 15th-century Italian artist Sassetta illustrates two episodes from Saint Francis' life (3.9). To the left, Francis, still a wealthy young man, gives his cloak to a poor man. To the right, Sassetta cleverly uses the house—its front wall made invisible so we can see inside—to create a separate

3.9 Sassetta. *St. Francis Giving His Mantle to a Poor Man and the Vision of the Heavenly City.* c. 1437–44. Oil on panel, 34¼ × 20¾".
The National Gallery, London

space, a sort of "painting within a painting," for the next part of the story. Here, an angel appears while Francis is sleeping and grants him a dream vision of the Heavenly City of God. The angel's upraised hand leads our eyes to the vision, which is portrayed at the top of the panel.

These "painting within a painting" areas are called space cells, and artists in many cultures have used them for narration. The Indian painter Sahibdin made ingenious use of space cells to relate a complicated episode from the epic poem *Ramayana*, or *Story of Rama* (3.10). One of the two great founding Indian epics, the *Ramayana* is attributed to the legendary poet Valmiki, and portions of it date as far back as 500 B.C.E. Rama, the hero of the epic, is a prince and an incarnation of the Hindu god Vishnu. He is heir to the throne of an important Indian kingdom, but because of jealous intrigue he is sent into exile before he can be crowned. Soon afterward, his wife, Sita, is carried off by the demon Ravana. The epic chronicles Rama's search for Sita and his long journey back to his rightful position as a ruler.

In the episode depicted here, Rama suffers a setback as he battles Ravana for Sita's release. The story begins in the small, rose-colored space cell to the right, where Ravana, portrayed with twenty heads and a whirlwind of arms, confers with his son Indrajit on a plan to defeat Rama, who is about to attack the palace. Below, the plan finalized, Indrajit is shown leaving the palace with his warriors. The action now shifts to the left side of the page, where Indrajit, aloft in an airborne chariot, shoots arrows down at Rama and his companion, Lakshmana. The arrows turn into snakes, binding the two heroes. The story continues on the ground, where Indrajit assures the monkey-king Sugriva that Rama and Lakshmana are not dead but successfully captured. In the yellow cell at the center of the painting, Indrajit stages a triumphal procession back into the palace, where, in the upper right corner, he is joyfully received by Ravana. Meanwhile, Sita, imprisoned in the garden depicted in the yellow space cell immediately below, receives a visit from the demoness Trijata, who takes her in a flying chariot ride (upper left) to witness Rama's defeat. Sahibdin's illustration was made for an audience who knew the epic tale almost by heart and would have delighted in puzzling out the painting's ingenious construction.

3.10 Sahibdin and workshop. Rama and Lakshmana Bound by Arrow-Snakes, from the Ramayana. Mewar, c. 1650–52. Opaque watercolor on paper, approx. 9 × 153/8". The British Library, London

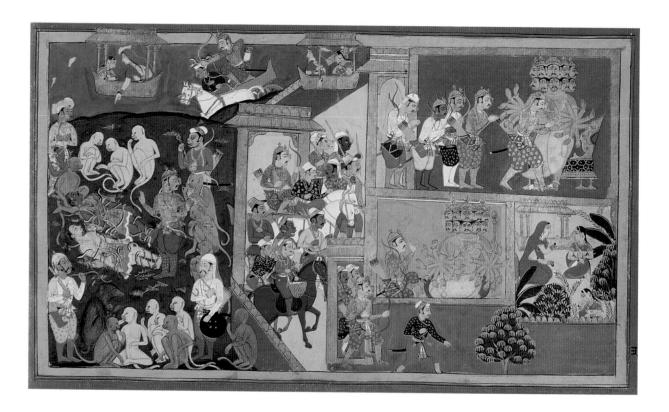

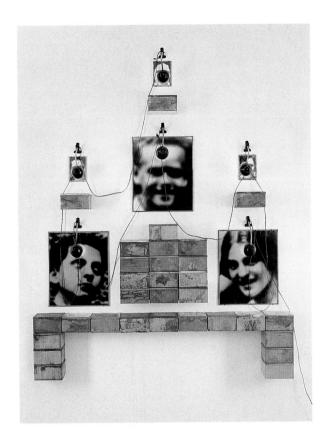

History has furnished artists with many stories, for history itself is nothing more than a story we tell ourselves about the past, a story we write and rewrite. In Altar to the Chases High School (3.11), Christian Boltanski draws on our memory of the historical episode known as the Holocaust, the mass murder of European Jews and other populations by the Nazis during World War II. Chases was a private Jewish high school in Vienna. Boltanski began with a photograph that he found of the graduating class of 1931. Eighteen years old in the photograph, the students would have been twenty-five when Austria was annexed by Germany at the start of the war. Most probably perished in the death camps. Boltanski rephotographed each face, then enlarged the results into a series of blurry portraits. The effect is as though someone long gone were calling out to us; we try to recognize them, but cannot quite. Our task is made even more difficult by the lights blocking their faces, lights that serve as halos on the one hand, but also remind us of interrogation lamps. We wonder, too, what the stacked tin boxes might hold. Ashes? Possessions? Documents? They have no labels, just as the blurred faces have almost no identities.

3.11 Christian Boltanski. Altar to the Chases High School. 1987. Photographs, tin biscuit boxes, and six metal lamps; 6'9½" × 7'2½". Museum of Contemporary Art, Los Angeles

Looking Outward: The Here and Now

The social order, the world of the sacred, history and the great stories of the past—all these are very grand and important themes. But art does not always have to reach so high. Sometimes it is enough just to look around ourselves and notice what our life is like here, now, in this place, at this time.

Among the earliest images of daily life to have come down to us are those that survived in the tombs of ancient Egypt. Egyptians imagined the afterlife as resembling earthly life in every detail, except that it continued through eternity. To ensure the prosperity of the deceased in the afterlife, scenes of

3.12 Model depicting the counting of livestock, from the tomb of Meketre, Deir el-Bahri. Dynasty 11, 2134–1991 B.C.E. Painted wood, length 5'8".
Egyptian Museum, Cairo

3.13 Court Ladies
Preparing Newly Woven
Silk, detail. Attributed to
the emperor Huizong
(1082–1135) but probably
by a court painter.
Handscroll, ink, colors, and
gold on silk; height 14½".
Museum of Fine Arts, Boston

the pleasures and bounty of life in Egypt were painted or carved on the tomb walls. Sometimes models were substituted for paintings (3.12).

This model was one of many found in the tomb of an Egyptian official named Meketre, who died around 1990 B.C.E. Meketre himself is depicted at the center, seated on a chair in the shade of a pavilion. Seated on the floor to his left is his son; to his right are several scribes (professional writers) with their writing materials ready. Overseers of Meketre's estate stand by as herders drive his cattle before the reviewing stand so that the scribes can count them. The herders' gestures are animated as they coax the cattle along with their sticks, and the cattle themselves are beautifully observed in their diverse markings.

Another model from Meketre's tomb depicts women at work spinning and weaving cloth. They would probably have been producing linen, which Egyptians excelled at. In China, the favored material since ancient times has been silk. Court Ladies Preparing Newly Woven Silk (3.13) is a scene from a long handscroll depicting women weaving, ironing, and folding lengths of silk. The painting is a copy made during the 12th century of a famous 8th-century work by Zhang Xuan, now lost. In this scene, four ladies in their elegant robes stretch a length of silk. The woman facing us irons it with a flat-bottomed pan

full of hot coals taken from the brazier visible at the right. A little girl too small to share in the task clowns around for our benefit. If this is a scene from everyday life, it is a very rarefied life indeed. These are ladies of the imperial court, and the painting is just as much an exercise in portraying beautiful women as it is in showing their virtuous sense of domestic duty.

Moving from the Chinese scroll to Edward Hopper's Gas (3.14), we leave the exalted world of the imperial court for the everyday world of mid-20thcentury America. In place of the women's sense of community in a shared task, we find a solitary man tending to the gasoline pumps at his small, roadside service station. (Yes, gasoline pumps once looked like that.) Hopper had a gift for depicting empty places and lonely moments. Here, he conjures that magical hour when artificial light mingles with the light of the dying day. Our eyes are drawn to the red of the gasoline pumps, then on into the shadows where the road disappears, as though we were forever leaving the scene behind, forever passing by. The man is alone. The road is deserted. (We would see the light from the headlights if a car were approaching.) On the gently lit signboard, Pegasus, the mythical winged horse, leaps into the sky, which will soon fill with stars. It is an ordinary evening, and Hopper celebrates its quiet, unassuming ordinariness.

Living in New York in the 1960s, Robert Rauschenberg found that the visual impact of daily life had outgrown the ability of any single image to convey it. Instead, to communicate the energy and vitality of his time and place, Rauschenberg treated his canvas like a gigantic page in a scrapbook. The result is a kind of controlled chaos in which photographic images drawn from many sources are linked by a poetic process of free association. Windward, for example, includes images of the Statue of Liberty, a bald eagle against a rainbow, the Sistine Chapel with Michelangelo's famous frescoes (upper left), Sunkist oranges, Manhattan rooftops and their distinctive water towers (in red), building facades (in blue), and construction workers in plaid shirts and hard hats (in blue, lower right) (3.15). Part of our pleasure as viewers lies in teasing out their visual and conceptual connections.

3.15 Robert Rauschenberg. Windward. 1963. Oil and silkscreened ink on canvas. $8' \times 5'10''$.

Fondation Beyeler, Riehen/Basel

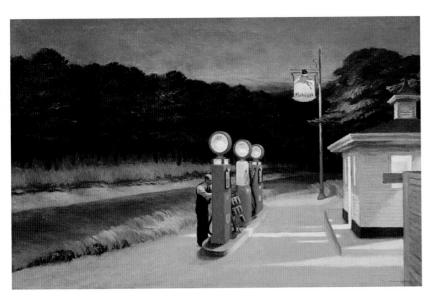

3.14 Edward Hopper. Gas. 1940. Oil on canvas, $26\frac{1}{4} \times 40\frac{1}{4}$ ". The Museum of Modern Art, New York

ARTISTS Robert Rauschenberg (1925–2008)

How should we categorize the works of Rauschenberg? How does his style capture the culture and the events of his time? What are some of his dominant themes?

orn in Port Arthur, Texas, Milton Rauschenberg—who later became known as Bob and then Robert—had no exposure to art as such until he was seventeen. His original intention to become a pharmacist faded when he was expelled from the University of Texas within six months, for failure (he claims) to dissect a frog. After three years in the Navy during World War II, Rauschenberg spent a year at the Kansas City Art Institute; then he traveled to Paris for further study. At the Académie Julian in Paris he met the artist Susan Weil, whom he later married.

Upon his return to the United States in 1948, Rauschenberg enrolled in the now-famous art program headed by the painter Josef Albers at Black Mountain College in North Carolina. Many of his longterm attachments and interests developed during this period, including his close working relationship with the avant-garde choreographer Merce Cunningham. In 1950 Rauschenberg moved to New York, where he supported himself partly by doing window displays for the fashionable Fifth Avenue stores Bonwit Teller and Tiffany's.

Rauschenberg's work began to attract critical attention soon after his first one-man exhibition at the Betty Parsons Gallery in New York. The artist reports that between the time Parsons selected the works to be exhibited and the opening of the show, he had completely reworked everything, and that "Betty was surprised." More surprises were soon to come from this steadily unpredictable artist.

The range of Rauschenberg's work makes him difficult to categorize. In addition to paintings, prints, and combination pieces, he did extensive set and costume design for dances by Cunningham and others, as well as graphic design for magazines and books. "Happenings" and performance art played a role in his work from the very beginning. In 1952, at Black Mountain College, he participated in Theater Piece #1, by the composer John Cage, which included improvised dance, recitations, piano music, the playing of old records, and projected slides of Rauschenberg's paintings. Even the works usually classified as paintings are anything but conventional. One has an actual stuffed bird attached to the front of the canvas. Another consists of a bed, with a quilt on it, hung upright on the wall and splashed with paint. Works that might be called sculptures are primarily assemblage; for example, Sor Aqua (1973) is composed of a bathtub (with water) above which a large chunk of metal seems to be flying.

In his later years, the artist devoted much of his time to ROCI (pronounced "Rocky"), his Rauschenberg Overseas Culture Interchange, which had as its goal promoting international friendship, understanding, and peace. Through ROCI he brought his work to Mexico, Chile, China, Tibet, Germany, Venezuela, Japan, Cuba, and the former Soviet Union.

We get from Rauschenberg a sense of boundaries being dissolved—boundaries between media, between art and nonart, between art and life. He said: "The strongest thing about my work . . . is the fact that I chose to ennoble the ordinary."

Robert Rauschenberg at home in Captiva, June 1992. Photograph by Richard Schulman.

The Statue of Liberty and the eagle are symbols of the United States, and the statue is more specifically a tourist attraction of New York. Sunkist oranges are an American product, but Rauschenberg likes their name as well: sun-kissed, kissed by the sun. In a repeat of the image directly below, he paints white all the oranges but one. The single orange becomes a sun, and the rest are clouds. "Sun-kissed" also applies to the rainbow, which is moist air kissed by the sun. It applies more generally to a clear day in New York, and in the company of the eagle and the statue it evokes the sentiments expressed in one of our most popular patriotic songs, which begins "O beautiful for spacious skies." Again and again we find the optimistic gesture of raising up: Liberty raises her torch high, the rooftops hold aloft their water towers, the Sistine Chapel holds up its great vaulted ceiling, the construction workers build a skyscraper.

Looking Inward: The Human Experience

An Egyptian official, a lady of the imperial Chinese court, and a gas-station attendant in rural America would all have had very different lives. They would have known different stories, worshiped different gods, seen different sights, and had different understandings of the world and their place in it. Yet they also would have shared certain experiences, just by virtue of being human. We are all of us born, we pass through childhood, we mature into sexual beings, we search for love, we grow old, we die. We experience doubt and wonder, happiness and sorrow, loneliness and despair.

Surely one of the most common of human wishes is to talk, if only we could, if only for a moment, with someone who is no longer here. Many religions embrace the idea that the dead form a vast spirit community capable of helping us. Many rituals have been devised to honor ancestors and appease their spirits. But all the rituals in the world do not compensate for the ache we sometimes feel when we wish we could speak to those who came before—to tell them what we have become, to ask for guidance, to compare experiences, to explain, to listen.

Meta Warrick Fuller's poignant sculpture *Talking Skull* depicts that wish being granted (3.16). Kneeling before the skull, naked and vulnerable, the boy seems to hear an answer to his pleading. On one level, *Talking Skull* embodies a universal message about the desire for communion beyond the boundaries of our brief lifetime. But it is also a specifically African-American work that addresses the traumatic rupture with ancestral culture that slavery had produced.

3.16 Meta Warrick Fuller. *Talking Skull*. 1937. Bronze, $28 \times 40 \times 15$ ". Museum of African American History, Boston and Nantucket

Fuller was a pioneering African-American artist. Born in 1877, she pursued her artistic training in both the United States and Europe, mastering the conservative, academic style that brought mainstream recognition to artists in her day. Like many of her generation she sought out themes that would help American blacks reconnect with and take pride in their African heritage.

Looking at Fuller's sculpture, we enter into the boy's thoughts through empathy. Fuller counts on this ability, and her artistry facilitates it by giving us numerous clues: the pose, the nakedness, the intense gaze, the open mouth. In *Self-Portrait with Monkeys* (3.17), the Mexican artist Frida Kahlo does not provide us with an easy way into her thoughts. She seems, rather, to hold us at arm's length with her gaze, to insist that we cannot truly know her.

Kahlo began to paint while recovering from a streetcar accident that left her body shattered and unable to bear children. She would know periods of crippling pain for the rest of her life and undergo dozens of operations. Her first work was a self-portrait, as though to affirm that she still existed. She continued to paint self-portraits over the course of her career. In them she expressed her experience as a woman, as an artist, as a Mexican. Often, as here, she paints herself as the still center of a busy visual field. Wearing an embroidered Mexican dress, she regards us coolly, skeptically. Or perhaps it is herself in the mirror that she sees.

Her two pet monkeys seem both protective and possessive in their gestures. Their gazes tell us no more than hers, but she and they clearly share an understanding that excludes us. Behind them two more monkeys peer out from the foliage. Next to her head, as though she were thinking it, a bird of paradise flower displays its extravagant, flamelike petals—exotic, proud, desirable, and slightly menacing. European visitors admired Kahlo's paintings for their dream imagery, but she herself rejected such praise. "I never painted dreams," she said. "I painted my own reality."²

One of the most reticent yet complete evocations of our existence and its fundamental questions is the Dutch painter Johannes Vermeer's quiet masterpiece *Woman Holding a Balance* (3.18). Stillness pervades the picture. A gentle half-light filtered through the curtained window reveals a woman contemplating

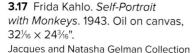

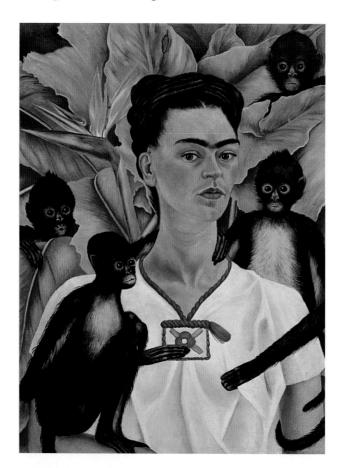

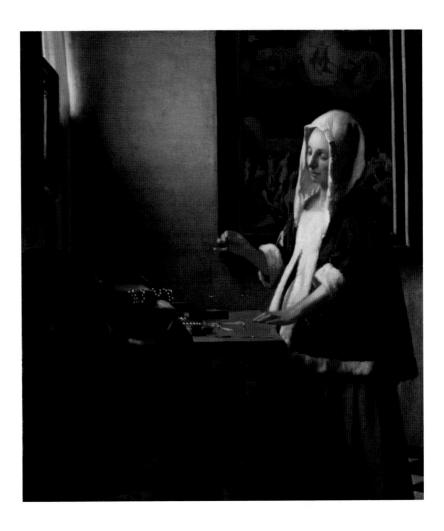

an empty jeweler's balance. She holds the balance and its two glinting trays delicately with her right hand, which falls in the exact center of the composition. The frame of the painting on the wall behind catches the light, drawing our attention. The painting is a depiction of the Last Judgment, when according to Christian belief Christ shall come again to judge, to weigh souls. On the table, the light picks out strands of pearls. Jewels and jewelry often serve as symbols of vanity and the temptations of earthly treasure. Light is reflected, too, in the surface of the mirror, next to the window. The mirror suggests self-knowledge, and indeed if the woman were to look up, she would be facing directly into it. Scholars have debated whether the woman is pregnant or whether the fashion of the day simply makes her appear so. Either way, we can say that her form evokes pregnancy, the miracle of birth, and the renewal of life.

Birth, death, the decisions we must weigh on our journey through life, the temptations of vanity, the problem of self-knowledge, the question of life after death—all these issues are gently touched on in this most understated of paintings.

Invention and Fantasy

Renaissance theorists likened painting to poetry. With words, a poet could conjure an imaginary world and fill it with people and events. Painting was even better, for it could bring an imaginary world to life before your eyes. Poetry had long been considered an art, and the idea that painting was comparable to it is one of the factors that led to painting's being considered an art as well.

One of the most bizarrely inventive artists ever to wield a brush was the Netherlandish painter Hieronymus Bosch. When we first encounter his

3.18 Johannes Vermeer. Woman Holding a Balance. c. 1664. Oil on canvas, 15\(^1/8\) × 14". National Gallery of Art, Washington, D.C.

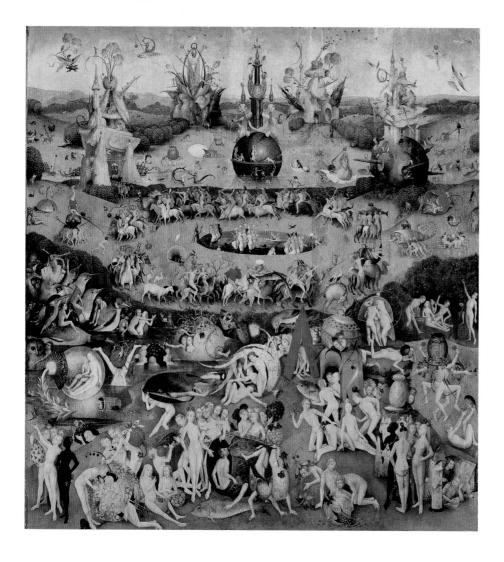

3.19 Hieronymus Bosch. The Garden of Earthly Delights, center section. c. 1505–10. Oil on panel, 7'25%" × 6'4¾". Museo del Prado, Madrid

The Garden of Earthly Delights (3.19), we might think we have wandered into a fun house of a particularly macabre kind. The Garden of Earthly Delights is the central and largest panel of a triptych, a painting in three sections. The outer two sections, painted both front and back, can close like a pair of shutters over this central image. Closed, they depict the creation of the world; open, they illustrate the earthly paradise of Eden (left) and Hell (right). Between Eden and Hell, Bosch set The Garden of Earthly Delights, which depicts the false paradise of love—false because, though deeply pleasurable, it can lead humanity away from the bonds of marriage toward the deadly sin of Lust, and thus damnation. Hundreds of nude humans cavort in a fantasy landscape inhabited by giant plants and outsized birds and animals. The people are busy and inventive in the things they do to and with each other (and to and with the animals and plants). They seem to be having a fine time, but their goings-on are so strange that we are both intrigued and repelled by them. Can these truly be delights?

A far more benign imagination was that of Henri Rousseau. Rousseau worked in France during the late 19th and early 20th centuries. He was acquainted with all the up-and-coming artists of the Parisian scene, and sometimes he exhibited with them. The naiveté of his expression came not so much from ignorance of formal art tradition as from indifference to that tradition. Rousseau loved to paint jungle scenes, but they were wholly products of fantasy, for in fact he never left France. Instead, he assembled his exotic visions from illustrated books, from travel magazines, and from sketching trips to the zoo, the natural history museum, and especially the great tropical greenhouses of the Paris botanical garden. Entering them, he said, was like walking into a dream. In his last painting, he gave this dream to a young woman (3.20). Reclining nude on a velvet sofa, she seems unsurprised to find herself in a dense forest

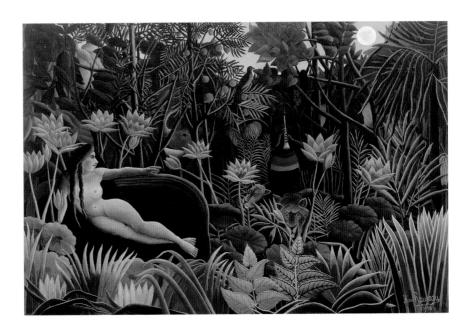

of stylized foliage, serenaded by a dark-skinned musician wearing a loincloth. Perhaps it is his music that has cast this spell in which giant lotuses grow on land, lions are as tame as house cats, and a full moon shines during the day.

In her installation Love Is Calling (3.21), Japanese artist Yayoi Kusama created a space that we experience as a fantasy, though in fact it has its origins in her mental reality. Since childhood, Kusama has suffered from hallucinations in which small motifs suddenly multiply into infinity, covering everything in sight, including her own body. As a child, she feared she might dissolve into their proliferation and cease to exist. As an adult, she translates these experiences into art. Love Is Calling is an Infinity Mirrored Room, a room lined with mirrors so that anything in it multiplies in endless reflections. Kusama created her first Infinity Mirrored Room in 1965, carpeting its floor with stuffed fabric protuberances covered in red polka dots. She began to hold gatherings in which she painted people with polka dots as well. "Polka dots are a way to infinity," she proclaimed. "When we obliterate nature and our bodies with polka dots, we become part of the unity of our environment. I become part of the eternal, and we obliterate ourselves in Love." In Love Is Calling, inflatable tentacle-like forms covered in polka dots descend from the ceiling and rise from the floor. Lit from within in shifting colors, they illuminate the darkened interior. A recording of Kusama reciting a love poem plays continuously. Only a few viewers at a time are allowed into Love Is Calling. There, they can obliterate themselves, if not in love, then at least in wonder and bliss.

3.20 Henri Rousseau. *The Dream*. 1910. Oil on canvas, 6'8½" × 9'9½". The Museum of Modern Art, New York

3.21 Yayoi Kusama. *Love is Calling*. 2013. Wood, metal, glass mirrors, tile, acrylic panel, rubber, blowers, lighting element, speakers, and sound; 14'6½" × 28'45%" × 19'113%". © Yayoi Kusama. Courtesy of David Zwirner, New York; Ota Fine Arts, Tokyo/ Singapore; Victoria Miro, London; KUSAMA Enterprise

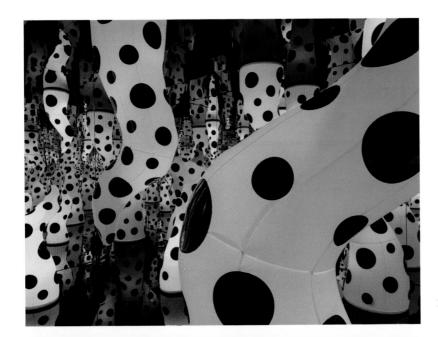

ARTISTS Yayoi Kusama (b. 1929)

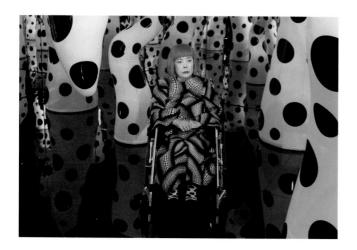

Why does Kusama refer to herself as an obsessional artist? What might the polka dots she so often paints have to do with the hallucinations she experiences? She has spoken of herself as an outsider. Why?

y art originates from hallucinations only I can see," Yayoi Kusama says matter-of-factly. "I translate the hallucinations and obsessional images that plague me into sculptures and paintings. . . . I create pieces even when I don't see hallucinations, though." The first two sentences fascinate, but we would do well to pay attention to the third sentence as well, for it hints at the discipline, ambition, and willpower that have enabled her career.

Kusama was born into a prosperous family in the city of Matsumoto, Japan. By her own account, her childhood was not a happy one. Her father chased after women; her mother was verbally and physically abusive. Kusama drew incessantly, and she began to experience the hallucinations she has often described in which a small motif multiplies uncontrollably across her field of vision.

At 19, Kusama enrolled briefly in art school to study *nihonga*, Japanese-style painting. On her own, she absorbed current directions in European and American art through magazines and journals. Always prolific, she exhibited hundreds of abstract works on paper, which began to attract critical notice.

Convinced that the future lay in New York, Kusama left Japan for the United States in 1957. She was determined, she said, to become a star. As her calling card, she conceived a series of monumental, monochromatic paintings called Infinity Nets-vast expanses of canvas covered with small loops of paint. "They were about an obsession: infinite repetition,"⁵ she says. A few years later, her reputation now growing, she turned her attention to sculpture, covering domestic objects with stuffed fabric protuberances that were unmistakably phallic. She called it her Sex Obsession series, created in response to her fear of sex. Her first installation followed quickly in 1963-a salvaged rowboat bristling with stuffed fabric protuberances set in a room whose floor, ceiling, and walls were papered with silkscreened posters of a photograph of the sculpture. Present at the opening was Andy Warhol, who three years would raid the idea for his now famous Cow Wallpaper. Next came the first Infinity Mirrored Room, which contained an endlessly reflecting accumulation of stuffed fabric phalli painted with red polka dots. Polka dots became Kusama's trademark motif as she moved away from making objects for gallery display to creating happenings in the streets, in clubs, and in her studio, where she painted polka dots on naked participants. She gave performances, made an experimental film, and founded a fashion company, all as part of her art.

Kusama returned to Japan in 1973. Her re-entry into conservative Japanese society was traumatic. Plagued anew by hallucinations as well as by physical illnesses, she moved permanently to a psychiatric hospital in 1977. She began writing novels (twelve have been published to date), and although she continued to make art, she rarely exhibited outside Japan.

In 1989, a major international retrospective recalled Kusama to Western memory and introduced her to a new and enthusiastic generation. Since then, her career has surged and she has become one of the most popular and widely recognized artists in the world—a star, in fact. "I have had so many hardships, with people saying various things about me," she told an interviewer. "Time is finally turning a kind eye on me. But it barely matters, for I am dashing into the future."

Yayoi Kusama in her installation *Love is Calling*, 2013. © Yayoi Kusama. Courtesy of David Zwirner, New York; Ota Fine Arts, Tokyo/Singapore; Victoria Miro, London; KUSAMA Enterprise

The Natural World

As humans, we make our own environment. From the first tools of the earliest hominids to today's towering skyscrapers, we have shaped the world around us to our needs. This manufactured environment, though, has its setting in quite a different environment, that of the natural world. Nature and our relationship to it are themes that have often been addressed through art.

During the 19th century, many American painters set themselves the American landscape as a subject. One of the first of these was Thomas Cole, who as a young man had immigrated to America from England. Cole's most famous painting is *The Oxbow*, which depicts the great looping bend (oxbow) of the Connecticut River as seen from the heights of nearby Mount Holyoke, in Massachusetts (3.22). To the left, a violent thunderstorm darkens the sky as it passes over the mountain wilderness. To the right, emerging into the sunlight after the storm, a broad settled valley extends as far as the eye can see. Fields have been cleared for grazing and crops. Minute plumes of smoke mark scattered farmhouses, and a few boats dot the river. Cole even gives us a role to play: we have accompanied him on his painting expedition and climbed up a little higher for an even better view. On a promontory to the right, we see the artist's umbrella and knapsack. A little to the left and down from the umbrella, Thomas Cole himself, seated in front of a painting in progress, looks up at us over his shoulder.

Cole developed the painting in his studio from a sketch he had made at the site, though he also introduced a number of inventions to make a more effective composition. The shattered and gnarled trees in the left foreground, for example, are a device he often used, and even the storm itself is probably a fiction, though he certainly could have seen such storms. But the view of the river bend from the mountain, a famous sight in Cole's day, is largely faithful

3.22 Thomas Cole. The Oxbow (View from Mount Holyoke, Northampton, Massachusetts, After a Thunderstorm). 1836. Oil on canvas, 4'3½" × 6'4". The Metropolitan Museum of Art, New York

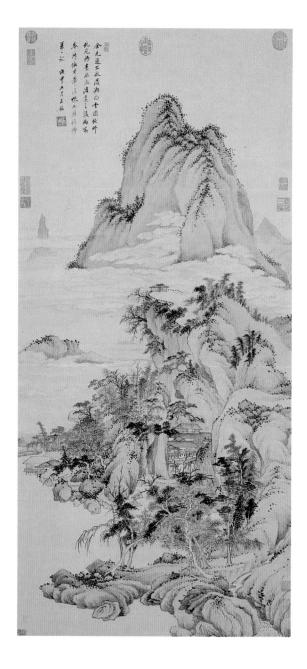

3.23 Wang Jian. White Clouds over Xiao and Xiang. 1668. Hanging scroll, ink and color on paper; height 4'5¼". Freer Gallery of Art, Smithsonian Institution, Washington, D.C.

to his observation. In contrast, Wang Jian may never have seen the view he depicts in White Clouds over Xiao and Xiang (3.23), nor would his audience have expected him to. Landscape is the most important and honored subject in the Chinese painting tradition, but its purpose was never to record the details of a particular site or view. Rather, painters learned to paint mountains, rocks, trees, and water so that they could construct imaginary landscapes for viewers to wander through in the mind's eye. Here, we might stroll along the narrow footpath by the water's edge to the pavilions that sit out over the lake, visit the rambling house nestled in the hillside, or stand in the pavilion on the overlook higher up, taking in the scenery. Whereas Cole's painting places us on the mountain and depicts what can be seen from a fixed position, Wang Jian's suspends us in midair and depicts a view that we could see only if we were mobile, like a bird.

In his inscription, Wang Jian writes that his painting was inspired by a work by the early 14th-century master Zhao Mengfu, who in turn admired Dong Yuan, a 10th-century painter known for a view of this same region. In just a couple of sentences, Wang Jian situates himself in a centuries-old tradition of painterly and poetic meditations on the Xiao and Xiang Rivers and the Jiuyi Mountains they flow through, a landscape rich in historical, literary,

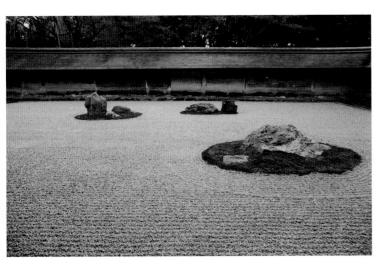

3.24 Stone and gravel garden, Ryoan-ji Temple, Kyoto. c. 1488–1500, with subsequent modifications.

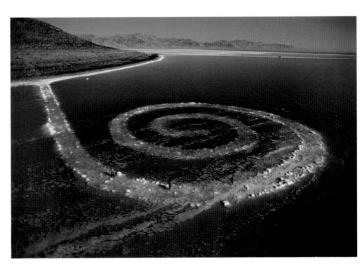

3.25 Robert Smithson. *Spiral Jetty*, Great Salt Lake, Utah, 1970. Black rock, salt crystals, earth, and water; length of coil 1,500'.

and artistic associations. All of that was more important to the painter and his audience than topographical accuracy.

Nature has been more than a subject for art; it has also served as a material for art. The desire to portray landscapes has been matched by the desire to create them for the pleasure of our eyes. A work such as the famed stone and gravel garden of the Buddhist temple of Ryoan-ji in Kyoto, Japan, seems to occupy a position halfway between sculpture and landscape gardening (3.24). Created toward the end of the 15th century and maintained continuously since then, the garden consists solely of five groupings of rocks set in a rectangular expanse of raked white gravel and surrounded by an earthen wall. A simple wooden viewing platform runs along one side. Over time, moss has grown up around the rock groupings, and oil in the clay walls has seeped to the surface, forming patterns that call to mind traditional Japanese ink paintings of landscape. The garden is a place of meditation, and viewers are invited to find their own meanings in it.

The simplicity of Ryoan-ji finds an echo in *Spiral Jetty*, an earthwork built by American artist Robert Smithson in 1970 in the Great Salt Lake, Utah (3.25). Smithson had become fascinated with the ecology of salt lakes, especially with the microbacteria that tinge their water shades of red. After viewing the Great Salt Lake in Utah, he leased a parcel of land on its shore and began work on this large coil of rock and earth. Smithson was drawn to the idea that an artist could participate in the shaping of landscape almost as a geological force. Like the garden at Ryoan-ji, *Spiral Jetty* continued to change according to natural processes after it was finished. Salt crystals accumulated and sparkled on its edges. Depths of water in and around it showed themselves in different tints of transparent violet, pink, and red. *Spiral Jetty* was submerged by the rising waters of the lake soon after it was created. Recently it resurfaced, transformed by a coating of salt crystals.

Art and Art

Artists learn to make art by looking at art. They look at the art of the past to learn about their predecessors, and they look at the art of the present to situate themselves amid its currents and get their bearings. It should not surprise us, then, that artists often make art about art itself—about learning, making, and viewing it; about its nature and social setting; about specific movements, styles, or works.

Jeff Wall is an artist who often sets up a dialogue with earlier art in his work. A Sudden Gust of Wind (after Hokusai) (3.27) shows him thinking about Hokusai's Ejiri in Suruga Province (3.26). Wall takes seriously the idea, touched on in Chapter 2, that photography has taken over from painting the project of depicting modern life. But he does not practice photography in a straightforward way, going into the world to take pictures of objects he sees or events he witnesses. Instead, he uses the technology of photography to construct an image, much as a painter organizes a painting or a film director goes about making the artificial reality of a film. He builds a set or scouts a location, he sets up the lighting or waits for the right weather, and he costumes and poses his models. Often, as here, he uses digital technology to combine many separately photographed elements into a single image. Wall displays the finished works as large-format transparencies lit from behind. A Sudden Gust of Wind is almost the size of a billboard, a glowing billboard.

Typically, what Wall wants us to see only comes into focus once we have the "art behind the art" in mind. Hokusai's *Ejiri in Suruga Province* is from

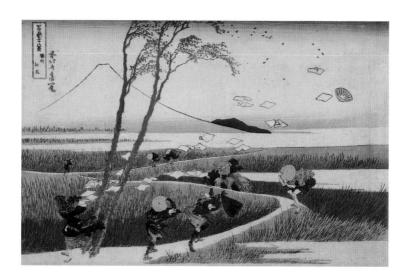

3.27 Jeff Wall. A Sudden Gust of Wind (after Hokusai). 1993. Transparency in lightbox, 7'67%" × 12'45%". Courtesy the artist

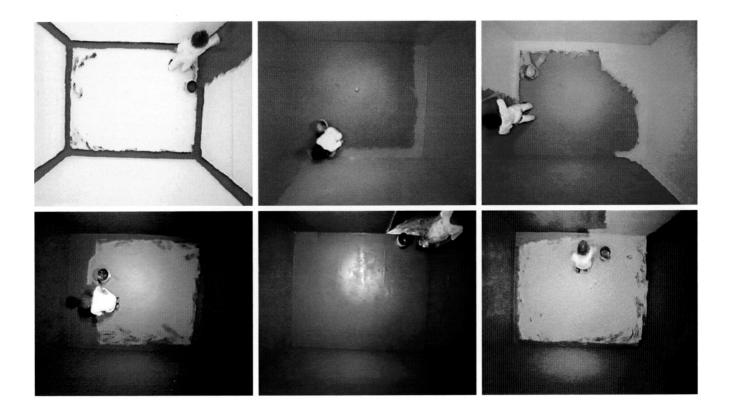

Thirty-Six Views of Mt. Fuji, a series of views of daily life in Japan linked by the presence of the serene mountain in the distance. Like Hokusai, Wall sets his scene in a nondescript place, a flat land that is nowhere in particular. He re-creates the two trees, the travelers, and the wind-scattered papers. But there is no sublime mountain in the background, nothing to give the scene a larger meaning or sense of purpose. Without knowing Hokusai's print, we would not realize that the most powerful presence in Wall's photograph is an absence, the mountain that is not there.

Whereas Wall's photograph links back to a specific work of art, John Baldessari's delightful video *Six Colorful Inside Jobs* playfully addresses the idea of art itself (3.28). Baldessari's father was a landlord, and in his youth the artist used to help out by painting the apartments. As he tells it, "I used to occupy my mind as I was painting the walls by saying to myself, 'Now I'm painting a wall, now I'm making a painting.' And it would just be a conceptual exercise—the physical activity was the same, I was just calling it differently each time. So I began to think about, well, what separated one from the other? Why was one different?"⁷

Years later, Baldessari reached back to this experience to create *Six Colorful Inside Jobs*. He hired a man to paint the floor and walls of a windowless room a different color each day for six days, while a film camera mounted overhead recorded a bird's-eye view of his progress. The colors he chose are immediately familiar to any art student: red, yellow, blue, green, orange, and violet—the three primary and three secondary colors of the color wheel (see 4.24). Each day's work took the painter about four hours, which Baldessari then compressed to five frenetic minutes.

The overhead view and the allover color work to flatten the space, making it look like a monochrome (one-color) painting. How strange, then, when a door opens and a little man enters. Scurrying around with comic energy (and pausing occasionally for a cigarette break), he repaints the painting, then lets himself out. A few seconds later, he returns, having evidently changed his mind: the painting should not be orange, but yellow!

The six days of the project slyly refer to another famous act of creation, the biblical one. On the seventh day, we presume, the painter rests. Six Colorful Inside Jobs is about work as art and art as work. As any artist will tell you, bursts of inspiration are wonderful, but a great deal of creating a work of art is just work—putting in the hours to get it done.

3.28 John Baldessari. Six Colorful Inside Jobs. 1977. 16mm film transferred to video (color, silent), 32:53 min. The Museum of Modern Art, New York. Courtesy the artist and Marian Goodman Gallery

4.1 Elizabeth Murray. The Sun and the Moon. 2004–05. Oil on panel, mounted on wood, $9'9" \times 8'111/2" \times 2"$. The Phillips Collection, Washington, D.C.

PART TWO

The Vocabulary of Art

The Visual Elements

t first glance, Elizabeth Murray's *The Sun and the Moon* looks like nothing so much as a controlled explosion of colorful jigsaw-puzzle pieces (4.1). As we look longer, some of the pieces come into focus. There's a pink-and-red figure, a person, stepping over . . . is it an orange cat? We can make out the cat's two ears, its open mouth (with a representation of sound coming out, as in a cartoon), and its long curling tail, which laces through . . . is it a window frame? Other elements are less clear, though by now we suspect that they, too, must represent abstractions of sights and sounds.

Murray's painting strikes a clever balance between what we see in abstract terms (an orange shape) and what we eventually realize is represented (a cat). But shapes are not the only thing that our eyes take in as we try to make sense of the painting. We distinguish the colors and notice their range, from pale yellow to dark violet. We notice that the shapes are edged in lines, and that some lines inside the shapes seem to suggest texture, as in the blue-green lattice formation in the upper right, which may represent pieces of wood. We see that certain shapes repeat, though not regularly enough to form a pattern. We notice the spaces between the pieces of the painting, and we observe that light from above has caused the pieces of the painting to cast shadows, suggesting that they have some mass, like a shallow sculpture.

The eight terms that helped us analyze our visual experience of Murray's painting—line, shape, mass, light, color, texture, pattern, and space—are the ingredients that an artist has available in making any work of art. Called the visual elements, they are the elements that we perceive and respond to when we look at a work's form. During the 20th century, time and motion were added to the traditional list of elements by artists seeking to expand and modernize artistic practice, and this chapter considers them as well.

Line

Strictly defined, a line is a path traced by a moving point. You poise your pencil on a sheet of paper and move its point along the surface to make a line. When you sit down to write a letter or take out your date book to jot down a note to yourself, you are making lines, lines that are symbols of sounds.

Artists, too, use lines as symbols. Keith Haring used thickly brushed green lines to portray a winged merman appearing miraculously before an

4.2 Keith Haring. *Untitled*. 1982. Vinyl paint on vinyl tarpaulin, 6 × 6'. Hamburger Bahnhof, Museum für Gegenwart, Berlin

4.3 Sarah Sze. *Hidden Relief*. 2001. Installation at the Asia Society, New York, 2001–04. Mixed media, dimensions variable. Courtesy of the Artist and Victoria Miro, London. © Sarah Sze

appreciative dolphin (4.2). The wavy lines that indicate spiritual energy radiating from the apparition's head are clearly symbolic. But in fact all the lines in the drawing are symbolic. The merman, for example, is drawn with a green line, but in reality there is no line separating a body from the air around it. Rather, such lines are symbols of perception. Our mind detaches a figure from everything around it by perceiving a boundary between one region (a body) and another (the air). In drawing, we indicate that boundary with a line.

Lines can be expressive in themselves. Sarah Sze's installation *Hidden Relief* prominently features lines that "draw" curves, circles, rules, and lattice formations in the air (4.3). Sze assembles her works from commonplace industrial products such as measuring sticks, string, lamps, ladders, toothpicks, plastic tubes, and kitchen implements. In her hands, we become aware of them as visual elements, bits of ready-made line, mass, color, and shape. (The squat blue cylindrical forms here are plastic bottle caps; the white circles are slices of Styrofoam cups.) Installed in a corner of a room, *Hidden Relief* is not particularly large, but Sze's close-up photograph makes it seem like a universe. Our eyes follow the roller-coaster ride of the yellow arcs, spin like figure skaters through the flock of white circles, and speed down the taut string lines that converge on the yellow lamp as we explore this strange new world.

The ways that Haring and Sze use line—to record the borders of form and to convey direction and motion—are the primary functions of line in art. We look more closely at them below.

Contour and Outline

Strictly speaking, an outline defines a two-dimensional shape. For example, drawing with chalk on a blackboard, you might outline the shape of your home state. On a dress pattern, dotted lines outline the shapes of the various pieces. But if you were to make the dress and then draw someone wearing it, you would be drawing the dress's contours. Contours are the boundaries we perceive of three-dimensional forms, and **contour lines** are the lines we draw to record those boundaries. Jennifer Pastor used pencil to make a contour drawing of a cowboy riding a bull at a rodeo, one of a series of drawings that record the entire ride from beginning to end (4.4). Her confident, even lines capture the contours so skillfully that they suggest fully rounded forms.

4.4 Jennifer Pastor. Sequence 6 from *Flow Chart for "The Perfect Ride" Animation*. 2000. Pencil on paper, 13½ × 17".

Courtesy Regen Projects, Los Angeles.

© Jennifer Pastor

Direction and Movement

In following the looping lines of Sarah Sze's *Hidden Relief*, we were doing what comes naturally. Our eyes tend to follow lines to see where they are going, like a train following a track. Artists can use this tendency to direct our eyes around an image and to suggest movement.

Directional lines play an important role in Henri Cartier-Bresson's photograph of a small Italian town (4.5). For Cartier-Bresson, the success of a photograph hinged on what he called the "decisive moment." Here, for example, what probably drew his attention was the woman climbing the stairs and balancing a tray of bread on her head. The small loaves resemble the paving stones so closely that it looks as though a piece of the street were suddenly in motion. Visual coincidences like this delighted Cartier-Bresson, but the decisive moment for the photograph occurred just as the woman was framed by the lines of the iron archway, creating a picture within a picture. Our eyes slide down the line of the steeply pitched railing right to her. Other railing lines carry our eyes into the background, where a cluster of town dwellers stand in the open square. Without the lines of the iron railings, our eyes would not move so efficiently through the picture, and we might miss what Cartier-Bresson wants us to notice.

You may have remarked that the lines our eyes followed most readily were diagonal lines. Most of us have instinctive reactions to the direction of

4.5 Henri Cartier-Bresson. *Aquila, Abruzzi, Italy.* 1951. Photograph.

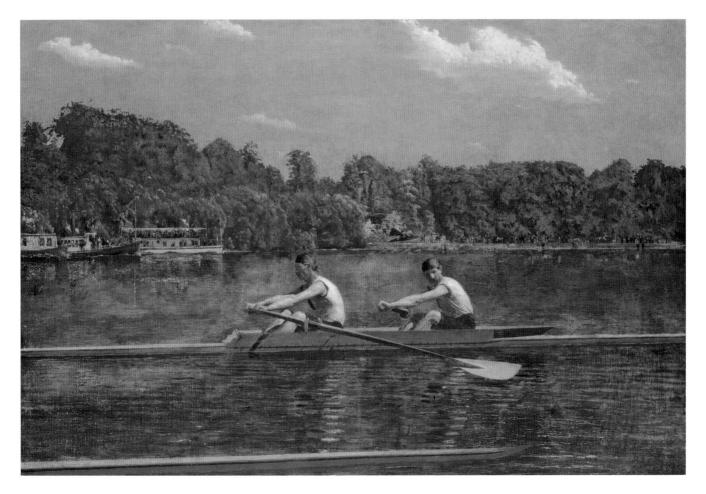

4.6 Thomas Eakins. *The Biglin Brothers Racing.* 1873–74. Oil on canvas, $24\% \times 36\%$ ". National Gallery of Art, Washington, D.C.

line, which are related to our experience of gravity. Flat, horizontal lines seem placid, like the horizon line or a body in repose. Vertical lines, like those of an upright body or a skyscraper jutting up from the ground, may have an assertive quality; they defy gravity in their upward thrust. But the most dynamic lines are the diagonals, which almost always imply action. Think of a runner hurtling down the track or a skier down the slope. The body leans forward, so that only the forward motion keeps it from toppling over. Diagonal lines in art have the same effect. We sense motion because the lines seem unstable; we half expect them to topple over.

Thomas Eakins' *The Biglin Brothers Racing* (4.6) is stabilized by the long, calm horizontal of the distant shore. The two boats in the foreground are set on the gentlest of diagonals—only a hint, but it is enough to convey their motion. More pronounced diagonals are found in the men's arms and oars. In rowing, arms and oars literally provide the power that sets the boat in motion. In Eakins' painting, their diagonals provide the visual power. If you place a ruler over the near oar and then slide it slowly upward, you will see that the treetops to the left and the clouds in the sky repeat this exact diagonal (4.7). It is as if the swing of the oar set the entire painting in motion. The subdued diagonals of Eakins' painting perfectly capture the streamlined quality of sculling, in which slender boats knife smoothly and rapidly through the calm water of a river or lake.

Eakins' painting demonstrates that we experience more than literal drawn lines as lines. In fact, we react to any linear form as a line. For example, we can talk about the line of the men's arms or the line of an oar. Oars and arms are not lines, but they are linear. We also react to lines formed by edges. For example, the white contours of the men's backs contrast strongly with the dark behind them, and we perceive the edges of the backs as lines.

4.7 Linear analysis of *The Biglin Brothers Racing*.

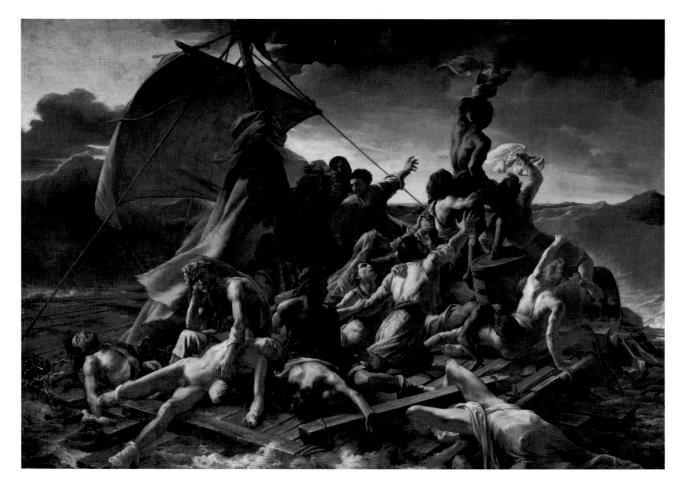

4.8 Théodore Géricault. The Raft of the Medusa. 1818–19. Oil on canvas, $16'1\%" \times 23'9"$. Musée du Louvre, Paris

4.9 Linear analysis of *The Raft of the Medusa*.

There is a great contrast in linear movement, and thus in emotional effect, between Eakins' work and the next illustration, Théodore Géricault's *The Raft of the Medusa* (4.8). Géricault's work is based on an actual event, the wreck of the French government ship *Medusa* off North Africa in 1816. Only a few of those on board survived, some by clinging to a raft. Géricault chose to depict the moment when those on the raft sighted a rescue ship. Virtually all the lines in the composition are diagonal. Géricault uses them to create two conflicting centers of interest, thus increasing the tension of the scene (4.9). Picked out by the light, the writhing limbs of the survivors carry our eyes upward to the right, where a dark figure silhouetted dramatically against the sky waves his shirt to attract the rescuers' attention. A lone rope, also silhouetted, carries our eyes leftward to the dark form of the sail, where we realize that the wind is not taking the survivors toward their salvation, but away from it.

Implied Lines

In addition to actual lines, linear forms, and lines formed by edges, our eyes also pick up on lines that are only implied. A common example from everyday life is the dotted line, where a series of dots are spaced closely enough that our mind connects them. The 18th-century French painter Jean-Antoine Watteau created a sort of dotted line of amorous couples in *The Embarkation for Cythera* (4.10). Starting with the seated couple at the right, our eyes trace a line that curves in a gentle S and leaves us evaporating into the gauzy air with the infant cupids (4.11). Cythera is the mythological island of love. Watteau specialized in elegant scenes in which aristocratic men and women gather in a leafy setting to play at love. Often, as here, the scenes are tinged with a gentle melancholy.

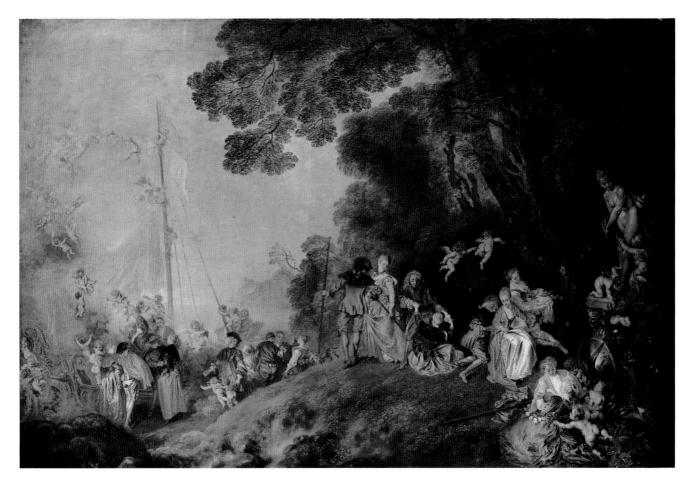

4.10 Jean-Antoine Watteau. *The Embarkation for Cythera*. 1718–19(?). Oil on canvas, 4'2''%'' × 6'4%''. Schloss Charlottenburg, Staatliche Schlösser und Gärten Berlin

In representational art, the same directional cues we follow in life can create implied lines. When a person stops on a street corner and gazes upward, other passersby will also stop and look up, following the "line" of sight. When someone points a finger, we automatically follow the direction of the point. Watteau uses these implied lines here as well. Looking at the painting, we are drawn eventually to the statue of Venus at the far right. We could be "stuck" there if it were not for her extended arm, which directs our attention down to the first couple below, where the winding procession begins. In addition, most of the couples look at each other, but the most prominent gazes are directed to the right, especially that of the woman who turns at the crest of the hill to look at the couple behind her. The graceful procession toward the shore is undercut by the constant tug of backward glances, and in following them we too are gently pulled back. It is this that gives the painting its slight air of melancholy, prompting many scholars to wonder whether the couples are heading toward the island of love, or whether they are leaving it.

4.11 Linear analysis of *The Embarkation for Cythera*.

Shape and Mass

A **shape** is a two-dimensional form. It occupies an area with identifiable boundaries. Boundaries may be created by line (a square outlined in pencil on white paper), a shift in texture (a square of unmowed lawn in the middle of mowed lawn), or a shift in color (blue polka dots on a red shirt). A **mass** is a three-dimensional form that occupies a volume of space. We speak of a mass of clay, the mass of a mountain, the masses of a work of architecture.

The volume of space displaced by the masses of Bill Reid's monumental sculpture *The Raven and the First Men* (4.12) is considerable! Carved from blocks of laminated cedar, the work depicts the birth of humankind as told in the creation stories of the Haida, a people of the Pacific Northwest Coast. The giant bird is a spirit hero called Raven. It was he who discovered the first humans hiding in a clam shell and coaxed them out into the world. The photograph of Reid's sculpture shows how light and shadow reveal the three-dimensional form of a mass to us, letting us sense where it bulges outward or recedes, where it is concave and where convex. But we cannot fully understand mass from a single two-dimensional representation. We would have to walk around the sculpture in person, or have it slowly circled with a video camera, to get a complete idea of its form.

Unlike the masses of *The Raven and the First Men*, the subtle, shadowy shapes of Emmi Whitehorse's *Chanter* are fully available to us on the page (4.13). A Navajo artist, Whitehorse is inspired in part by the signs and symbols carved centuries ago into the cliffs of her native region. The shapes in *Chanter* seem to appear and disappear into the background. Some are defined by line, others by a shift in color or value. Still other shapes are only implied—partially indicated in a way that encourages our mind to complete them.

Shapes and masses can be divided into two broad categories, geometric and organic. Geometric shapes and masses approximate the regular, named shapes and volumes of geometry such as square, triangle, circle, cube, pyramid,

4.12 Bill Reid. *The Raven and the First Men.* 1980. Laminated yellow cedar, height 6'2¼". Courtesy UBC Museum of Anthropology, Vancouver, Canada

4.13 Emmi Whitehorse. *Chanter.* 1991. Oil on paper, mounted on canvas, $39\% \times 28$ ". Saint Louis Art Museum

and sphere. Organic shapes and masses are irregular and evoke the living forms of nature. The masses of Reid's sculpture are organic, whereas Whitehorse used both geometric and organic shapes in her painting. The abstract blue bird at the upper left is organic, for example, and the upside-down houselike shapes outlined in white at the top right, rectangle on triangle, are geometric.

We perceive shapes by mentally detaching them from their surroundings and recognizing them as distinct and coherent. We refer to this relationship as figure and ground. A **figure** is the shape we detach and focus on; the **ground** is the surrounding visual information the figure stands out from, the background. In the photograph of *The Raven and the First Men*, we easily recognize the sculpture as the principal figure and the rest of the image as the ground. In *Chanter*, on the other hand, things are not always so clear. For example, the dark blue figure of the bird at the upper left detaches clearly from the pale ground, but just below it this pale ground turns into a figure as well. Figure and ground shift and interpenetrate across the painting, creating a fluid sense of space and a dreamlike atmosphere.

The Aztec feathered shield illustrated next presents us with a further visual puzzle (4.14). Made for a military officer as a sign of rank, it can be understood equally well as a light figure on a dark ground or a dark figure on a light ground. If you place a piece of tracing paper over the image and trace the outlines of the light figure, you will find that you have automatically drawn the dark figure as well. In fact, any shape created on a limited, two-dimensional surface creates a second, complementary shape. This is because the surface is already a shape itself—the shield is a circle, *Chanter* and the photograph of *The Raven and the First Men* are rectangles. Any two-dimensional image is thus also a system of interlocking shapes. The shapes we perceive as figures we call **positive shapes**; the shapes of the ground are **negative shapes**. In the photograph of Reid's sculpture, for example, negative shapes appear between the bird's wings and its body. Artists learn to pay equal attention to positive and negative shapes in their work, and we will be better viewers for cultivating this habit as well.

Implied Shapes

Figure **4.15** shows three black circles, each with a wedge taken out, but the very first thing that most of us see is a floating white triangle. Our mind instantly perceived the visual information as a whole—even though that whole doesn't exist! Through optical puzzles such as this, psychology provided a scientific explanation for something that artists had been doing intuitively for centuries, using implied shapes to unify their compositions. In *The Madonna of the*

4.14 Circular shield with stepped fret design. Aztec, before 1521. Feathers, diameter 275%". Landesmuseum Württemberg, Stuttgart

4.15 The triangle that isn't there.

4.16 Raphael. The Madonna of the Meadows. 1505. Oil on panel, $44\frac{1}{2} \times 34\frac{1}{4}$ ". Kunsthistorisches Museum, Vienna

Meadows (4.16), Raphael has grouped the figures of Mary, the young John the Baptist (left), and the young Jesus (right) so that we perceive them as a single, triangular whole. Mary's head defines the apex, and John the Baptist the lower left corner. Defining the lower right corner is Mary's exposed foot, which draws our eye because of the way the pale flesh contrasts with the darker tones around it. If you place a finger over the foot, the implied triangle becomes much less definite, even though it is reinforced by Mary's red and blue robes.

Just as artists use implied lines to help direct our eyes around a composition, they have used implied shapes to create a sense of order, so that we perceive a work of art as a unified and harmonious whole.

Light

To our distant ancestors light seemed so miraculous that the sun was often considered to be a god and the moon a goddess. Today we know that light is a type of radiant energy, and we have learned how to generate it ourselves through electricity, yet our day-to-day experience of the varying qualities and effects of light is no less marvelous.

Doug Wheeler is a contemporary artist whose work increases our awareness of light as a presence in the world (4.17). D-N SF 12 PG VI 14 is illustrated here as installed in the atrium of the Palazzo Grassi, a museum in Venice. An atrium is a large interior courtyard open to the sky or roofed in glass. The atrium of the Palazzo Grassi is surrounded on all four sides by massive stone columns, some of which can be seen in the photograph illustrated here. Others, which should be visible on the other side of the atrium, have vanished, swallowed up by white light. Intellectually, we know that infinity cannot suddenly open up inside of a building, but that is exactly what seems to have happened. Wheeler works his magic with simple means: a continuously curving fiberglass shell painted brilliant white, a smooth white floor, and carefully controlled lighting that eliminates any shadows that would give us visual cues. Reflected from flawless, uninterrupted surfaces, the light takes on a material presence, as though we could reach out and touch it.

Wheeler's art draws on a childhood spent in the open spaces of the American Southwest. "When I was young, I'd have to get up at 4:30 and 'ride' fence line, which was my chore before breakfast," he recalled in an interview. "The idea was to check different sections of the fence to repair any spots that were compromised. So at first it's dark and you can barely see, and then gradually the light is coming in. The sky was always everything. If there were a couple of scattered cumulus clouds, I found that the clouds created this sense of space, defining space, making it feel dimensional. . . . That's what I started playing with as an artist: not looking at things but the tension in between things."

Implied Light: Modeling Mass in Two Dimensions

Wheeler's art is disorienting because it undercuts the most fundamental purpose that light serves for us, which is to reveal the material world to our eyes in a way that helps us understand forms and spatial relationships. In Manuel

4.17 Doug Wheeler. *D-N SF 12 PG VI 14*. 2012. Installation at the Palazzo Grassi, Venice, April 13–December 31, 2014. Reinforced fiberglass, titanium dioxide paint, LED lights, and DMX control; 24'6" × 42' × 42'. Courtesy David Zwirner, New York/London

4.18 Manuel Alvarez Bravo. La visita (The Visit). 1935 or 1945, printed 1979. Gelatin silver print, $6\frac{5}{8} \times 9\frac{3}{8}$ ".

Museum of Fine Arts, Houston, Texas.
© Colette Urbajtel/Archivo Manuel
Alvarez Bravo

4.19 Value scale in gray.

Alvarez Bravo's photograph *The Visit* (4.18), we understand something of the texture of the back wall and the masses of the robed sculptures because of the way light and shadow **model** them, or give them a three-dimensional appearance. We cannot see the source of light in the photograph, but we understand from the way the shadows fall that it is off to the right, and that the statues are facing almost directly into it.

Black-and-white film has transposed the colors of the original scene into their relative **values**, shades of light and dark. For example, we understand that the statues' cloaks are of a darker color than their robes, even though we don't know what the two colors are. Value exists in a seamless continuum from white (the lightest value) to black (the darkest value). For convenience, we often simplify this continuum into a scale, a sequence of equal perceptual steps (4.19). The value scale here goes from black to white in nine steps (including both end points). Our eyes are more sensitive than film and can distinguish a greater and more subtle range of values. Nevertheless, thanks to black-and-white photography, we can readily understand the idea that the world we see in full color can also be expressed in shades of light and dark, and that every color can also be spoken of in terms of its value.

Photography easily demonstrates how value models mass for our eyes. But photography was invented only in the mid-19th century. Long before then, European painters had become interested in modeling mass in two dimensions through value. Discovered and perfected by Italian painters during the Renaissance, the technique is called chiaroscuro, Italian for light/dark. With chiaroscuro, artists employ values-lights and darks-to record contrasts of light and shadow in the natural world, contrasts that model mass for our eyes. One of the great masters of chiaroscuro was Leonardo da Vinci. His unfinished drawing of The Virgin and St. Anne with the Christ Child and John the Baptist (4.20) shows the miraculous effects he could achieve. Working on a middle-value brown paper, Leonardo applied charcoal for a range of darks and white chalk for lighter values. The figures seem to be breathed onto the paper, bathed in a soft, allover light that comes from everywhere and nowhere. The roundness that Leonardo's mastery conveys is immediately evident if we look between the heads of the two children at the raised hand of Saint Anne. Drawn with a contour line but not modeled, it looks jarringly flat, as though it does not yet belong to the rest of the image.

Leonardo used continuous tones in his drawing, values that grade evenly into one other. But value can also be indicated with surprising richness by line alone. In the etching shown here, Charles White relied solely on line to model the head of a woman seen in profile (4.21). Taking the pale gray of the paper as the highest value, White indicated the next step down in value with

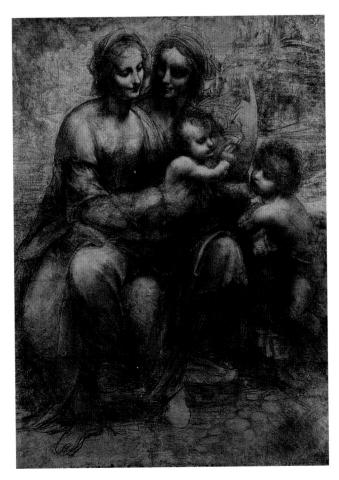

4.20 Leonardo da Vinci. The Virgin and St. Anne with the Christ Child and John the Baptist. c. 1499–1500. Charcoal, black and white chalk on brown paper, $54\% \times 39\%$ ". The National Gallery, London

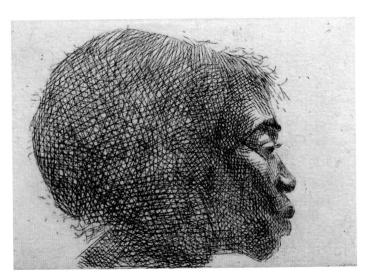

4.21 Charles White. *Untitled*. 1979. Etching, $4 \times 5\frac{1}{2}$ ". The Charles White Archives

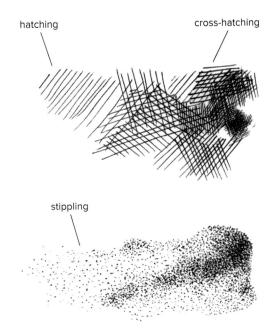

hatching, areas of closely spaced parallel lines, as on the front of the forehead or the side of the nose. Darker values were achieved through additional sets of parallel lines laid across the first, a technique called **cross-hatching**. Seen from up close the effect seems coarse, but at a certain distance the dark hatch marks seem to average out with the lighter paper into nuanced areas of gray, an effect of perception called optical mixing. Another technique for suggesting value is **stippling**, in which areas of dots average out through optical mixing into values (4.22). As with hatching, the depth of the value depends on density: the more dots in a given area, the darker it appears.

4.22 Techniques for modeling mass with lines: hatching, cross-hatching, and stippling.

Color

It is probably safe to say that none of the visual elements gives us as much pleasure as color. Many people have a favorite color that they are drawn to. They will buy a shirt in that color just for the pleasure of clothing themselves in it, or paint the walls of their room that color for the pleasure of being surrounded by it. Various studies have suggested that color affects a wide range of

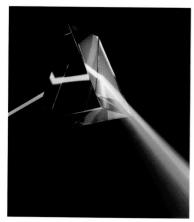

a

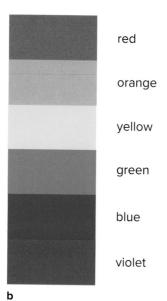

4.23 a. White light separated into spectral colors by a prism. b. The colors of the visible spectrum.

psychological and even physiological responses. One particular shade of pink, known as Baker-Miller pink, has been shown to calm agitated or aggressive behavior, producing a tranquilizing effect that lasts for about half an hour. In Tokyo, blue lighting installed at the ends of train platforms has been effective in reducing the number of people who attempt suicide by diving in front of oncoming trains. A recent German study suggests that seeing the color green can boost creativity. The mechanism involved in these color responses is still unclear, but such studies indicate that color affects the human brain and body in powerful ways.

Color Theory

Much of our present-day color theory can be traced back to experiments made by Sir Isaac Newton, who is better known for his work with the laws of gravity. In 1666 Newton passed a ray of sunlight through a prism, a transparent glass form with nonparallel sides. He observed that the ray of sunlight broke up or **refracted** into different colors, which were arranged in the order of the colors of the rainbow (4.23). By setting up a second prism, Newton found he could recombine the rainbow colors into white light, like the original sunlight. These experiments proved that colors are actually components of light.

In fact, all colors are dependent on light, and no object possesses color intrinsically. You may own a red shirt and a blue pen and a purple chair, but

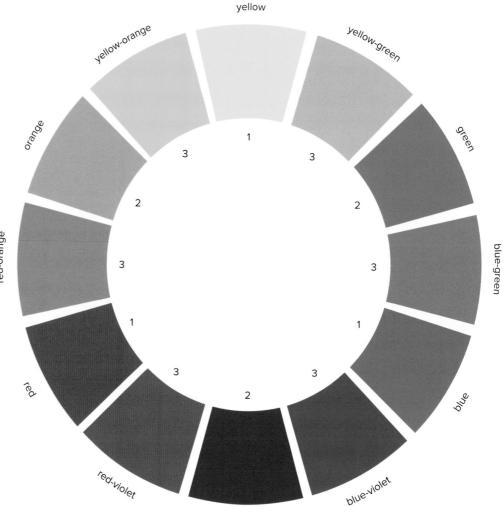

4.24 Color wheel.

violet

those items have no color in and of themselves. What we perceive as color is reflected light rays. When light strikes the red shirt, for example, the shirt absorbs all the color rays except the red ones, which are reflected, so your eye perceives red. The purple chair reflects the purple rays and absorbs all the others, and so on. Both the physiological activity of the human eye and the science of electromagnetic wavelengths take part in this process.

If we take the colors separated out by Newton's prism—red, orange, yellow, green, blue, and violet—add the transitional color red-violet (which does not exist in the rainbow), and arrange these colors in a circle, we have a **color wheel** (4.24). Different theorists have constructed different color wheels, but the one shown here is fairly standard.

Primary colors—red, yellow, and blue—are labeled with the numeral 1 on the color wheel. They are called primary because (theoretically at least) they cannot be made by any mixture of other colors.

Secondary colors—orange, green, and violet—are labeled with the numeral 2. Each is made by combining two primary colors.

Intermediate colors, also known as **tertiary colors**, labeled number 3, are the product of a primary color and an adjacent secondary color. For instance, mixing yellow with green yields yellow-green.

We speak of the colors on the red-orange side of the wheel as warm colors, perhaps because of their association with sunlight and firelight. The colors on the blue-green side are cool colors, again probably because of their association with sky, water, shade, and so on.

During the 19th century, many scientific color theories were published, and painters were quick to try to take advantage of their findings. Some painters, for example, stopped using black altogether on the grounds that it was not a color found in the natural spectrum. Impressionist painter Camille Pissarro left us a witty demonstration of what could be accomplished using what he called a spectral palette (4.25). Palette refers to the wooden board on which artists traditionally set out their pigments, but it also refers to the range of pigments they select, either for a particular painting or characteristically. Pissarro here gives us both meanings, creating a painting on his wooden palette and leaving the colors he set out to make it around the edge. From the upper right, they are white, yellow, red, violet, blue, and green. Using only these colors and their mixtures, Pissarro painted a delightful landscape of a farmer and his wife with their hay wagon.

4.25 Camille Pissarro. *Palette with a Landscape*. c. 1878. Oil on wooden palette, $9\frac{1}{2} \times 13\frac{5}{8}$ ". Sterling and Francine Clark Institute, Williamstown, Massachusetts

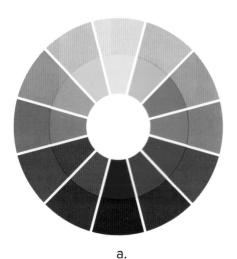

4.26 Color value and intensity.

- **a**. The spectral colors and their corresponding gray-scale values.
- **b**. Blue in a range of values.
- **c**. Yellow-orange progressively dulled with gray.
- **d**. Yellow-orange progressively dulled with blue-violet.

a.

4.27 a. Light primaries and their additive mixtures.

b. Pigment primaries and their subtractive mixtures.

Color Properties

Any color has three properties: hue, value, and intensity.

Hue is the name of the color according to the categories of the color wheel—green or red or blue-violet.

Value refers to relative lightness or darkness. Most colors are recognizable in a full range of values; for instance, we identify as "red" everything from palest pink to darkest maroon. In addition, all hues have what is known as a normal value—the value at which we expect to find that hue. We think of yellow as a "light" color and violet as a "dark" color, for example, even though each has a full range of values. Figure 4.26 shows the hues of the color wheel in relation to a gray value scale (a) and the hue blue taken through a range of values (b).

A color lighter than the hue's normal value is known as a **tint**; for example, pink is a tint of red. A color darker than the hue's normal value is called a **shade**; maroon is a shade of red.

Intensity—also called **chroma** or **saturation**—refers to the relative purity of a color. Colors may be pure and saturated, as they appear on the color wheel, or they may be dulled and softened to some degree. The purest colors are said to have high intensity; duller colors, lower intensity. To lower the intensity of a color when mixing paints or dyes, the artist may add a combination of black and white (gray) or may add a little of the color's complement, the hue directly opposite to it on the color wheel. Figure 4.26 shows a saturated yellow-orange lowered first with gray (c) and then with blue-violet (d).

Light and Pigment

Colors behave differently depending on whether an artist is working with light or with pigment. In light, as Newton's experiments showed, white is the sum of all colors. People who work directly with light—such as lighting designers who illuminate settings for film, theater, or video productions—learn to mix color by an additive process, in which colors of light mix to produce still lighter colors. For example, red and green light mix to produce yellow light. Add blue light to the mix and the result is white. Thus red, green, and blue form the lighting designer's primary triad (4.27a).

Pigments, like any other object in the world, have to our eyes the color that they reflect. A red pigment, for example, absorbs all the colors in the spectrum except red. When pigments of different hues are mixed, the resulting color is darker and duller, because together they absorb still more colors from the spectrum. Mixing pigments is thus known as a subtractive process (4.27b). The closer two pigments are to being complementary colors on the color wheel, the duller their mixture will appear, for the more they will subtract each other from the mix. For example, whereas red and green light mix to produce yellow light, red and green pigment mix to produce a grayish brown or brownish gray pigment.

Color Harmonies

A color harmony, sometimes called a color scheme, is the selective use of two or more colors in a single composition. We tend to think of this especially in relation to interior design; you may say, for instance, "The color scheme in my kitchen is blue and green with touches of brown." But color harmonies also apply to the pictorial arts, although they may be more difficult to spot because of differences in value and intensity.

Monochromatic harmonies are composed of variations on the same hue, often with differences of value and intensity. A painting all in reds, pinks, and maroons would be considered to have a monochromatic harmony. In *In Bed* (4.28), Inka Essenhigh used tints and shades of blue to depict a slightly sinister scene in which fiendish sprites tug at a sleeping woman.

Complementary harmonies involve colors directly opposite each other on the color wheel, such as red and green. Complementaries "react" with each other more vividly than with other colors, and thus areas of complementary color placed next to or even near each other make both hues appear more intense. The glow of the red gasoline pumps in Hopper's Gas, for example, owes much to the presence of the green foliage in the background (see 3.14). The yellow-and-orange fire in J. M. W. Turner's The Burning of the Houses of Parliament (see 5.11) would not burn as brightly had Turner not depicted the night sky in blue and violet. Claude Monet evoked the brilliance of a summer day by setting an orange roof against the blue sea in Fisherman's Cottage on the Cliffs at Varengeville (see 2.5).

Analogous harmonies combine colors adjacent to one another on the color wheel, as in Diana Cooper's *The Site* (4.29), which moves from yellow through yellow-orange, orange, and red-orange to red.

Triadic harmonies are composed of any three colors equidistant from each other on the color wheel. In his mature works, Piet Mondrian famously

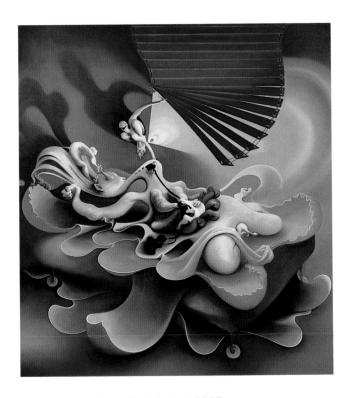

4.28 Inka Essenhigh. *In Bed.* 2005. Oil on canvas, 5'8" \times 5'2". Courtesy the artist, Victoria Miro, London, and 303 Gallery, New York. © Inka Essenhigh

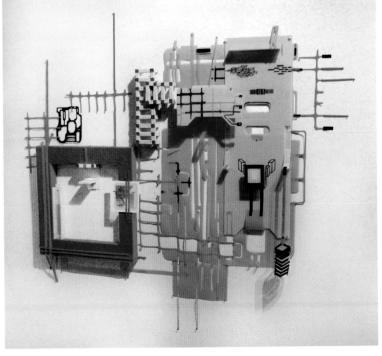

4.29 Diana Cooper. *The Site.* 2006. Corrugated plastic, vinyl, felt, map pins, acrylic paint, Velcro, paper, construction fence, neoprene foam; $58 \times 65 \times 5$ ".

Courtesy Postmasters Gallery, New York

4.30 Demonstration of complementary color afterimage. Stare for a time at the black dot in the middle of the colored square. Then, with your eyes unfocused, stare at the white square above it. The colors will appear in ghostly reverse, with a blue-green inner square and a red outer square.

limited his colors to the primary triad of red, yellow, and blue (see *Trafalgar Square*, 21.26). The same triadic harmony in another guise dominates Jean-Auguste-Dominique Ingres' *Jupiter and Thetis* (see 21.1). Paul Gauguin's *Te Aa No Areois* (see 21.8) owes a great deal to the triadic harmony of blue-green, red-violet, and yellow-orange, as well as to the complementary opposition of blue-green and red-orange.

Numerous other color harmonies have been identified and named. Artists themselves, however, are more likely to speak generally of working with a **restricted palette** or an **open palette**. Working with a restricted palette, artists limit themselves to a few pigments and their mixtures, tints, and shades. For an example of a painting created with a restricted palette, look at John Singleton Copley's *Paul Revere*, in Chapter 17 (see 17.20). For an example of a painting created with an open palette, look again at Manohar's *Jahangir Receives a Cup from Khusrau*, in Chapter 1 (see 1.8).

Optical Effects of Color

Certain uses and combinations of colors can "play tricks" on our eyes or, more accurately, on the way we perceive colors registered by our eyes. One effect we have already touched on is **simultaneous contrast**, where complementary colors appear more intense when placed side by side. Simultaneous contrast is related to another fascinating optical effect, **afterimage**. Prolonged staring at any saturated color fatigues the receptors in our eyes, which compensate when allowed to rest by producing the color's complementary as a ghostly afterimage in the mind. You can experience this effect by following the instructions in the caption to Figure **4.30**.

Formulated and popularized during the 19th century, the principle of simultaneous contrast and the optical effect of afterimage were taken into account by artists of the time, especially by the Impressionist painters. Monet, for example, based many of his paintings on complementary pairings, including Fisherman's Cottage on the Cliffs at Varengeville, which we looked at in Chapter 2 (see 2.5). More subtly, Impressionist painters tinted the shadows in their paintings with the complementary color of a nearby highlight, thus recording the way the eye, resting by looking at a shadow, colors that shadow by producing an afterimage. In Monet's Autumn Effect at Argenteuil (see 21.5), the shadows along the bank are tinted blue-green and blue-violet as an afterimage of the yellow-orange and red-orange highlights of the foliage.

Some colors seem to "advance," others to "recede." Interior designers know that if you place a bright red chair in a room, it will seem larger and farther forward than the same chair upholstered in beige or pale blue. Thus, color can dramatically influence our perceptions of space and size. In general, colors that create the illusion of large size and advancing are those with the warmer hues (red, orange, yellow), high intensity, and dark value; small size and receding are suggested by colors with cooler hues (blue, green), low intensity, and light value.

Colors can be mixed in light or pigment, but they can also be mixed by the eyes. When small patches of different colors are close together, the eye may blend them to produce a new color. This is called **optical color mixture**, and it is an important feature in the painting of Georges Seurat.

Seurat was familiar with the color theories of his day, which seemed to hold out the possibility of placing painting on a scientific footing. Most artists blend their colors, either on a palette or on the canvas itself, to produce gradations of hue, but Seurat did not. Instead, he laid down his paints by placing many thousands of tiny dots—or points—of pure color next to each other, a process that came to be called **pointillism**. From a distance of a few inches, a painting such as *Evening*, *Honfleur* appears to be nothing but a jumble of colored dots (4.31). As the viewer steps back, however, the dots gradually coalesce into shapes, and an image emerges of the shore at Honfleur, a seaside town

in France. Seurat's dots never quite fuse entirely. They remain just distinct enough to give the surface of the painting a lively texture, and they create a sort of shimmer as their colors interact. In a letter he sent from Honfleur to his friend the painter Paul Signac, Seurat spoke of the sea as being "an almost indefinable gray." His technique of optical mixing is well suited to producing just such indefinable colors. Seurat sometimes painted frames for his paintings using the same pointillist technique; *Evening, Honfleur* has one of the few frames to have survived. We can see how Seurat used contrasting values and complementary colors on the frame to make the sky, sea, and sand seem more luminous. Fundamentally blue, it tilts subtly toward violet, green, orange, and red as it makes its way around the painting.

Optical mixing is perhaps most familiar to us today through computers, whose screen images are made up of discrete units called pixels, short for picture elements. Most computer users have noticed that enlarging an image eventually causes it to disintegrate into its component pixels, which appear as squares of color set in a grid pattern. Reversing the process, we can watch as the pixels grow smaller and the image comes back into focus.

In works such as *Hendrix*, Devorah Sperber explores our brain's capacity for assembling images from discrete units of visual information by using spools

4.31 Georges Seurat. Evening, Honfleur. 1886. Oil on canvas, $25\frac{3}{4} \times 32$ ".

The Museum of Modern Art, New York

4.33 Devorah Sperber. *Hendrix*, detail. Courtesy of the artist

4.32 Devorah Sperber. *Hendrix*. 2009. 1,292 spools of thread, stainless steel ball chain and hanging apparatus, clear acrylic sphere, and metal stand; panel of spools 60 × 48", viewing sphere set at a distance of 5'. Courtesy of the artist

of colored thread as the equivalent of pixels (4.32, 4.33). Just as pixels are digital samplings of an original image, so Sperber's thread colors match crude samplings of a photograph of the musician Jimi Hendrix, turned upside down. Seen from a few feet away in person, the 1,292 spools form a large, gridded, seemingly non-representational composition. If we were to step back far enough, an image would gradually come into focus, but Sperber spares us the trouble by placing a clear acrylic sphere in front of the work. The sphere acts as a lens, gathering in visual information, miniaturizing it, and rotating it 180 degrees. (Our eyes work the same way.) The illustration in Figure 4.33 shows how Hendrix's face comes into focus in the viewing sphere, and also how the spools themselves appear from up close. By providing a way for us to see the image and its components at the same time, Sperber makes us aware of the brain's role in constructing our visual reality.

Emotional Effects of Color

Color affects us on such a basic level that few would deny that we have a direct emotional response to it. The problem comes when we try to find universal principles, for we quickly discover that emotional responses to color are both culturally conditioned and intensely personal. For most people brought up in America, red and green have strong cultural associations with Christmas. Vincent van Gogh, however, once made a painting of a café interior that juxtaposed red and green to suggest what he called "the terrible passions of humanity." For the German painter Franz Marc, blue was the color of male spirituality. In India, it is associated with the Hindu deity Krishna, who is traditionally depicted with blue skin, for sacred texts describe him as being the color of water-filled clouds. As the color of the sky and the ocean, blue is often associated with freedom. It is a "cool" color and has been shown to have a calming effect.

James Abbott McNeill Whistler certainly had calm in mind when he chose blue for the overall color of his *Nocturne in Blue and Gold* (**4.34**). Except for a distant spangle of fireworks and the reflection of a few lights in the water, the painting is entirely monochromatic, brushed in shades of grayish blue. Blue contributes significantly to the subdued emotional mood of the painting, although it does not create it all alone. The strong, stable vertical lines of the pier, the reassuring horizontals of the bridge and the horizon, the evident tranquility of the scene with its lone boatman silhouetted on the stern of his craft—these elements also play a role in the emotional "temperature" of the work.

Edvard Munch's harrowing painting *The Scream* also depicts a bridge, but the effect is much different (4.35). "It was a time when life had ripped my soul open," Munch wrote in his diary. "The sun was going down . . . It was like a flaming sword of blood . . . The sky was like blood sliced with strips of fire . . . I felt a great scream—and I heard, yes, a great scream—the colors in nature broke the lines of nature, the lines and colors vibrated with motion . . . I painted the picture Scream then." Munch uses red to indicate horror,

4.35 Edvard Munch. *The Scream*. 1893. Tempera and casein on cardboard, 36 × 29". Nasjonalgalleriet, Oslo

4.34 James Abbott McNeill Whistler. Nocturne in Blue and Gold (Old Battersea Bridge). c. 1872–75. Oil on canvas, $26\% \times 20\%$ ". Tate, London

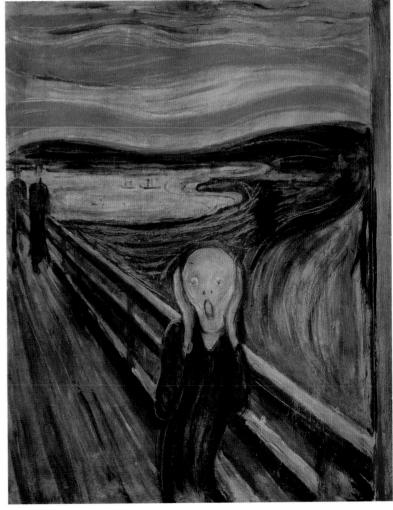

blood, and anguish. But how, outside of his diary, are we to know that Munch did not intend simply to depict a splendid sunset? As in Whistler's *Nocturne*, color does not carry the entire expressive burden by itself. Whereas Whistler's painting is characterized by reassuring vertical and horizontal lines, here unstable diagonals and swirling lines dominate. The horizontal of the horizon is almost obliterated. The figure in the foreground clasps his hands over his ears to block the piercing sound. His head has become a death's head, his body wavers unsteadily. In contrast, the two pedestrians in the background remain unaffected. Evidently, they hear nothing out of the ordinary. The scream is a silent one, the interior cry of a soul projected onto nature.

Texture and Pattern

Texture refers to surface quality—a perception of smooth or rough, flat or bumpy, fine or coarse. Our world would be bland and uninteresting without contrasts of texture. Most of us, when we encounter a dog or a cat, are moved to pet the animal, partly because the animal likes it, but also because we enjoy the feel of the fur's texture against our hands. In planning our clothes, we instinctively take texture into account. We might put on a thick, nubby sweater over a smooth cotton shirt and enjoy the contrast. We look for this textural interest in all facets of our environment. Few people can resist running their hands over a smooth chunk of marble or a glossy length of silk or a drape of velvet. This is the outstanding feature of texture: it makes us want to touch it.

Actual Texture

Actual texture is literally tactile, a quality we could experience through touch. It would be a pleasure to run our hands along the smooth industrial surfaces around the perimeter of Mona Hatoum's steel *Dormiente* (4.36). But anyone who has ever scraped their knuckles on a kitchen grater would be very careful about exploring the rough texture of the two central fields. *Dormiente* is Italian for a sleeping person. The title asks us to imagine this large-scale grater as a bed, thus encouraging us to contemplate the exact experience we would rather not consider: the intimate contact of our vulnerable flesh with its jagged metal protrusions. "In my work I often take familiar, everyday things and make them unfamiliar, reveal the uncanny in them," Hatoum says. "I like it when something is simultaneously attractive and forbidding—both seductive and dangerous." 5

Like any other visual element, texture can contribute to our understanding and interpretation of a work. Constantin Brancusi patiently polished his

4.36 Mona Hatoum.

Dormiente. 2008.

Mild steel, 10½ × 90⅙ × 39¾".

© Mona Hatoum. Courtesy GALLERIA CONTINUA San Gimignano/Beijing/
Les Moulins and White Cube

crossing cultures Japanese Prints

What similarities can we discern from Hiroshige's prints and Whistler's paintings? What aspects of linear perspective are shown in these works, and what effects do they create?

aintings such as *Nocturne in Blue and Gold (Old Battersea Bridge)* (see 4.34) so enraged the English critic John Ruskin that he accused the artist, James Whistler, of flinging a pot of paint in the public's face. The articulate and flamboyant Whistler promptly took Ruskin to court. What angered Ruskin was that the painting didn't really resemble Battersea Bridge at all. "I do not intend it to be a 'correct' portrait of the bridge," Whistler replied. The painting was a moonlit scene, he continued, a reverie, and people could see something in it or not, as they liked.⁶

It is difficult to say whether Whistler would have helped or hurt his case by drawing the judge's attention to his collection of Japanese prints, which included the two works by Ando Hiroshige illustrated here. With its dramatically cropped bridge, lone boatman, and moonlit river, Hiroshige's Riverside Bamboo Market, Kyobashi served as the principal model for Whistler's

composition, though he imported the idea of fireworks from the Japanese master's *Fireworks at Ryogoku*.

Whistler had fallen under the spell of Japanese prints during his stay in Paris in the late 1850s. He was hardly the only one. Almost all the Impressionist painters in France collected Japanese prints, and many of the painters of the next generation were influenced by them as well. Why prints, and why then? In 1854, Japan, after being virtually closed to foreigners for over two hundred years, had opened itself up to the outside world again. Europe, England, and America were suddenly fascinated by all things Japanese, but it was principally in Paris that artists seriously studied prints, which

were the first examples of Japanese art to be imported in quantity. Elsewhere in this book, their influence can be seen in Mary Cassatt's *The Boating Party* (21.11) and Henri de Toulouse-Lautrec's *La Goulue at the Moulin Rouge* (10.9).

Interestingly, one of the factors that allowed Western artists to borrow compositional ideas from Japanese prints so easily was that influence had already flowed in the other direction. The Western system of linear perspective had long been known to Japanese artists. During the 18th century, printmakers even created a special type of print called *uki-e*, "perspective pictures." By Hiroshige's time, printmakers had fully absorbed Western perspective into their own styles, especially in landscape, as the two examples here show so well.

⁽left) Ando Hiroshige. *Riverside Bamboo Market, Kyobashi*, view 76 from *One Hundred Famous Views of Edo*. 1857. Brooklyn Museum of Art, New York.

⁽right) Ando Hiroshige. Fireworks at Ryogoku, view 98 from One Hundred Famous Views of Edo. 1857. Rijksmuseum, Amsterdam.

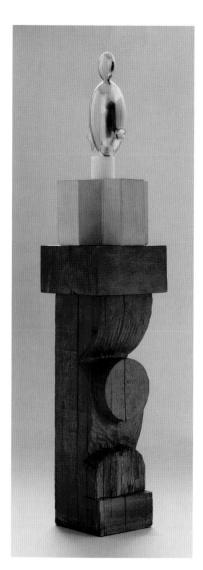

4.37 Constantin Brancusi. *Blond Negress, II.* 1933 (after a marble of 1928). Bronze, on a four-part pedestal of marble, limestone, and oak; total height 5'11½".

The Museum of Modern Art, New York

marble sculptures to a smooth finish and his bronze works to a brilliant shine (4.37). The wooden bases he carved to support them, however, he usually left in a rougher, less finished state. On the base here, gouges from his chisel can still be seen. The base supports three geometric elements: a rectangular prism of wood, a cross-shaped prism of limestone, and a polished white marble cylinder. At each step the texture grows smoother and more refined, like an idea taking shape and becoming increasingly precise.

Visual Texture

That we can appreciate the textures of Hatoum's *Dormiente* or Brancusi's *Blond Negress, II* in a photograph shows that texture has a visual component as well as a tactile one. In fact, even before touching a surface, we have formed an idea of its texture by observing the way it reflects light and associating what we see with a sense memory of touch. Brancusi's use of texture can thus be significant for us even though we would certainly not be permitted to touch the sculpture in a museum, and Hatoum's use of texture can give us a deeply unsettling visual experience even if we do not run our hands over *Dormiente*.

Naturalistic painting can suggest the texture of objects in the world in the same way that photography does, by faithfully recording the way light plays over their surfaces. Centuries before photography was invented, Dutch still-life painters delighted in capturing visual texture in paint, and no one was better at it than Willem Kalf (4.38). Notice here how reflected light conveys the hard, smooth surface of the glazed porcelain bowl and shadows capture the minutely pitted skin of the lemon and the soft, tufted texture of the rug.

Our word texture is derived from the Latin *textus*, the past participle of *textere*, to weave. It is easy to imagine how the experience of appreciating woven cloth by touching it was transferred to the experience of touching surfaces in general. In addition to its literal meaning, we have also come to use the word figuratively in a variety of ways, often for things we can imagine as woven. For example, we could describe a poem as woven of words, a symphony

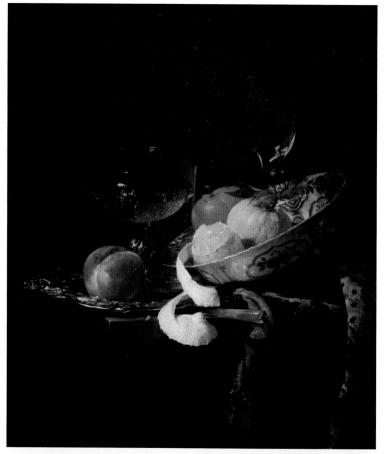

4.38 Willem Kalf. *Still Life with Glass Goblet and Porcelain Bowl.* 1655. Oil on canvas, 24% × 22". Museum Boijmans Van Beuningen, Rotterdam

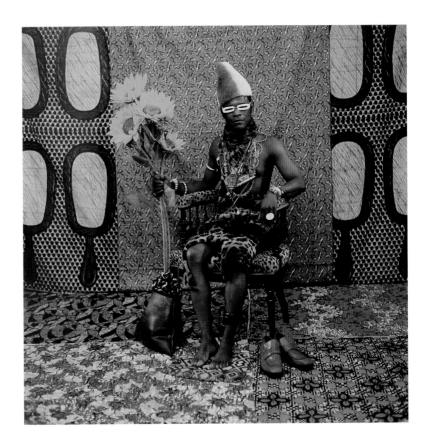

as woven of notes played by many instruments, and a painting as woven of brush strokes. In each case, we can speak of the work's texture—aural texture for the poem and the symphony, and visual texture for the painting. Earlier in this chapter we spoke of the lively texture produced by Seurat's pointillist technique (see 4.31), for the dots seem to weave a tapestry of color. Paintings by Van Gogh have a characteristic visual texture created by his typically short, unblended brush strokes (see 1.10, 2.1).

4.39 Samuel Fosso. The Chief: He Who Sold Africa to the Colonists, from Self-Portraits I–V. 1997. Chromogenic print, 20 × 20".

© Samuel Fosso. Courtesy Jack Shainman Gallery and Galerie Jean Marc Patras

Pattern

Pattern is any decorative, repetitive motif or design. Pattern can create visual texture, although visual texture may not always be seen as a pattern. An interesting aspect of pattern is that it tends to flatten our perception of mass and space. The self-portrait here by African photographer Samuel Fosso illustrates the visual "buzz" and spatial ambiguity that patterns can produce (4.39). Everything clamors for our attention at once. Elements that should stay calmly in the background or firmly underfoot seem to come forward to meet us. In the middle of it all sits the artist, dressed as an outrageous parody of a traditional ruler. (For an example of the sort of royal display that Fosso is mocking, see 18.12.)

Space

The word "space," especially in our technological world, sometimes conveys the idea of nothingness. We think of outer space as a huge void, hostile to human life. A person who is "spaced out" is blank, unfocused, not really "there." But the space in and around a work of art is not a void, and it is very much there. It is a dynamic visual element that interacts with the lines and shapes and colors and textures of a work of art to give them definition. Consider space in this way: How could there be a line if there were not the spaces on either side of it to mark its edges? How could there be a shape without the space around it to set it off?

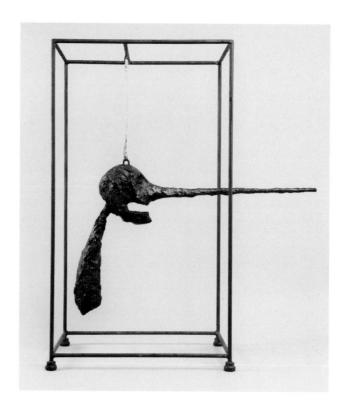

4.40 Alberto Giacometti. The Nose. 1947. Bronze, iron, twine, and steel wire; $32 \times 28 \% \times 15 \%$ ". Collection Fondation Alberto & Annette Giacometti

Three-Dimensional Space

Sculpture, architecture, and all other forms with mass exist in three-dimensional space—that is, the actual space in which our bodies also stand. These works of art take their character from the ways in which they carve out volumes of space within and around them.

The sculptor Alberto Giacometti was fascinated by how we perceive objects in space. He was intent on finding ways to suggest in his work the space he sensed between himself and his model, and also to situate his own sculptures in space for viewers. In *The Nose* (4.40), he went so far as to frame a cubic volume of space around his disturbing sculpture of a head. The image was prompted by a visit Giacometti paid to a friend in the hospital. As Giacometti looked down at his friend's face, gaunt and wasted with illness, it seemed to him that the eyes and cheeks were sinking farther down and that the bony nose was growing longer. He captured that momentary vision of death in this sculpture, which he then suspended in space like a hanged man, or like a shrunken head in an ethnographic museum.

Architecture in particular can be thought of as a means of shaping space. Without the walls and ceilings of a room, space would be limitless; with them, space suddenly has boundaries, and therefore volume. Whereas from the outside we appreciate a work of architecture for its sculptural masses, from the inside we experience it as a shaped space or a sequence of shaped spaces. Do Ho Suh's installation *Reflection* produces a heightened awareness of the shaped space it occupies by modifying that space in an unexpected and disorienting way (4.41). Reflection consists of two identical replicas of the traditional Korean entry gate that stood before the artist's childhood home. Made of blue nylon stretched over a framework of slender steel tubing, the meticulously detailed gates are translucent, allowing us to see into and through them. Suh sets them base to base in mirror image on a taut field of blue nylon mesh that bisects the space of the room horizontally. Entering visitors are confronted with an inverted, suspended gate, a reflection that seems more real, more present, than the gate it reflects, which rises upright into the space above, softened and blurred by the blue haze of the nylon field. Reflection is about memory—a gate and the memory of a gate, time present and time past, though which is which, and where we are in relation to the two, are difficult to say.

Implied Space: Suggesting Depth in Two Dimensions

Architecture, sculpture, and other art forms that exist in three dimensions work with actual space. When we view the work, we inhabit the same space it does, and we need to walk around it or through it to experience it completely. With painting, drawing, and other two-dimensional art forms, the actual space is the flat surface of the work itself, which we tend to see all at once. Yet on this literal surface, called the **picture plane**, other quantities and dimensions of space can be implied. For example, if you take an ordinary notebook page and draw a tiny dog in the center, the page has suddenly become a large space, a field for the dog to roam about in. If you draw a dog that takes up the entire page, the page has become a much smaller space, just big enough for the dog.

Suppose now that you draw two dogs and perhaps a tree, and you want to show where they are in relation to one another. One dog is behind the tree, say, and the other is running toward it from the distance. These relationships take place in the third dimension, depth. There are many visual cues that we use to perceive spatial relationships in depth. One of the simplest is overlap: we understand that when two forms overlap, the one we perceive as complete is in front of the one we perceive as partial. A second visual cue is position: seated at a desk, for example, we look down to see the objects closest to us and raise our head up to see objects that are farther away.

4.41 Do Ho Suh. *Reflection*. 2004. Installation at Lehmann Maupin Gallery, New York, 2007. Nylon and stainless steel tube, dimensions variable, edition of two, each gate life-size.

Courtesy Lehmann Maupin Gallery, New York. © Do Ho Suh, 2004

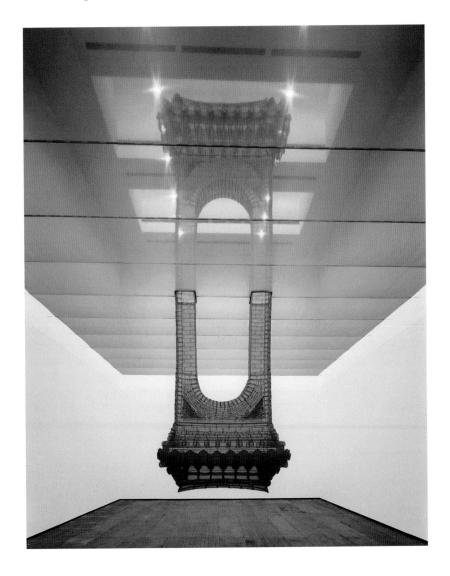

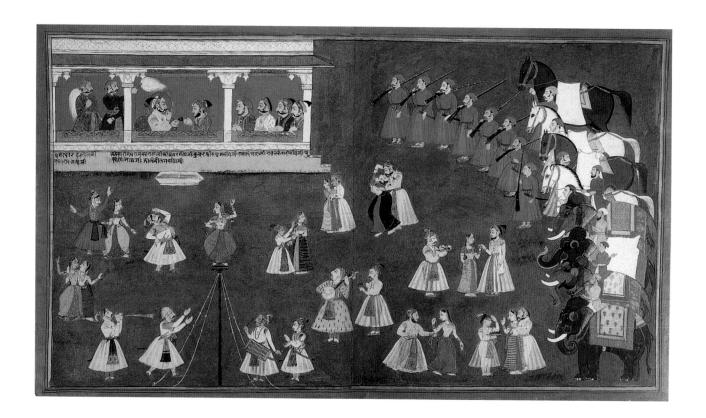

4.42 Maharana Amar Singh II, Prince Sangram Singh, and Courtiers Watch the Performance of an Acrobat and Musicians.
Rajasthan, Mewar, c. 1705–08.
Ink, opaque watercolor, and gold on paper; 20½ × 35¾".
The Metropolitan Museum of Art, New York

Many artistic cultures have relied entirely on those two basic cues to imply depth in two dimensions (4.42). In this lively scene of acrobats and musicians performing before an Indian prince, we understand that the performers toward the bottom of the page are nearer to us than ones higher up, and that the overlapping elephants and horses are standing next to each other in a row that recedes away from us. The most important person in the scene is the prince, and the painting makes this clear. Framed by the architectural setting, he sits amid his courtiers and attendants, all of whom are looking at him. The prince, too, is depicted in profile and does not seem to be watching the performance. Yet this seeming inattention is not to be taken literally. The prince would certainly have watched such a wonderful event. Indian artists favored profile views, for they give the least information about depth, and so lend themselves well to the overall flatness of Indian painting.

LINEAR PERSPECTIVE The sense of space in the Indian painting is conceptually convincing, but not optically convincing. For example, we understand perfectly well that the prince's pavilion is on the distant side of the acrobats, but there is actually no evidence to tell our eyes that it is not hovering in the air directly over them. Similarly, we understand that the elephants and horses represent rounded forms even though they appear to our eyes as flat shapes fanned out like a deck of cards on the picture plane. Together, the flatness of Indian painting, the preference for profiles, the use of saturated colors, and the conceptual construction of space make up a coherent system for depicting the world. They work together to give Indian artists tremendous flexibility in assembling complex, vivid, and visually delightful scenes such as this one while preserving narrative clarity.

The chiaroscuro technique developed by Italian artists of the 15th century also forms part of a larger system for depicting the world. Just as Renaissance artists took note of the optical evidence of light and shadow to model rounded forms, they also developed a technique for constructing an optically convincing space to set those forms in. This technique, called **linear perspective**, is based in the systematic application of two observations:

- Forms seem to diminish in size as they recede from us.
- Parallel lines receding into the distance seem to converge, until they meet at a point on the horizon line where they disappear. This point is known as the **vanishing point**.

You can visualize this second idea if you remember gazing down a straight highway. As the highway recedes farther from you, the two edges seem to draw closer together, until they disappear at the horizon line (4.43).

The development of linear perspective profoundly changed how artists viewed the picture plane. For medieval European artists, as for Indian artists, a painting was primarily a flat surface covered with shapes and colors. For Renaissance artists, it became a window onto a scene. The picture plane was reconceived as a sort of windowpane, and the painted view was imagined as receding from it into the distance.

Renaissance artists took up linear perspective with as much delight as a child takes up a new toy. Many paintings were created for no other reason than to show off the possibilities of this new technique (4.44). Here, the lines of the stone pavement lay bare the mechanics of linear perspective. We can actually observe the receding lines growing closer, and we can easily continue

4.43 Basic principles of linear perspective.

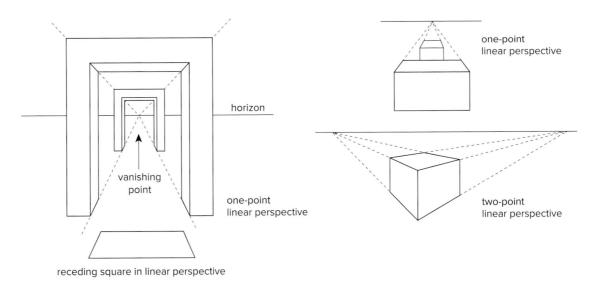

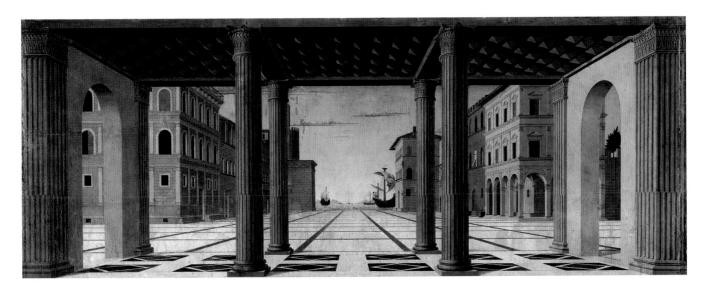

4.44 Francesco di Giorgio Martini (attr.). *Architectural Perspective*. Late 15th century. Furniture decoration on poplar wood, 4'35%" × 7'75%". Staatliche Museen zu Berlin, Preussischer Kulturbesitz, Gemäldegalerie

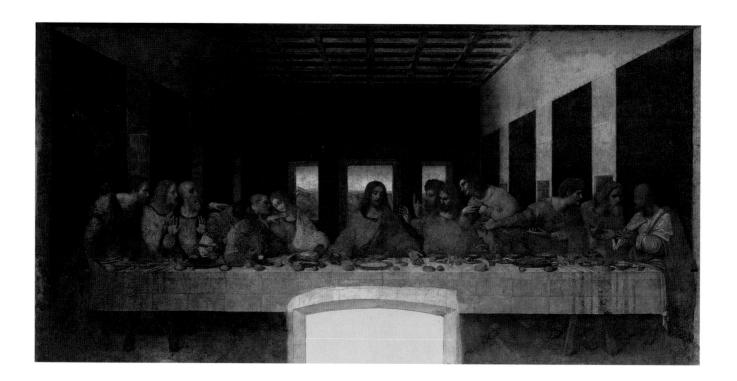

4.45 Leonardo da Vinci. *The Last Supper* (after restoration). c. 1495–97. Fresco, 15'1½" × 28'10½". Refectory, Santa Maria delle Grazie, Milan

them in our imagination until they converge at a central point on the horizon, where the sea meets the sky. The rooflines of the various buildings converge at the same point, as do the lines that divide the ceiling of the covered portico in the immediate foreground.

Leonardo da Vinci used linear perspective to construct a very similar space for his portrayal of *The Last Supper* (4.45). It was, above all, the measurable quality of the space created through linear perspective that intrigued Renaissance artists. Here, regular divisions of the ceiling measure out the recession just as the regular divisions of the pavement did in the preceding example.

Painted on a monastery wall in Milan, *The Last Supper* depicts the final gathering of Jesus Christ with his disciples, the Passover meal they shared before Jesus was brought to trial and crucified. Leonardo captures a particular moment in the story, as related in the Gospel of Matthew in the Bible. Jesus, shown at the center of the composition, has just said to his followers: "One of you shall betray me." The disciples, Matthew tells us, "were exceeding sorrowful, and began every one of them to say unto him, Lord, is it I?"

In Leonardo's portrayal, each of the disciples reacts differently to the terrible prediction. Some are shocked, some dismayed, some puzzled—but only one, only Judas, knows that, indeed, it is he. Falling back from Jesus' words, the traitor Judas, seated fourth from the left with his elbow on the table, clutches a bag containing thirty pieces of silver, his price for handing over his leader to the authorities.

To show this fateful moment, Leonardo places the group in a large banquet hall, its architectural space constructed in careful perspective. Cloth hangings on the side walls and panels in the ceiling are drawn so as to recede into space. Their lines converge at a vanishing point behind Jesus' head, at the exact center of the picture. Thus, our attention is directed forcefully toward the most important part of the composition, the face of Jesus. The central opening in the back wall, a rectangular window, also helps to focus our attention on Jesus and creates a "halo" effect around his head.

In the hands of the greatest artists, perspective became a vehicle for meaning, just as any other visual element. Here, for example, it is correct to say that the space is constructed so that the lines converge at a vanishing point in the distance behind Christ's head. But if we view the painting as a flat surface, we see that these lines can also be interpreted as radiating from

THINKING ABOUT ART Conservation

Why are restoration projects controversial? Are such works no longer original or no longer the artists' own? Do artists create works with the intention to withstand time?

orks of art age. Light, atmospheric conditions, microbes, and pollutants can cause some pigments to darken and others to fade, varnish to yellow, paint to flake, paper to develop blotches, canvas to rot, wood to crack, marble to decompose, bronze to suffer corrosion, and dirt, dust, and grime to work their way into just about everything. As a final irony, our very presence—the moisture of our breath, the warmth of our bodies, the oils left from a casual touch—can pose a danger to the works of art we so admire.

Conservation aims to slow the inevitable effects of time by keeping works of art in the safest possible conditions. It is one of the most important tasks of museums, where it is the job of highly trained specialists. Museums take many steps to prolong the life of objects in their care. Vulnerable objects are displayed in glass cases, where temperature and humidity can be carefully controlled. Works on paper are exhibited at low light-levels, and paintings are kept away from direct sunlight (and camera flashes). Each object is examined regularly for signs of deterioration.

For larger works outside museum settings, public access may need to be limited. Since 1963, for example, the famous Lascaux caves (see 14.1) have been closed

to all but five visitors per day, five days a week. (Tourists are directed to a nearby replica of the caves.) The Scrovegni Chapel, whose walls boast an important cycle of frescoes by Giotto (see 15.26), has recently been placed in a sort of "iron lung"—a closed, air-conditioned environment that purifies the air inside the chapel and continuously monitors its atmosphere. Visitors are permitted in groups of twenty-five, and they may remain for only fifteen minutes. In between groups, the chapel "rests" for fifteen minutes so that its microclimate can restabilize.

Occasionally, the decision is taken to clean or restore a work in an attempt to roll back the effects of time. The decision can be controversial. In the past, techniques used for cleaning and restoration have sometimes done more harm than good. Even today, with methods informed by the

latest scientific findings, heated debates about what technique to use, or even whether to proceed at all, are not uncommon.

Among the most highly publicized of recent conservation projects was the restoration of Leonardo's Last Supper, a detail of which is shown here. In painting the mural, Leonardo had experimented with a new technique of his own devising. The results began to deteriorate not long after he finished. Over the centuries, a series of well-intentioned but heavy-handed restorations left experts wondering what, if anything, was left of Leonardo's original work. Beginning in 1977, a team of restorers under the direction of Dr. Pinan Brambilla Barcilon labored for over twenty years to determine which flecks of paint remained from Leonardo's hand and to remove everything else. Areas where nothing was left at all were filled in with pale, removable watercolor that lessens the visual shock of the absence while being clearly distinguishable from the original pigment. What remains is a more luminous but far more fragmentary image than we had before. Our only comfort is that at least it is all by Leonardo.

⁽left) Dr. Pinan Brambilla Barcilon before a restored portion of Leonardo's *Last Supper*.

⁽right) A portion of the mural before restoration.

4.46 Hans Baldung Grien.

The Groom and the Witch. c. 1540.

Woodcut, image 13¹⁵/₁₆ × 7⁷/₈".

National Gallery of Art, Washington, D.C.

4.47 Albrecht Dürer. *Draftsman Drawing a Reclining Nude*, from *The Art of Measurement*. c. 1527. Woodcut, 3 × 8½". Rijksmuseum, Amsterdam

Christ's head, as all of creation radiates from the mind of God. Leonardo has purposefully minimized Christ's shoulders so that his arms, too, take part in the system of radiating lines. Spreading his hands, then, God opens space to this moment, which He had foreseen since the beginning of time.

FORESHORTENING For pictorial space to be consistent, the logic of linear perspective must apply to every form that recedes into the distance, including objects and human and animal forms. This effect is called **foreshortening**. You can understand the challenge presented by foreshortening by closing one eye and pointing upward with your index finger in front of your open eye. Gradually shift your hand until your index finger is pointing away from you and you are staring directly down its length and into the distance. You know that your finger has not changed in length, and yet it appears much shorter than it did when it was upright. It appears foreshortened.

Hans Baldung Grien portrays two foreshortened figures in *The Groom and the Witch* (**4.46**). The groom, lying perpendicular to the picture plane, is foreshortened. If we were to shift him so that he lay parallel to the picture plane with his head to the left and his feet to the right, we would have to stretch him back out. The horse, standing at a 45-degree angle to the picture plane, is also foreshortened, with the distance between his rump and his forequarters compressed by the odd angle at which we see him.

Foreshortening presented great difficulties to artists, for the complex, organic masses of a horse or a man do not offer the simple receding lines of architecture. Hans Baldung Grien's teacher, Albrecht Dürer, left us this wonderful image of an artist wrestling logically with a problem of extreme foreshortening (4.47). From our point of view, the woman lies parallel to the picture plane. From the point of view of the artist, however, she is directly perpendicular to it. Her knees are closest to him, her head farthest away. He has actually constructed a picture plane in the form of a gridded window through which he looks at his model. On the table before him lies a sheet of paper, gridded to match. Standing on the table within the embrace of his arms is an obelisk whose tip just reaches his eye. The obelisk serves to focus his glance, making sure that every time he returns his gaze to the model, it is at the exact same height.

Our artist will work slowly back and forth. Looking across the tip of the obelisk with one eye open, he will observe his model through the grid. Looking down, he will open both eyes and quickly draw from memory what he saw, using the grid lines as reference points. Looking up again, he will refocus one eye on his model over the obelisk and memorize another small bit. Glance by glance, he will complete the drawing.

Dürer's image illustrates well the strengths and drawbacks of linear perspective. It is a scientifically accurate system for rendering space and relationships within space as we perceive them standing in one fixed place, with one eye open, staring at fixed points along one eye level. But in life we have two

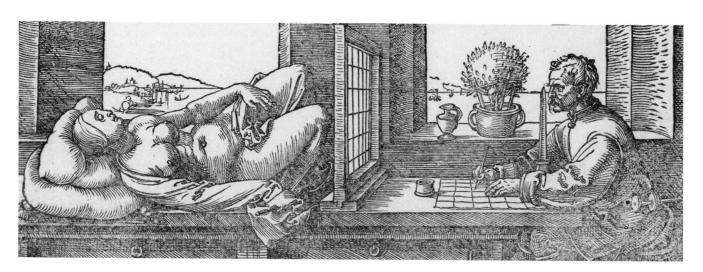

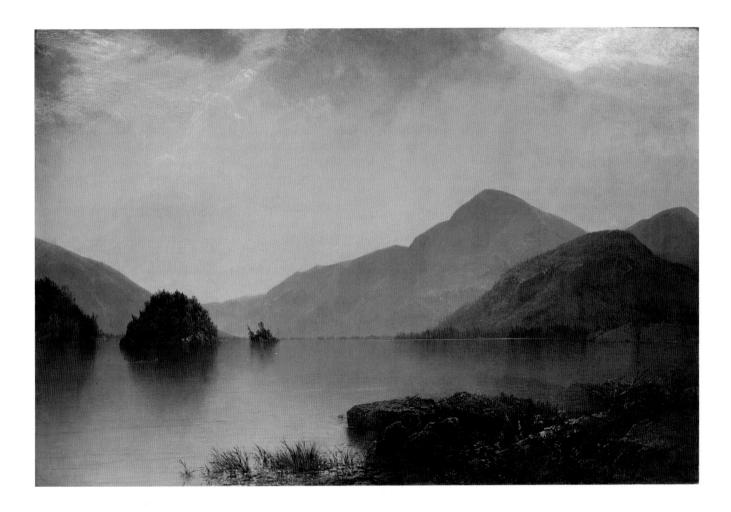

eyes, not one, and they are always in motion. Nevertheless, the principles of linear perspective dominated Western views of space for almost five hundred years, and they continue to influence us through images generated by the camera, which also shows the view seen by one eye (the lens) staring at a point on a fixed level (the center focus).

ATMOSPHERIC PERSPECTIVE Staring off into a series of hills, you may notice that each succeeding range appears paler, bluer, and less distinct. This is an optical effect caused by the atmosphere that interposes itself between us and the objects we perceive. Particles of moisture and dust suspended in the atmosphere scatter light. Of all the colors of the spectrum, blue scatters the most; hence the sky itself appears to be blue, and things take on a bluish tinge as their distance from us increases. The first European artist to apply this observation systematically was Leonardo da Vinci, who called the effect "aerial perspective." A more common term today is **atmospheric perspective**.

Atmospheric perspective is the third and final element of the optically based system for representing the world that was developed during the Renaissance. For as long as naturalism remained a goal of Western art, these three techniques—modeling form through value, constructing space with linear perspective, and suggesting receding landscape through atmospheric perspective—remained central to painting.

John Frederick Kensett's view of *Lake George* is an exquisite example of beautifully modulated atmospheric perspective (4.48). With its rocky outcropping, fallen tree trunk, green leaves, and water grasses, the shore in the foreground is clear and detailed. Small islands nearby are less distinct, but the trees are still green. Marking our progression into the distance, the three hills along the farther shores grow progressively more hazy and tinged with blue,

4.48 John Frederick Kensett. *Lake George*. 1869. Oil on canvas, 3'8%" × 5'6%". The Metropolitan Museum of Art, New York

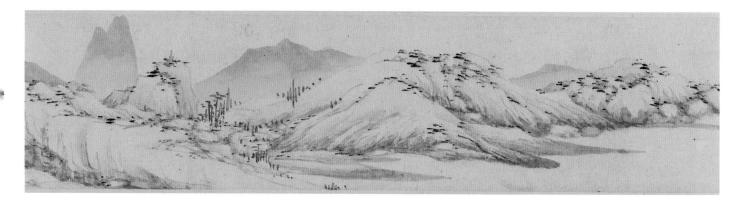

4.49 Shen Zhou. *Autumn Colors among Streams and Mountains*. c. 1490–1500. Handscroll, ink on paper, image 8½" × 21½". The Metropolitan Museum of Art, New York

which takes over completely as the farthest hill follows the curve of the lake away from us and disappears from view.

Chinese and Japanese painters also relied on atmospheric perspective to suggest broad vistas of receding landscape. In Shen Zhou's *Autumn Colors among Streams and Mountains* (4.49), the gentle hills along the shore are built up from layers of contour strokes, anchored by local gray washes, and detailed with barren tree trunks and black dots indicating foliage. The mountains that rise in the distance, in contrast, are simply rendered in washes of pale gray ink. The colors of the title are left to the viewer's imagination.

Autumn Colors among Streams and Mountains is an example of a handscroll, an intimate format of painting developed in China. Small enough to be held in the hands, as the name indicates, a handscroll was commonly only a foot or so in height, but many feet long. Autumn Colors among Streams and Mountains, for example, is about 8 inches in height and just over 21 feet long. We illustrate only a small section of it. Handscrolls were not displayed completely unrolled, as today we might see them in museums. Rather, they were kept rolled up and taken out for viewing only occasionally. Viewers would savor the painting slowly, setting it on a table and unrolling a foot or two at a time. Working their way from one end of the scroll to the other, they journeyed through a landscape that commonly alternated stretches of open water and lowlands with hills and mountains. In Autumn Colors among Streams and Mountains, Shen Zhou paid homage to the quartet of painters known as the Four Masters of the Yuan Dynasty by imitating their styles one after the other—an added pleasure for cultivated viewers.

ISOMETRIC PERSPECTIVE As we have seen, the converging lines of linear perspective are based on the fixed viewpoint of an earthbound viewer. The viewpoint in Chinese painting, however, is typically mobile and airborne, and so converging lines have no place in their system of representation. Islamic painting often employs an aerial viewpoint as well, so that scenes are depicted in their totality as God might see and understand them. To suggest regular forms such as a building receding from the picture plane, Chinese and Muslim painters use diagonal lines, but without allowing parallels to converge. This system is known as **isometric perspective** (4.50). In the page illustrated here from a manuscript of the *Sulaymannama* (*History of Sulayman*),

4.50 Basic principles of isometric perspective.

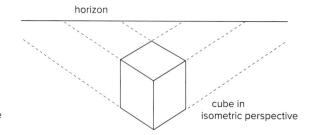

receding rectangle in isometric perspective

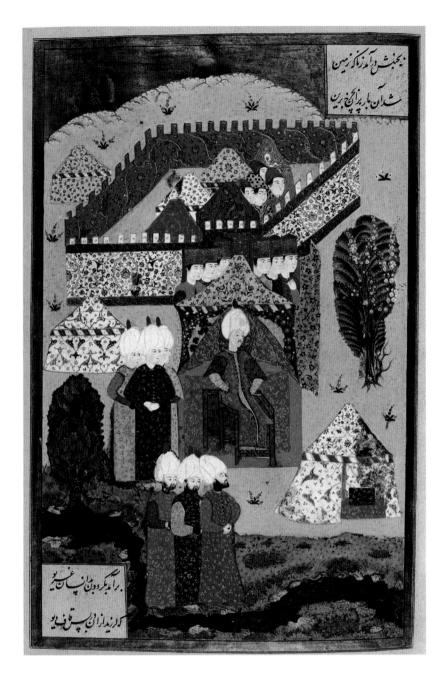

the blue-and-white fortress in the background is portrayed using isometric perspective (4.51). The side walls recede to the right in parallel diagonal lines; the rear wall is as wide as the wall nearest us. Sulayman was a famous Ottoman sultan of the 16th century. Toward the end of his reign, his official history was written by the poet Arifi, transcribed by a famous calligrapher, and lavishly illustrated by court artists.

4.51 The Siege of Belgrade, from a manuscript of Sulaymannama. Istanbul, 1558. Ink and opaque colors on paper. Topkapi Palace Library, Istanbul

Time and Motion

Time and motion have always been linked to art, if only because time is the element in which we live and motion is the very sign of life. It was only during the 20th century, however, that time and motion truly took their places as elements of Western art, and this for the simple reason that through advances in science and technology, daily life itself became far more dynamic, and the nature of time and its relationship to space and the universe more a matter for thought.

During the 1930s, the American artist Alexander Calder set sculpture in motion with works that came to be called mobiles. Constructed from abstract forms suspended on slender lengths of wire, they respond by their own weight to the lightest currents of air. Calder also created works he called stabiles—sculptures that did not move but sat still on the ground like everyone else's. Often, he combined the two ideas, as here in his monumental *Southern Cross* (4.52), where an orange stabile holds aloft a black mobile. *Southern Cross* is the popular name for a constellation called Crux, visible in the southern hemisphere. Sailors on the southern seas used to steer by it. Calder's mobile constellation seems to be made of pieces of night, and his stabile looks suspiciously capable of movement, as though it might skitter away on its pointy legs.

Art that moves is called **kinetic** art, from the Greek word *kinetos*, moving. Calder is considered to be one of its founders. But motion in the experience of art is not confined to the artworks themselves. As viewers, we also move, walking around and under Calder's *Southern Cross*, for example, to experience what it looks like from different distances and angles. We walk through architecture to explore its spaces, we draw near to and away from paintings to notice details or allow them to blur back into the whole. As we saw in Chapter 2, artists of the 20th century became increasingly conscious of the viewer's motion over time, especially in the context of gallery and museum spaces.

In works such as *Inside Out*, Richard Serra creates sculpture that is both an object for us to look at and a place for us to explore (4.53). "I've learned a great deal from looking at and walking through architecture," Serra has said. "It has enabled me to understand space in relation to movement." *Inside Out* partakes of the dual nature of architecture: from the outside we view it as an object; from the inside we experience it as shaped space. The plan of the sculpture is clear when seen from an elevated viewpoint, as in the illustration here. But to viewers approaching the sculpture on foot, the plan is hidden, for the work is over 13 feet tall. *Inside Out* confronts us as a curved steel wall, like a fortress or the hull of a ship. Circling it, we eventually happen on a pair of openings. The gentler, more inviting one brings us to a rounded clearing but no further. The more forbidding opening takes us on a journey down a narrow, winding canyon. Towering walls to either side lean outward, then inward, continuously modifying the space and our physical experience of it. We can't know where we are going, what there is to discover, or even how we will eventually get out.

4.52 Alexander Calder. Southern Cross. 1963. Sheet metal, rod, bolts, and paint; height 20'3". Courtesy Storm King Art Center, Mountainville, New York

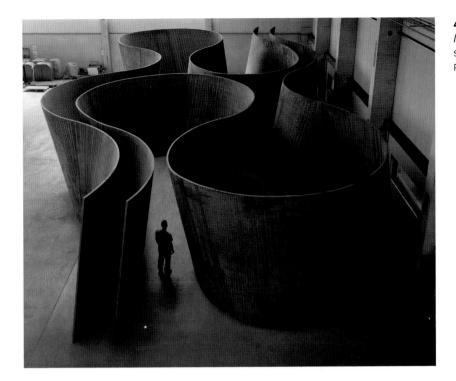

4.53 Richard Serra. *Inside Out.* 2013. Weatherproof steel, 13'2" × 81'10" × 40'2½". Photo by Lorenz Kienzle

Nick Cave makes art that depends for its full effect on the motion of yet another potential participant, the performer. Cave makes sculptures he calls *Soundsuits* (4.54). Although we can appreciate them in a gallery setting, where they stand motionless before us, most of them are made to be worn and danced. Like masquerades, the great African art form, Cave's *Soundsuits* are art that is meant to be seen in motion.

Soundsuits take their name from the first one Cave made, back during the racially tense times of the early 1990s. An amateur video documenting the brutal beating of an African-American man by members of the Los Angeles police force had been widely shown on the news media. Riots broke out in several cities after a jury acquitted three of the four officers involved. "I started thinking about myself more and more as a black man," Cave recalls, "as someone who was discarded, devalued, viewed as less than." Sitting one day on a park bench, he began to consider the twigs that lay on the ground around him as similarly rejected, valueless things. He gathered up armfuls of them and brought them back to his studio, where he cut them into 3-inch lengths and wired them to a bodysuit he had made, completely covering it from head to toe. Cave had intended the work as a sculpture, but he immediately realized that he could wear it. "I put it on and jumped around and was just amazed. It made this fabulous rustling sound. And because it was so heavy, I had to stand very erect, and that alone brought the idea of dance back into my head."8 Just as important, Cave realized, he could disappear into the suit, and no one could tell from the outside whether he was black, white, orange, or purple. Since that initial impulse to give form to feelings in the face of events, Cave has created hundreds of Soundsuits using scavenged materials and items purchased from thrift shops, flea markets, and garage sales. They dance before us, a race of joyous, mysterious, silly, mournful, disturbing, majestic, extravagant beings that make their own music. We could put one on and join in.

The Greek word *kinetos* also gave us the word *cinema*, certainly the most significant new art form of the 20th century. Film and, later, video provided artists with new ways to work with time and motion. As these technologies become increasingly affordable and available, artists experimented with them more and more, to the point where video became an important medium for contemporary art.

4.54 Nick Cave. Soundsuit. 2011. Knits and appliqué, metal armature, vintage black-faced voodoo dolls, black bugle beads, vintage mammy's cozy, hand mirrors, wiggle eyes, and Felix the Cat vintage leather mask; height 10'. Courtesy the artist and Jack Shainman Gallery, New York

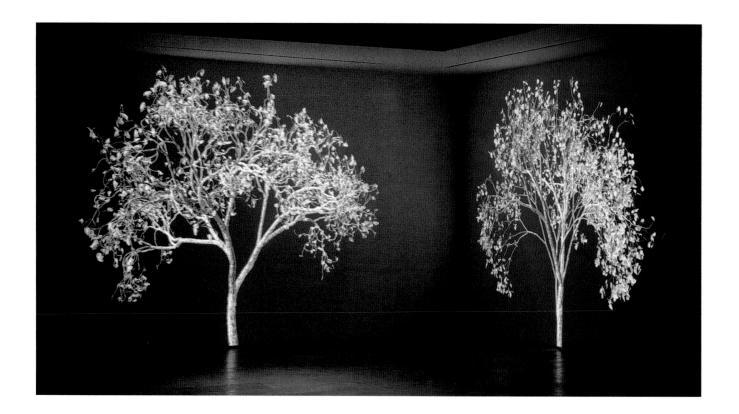

4.55 Jennifer Steinkamp. *Dervish*, detail. 2004. Video installation at Lehmann Maupin Gallery, New York, January 10–February 14, 2004. Each tree 12 × 16' (size variable). Courtesy of the artist and Lehmann Maupin Gallery, New York

More recently, digital animation technology has allowed artists to create videos that do not necessarily rely on camera images. A beautiful example is Jennifer Steinkamp's installation *Dervish* (4.55). The installation was named for the order of Sufi mystics known in English as whirling dervishes, who enter into a state of spiritual ecstasy by means of a spinning dance. *Dervish* consisted of four digitally animated images of trees, each called *Dervish*, projected onto the walls of a darkened room. (The photograph here shows two of the trees.) Each individual branch, leaf, and blossom seemed alive as the trees twirled slowly, first one way and then the other, their virtual roots holding firm in the virtual ground, their trunks twisting like wrung laundry. Even more magically, each tree cycled through the seasons as it swayed, with spring blossoms giving way to summer foliage, then autumn colors, then bare branches.

To create her trees, Steinkamp began with an image of a maple. She modified each element digitally until she had created a tree that resembled no known tree at all, a completely artificial and virtual tree. Her only rule in her art, she says, is that everything must be simulated. Each *Dervish* can be programmed to display whatever season the viewer is in the mood for, or to change seasons on cue (the sound of a slamming door, for example, could cause spring to turn into summer). With strategies such as these, many digital artists surrender ultimate control over their creations.

Line, shape, mass, light, value, color, texture, pattern, space, time, and motion—these are the raw materials, the elements, of a work of art. To introduce them, we have had to look at each one individually, examining its role in various works of art. But in fact, we do not perceive the elements one at a time but together, and almost any given work of art is not an example of one element but of many. In the next chapter, we examine how artists organize these elements into art, how this organization structures our experience of looking, and how an understanding of the visual elements and their organization can help us to see more fully.

5

Principles of Design

hen an artist sets about making any work, he or she is faced with infinite choices. How big or small? What kinds of lines and where should the lines go? What kinds of shapes? How much space between the shapes? How many colors and how much of each one? What amounts of light and dark values? Somehow, the elements discussed in Chapter 4—line, shape, mass, light, color, texture, pattern, space, and possibly time and motion—must be organized in such a way as to satisfy the artist's expressive intent. In two-dimensional art, this organization is often called **composition**, but the more inclusive term, applicable to all kinds of art, is **design**. The task of making the decisions involved in designing a work of art would be paralyzing were it not for certain guidelines that, once understood, become almost instinctive. These guidelines are usually known as the principles of design.

All of us have some built-in sense of what looks right or wrong, what "works" or doesn't. Some—including most artists—have a stronger sense of what "works" than others. If two families each decorate a living room, and one room is attractive, welcoming, and pulled together while the other seems drab and uninviting, we might say that the first family has better "taste." Taste is a common term that, in this context, describes how some people make visual selections. What we really mean by "good taste," often, is that some people have a better grasp of the principles of design and how to apply them

in everyday situations.

The principles of design are a natural part of perception. Most of us are not conscious of them in everyday life, but artists usually are very aware of them, because they have trained themselves to be aware. These principles codify, or explain systematically, our sense of "rightness" and help to show why certain designs work better than others. For the artist they offer guidelines for making the most effective choices; for the observer an understanding of the principles of design gives greater insight into works of art.

The principles of design most often identified are unity and variety, balance, emphasis and subordination, proportion and scale, and rhythm. This chapter illustrates twenty-eight works of art that show these principles very clearly. But *any* work of art, regardless of its form or the culture in which it was made, could be discussed in terms of the principles of design, for they

are integral to all art.

Unity and Variety

Unity is a sense of oneness, of things belonging together and making up a coherent whole. Variety is difference, which provides interest. We discuss them together because the two generally coexist in a work of art. A solid wall painted white certainly has unity, but it is not likely to hold your interest for long. Take that same blank wall and ask fifty people each to make a mark on it and you will get plenty of variety, but there probably will be no unity whatever. In fact, there will be so *much* variety that no one can form a meaningful visual impression. Unity and variety exist on a spectrum, with total blandness at one end, total disorder at the other. For most works of art, the artist strives to find just the right point on that spectrum—the point at which there is sufficient visual unity enlivened by sufficient variety.

The first thing that strikes us when we look at Henri Matisse's *Memory of Oceania* (**5.1**) is the exhilarating variety of the colors and shapes. On longer acquaintance, however, we can begin to see how the composition is unified around a few simple principles. The colors are in fact limited to six plus black and white, and all of them but the pale yellow in the upper left corner repeat, creating visual connections across the picture plane. The shapes, though highly varied, fall into three "families"—rectangles (mostly concentrated in the upper right quadrant), simple curves (mostly concentrated at the lower right), and waves (blue and white, alternating in positive and negative shapes at the far left and far right). Only the pale yellow shape is without an echo. After a lifetime spent painting in his native France, Matisse had voyaged to Tahiti, in the South Pacific, hoping to refresh his eyes in a different kind of light. *Memory of Oceania* is a distillation of what he found there.

5.1 Henri Matisse. *Memory of Oceania*. 1953. Gouache on paper, cut and pasted, and charcoal on white paper; 9'4" × 9'47/s".

The Museum of Modern Art, New York

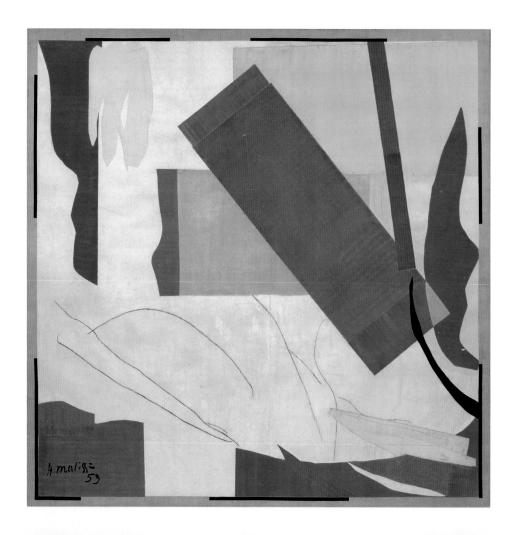

5.2 Yayoi Kusama. *Infinity Nets [AOWFA]*. 2013. Acrylic on canvas, 4'9⁵/₆" × 3'8¹/₈". © Yayoi Kusama. Courtesy of David Zwirner, New York; Ota Fine Arts, Tokyo/Singapore; Victoria Miro, London; KUSAMA Enterprise

At first glance, Yayoi Kusama's *Infinity Nets [AOWFA]* (5.2) seems to take the principle of unity to an extreme: The painting consists entirely of a small looping stroke repeated again and again, the loops gathering into chains, the chains joining like stitches in crochet or the knotted loops of a net. Only the edges of the painting put a stop to the repetition and accumulation, which could conceivably continue forever. Kusama refers to herself as an obsessional artist, a description amply borne out by paintings such as this one. She exhibited her first *Infinity Net* paintings in 1959, and she has been making them ever since. Yet as our eyes adjust to the image, we begin to notice subtle variations everywhere. The repetition is far from machinelike. Rather, the painting is emphatically handmade. Each loop is distinctly formed; the chains tend to gather into overlapping whorls and folds; zones of subtle color variation arise. The painting presents a very different interpretation of unity and variety than Matisse's work, but it is composed of unity and variety nevertheless.

The two works we have just considered demonstrate *visual* unity—unity based in the elements of shape, line, color, and so on. Art can also be unified *conceptually*, that is, through a unity of ideas. Annette Messager relies largely on conceptual unity in her assemblage called *Mes Voeux* (French for "my wishes," **5.3**). If we think about what the photographs have in common, we realize that they all portray isolated body parts—knee, throat, mouth, ear, hand. The framed texts ask not only to be looked at but also to be read. Two repeat the word *tenderness* over and over again; another, the word *shame*. Understanding the grouping as a kind of body itself places *consolation* at the head, *tenderness* at the arms, *shame* at the genitals, and *luck* at the legs. Repeating shapes and restricted color give visual unity to the work, but it is conceptual unity that asks for our interpretation.

5.3 Annette Messager. *Mes Voeux*. 1989. Framed photographs and handwritten texts, suspended with twine; 59" × 15³/₄".

Courtesy Marian Goodman Gallery, Paris

Balance
Isamu Noguchi Rod Cuba
Isamu Noguchi Rod Cuba

5.4 Isamu Noguchi. Red Cube.1968. Steel painted red, height 24'.Courtesy of The Noguchi Museum, New York Isamu Noguchi's delightful sculpture *Red Cube* (**5.4**) balances impossibly on one point. Noguchi wittily took the industrial materials and rectangular forms of mid-20th-century architecture and stood them on end, as though the buildings all around were pedestrians and his sculpture a dancer in their midst.

Noguchi's sculpture balances because its weight is distributed evenly around a central axis. The photograph of the sculpture is balanced as well, balanced *visually*. The simple red form set starkly against a dark background draws our attention strongly to the right. The white letters pull our eyes more gently to the left, as do the dark windows and the open hollow of the sculpture itself. Sculpture, hollow, letters, windows—all have a certain visual weight, and together they balance the photograph so that our gaze is never "stuck" in one place but moves freely around the image.

Visual weight refers to the apparent "heaviness" or "lightness" of the forms arranged in a composition, as gauged by how insistently they draw our eyes. When visual weight is equally distributed to either side of a felt or implied center of gravity, we feel that the composition is balanced.

Symmetrical Balance

With **symmetrical** balance, the forms of a composition mirror each other across a central axis, an imaginary straight line that divides the composition in half. The two halves of the composition thus correspond exactly, with the axis as the center of gravity. For example, the colorful shapes in Haruka Kojin's *reflectwo* mirror each other across a horizontal axis (5.5). The upper and lower halves of the work correspond exactly. *Reflectwo* evokes a wooded shoreline reflected in a still water surface. It was inspired by an experience the artist had as a university student while walking late one night along a river near her school: so perfectly did a tall tree join with its reflection that it seemed as though a gigantic tower were floating in the air before her, perfect and eternal. She felt disoriented, lost in space, as in a dream. Kojin gave form to her vision by using fabric petals from artificial flowers, flattened, grouped, and suspended

5.5 Haruka Kojin. *reflectwo*. 2007. Installation at the Museu de Arte Moderna de São Paulo, April 10–June 22, 2008. Artificial flower petals, acrylic, string; dimensions variable. Courtesy the artist and SCAI the Bathhouse, Tokyo

by threads from the ceiling. *Reflectwo* seems to float before us, beautiful and eerie. The petal groupings are hung in depth, some farther forward, some farther back, so that their relationships shift slightly as viewers move, the perfect symmetry of the whole revealing itself for a moment and then vanishing, like Kojin's vision.

Georgia O'Keeffe employed a less rigorous form of symmetrical balance in Deer's Skull with Pedernal (5.6). The skull itself is perfectly symmetrical, and O'Keeffe sets it directly on the vertical axis. She then softens the symmetry with subtle shifts in balance. Toward the top of the image, the dead tree branches off to the right, its branches rhyming with the skull's horns. To the bottom of the image, the trunk swerves off to the right as well, but a pale upward-thrusting branch, a lone cloud, and the distinctive silhouette of Pedernal Mountain all add visual weight to the left. This relaxed and yet fundamentally symmetrical approach is sometimes called relieved symmetry.

5.6 Georgia O'Keeffe. *Deer's Skull with Pedernal.* 1936. Oil on canvas, 36×30 ". Museum of Fine Arts, Boston

ARTISTS Georgia O'Keeffe (1887-1986)

In what ways do you think place influences an artist's development? How did O'Keeffe employ the terrain of the Southwest in her drawings and paintings? Although she wasn't a member of a particular "school" or style, how would you describe her work and legacy?

t last! A woman on paper!" According to legend, that was the reaction of the famed photographer and art dealer Alfred Stieglitz, in 1916, when he first saw the work of Georgia O'Keeffe. Whether accurate or not, the quote sums up Stieglitz' view of O'Keeffe as the first great artist to bring to her work the true essence and experience of womanhood. Ultimately, much of the critical art world came to share Stieglitz' opinion.

O'Keeffe was born on a farm in Wisconsin. She received a thorough, if conventional, art training at the School of the Art Institute of Chicago and the Art Students League in New York. During the early years, she supported herself by teaching art in schools and colleges. By 1912 she was teaching in Amarillo, Texas—the beginning of a lifelong infatuation with the terrain of the Southwest.

In the winter of 1915–16 O'Keeffe sent a number of drawings to a friend in New York, asking her not to show the drawings to anyone. The friend violated that trust—and no doubt helped to set the path for O'Keeffe's entire life and career. She took the drawings to Stieglitz.

By 1916 Stieglitz had gained considerable fame, not only as a photographer, but also, through his 291 gallery, as an exhibitor of the most innovative European and American painters. He was stunned by O'Keeffe's work. Later that year he included her in a group show at 291, and in 1917 he gave her a solo exhibition. That was the beginning of an extraordinary artistic and personal collaboration that would last until Stieglitz' death in 1946.

O'Keeffe moved to New York. Stieglitz left his wife and lived with her. O'Keeffe painted; Stieglitz exhibited her work and made hundreds of photographs of her. The couple married in 1924, but their union was always an unconventional one. For more than a quarter-century, their paths crossed and separated. Stieglitz was most at home in New York City and at his family's summer place at Lake George. O'Keeffe was drawn increasingly to the stark landscapes of Texas and New Mexico. O'Keeffe treasured her husband's presence but could paint at her best only in the Southwest. Stieglitz longed for her company but also wanted her paintings for his gallery.

O'Keeffe gained critical acclaim with her first exhibition, and it never entirely left her. Although major showings of her work were rare after Stieglitz died, no one forgot Georgia O'Keeffe. She was part of no "school" or style. Her work took an exceptionally personal path, as did her life. She dressed almost exclusively in black. She came and went as she pleased and accepted into her world only those people whom she found talented and interesting. More than most, O'Keeffe marched to her own drum.

After 1949 O'Keeffe lived permanently in New Mexico, the area with which she is most closely associated. In 1972, when she was eighty-four years old, a potter in his twenties, Juan Hamilton, came into her life, and they became close companions. Rumors that they married are probably unfounded, but Hamilton remained with the increasingly feeble, almost-blind artist until her death.

Early on, in her thirties, O'Keeffe had expressed her impatience with other people's standards for life and art: "I decided I was a very stupid fool not to at least paint as I wanted to and say what I wanted to when I painted as that seemed to be the only thing I could do that didn't concern anybody but myself—that was nobody's business but my own."

Alfred Stieglitz. *Georgia O'Keeffe*. Gelatin silver print, $9\frac{1}{3} \times 7\frac{3}{6}$ ". The Metropolitan Museum of Art, New York.

The central placement of the symmetrical deer skull gives O'Keeffe's painting a forceful, formal presence, as though it were a coat of arms or a symbol on a banner. Indeed, symmetrical balance is often used to express order, harmony, and authority, whether earthly and social or cosmic and spiritual. Cosmic order is the subject of one of the most distinctive of world art forms, the mandala (5.7). A mandala is a diagram of a cosmic realm. The most famous mandalas are connected with Buddhism, though there are Hindu mandalas as well. The mandala here is a Tibetan Buddhist one, and it depicts the cosmic realm emanating from the female buddha Jnanadakini, the Sky-goer of Transcendental Insight, who is shown seated in its centermost square. Everything radiates outward from her, including four more female buddhas, deities of the cardinal points (north, south, east, west), and other celestial beings.

The word *mandala* means "circle" in Sanskrit, the ritual language of early South Asia, where both Buddhism and Hinduism first took form. For practitioners, a mandala serves to focus meditation in the goal of achieving enlightenment. The basic message of its clear geometry and symmetry is this: we are living in a universe that makes sense, even if its logic and order are hidden from us during our brief lifetimes. Much religious art uses symmetrical balance to convey the same message.

5.7 Newar artists at Densatil Monastery, Central Tibet. *Thirteen-Deity Jnanadakini Mandala*. 1417–47. Distemper on cotton cloth, 33½ × 28½". The Metropolitan Museum of Art, New York

5.8 Some principles of visual balance.

5.9 Gustav Klimt. Death and Life. Before 1911, finished 1915. Oil on canvas, $5'10'' \times 6'6''$. Museum Leopold, Vienna

Asymmetrical Balance

When you stand with your feet flat on the floor and your arms at your sides, you are in symmetrical balance. But if you thrust an arm out in one direction and a leg out in the other, your balance is **asymmetrical** (not symmetrical). Similarly, an asymmetrical composition has two sides that do not match. If it seems to be balanced, that is because the visual weights in the two halves are very similar. What looks "heavy" and what looks "light"? The only possible answer is, that depends. We do not perceive absolutes but relationships. The heaviness or lightness of any form varies depending on its size in relation to other sizes around it, its color in relation to other colors around it, and its placement in the composition in relation to the placement of other forms there. The drawing (5.8) illustrates some very general precepts about asymmetrical or informal balance:

- 1. A large form is visually heavier than a smaller form.
- 2. A dark-value form is visually heavier than a light-value form of the same size.
- 3. A textured form is visually heavier than a smooth form of the same size.
- 4. A complex form is visually heavier than a simple form of the same size.
- 5. Two or more small forms can balance a larger one.
- 6. A smaller dark form can balance a larger light one.

Those are only a few of the possibilities. Keeping them in mind, you may still wonder, but how does an artist actually go about balancing a composition? The answer is unsatisfactory but true: the composition is balanced when it looks balanced. An understanding of visual weights can help the artist achieve balance or see what is wrong when balance is off, but it is no exact science.

In Gustav Klimt's *Death and Life* (5.9), asymmetrical balance dramatizes the opposition between life, envisioned to the right as a billowing form of light-hued patterns and slumbering human figures, and death, a dark skeletal presence at the far left, robed in a chilling pattern of grave markers. The two halves of the painting are linked by the gaze that passes between death and the woman he has come to claim. Klimt has placed her face exactly on the vertical axis of the painting, which here serves as a sort of symbolic border between life and death. The only waking person in the dreaming cloud of life, she smiles awkwardly and gestures as if to say, "Me?" Death leers back, "Yes, you." The intensity of their gaze exerts a strong pull on our attention to the upper left, and Klimt balances this with an equal pull of visual weight to the right and down.

It would be difficult to imagine a more daring asymmetrical composition than Tawaraya Sotatsu's ink painting of *The Zen Priest Choka* (5.10). The forms are placed so far to the left as to be barely on the page! Sotatsu relies on an implied line of vision both to balance the composition and to reveal its meaning. We naturally raise our eyes to look at the form of the priest sitting in the tree—that's all there is to look at. We then follow the direction of his gaze down to . . . nothing. Meditation on emptiness is one of the exercises prescribed by Zen Buddhism, and this ingenious painting makes it clear. Our eyes repeatedly seek out the priest, who repeatedly sends us back to focus on nothingness.

For a masterful example of asymmetrical balance as it is more typically found in Western painting, we turn to *The Burning of the Houses of Parliament* by the English painter J. M. W. Turner (5.11). Turner was an eyewitness to the catastrophe, which he watched from a boat on the River Thames in London. In his painting, he places the viewer on the opposite bank of the river. Our eyes are immediately drawn to the spectacular conflagration in the distance at the left. Turner balances this leftward attraction with the large white form of the

5.11 Joseph Mallord William Turner. The Burning of the Houses of Parliament. c. 1835. Oil on canvas, $36\% \times 48\%$ ". Philadelphia Museum of Art

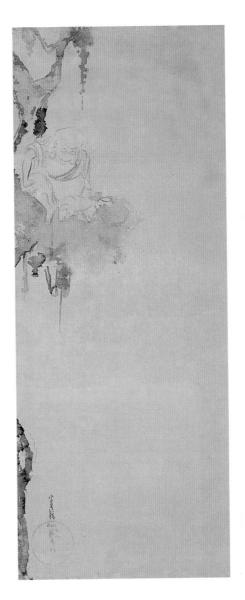

5.10 Tawaraya (Nonomura) Sotatsu. *The Zen Priest Choka*. Edo period, late 16th–early 17th century. Hanging scroll, ink on paper, $37\% \times 15\%$ ".

bridge to the right, which brings us to the foreground of the painting where a crowd has gathered. A single white street lamp—the lightest value in the painting—draws our eyes to the left, and from there we circle back to the flames, this time allowing the directional lines of the rose-tinged blue-gray smoke to carry our eyes off into the night sky, where a few stars shine.

Turner's composition leads our eyes on a journey around the implied depth of the painting. Depth, or the lack of it, is a fascinating issue in Edouard Manet's A Bar at the Folies-Bergère (5.12). The barmaid seems to stand before a large interior that recedes far back into the distance. Actually, she is wedged into a narrow space between the marble bar and a large mirror, which reflects all that she can see but cannot participate in. Her own reflection is displaced to the right, where we see that she is waiting on a man who must be standing where we are standing as we view the painting. Around the central, symmetrical form of the barmaid Manet scatters a dazzling display of visual weights and counterweights. The large dark form of the barmaid's reflection, the bowl of oranges next to the green bottle on the bar, the bottles to either side and their reflections in the mirror, the massive chandeliers and the moonlike white globes in the background, the woman in white who props her elbows on the balcony, even the green-clad feet of the trapeze artist visible at the upper left corner-all have a role to play. Place your finger over any element and you can see the life go out of that part of the painting and the overall balance become destabilized.

5.12 Edouard Manet. *A Bar at the Folies-Bergère*. 1881–82. Oil on canvas, 3'13'4" × 4'3'4". The Samuel Courtauld Trust, Courtauld Institute of Art Gallery, London

THINKING ABOUT ART Points of View

What is the first thing you notice when looking at this drawing of Manet's painting? Which of the points of view best describes your approach to thinking about art? In what ways do you think these intellectual tools help or constrain a viewer's appreciation of the work?

hen Edouard Manet's *Bar at the Folies-Bergère* was exhibited for the first time, the cartoonist Stop contributed this drawing of it to a Paris newspaper. Thanks to Stop, we can see that what strikes us as strange about the painting struck its first viewers as strange, too: why doesn't the reflection in the mirror match the scene before it, and where is the man whose reflection we see at the right? In a caption to his drawing, Stop joked that he felt it was his duty to correct those problems, which were no doubt due to the painter's momentary distraction.

Critics in Manet's day had a point of view, which was that a painting, before it was anything else, should at least be an accurate and believable representation. Today, with the benefit of hindsight, we begin with the assumption that what we see is what Manet intended. X-ray photographs of the painting in fact reveal that Manet twice shifted the barmaid's reflection further to

the right. When he began, the composition was far more naturalistic. The barmaid's pose changed as well: she was not so still and symmetrical at first. We see the result of a long creative process. But how are we to interpret it? What is our point of view?

Art historians have developed many points of view, each with its own set of intellectual tools for seeing and making sense. One approach is called formalism. Formalism focuses on the formal elements of a work, especially its style. Viewed formally, Manet's Bar marks a milestone in the development of modern art, for the changes he made while creating it tended to eliminate any clear story it was telling and to flatten the space it was depicting-two prominent characteristics of modernism. Another approach is iconography, which focuses on subject matter and its meanings. Viewers taking an iconographic point of view have noticed that the painting contains the traditional elements of a vanitas image, with the reflected man taking the place of Death (see 5.29). A biographical point of view explores links between an artist's life and work. Scholars have noted that Manet was gravely ill when he painted the Bar. He could no longer go to such places as the Folies-Bergère, which had formerly delighted him.

Psychoanalysis provides another set of tools for looking at the relationship between creators and their creations. Scholars following this approach have talked about what one psychoanalyst calls the mirror stage of human development, when an infant first forms a sense of self, forever sundering the unity it felt while gazing into its mother's eyes. Another approach sets art in the social context of its time. Marxism has provided scholars with useful tools for looking at the economic basis of society and the dynamics of class within it. The barmaid, for example, is a member of the working class. Her job is to be pretty for the customers, and perhaps to be available in other ways as well. Feminism provides still other insights based in the observation that making and viewing art are gendered activities, which is to say that a culture's ideas about maleness and femaleness are in play. Feminist scholars have examined the complicated dynamic of gendered gazes in and around the painting-Manet's, the barmaid's, her customer's, those of the spectators in the background, and the viewer's.²

Stop. Edouard Manet, Une Marchande de Consolation aux Folies-Bergère. Wood engraving from Le Journal Amusant, May 27, 1882.

Balance, then, encourages our active participation in looking. By using balance to lead our eyes around a work, artists structure our experience of it. As an important aspect of form, balance also helps communicate a mood or meaning. The promise of an unchanging, eternal paradise is embodied in the stable, symmetrical balance of the *Jnanadakini Mandala* (5.7), just as the dramatic confrontation of life and death is embodied in the dynamic asymmetrical balance of Klimt's *Death and Life* (5.9).

Emphasis and Subordination

Emphasis and subordination are complementary concepts. Emphasis means that our attention is drawn more to certain parts of a composition than to others. If the emphasis is on a relatively small, clearly defined area, we call this a focal point. Subordination means that certain areas of the composition are purposefully made less visually interesting, so that the areas of emphasis stand out.

There are many ways to create emphasis. In *The Banjo Lesson* (5.13), Henry Ossawa Tanner used size and placement to emphasize the figures of the old man and the young boy. Tanner set the pair in the foreground, and he posed

5.13 Henry Ossawa Tanner. The Banjo Lesson. 1893. Oil on canvas, $49 \times 35\%$ ". Hampton University Museum, Hampton, Virginia

them so that their visual weights combine to form a single mass, the largest form in the painting. Strongly contrasting values of dark skin against a pale background add further emphasis. Within this emphasized area, Tanner uses directional lines of sight to create a focal point on the circular body of the banjo and the boy's hand on it. Again contrast plays a role, for the light form of the banjo is set amid darker values, and the boy's hand contrasts dark against light. Tanner has subordinated the background so that it does not interfere, blurring the detail and working in a narrow range of light values. Imagine, for example, if one of the pictures depicted hanging on the far wall were painted in bright colors and minute detail. It would "jump out" of the painting and steal the focus away from what Tanner wants us to notice.

In his autumnal *Still Life with Compotier, Pitcher, and Fruit* (**5.14**), Paul Cézanne arranged a white napkin to create a central focal area and subordinated the rest of the image through a closely harmonized palette of earth tones. Drawn up into a peak at the center, the napkin looks like a domestic version of Mont Sainte-Victoire, the mountain that Cézanne painted so often (see 21.9). A white fruit dish (compotier) and a white pitcher flank the peak, lending additional visual weight to the center of the composition. Over this base of dark and light values, Cézanne scattered red, orange, yellow, and green fruits, patches of intense color. Each a brilliant focal point in its own right, the fruits

5.14 Paul Cézanne. Still Life with Compotier, Pitcher, and Fruit. 1892–94. Oil on canvas, 28¼ × 36¼".

The Barnes Foundation, Philadelphia

5.15 Francisco de Goya. *Executions of the Third of May, 1808.* 1814–15. Oil on canvas, 8'9" × 13'4". Museo Del Prado, Madrid

are gathered into the larger order of the composition by the white cloth, and they culminate in the pyramid of oranges and apples raised high by the bowl.

Francisco de Goya used almost the same color scheme to much different effect in Executions of the Third of May, 1808 (5.15). Once again, white, yellow, and red demand our attention by creating a dramatic focal area against a background of earth tones and black. This time, however, the subject is not a napkin and fruit but a man about to die, the blood of those who have preceded him, and a lantern that casts a light as harsh as the sound of a scream. The scene is set as minimally as possible so that nothing distracts our attention from the terrible slaughter. A barren hillside. Madrid. Darkness. The event Goya depicted occurred during the invasion of Spain by Napoleon, when a popular uprising in Madrid was brutally suppressed by occupying French soldiers. In addition to dramatic contrasts in value, Goya uses psychological forces to direct not only our attention but also our sympathy. Faces serve as natural focal points. The victims of the firing squad have faces, and we can read their expressions; the soldiers are faceless, as though they were not even human. They lunge forward as we look at them, creating directional forces that send us back again to the incipient martyr, his hands flung outward in a gesture of crucifixion.

Scale and Proportion

Proportion and scale both have to do with size. **Scale** means size in relation to a standard or "normal" size. Normal size is the size we expect something to be. For example, a model airplane is smaller in scale than a real airplane; a 10-pound prize-winning tomato at the county fair is a tomato on a large scale. The artist Claes Oldenburg delights in the effects that a radical shift in scale can produce. In *Plantoir*, created with Coosje van Bruggen, he presents a humble gardening tool on a heroic scale (**5.16**). Perhaps it is a monument, but to what? Part of the delight in coming across a sculpture by Oldenburg and Van Bruggen is the shock of having our own scale overthrown as the measure of all things. Many fairy tales and adventure stories tell of humans who find themselves in a land of giants. In the sculptures of Oldenburg and Van Bruggen, the giants seem to have left an item or two behind.

The Belgian painter René Magritte used many pictorial strategies to suggest that the world around us might not be as rational and ordered as we like to think. One of his favorites was a shift in scale. In *Delusions of Grandeur II* (5.17), he invented a sort of telescoping woman, with each section rising out of the one before and continuing on a smaller scale. Transforming one element into another was also a favorite ploy, as when the sky, which looks perfectly normal at the horizon, is revealed farther up to be made of solid blue blocks.

 $\label{eq:5.17} \textbf{5.17} \ \ \text{Ren\'e Magritte}. \ \ \textit{Delusions of Grandeur II}. \ 1948.$ Oil on canvas, $39\% \times 32\%$ ". Hirshhorn Museum and Sculpture Garden, Smithsonian Institution, Washington, D.C.

Proportion refers to size relationships between parts of a whole, or between two or more items perceived as a unit. For example, the proportions of each section of the body in the painting by Magritte are naturalistic. The breasts in the top section are in the correct proportion to the size of the neck and arm openings; the navel in the middle section is in the correct proportion to the overall size of the belly.

Many artistic cultures have developed a fixed set of proportions for depicting a "correct" or "perfect" human form. Ancient Egyptian artists, for example, relied on a squared grid to govern the proportions of their figures (5.18). Unfinished fragments such as this give us a rare insight into their working methods, for in finished works the grid is no longer evident. Egyptian artists took the palm of the hand as the basic unit of measurement. Looking at the illustration, you can see that each palm (or back) of a hand occupies one square of the grid. A standing figure measures 18 units from the soles of the feet to the hairline, with the knee falling at horizontal 6, the elbow at horizontal 12, the nipple at 14, and so on. The shoulders of a standing male were 6 units wide; the waist about 2½ units.

Artists have often varied human proportions for symbolic or aesthetic purposes, as in this royal altar from the African kingdom of Benin (5.19).

5.18 Stela of the sculptor Userwer, detail. Egypt, Dynasty 12, 1991–1783 B.C.E. Limestone. The British Museum, London

5.19 A royal altar to the hand (*ikegobo*). Benin, 18th century. Brass, height 17¾". The British Museum, London

5.20 Leonardo da Vinci. Study of Human Proportions According to Vitruvius. c. 1485–90. Pen and ink, 13½ × 9¾". Gallerie dell'Accademia. Venice

Cast in brass, the altar is dedicated to the king's hand, a symbol of physical prowess. Hands are depicted around its base, where they alternate with rams' heads. The king is shown seated atop the altar, flanked by attendants in a symmetrical composition. The composition expresses a social hierarchy. As the most important person, the king is at the center. He is also portrayed on a larger scale than his attendants. The use of scale to indicate relative importance is called **hierarchical scale**. Proportionally, the king's head takes up a full third of his total height. "Great Head" is one of the terms used in praise of the king, who is felt to rule his subjects as the head, the seat of wisdom and judgment, rules the body. Representations of the king make these ideas manifest through proportion.

Among the many ideas from ancient Greece and Rome that were revived during the Renaissance was the notion that numerical relationships held the key to beauty, and that perfect human proportions reflected a divine order. Leonardo da Vinci was only one of many artists to become fascinated with the ideas of Vitruvius, a Roman architect of the first century B.C.E. whose treatise on architecture, widely read during the Renaissance, related the perfected male form to the perfect geometry of the square and the circle (5.20). Leonardo's figure stands inside a square defined by his height and the span of his arms, and a circle centered at his navel.

A proportion that has fascinated many artists and architects since its discovery by the ancient Greeks is the ratio known as the golden section. A golden section divides a length into two unequal segments in such a way that the smaller segment has the same ratio to the larger segment as the larger segment has to the whole. The ratio of the two segments works out to approximately 1 to 1.618. The golden section is more easily constructed than it is explained; Figure **5.21** takes you through the steps.

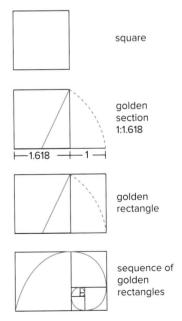

5.21 Proportions of the golden section and golden rectangle.

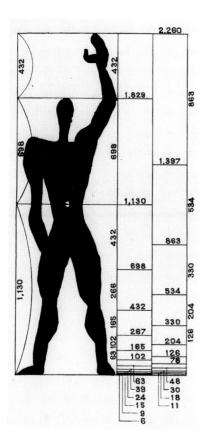

5.22 Le Corbusier. The Modulor. 1945.

Courtesy Fondation Le Corbusier

A rectangle constructed using the proportions of the golden section is called a golden rectangle. One of the most interesting characteristics of the golden rectangle, as Figure 5.21 shows, is that when a square is cut off from one end, the remaining shape is also a golden rectangle—a sequence that can be repeated endlessly and relates to such natural phenomena as the spiraling outward growth of a shell.

Artists and architects have often turned to the golden section when they sought a rational yet subtle organizing principle for their work. During the 20th century, the French architect Le Corbusier related the golden section to human proportions in a tool he called the Modulor (5.22). The Modulor is based on two overlapping golden sections. The first extends from the feet to the top of the head, with the section division falling at the navel; the second extends from the navel to the tip of an upraised hand, with the section division falling at the top of the head. Using the height of an average adult, Le Corbusier derived several series of measurements based in the golden section. Le Corbusier offered the Modulor to architects as a tool that could help them arrive at proportions that were both poetic and practical. He used the Modulor himself in many of his own buildings, including the hilltop chapel of Notre-Dame-du-Haut (5.23), of which he wrote, "Hand-written over the facade is: Modulor throughout." Corbusier's Modulor acknowledges that there are no absolutes, only relationships, and that we experience the world in proportion to ourselves.

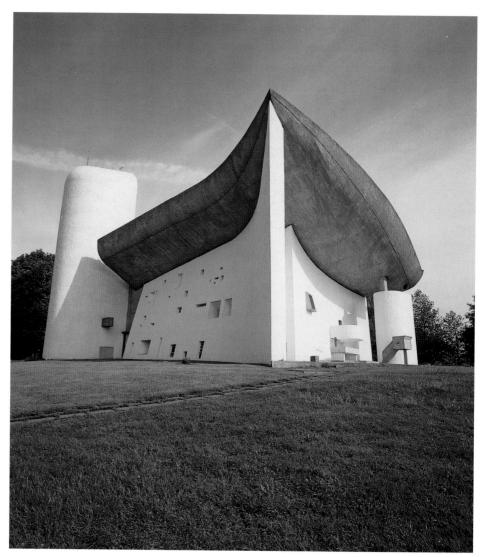

5.23 Le Corbusier. Notre-Dame-du-Haut, Ronchamp, France. Exterior view from southeast. 1950–55.

Rhythm

Rhythm is based in repetition, and it is a basic part of the world we find ourselves in. We speak of the rhythm of the seasons, which recur in the same pattern every year, the rhythm of the cycles of the moon, the rhythm of waves upon the shore. These natural rhythms measure out the passing of time, organizing our experience of it. To the extent that our arts take place in time, they, too, structure experience through rhythm. Music and dance are the most obvious examples. Poetry, which is recited or read over time, also uses rhythm for structure and expression. Looking at art takes time as well, and rhythm is one of the means that artists use to structure our experience.

Through repetition, any of the visual elements can take on a rhythm within a work. In Maya Lin's *Storm King Wavefield*, mass provides the rhythm, the mass of a wave form repeated again and again (5.24). *Storm King Wavefield* is the last in a series of three earthwork wave fields that Lin has created. As in the two earlier fields, its basic repeating unit is modeled on a naturally occurring water-wave formation called the Stokes wave, which Lin encountered while learning about fluid dynamics—the branch of physics that studies fluids in motion, including ocean waves. The line describing the rise and fall of the Stokes wave pleased her, and she set about translating its shape into a three-dimensional form. Arranged in seven rows over 4 acres of land, the grass-covered earthen wave forms reach heights of 10 to 15 feet, towering over visitors who venture into the troughs between them. Only from an elevated vantage point, as in the photograph illustrated here, can we understand the rhythmic ordering of the whole.

5.24 Maya Lin. *Storm King Wavefield*. 2007–08. Earth and grass, 240,000 square feet (11-acre site) at Storm King Art Center, Mountainville, New York. © Maya Lin Studio, courtesy Pace Gallery

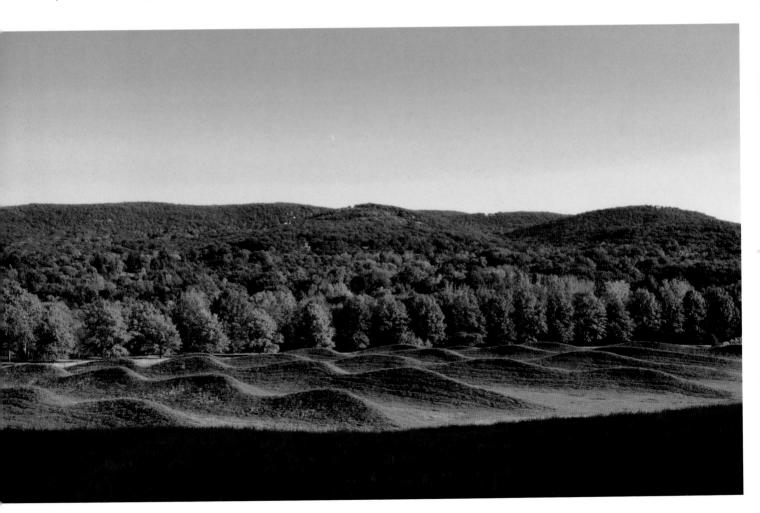

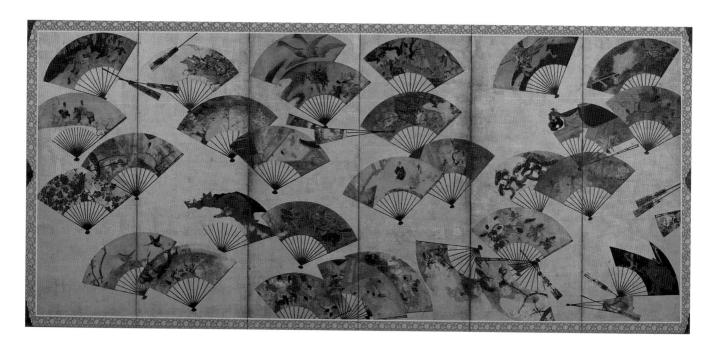

5.25 Tawaraya Sotatsu. *Painted Fans Mounted on a Screen*. Early 17th century. Six-panel folding screen, color, gold, and silver over gold on paper; 5'7" × 12'5". Freer Gallery of Art, Smithsonian Institution, Washington, D.C.

In Tawaraya Sotatsu's *Painted Fans Mounted on a Screen* (**5.25**), it is shape that creates the rhythm—the repeating arcs of open fans tilting this way and that across the panels of the screen. Twelve closed fans dart among them, adding sharper, more linear accents. Sotatsu headed a workshop that employed artists to decorate fans with miniature paintings. In the normal course of events, the thirty paintings here would each have been mounted on a bamboo or lacquer framework to create a fan. Instead, they were pasted onto a folding screen over painted frameworks. Each a composition in its own right, the fans are gathered into a new whole by the rhythm of their repeating shapes.

5.26 Paul Klee. *Landscape with Yellow Birds*. 1923. Watercolor and gouache on paper, $13\% \times 17\%$ ". Private Collection

Paul Klee organized his strange little *Landscape with Yellow Birds* around several rhythms (**5.26**). First, there is the rhythm of the bulging, tapered silvery forms, which sway this way and that as they repeat across the image. Then there is the constellation of alert little yellow birds, which hold the composition together by forming an implied oval as our eyes follow them around the landscape. Perhaps they are circling the full moon, which forms part of an implied arc of circular rhythms. (The rest of the circles are in red.)

Earlier, we discussed how architects use proportion to create harmonious masses and spatial volumes—the positive and negative elements of a building. Through rhythm, they can articulate those proportions. When we articulate our speech, we take care to pronounce consonants and vowels clearly so that each syllable is distinct. Our goal is to be understood. Similarly, architects use rhythm to divide a building into distinct visual units so that we can grasp its logic. Renaissance architect Leon Battista Alberti used rhythms to articulate the monumental facade (exterior face) of the church of Sant'Andrea (5.27). A repeating vertical rhythm of pilasters (flat, ornamental columns) marks off one-quarter intervals across the facade, like an even beat. (There would be a fifth pilaster in the exact center if the large entryway did not intervene.) The arch of the large entryway is repeated in smaller arches between the pilasters. Similarly, the large rectangle of the principal doorway in this arched entryway repeats in the smaller side doors on the facade. (To see how the rhythms announced on the facade are carried through inside the church, see 16.4.)

5.27 Leon Battista Alberti. Facade of Sant'Andrea, Mantua. Designed 1470.

Elements and Principles: A Summary

In the second chapter of this book, we examined two paintings by Henri Matisse to explore how form could suggest meaning (see 2.25, 2.26). This chapter and the preceding one have introduced the vocabulary of formal analysis, the terms that help us see and describe what we see. In the process, we have examined many artworks, each from a particular formal point of view—as an example of line, value, balance, rhythm, and so on. Before leaving this section, we should analyze one work more fully to show how these points of view combine into a more complete way of seeing, and to suggest again how form invites interpretation. The work we will look at is Pablo Picasso's *Girl Before a Mirror* (5.28).

Painted in 1932, Girl Before a Mirror was probably inspired by Marie-Thérèse Walter, Picasso's lover at the time. In Western art, the motif of a woman before a mirror often calls to mind the vanitas tradition. Sometimes in such paintings, a woman stares into a mirror only to find a death's head staring back. In Chapter 1, we looked at a modern vanitas by Audrey Flack in which a framed photograph of a young girl is juxtaposed with a framed reflection of a skull (see 1.15). An older example is Hans Baldung Grien's The Three Ages of Woman, and Death (5.29). Here, the beautiful woman admiring herself in the mirror could see as well the reflection of Death, who stands behind her holding an hourglass over her head. Her child self plays at her feet; her aged self tries, futilely, to ward Death off. Another tradition that comes to mind is

5.28 Pablo Picasso. *Girl Before a Mirror*. 1932. Oil on canvas, $5'4" \times 4'3'_4"$. The Museum of Modern Art, New York

5.29 Hans Baldung Grien. The Three Ages of Woman, and Death. 1510. Oil on limewood, $18\% \times 12\%$ ". Kunsthistorisches Museum, Vienna

that of female beauty itself, and of men taking delight in painting a beautiful woman admiring herself. Of this there exists no more voluptuous example than Titian's *Venus with a Mirror* (5.30). Attended by cherubs, the goddess of love contemplates her eternal, unchanging beauty. We, through Titian, gaze at her. Finally, living in Paris, Picasso would have known that the French name for the type of mirror he painted was *psyché*, after the Greek goddess Psyche. Viewed as the personification of the human soul, she was loved by Eros, the god of love, who forbade her to look on him. This is some of the cultural context that Picasso could have expected viewers to bring to the painting. Now, what do we see?

Oriented vertically, *Girl Before a Mirror* is over 5 feet in height. The woman and her reflection occupy almost the entire canvas. Thus, she is not miniaturized, as in the illustration here, but portrayed larger than life-size. The scale of the painting and of the woman represented within it makes a powerful impression when seen in person. We confront the work on an equal footing as a presence that rises up before us.

The design is based in symmetrical balance, with the woman on the left and her mirror image on the right. The left post of the mirror falls near the vertical axis, dividing the composition in two. The fundamental symmetry

5.30 Titian. *Venus with a Mirror.* c. 1555. Oil on canvas, 4'1" × 3'5½". National Gallery of Art, Washington, D.C.

draws our attention to the ways in which the two sides are *not* alike, for it sets them in opposition. Indeed, the reflection of the girl's face in the mirror does not double her exactly. Warm colors are reflected as cool colors, and firm shapes become fluid. This is not the death's head of a traditional *vanitas*, but it is a transformation nevertheless, and it evokes a mysterious, shadowy realm of uncertainty—perhaps the girl's thoughts, perhaps her unconscious, perhaps her soul, perhaps her mortality.

A composition divided so cleanly in two could easily break apart, and Picasso uses several means to tie the two halves together (5.31). The most important is the girl's gesture as she reaches out to the far edge of the mirror, almost in an embrace. The gesture links the girl and her reflection, and it is so important to the composition that Picasso reinforces it with a red-striped shape that begins on the girl's chest and extends to her fingertips. Together, gesture and shape set up a pendulum motion, and as we look at the painting, our eyes swing rhythmically back and forth from one side to the other.

Overall, the unity of the composition rests on the rhythmical curves and repeating circles of the girl and her reflection, culminating in the great oval of the mirror itself. A second unifying device is the lushly painted wallpaper, which extends across the entire canvas. Its diagonal geometric grid acts as a foil for the sweeping organic curves of the girl, and it is almost as important

5.31 Pablo Picasso. *Girl Before a Mirror.* 1932. Oil on canvas, $5'4" \times 4'3\%"$.

The Museum of Modern Art, New York

a presence in the painting as she is. Color unifies the composition as well, for although the colors are brilliantly varied, they fall generally in the same range of intensities and values, with the important exception of the girl herself.

And what of the girl? Picasso directs our attention first of all to her face, a natural focal point. He emphasizes it by painting one half bright yellow and by surrounding her head with an oval of white and green that isolates it from the busy pattern of the background and provides enough visual weight to balance the form of the mirror. He also modifies its proportions so that her facial features occupy the entire space of her head. With her yellow hair, circular half-yellow face, and white aura, she is like the sun of the painting, its source of light.

The pale violet portion of her face is depicted in profile, gazing at the mirror. With the addition of the yellow portion, she turns her head to look at us—or at Picasso. Cool, pale colors set off by black shapes and lines draw our attention to her body, which is also divided vertically. The left portion is clothed in a striped garment, perhaps a bathing suit; the right portion is nude. The swell of the belly evokes childbearing and the renewal of life. In a remarkable X-ray view, Picasso even paints through her skin to the womb inside, envisioned as another circle. Her biological destiny is emphasized in the mirror image as well, for this part of her body is reflected confidently. Picasso draws our attention to it through an abrupt shift in value—in the dark world of the mirror, the breasts and the belly are white.

What is the painting about? It does not have a single meaning, but many layers of meanings and associations. It is about a girl contemplating herself in a mirror, quiet before her own inner mysteries, aware of her life-affirming sexuality and procreative powers. It is about Picasso meditating on women as sensuous symbols of beauty, abundance, and fertility. It is also about Picasso looking with a lover's possessive gaze at Marie-Thérèse Walter, seeing through her clothing to the flesh underneath. Hovering behind the image are the tradition of the *vanitas* and its theme of mortality, and the story of Psyche, a girl who is aware of being loved and being gazed upon, and who turns fatefully to look at her lover.

Picasso did not have a checklist as he worked, dutifully adding the visual elements in the correct proportions of unity, variety, balance, scale, proportion, and rhythm. His student days were far behind him, and such thinking was by now second nature. But as the numerous reworkings evident in the finished painting show, he changed his mind often and made constant adjustments as he worked. Why? Any number of reasons, probably—because the balance was off, because his eye was not traveling freely over the canvas, because there was too much focus here and not enough there, because the mood of the colors was not right. The painting is the end result of all his decisions, a project he stopped at the moment when, as the picture's first viewer, he was content with what he saw. As later viewers, we articulate the elements and principles to make ourselves aware of the dynamic of seeing. With experience, this becomes second nature to us as well.

6.1 Shahzia Sikander. 1, from 51 Ways of Looking (Group B). 2004. Graphite on paper, 12×9 ". \odot Shahzia Sikander. Image courtesy Sikkema Jenkins & Co., New York

PART THREE

Two-Dimensional Media

6

Drawing

verybody draws. We routinely give children drawing materials so that they can entertain and express themselves, and they take to it so naturally that there can scarcely be a person above the age of two who has never made a drawing. And who even needs special materials? A pebble scraped across a flat stone will draw a line. A stick dragged through the snow. The shaft of a feather in the smooth, wet sand. Our finger on a fogged-up windowpane.

Even if we have left the habit of drawing behind with our childhood, we retain a familiar connection to it. Perhaps it is this that makes drawings by even the most accomplished artists feel somehow not so far removed from our

own experience. This is where we overlap.

The drawing on the facing page was executed in pencil on paper, ordinary materials that most of us have close at hand (6.1). Working in a beautifully controlled range of values, Shahzia Sikander created an image of layered images. In the faintest image, the deepest layer, we can make out an architectural setting, a fragment of a South Asian palace. Before it, a figure-male, it seems, though the head and the torso fade away-is seated on an ornate chair. A woman sits on the floor nearby, and in between them we can distinguish a curled-up cat, an inquisitive rabbit, and a mythical beast, a griffin. Perhaps these are part of a story she is telling him, like Scheherazade. In the next layer, a woman's head and pale bust command our attention. Her hairstyle suggests that she may be a gopi, one of the female cowherds who appear in Hindu mythology as companions and lovers of the god Krishna. In traditional depictions, the gopis gather adoringly around the god. The gopi here, however, seems to have floated free of the role that the tales assign to her. She rises before us as an individual, a contemplative woman. Like the other figures, though, she is a fragment. She cannot speak. Where her lower face would be, the topmost layer of imagery takes precedence: a system of tangled lines, starburst blossoms, dark circles hung like planets, and a flock of small gopi hairdos.

Many older drawings we see today were never intended for exhibition. Preliminary sketches for paintings or sculptures, ideas quickly jotted down for later development, studies that linger on a detail of the visible world, they retain a kind of intimacy that can offer fascinating glimpses into the creative process. Pablo Picasso, mindful of his own legacy, began early on to date and save all his sketches. Thanks to that habit, we have almost a complete visual record of his mind at work. Illustrated here is his first sketch for

6.2 Pablo Picasso. First composition study for *Guernica*. May 1, 1937. Pencil on blue paper, $8\% \times 10\%$ ". Museo Nacional Centro de Arte Reina Sofia, Madrid

6.3 Leonardo da Vinci. Star of Bethlehem and Other Plants. c. 1506–08. Red chalk and pen, 7^{5} /8 × 6^{3} /8". The Royal Collection, Windsor Castle, Windsor, England

his great antifascist mural *Guernica* (**6.2**; for the completed mural see 3.8). Much changed between this first rapidly sketched idea and the final painting, but one essential gesture is already in place: the horror will be revealed to us by the light of a lamp held by a figure leaning out of an upper-story window.

Artists may draw for no other reason than to understand the world around them, to investigate its forms. There is no better exercise in seeing than to take a small part of the natural world and try to draw it in all its detail. Leonardo da Vinci had the curiosity and the powers of observation of a natural scientist. Some of his sketches served as studies that might find their way into larger compositions, but he also filled notebook after notebook with investigative drawings for their own sake. The drawing here (6.3) reflects his interest in parallels between the behavior of currents of water and the motions of waving grasses.

Young artists looking for fresh territory to explore often turn received wisdom on its head, just to free up some space for themselves. In this spirit, many contemporary artists have turned to drawing as a primary means of

ARTISTS Leonardo da Vinci (1452-1519)

How does Leonardo embody the Renaissance? How do his works show his attention to form and action? What is his philosophy on art based on his creations and abilities?

o clues are offered by the scant knowledge about Leonardo da Vinci's origins to explain what spawned perhaps the most complex imagination of all time. Leonardo was the illegitimate son of a peasant woman known only as Caterina and a fairly well-to-do notary, Piero da Vinci. He was raised in his father's house at Vinci and, when he was about fifteen, was apprenticed to the Florentine artist Andrea del Verrocchio, in whose workshop he remained for ten years. It is said the pupil's talent so impressed his master that Verrocchio gave up painting forever.

In 1482 Leonardo left Florence for Milan, where he became official artist to Lodovico Sforza, duke of that city. There the artist undertook many projects, foremost among them his famous painting of the *Last Supper* (see 4.45). Leonardo remained with Sforza until the latter's fall from power in 1499, after which he returned to Florence.

Sketches and written records indicate that Leonardo worked as a sculptor, but no examples remain. Only about a dozen paintings can be definitely attributed to him, and several of those are unfinished. There are, however, hundreds of drawings, and the thousands of pages from his detailed notebook testify to the man's extraordinary genius. If Leonardo completed relatively few artistic works, this can only be ascribed to the enormous breadth of his interests, which caused him repeatedly to turn from one subject to another. He was a skilled architect and engineer, engrossed in the problems of city planning, sanitary disposal, military engineering, and even the design of weapons. He made sketches for a crude submarine, a helicopter, and an airplane-with characteristic thoroughness also designing a parachute in case the airplane should fail. He made innovative studies in astronomy, anatomy, botany, geology, optics, and, above all, mathematics. His contemporaries reported his great talent as a musician—he played and improvised on the lute—as well as his love of inventive practical jokes.

In 1507 Leonardo was appointed court painter to the king of France, Louis XII, who happened to be in Milan at the time. Nine years later the aging artist was named court painter to Louis' successor, Francis I. Francis seems to have revered him for his towering reputation as an artist and his crisp intellect but to have expected little artistic production from the old man. The king provided comfortable lodgings in the city of Amboise, where Leonardo died.

Solitary all his life, Leonardo did not marry, and he formed very few close attachments. His obsession seems to have been with getting it all down, recording the fertile outpourings of his brain and hand. In his *Treatise on Painting*, assembled from his notebook pages and published after his death, he advised painters to follow his method: "You should often amuse yourself when you take a walk for recreation, in watching and taking note of the attitudes and actions of men as they talk and dispute, or laugh or come to blows with one another . . . noting these down with rapid strokes, in a little pocket-book which you ought always to carry with you . . . for there is such an infinite number of forms and actions of things that the memory is incapable of preserving them."

Leonardo da Vinci. Self-Portrait. c. 1512. Red chalk on paper, 13 \times 8½". Biblioteca Reale, Turin.

6.4 Mark Grotjahn. *Untitled* (Full Color Butterfly 772). 2009. Color pencil on paper, 6'1%" × 3'11¾". Courtesy the artist and Blum & Poe. © Mark Grotjahn

expression, producing finished works on a scale that we traditionally associate with paintings. An example is Mark Grotjahn's *Untitled (Full Color Butterfly 772)* (6.4). Patiently drawn with color pencils, the work is just over 6 feet in height. *Untitled (Full Color Butterfly 772)* is one of a series of drawings that exploit a motif Grotjahn created by upending two sets of single-point perspective lines and pointing them toward each other. The two vanishing points are never aligned, however—one is always higher than the other—and the horizon line, now vertical, is difficult to discern. These subtle adjustments cause a kind of slippage to occur that throws us off balance. The lines that command the edges of the drawing so forcefully radiate from an unstable center, where our eyes seek but cannot find a resting point.

The drawings we have been looking at are all on paper, a material we associate closely with drawing. Historically, however, many other surfaces have been used to draw on. Among the oldest representational images that we know

crossing cultures Paper

How has paper turned from being solely a material to a category of art and design? What would the art world be like if paper were abandoned for the digital medium?

ur word paper is derived from the Latin word papyrus, which the ancient Romans used to designate both a plant that grew along the banks of the Nile River and the writing material that the ancient Egyptians made from it. Yet the link to papyrus is misleading, for although paper may have reminded later Europeans of papyrus, it is made quite differently, and it was invented not in Egypt but in China. Traditional Chinese histories date the invention to 105 c.E. and attribute it to Cai Lun, a eunuch who served in the imperial court. Archaeologists have discovered fragments of paper in China that are far older, however, and scholars now agree that the process was known by the 2nd century B.C.E., well before Cai's time.

Paper is made from plant fibers, beaten to a pulp, mixed with water, then spread in a thin layer over a fine mesh surface and left to dry. To produce uniform sheets by hand (all paper was handmade until the 19th century), a mold is used—imagine a rectangle of wire or bamboo mesh attached to a wooden frame to form a shallow tray. The mold is dipped into a vat of

thinned pulp, then lifted out, carrying with it a very fine layer of fibers. Before it can receive painting or writing with ink, paper must be *sized*, treated with a substance such as starch or glue to make it less absorbent (otherwise it acts as a blotter). Techniques for sizing had certainly been perfected by Cai Lun's time, for paper was already in use then for writing with brush and ink in the Chinese way.

The secret of paper spread from China to neighboring peoples through Buddhism: monks preaching their faith brought along brushes, ink, and papermaking know-how so that religious texts could be copied and circulated. Knowledge of papermaking was transmitted in this way to Korea, Japan, and Vietnam. As Islam extended into Central Asia during the 8th century, Muslims, too, came into contact with China and Buddhism. Legend has it that the secret of paper passed into Islamic culture when Muslim soldiers captured a group of Chinese papermakers during a famous battle in 751 C.E. The truth is probably less dramatic, a tale of cultural contact and exchange.

Over the ensuing centuries, Asian and Muslim papermakers made enormous strides, learning to make paper of ever greater variety and refinement. Their long centuries of contact can be seen in the pages reproduced here. Tinted blue, sprinkled with gold, and painted with a gold landscape, the paper was made in China. It was probably sent by a 15th-century Chinese emperor as a gift to the ruler of Iran, who in turn presented it to the famous calligrapher Sultan-Ali Qaini, who used it for a manuscript of Persian poems.

The transfer of paper and papermaking from Islamic lands to Christian Europe was a gradual and scattered affair. Christians under Muslim rule (as in Spain) or in close contact with Islamic culture (as in Sicily) bought paper from Muslim papermakers for well over a century before gradually starting to make it themselves. In northern Italy, paper manufacturing first flowered during the 13th century, using techniques that were probably learned from contacts made during the Crusades. It was not until the 14th century that a paper mill was founded north of the Alps, however, and that the word *paper* finally entered the English language—some 1,500 years after the material was first invented.

Blue Chinese paper with decoration in gold, inscribed by Sultan-Ali Qaini with a poem by Haydar. Tabriz, 1478. New York Public Library. of are the Paleolithic cave drawings in southern France (see 14.1) and in Spain, some engraved on the cave walls with a hard stone, others drawn with a chunk of charcoal. With the development of pottery during the Neolithic era, fired clay became a surface for drawing in many cultures. The durability of fired clay has meant that many examples have survived when works in more perishable materials have not. For example, we know of ancient Greek painting only from literary sources, for not a single example has come down to us. Thanks to the Greek custom of drawing on pottery, however, we have some understanding of what those paintings might have looked like (see 14.23). The Greeks also drew and wrote on papyrus, a paperlike material developed in ancient Egypt that was made from pressed plant stems. Rivaling papyrus was a later invention, parchment. Made from treated animal skins, it was widely used throughout the Roman Empire and continued as the surface of choice in medieval Europe. The ancient Chinese drew on silk, their special material, and many Chinese artists still do. It is the Chinese, too, who are credited with the invention of paper.

Today, artists have a wide array of drawing surfaces and materials to choose from. Some materials have their origins in the distant past; others were developed more recently. In this chapter, we examine some of the traditional materials that have been used for drawing and the effects they can produce. Then we look briefly at how the most common drawing surface, paper, became a medium in its own right.

Materials for Drawing

Drawing media can be divided into two broad groups: dry media and liquid media. Dry media are generally applied directly in stick form. As the stick is dragged over a suitably abrasive surface, it leaves particles of itself behind. Liquid media are generally applied with a tool such as a pen or a brush. Although some media are naturally occurring, most of today's media are manufactured, usually by combining powdered **pigment** (coloring material) with a **binder**, a substance that allows it to be shaped into sticks (for dry media), to be suspended in fluid (for liquid media), and to adhere to the drawing surface.

Dry Media

GRAPHITE A soft, crystalline form of carbon first discovered in the 16th century, graphite is a naturally occurring drawing medium. Pure, solid graphite need only be mined, then shaped into a convenient form. Dragged across an abrasive surface, it leaves a trail of dark gray particles that have a slight sheen.

Graphite was adopted as a drawing medium soon after its discovery. But pure, solid graphite is rare and precious. (In fact, there is only one known deposit.) More commonly, graphite must be extracted from various ores and purified, resulting in a powder. Toward the end of the 18th century, a technique was discovered for binding powdered graphite with fine clay to make a cylindrical drawing stick. Encased in wood, it became what we know as a pencil, today the most common drawing medium of all.

Varying the percentage of clay in the graphite compound allows manufacturers to produce pencils that range from very hard (lots of clay) to very soft (a minimal amount of clay). The softer the pencil, the darker and richer the line it produces. The harder the pencil, the more pale and silvery the line. In his drawing *Prince among Thieves with Flowers* (6.5), Chris Ofili used a comparatively soft pencil for the image of the bearded man and a harder pencil for the pale but still precise flowers in the background. From a standard viewing distance, the lines that define the figure seem to be made of dots. But as viewers draw closer, the dots reveal themselves to be tiny heads, each sporting an afro, a black hairstyle popular during the 1970s. A British artist of African

ancestry, Ofili often uses imagery associated with the sense of black identity that emerged during the 1960s and 1970s, treating it with a complicated mixture of nostalgia, irony, affection, and respect.

METALPOINT Metalpoint, the ancestor of the graphite pencil, is an old technique that was especially popular during the Renaissance. Few artists use it now, because it is not very forgiving of mistakes or indecision. Once put down, the lines cannot easily be changed or erased. The drawing medium is a thin wire made of a relatively soft metal such as silver, set in a holder for convenience. The drawing surface must be prepared by covering it with a ground, a preliminary coating of paint. Traditional metalpoint ground recipes call for a mixture of bone ash, glue, and white pigment in water. As the point of the wire is drawn across the dried ground, it leaves behind a thin trail of metal particles that soon tarnish to a pale gray.

Metalpoint drawings are characterized by a fine, delicate line of uniform width. Making thrifty use of a single sheet of paper, Filippino Lippi drew two figure studies in metalpoint on a pale pink ground, building up the areas of shadow with fine hatching and cross-hatching, then delicately painting in

6.5 Chris Ofili. *Prince among Thieves with Flowers*. 1999. Pencil on paper, 29³/₄ × 22¹/₄". The Museum of Modern Art, New York

6.6 Filippino Lippi. Figure Studies: Standing Nude and Seated Man Reading. c. 1480. Metalpoint, heightened with white gouache, on pale pink prepared paper; 91% × 8½".

The Metropolitan Museum of Art, New York highlights in white (6.6). The models were probably workshop apprentices. Renaissance apprentices often posed for one another and for the master, and thus found their way into innumerable paintings. The figure on the left, for example, may well have been incorporated into a painting as Saint Sebastian, who was typically depicted with his arms bound and wearing only a loincloth.

CHARCOAL Charcoal is charred wood. Techniques for manufacturing it have been known since ancient times. The best-quality artist's charcoal is made from special vine or willow twigs, slowly heated in an airtight chamber until only sticks of carbon remain—black, brittle, and featherweight. Natural charcoal creates a soft, scattered line that smudges easily and can be erased with a few flicks of a cloth. For denser, more durable, or more detailed work, sticks of compressed charcoal are available, as are charcoal pencils made along the same lines as graphite pencils. Yvonne Jacquette's *Three Mile Island, Night I* illustrates well the tonal range of charcoal, deepening from sketchy, pale gray to thick, velvety black (6.7). Jacquette has made a specialty out of depicting landscape as seen from an airplane. With the popularization of air travel during the second half of the 20th century, this view became common. Yet although we might consider it fundamental to our modern experience of the world, it has rarely been treated in art.

CRAYON, PASTEL, AND CHALK The dry media we have discussed so far—graphite, metalpoint, and charcoal—allow artists to work with a range of values on the gray scale. With crayon, pastel, and chalk, a full range of colors becomes available.

Crayons and pastels are made of powdered pigments, the same as those used to make paints, mixed with a binder. For crayons, the binder is a greasy or waxy substance. The coloring crayons we give to children, for example, use a wax binder. Finer, denser, more brilliant versions of these crayons have been developed for artists. Another children's product, a crayon using a binder of wax and oil, has also inspired an artist-quality equivalent. Known somewhat confusingly as oil pastels, they are as brilliant as artist-quality wax crayons but with a creamier consistency that facilitates blending. Crayons made with waxy or greasy binders, in contrast, tend to favor discrete strokes that can be layered but not blended.

Perhaps the most well-known artist's crayon is the conté crayon. Developed in France at the turn of the 19th century, it consists of compressed pigment compounded with clay and a small amount of greasy binder. Initially conceived as a substitute for natural black and red chalks (discussed later), conté crayons have since become available in a full range of colors.

One artist who comes readily to mind in discussing conté crayon drawings is Georges Seurat. In Chapter 4, we looked at Seurat's painting technique, pointillism, in which tiny dots of color are massed together to build form. Seurat also did many drawings. By working in conté crayon on rough-textured paper, he could approximate the effect of color dots in paint. *Café-concert* is one of several drawings Seurat made of an entertainment that was all the

6.7 Yvonne Jacquette. Three Mile Island, Night I. 1982. Charcoal on laminated tracing paper, 4'13/6" × 3'2". Hirshhorn Museum and Sculpture Garden, Washington, D.C. Courtesy DC Moore Gallery, New York

6.8 Georges Seurat. *Café-concert*. c. 1887. Conté crayon heightened with white chalk on paper, $12\frac{5}{6} \times 9\frac{1}{4}$ ". The Cleveland Museum of Art

6.9 Edgar Degas. *The Singer in Green*. c. 1884. Pastel on light blue laid paper, 23¾ × 18¼". The Metropolitan Museum of Art, New York

rage in his day (6.8). The cafés and their performers were condescended to by serious (and snobbish) cultural commentators, but ordinary people flocked to them. Artists went as well, attracted by the effects of the lighting, the colorful personalities of the performers, and the fascinating social mix of the crowd. By simplifying his forms and downplaying any sense of motion, Seurat tends to bring out the eerie side of almost any situation. Here, the distant, brightly lit female performer is watched rather spookily by an impassive audience of bowler-hatted men.

Another artist attracted to the café-concerts was Edgar Degas. Whereas Seurat's drawing was made from the back of the hall, Degas' The Singer in Green (6.9) puts us right on stage next to the performer, who touches her shoulder in a gesture that Degas borrowed from one of his favorite café singers. Degas created his drawing in pastel. Pastel consists of pigment bound with a nongreasy binder such as a solution of gum arabic or gum tragacanth (natural gums made from hardened sap) in water. The principle is simple enough that artists can manufacture their own if they so choose, mixing pigment and binder into a doughy paste, then rolling the paste into sticks and letting it dry. Available in a full range of colors and several degrees of hardness, pastel is often considered a borderline medium, somewhere between painting and drawing. Artists favor soft pastels for most work, reserving the harder ones for special effects or details. Because they are bound so lightly, pastels leave a velvety line of almost pure pigment. They can be easily blended by blurring one color into another, obliterating the individual strokes and creating smoothly graduated tones. Here, Degas has blended the tones that model the girl's face and upper torso as she is lit from below by the footlights. Her dress is treated more freely, with the individual strokes still apparent. The background is suggested through blended earth tones and roughly applied blue-greens that show the texture of the paper.

To geologists, "chalk" names a kind of soft, white limestone. In art, the word has been used less precisely to name three soft, finely textured stones that can be used for drawing: black chalk (a composite of carbon and clay), red chalk (iron oxide and clay), and white chalk (calcite or calcium carbonate). Like graphite, these stones need only be mined and then cut into convenient sizes for use. Seurat used discrete touches of white chalk to heighten his conté crayon drawing of the *Café-concert* (6.8); Leonardo drew his self-portrait in red chalk (see page 143). Natural chalks have largely been replaced today by conté crayons and pastels, though they are still available to artists who seek them out.

Liquid Media

PEN AND INK Drawing inks generally consist of ultrafine particles of pigment suspended in water. A binder such as gum arabic is added to hold the particles in suspension and help them adhere to the drawing surface. Inks today are available in a range of colors. Historically, however, black and brown inks have predominated, manufactured from a great variety of ingenious recipes since at least the 4th century B.C.E.

There are endless ways to get ink onto paper. You could soak a bit of sponge with it and swipe a drawing onto the page. You could use fingertips, or a twig. But if you want a controlled, sustained, flexible line, you'll reach for a brush or a pen. Traditional artist's pens are made to be dipped in ink, then set to paper. Depending on the qualities of the nib—the part of a pen that conveys ink to the drawing surface—the line a pen makes may be thick or thin, even in width or variable, stubby and coarse or smooth and flowing.

Today most pen nibs are made of metal, but this is a comparatively recent innovation, dating only from the second half of the 19th century. Before then, artists generally used either reed pens—pens cut from the hollow stems of certain plants—or quill pens—pens cut from the hollow shafts of the wing feathers of large birds. Both reed and quill pens respond sensitively to shifts in pressure, lending themselves naturally to the sort of varied, gestural lines we see in Rembrandt van Rijn's *Cottage among Trees* (6.10). One of the greatest draftsmen

6.10 Rembrandt van Rijn. Cottage among Trees. 1648–50. Pen and brown ink, brush and brown wash, on paper washed with brown; $6\frac{3}{4} \times 10\frac{7}{6}$ ". The Metropolitan Museum of Art, New York

6.11 Julie Mehretu. *Untitled*. 2001. Ink, colored pencil, and cut paper on Mylar; $21\frac{1}{2} \times 27\frac{3}{8}$ " overall framed. Seattle Art Museum. Courtesy

Seattle Art Museum. Courtesy Marian Goodman Gallery, New York. © Julie Mehretu lifetime. Many record ideas for paintings or prints, but many more are simply drawings done for the pleasure of drawing.

The wind-tossed foliage of the trees shows Rembrandt's virtuosity at its

who ever lived, Rembrandt made thousands of drawings over the course of his

The wind-tossed foliage of the trees shows Rembrandt's virtuosity at its most rapid and effortless, whereas the solid volumes of the cottage were more slowly and methodically built up. Here and there, Rembrandt used a **wash**, ink diluted with water and applied with a brush, to give greater solidity to the cottage and to soften the shadows beneath the trees. Before beginning his drawing, he prepared the paper by applying an allover wash of pale brown. By tinting the paper, Rembrandt lowered the contrast between the dark ink and the ground, creating a more atmospheric, harmonious, and unified image.

A more recently developed type of ink pen is the rapidograph, a metal-tipped instrument that channels a reservoir of ink into a fine, even, unvarying line. Compared with the line traced by a reed or quill pen, a line drawn with a rapidograph can seem mechanical and impersonal. In fact, the rapidograph was invented as a tool for technical drawing, such as the drawings that illustrate architectural systems in Chapter 13 of this book (see pages 286–302). Before the advent of the computer, architects often used the rapidograph to draw precise images of buildings they were planning.

Julie Mehretu purposefully evokes the association of the rapidograph with architecture in drawings such as the untitled example here (6.11). Fragments of urban plans along with details of buildings and infrastructure seem caught up in an explosive whirlwind. Mehretu's drawings thrive on the contrast between their seemingly apocalyptic subject matter and their cool, detached style, a style in which the even line of the rapidograph plays an important role. Mehretu makes her drawings on translucent Mylar, a polyester film used in architectural drafting. Often, as in the drawing here, she works on multiple, superimposed sheets of Mylar, so that elements placed on an underlayer appear as though seen through a fog.

BRUSH AND INK The soft and supple brushes used for watercolor can also be used with ink. In No Title (Not a single . . .), Raymond Pettibon used a fine brush to draw the slender, even lines of the text at the upper left (6.12). He used a larger brush and a looser, more varied line to create the image. The text is taken from an 18th-century novel by Laurence Sterne that relates an anecdote that ultimately reaches back to a 2nd-century writer called Lucian of Samosata. In an essay, Lucian recounts the strange tale of the ancient Greek town of Abdera, whose citizens fell under the spell of a play in which the hero pleads with Cupid, the god of love. The next day, the hero's speech was on every man's lips; for weeks afterward, men spoke only of love. "Not a single armorer had a heart to forge one instrument of death," Sterne writes in his retelling. "Friendship and Virtue met together and kiss'd each other in the street-the golden age returned." Pettibon juxtaposes a phrase from this ancient tale with an ambiguous image from our own day and age. The nature of the encounter between the two men is far from clear. If it is amorous, it is also furtive and fearful.

The concept of using a brush for drawing shows how difficult it can be to define where drawing leaves off and painting begins. We tend to classify Pettibon's work as a drawing because it was created on paper, is in black and

6.12 Raymond Pettibon. *No Title* (*Not a single . . .*). 1990. Pen, brush, and ink on paper, $23\frac{1}{2} \times 18$ ". The Museum of Modern Art, New York. Courtesy the artist, David Zwirner, New York/London, and Regens Projects, Los Angeles

white, and is largely linear in character—that is, Pettibon used the brush largely to make lines. Taken together, these characteristics are more closely associated with the Western tradition of drawing than with painting. But if we shift our focus to China or Japan, we find a long tradition of works made with brush and black ink on paper, often linear in character, which by custom we call paintings. Turn back, for example, to Shen Zhou's *Autumn Colors among Streams and Mountains* (see 4.49) or ahead to Ni Zan's *Rongxi Studio* (see 19.21). Both were created with brush and ink on paper, and both are primarily linear. Yet within the cultural traditions of East Asia, both are clearly associated with the practice of painting.

Drawing and Beyond: Paper as a Medium

For centuries an artisanal product, made by hand one sheet at a time, paper began to be produced by machine during the 19th century. Instead of individual sheets, machines manufactured paper in continuous rolls over 12 feet wide at a rate of hundreds of feet per minute. Printing, too, became industrialized, with steam-driven rotary printers capable of turning out millions of pages per day. By the early 20th century, paper had become the ubiquitous material we know today. In the form of newspapers, magazines, advertising posters, and other products, it flooded daily life with printed words and images.

In 1912 this new visual reality found its way into art in a revolutionary way: not through representation, but literally. The first step was taken by Picasso, who pasted a bit of patterned oilcloth onto a painting of a still life. But it was Picasso's friend Georges Braque who later that year began to experiment

6.13 Georges Braque. *Still Life* on *Table: "Gillette."* 1914. Charcoal, pasted paper, and gouache; $18\% \times 24\%$ ".

Musée National d'Art Moderne, Centre Georges Pompidou, Paris

in earnest with bringing pieces of industrially printed paper directly into his drawings (6.13). Here, rectangular shapes sliced from a newspaper and from a roll of imitation-wood-grain wallpaper have been incorporated into a charcoal drawing of a café table set with a wine glass and a bottle. Also pasted onto the drawing is a dark shape-perhaps representing a shadow-cut from a piece of painted paper. In a playful gesture, Braque included a razor-shaped advertisement for Gillette safety razors in the center of the composition, drawing our attention to how the work was made.

Braque's invention, taken up immediately by Picasso, became known as papier collé, French for "pasted paper." A broader term for it is collage, again from the French for "pasting" or "gluing." Whereas papier collé is by definition made of paper, collage does not imply any specific materials.

After Picasso and Braque, many artists adopted this method of composing a picture by gathering bits and pieces from various sources. An artist who made very personal use of collage was Romare Bearden. Pieced together from bits of photographic magazine illustrations, Mysteries (6.14) is one of a series of works that evoke the texture of everyday life as Bearden had known it growing up as an African American in rural North Carolina. In Bearden's hands, the technique of collage alludes both to the African-American folk tradition of quilting, which also pieces together a whole from many fragments, and to the rhythms and improvisatory nature of jazz, another art form with African roots. The face on the far left includes a portion of an African sculpture (the mouth and nose). In the background appears a photograph of a train. A recurring symbol in Bearden's work, trains stand for the outside world, especially the white world. "A train was always something that could take you away and could also bring you to where you were," the artist explained. "And in the little towns it's the black people who live near the trains."

6.14 Romare Bearden. Mysteries. 1964. Collage, polymer paint, and pencil on board; $11\frac{1}{4} \times 14\frac{1}{4}$ ". Museum of Fine Arts, Boston

6.15 Wangechi Mutu. *Hide and Seek, Kill or Speak.* 2004.
Paint, ink, collage, and mixed media on Mylar; 4' × 3'6".
Courtesy the artist and Susanne Vielmetter Los Angeles Projects

Kenyan-born artist Wangechi Mutu uses collage to link her work to the larger world of photographic images that circulate in media such as fashion magazines and *National Geographic*. *Hide and Seek, Kill or Speak* depicts a woman crouching in the African grasslands (6.15). Her hair writhes down the length of her spine like a mane, suggesting that in some way she is an animal. Her body is spotted and marbled, evoking expensive designer fabrics but also camouflage or disease. Collaged elements cut from photographs of a motorcycle transform her feet into high-heeled machines and her forearms and hands into mechanical extensions. Her lips, eyes, and ear are cut from photographs as well. The title of the work evokes the deadly conflicts that have so often erupted in African societies. (The splattered gray in the background might indicate an explosion.) Yet the image of the woman is disturbingly ambiguous, made of clashing signs of glamour and violence, danger and desire.

In *Untitled (cut-out 4)* Mona Hatoum also relies on clashing signs, this time of innocence and experience (**6.16**). Silhouettes of two men with guns confront their mirror image again and again. Naively stylized starbursts stand in for exploding grenades or bombs. Two medallions that look like blossoms turn out to have skulls for petals. Delicate, miniaturized, decorative, and lethal, the scenes were made from a single sheet of tissue paper, folded, cut,

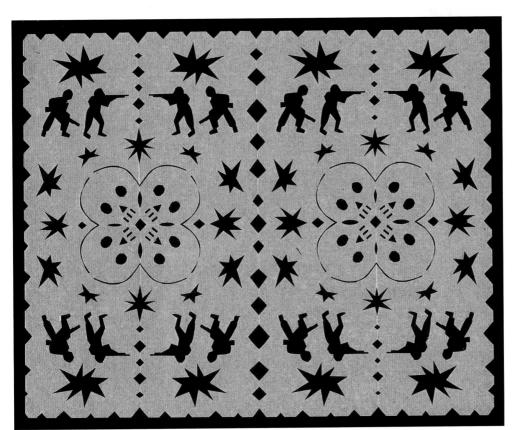

6.16 Mona Hatoum. *Untitled* (cut-out 4). 2009. Tissue paper, $10\frac{5}{6} \times 13\frac{8}{6}$ ".

Mona Hatoum. Courtesy Galerie Chantal Crousel

and opened up—the technique we teach to children so they can delight in making paper snowflakes or chains of people holding hands.

Mia Pearlman takes paper into the realm of sculpture. She uses paper to make site-specific installations such as *Inrush* (6.17). We can think of Pearlman's installations as exploded drawings. She begins by making line drawings in brush and ink on large rolls of paper. Then she cuts out selected areas to make versions of the drawings in positive and negative shapes. She assembles the openwork drawings on site to create delicate yet turbulent sculptural forms, often setting them in front of a window so they seem lit from within. For the artist, "these drawings and their shadows capture a weightless world in flux, frozen in time, tottering on the brink of being and not being." Easily available, inexpensive, lightweight, ubiquitous, paper has grown from a self-effacing support for drawings to take on a starring role.

Painting

o the Muslim ruler Akbar, writing in the 16th century, it seemed that painters had a unique appreciation of the divine, for "in sketching anything that has life . . . [a painter] must come to feel that he cannot bestow individuality upon his work, and is thus forced to think of God, the Giver of Life, and will thus increase his knowledge." In the opinion of Zhang Yanyuan, a Chinese painter and scholar who lived some seven centuries earlier, painting existed "to enlighten ethics, improve human relationships, divine the changes of nature, and explore hidden truths." Leonardo da Vinci proudly claimed that "painting embraces and contains within itself all things produced by nature," and for the 17th-century Spanish playwright Pedro Calderón de la Barca, painting was "the sum of all arts . . . the principal art, which encompasses all the others." 1

Clearly, painting has inspired extravagant admiration in cultures where it is practiced. Even today, if you ask ten people to envision a work of art, nine of them are likely to imagine a painting. But what is a painting, exactly? What is it made of, and how? This chapter examines some of the standard media and techniques that painters have used across the centuries. We begin with some basic concepts and vocabulary.

Paint is made of pigment, powdered color, compounded with a medium or vehicle, a liquid that holds the particles of pigment together without dissolving them. The vehicle generally acts as or includes a binder, an ingredient that ensures that the paint, even when diluted and spread thinly, will adhere to the surface. Without a binder, pigments would simply powder off as the paint dried.

Artists' paints are generally made to a pastelike consistency and need to be diluted to be brushed freely. Aqueous media can be diluted with water. Watercolors are an example of an aqueous medium. Nonaqueous media require some other diluent. Oil paints are an example of a nonaqueous medium; these can be diluted with turpentine or mineral spirits. Paints are applied to a support, which is the canvas, paper, wood panel, wall, or other surface on which the artist works. The support may be prepared to receive paint with a ground or primer, a preliminary coating.

Some pigments and binders have been known since ancient times. Others have been developed only recently. Two techniques perfected in the ancient world that are still in use today are encaustic and fresco, and we begin our

discussion with them.

Encaustic

Encaustic paints consist of pigment mixed with wax and resin. When the colors are heated, the wax melts and the paint can be brushed easily. When the wax cools, the paint hardens. After the painting is completed, there may be a final "burning in" as a heat source is passed close to the surface of the painting to fuse the colors.

Literary sources tell us that encaustic was an important technique in ancient Greece. (The word *encaustic* comes from the Greek for "burning in.") The earliest encaustic paintings to have survived, however, are funeral portraits created during the first centuries of our era in Egypt, which was then under Roman rule (7.1). Portraits such as this were set into the casings of mummified bodies to identify and memorialize the dead (see 14.34). The colors of this painting, almost as fresh as the day they were set down, testify to the permanence of encaustic.

The technique of encaustic was forgotten within a few centuries after the fall of the Roman Empire, but it was redeveloped during the 19th century, partly in response to the discovery of the Roman-Egyptian portraits. One of the foremost contemporary artists to experiment with encaustic is Jasper Johns (7.2). *Numbers in Color* is painted in encaustic over a collage of paper on canvas. Encaustic allowed Johns to build up a richly textured paint surface. (Think of candle drippings and you will get the idea.) Moreover, wax will not harm the paper over time as oil paint would.

Fresco

With fresco, pigments are mixed with water and applied to a plaster support, usually a wall or a ceiling coated in plaster. The plaster may be dry, in which case the technique is known as *fresco secco*, Italian for "dry fresco." But most often when speaking about fresco, we mean *buon fresco*, "true fresco," in which paint made simply of pigment and water is applied to wet lime plaster. As the plaster dries, the lime undergoes a chemical transformation and acts as a binder, fusing the pigment with the plaster surface.

Fresco is above all a wall-painting technique, and it has been used for large-scale murals since ancient times. Probably no other painting medium requires such careful planning and such hard physical labor. The plaster can be painted only when it has the proper degree of dampness; therefore, the artist must plan each day's work and spread plaster only in the area that can be painted in one session. (Michelangelo could cover about one square yard of wall or ceiling in a day.) Work may be guided by a full-size drawing of the entire project called a **cartoon**. Once the cartoon is finalized, its contour lines are perforated with pinprick-size holes. The drawing is transferred to the prepared surface by placing a portion of the cartoon over the damp plaster and rubbing pigment through the holes. The cartoon is then removed, leaving dotted lines on the plaster surface. With a brush dipped in paint the artist "connects the dots" to re-create the drawing; then the work of painting begins.

There is nothing tentative about fresco. Whereas in some media the artist can experiment, try out forms, and then paint over them to make corrections, every touch of the brush in fresco is a commitment. The only way an artist can correct mistakes or change the forms is to let the plaster dry, chip it away, and start all over again.

Frescoes have survived to the present day from the civilizations of the ancient Mediterranean (see 14.31), from China and India (see 19.6), and from the early civilizations of Mexico. Among the works we consider the greatest of all in Western art are the magnificent frescoes of the Italian Renaissance.

While Michelangelo was at work on the frescoes of the Sistine Chapel ceiling (see 16.9, 16.10), Pope Julius II asked Raphael to decorate the walls of several rooms in the Vatican Palace. Raphael's fresco for the end wall of

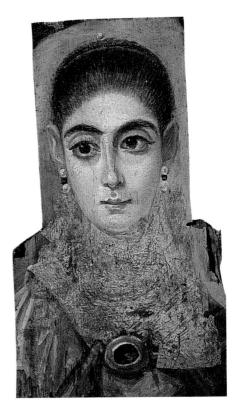

7.1 Young Woman with a Gold Pectoral, from Fayum. 100–150 C.E. Encaustic on wood, height 125%".

Musée du Louvre, Paris

7.2 Jasper Johns. *Numbers in Color.* 1958–59. Encaustic and collage on canvas, $5'6\frac{1}{2}" \times 4'1\frac{1}{2}"$. Albright-Knox Art Gallery, Buffalo, N.Y.

the Stanza della Segnatura, a room that may have been the Pope's library, is considered by many to be the summation of Renaissance art. It is called *The School of Athens* (7.3) and depicts the Greek philosophers Plato and Aristotle, centered in the composition and framed by the arch, along with their followers and students. The "school" in question means the two schools of philosophy represented by the two Classical thinkers—Plato's the more abstract and metaphysical, Aristotle's the more earthly and physical.

Everything about Raphael's composition celebrates the Renaissance ideals of perfection, beauty, naturalistic representation, and noble principles. The towering architectural setting is drawn in linear perspective with the vanishing point falling between the two central figures. The figures, perhaps influenced by Michelangelo's figures on the Sistine ceiling, are idealized—more perfect than life, full-bodied and dynamic. *The School of Athens* reflects Raphael's vision of one Golden Age—the Renaissance—and connects it with the Golden Age of Greece two thousand years earlier.

The most celebrated frescoes of the 20th century were created in Mexico, where the revolutionary government that came into power in 1921 after a decade of civil war commissioned artists to create murals about Mexico itself—the glories of its ancient civilizations, its political struggles, its people, and its hopes for the future. *Mixtec Culture* (7.4) is one of a series of frescoes painted by Diego Rivera in the National Palace in Mexico City. Mixtec people still live in Mexico, as do descendants of all the early civilizations of the region. The Mixtec kingdoms were known for their arts, and Rivera has portrayed a peaceful community of artists at work. To the left, two men, probably nobles, are being fitted with the elaborate ritual headdresses, masks, and capes that were a prominent part of many ancient Mexican cultures (see 20.10, 20.12). To the right, smiths are melting and casting gold. In the foreground are potters, sculptors, feather workers, mask makers, and scribes. In the background, people pan for gold in the stream.

7.3 Raphael. *The School of Athens.* 1510–11. Fresco, 26×18 '. Stanza della Segnatura, Vatican, Rome

7.4 Diego Rivera. *Mixtec Culture*. 1942. Fresco, 16'15%" \times 10'55%". Palacio Nacional, Mexico City

Tempera

Tempera shares qualities with both watercolor and oil paint. Like watercolor, tempera is an aqueous medium. Like oil paint, it dries to a tough, insoluble film. Yet whereas oil paint tends to yellow and darken with age, tempera colors retain their brilliance and clarity for centuries. Technically, tempera is paint in which the vehicle is an emulsion, which is a stable mixture of an aqueous liquid with an oil, fat, wax, or resin. A familiar example of an emulsion is milk, which consists of minute droplets of fat suspended in liquid. A derivative of milk called casein is one of the many vehicles that can be used to make tempera colors. The most famous tempera vehicle, however, is another naturally occurring emulsion, egg yolk. Tempera dries very quickly, and so colors cannot be blended easily once they are set down. Although tempera can be diluted with water and applied in a broad wash, painters who use it most commonly build up forms gradually with fine hatching and cross-hatching strokes, much like a drawing. Traditionally, tempera was used on a wood panel support prepared with a ground of gesso, a mixture of white pigment and glue that sealed the wood and could be sanded and rubbed to a smooth, ivorylike finish.

A lovely example of tempera painting as it was practiced during the early Renaissance is *Saint Anthony Abbot Tempted by a Heap of Gold* (7.5, next page). One of eight panels illustrating episodes from the life of Saint Anthony, it was painted by a 15th-century Sienese artist we know as the Master of the Osservanza.

7.5 Master of the Osservanza. *St. Anthony Abbot Tempted by a Heap of Gold.* c. 1435. Tempera and gold on wood, image area $18\% \times 13\%$ ".

The Metropolitan Museum of Art, New York

7.6 Jacob Lawrence. In many of the communities the Negro press was read continually because of its attitude and its encouragement of the movement. Panel 20 from The Migration Series. 1940–41. Tempera on composition board, 18×12 ". The Museum of Modern Art, New York

Anthony Abbot lived in Egypt, dying there in 356 C.E. A popular account of his life written soon after inspired numerous paintings over the centuries. This panel depicts Anthony setting out from a salmon-colored church along a stony path into the desert wilderness, where the devil will put many temptations in his way. One temptation was a heap of gold, originally depicted at the lower left. Anthony recoils at the sight of it, his hands raised in surprise. The Osservanza Master has built up the forms of his work slowly and patiently through layers of small, precise brush strokes. Particularly charming are the barren hills and scraggly trees of the landscape—the painter's attempt to imagine what a desert must look like.

Workshop apprentices would have made the Osservanza Master's colors fresh daily, grinding the pigments with water to form a paste, then mixing the paste with diluted egg yolk. They would have made just enough for one day's work, since tempera colors do not keep. Not long after the Osservanza Master's time, tempera fell out of favor in Europe. The technique was forgotten until the 19th century, when it was revived based on descriptions in an early Renaissance artist's handbook. Today, tempera is available commercially in tubes, though many painters still prefer to make their own.

One modern painter who experimented with both commercial and hand-made tempera was Jacob Lawrence. Like the Osservanza Master, Lawrence used tempera to make a series of images that tell a story, in this case the story of the Great Migration—the migration of thousands of African Americans from the South to the North beginning about 1910 (7.6). Lawrence has said that he was drawn to the "raw, sharp, rough" effect of tempera colors, qualities he brings out quite well in his scrappy handling here, with paint applied sparingly to simplified forms.

ARTISTS Jacob Lawrence (1917-2000)

What themes from his personal life does Lawrence share through his art? Why is a series a more appropriate method of delivering his themes?

he name "Harlem" is associated in many people's minds with hardship and poverty. Poverty Harlem has always known, but during the 1920s it experienced a tremendous cultural upsurge that has come to be called the Harlem Renaissance. So many of the greatest names in black culture—musicians, writers, artists, poets, scientists—lived or worked in Harlem at the time, or simply took their inspiration from its intellectual energy. To Harlem, in about 1930, came a young teenager named Jacob Lawrence, relocating from Philadelphia with his mother, brother, and sister. The flowering of the Harlem Renaissance had passed, but there remained enough momentum to help turn the child of a poor family into one of the most distinguished American artists of his generation.

Young Lawrence's home life was not happy, but he had several islands of refuge: the public library, the Harlem Art Workshop, and the Metropolitan Museum of Art. He studied at the Harlem Art Workshop from 1932 to 1934 and received much encouragement from two noted black artists, Charles Alston and Augusta Savage. By the age of twenty, Lawrence had begun to

exhibit his work. A year later he, like so many others, was being supported by the W.P.A. Art Project, a government-sponsored program to help artists get through the economic void of the Great Depression.

Even that early in his career, Lawrence had established the themes that would dominate his work. The subject matter comes from his own experience, from black experience: the hardships of poor people in the ghettos, the violence that greeted blacks moving from the South to the urban North, the upheaval of the civil rights movement during the 1960s. Nearly always his art has a narrative content or "story," and often the titles are lengthy. Although Lawrence did paint individual pictures, the bulk of his production was in series, such as *The Migration Series* and *Theater*, some of them having as many as sixty images.

The year 1941 was significant for Lawrence's life and career. He married the painter Gwendolyn Knight, and he acquired his first dealer when Edith Halpert of the Downtown Gallery in New York featured him in a major exhibition. The show was successful, and it resulted in the purchase of Lawrence's *Migration Series* by two important museums.

From that point Lawrence's career prospered. His paintings were always in demand, and he was sought after as an illustrator of magazine covers, posters, and books. His influence continued through his teaching—first at Black Mountain College in North Carolina, later at Pratt Institute, the Art Students League, and the University of Washington. In 1978 he was elected to the National Council on the Arts.

Many people would call Lawrence's paintings instruments of social protest, but his images, however stark, have more the character of reporting than of protest. It is as though he is telling us, "This is what happened, this is the way it is." What happened, of course, happened to black Americans, and Lawrence the world-famous painter did not seem to lose sight of Lawrence the poor youth in Harlem. As he said, "My belief is that it is most important for an artist to develop an approach and philosophy about life—if he has developed this philosophy he does not put paint on canvas, he puts himself on canvas."²

Jacob Lawrence. Self-Portrait. 1977. Gouache on paper, 23 \times 31". National Academy Museum, New York.

Oil

Oil paints consist of pigment compounded with oil. Historically, the most commonly used oils have been linseed oil, poppy seed oil, and walnut oil. Today, commercial manufacturers of artists' colors often grind darker pigments with linseed oil and light pigments such as white and yellow with poppy seed oil or safflower oil, which do not yellow over time, as linseed oil tends to do. What all these oils have in common is that they will dry at room temperature, leaving the pigment particles suspended in a transparent film.

Oil was known as a medium in western Europe as early as the 12th century, but it did not begin its rise to popularity until two centuries later. By the 15th century, oil paint had eclipsed tempera as the medium of choice in northern Europe. It would soon conquer southern Europe as well. From that time and for about five hundred years, the word "painting" in Western culture was virtually synonymous with "oil painting." Only since the 1950s, with the introduction of acrylics (discussed later in this chapter), has the supremacy of

oil been challenged.

A beautiful example of oil painting from its first decades of popularity is A Goldsmith in His Shop by Petrus Christus (7.7). The scene is set in the prosperous Netherlandish city of Bruges, where Christus spent his career. A richly dressed young couple is paying a visit to the local goldsmith. Soon to be married (her betrothal girdle is displayed on the counter), they have come to purchase a ring. The seated goldsmith holds a jeweler's balance with a ring in one tray and a weight in the other. Gold coins and additional weights are

7.7 Petrus Christus. A Goldsmith in His Shop. 1449. Oil on wood, $38\% \times 33\%$ ".

The Metropolitan Museum of Art. New York

stacked on the counter. A convex mirror reflects the streetscape outside and two passersby, one of whom carries a falcon perched on his gloved hand. To the right, a green curtain has been drawn back to reveal a fascinating display of the goldsmith's raw materials—coral, crystal, porphyry, seed pearls, and beads. Finished products are displayed as well—rings, brooches, a gold-lidded crystal container, and polished pewter vessels with gold fittings.

When oil paints were first introduced, most artists, including Petrus Christus, continued working on wood panels. Gradually, however, artists adopted canvas, which offered two great advantages. For one thing, the changing styles favored larger and larger paintings. Whereas wood panels were heavy and liable to crack, the lighter linen canvas could be stretched to almost unlimited size. Second, as artists came to serve distant patrons, their canvases could be rolled up for easy and safe shipment. Canvas was prepared by stretching it over a wooden frame, sizing it with glue to seal the fibers and protect them from the corrosive action of oil paint, and then coating it with a white, oil-base ground. Some painters then applied a thin layer of color over the ground, most often a warm brown or a cool, pale gray.

Unlike tempera, oil paint dries very slowly, allowing artists far more time to manipulate the paint. Colors can be laid down next to each other and blended softly and seamlessly. They can be painted wet-on-wet, with a new color painted into a color not yet dry. They can be scraped away partially or altogether for revisions or effects. Again unlike tempera, oil paint can be applied in a range of consistencies, from very thick to very thin. Petrus Christus, for example, did much of his painting in **glazes**—thin veils of translucent color like stained glass applied over a layer of opaque paint.

Painting as practiced by artists such as Christus is a slow and time-consuming affair. The composition is generally worked out in advance down to the least detail, drawn on the ground, then built up methodically, with layer after layer of opaque paints and glazes. Artists who favor a less fussy, more spontaneous approach may work directly in opaque colors on the white ground, a technique sometimes called *alla prima* (ahl-lah PREE-mah), Italian for "at first." Also known as "direct painting" or "wet-on-wet," *alla prima* implies that the painting was completed all at once, in a single session, though in fact it may only look that way.

Amy Sillman's *Nut* takes advantage of oil paint's unique characteristics in a contemporary way (7.8). The surface has been worked and reworked,

7.8 Amy Sillman. *Nut*. 2011. Oil on canvas, 7'7" × 7'. Artwork © 2015 Amy Sillman. Image courtesy Sikkema Jenkins & Co., New York

with colors brushed on, brushed over, scraped away, and reapplied, now in a thinned, translucent layer (the long green form), now in thick, opaque strokes (the lavender Y-form). Underlayers are allowed, even encouraged, to show through, traces of the painting's development. It's impossible to say what memories or experiences triggered *Nut*, but the painting evolved in a way that allows us to distinguish (perhaps) two legs, a dangling arm, and a hand poised over the hem of a woman's coat drawn in an underlayer. Diagrammatic lines in white, green, and violet form a sort of scaffolding.

Watercolor, Gouache, and Similar Media

Watercolor consists of pigment in a vehicle of water and gum arabic, a sticky plant substance that acts as the binder. As with drawing, the most common support for watercolor is paper. Also like drawing, watercolor is commonly thought of as an intimate art, small in scale and free in execution. Eclipsed for several centuries by the prestige of oil paints, watercolors were in fact often used for small and intimate works. Easy to carry and requiring only a glass of water for use, they could readily be taken on sketching expeditions outdoors and were a favorite medium for amateur artists.

The leading characteristic of watercolors is their transparency. They are not applied thickly, like oil paints, but thinly in translucent washes. Although opaque white watercolor is available, this is reserved for special uses. More usually, the white of the paper serves for white, and dark areas are built up through several layers of transparent washes, which take on depth without ever becoming completely opaque. John Singer Sargent's *Mountain Stream* (7.9) is a

7.9 John Singer Sargent.

Mountain Stream. c. 1912–14.

Watercolor and graphite on paper,
13¾ × 21".

The Metropolitan Museum of Art.

The Metropolitan Museum of Art, New York

perfect example of what we might think of as "classic" watercolor technique. Controlled and yet spontaneous in feeling, it gives the impression of having been dashed off in a single sitting. The white of the paper serves for the foam of the rushing stream, and even the shadows on the opposite shore retain a translucent quality.

Gouache is watercolor with inert white pigment added. Inert pigment is pigment that becomes colorless or virtually colorless in paint. In gouache, it serves to make the colors opaque, which means that when used at full strength, they can completely hide any ground or other color they are painted over. The poster paints given to children are basically gouache, although not of artist's quality. Like watercolor, gouache can be applied in a translucent wash, although that is not its primary use. It dries quickly and uniformly and is especially well suited to large areas of flat, saturated color. The Cuban painter Wifredo Lam exploits both the transparent and the opaque possibilities of gouache in *The Jungle* (7.10). Human and animal forms mingle in this fascinating work, which contains references to *Santería*, a Caribbean religion that combines West African and Roman Catholic beliefs.

Many cultures have developed paints that are similar to watercolor and gouache. Traditional Chinese artists, for example, paint with black ink made by mixing oil soot with animal glue. The resulting doughy paste is kneaded, then pressed into a mold and allowed to harden into a slender block known as an ink stick. A painter (or a scribe, since the same ink is used for writing) prepares a session's supply of ink by grinding the stick with water on an ink stone—a fine-grained stone shaped to offer a smooth grinding surface and a well for water. Traditional colors are made in the same way, with powdered pigments ground in water and bound with animal glue. Some pigments yield transparent tones that resemble watercolor; others produce opaque colors that more closely resemble gouache.

The earliest known ink sticks date from the period in Chinese history known as the Warring States (c. 450–221 B.C.E.). Ink sticks are still manufactured today, making them perhaps the oldest painting medium in continuous use. Chang Dai Chien used ink and colors to paint *Mountains Clearing After Rain*

7.10 Wifredo Lam. *The Jungle*. 1943. Gouache on paper mounted on canvas, 7'10¼" × 7'6½". The Museum of Modern Art, New York

7.11 Chang Dai Chien (Zhang Daqian). *Mountains Clearing After Rain.* c. 1965–70. Hanging scroll, ink and color on paper, $52 \times 23\%$ ". The Metropolitan Museum of Art, New York

(7.11). In a display of virtuosity, Chang floated his pigments onto the paper in billowing, amorphous shapes, then transformed the results into a recognizable landscape by adding a cluster of houses, a boat, and some branches with a few deft strokes. The result is like a magic trick we could watch again and again.

Traditional artists in India and the Islamic world also use ink and colors. Ink is made with soot and animal glue, as in China. Paints are made by grinding pigments in water with a binder of animal glue or gum arabic, according to local preference. Painters in these traditions generally favor opaque, gouache-like colors for their work, as you can see if you look back at such paintings as Jahangir Receives a Cup from Khusrau (1.8) or Maharana Amar Singh II, Prince Sangram Singh, and Courtiers Watch the Performance of an Acrobat and Musicians (4.42).

Acrylic

The enormous developments in chemistry during the early 20th century had an impact in artists' studios. By the 1930s, chemists had learned to make strong, weatherproof, industrial paints using a vehicle of synthetic plastic resins. Artists began to experiment with these paints almost immediately. By the 1950s, chemists had made many advances in the new technology and had also adapted it to artists' requirements for permanence. For the first time since it was developed, oil paint had a challenger as the principal medium for Western painting.

These new synthetic artists' colors are broadly known as **acrylics**, although a more exact name for them is polymer paints. The vehicle consists of acrylic resin, polymerized (its simple molecules linked into long chains) through emulsion in water. As acrylic paint dries, the resin particles coalesce to form a

tough, flexible, and waterproof film.

Depending on how they are used, acrylics can mimic the effects of oil paint, watercolor, gouache, and even tempera. They can be used on prepared or raw canvas, and also on paper and fabric. They can be layered into a heavy **impasto** like oils or diluted with water and spread in translucent washes like watercolor. Like tempera, they dry quickly and permanently. (Artists using acrylics usually rest their brushes in water while working, for if the paint dries on the brush, it is extremely difficult to remove.)

Brazilian painter Beatriz Milhazes developed an unusual technique for working with acrylics. To create a painting such as *Mariposa* (7.12), Milhazes first paints each motif separately on a sheet of clear plastic. When the paint has dried, she glues the motif face down onto the canvas and peels away the plastic backing, revealing the motif's smooth underside. Motif by motif, element by

7.12 Beatriz Milhazes. Mariposa.
2004. Acrylic on canvas, 8'2" × 8'2".
© Beatriz Milhazes. Courtesy James
Cohan Gallery, New York/Shanghai

element, Milhazes builds up her painting as though she were making a collage. The technique demands that the artist plan ahead, for each motif must be painted in reverse, both in the way its colors are layered (since it is the underside that will show) and in its orientation (since attaching it face down will reverse right and left).

Painting and Beyond: Off the Wall!

Most of the paintings we have looked at in this chapter are **easel paintings**—a term for paintings executed on an easel or a similar support. An easel is a portable stand that props a painting-in-progress up vertically so that the artist can work facing it, in the position that a viewer will eventually take. The painting that Diego Velázquez depicts himself working on in *Las Meninas* is propped up against an easel, for example (see 17.11). Unlike frescoes or murals, easel paintings are portable objects, generally rectangular in format, that can be hung on any wall big enough to accommodate them.

Easel painting came into prominence during the Renaissance, and it has dominated the Western painting tradition ever since. Chances are that if you were asked to imagine a painting, it is an easel painting that would come to mind. Modern artists seeking new means of expression (and having new things to express) have pushed at the boundaries of easel painting, imagining other ways for paintings to be made and experienced. In the 1940s, for example, Jackson Pollock did away with the easel and spread his canvas on the floor so that he could spatter and drip paint onto it from above (see 22.1). A few years later, Pollock's younger colleague Helen Frankenthaler followed his lead, placing raw, unprimed canvas on the floor and flooding it with thinned paint that soaked into the fabric like dye (see 22.5). During the 1960s, Lynda Benglis took their ideas a step further, pouring her colors directly onto the floor . . . and leaving them there (7.13).

7.13 Lynda Benglis painting on the floor with pigmented latex, University of Rhode Island, 1969.

Working with large cans of latex into which she had stirred pigments, Benglis poured overlapping flows of vivid color onto the floor, creating works she called "fallen paintings." Many of her fallen paintings, like the one she is shown working on in the illustration here, were site-specific and temporary, created in an exhibition space and then discarded when the exhibition was over. Others were created in her studio and detached from the floor, making them portable and permanent. With Benglis, painting not only left the wall but also broke free of traditional geometric formats, for the shape of the fallen paintings was determined by the flow of the latex. Benglis' fallen paintings have a sculptural presence, like a very low relief, and they share the viewer's space in the way that sculpture does.

A number of artists have since worked in the space that Benglis and others opened up between painting, sculpture, and installation. One is the Berlin-based artist Katharina Grosse, whose exuberant spray-painted colors run riot over walls, windows, fiberglass sculptures, fabricated boulders, articles of clothing, and piles of earth in One Floor Up More Highly (7.14). Huge, elongated blocks of white Styrofoam establish a visual link with the white walls of the space. The artist has compared them to crystallized light, like sunlight so blinding that it blocks our view for a moment. Unavoidably, the illustration here gathers the work into the traditional rectangular view of an easel painting, as though reclaiming it for the territory it has escaped from. (Photography does this to our lived experience all the time, whether we notice it or not.) In fact, the artist does not intend the work to be a composition in the traditional sense at all. It is not meant to appear unified from a certain point of view outside the work. It is meant to be experienced from inside, moment by moment. "We put it together as we move, every second anew," says Grosse. "We continually remake this surrounding just as we do when we perceive the world. To see the installation as a coherent unit is an illusion."3

7.14 Katharina Grosse. One Floor Up More Highly, detail. 2010. Installation at Mass MoCA, December 22, 2010—October 31, 2011. Soil, wood, acrylic, Styrofoam, acrylic on glass-fiber-reinforced plastic, and acrylic on canvas.

The Idea of a Painting: Painting without Paint

What makes a work of art a painting? The most obvious answer would seem to be "paint," but a number of artists today are challenging that assumption. They make works that have the scale and force of paintings, that are clearly informed by the history and tradition of painting, and yet that do not use paint as a medium.

Mark Bradford makes paintings from posters and billboard paper he finds in his neighborhood and on his travels. He soaks thick, layered accumulations of advertisements in water until their glue softens and the layers separate. From this weathered, scavenged material, he builds up a layered surface on a canvas support, often incorporating other elements such as twine, caulking, and black carbon paper. Then he goes to work with a power sander, excavating the layers, erasing and revealing. He may use bleach to eat away at the colors, or paste still more paper over the distressed surface and work it over in turn. One result of this process is the monumental *Black Venus* (7.15).

Black Venus reflects Bradford's lifelong interest in imaginary maps. It was inspired by an upscale neighborhood in Los Angeles that is home to many affluent African Americans. Bradford began the piece by printing online maps of specific addresses in the neighborhood and making drawings from them. From the drawings, he cut up paper and glued it down. "But somewhere along the line the map and the actual address collapsed into imagination," Bradford relates, "and that's where Black Venus came from. I'm always removing myself from the first thing, the first impulse."

Bradford calls his works paintings, he says, because they are made on a stretched canvas support, just as oil paintings are. "Some people describe them as collage, but I feel like I'm a traditional painter," he says. "I just don't use paint. But I do set up my studio in a very formal and kind of traditional way, and I use the logic of paint. I use the concepts of painting." 5

Another artist who makes paintings without paint is Channing Hansen. Hansen knits paintings using yarns that he spins by hand and dyes himself. Hansen had been making sculpture and performance for many years when he took up knitting to keep his hands busy while he was away from the studio. The

7.15 Mark Bradford. *Black Venus*. 2005. Billboard paper, photomechanical reproductions, acrylic gel medium, carbon paper, and additional mixed media; 10'10" × 16'4".

© Mark Bradford. Courtesy Sikkema Jenkins & Co., New York

more he knit, the more he saw its potential as a medium for art. Wanting to thoroughly understand his materials, Hansen learned how to spin. (He is a proud member of the Greater Los Angeles Spinners Guild.) He has even participated in a sheep shearing to understand how wool is harvested. "I like to go to the very root of something," he says simply."

Spinning and dying yarn link Hansen to such age-old technologies as weaving and pottery, but what he subsequently does with the yarn is inspired by contemporary science, computer code, and the heritage of Fluxus, an avantgarde movement that disseminated lists of instructions to serve as scores for events and performances. Practical knitting—the kind that produces a sweater or a cap-proceeds according to a pattern, which consists of row-by-row instructions that specify how many stiches to begin with, when to increase or decrease their number, what type of knitting stitch to use and for how long, when to change colors, and so on. Hansen also knits according to instructions, but his instructions are generated by a computer algorithm. A self-described "armchair physicist," Hansen is fascinated by such concerns of contemporary physics as higher-dimensional spaces and quantum mechanics. The code he wrote uses a random number generator that exploits a quantum optics process to pick from a list of instructions he gives it. The results direct every aspect of the knitting, including colors, fiber types, patterns, textures, and their interplay. The algorithm "takes my subjectivity out of the equation and tells me what to do-including the mistakes," he explains. When the knitting is completed, Hansen stretches the finished textile over the same type of rectangular wooden chassis that canvas is stretched on for traditional paintings. Often, as in ALGO 54 1.0, the support shows through the work to become part of the image (7.16). Hansen's code mutates and expands with each piece he makes. ALGO 54 was named for its 54th iteration.

7.16 Channing Hansen. ALGO 54 1.0. 2014. Blue-faced Leicester wool, bamboo, Coopworth wool, mohair, silk, Tencel, Tunis wool, Tussah silk, Wensleydale fibers, holographic polymers, cedar; $3'9" \times 3'4\%"$. Courtesy of the artist and Marc Selwyn Fine Art, Beverly Hills

Sumptuous Images: Mosaic and Tapestry

When painting rose to prominence during the Renaissance, it found itself in the company of two other highly esteemed techniques for creating monumental, two-dimensional images: mosaic and tapestry. Painters were often called upon to create designs for these media, which were then carried out by specialized workshops.

Mosaic is made of small, closely spaced particles called **tesserae** (singular **tessera**) embedded in a binder such as mortar or cement. Tesserae function similarly to the dots in a pointillist painting: each one contributes a small patch of pure color to the construction of an image, which comes into focus at a certain distance (see 4.31). Like fresco, mosaic is well suited to decorating architectural surfaces such as walls and ceilings. Unlike fresco, however, mosaic is sturdy enough to stand up to the elements, and so it can be used for floors and outdoor surfaces as well.

The ancient Greeks made floor mosaics using small pebbles as tesserae. Later, the practice arose of fabricating tesserae from natural materials such as colored marble or manufactured materials such as glass. The ancient Romans adopted the technique of mosaic along with many other aspects of Greek artistic culture, using it not only for floors but also for walls and ceilings. After Christianity came to power within the Roman Empire, mosaic was used to decorate churches and other Christian religious buildings.

The Mausoleum of Galla Placidia contains some of the most beautiful of these early Christian mosaics to have come down to us (7.17). Galla Placidia was a Roman empress and patron of the arts who lived during the first half of the 5th century. Her name has long been associated with this small mausoleum,

7.17 Interior, Mausoleum of Galla Placidia, Ravenna. c. 425–26.

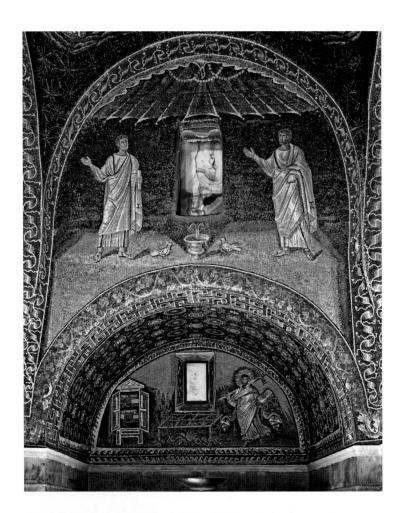

and although scholars no longer believe that she was buried in it, she may well have sponsored its construction. The entire upper portion of the interior is covered with mosaics made of glass tesserae. In the detail illustrated here, two apostles standing to either side of an alabaster window panel raise their hands in greeting. In the smaller scene below we see an open cabinet containing the four books of the Gospels, a gridiron set over a roaring fire, and a man carrying a cross over his right shoulder and holding an open book in his left hand. The man has long been identified as Saint Lawrence, who was martyred by being roasted alive on a gridiron, though he may instead represent Saint Vincent of Saragossa, also tortured on a gridiron, who was martyred after refusing to consign the Gospels to the flames.

The 15th-century Renaissance painter Domenico Ghirlandaio spoke of mosaics as "painting for eternity." Although their brilliant colors and glittering surfaces may not actually last forever, mosaics are far more durable than paintings, and that is part of their appeal. Ghirlandaio himself designed several mosaics, as did a number of other Renaissance artists, including Raphael. Nevertheless, mosaic was largely abandoned in favor of fresco, which was faster, far less costly, and better suited to the new Renaissance interest in naturalism.

Interest in mosaic revived in the 19th century, and a number of important workshops were established. Rich with historical associations, mosaic has since reclaimed a place in artistic practice. A recent example is Nancy Spero's Artemis, Acrobats, Divas, and Dancers (7.18). The whole work consists of fortyeight panels of glass mosaics set into the tile walls of a New York City subway station. The station serves Lincoln Center, home to many performing-arts organizations. A small repertoire of figures—ancient Egyptian musicians, arching acrobats, dancers ancient and modern, the ancient Greek goddess Artemis, and a glamorously robed diva (female opera singer)-appear again and again in various combinations across the panels, as though taking part in a theatrical performance or a ritual. The diva, illustrated here, was a new image for Spero, but many of the other figures had appeared often in her paintings over the years, reflecting her ongoing themes and concerns.

Tapestry refers to a particular weaving technique, and also to the wall hangings made using it. Weaving involves interlacing two sets of threads at right angles to each other. One set of threads, called the warp, is held taut,

7.18 Nancy Spero. Artemis, Acrobats, Divas, and Dancers, detail. 1999-2001. Permanent installation in the 66th Street-Lincoln Center subway station, New York. Glass and ceramic mosaic.

7.19 Charles Le Brun. *The Battle of the Granicus*, from a five-piece set of the *Story of Alexander*. 1680–87. Wool, silk, and gilt-metal-wrapped silk thread; 15'11" × 27'85%". Kunsthistorisches Museum, Vienna

usually by a loom. The second set, called the weft, is passed through the warp threads, winding over and under them in a set pattern. In ordinary cloth weaving, the weft thread passes back and forth from one edge of the warp to the other, evenly building up a textile. In tapestry weaving, weft threads do not cross the entire warp but, rather, are woven in locally to build up zones of color. You can imagine the warp of a tapestry as a blank canvas stretched out on the loom. (The warp threads are not dyed.) The weft threads are the weaver's palette of colors.

Tapestry weave has been used in many cultures to create textiles such as rugs or garments. In Europe, it was also used to create monumental pictorial wall hangings. Tapestry production began in Europe during the Middle Ages; the earliest surviving examples date from the 11th century. The hangings were commonly woven in sets that illustrated a theme or depicted episodes from a famous story. Starting during the Renaissance, prominent painters were commissioned to design tapestries. As with frescoes, designs for tapestry were produced as cartoons—full-scale painted drawings on paper. The cartoons were sent to weaving workshops to be translated into tapestry.

The Battle of the Granicus, designed by the painter Charles Le Brun for the French king Louis XIV, shows how closely tapestry and painting became intertwined (7.19). The Battle of the Granicus began as a painting, one of five monumental canvases narrating the life of the ancient Macedonian conqueror Alexander the Great. The king had commissioned the paintings from Le Brun, and he was so taken with them that he ordered that they be reproduced as tapestries. Le Brun prepared two sets of cartoons for two different tapestry workshops, and he fleshed out the five monumental scenes with six smaller ones. Eight sets of the tapestries were woven in all. One set was installed in a room in the royal residence; the others were saved for ceremonial display or given by the king as diplomatic gifts.

Over 27 feet long and almost 16 feet in height, *The Battle of the Granicus* reproduces a slightly cropped and lightly reworked version of Le Brun's original painting. Massed in a dramatic diagonal, Alexander's men surge up from the River Granicus and into battle against the forces of Persia. Alexander

himself is depicted at the center wearing a magnificent plumed helmet, a sword in his outstretched right hand, his face a mask of fury. The turbulent scene is set in a woven frame flanked by borders that depict architectural ornamentssculpted busts, garlands, shields, weapons, and the royal emblem and motto. In other words, the tapestry does not merely depict the scene itself but also suggests a framed painting of the scene hung in a rich architectural setting.

The passing of the aristocratic world that prized and commissioned tapestries coincided with the modern formulation of "art," in which painting and sculpture took pride of place. Tapestry was now spoken of as a decorative art or a craft. (We discuss these categories further in Chapter 12.) Tapestry workshops were still a focus of national pride, however, and artists continued to work with them. In fact, the principles of simultaneous contrast and optical blending, discussed in Chapter 4, were first articulated by the director of a tapestry workshop interested in the effects of juxtaposing differently colored threads. During the 20th century, tapestry gave rise to the new medium of fiber art, as more and more artists grew interested in weaving. (For more about fiber art, see Chapters 12 and 22.) Today, when our definition of art has expanded to embrace a broad variety of media and techniques, a number of artists have again turned to realizing their ideas as tapestries.

One such artist is Pae White, who has exhibited tapestries depicting such unlikely subjects as crumpled aluminum and lazily curling smoke (7.20). Instead of a cartoon, White begins with a digital photograph. Working closely with a tapestry workshop in Belgium, she settles on the color palette and weaving patterns that will best give the image material form. A digital file of weaving instructions is prepared, and the tapestry is woven from them on a

computer-driven loom.

Forty feet long, Still, Untitled reprises the scale of the monumental tapestries of the past, inviting us to draw comparisons between then and now. Gone are the complex historical, mythological, and allegorical subjects that intrigued and flattered aristocratic patrons such as Louis XIV. Those aren't for us, in our time and place. We content ourselves with humbler fare, the everyday beauty of a plume of smoke, frozen by photography so that we can take in every detail. An intriguing aspect of tapestry is that the image is not on the material, the way paint is on canvas, but, rather, embedded in the material, part of its essence. White has described her smoke tapestries as "cotton's dream of becoming something else"—a dense, textured, weighty textile dreaming about being as insubstantial and fleeting as a wisp of smoke.

7.20 Pae White. Still, Untitled. 2010. Cotton and polyester tapestry, $12 \times 40'$. Collection of Sandretto Re Rebaudengo, Turin

8

Prints

f you have ever accidentally tracked mud into the house in your sneakers, then you understand the basic principle of making a **print**. When you stepped in the mud, some of it stuck to the raised surfaces of the sole of your sneakers. When you stepped on the floor afterward, the pressure of your weight transferred the mud from the raised surfaces of your sneaker to the floor, leaving an image. If you took a second step, the print you made was probably fainter, because there wasn't as much mud left on the sneaker. You would have to step in the mud again to produce a second print as good as the first one. With a little practice, you could probably make a row of sneaker prints that were almost exactly identical.

In the vocabulary of printmaking, the sole of your sneaker served as a **matrix**, a surface on which a design is prepared before being transferred through pressure to a receiving surface such as paper. The printed image it left is called an *impression*. You probably didn't make your own sneaker, but an artist makes a matrix to create prints from it. A single matrix can be used to create many impressions, all of them almost identical, and each of them considered to be an original work of art. For that reason, printing is called an art of multiples.

With the development of industrial printing technologies during the modern era, we have come to recognize a difference in value between original artists' prints and mass-produced reproductions such as the images in this book or a poster bought in a museum shop. Two broadly agreed-upon principles have been adopted to distinguish original artists' prints from commercial reproductions.

The first is that the artist performs or oversees the printing process and examines each impression for quality. The artist signs each impression he or she approves; rejected impressions must be destroyed. The second is that there may be a declared limit to the number of impressions that will be made. This number, called an **edition**, is also written by the artist on each approved impression, along with the number of the impression within that edition. For example, a print numbered 10/100 is the tenth impression of a limited edition of one hundred. Once the entire edition has been printed, approved, signed, and numbered, the printing surface is canceled (by scratching cross marks on it) or destroyed so that no further prints can be made from it.

Prints, however, were made for hundreds of years before these standards were in place. From the beginning, they have served to disseminate visual information and to bring the pleasure of owning art within reach of a broad public.

Three historical methods for making art prints—relief, intaglio, and lithography—were joined in the 20th century by screenprinting and in the 21st by digital inkjet. This chapter takes up each method in turn, then closes with a look at some innovative ways in which contemporary artists are using printed images.

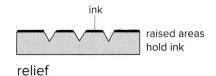

Relief

The term **relief** describes any printing method in which the image to be printed is *raised* from a background (8.1). Think of a rubber stamp. When you look at the stamp itself, you may see the words "First Class" or "Special Delivery" standing out from the background in reverse. You press the stamp to an ink pad, then to paper, and the words print right side out—a mirror image of the stamp. All relief processes work according to this general principle.

Any surface from which the background areas can be carved away is suitable for relief printing, but the material most commonly associated with relief printing is wood.

Woodcut

To make a **woodcut**, the artist first draws the desired image on a block of wood. Then all the areas that are not meant to print are cut and gouged out of the wood so that the image stands out in relief. When the block is inked, only the raised areas take the ink. Finally, the block is pressed on paper, or paper is placed on the block and rubbed to transfer the ink and make the print.

The earliest surviving woodcut image was made in China (8.2). Dated 868 C.E., this portrayal of the Buddha preaching appears at the beginning of the world's earliest known printed book, a copy of the Diamond Sutra, an important Buddhist text. The image probably reproduces an original drawing in brush and ink executed in the slender, even-width lines that Chinese writers likened to iron wire. Although only one copy survives, the edition of the sutra must have been quite large, for a postscript at the end of the 18-foot-long scroll tells us that the project was undertaken at the expense of one Wang Jie, "for universal free distribution." Two great Chinese inventions, paper and printing, are here united.

incise hold intaglio

incised areas hold ink

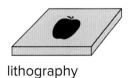

image area holds ink; non-image areas repel ink

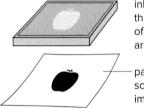

ink passes through areas of screen that are not blocked

paper with screened image

screenprinting

microscopic nozzles spray droplets of ink onto paper according to data in digital image file

8.1 Five basic print methods.

8.2 Preface to the Diamond Sutra. 868. Woodblock handscroll. The British Library, London

In Europe, woodblocks had been used to print patterns on textiles since as early as the 6th century C.E., but it was not until the introduction of paper that printing anything else became practical. Soon after, in the mid-15th century, the invention of the printing press and movable type launched Europe's first great "information revolution." For the first time in the West, information could be widely disseminated. Woodcuts quickly found a place as book illustrations, for the block could be placed on the same framework as the type, and the entire page inked and printed at the same time. As in China, the first printed books in Europe were illustrated with woodcuts.

With the introduction of **engraving** and other printmaking techniques discussed later in this chapter, woodcut gradually fell out of favor with European artists. Compared with these later techniques, it seemed coarse and unrefined. Those very qualities drew artists to woodcut again in the early 20th century, when many rejected the refinement of the past in favor of bolder, starker, more urgent images, such as *The Widow*, by Käthe Kollwitz (8.3). Head bowed, eyes cast down, the woman closes in on herself in grief, as though she were fitting herself into her own coffin. Her rough hands hint at a life of hard work; her swelling belly suggests that she is pregnant with a child who will never know its father. Kollwitz allowed traces of the cut-away portions of the block to print, evoking the energy and even the violence of the cutting and gouging that cleared the background away. *The Widow* is from a portfolio of seven prints called *War*. Created in the aftermath of World War I, the prints evoke the trauma of the war from the perspective of those left behind, mainly women.

By the 14th century, China had advanced to the next step in woodcut by using multiple blocks to print images in full color. A few centuries later, this technique was transmitted to Japan, where during the 18th century it was brought to a level of perfection that has made Japanese prints famous the world over (see 2.22, 3.26, and 19.34).

8.3 Käthe Kollwitz. *The Widow*, from *War*. 1921–22, published 1923. Woodcut, image size 14⁵% × 9⁵%. The Museum of Modern Art, New York

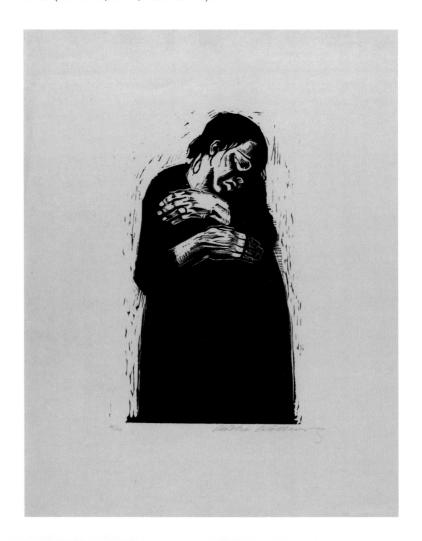

ARTISTS Käthe Kollwitz (1867–1945)

What are some defining elements and principles that stand out in Kollwitz' works? What does the artist's concentration on black and white reveal about her style and themes? How do her works show her political and emotional struggles?

n a time when the word "artist" usually meant a painter or a sculptor, Käthe Kollwitz did the bulk of her work in prints and drawings. In a time when vivid, sometimes startling color was preoccupying the art world, Kollwitz concentrated on black and white. And in a time when nearly all artists were men, Kollwitz was—triumphantly—a woman, a woman whose life and art focused on the special concerns of women. Taken together, those factors might have doomed a lesser artist to obscurity, but not one of Kollwitz' great gifts and powerful personality.

Käthe Schmidt was born in Königsberg (then in Prussia, now part of Russia), the second child in an intellectually active middle-class family. Her parents were remarkably enlightened in encouraging all their children to take an active part in political and social causes and to develop their talents—in Käthe's case a

talent for drawing. Käthe received the best art training then available for a woman, in Berlin and Munich. In 1891, after a seven-year engagement, she married Karl Kollwitz, a physician who seems to have been equally supportive of his wife's career. The couple established themselves in Berlin, where they kept a joint doctor's office and artist's studio for fifty years.

During her student days, Kollwitz had gradually focused on line and had come to realize that drafts-manship was her genius. Her conventional artistic training must have intensified the shock when she "suddenly saw that I was not a painter at all." She concentrated then on drawings and prints—etchings and woodcuts early on, lithographs when her eyesight grew weaker.

Five major themes dominate Kollwitz' art: the artist herself, in a great many self-portraits and images for which she served as model; the ties between mothers and their children; the hardships of the working classes, usually interpreted through women's plight; the unspeakable cruelties of war; and death as a force unto itself. As a socialist, Kollwitz identified passionately with the sufferings of working people; as a mother, she identified with the struggle of women to keep their children safe.

Kollwitz bore two sons—Hans in 1892 and Peter in 1896. The first of many tragedies that marked her later life came in 1914, with the death of Peter in World War I. She lived long enough to see her beloved grandson, also named Peter, killed in World War II. During the almost thirty years between those losses, she continued to work prolifically, but her obsession with death never left her.

Few artists have so touchingly described their attempts to achieve a certain goal, and their continual frustration at falling short. In Kollwitz' case, the artistic goals were generally realized, but the emotional and political goals—never: "While I drew, and wept along with the terrified children I was drawing, I really felt the burden I am bearing. I felt that I have no right to withdraw from the responsibility of being an advocate. It is my duty to voice the sufferings of men, the neverending sufferings heaped mountain-high. This is my task, but it is not an easy one to fulfill. Work is supposed to relieve you. . . . Did I feel relieved when I made the prints on war and knew that the war would go on raging? Certainly not."

Käthe Kollwitz. Self-Portrait with Hand on Her Forehead. 1910. Etching, $6 \times 5\%$ ". Kupferstich-Kabinett, Staatliche Kunstsammlungen, Dresden.

8.4 Motosugu Sugiyama. Sumida River, Late Autumn. 2001. Polychrome woodblock print, 17³/₄ × 23³/₄". Denver Art Museum

Produced by the thousands and cheaply sold, woodblock prints in Japan were a popular art, and they never enjoyed the prestige of painting. By the beginning of the 20th century, the tradition had almost died out, largely supplanted by photography and lithography—Western imports that were embraced as part of modernization. Paradoxically, it was Western admiration for the prints that prompted Japanese artists to reconsider them, launching a movement called *shin-hanga*, "new prints." *Shin-hanga* artists generally focused on traditional subject matter, catering to a taste for romanticized, nostalgic views of Japan. The movement's energies dissipated during the 1960s, but the penchant for nostalgic views continues to be felt in contemporary woodblock prints. It is rare to find a woodblock artist who embraces sleek, urban aspects of present-day Japan, as Motosugu Sugiyama does in *Sumida River*, *Late Autumn* (8.4).

The Sumida River flows through Tokyo and empties into Tokyo Bay. The print depicts an artificial island in the bay called Tsukishima, which is part of Chuo, a ward in the city's business district. Sugiyama knew this district well, for he himself had a successful business career in Tokyo. It was not until he retired at the age of seventy that he was able to devote himself to art full time. He would have carved a number of blocks to make this complex print, one for each color. As he worked, he would have verified their **registration**, that is, made sure that they would align correctly when printed, with no unwanted gaps or overlapping in the colors.

Wood Engraving

Like a woodcut, a **wood engraving** uses a block of wood as a matrix. But whereas a woodcut matrix is created on a surface cut *along* the grain, a wood engraving matrix is created on a surface cut *across* the grain, an end-grain block. If you imagine a piece of lumber—say a 1-foot length of 2-by-4—then a woodcut would use one of the 4-by-12-inch sides, whereas a wood engraving would use one of the 2-by-4-inch cut ends. Sanded to mirror smoothness and worked with finely pointed tools, an end grain block can be cut with equal ease in any direction and lends itself well to detail.

The tools used for wood engraving cut fine, narrow channels that show as white lines when the block is inked and printed. We can see the effect clearly in Rockwell Kent's *Workers of the World, Unite!* (8.5). The billowing clouds of smoke in the background, the modeling of the man's torso and trousers, and the menacing flames are all defined by fine white lines—narrow channels cut in the block by engraving tools.

Rockwell Kent created his urgent image in response to the Great Depression of the 1930s. During that difficult decade, many artists' sympathies lay with industrial workers and their efforts to unionize in order to have a collective voice in their own future. In Kent's image, a lone, heroic worker wields a shovel against the threat of oncoming bayonets. The fire provides a sense of disaster, while in the background can be seen a factory, the source of the worker's livelihood. With its combination of dramatic nighttime lighting, a common worker, and anonymous bayonets, the composition calls to mind Francisco de Goya's martyred Spaniards (see 5.15), now fighting back and refusing to die.

Linocut

A linoleum cut, or **linocut**, is very similar to a woodcut. Linoleum, however, is much softer than wood. The relative softness makes linoleum easier to cut, but it also limits the number of crisp impressions that can be produced, since the block wears down more quickly during printing. Linoleum has no grain, so it is possible to make cuts in any direction with equal ease.

John Muafangejo's *Men are working in Town* shows the almost liquid ease with which linoleum can be cut (**8.6**). One of southern Africa's most beloved artists, Muafangejo devoted most of his artistic career to linocuts. Among his

8.6 John Muafangejo, *Men are working in Town*. 1981. Linocut, 23½ × 16½". © 1995 John Muafangejo Trust

8.5 Rockwell Kent. *Workers of the World, Unite!* 1937. Wood engraving, 8×6 ". Library of Congress, Washington, D.C.

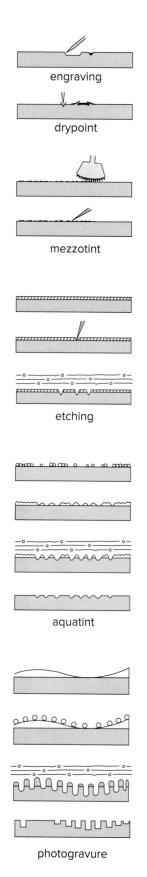

8.7 Platemaking methods for intaglio printing.

recurring themes was the daily life of the region's tribal peoples, who at the time were restricted to "homelands" established under a system of racial segregation known as apartheid. Muafangejo himself was a member of the Ovambo people. Dividing his image into three registers, Muafangejo depicts men working in town and in the mines, while women milk livestock, feed chickens, and cut down trees. Text labels each activity. Muafangejo wanted his art to be clear, and he said that his style was a "teaching style." Among the things he taught was a generous vision of a society based in racial harmony. In the words of one of his most famous prints, he urged "hope and optimism in spite of the present difficulties."

Intaglio

The second major category of printmaking techniques is **intaglio** (from an Italian word meaning "to cut"), which includes several related methods. Intaglio is exactly the reverse of relief, in that the areas meant to print are *below* the surface of the printing plate. The artist uses a sharp tool or acid to make depressions—lines or grooves—in a metal plate. When the plate is inked, the ink sinks into the depressions. Then the surface of the plate is wiped clean. When dampened paper is brought into contact with the plate under pressure, the paper is pushed into the depressions to pick up the image.

There are six basic types of intaglio printing: engraving, drypoint,

mezzotint, etching, aquatint, and photogravure.

Engraving

The oldest of the intaglio techniques, engraving developed from the medieval practice of incising (cutting) linear designs in armor and other metal surfaces. The armorer's art had achieved a high level of expertise, and it was just a short step to realizing that the engraved lines could be filled with ink and the design transferred to paper.

The basic tool of engraving is the burin, a sharp, V-shaped instrument used to cut lines into the metal plate (8.7). Shallow cuts produce a light, thin line; deeper gouges in the metal result in a thicker and darker line. Engraving is closely related to drawing in pen and ink in both technique and the visual effect of the work. Looking at a reproduction, it is hard to tell an engraving from a fine pen drawing. In both media, modeling and shading effects usually are achieved by hatching, cross-hatching, or stippling.

Until the invention of lithography and photography in the 19th century, engravings were the principal way in which works of art were reproduced and disseminated. Professional engravers were extraordinary draftsmen, capable of making extremely accurate copies of drawings, paintings, statues, and architecture. During the Renaissance, the awakening interest in ancient Roman art was fed by engravings, for no sooner was a newly discovered statue unearthed than it was recorded in a drawing, which was then engraved and distributed across Europe.

One of the greatest Renaissance printmakers was Albrecht Dürer. Although he considered himself primarily a painter, it was prints that brought Dürer his greatest renown. (They also brought him a steady income. Toward the end of his life, he noted that he would have made more money if he had stuck to engravings.) Between 1513 and 1514, Dürer created three prints so technically and artistically sophisticated that they have become known as the Master Engravings. One of these is *Saint Jerome in His Study* (8.8).

Jerome is depicted working patiently on his Latin translation of the Bible, his great life's work. Light floods in from the window, illuminating a calm interior constructed according to the principles of linear perspective, which Dürer

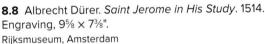

8.9 Louise Bourgeois. *Spider*. 1995. Drypoint, 15^{15} /₆ × 11^{13} /₆". The Museum of Modern Art, New York

had been at pains to learn on his two trips to Italy. In case we are in any doubt about just who it is we are looking at, standard elements of the iconography of Saint Jerome are present to reassure us: on the wall behind Jerome's head hangs his cardinal's hat. (A cardinal is a senior official of the Catholic Church.) In the foreground sleeps the lion that is said to have befriended the saint after he removed a thorn from its paw. A skull, a reminder of death, sits on the windowsill. Jerome would see it in the background if he were to glance up at the small crucifix on his desk, itself a reminder of Christ's death and of the promise of everlasting life. The rich chiaroscuro modeling and varied textures are accomplished entirely with fine hatching, cross-hatching, and stippling.

Drypoint

Drypoint is similar to engraving, except that the cutting instrument used is a drypoint needle. The artist draws on the plate, usually a copper plate, almost as freely as one can draw on paper with a pencil. As the needle scratches across the plate, it raises a burr, or thin ridge of metal (see 8.7). If left in place, the burr will hold ink along with the incised line, producing a soft, slightly blurred line when printed. The burr can also be scraped away, in which case the incised line only will hold ink, producing a fine, delicate line. Louise Bourgeois left the burr in place to produce the soft, rich blacks of *Spider* (8.9). Spiders were a recurring subject for Bourgeois, for whom they symbolized a protective, maternal presence. We illustrate one of her monumental sculptures of a spider in Chapter 11 (see 11.1).

ARTISTS Albrecht Dürer (1471–1528)

What influences of northern and southern European art can be found in the works of Dürer? How can we describe his approach to making art? What is his definition of aesthetics?

lbrecht Dürer is the first of the northern European artists who seems to us "modern" in his outlook. Unlike most of his colleagues, he had a strong sense of being an *artist*, not a craftsman, and he sought—and received—acceptance in the higher ranks of society. Moreover, Dürer appears to have understood his role in the history of art—sensed that his work would exert great influence on his contemporaries and on artists of the future. That awareness led him to date his works and sign them with the distinctive "AD" (visible in the left background of his self-portrait)—a fairly unusual practice at the time.

Born in the southern German city of Nuremberg, Dürer was the son of a goldsmith, to whom he was apprenticed as a boy. At the age of fifteen, young Albrecht was sent to study in the workshop of Michael Wolgemut, then considered a leading painter in Nuremberg. He stayed with Wolgemut for four years, after which he began a four-year period of wandering through northern Europe. In 1494 Dürer's father called him back to Nuremberg for an arranged marriage. (The marriage seems not to have been a happy one and produced no children.) Soon afterward, Dürer established himself as a master and opened his own studio.

Dürer made a great many paintings and drawings, but it is his output in prints (engravings, woodcuts, and etchings) that is truly extraordinary. Many people would argue that he was the greatest printmaker who ever lived. His genius derived partly from an ability to unite the best tendencies in northern and southern European art of that period, for Dürer was a well-traveled man. In 1494 he visited Italy, and he returned in 1505, staying two years in Venice, where he operated a studio. This second trip was a huge success, both artistically and socially. The artist received many commissions and enjoyed the high regard of the Venetian painters as well as of important patrons in the city. Upon his return to Germany, Dürer took his place among the leading writers and intellectuals of Nuremberg, who seem to have valued him for his knowledge and wit, as well as for his art. In 1515 he was appointed court painter to the Holy Roman Emperor Maximilian I.

The last years of Dürer's life were devoted largely to work on his books and treatises, through which he hoped to teach a scientific approach to painting and drawing. As a Renaissance artist, he was fascinated by perfection and by an ideal of beauty. He wrote: "What beauty is, I know not, though it adheres to many things. When we wish to bring it into our work we find it very hard. We must gather it together from far and wide, and especially in the case of the human figure throughout all its limbs from before and behind. One may often search through two or three hundred men without finding amongst them more than one or two points of beauty which can be made use of. You, therefore, if you desire to compose a fine figure, must take the head from some, the chest, arm, leg, hand, and foot from others; and likewise, search through all members of every kind. For from many beautiful things something good may be gathered, even as honey is gathered from many flowers.'

Albrecht Dürer. Self-Portrait at Age 28. 1500. Oil on wood, $26\frac{5}{6} \times 19\frac{5}{6}$ ". Alte Pinakothek, Munich.

Mezzotint

Almost all the major printmaking techniques developed anonymously. We do not know who was the first person to make a woodcut, or who first realized that the lines incised into metal for decoration could also hold ink and be pressured into printing. With **mezzotint**, however, we know precisely who invented it, and when: it was devised by a 17th-century amateur artist named Ludwig von Siegen, who lived in Utrecht, in the Netherlands. In 1642 Von Siegen sent a print created with his new technique to the king of the Netherlands, together with a letter boasting that "there is not a single engraver, a single artist of any kind, who can account for, or guess how this work is done." Mezzotint was indeed something new in printing, a method for producing finely graded tonal areas—areas of gray shading into one another—without using line.

Mezzotint is a reverse process, in which the artist works from dark to light. To prepare a mezzotint plate, the artist first roughens the entire plate with a sharp tool called a rocker. If the plate were inked and printed after this stage, it would print a sheet of paper entirely black, because each roughened spot would catch and hold the ink. Lighter tones can be created only by smoothing or rubbing out these rough spots so as not to trap the ink. To do this, the artist goes over portions of the plate with a burnisher (a smoothing tool) and/or a scraper to wear down the roughened burrs (see 8.7). Where the burrs are partially removed, the plate will print intermediate values. The lightest values print in areas where the burrs are smoothed away entirely.

Mezzotint found immediate favor as a method for reproducing famous paintings in black and white, thus making them available to a broad audience. Though less often used today for original prints than other techniques, it is still the first choice for artists who want a seamless range of values at their disposal, especially if they work on a small scale. Susan Rothenberg's *Mezzo Fist #1* illustrates clearly the reverse process of mezzotint, where the artist fishes up lighter values from a black ground (8.10). Ranging from dark gray to brilliant white, Rothenberg's image resembles a chalk drawing on a blackboard, complete with erasures—an effect only possible with mezzotint.

8.10 Susan Rothenberg. *Mezzo Fist #1*. 1990. Mezzotint on paper, image size $19\frac{1}{2} \times 19\frac{1}{2}$ ". Smithsonian American Art Museum, Washington, D.C.

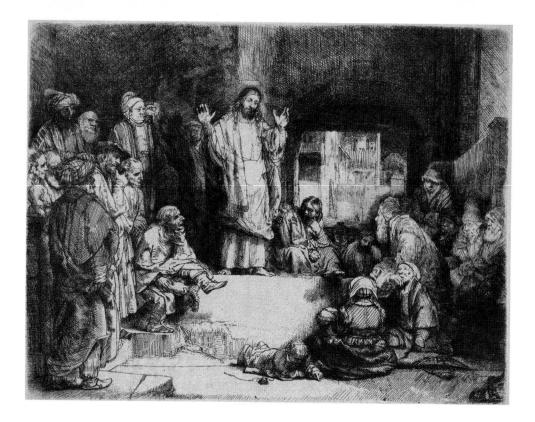

8.11 Rembrandt van Rijn. *Christ Preaching*. c. 1652. Etching, 6½ × 8". Rijksmuseum, Amsterdam

Etching

Etching is done with acids, which "eat" lines and depressions into a metal plate much as sharp tools cut those depressions in the other methods. To make an etching, the artist first coats the entire printing plate with an acid-resistant substance called a ground, made from beeswax, asphalt, and other materials. Next, the artist draws on the coated plate with an etching needle. The needle removes the ground, exposing the bare metal in areas meant to print (see 8.7). Then the entire plate is dipped in acid. Only the portions of the plate exposed by the needle are eaten into by the acid, leaving the rest of the plate intact. Finally, the ground is removed, and the plate is inked and printed. Etched lines are not as sharp and precise as those made by the engraver's burin, because the biting action of the acid is slightly irregular.

Rembrandt van Rijn, who was a prolific printmaker, made hundreds of etchings. Unfortunately, many of his plates were not canceled or destroyed. Long after his death, and long after the plates had worn down badly, people greedy to produce yet more "Rembrandts" struck impressions from the plates. These later impressions lack detail and give us little idea of what the artist intended. To get a true sense of Rembrandt's genius as an etcher, we must look at prints that are known to be early impressions, such as this impression of *Christ Preaching* (8.11). Using only line, Rembrandt gives us a world made of light and shade. He has set his scene in a humble quarter of town, possibly modeled on the Jewish section of the Amsterdam he knew well. Barefoot and bathed in sunlight, Christ preaches to the small but curious crowd that has gathered. His attention falls for a moment on the little boy in the foreground, who, too young to understand the importance of what he is hearing, has turned away to doodle with his finger in the dust. Rembrandt's greatness lay in part in his ability to imagine and portray such profoundly human moments.

Aquatint

A variation on the etching process, **aquatint** is a way of achieving flat areas of tone—gray values or intermediate values of color. Aquatint was invented around 1650 by a Dutch printmaker named Jan van de Velde, but it was not

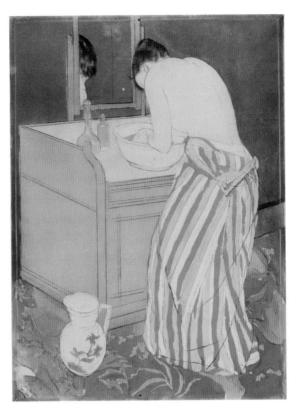

8.13 Mary Cassatt. Woman Bathing. 1891. Drypoint and aquatint, $14\frac{5}{6} \times 10\frac{1}{2}$ ". National Gallery of Art, Washington, D.C.

until the technique was included in two French printmaking manuals over a century later that it finally became widely known among artists.

To prepare a plate for aquatint, the artist first dusts it with finely powdered resin. The plate is then heated so that the resin sticks to it. Resin resists acid, so when the plate is immersed in acid, the acid will bite all around the resin particles, producing a pitted surface that holds ink evenly. The longer the acid bath, the deeper the bite; the deeper the bite, the more ink it will hold, and the darker it will print. To achieve a variety of tones with the same plate, the artist works in stages. First, areas that are not to be bitten at all, where the white of the paper will show untouched, are stopped out-painted with an acid-resistant varnish. The plate is then immersed in acid until the bite is deep enough to print the lightest desired tone. The areas that are to print in the lightest tone are then stopped out, and the plate is returned to the acid until the bite is deep enough to produce the second lightest tone. These areas are then stopped out, and the plate is returned to the acid yet again. The process continues until the full range of desired tones has been achieved. The resin and stop-out varnish are then scrubbed away using a solvent, and the plate is ready to be inked and printed.

Spanish artist Francisco de Goya used aquatint for his satirical print *Asta su Abuelo* (*And So Was His Grandfather*, **8.12**). Goya depicts an ass proudly displaying his family genealogy. It's clear that he comes from a long line of asses. Goya's immediate target was the Spanish aristocracy of his day, which inherited power and privilege thanks to noble pedigrees that went back for centuries. But we can easily update the satire to poke fun at people in our own time who are inordinately pleased with themselves. The graininess of the distinct tonal areas is typical of aquatint.

Because aquatint prints not lines but only areas of tone, it is usually combined with one of the other intaglio techniques—drypoint, etching, or engraving. Mary Cassatt employed the delicate line of drypoint for the contours of her exquisite *Woman Bathing* (8.13). The colors were printed in aquatint.

Aquatint lends itself beautifully to areas of unmodulated, translucent color, and it allowed Cassatt to transpose the effects of the Japanese woodcuts she admired so much to a European medium.

By combining techniques, the intaglio artist can get almost any result he or she wishes. Because the artist can achieve effects ranging from the most precisely drawn lines to the most subtle areas of tone, the possibilities for imagery are much greater than in the relief methods.

Photogravure

Developed during the 19th century, **photogravure** is an etching technique for printing photographic images. Like mezzotint, photogravure can print continuous tones, tones that shade evenly from light to dark. Like aquatint, it uses powdered resin to create a plate that can hold tone. We describe the process here for a black-and-white photograph, though color photographs can also be printed.

To create a photogravure, a full-size positive transparency of the photographic image is placed over a sheet of light-sensitized gelatin tissue (gelatin backed with paper) and exposed to ultraviolet light. The gelatin hardens in proportion to the amount of light it is exposed to, beginning on the surface and extending gradually downward. Thus, light passing through a blank area on the transparency will eventually harden the entire thickness of the gelatin; during the same amount of exposure time, light passing through gray areas will harden the gelatin only partway down, leaving a soft lower layer.

After exposure, the gelatin tissue is attached face down to a copper plate, reversing the image. (The paper backing is now on top.) The plate is placed in a bath of warm water, which causes the paper to float free and the soft gelatin to dissolve away, leaving only the hardened gelatin attached to the plate. What remains is a low relief of the image in hardened gelatin in which lighter areas are raised (the gelatin layer is thicker) and darker areas are sunken (the gelatin layer is thinner). This gelatin surface is now dusted with resin, as for aquatint, and the plate is heated to bind the resin to the surface. When the plate is immersed in acid, the acid eats through the gelatin and into the plate below, etching it. Because the gelatin varies in thickness, the bite will vary in depth: By the time the acid has eaten through the thickest layers of gelatin to reach the plate, the lowest layers will be deeply etched. The deeply etched areas will print velvety darks, the barely etched areas will print pale tones.

Photogravure was initially used to print photographs and photographic reproductions of paintings as book illustrations. Now that many contemporary artists are routinely working with photographic images, photogravure has become newly interesting as a printmaking technique. In Lorna Simpson's *Counting* (8.14), the three photographic images—the woman in a white dress, the small brick hut, the circles of braided hair—were printed using photogravure; the text labels were printed using silkscreen (discussed later in this chapter). Simpson's work often juxtaposes text and images, inviting us to explore their associations and make our own meanings. Her larger subject is African-American experience, especially women's experience.

Lithography

Like mezzotint, **lithography** owes its existence to a single inventor, in this case a young German actor and playwright named Alois Senefelder. While living in Munich during the 1790s, Senefelder began to experiment with etching processes in an effort to find an inexpensive way to print music, which had traditionally been engraved. Too poor to invest much money in copper plates, he tried working on the smooth Bavarian limestones that lined the streets of Munich, which he excavated from the street and brought to his studio. One day, when

8.14 Lorna Simpson. *Counting*. 1991. Photogravure and silkscreen, 6'1³/₄" × 3'1¹/₂".

Whitney Museum of American Art

he was experimenting with ingredients for drawing on the stone, his laundress appeared unexpectedly, and Senefelder hastily wrote out his laundry list on the stone, using his new combination of materials—wax, soap, and lampblack. Later, he decided to try immersing the stone in acid. To his delight he found that his laundry list appeared in slight relief on the stone. That event paved the way for his development of the lithographic process. Although the relief aspect eventually ceased to play a role, the groundwork for lithography had been laid.

Lithography is a **planographic** process, which means that the printing surface is flat—not raised as in relief or depressed as in intaglio. It depends, instead, on the principle that oil and water do not mix. To make a lithographic print, the artist first draws the image on the stone with a greasy material—usually a grease-based lithographic crayon or a greasy ink known by its German name, *tusche*. The stone is then subjected to a series of procedures, including treatment with an acid solution, that fix the drawing (bind it to the stone so that it will not smudge) and prepare it to be printed. To print the image, the printer dampens the stone with water, which soaks into the areas *not* coated with grease. When the stone is inked, the greasy ink sticks to the greasy image areas and is repelled by the water-soaked background areas. Although limestone is still the preferred surface for art prints, lithographs can also be made using zinc or aluminum plates.

For artists, lithography is the most direct and effortless of the print media, for they can work as freely with lithographic crayons and tusche on stone as they do with regular crayons and ink on paper. Preparing the stone for printing and the printing itself are highly specialized skills, however, and artists usually work on their lithographs at a printer's workshop, often directly under

the printer's guidance.

Philip Guston's *Curtain* illustrates well the direct quality of lithography (8.15). If you did not know it was a print, you could easily mistake it for a drawing in conté crayon. As often in Guston's work, the mood in *Curtain* is both

8.15 Philip Guston. *Curtain*. 1980, published 1981. Lithograph, image size (irregular) $29\frac{3}{4} \times 40\frac{3}{16}$ ". The Museum of Modern Art, New York

8.16 Elizabeth Catlett. Singing Their Songs. 1992. Color lithograph, 23×19 ".

Moore Energy Resources Elizabeth Catlett Collection, Washington, D.C. ominous and comic. Bulbous heads marked by a single staring eye loom up from the horizon—or are they sinking into the sand? One figure holds a cigarette, another has a bandage on his cheek and tape over his mouth. They seem wary and watchful. Three of them look expectantly at the smoker, who stares at the naked lightbulb overhead as though there were something suspicious about it. The curtain has risen on this little piece of theater. Or is it about to fall?

Color lithographs can be made by using one stone for each color. To ensure correct registration, an outline of the image is first transferred to each stone using a nongreasy substance that will not print. The stones are then worked and prepared in the normal way. Elizabeth Catlett employed flat colors, patterned grounds, and precise contours for her color lithograph *Singing Their Songs* (8.16). *Singing Their Songs* is one of a series of prints that Catlett made based on lines from Margaret Walker's remarkable poem "For My People." A touchstone of African-American literature, "For My People" builds its considerable power through repetition, with each stanza lifting its voice again in dedication. Catlett echoes this device, dividing her composition into four spaces the way a poem is divided into stanzas, and using each space to celebrate a new group—the people singing their songs, the people saying their prayers, the wise elders looking on, the young with their eyes on the future.

Screenprinting

To understand the basic principle of **screenprinting**, you need only picture the lettering stencils used by schoolchildren. The stencil is a piece of cardboard from which the forms of the alphabet letters have been cut out. To trace the letters onto paper, you simply place the stencil over the paper and fill in the holes with pencil or ink.

Today's art screenprinting works much the same way. The screen is a fine mesh of silk or synthetic fiber mounted in a frame, rather like a window screen. (Silk is the traditional material, so the process has often been called **silkscreen** or **serigraphy**—"silk writing.") Working from drawings, the printmaker stops out (blocks) screen areas that are *not* meant to print by plugging up the holes, usually with some kind of glue, so that no ink can pass through. Then the screen is placed over paper, and the ink is forced through the mesh with a tool called a squeegee. Only the areas not stopped out allow the ink to pass through and print on paper (see 8.1).

To make a color screenprint, the artist prepares one screen for each color. On the "blue" screen, for example, all areas not meant to print in blue are stopped out, and so on for each of the other colors. The preparation of multiple color screens is relatively easy and inexpensive. For that reason, it is not unusual to see serigraphs printed in ten, twenty, or more colors.

Ed Ruscha's screenprint *Standard Station* (8.17) takes advantage of the medium's ability to produce broad areas of flat, uniform color. Popularly used for such humble purposes as printing T-shirts and posters, screenprinting is well suited to the banal, everyday subject matter of a roadside gasoline station. The two-toned background was created using a technique called split fountain, in which two colors are placed on a single screen, and their zone of contact is carefully controlled.

Ed Ruscha has lived in Los Angeles since his student days, and one way to understand his work is to think of the giant white letters of the famous HOLLYWOOD sign that can be seen there against the hills. The dramatic diagonal of Ruscha's gasoline station projects the word STANDARD across the page as boldly as a beam of light projecting a film title onto a screen. Indeed, the sign itself resembles a movie theater marquee. Standard Oil was the name of the first and most famous of all oil companies. But Ruscha leaves out the word "oil" so that "standard" can take on its other meanings as well: a norm, a benchmark, a banner, a flag. His image of a standard station slyly links two fundamental elements of American life, our love affair with the movies, and our love affair with the automobile.

8.17 Ed Ruscha. *Standard Station*. 1966. Screenprint, image size $19\% \times 36^{15}\%$.

The Museum of Modern Art, New York

Monotype

There is one major exception to the rule, stated at the beginning of this chapter, that prints are an art of multiples. That exception is the **monotype**. Monotypes are made by an indirect process, like any other print, but, as the prefix "mono" implies, only one print results. To make a monotype, the artist draws on a metal plate or some other smooth surface, often with diluted oil paints. Then the plate is run through a press to transfer the image to paper. Or the artist may simply place a sheet of paper on the plate and hand-rub it to transfer the image. Either way, the original is destroyed or so altered that there can be no duplicate impressions. If a series of prints is planned, the artist must do more work on the plate.

Monotype offers several technical advantages. The range of colors is unlimited, as is the potential for lines or tones. No problems arise with cutting against a grain or into resistant metal. The artist can work as freely as in a direct process such as painting or drawing. Yet the medium is not as simple and straightforward as it seems, for the artist cannot be quite sure how the print will look when it comes through the press. Transferred by pressure from a nonabsorbent surface such as metal to the absorbent surface of paper, colors may blend and spread and contours may soften. The textures of brush strokes on the plate disappear into flatness on the paper. Differences between plate and print may be minute or dramatic, and the artist may try to control them as much as possible or play with the element of chance that they bring to the creative process.

Nicole Eisenman's whimsical, untitled monoprint depicts a romantic encounter between an unshaven man and a pet bird that seems to take them both by surprise (8.18). Brush strokes from where the paint was laid down on the plate are clearly visible in the sky and on the man's hand and torso. Eisenman enjoys visual puns, and the image may have been inspired by our idiom for a quick, light kiss: a peck on the lips.

8.18 Nicole Eisenman. *Untitled*. 2012. Monoprint on paper, 23½ × 19½", unique. Private Collection, New York. Courtesy the artist and Koenig & Clinton, New York

Inkjet

According to the traditional definition, a print is made from a matrix. For a woodcut or a wood engraving, for example, the matrix is a piece of wood; for a lithograph, the matrix is a slab of stone. Within the past few years, however, this definition has been blurred by the acceptance of digital inkjet prints as a fine-art medium. The inkjet printers used for fine-art prints are more sophisticated versions of the printers that many people have connected to their home computer. Like a home printer, a high-quality printer creates an image from a digital file by spraying mists of ink at a receptive surface such as a sheet of paper; there is no matrix. A high-quality printer is capable of printing with more colors than a home-grade printer, however, and it uses finer, pigment-based inks formulated to resist fading or altering in color over time.

British artist Fiona Rae generates the initial compositions for her paintings on the computer. "I use Photoshop as if it were a sophisticated photocopier," she says. "I can feed an image into it and flip the colors around to come up with a set of colors that might have taken me years to figure out by hand." Once the composition has reached a certain point, Rae freely paints a version of it onto a large canvas and continues from there. To create her inkjet print *Cute Motion!!*, she revisited a digital composition linked to one of her paintings and developed it further on its own (8.19). Brush strokes, paint drips, graphic symbols, flowers, letter forms, plant forms, tiny animals, and more all clamor for space and attention in a sort of joyful cacophony. Each print is finished by hand with three-dimensional elements pasted on—google eyes, small beaded flowers, tiny fuzzy spheres, and a small satin bow. *Cute Motion!!* is definitely not taking itself too seriously. This is art that just wants to have fun.

8.19 Fiona Rae. *Cute Motion!!* 2006. Inkjet with hand collage, 29 × 23". Edition of 40.

© Fiona Rae, courtesy Timothy Taylor Gallery and Pace Editions

Recent Directions: Printing on the World

Thanks to industrial versions of engraving, lithography, screenprinting, and inkjet, images are routinely printed on almost every imaginable surface around us—balloons, clothing, ceramics, CDs, packaging, textiles, wallpaper, decals, electronics, and more. Perhaps it should not surprise us, then, that artists are increasingly taking printed images into the third dimension as well. Like drawing and painting, prints today have left the wall to find a place in sculptures and installations.

Pepón Osorio's You're Never Ready consists of an X-ray image of his mother's skull printed onto a thick bed of black and white confetti (8.20). The confetti sits on the floor, as though it had been swept up after a party or a parade. Osorio came across the X-ray while he was cleaning out his mother's house after she had been moved to a care facility. He recalls staring at it and wondering what it meant. His reaction was to enlarge the image to 10 feet in height and make an inkjet print of it. The hard part was persuading someone to take on the challenge of printing on 100 pounds of confetti. ("It took me only, like, seven months to convince a printer to do it," Osorio says. "Everyone who I went to said forget it, you're crazy, I'm not doing this.") The surface Osorio chose to print on contributes to the meaning of the work in a way that a simple sheet of paper would not have, for confetti is closely associated with festive, celebratory occasions. Osorio envisioned You're Never Ready as a way of celebrating his mother's life and preparing himself for her death, though as his title indicates, one can never be truly ready.

8.20 Pepón Osorio. *You're Never Ready*. 2009. Inkjet on confetti, MDF support, loose confetti; 8' × 6' × 2".

Courtesy the Artist and Ronald Feldman Fine Arts, New York

Pepón Osorio's print belongs to the artistic tradition of *memento mori*, objects that remind us of our mortality (from the Latin, "remember that you must die"). Dario Robleto's work, in contrast, often has its roots in mourning, consolation, and remembrance, ways in which the living cope with loss. Robleto makes sculptures from evocative, emotionally charged fragments of the past. The hundreds of lights that call to us from the darkness in *Candles Un-burn, Suns Un-shine, Death Un-dies* are stage lights taken from album covers of live concerts by musicians who have since died (8.21). Music and the vinyl records that preserved it for so long are fundamental references for Robleto, who has compared his work to that of a DJ—sifting through half-forgotten recordings, looking for compelling moments that can be sampled or mixed to create something new.

Robleto arranged his hundreds of lights in a composition based on the Hubble Deep Field, a celebrated photographic image that captures numerous distant galaxies as they were billions of years ago. He printed his composition on vinyl wallpaper and set it on a curved, freestanding partition that embraces whoever stands to contemplate it. The album covers that the lights were taken from—by Patsy Cline, Bob Marley, Marvin Gaye, and many other musicians—belonged to Robleto, his mother, and his grandmother. One of the themes of the sculpture is how affection for certain musicians and songs is passed from one generation to the next. With age, the pleasure of listening gains an undertow of sadness as we are reminded of the people who listened before us who are no longer here.

With Caledonia Curry, better known as Swoon, prints return to the wall—but this time the wall is outdoors. Swoon makes large linocuts and woodcuts on lightweight paper, cuts the images free of their ground, then pastes them

8.21 Dario Robleto. Candles Un-burn, Suns Un-shine, Death Un-dies. 2011. Inkjet print on custom vinyl wall paper, 61° curved wall; 10' × 22½'. Courtesy the artist and ACME, Los Angeles

8.22 Swoon (Caledonia Curry). *Untitled (Kamayurá Woman).* 2011. Street installation in Brooklyn, New York, 2014. Hand-colored linocut, height approx. 8'.

up on urban walls and barriers (8.22). "For me pasting is about many things," she says, "and one of them is about declaring the walls of the city a public sounding board for our dreams, desires, and collective identity. I see these walls as a ground level, reachable and seeable-by-the masses bulletin board for a million voices needing outlets. And I am one of them."

Swoon's subjects are ordinary people, looked at closely, she says. She created the portrait illustrated here while traveling in Brazil in 2011. A young Kamayurá woman rises up like a spirit over a construction site, holding before her an emblematic arrangement of vegetation and wildlife. The Kamayurá are one of several indigenous peoples who were then fighting the Brazilian government's project to build a huge hydroelectric dam on the Xingu River, the principal river of their region and a major tributary of the Amazon. (They and the environmental groups protesting alongside them did not prevail. As of this writing, the dam is under construction, though it is still being contested.)

Swoon began her career as a street artist, but her work quickly drew the attention of an adventurous gallery owner, who invited her to create an installation. A number of museums have since followed his lead. "It's not street art once it's inside, but nitpicking over titles and definitions is a waste of precious breath," she says. "Just make something good."

9

Camera and Computer Arts

n the world of art, the camera and the computer were born yesterday. Although the earliest known drawn and painted images date back to the Stone Age, and the earliest surviving print was made well over one thousand years ago, images recorded by a camera or created on a computer belong entirely to our own modern era.

The camera relies on a natural phenomenon known since antiquity: that light reflected from an object can, under controlled circumstances, project an image of that object onto a surface. It was not until the 19th century, however, that a way was found to capture and preserve such a projected image. With that discovery, photography was born, and after photography, film and video,

which recorded the projected image in motion over time.

The computer, too, is rooted in discoveries of earlier times. The first true computer, an electronic machine that could be programmed to process information in the form of data, was built around 1938. Early computers were so large that a single machine occupied an entire room! Over the following decades, technological advances chipped away at the size even as they made computers faster, more powerful, more affordable, and easier to use. Beginning around 1980, the pace of change accelerated so dramatically that we have come to speak of a digital revolution. The personal computer, the compact disc, the scanner, the World Wide Web, the digital video disk, and the digital camera appeared in rapid succession, together making it possible to capture, store, manipulate, and circulate text, images, and sound as digital data. With the digital revolution, the camera and the computer became intertwined.

Camera and computer technologies are essential to business, advertising, education, government, mass media, and entertainment. They have commercial applications and personal applications, and they are widely available to both professional organizations and individual consumers. Among these individuals are artists, who have carved out a space for human expression within the vast flow of information and images that the camera and the computer have enabled. This chapter explores the camera arts—photography, film, and video—from their beginnings through the digital revolution. Then it looks at how artists have worked with the possibilities opened up by the global reach

of the Internet.

Photography

The earliest written record that has come down to us of the principle behind photography is from a Chinese philosopher named Mo Ti, who lived during the 5th century B.C.E. Mo Ti noticed that light passing through a pinhole opening into a darkened chamber would form an exact view of the world outside, but upside down. A century or so later, the ancient Greek philosopher Aristotle observed similar phenomena, and he wondered what caused them. Early in the 11th century C.E., the Arab mathematician and physicist Abu Ali Hasan Ibn al-Haitham, known in the West as Alhazen, set up an experiment in a dark room in which light from several candles passed through a pinhole in a partition, projecting images of the candle flames onto a surface on the other side. From his observations, Alhazen deduced (correctly) that light travels in straight lines, and he theorized (also correctly) that the human eye worked along this same principle: light reflected from objects passes through the narrow opening of the iris, projecting an image of the outside world onto a surface in the dark interior. Alhazen's works circulated in translation in Europe, where early scientists continued his investigations into the behavior of light, but it was not until the Renaissance that a practical device was developed to harness those principles. It was known as the camera obscura, Latin for "dark room."

You can make a camera obscura yourself. Find a light-tight room, even a closet or a very large cardboard box. Pierce a small hole, no bigger than the diameter of a pencil, in one wall of the room to admit light. Inside, hold a sheet of white paper a few inches from the hole. You will see an image of the scene outside the room projected on the paper—upside down and rather blurry, but recognizable.

With the development of lenses during the 16th century, the camera obscura could be made to focus the image it projected. Artists of the time, concerned with making optically convincing representations through perspective and chiaroscuro, welcomed this improved camera obscura as a drawing tool. The illustration here (9.1) appeared in a book called *The Great Art of Light and Shadow*, published in 1646. It depicts an elaborate version of a portable camera obscura (note the poles on the ground for carrying it). The roof and the fourth wall have been left out of the illustration to allow us to peer inside. Each of the four outer walls had a lens at its center. (Two lenses are shown

9.1 Camera Obscura, in cutaway view. 1646. Engraving. National Gallery of Art Library, Washington, D.C.

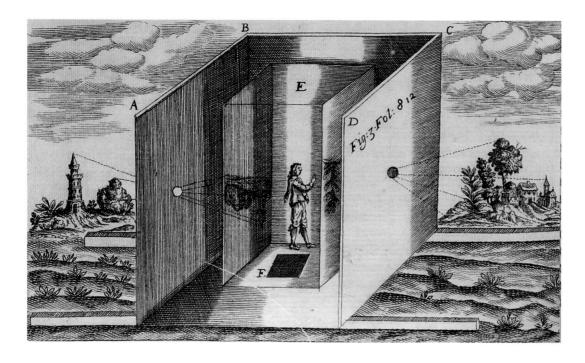

here, at left and right.) Entering through a trapdoor in the floor (marked F), the artist stood in an inner chamber made of four translucent paper screens. (The man here is drawn in miniature—the chamber was not really quite so large!) Each lens projected its view onto the paper chamber, and the artist traced the projections from the other side (thus not getting in the way of the light). It was none other than Leonardo da Vinci who first suggested this arrangement.

diaphragm with aperture (opening) film or array of sensors lens elements

9.2 The basic parts of a camera.

The Still Camera and Its Beginnings

Despite the sophistication of modern photographic equipment, the basic mechanism of the camera is simple, and it is no different in theory from that of the camera obscura. A camera is a light-tight box (9.2) with an opening at one end to admit light, a lens to focus and refract the light, and a light-sensitive surface to receive the light-image and hold it. The last of these—the holding of the image—was the major drawback of the camera obscura. It could project an image—but there was no way to preserve the image, much less walk away with it in your hand. It was to this end that a number of people in the 19th century directed their attention.

One of those investigators was Joseph Nicéphore Niépce, a French inventor. Working with a specially coated pewter plate in the camera obscura, Niépce managed, in 1826, to record a fuzzy version of the view from his window after an exposure of eight hours. Although we may now consider Niépce's "heliograph" (or sun-writing), as he called it, to be the first permanent photograph, the method was not really practical.

Niépce was corresponding with another Frenchman, Louis Jacques Mandé Daguerre, who was also experimenting with methods to fix the photographic image. The two men worked separately and communicated in code to keep their progress from prying eyes. When Niépce died in 1833, his son Isidore continued the experiments. It was Daguerre, however, who in 1837 made the breakthrough, recording an image in his studio that was clear and sharp, by methods that others could duplicate easily. Daguerre's light-sensitive surface was a copper plate coated with silver iodide, and he named his invention the **daguerreotype**.

Daguerre made the image illustrated here in 1839, the year the French government announced his discovery to the world (9.3). In the entrancing detail characteristic of daguerreotypes, it records a seemingly deserted boulevard in

9.3 Louis Jacques MandéDaguerre. Le Boulevard du Temple.1839. Daguerreotype.Bayerisches Nationalmuseum, Munich

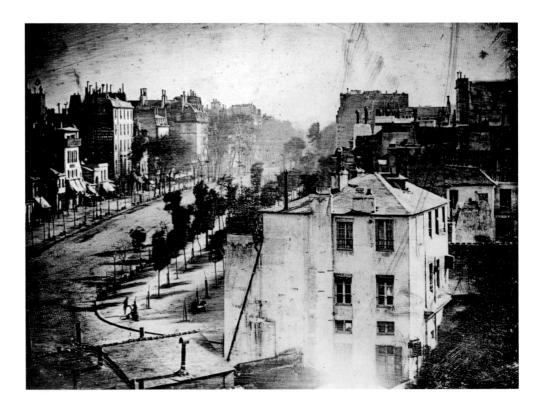

Paris. In fact, the boulevard was a bustling thoroughfare. To record an image, Daguerre's plate needed to be exposed to sunlight for ten or even twenty minutes! The only person to stand still long enough to be recorded was a man who had stopped to have his shoes shined. He and the partially obscured shoe shiner are among the first people ever to appear in a photograph, and certainly the first to have their image taken without knowing it.

Within two years after Daguerre's discovery was made public, dramatic improvements were made. From England came a better method for fixing the final image so that it didn't continue to change in the light, and also a more light-sensitive coating for the plate that reduced exposure time. From Vienna came an improved lens that gathered sixteen times as much light as previous lenses, further reducing exposure time to around thirty seconds. Although still a far cry from the split-second exposures that later technology would make possible, the daguerreotype was now poised to become the first commercially viable method for making permanent images from reflected light.

Daguerre's invention caused great excitement throughout Europe and North America. Entrepreneurs and the general public alike were quick to see the potential of photography, especially for portraits. It is hard to realize now, but until photography came along only the rich could afford to have their likenesses made, by sitting for a portrait painter. Within three years after Daguerre made his first plate, a "daguerreotype gallery for portraits" had opened in New York, and such galleries soon proliferated.

Yet for all its early success, the daguerreotype was ultimately a blind alley for photography. The process produces a *positive* image, an image in which light and dark values appear correctly. This image is unique and cannot be reproduced. The plate is the photograph. The future of photography instead lay with technology that produced a *negative* image, one in which light and dark values were reversed. This negative could be used again and again to create multiple positive images on light-sensitive paper. Instead of a single precious and delicate object, photography found its essence as an art of potentially unlimited, low-cost multiples. An early version of the negative/positive print process was the calotype, which used a paper negative. Toward the middle of the 19th century, the vastly superior collodion process was developed, which produced a negative on glass.

Portraits remained an important use of the new medium, providing a steady source of income for commercial photographers. One of the finest portraitists of the time, however, was an amateur, an English woman named Julia Margaret Cameron. Cameron's social circle included some of the most famous writers, artists, and intellectuals of her time, and she drew on her friendships to create memorable portraits of such luminaries as the naturalist Charles Darwin, the American poet Henry Wadsworth Longfellow, the Shakespearean actress Ellen Terry, and the English poet Alfred, Lord Tennyson. Some of Cameron's loveliest photographs, though, portray someone who was not famous at all, her niece Julia Jackson (9.4). In contrast to the sharp focus and even lighting preferred by commercial portrait photographers, Cameron explored more poetic effects, with a softened focus and a moody play of light and shadow. Julia's calm, forthright gaze reaches out to our time from hers. She was twenty-one years old and about to be married to a man who would soon die. Her second marriage would produce two daughters, one a painter, the other the novelist Virginia Woolf.

The long exposure time and bulky equipment of early photography meant that a photograph was still a special occasion, an occasion for standing still. By the 1880s, however, technical advances had reduced exposure time to a fraction of a second, allowing cameras to capture life as it happened, without asking it to pose. Then, in 1888, an American named George Eastman developed a camera called the Kodak that changed photography forever. Unlike earlier cameras, the Kodak was lightweight and handheld, which meant it could be taken anywhere. Sold with the slogan "You press the button, we do the rest," the camera came loaded with a new invention, a roll of film, enough for one hundred photographs. Users simply took the pictures (which quickly became

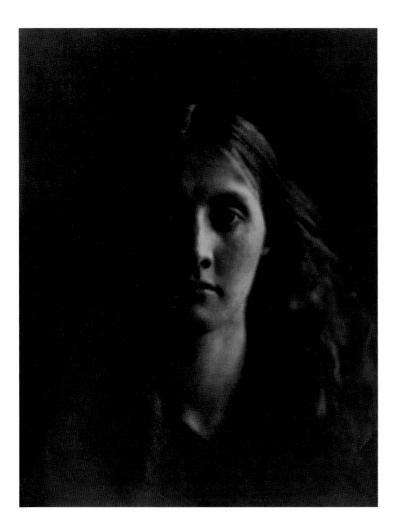

9.4 Julia Margaret Cameron. Julia Jackson. 1867. Albumen print from glass negative, 10^{13} /₆ × 8//₈". The Metropolitan Museum of Art, New York

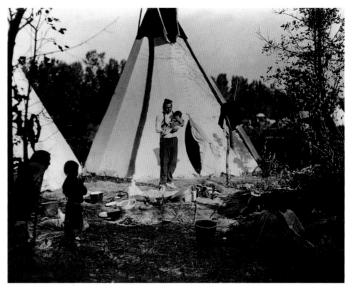

known as "snapshots") and sent the camera back to the company. Their developed and printed photographs were returned to them along with their camera, reloaded with film.

The Kodak and cameras like it opened photography up to amateurs, and it quickly became a popular hobby. Although serious photographers continued (and still continue) to oversee the development and printing of their own work, they, too, benefited from the portable, lightweight technology. Almost anywhere a person could go, a camera could now go; almost anything a person could see, a camera could record. Daily life, the life any one of us lives, became photography's newest and perhaps most profound subject.

Taken in 1910, Crow Camp, 1910 (9.5) records a moment in the life of a Crow Indian family. A man stands in front of a dwelling, a tipi. In his arms he gently cradles a child. His wife and family look on from the foreground. The photograph may record a naming ceremony, a Crow tradition that continues to this day. Many fascinating photographs of American Indians have been preserved from the early decades of photography, most taken by European Americans determined to document what they saw as an exotic, sometimes noble, sometimes savage, but certainly vanishing way of life. What is remarkable about this photograph, however, is precisely that it is unremarkable, an ordinary human moment of family affection and intimacy. Not incidentally, the photographer, Richard Throssel, was an American Indian himself, born with Cree heritage and later adopted by the Crow people. He had been living on the Crow reservation for eight years when he captured this moment. The view is a view from inside, not "this is how we see you" but "this is how we see ourselves, this is what is important to us."

9.5 Richard Throssel.Crow Camp, 1910.Modern print from a negative in the Lorenzo Creel Collection, Special Collections, University of Nevada, Reno Library

Bearing Witness and Documenting

One way in which photography changed the world was in the sheer quantity of images that could be created and put into circulation. Whereas a painter might take weeks or even months to compose and execute a scene of daily life, a photographer could produce dozens of such scenes in a single day. But what purpose could this facility be put to? What was the advantage of quantity and speed? One early answer was that photography could record what was seen as history unfolded, or preserve a visual record of what existed for a time. We could call these purposes bearing witness and documenting, and they continue to play important roles today.

Photographs bearing witness to events appear in newspapers and magazines the world over. It wasn't always this way. Newspapers during the 19th century were illustrated with wood engravings or lithographs. Artists were sent as reporters to major news events or drew images after the fact based on eyewitness accounts. The first important conflict to be documented in photography was the American Civil War. Long exposure times, however, limited the photographs to posed portraits and images of the dead. Any "action" images that appeared with newspaper articles still had to be drawn, and even suitable photographs had to be recopied as engravings or lithographs, for the technology did not yet exist to print photographs commercially on ordinary paper. Then, around 1900, the first process for photomechanical reproduction—high-speed printing of photographs along with type—came into being, and with it a new concept, photojournalism.

Photojournalism quickly became concerned about more than just getting a photograph to illustrate an article. Although a single photograph may be all the general public sees at the time, photojournalists often create a significant body of work around an event, a place, or a culture. A historical episode that brought out the best in many of the finest photographers of the day was the Great Depression in the United States. The Great Depression, which began in 1929 and lasted until the onset of World War II, caused hardships for photographers as well as for the population as a whole. To ease the first problem and document the second, the Farm Security Administration (F.S.A.) of the U.S. Department of Agriculture subsidized photographers and sent them out to record conditions across the nation. One of those photographers was Dorothea Lange.

Dorothea Lange's travels for the F.S.A. took her to nearly every part of the country. In one summer alone she logged 17,000 miles in her car. Lange devoted her attention to the migrants who had been uprooted from their farms by the combined effects of Depression and drought. Lange's best-known image from this time is the haunting *Migrant Mother* (9.6). From this worried mother and her tattered clothing, from the two children who huddle against her, hiding their faces from the stranger with the camera, Lange created a photograph that touched the hearts of the world. "I do not remember how I explained my presence or my camera to her but I do remember she asked me no questions," the photographer recalled years later. "I made five exposures, working closer and closer from the same direction. I did not ask her name or her history. . . ."
F.S.A. photos like this one were offered free to newspapers and magazines.

A photograph, of course, shows us the present moment, a split-second of today. But the present is always slipping into the past, and what exists today may well not exist tomorrow. That basic realization inspires photographers who use their artistic skills to document. Raghubir Singh, for example, devoted much of his career to documenting life in the vast and varied subcontinent of India. Singh realized the importance of his project while traveling around India with a colleague, a famous American photographer. Singh noticed that the subjects that attracted the American were not the same as the ones he himself was drawn to. "I realized that the beauty of my homeland meant little to him," Singh later wrote. Following artistic trends current in the West, the American wanted to create stark black-and-white images of the poorest

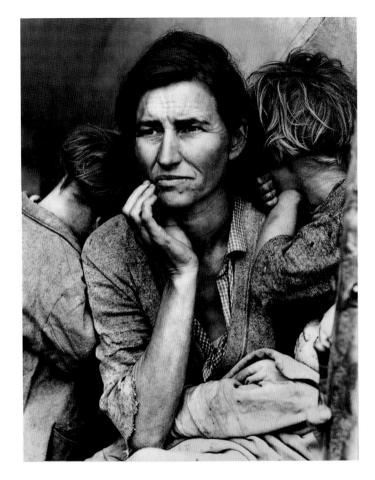

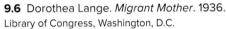

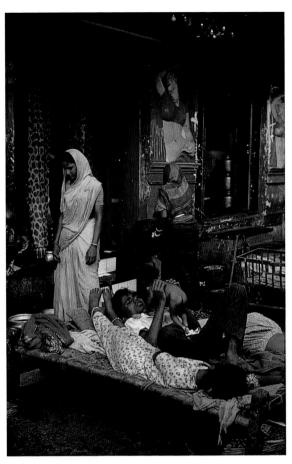

9.7 Raghubir Singh. *A Family, Kamathipura, Mumbai, Maharastra*. 1977.

Photo © 2015 Succession Raghubir Singh

neighborhoods in India's chaotic, overcrowded cities. Singh, in contrast, saw what he described as "the lyric poetry inherent in the life of India." He insisted that it could be captured only in color, which he viewed as an essential element of Indian culture.

The lyric poetry that delighted Singh is evident in his image of *A Family, Kamathipura, Mumbai, Maharastra* (9.7). Formerly known as Bombay, Mumbai is a major metropolis that attracts a constant stream of immigrants from small towns and rural regions. They come to the city looking for work, and many, like this family, end up living on the street. Singh's photograph does not document their condition so much as capture a moment of unexpected beauty and mystery that passed through them. Repeating reds link the scene before us to the poster on the wall. The sensuous woman depicted there seems to have some relationship—though we cannot say precisely what it is—with the gentle woman in yellow who lowers her gaze.

Photography and Art

The development of photography has been seen as freeing painting and sculpture from practical tasks such as recording appearances and events, and it is certainly true that Western artists began to explore the potential of abstraction and nonrepresentation only after photography was well established. Ironically, to many people's way of thinking, the older forms took the definition of "art"

with them, leaving photography to assume many of the traditional functions of art with none of the rewards.

Yet from the beginning there were photographers and critics who insisted that photography could also be practiced as an art. Today, over 150 years later, photography is fully integrated into the art world of museums and galleries, and many artists who are not primarily photographers work with photographic images. This brief section looks at how photography found its way both as an art and into art.

One characteristic of photographs that disqualified them as art in many people's eyes was their sharply detailed objectivity, which seemed to preclude personal expression. Another stumbling block was the medium's increasing popularity and ease. The recently introduced Kodak camera had brought photography within reach of almost everyone, reinforcing the notion that it was simply a matter of framing the view and pushing a button. As Eastman's slogan promised, "we do the rest."

It was precisely "the rest" that obsessed the photographers of the international Pictorialist movement, the most influential of the movements that sought to have photography accepted as an art. Pictorialists embraced labor-intensive printing techniques that allowed them to blur unwanted detail, enhance tonal range, soften focus, and add highlights and delicate veils of color, resulting in images that drew close to painting in their effects. A classic example of Pictorialism in America is Edward Steichen's *The Flatiron* (9.8). One of New

9.8 Edward J. Steichen. The Flatiron. 1904, printed 1909. Gum bichromate over platinum print, $18^{13}\%6 \times 15\%$ ". The Metropolitan Museum of Art, New York

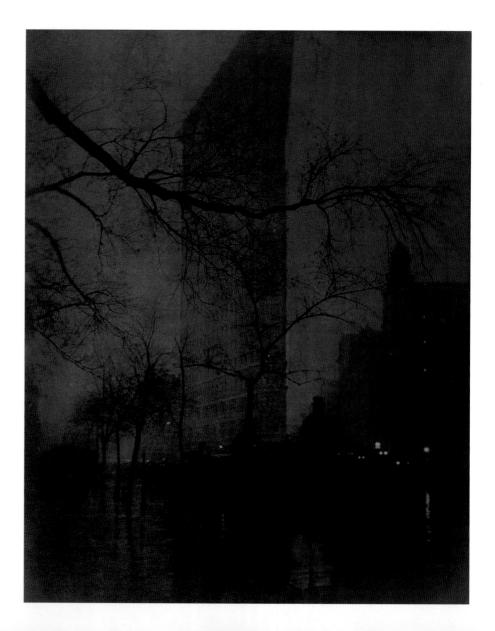

York's early skyscrapers, the Flatiron building was only two years old when Steichen photographed it. His moody, atmospheric image bears a clear debt to Whistler's *Nocturne in Blue and Gold* and the Japanese prints that inspired it (see 4.34 and page 99), thus staking a claim to citizenship in the realm of art.

Pictorialism flourished from 1889 until the outbreak of World War I, during which time it successfully demonstrated that photographs could be as beautiful and expressive as paintings. But with developments such as abstraction, Cubism, and nonrepresentation, painting was changing, and photography would change as well. In retrospect, the image that most clearly foretold the new direction was The Steerage, by Steichen's Pictorialist colleague Alfred Stieglitz (9.9). The story of how *The Steerage* was made is often told, both for its inherent drama and because it makes a point about what Stieglitz thought a photograph should be. In 1907 Stieglitz was aboard ship on his way to Europe, traveling first class. One day as he was walking the deck, he happened to look down into the lowest-class section, called steerage. Before him he saw a perfectly composed photograph—the smokestack leaning to the left at one end, the iron stairway leaning to the right at the other, the chained drawbridge cutting across, even such details as the round straw hat on the man looking down and the grouping of women and children below. Stieglitz knew he had only one unexposed plate left (the equivalent of one exposure at the end of a roll of film). He raced to his cabin to get his camera. When he returned, the scene was exactly the same; no one had moved. That one plate became *The Steerage*.

9.9 Alfred Stieglitz. *The Steerage*. 1907. Photogravure, 12⁵/₈ × 10³/₆". The Museum of Modern Art, New York

The type of photography that Stieglitz championed came to be known as "pure" or "straight" photography. Practitioners of straight photography consider it a point of honor not to crop or manipulate their photographs in any way. The composition is entirely visualized in advance, framed with the view-finder, then photographed and printed. With its emphasis on formal values and faithfulness to the essence of the medium, the aesthetic of straight photography was enormously influential for much of the 20th century.

Steichen and Stieglitz practiced photography as an art. Other artists have made photography itself part of the subject of their art, examining its role in society, the particular vision of the world it promotes, and the assumptions we make about it. One of the first artists to look critically at photography was Hannah Höch. Born in 1889, Höch came of age during the decades when photomechanical reproduction first allowed photographic images to appear in newspapers, periodicals, posters, and advertising. Everyday life was suddenly flooded with images, and a constant flow of secondhand reality began to compete with direct experience.

Höch's response was to use these "found" images as a new kind of raw material. In works such as *Cut with the Kitchen Knife* . . . (9.10), she combined images and letters she had clipped from printed sources to portray the overwhelming experience of a modern city with its masses of people and machines. The word *dada* that appears in several places refers to the art movement that Höch belonged to. **Dada** was formed in 1916 as a reaction to the unprecedented slaughter of World War I, which was then being fought. The word *dada* itself has no meaning, for, faced with the horror of mechanized killing and the corruption of the societies that allowed it, Dada refused to make sense in traditional ways. A Dada manifesto written in 1918, the year the war ended, called for an art "which has been visibly shattered by the explosions of the last week, which is forever trying to collect its limbs after yesterday's crash. The best and most extraordinary artists will be those who every hour snatch the

9.10 Hannah Höch. Cut with the Kitchen Knife Dada through Germany's Last Weimar Beer Belly Cultural Epoch. 1919. Collage, 44½ × 35½". Staatliche Museen zu Berlin, Preussischer Kulturbesitz, Nationalgalerie

tatters of their bodies out of the frenzied cataract of life."³ Höch, for her part, spent her life snatching bits and pieces from the frenzied cataract of images.

Another artist formed by the ideas of Dada was Emmanuel Radnitzky, better known as Man Ray. Trained as a painter, Man Ray initially learned photography to document his paintings. When a year or two later he turned his attention to the art of photography itself, he reacted with characteristic Dada abandon: he threw away the camera. Instead of placing himself before the world armed with a camera and film, Man Ray retired to the darkroom and began to experiment with the light-sensitive paper that photographs are printed on. He discovered that an object placed on the paper would leave its own shadow in white when the paper darkened upon exposure to light. Working with that simple idea, he invented a technique he called the rayograph (also known as the rayogram, 9.11). Through such simple strategies as shifting the objects over time, suspending them at various heights over the paper, removing some and adding others, or shifting the light source, Man Ray created mysterious images that looked like ordinary photographs but that did not correspond to preconceived ideas of what a photograph was. Rayographs are far removed from the ideal of straight photography championed by Stieglitz and his followers. Yet, if we think of photography as a tool for making images instead of as a tool for recording the world, then there are no right or wrong ways to use it—only choices, discoveries, and experiments.

One complaint that had been lodged against photography from the very beginning was that it recorded the world in black-and-white instead of in full color. Early techniques for color were in place by around 1910, but it was not until the 1930s that color began to be widely used, and then only in advertising. Serious photographers continued for decades to prefer black-and-white, feeling that color lacked dignity and was suitable only for vulgar commercial photography. Such prejudices began to crumble during the 1960s and 1970s. Today many artists have adopted color photography as a primary means of making images.

9.11 Man Ray. Champs délicieux, second rayogram. 1922. Rayogram, silver salt print, $8\frac{3}{4} \times 7\frac{1}{2}$ ". Musée National d'Art Moderne, Centre Georges Pompidou, Paris

One such artist is Cindy Sherman. Sherman uses photography to create images of herself as someone else, often a woman she has invented or a woman who appears in a famous work of art. The characters that Sherman invents seem to represent types rather than individuals—the abandoned girlfriend, the vengeful hussy, the pert secretary, the society drunk, the party girl, the androgynous youth, and many others. Yet as we look, we realize that these are categories that we ourselves bring to the images, for the photographs are all called simply *Untitled*. Here, for example, is *Untitled #123* (9.12). As you invent a story for the woman Sherman portrays, you will find that you have made assumptions about what kind of person she is, assumptions based in part on the stereotypes you have absorbed through the films, television shows, and advertising images that surround us.

The computer has been welcomed by many artists who work with photography as a natural extension of the medium. Developed during the 1990s, digital cameras use no film at all but, instead, store photographs as data. For photojournalists, digital cameras allow images to be transmitted back to a newspaper over the Internet. For artists, the technology allows them to gather photographic images, feed them into a computer, work with them, and print the end product as a photograph.

9.12 Cindy Sherman. *Untitled #123*. 1983. Chromogenic color print, 5'4½" × 3'8¼".

Courtesy the artist and Metro Pictures Gallery, New York

THINKING ABOUT ART Censorship

What boundaries, if any, should be imposed on artists? How much of the public's reaction should artists take into consideration? Are there works that are no longer creative, cultural expressions, but offensive, obscene artifacts meant only to shock?

n 1857 an Italian nobleman sent an extravagant gift to Queen Victoria of England: a life-size plaster cast of Michelangelo's famous statue of *David* (see 16.8). The Queen sent it off to a museum still in its crate. When she came to have a look at the statue, its nudity so shocked her that officials commissioned a sculptor to create a large white fig leaf to cover the statue's genitals. The leaf was removable. Notified of an upcoming visit by sensitive ladies, museum officials would rush to put the fig leaf in place. After the visitors had departed, they would take it off again.

The 19th century was a great one for fig leaves. Numerous statues were fitted with convenient foliage so that they would not offend contemporary standards about what was acceptable for the refined public to view. Most of those coverings have since been removed,

but disputes over what the public should be allowed to see and who has the right to decide are still very much with us.

One of the most famous controversies of recent decades erupted around the work of a photographer named Robert Mapplethorpe, seen here in a self-portrait taken the year before his death in 1989. Mapplethorpe was known for elegant photographs of flowers, portraits of well-known people, and highly stylized male and female nudes. But he also created a small body of work known as the *X Portfolio*, which featured homoerotic photographs, including some of sadomas-ochistic sexual practices.

In 1988, a touring exhibition was organized that included several images from the *X Portfolio*. Part of the funding for the exhibit came from the National Endowment for the Arts—in other words, from taxpayer monies controlled by Congress. Denouncing the photographs as "morally reprehensible trash," Congressional conservatives moved variously to slash funding for the National Endowment, to eliminate it, to forbid grants to all art deemed offensive, and to deny grants to institutions that had shown offensive art in the past. In this contentious atmosphere, the Mapplethorpe show arrived at the Contemporary Arts Center in Cincinnati in the spring of 1990. On opening day, the museum and its director were indicted by a grand jury on obscenity charges.

Artistic expression is protected as a form of free speech under our Constitution's First Amendment. But free speech is not absolute, and the Supreme Court has historically held that works deemed obscene may be banned. The problem lies in defining where art leaves off and obscenity begins. Acknowledging that the matter is largely subjective, the Court's current standard holds that a work may be considered obscene if an average person applying contemporary community standards would find that it appeals primarily to prurient interests, depicts sexual conduct in an offensive way, and lacks serious artistic value. All three criteria must be met.

In the end, a jury of average citizens in Cincinnati found that Mapplethorpe's work was intended seriously as art, even if it was art they did not personally like. Both the museum and its director were cleared of all charges. The event was not without consequences, however. In 1996, under continuing pressure from conservative organizations, Congress slashed funding for the National Endowment for the Arts, and grants for individual visual artists were eliminated. As of this writing, funding has still not returned to earlier levels.

Robert Mapplethorpe. Self-Portrait. 1988. Photograph.

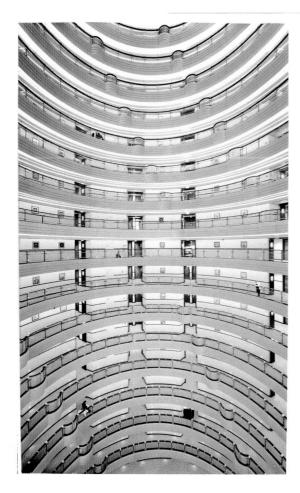

9.14 Thomas Ruff. Substratum 12 III. 2003. C-print and Diasec, image size 8'4" \times 5'5½". Courtesy the artist and VG Bild-Kunst

Andreas Gursky uses both film and digital technology to create works such as Shanghai (9.13). Gursky shoots his initial photographs with a large-format camera on individual 5 \times 7-inch sheets of color film. He scans the resulting negatives into the computer. Using photo-editing software, he combines the negatives into a single seamless image, which he modifies until he is satisfied with every detail. The result is then generated as a new color negative and printed as a photograph—a very large photograph. At almost 10 feet in height, Shanghai has the kind of forceful presence we usually associate with paintings or billboards. In fact, like color and digital manipulation, large sizes were first pioneered in advertising. Gursky's success as an artist makes it possible for him to absorb the costs associated with creating photographs on this scale. It also enables him to travel to such places as Shanghai, where he found this cavernous hotel. A pure product of globalization, the anonymous interior could just as easily be in Atlanta, Sydney, Berlin, or any number of other cities.

Thomas Ruff takes the use of the computer a step further in series of works he calls *Substrata*, meaning underlayers (9.14). Rather than scan his own photographs into the computer, Ruff downloads images he finds on the Internet. For the *Substrata* series, Ruff used images taken from Japanese manga (comic books) and anime (animated films). Ruff layers the images one on top of the other, making them difficult to decipher individually. He manipulates the resulting image, blurring the contours until all traces of recognizable representation have disappeared, then prints the result. Like Gursky, Ruff works on a very large scale. *Substratum* 12 *III*, illustrated here, is over 8 feet in height.

In the tradition of Man Ray, Ruff has produced photographs without the aid of a camera at all. The raw material he uses, anime and manga images, depicts stories about fantasy worlds. When Ruff finds the images, they are

doubly disconnected from reality: once by their imaginary subject matter, and a second time through their virtual existence on the Internet. Layering and blurring them, Ruff further dissolves their stories until they have no memory of their former life, existing only as a glowing, pulsating, jewel-toned field of light on a monitor. Then he gives them material form as a photograph.

Film

Throughout history, artists have tried to create the illusion of motion in a still image. Painters have drawn galloping horses, running people, action of all kinds—never being sure that their depictions of the movement were "correct" and lifelike. To draw a running horse with absolute realism, for instance, the artist would have to freeze the horse in one moment of the run, but because the motion is too quick for the eye to follow, the artist had no assurance a running horse ever does take a particular pose. In 1878 a man named Eadweard Muybridge addressed this problem, and the story behind his solution is a classic in the history of photography.

Leland Stanford, a former governor of California, had bet a friend 25 thousand dollars that a horse at full gallop sometimes has all four feet off the ground. Since observation by the naked eye could not settle the bet one way or the other, Stanford hired Muybridge, known as a photographer of land-scapes, to photograph one of the governor's racehorses. Muybridge devised an ingenious method to take the pictures. He set up twenty-four cameras, each connected to a black thread stretched across the racecourse. As Stanford's mare ran down the track, she snapped the threads that triggered the cameras' shutters—and proved conclusively that a running horse does gather all four feet off the ground at certain times (9.15). Stanford won the bet, and Muybridge went on to more ambitious studies of motion. In 1887 he published *Animal Locomotion*, his most important work. With 781 plates of people and animals

9.15 Eadweard Muybridge. *Horse Galloping*. 1878. Collotype, $9\% \times 12$ ". Library of Congress, Washington, D.C.

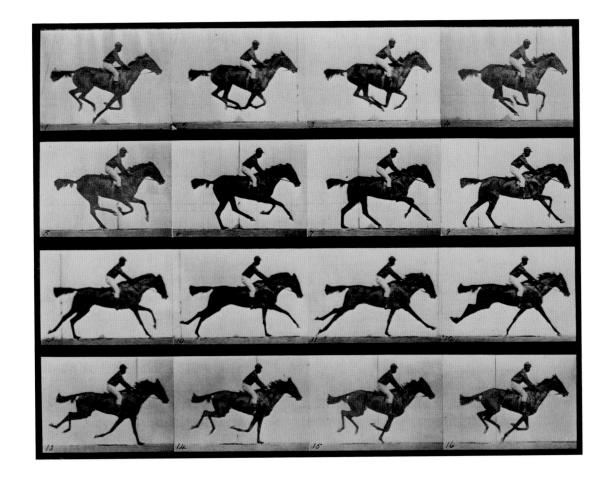

in sequential motion, *Animal Locomotion* allowed the world to see for the first time what positions living creatures really assume when they move.

Eadweard Muybridge's experiments in the 1880s had two direct descendants. One was stop-motion photography, which became possible as both films and cameras became faster and faster. The other was *continuous*-motion photography. Undoubtedly, Muybridge had whetted the public's appetite to see *real* motion captured on film. The little room with a view had glimpsed a different world, a world that does not stand still but spins and moves and dances.

The Origins of Motion Pictures

Film depends on a phenomenon called persistence of vision. The human brain retains a visual image for a fraction of a second longer than the eye actually records it. If this were not true, your visual perception of the world would be continually interrupted by blinks of your eyes. Instead, your brain "carries over" the visual image during the split second while the eyes are closed. Similarly, the brain carries over when still images are flashed before the eyes with only the briefest space between them. Motion-picture film is not real motion but a series of still images projected at a speed of twenty-four frames per second, which makes the action seem continuous.

Interest in moving pictures really predates the development of the still camera. As early as 1832 a toy was patented in Europe in which a series of drawn images, each slightly different from the next, was made to spin in a revolving wheel so that the image appeared to move. Eadweard Muybridge later applied this principle to his multiple photographic images, spinning them in a wheel he called the zoopraxiscope.

Commercial applications of the motion picture, however, awaited three major developments. In 1888 the American George Eastman introduced celluloid film, which made it possible to string images together. Another big step was taken by Thomas Edison, the famous American inventor. It was in Edison's laboratory, in 1894, that technicians created what was apparently the first genuine motion picture. Lasting only a few seconds, the film was made on celluloid. Its "star" was one of Edison's mechanics, a man who could sneeze amusingly on command. Its title: *Fred Ott's Sneeze*.

One major problem remained. There was no satisfactory method for projecting the films to an audience. Here the challenge was taken up by two Frenchmen, brothers appropriately named Lumière (lumière means "light"), who in 1895 succeeded in building a workable film projector. In December of that year, they held the first commercial film screening in history, showing a program of ten short films to a paying audience in a large Paris café. From that point the motion-picture industry was off and running.

Exploring the Possibilities

From the beginning of motion pictures, there was no doubt about what the new technology would do best: at last visual art could tell stories. Paintings had always been able to allude to stories, or imply stories, or depict episodes from stories. Photography could do those things as well. But with film, stories could unfold over time and in motion, as they did in life or on stage in the theater.

One early film that the Lumière brothers showed told a brief, real-life story about a train pulling into a station. It was a documentary of something that had happened. Of course, not all stories we tell are set in the present time or the real world, at least not in the parts of it where a camera can travel. They may be set in an imaginary future, or in the historical past, or at the bottom of the sea, or at the center of the Earth. Early filmmakers, already familiar with the tricks that photography could play, quickly set out to explore the new

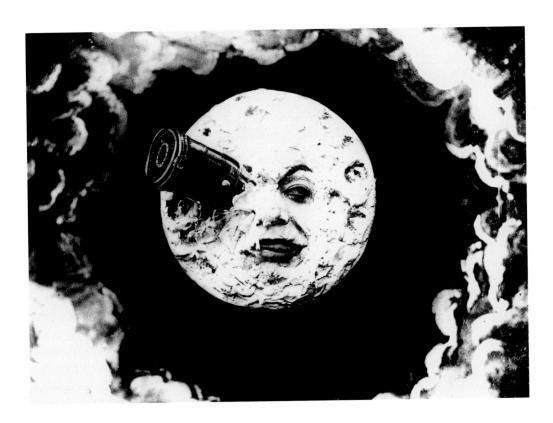

medium's ability to tell imaginary tales. A wonderful early example is *A Trip to the Moon*, by the French filmmaker Georges Méliès (9.16). Méliès made his film in 1902, when space travel was far in the future. One of the first science-fiction films ever made, *A Trip to the Moon* tells the story of a group of scientists who travel to the moon. How do they get there? They invent a "space-gun," which looks a lot like a cannon, and shoot themselves into space in a capsule that looks like a giant bullet. After landing smack in the moon's eye (ouch!), the adventurers do battle with a race of underground moon beings. The moon people win, taking the invaders prisoner. But the scientists manage to escape and return to Earth, where they are greeted by a cheering crowd.

Méliès created his fourteen-minute film in a studio using painted scenery, just like that for a theatrical production. By the simple means of stop-motion photography, he also created sophisticated special effects. For example, on the moon, an opened umbrella belonging to one of the scientists suddenly turns into a giant mushroom. Méliès filmed the umbrella, then stopped the camera, replaced the umbrella with the mushroom, and began filming again. When the film was shown, the transformation seemed to happen by magic.

Méliès made his films using human actors. Other early filmmakers quickly discovered that stories could be "acted" by objects or drawings that seemed to come to life by themselves, a magical effect called animation, meaning "bringing to life." Animation takes advantage of the fact that although a film camera can shoot continuously as motion unfolds, it can also shoot a single frame of film at a time. If you place, say, a spoon on a table, then shoot a single frame of it, then shift the spoon slightly and shoot another frame, then shift it again and shoot a third frame, when the film is projected, the spoon will appear to move by itself. Animating objects in this way is called pixilation, and early filmmakers were quite inventive with it. A French film made in 1907 included a sequence in which a knife buttered a piece of breakfast toast all by itself.

Hand-drawn animation works on the same frame-by-frame principle, except that in this case it is a drawing or a cartoon that is photographed, not an object. To imagine the work involved, look back at Muybridge's sequential photographs of a horse galloping (9.15). If you drew each of those images and photographed your drawings in sequence, you would produce a very short

9.16 The space capsule lands, frame from *A Trip to the Moon*, directed by Georges Méliès. 1902.

9.17 Winsor McCay. *Gertie the Trained Dinosaur*. 1914.

animated film. Animation is a time-consuming and laborious way of making a movie, for between twelve and twenty-four drawings are required per *second* of running time to create the illusion of smooth motion. An animated cartoon only three minutes in length may thus require up to 4,320 individual drawings!

One of the pioneers of animation in the United States was Winsor McCay. Before turning to animation, McCay was already famous for his innovative comic strip *Little Nemo*, which he began drawing for the *New York Daily Herald* in 1905. He was also a successful stage performer, where he appeared as a chalk-talk artist—someone who told stories and illustrated them at the same time on a chalkboard. McCay made several short animated features, but his most famous creation was *Gertie the Trained Dinosaur* (9.17). McCay created Gertie for his stage act. He had her projected onto a large sketchpad set on an easel. The effect was as though one of his own drawings had suddenly come to life. McCay interacted with the cartoon as it played, scolding Gertie, for example, who reacted by acting contrite. Gertie was not the first animal character invented for animated features, but she was the first to have a distinct personality, and as such she is the ancestor of Mickey Mouse, Donald Duck, Bugs Bunny, and other famous animated animal characters.

When it came to filming a story, early filmmakers looked naturally to theater as a model. At their most basic, they set up a camera in front of a staged performance and let it record the view, as though the camera were an audience member who stared straight ahead and never blinked. In fact, however, as audience members we don't quite sit and stare at the entire stage. We focus here and there, we follow the action. We concentrate sometimes on the setting, sometimes on a face, sometimes on a gesture. Filmmakers soon realized that the camera could do those things as well, entering the story and making it more vivid for spectators. A camera could film from close up or from a distance; it could film from above or from below or to one side; it could film while moving toward or pulling back from or gliding alongside a view; it could film while turning from left to right or right to left or scanning from high to low or low to high. In all those ways, a camera could film a shot, a continuous sequence of frames. Planning what kinds of shots to film quickly became an important aspect of gathering the "raw material" for a movie. The shots were then edited-pieced together to create storytelling sequences, which were in turn joined to create a complete film.

Editing quickly emerged as fundamental to effective filmmaking. One of the most influential early masters of editing was the Soviet Russian filmmaker Sergei Eisenstein. Many filmmakers had concerned themselves with editing for clarity and continuity, making sure that shots followed each other smoothly and logically so that the audience could follow the story. Eisenstein, however, became just as interested in the expressive possibilities of editing, including changing the rhythm of how quickly one shot succeeded another, breaking a single action down into several shots, and alternating shots of different subjects so that viewers would understand a symbolic connection between them.

Many of Eisenstein's editing techniques can be seen in *Battleship Potemkin* (9.18), a 1925 film that became an international hit. The movie tells the story of an uprising by sailors angered at how unjustly they have been treated by their ship's officers. In one scene, a sailor's anger boils over while he and some shipmates are washing dishes. He raises a dish over his head and smashes it to bits on the counter. Eisenstein used ten shots for the action, editing them together in such a rapid and violent rhythm that the brief moment stands apart from everything that happened before, its full importance clear.

With special effects, animation, and editing, the fundamental possibilities of film as a visual medium were identified and explored by the very first generation of filmmakers. A steady stream of technological advances since then has provided today's filmmakers with a far more sophisticated set of tools to work with, but the essential elements of filmmaking have not changed.

9.18 Scene from *Battleship Potemkin*, directed by Sergei Eisenstein. 1925.

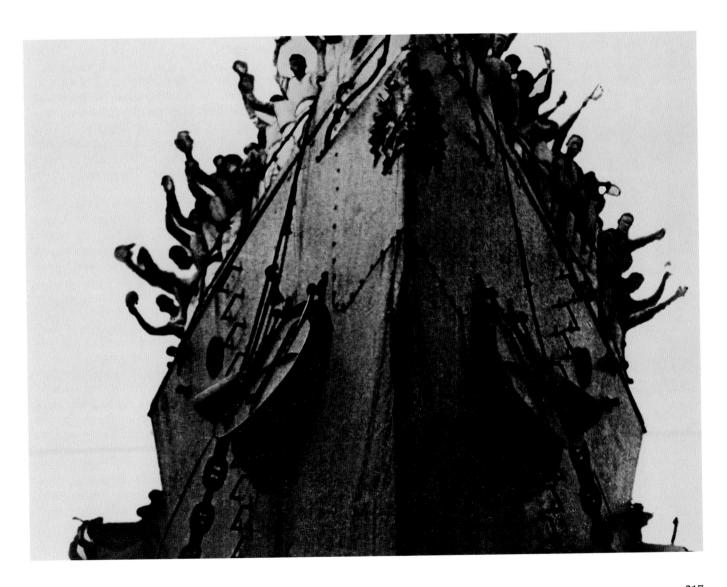

Film and Art

Film was hailed initially as a wonderful medium for creating popular entertainments and disseminating information. Yet from the beginning, there were people who claimed that, like photography, it could be practiced as an art. During the 1920s, the expression "art cinema" came into use, usually to indicate an independent movie that did not conform to popular storytelling techniques or aim to please a mass audience. Often, these films were shown by small, specialized theaters, by cinema societies, or even by art museums—a network of venues that existed apart from the major commercial theaters. But in such a collaborative medium as film, who was the artist? The actors? The writers? The editor who put it together? All of them were artists in a way. Yet the most satisfying films, most viewers agreed, were those that seemed to be guided by a single vision. Many felt that this person was the director. During the 1950s, a group of young French film critics articulated this view with special force: the director, they said, was a film's *auteur*, French for "author."

An **auteur** is a director whose films are marked by a consistent, individual style, just as a traditional artist's paintings or sculptures are. This style is the result of the director's control over as many aspects of the film as possible. Usually, an auteur will be closely involved in conceiving the idea for the film's story and in writing the script. He or she will direct the film, work with the camera operators to plan and frame each shot, then work closely with the editor when the final film is assembled.

The young critics behind the auteur concept were hoping to become filmmakers themselves, and their writings described the kinds of films they admired and wanted to make. And make them they did, in the process launching a vibrant movement known as the New Wave. One of the first New Wave films to appear was Jean-Luc Godard's *Breathless* (9.19). The story of *Breathless* is fairly simple. A handsome petty criminal (Michel, played by Jean-Paul Belmondo) steals a car and heads north to Paris. On the way, he shoots a policeman who had pulled him over for speeding. In Paris, he meets up with a pretty American student journalist he knows (Patricia, played by Jean Seberg). They talk, make love, go to the movies, steal cars, and plan to escape to Italy. But Patricia does not want to be in love, and to prove to herself that she isn't, she calls the police and turns Michel in.

The revolutionary nature of *Breathless* does not lie in the story, however, but in the way it is told. The rhythms of the editing are fast and nervous, giving the film a spontaneous, youthful energy. Jump cuts—cuts where either the figures or the background change abruptly, interrupting the smooth visual flow—abound. The camera is sometimes unsteady, as though it were being held by someone walking. The dialogue is part gangster film, part philosophy, and includes quotes from famous works of literature. Finally, the film contains allusions to famous films of the past, and the actors play characters who have been formed as much by the movies as by anything else. With the New Wave, the movies became self-conscious, just as painting had almost a century earlier. (See the discussion of Edouard Manet's *Le Déjeuner sur l'herbe*, page 475.)

We might say that film called a new kind of artist into being, someone as finely attuned to words as to images, gifted in structuring an experience that unfolds over time, able to communicate and collaborate with actors and production specialists, and as aware of the heritage of great films as painters are of the heritage of great paintings. As for traditionally trained visual artists, the expense of making a film, together with the specialized equipment and technical knowledge involved, generally kept them from experimenting with the new medium. It would not be until the invention of video, discussed later in this chapter, that visual artists began to work with recorded time and motion in significant numbers. Nevertheless, alongside the rich, international history of the film industry runs a slender history of films by artists.

One artist who had an unusually prolific engagement with film was Andy Warhol. Warhol was one of the leading artists of the Pop art movement during

9.19 Jean-Paul Belmondo and Jean Seberg in a scene from *Breathless*, directed by Jean-Luc Godard. 1960.

the 1960s. "Pop" is short for popular, and nothing was more popular by that time than the movies. Affordable film cameras had become widely available to the general public, leading to a thriving scene in underground or experimental filmmaking. Warhol had rented a large loft space in downtown New York. He called it the Factory, for it was a place where his art was to be manufacturedby himself, his assistants, his friends, hangers-on, visiting celebrities, and all manner of people. In that setting, Warhol began making films. Warhol's early films were all silent and filmed in black-and-white. They resemble his paintings of the time in that they challenge our idea that something will "happen." For example, Warhol's 1963 film Kiss consisted of close-ups of couple after couple, kissing for three minutes, much like his paintings of soup cans consisted of can after can of soup, sometimes all the same flavor, sometimes different flavors. An even more radical film, Empire, followed the next year (9.20). Warhol and some friends set up a rented camera on the 44th floor of a building with a view of the Empire State Building. They filmed the Empire State Building for over six hours, from dusk until around 3 a.m. During all that time, the camera did not move. The composition shown in the illustration here did not change. The reels of film were then spliced end to end and projected at a slower speed, producing an eight-hour film. What was the film about? Empire, Warhol said, was a way of watching time pass.

Artists also began to use film to document actions or activities that they were proposing as art. One of the most influential artists to do this was Bruce Nauman. Then a young artist just at the start of his career, Nauman had begun teaching at the San Francisco Art Institute, where as a new faculty member he found himself isolated. "I had no support structure for my art then . . . there was no chance to talk about my work," he later recalled. "And a lot of things I was doing didn't make sense so I quit doing them. That left me alone in the studio: this in turn raised the fundamental question of what an artist does when left alone in the studio. My conclusion was that [if] I was an artist and I was in the studio, then whatever I was doing in the studio must be art. . . . At this point art became more of an activity and less of a product."

9.20 Andy Warhol. *Empire*. 1964. 16mm film, black-and-white, silent; 8 hours 5 minutes at 16 frames per second. Andy Warhol Museum, Pittsburgh

9.21 Bruce Nauman. Dance or Exercise on the Perimeter of a Square (Square Dance).
1967–68. 16mm black-and-white film with sound, transferred to video; length 8:24 min.
Courtesy Electronic Arts Intermix, New York

Nauman began structuring activities by naming them, thereby setting limits. Then he filmed himself performing the activities in his studio. Typical activities had bland, descriptive titles such as Bouncing Two Balls Between the Floor and Ceiling with Changing Rhythms or Dance or Exercise on the Perimeter of a Square (Square Dance) (9.21). The plain titles were matched by plain, unedited camera work. Like Warhol in Empire, Nauman set the camera on a stand, turned it on, and let it record whatever happened in front of it. For Dance or Exercise on the Perimeter of a Square (Square Dance), Nauman outlined a square on his studio floor with masking tape and marked the midpoint of each side. The dance (or exercise) Nauman devised is repetitive: standing at the midpoint of a length of the square, he alternately taps the corner to his right with his right foot, then the corner to his left with his left foot, in time to the beat of a metronome. He repeats this action sixty times (thirty times per foot), then moves to the next midpoint. He works his way around the square clockwise facing outward, then counterclockwise facing inward. Then the video ends. Without being a dancer, Nauman conceived of the activities as dance problems, and he practiced each piece extensively before performing it for the camera, becoming aware of his body in space and gaining control over the movements.

Video

Warhol made virtually all his films during the five years between 1963 and 1968. During those same years, another technology that could record and play back images in motion was made available to the general public, and it quickly became more popular with artists than film had ever been. That technology was video.

Just as radio had been invented to allow sound captured by a microphone to be transmitted over the air, so video was invented to do the same for moving images captured by a camera. A video camera converts a moving image into electronic signals. The signals are transmitted to a monitor, which decodes them and reconstitutes the image for display. The most famous monitor, of course, is the television. First demonstrated in the United States in 1939 in connection with the opening of the New York World's Fair, television sets became standard fixtures in American homes by around 1950.

One of the first artists to work with video was Nam June Paik. Paik was as fascinated by television sets themselves—their evolving styles and designs—as

by the moving video image. One of his best-known early works is *TV Buddha* (9.22), an installation in which a sculpture of the Buddha contemplates its own image on a futuristic-style television that resembles an astronaut's helmet. Or is it the video camera that contemplates the Buddha? The camera and its hookup to the television are in full view, for Paik wants us to be aware of the entire mechanism of the relationship. Past and future confront each other here, as do religion and secular entertainment, alternative forms of representation, and stillness and movement. Viewers appear briefly on the screen as they stand behind the statue, their fleeting presence contrasting with the eternal existence of the Buddha and the unblinking stare of the camera.

There were several reasons why artists took quickly to video. One was that it could be recorded and then played back immediately on a monitor, eliminating the wait for film to be developed. Monitors, moreover, lent themselves well to exhibition in gallery spaces where new art was shown. Less than five minutes long, *Third Tape*, by Peter Campus, is a classic work of early video art (9.23). The video unfolds in three segments, each of which features a man

9.22 Nam June Paik. *TV Buddha*. 1974. Closed-circuit video installation with bronze sculpture, monitor, and video camera; dimensions vary with installation. Stedelijk Museum, Amsterdam

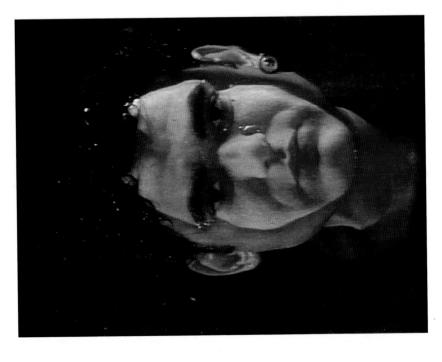

9.23 Peter Campus. *Third Tape*. 1976. Color video with sound, length 4:31 min.

Courtesy the artist and Cristin Tierney Gallery, New York

performing an action that distorts or abstracts his image. In the first segment, he faces the camera and binds his head tightly with fishing line, cutting across his face as though he were slicing himself into cross-sections. In the second, a hand places mirrored tiles one by one on a black surface. In them is reflected a fragmented view of the man's face looking down from above. In the third segment, illustrated here, the camera looks up through a tank of water as the man gradually immerses his face in it, creating a strange effect.

During the 1990s, digital video became available, along with technology that allowed video stored digitally on disk to be projected onto a wall or some other surface instead of being fed to a monitor. Because it can be fed into a computer for further manipulation, digital video gives artists access to the same programs that today's filmmakers use for editing, adding a soundtrack, and creating special effects. Iranian-born artist Shirin Neshat's most recent project shows how the worlds of the video artist and the filmmaker have drawn closer together.

Neshat recently completed a series of five large-scale video installations inspired by *Women without Men*, a novel by the contemporary Iranian writer Shahrnush Parsipur (9.24). *Women without Men* tells the story of a small group of women who live briefly together in a house with a large garden not far from the Iranian capital of Teheran. They come together by chance, each one having suffered and then escaped the world of male authority in her own way. Each of Neshat's brief videos takes up the story of one of the women in the book, but it does not retell the story literally. Rather, it meditates freely on the story's events, themes, and imagery. Repeating imagery links the videos in subtle ways, as does the choice of actors, some of whom play more than one role across the series. Shown in gallery or museum spaces, the videos are projected onto the walls, each in its own room. Viewers can wander from one to the other in any order, as they choose.

Neshat also made a full-length feature film inspired by the book, just as an independent filmmaker might. In contrast to the videos, the film offers a clearer story, with characters whose development over time is more evident. The two projects illustrate how at least one artist draws a distinction between videos for a gallery setting and an art audience, and film for a theater setting and a cinema audience.

Neshat, like the artists in this section before her, captured her own video using a camera. In contrast, Cory Arcangel works with found video, such as outmoded video games and amateur videos posted on YouTube. To create his

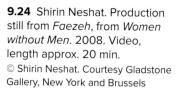

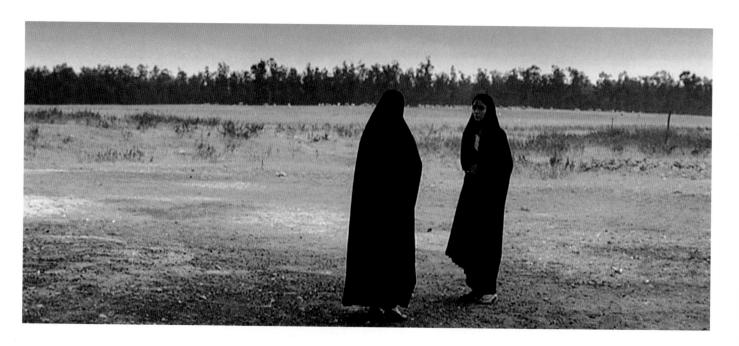

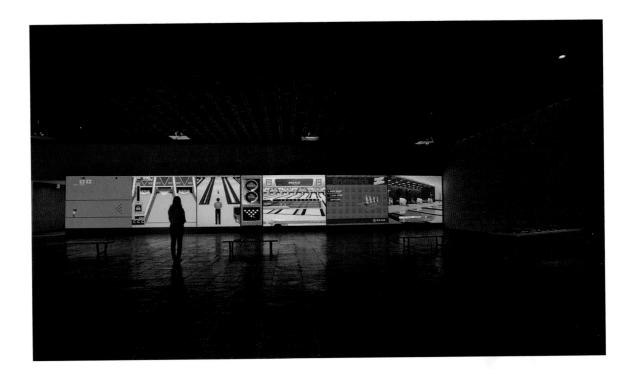

installation *Various Self Playing Bowling Games*, Arcangel collected fourteen bowling video games dating from 1977 to 2001 and hacked their controllers so that the player characters throw nothing but gutter balls. Projected side by side in chronological order, *Various Self Playing Bowling Games* confronts us with failure on a cinematic scale (9.25). The machines play game after game, but no player ever scores. The animation technology gets better and better over time, but we still experience nothing but frustration. "All you're left with," says the artist, "is a repeated, infinite letdown." The illustration here shows six of the games, all that would fit on a wall at the Whitney Museum in New York; the gallery in London that co-commissioned the work had a wall long enough to show all fourteen games. *Various Self Playing Bowling Games* is about the pathos of our infatuation with technology, the absurdity of identifying with a virtual player in order to play a virtual game, and, in the words of the artist, "the short circuits in human nature caused by everyone staring at their phones or being on Facebook all the time."

9.25 Cory Arcangel.

Various Self Playing Bowling
Games. 2011. Installation view,
Pro Tools, Whitney Museum
of American Art, New York, 2011.
Hacked video-game controllers,
game consoles, cartridges,
disks, and video; dimensions
variable. Co-commissioned by
the Whitney Museum of American
Art, New York, and the Barbican
Art Gallery, London.

© Cory Arcangel. Image courtesy Cory Arcangel and Team Gallery, New York. Photo by Adam Reich

The Internet

Thus far in this book, we have discussed the computer as a tool that expands the possibilities of older art forms such as printmaking, photography, film, and video. Yet, in addition to being a tool, the computer is a place. Images can be created, stored, and looked at on a computer without being given a traditional material form at all. With the development of the Internet, the World Wide Web, and browser applications capable of finding and displaying Web pages, a computer became a gateway to a new kind of public space, one that was global in scope and potentially accessible to everyone. Not only could anyone find information on the Internet, but anyone could also claim a presence on the Internet by creating a site on the World Wide Web, a Web site.

Art that uses the Internet as a medium is known as Internet art or, more casually, net art. Since its beginnings in the 1990s, net art has typically taken the form of e-mails, Web pages, or software—a set of step-by-step instructions that can be executed by a computer. Net art is often interactive, allowing

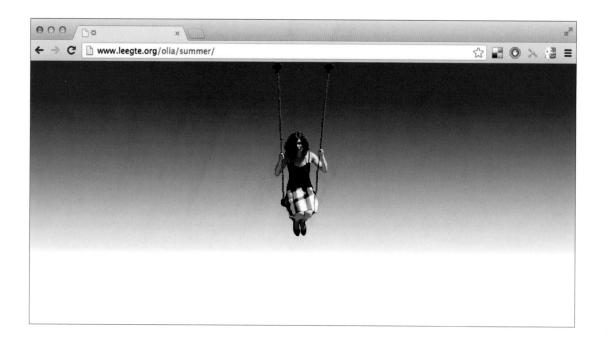

9.26 Olia Lialina. *Summer*. 2013. Graphics Interchange Format (GIF) animation, frames distributed among twenty-five servers.

visitors to explore a space that has been created on the Internet or influence an image as it evolves on the computer monitor.

One of the early pioneers of net art was Russian artist Olia Lialina. My Boyfriend Came Back from the War, an interactive work she created in 1996, was one of the first examples of net art to become widely known (see 22.30). The slow speed of the dial-up Internet service available at the time was an integral part of My Boyfriend Came Back from the War. Slowly loading frames of words and images expressed the reunited couple's halting and painful conversation, punctuated by silences. A more recent work, Summer, depends for its effect on today's high-speed access (9.26). Summer is a graphics interchange format (GIF) animation. Like traditional animation, GIFs consist of a series of still images which, when shown sequentially at high speed, produce the illusion of motion. Summer consists of twenty-one frames designed to play in a continuous loop. Lialina distributed them among twenty-one different servers, one frame per server. A computer has to leap from server to server and display each image instantaneously in order to play the GIF, which depicts Lialina herself swinging from the location bar at the top of the browser window.

The motion begins haltingly as the computer contacts each site and retrieves the frame it hosts. What happens next depends on whether all the servers happen to be running and how fast the viewer's connection is. Part of the pleasure of *Summer* is having the entire computer screen given over to someone doing nothing more than playing on a swing. But just as delightful is watching the twenty-one Web addresses frantically cycling in the location bar, making it clear just how much effort it takes to produce the effect of effortlessness. "I like to swing on the location bar of the browser," Lialina says, "and I like to know that the speed of swinging depends on the connection speed, and that you can't watch this GIF offline."

No phenomenon more clearly illustrates the idea of the Internet as a place than the online, 3-D virtual-reality environment known as Second Life. Millions of people from around the world are "residents" of Second Life, where they can buy property, build, travel, explore, play, party, and meet other residents. Before they can do any of those things, however, they must select and name their avatar, the animated persona who will represent them in the virtual world.

Chinese artist Cao Fei is present on Second Life as an avatar named China Tracy. For six months, Cao recorded China Tracy's experiences in Second Life on video. From those many hours of material she created a three-part, thirty-minute film called *i.Mirror* (9.27). The opening credits announce it as "a Second Life documentary film by China Tracy." As of this writing,

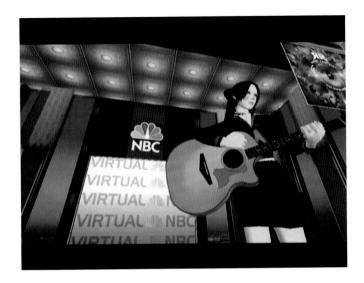

9.28 Aram Bartholl. *Map.* 2006–10. Public installation at Arles, France, July 2011. Wood, color, wire, screws, glue, and nails; height 19'8¼".

a low-resolution version of *i.Mirror* can be viewed on China Tracy's YouTube space, youtube.com/user/ChinaTracy.

The first part of *i.Mirror* is dominated by images of emptiness and solitude. The second part chronicles a delicate romance between China Tracy and a man she meets, Hug Yue. Young and handsome in Second Life, he turns out to be an older American in real life, and toward the end of their bittersweet encounters, he meets her more honestly as an older avatar. The third part of *i.Mirror* documents some unknown residents of Second Life, at first singly, then in loving couples, and finally as they are drawn by music to dance together.

A melancholy and yet ultimately hopeful film, *i.Mirror* is an example of a new artistic practice called machinima, from "machine cinema," in which real-time computer-generated 3-D video from such sources as online games or Second Life is recorded and used as raw material for a film, just as traditional filmmakers use shots of live actors in the real world.

Recently, many observers have discerned the beginnings of a post-Internet era. "Post-Internet" does not mean that the Internet is over but that it is no longer new. We are accustomed to its presence. A generation has grown up that has always known it. Post-Internet art may reside online or it may take the form of an object, often one that embodies critical thinking about the Internet itself—its visual culture, its networks of information and communication, and its role in our experience of the world.

A clever and thought-provoking example of post-Internet art is Aram Bartholl's ongoing project *Map* (9.28). The central element of *Map* is a large wooden sculpture that materializes the marker Google drops on its online maps to indicate a location. When the map is switched to satellite view, the pin remains, now seemingly part of the real world. Bartholl scaled his sculpture to the size the pin appears to be in the satellite view's highest magnification, when we have zoomed in as close as the program will allow. (The pin itself does not change size when the view is magnified; only its scale in relation to the objects in the view changes.) He brings his sculptural marker to a city and sets it up temporarily in the place that Google Maps designates as the city's center. "Transferred to physical space, the map marker questions the relation of the digital information space to everyday life public city space," he writes. "The perception of the city is increasingly influenced by geolocation services."

Communications technologies of the modern age, the camera and the computer have transformed our world. They were not developed with art in mind; yet, because artists chose to work with them, they have yielded new art forms for our era.

10

Graphic Design

arlier chapters have emphasized that art is open to interpretation, and that a work of art can hold many meanings. This chapter explores the issue of meaning from another point of view, for a graphic designer's task is to try to limit interpretation and to control meaning as much as possible. Graphic design has as its goal the communication of some *specific* message to a group of people, and the success of a design is measured by how well that message is conveyed. The message might be "This is a good product to buy," or "This way to the elevators (or restrooms or library)," or any of countless others. If it can be demonstrated that the public received the intended message—because the product sold well or the traveler found the right services—then the design has worked.

Graphic designers attend to the visual presentation of information as it is embodied in words and/or images. Books, book jackets, newspapers, magazines, advertisements, packaging, Web sites, CD covers, television and film credits, road signs, and corporate logos are among the many items that must be designed before they can be printed or produced.

Graphic design is as old as civilization itself. The development of written languages, for example, entailed a lengthy process of graphic design, as scribes gradually agreed that certain **symbols** would represent specific words or sounds. Over the centuries, those symbols were refined, clarified, simplified, and standardized—generation after generation of anonymous design work. The field as we know it today, however, has its roots in two more-recent developments: the invention of the printing press in the 15th century and the Industrial Revolution of the 18th and 19th centuries.

Anyone can write up a notice to be posted on a door. The printing press made it possible to devise a notice that could be reproduced hundreds of times and distributed widely. Someone, however, had to decide exactly how the notice would look; they had to design it. How would the words be placed on the page? Which words should be in large type, which in small? Should there be a border around them? An image to accompany them?

The Industrial Revolution, for its part, dramatically increased the commercial applications of graphic design. Before the Industrial Revolution, most products were grown or produced locally to serve a local population. A person who wanted a new pair of shoes, say, could walk down the road to the village cobbler, or perhaps wait for the monthly fair at which several cobblers from neighboring towns might appear. With the advent of machines, huge quantities of goods were produced in centralized factories for wide distribution. For manufacturers to succeed in this newly competitive and anonymous

environment, they had to market both themselves and their wares through advertising, distinctive packaging, and other graphic means. At the same time, the invention of faster presses, automated typesetting, lithography, and photography expanded designers' capabilities, and the growth of newspapers and magazines expanded their reach.

Today international commerce, communications, and travel continue to feed the need for graphic design; and technological developments, most nota-

bly the computer, continue to broaden its possibilities.

Signs and Symbols

On the most basic level, we communicate through symbols. The sound of the syllable *dog*, for example, has no direct relation to the animal it stands for. In Spanish, after all, the syllables *perro* indicate the same animal. Each word is part of a larger symbolic system, a language. Visual communication is also symbolic. Letters are symbols that represent sounds; the lines that we use to draw representational images are symbols for perception.

Symbols convey information or embody ideas. Some are so common that we find it difficult to believe they didn't always exist. Who, for example, first used arrows to indicate directions? We follow them instinctively now, but at some point they were new and had to be explained. Other symbols embody more complex ideas and associations. Two well-known and ancient symbols

are the yin-yang symbol and the swastika (10.1).

The yin-yang symbol, also known as the *taiji* (or *tai chi*) diagram, embodies the worldview expressed in ancient Chinese philosophy. It gives elegant visual form to ideas about the dynamic balance of opposites that are believed to make up the universe and explain existence: male (yang) and female (yin), being and nonbeing, light and dark, action and inaction, and so on. The symbol makes it clear that these opposites are mutually interdependent, that as one increases the other decreases, that a portion of each is in the other, that they are defined by each other, that both are necessary to make the whole, and many other ideas. It is a model of successful graphic design.

The swastika has an important lesson to teach about symbols, which is that they have no meaning in themselves but are given a meaning by a society or a culture. The swastika was first used as a symbol in India and Central Asia, possibly as early as 3000 B.C.E. It takes its name from the Sanskrit word svastika, meaning "good luck" or "good fortune." (Sanskrit was the most important language of ancient India.) In Asia, the swastika is still widely used as an auspicious symbol, even on commercial products. Until the 1930s, the swastika was a popular good-luck symbol in the West as well. Today, however, it is so thoroughly associated with the Nazis, who adopted it as their emblem, that it has become for us a symbol of fascism, racial hatred, and the unspeakable atrocities of the concentration camps. Our instinctive recoil from the swastika underscores not only the power of symbols to serve as repositories for ideas and associations but also the ability of those ideas and associations to change, sometimes radically.

10.1 Yin-yang symbol (left) and swastika (right).

10.2 Poster created as a promotion by the Cook and Shanosky design firm, featuring the symbols they designed for use by the U.S. Department of Transportation in 1974.

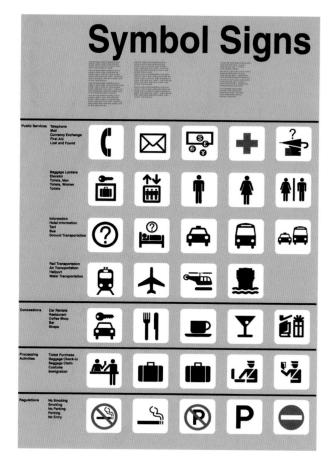

10.3 Paul Rand. Logos for IBM (1956), UPS (1961), and ABC (1962; © American Broadcasting Companies, Inc.)

10.4 Current logos of UPS (2003) and ABC (2013; © American Broadcasting Companies, Inc.)

Graphic designers are often asked to create visual symbols. In 1974 the U.S. Department of Transportation commissioned the American Institute of Graphic Arts to develop a set of symbols that could communicate essential information across language barriers to international travelers (10.2). Designers selected by the institute researched symbols then in use in transportation centers around the world, evaluating them for clarity and effectiveness. Their findings informed the design of the symbols illustrated here, which were drawn by the firm of Cook and Shanosky Associates. Today the symbols are a familiar part of signs in airports and train stations, where they help direct travelers to bus and taxi stands, telephones, hotel information, restrooms, and other key facilities.

Among the most pervasive symbols in our visual environment today are logos and trademarks, which are symbols of an organization or a product. An impressive number of these are the work of Paul Rand, one of the most influential of all American graphic designers (10.3). Simple, clear, distinctive, and memorable, each of these corporate logos has become familiar to millions of people around the world, instantly calling to mind the company and its products or services. As with any symbol, a logo means nothing in itself. It is up to an organization to make its logo familiar and to persuade people through sound business practices to associate it with such virtues as service, quality, and dependability.

Because symbols serve as focal points for associations of ideas and emotions, one of the most effective ways for a company to change its image is to redo its logo. Both ABC and United Parcel Service have updated their logos (10.4). The new logos emphasize continuity with the past by retaining essential elements of Paul Rand's original 1960s designs even as they add a fresh, dynamic look by suggesting reflective, three-dimensional forms instead of flat shapes. The new UPS logo does away with Rand's string-tied package, which no longer conveys the range of services that UPS provides. The upper edge of the shield form now curves into space. An asymmetrical, brown, interior field curves up to meet it, creating a strong sense of movement. ABC's lightly

dimensional new logo appears to glow richly from within with deep red, blue,

or yellow light, the white letters floating every so slightly before it.

A logo often serves as the fundamental element of a brand identity program, a larger design undertaking that unifies a brand's overall visual presence. Guidelines for typography, color palette, layout, and imagery are developed for application to letterheads, business cards, packaging, marketing materials, Web sites, office design, and more to project a consistent image that reflects how the brand wants to be perceived.

When AOL split from Time Warner in 2009 to become an independent company, it marked the occasion by unveiling a new logo and brand identity developed by Wolff Olins, an international brand consultancy (10.5). Formerly known as America Online, AOL had achieved great success during the early days of the Internet as an access provider before merging with Time Warner in 2001. In splitting off from Time Warner, AOL was not only reestablishing itself as an independent company but also changing its fundamental mission: the new AOL would focus on providing content-information and entertainment-including a high percentage of original content produced by journalists, artists, and musicians. The challenge to Wolff Olins was to refresh and rejuvenate AOL's image while also signaling its new direction.

The design centers on an updated wordmark, or logotype—a standardized text logo. AOL's wordmark is "Aol.", set in a custom-designed font. The lowercase letters relax the logo and distance it from its origin as an initialism. The period is intended to signal confidence and completeness (as in "AOL has the best online content, period"); it also evokes the dot of Internet addresses. Displayed in white on a white background, the "invisible" wordmark is revealed only when a colorful image passes behind it. Hundreds of images and motion graphics have been commissioned from artists and designers to appear behind the AOL wordmark, suggesting the broad range of AOL's content offerings and associating the company with youthful, creative energy. Much of the commissioned art favors bright, saturated colors, an aesthetic carried through to the redesigned Web site and the office furnishings, both of which also feature judicious splashes of bright color on a white background.

10.5 Wolff Olins: Malcolm Buick and Jordan Crane, creative directors. AOL brand identity program. 2009.

AAAA BBB CCC DDD

10.6 Albrecht Dürer. Letters, from *Treatise on Measurement.* 1525.

10.7 Joan Dobkin. Informational leaflet for Amnesty International. 1991.

Typography and Layout

Cultures throughout history have appreciated the visual aspects of their written language. In China, Japan, and Islamic cultures, calligraphy is considered an art. Although personal writing in the West has never been granted that status, letters for public architectural inscriptions have been carefully designed since the time of the ancient Romans, whose alphabet we have inherited. With the invention of movable type around 1450, the alphabet again drew the attention of designers. Someone had to decide on the exact form of each letter, creating a visually unified alphabet that could be mass-produced as a **typeface**, a style of type. No less an artist than Albrecht Dürer turned his attention to the design of well-balanced letterforms (10.6). Constructing each letter within a square, Dürer paid special attention to the balance of thick and thin lines and to the visual weight of the serifs, the short cross-lines that finish the principal strokes (at the base of the As, for example).

The letters Dürer designed would have been laboriously carved in wood or cast in metal, and they would have been set (placed in position) by hand before printing. Today type is created and set by computer and photographic methods. The design of typefaces continues to be an important and often highly specialized field, and graphic designers have literally thousands of styles to choose from. The text of this book, for example, is set in URW Palladio, which is easy to read, legible in fairly small sizes, and not tiring to the eyes. The chapter titles, in contrast, are set in a sans-serif face, a face without finishing lines on the strokes, called Proxima Nova.

Joan Dobkin combined commercial typefaces and handmade letterforms in her informational leaflet for Amnesty International, an organization that monitors human rights around the world (10.7). Menacing phrases jump out at us from a disorienting tangle of words: *you are next* and *Already told you*. The word *disappear* itself disappears. Dobkin took the texts from first-person accounts of political terror in El Salvador. By fragmenting and layering their words, she communicates the helplessness and terror felt by the victims to

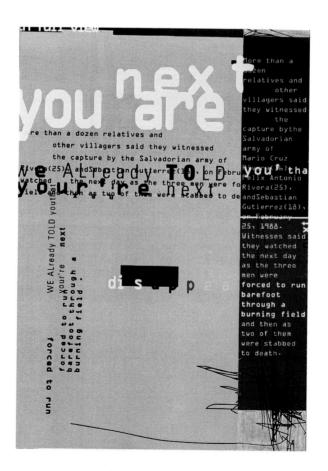

New	New laven AM 2:18 7:44	New York	New Haven	New York	New Haven
AM 12:35 5:40 7:05 8:05	AM 2:18 7:44	York PM	Haven		
12:35 5:40 7:05 8:05	2:18				THE RESIDENCE
10:05 11:05 12:05 1:05 PM	8:45 9:45 10:45 11:45 12:45 1:45 2:45 PM	2:05 3:05 7 4:01 4:41 7 4:59 X7 5:02E X7 5:20 X 5:42 X7 6:07E PM	PM 3:45 4:45 5:45 6:25 6:53 7:06 7:26 7:46 PM	PM 7 8:25 7 7:05 7 8:05 7 9:05 10:05 11:20 12:35	P 8: 9: 10: 11: 2:
s	ATURD	AY, SUND	AY & HO	LIDAYS	
AM 12:35 5:40 8:05 10:05 12:05 PM	AM 2:18 7:37 9:45 11:47 1:45 PM	PM 2:05 \$ 3:05 4:05 5:05 6:05 PM	PM 3:45 \$ 4:45 5:45 6:48 7:48 PM	PM 7:05 H 8:05 9:05 11:20 12:35 AM	8: H 9: 10: 1: 2: A
		own here		rated by	

Monday to Friday, except holidays	Saturday, Sunday, and holidays
Leaves Arrives New York New Haven	Leaves Arrives New York New Haver
12.35 am 2.18	12.35 am 2.18
5.40 am 7.44 am	5.40 am 7.37 am
7.05 8.45	
8.05 9.45	8.05 9.45
9.05 10.45	
10.05 11.45	10.05 11.47
11.05 12.45 pm	
12.05 pm 1.45	12.05 pm 1.45 pm
1.05 2.45	
2.05 3.45	2.05 3.45
3.05 4.45	3.05 Saturdays 4.45
4.01 5.45	4.05 5.45
4.41 6.25	
4.59 6.53	
4.01 5.45 7 8 8 8 8 8 8 8 8 8 8 8 8 8 8 8 8 8 8	5.05 6.48
5.20 • 7.08 李5	
4.41 6.25 ar paxod ii suit 16 6.25 shap ha gad, 16 6.53 app ha gad, 16 6.60 shap ha gad, 16 6	
x 6.07 • 7.46 km/s	6.05 7.48
	7.05 8.45
7.05 8.56	7.05 8.45 8.05 Sundays 9.45
8.05 9.45 9.05 10.50	9.05 10.45
9.05 10.50 10.05 11.45	9.03 10.43
11.20 1.05 am	11.20 1.00 am
12.35 am 2.18	12.35 am 2.18
12.33 am 2.10	12.55am 2.10

provoke a direct, emotional response from the pamphlet's target audience: potential supporters of Amnesty International.

However evocative the cover portion of Dobkin's design may be, inside the leaflet a certain amount of information needs to be presented, and presented clearly. One of the most important tasks of a graphic designer is to devise visual presentations that make potentially confusing information easier to grasp. The effect that design can have on our ability to get the information we need quickly and easily is well illustrated by two train schedules (10.8). To the left is the schedule that the railroad company distributed for many years. To the right is the same schedule as redesigned by student Ani Stern and her instructor, noted graphic design expert Edward Tufte. The redesign acts as a criticism of the original, and comparing the two can teach us something about what distinguishes a successful design from a less successful one.

On the schedule to the left, only a small portion of the page is devoted to the actual departure and arrival times, which thus appear cramped and crowded. And yet this is the most important information the schedule has to convey! Train times across the day are split into three pairs of columns, so that the eye needs to follow a tricky serpentine path through them. Rush hour times are distinguished with a tinted ground, making them more difficult to read. Mysterious symbols crowd the schedule still further, and much space is wasted below in explaining them. Numerous ruled compartments give the impression of organization, but in fact they do little useful work. Weekend train times are set so far from the arrival and departure headings that it is not immediately clear how they are organized.

The redesign clears up all those problems and more. The train times are presented in two pairs of columns, clearly separated: weekdays to the left, weekends and holidays to the right. Unnecessary ruled lines are eliminated, and many of the annotations are taken up into the schedule itself. The colon in time listings has been replaced with a visually simpler period.

10.8 Metro North Railroad. Schedule for the New York—New Haven line, c. 1989 (left). The same schedule as redesigned by Ani Stern and Edward Tufte, 1990 (right).

A **layout** is a designer's blueprint for an extended work in print, such as a book or a magazine. It includes such specifications as the dimensions of the page, the width of the margins, the sizes and styles of type for text and headings, the style and placement of running heads or feet (lines at the top or bottom of the page that commonly give the chapter or part title and page number), and many other elements. The layout of this book, for example, places a single column of text asymmetrically on the page, leaving a slender outer column (for captions) and a narrow inner margin. Each spread (two facing pages) is thus fundamentally symmetrical, with left and right pages in mirror image. Illustrations are placed to relieve and even disguise this symmetry, and the page-makeup artists took pains to arrange each spread in a pleasing asymmetrical composition.

Word and Image

Among the services offered by early printers in the 15th century was the design and printing of single sheets called broadsides. Handed out to town dwellers and posted in public spaces, broadsides argued political or religious causes, told of recent events, advertised upcoming festivals and fairs, or circulated woodcut portraits of civic and religious leaders. They were the direct ancestors not only of advertising and posters but also of leaflets, brochures, newspapers, and magazines.

With the development of color lithography in the 19th century, posters came into their own as the most eye-catching form of advertising, for color printing was not yet practical in magazines or newspapers, and television was still a hundred years away. Among the most famous of all 19th-century posters are those created by Henri de Toulouse-Lautrec for the cabarets and dance halls of Paris (10.9). In this poster for a famous dance hall called the Moulin

10.9 Henri de Toulouse-Lautrec. *La Goulue at the Moulin Rouge*. 1891. Poster, lithograph printed in four colors, $6'2\%" \times 3'9'\%"$. The Metropolitan Museum of Art, New York

10.10 SenseTeam: Hei Yiyang, creative director. Poster for *X Exhibition 07: Graphic Design in China.* 2007.

Rouge, the star performer, La Goulue, is shown dancing the cancan, while in the foreground rises the wispy silhouette of another star attraction, Valentin, known as "the boneless one." The flattened, simplified forms and the dramatically cropped composition show the influence of Japanese prints, then so popular in Europe. Toulouse-Lautrec's posters were immediately recognized as collectors' items, and instructions circulated secretly for detaching them from the kiosks on which they were pasted.

Toulouse-Lautrec drew directly on a lithographic stone like the traditionally trained artist that he was. Today most graphic artists create their designs on a computer and generate digital files that will be sent to an industrial printer. SenseTeam's poster for an exhibition of Chinese graphic design began with a digital photograph of a young man carrying an armful of lit fluorescent tubes and a tangle of electric cords (10.10). The intriguing image suggests that he is working on a project of some kind. Assembled from line segments, the text laid over the image brings to mind the numerals and letters familiar from digital displays on clocks, stereo components, and other electronics. A closer look reveals that the letters and characters were constructed from lengths of lit fluorescent tubing, photographed and then miniaturized. Is this what the young man is up to? The layout includes a witty interaction between the text and the image, further linking them: note the way two of the Chinese characters fit the model's eyes like a pair of glasses. Visitors to the exhibit would find that the signage there was made from fluorescent tubes such as the ones the young man is shown carrying. Beginning outside the exhibition space, the signage drew people in with light and then served as lighting for the exhibit itself.

The sophisticated graphics, video, and music-editing programs now widely available allow amateurs to create their own advertisements in response to professionally produced work. One advertisement that inspired a great deal of amateur creativity was the iPod Silhouette campaign (10.11). The iPod was launched in 2001, but it was not until the Silhouette advertisements appeared that sales skyrocketed. The black silhouettes of young people dancing against neon-colored backgrounds to music they heard over a handheld white iPod

10.11 TBWA\Chiat\Day. iPod silhouette advertisement campaign. 2004.

were graphically bold, clear, and simple. The minimal text and Apple logo were also set in white, linking them clearly with the product. Realized as posters, billboards, and television commercials, the advertisements stood out easily in cluttered visual environments, and they conveyed an image of unselfconscious

enjoyment that appealed to a broad public.

Instructions for how to duplicate the advertisements quickly proliferated on the Internet, enabling thousands of imitations, variations, homages, and parodies. A later version of the iPod, the iPod Touch, inspired an eighteen-year-old university student to create a thirty-second video tour of the product using video clips from Apple's Web site and a song by the Brazilian band CSS. Posted on YouTube, the video was discovered by employees at Apple's marketing department, who asked their advertising agency to contact the student about transforming the video into a television commercial. Such usergenerated advertising is increasingly recognized as a way for brands to enter into a dialogue with consumers, whose creativity has been unleashed by today's digital technologies.

Motion and Interactivity

With the development of film and television, graphic design was set in motion. Words and images worked together in film titles, television program titles, and advertisements, all of which needed to be designed. With the digital revolution, a new element was added for designers to work with, interactivity—the possibility of give-and-take between users and technology by means of an interface.

In the forefront of today's motion graphics are designers who generate videos on the computer by writing code. A dramatic example is this video about the Audi TT sedan created by British designers Matt Pyke at Universal Everything and Karsten Schmidt at PostSpectacular (10.12). As the video begins, vividly colored lines stream rapidly away from us into the depths of a black space. Their swarming gradually reveals the silhouette of a car that pivots and then drives away, leaving the lines swirling in the turbulence of its wake. The effect is magical, for the car is never seen. It is implied by the void left by the streaming lines.

10.12 Matt Pyke (Universal Everything) and Karsten Schmidt (PostSpectacular). *High Performance Art*. 2007. Viral/HD television video for Audi TT Movement.

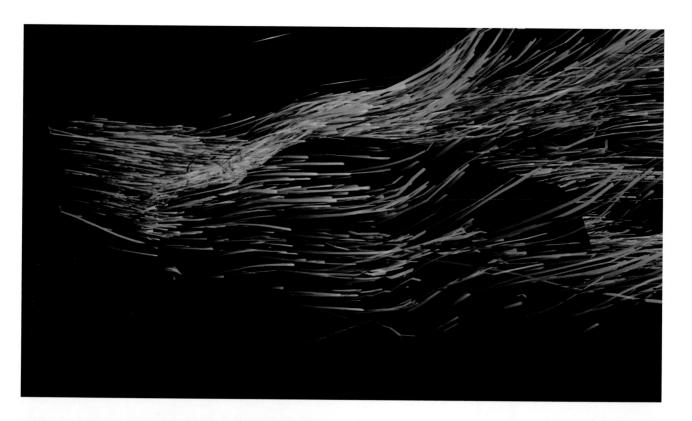

The video was created using a programming language called Processing, which was developed with artists and designers in mind. Pyke and Schmidt used Processing to create a virtual wind tunnel. The streaming lines in the video indicate wind flow. The program generated video in real time at full, high-definition resolution, with no further production work necessary. The video ran as a traditional advertisement on television, but it was also released onto the Internet as a viral video to be forwarded from person to person and posted on sharing sites around the world.

As we have seen, graphic design can reveal information by organizing facts or data in a visually coherent way. The train schedules discussed earlier are examples of this (see 10.8). Both take the facts of arrival and departure times and arrange them so that we can more easily retrieve the information we need. The redesigned schedule reveals even more information than the original schedule does, for it shows the relationship between weekday and weekend train times. The original schedule is not arranged in a way that makes that information visible. We can see these same principles at work in an interactive setting on a Web site called *Graffiti Archaeology* (10.13). Like the train schedules, *Graffiti Archaeology* takes isolated facts—in this case individual photographs—and sets them in a structure that reveals the information they contain.

Designed by Cassidy Curtis, *Graffiti Archaeology* makes visible the evolution of graffiti sites over time as graffiti writers paint on top of each other's work. To the left is a list of sites, grouped by general area. When a site is selected, all the available images for it are loaded onto the screen, with the most recent layer displayed on top. A graphic display at the bottom of the screen shows how many layers of photographs are available and situates them on a time line. Moving backward in time, we can peel back layer after layer of imagery to see what is hidden underneath. At the lower left, zoom controls and a navigator allow us to examine images in greater detail.

One special challenge for interaction designers is how to create visual clarity from the vast quantities of data that computers are capable of processing. W. Bradford Paley takes up this challenge in TextArc, a program that

10.13 Cassidy Curtis. *Graffiti Archaeology*. 2004–present. Interactive Web site. Web page illustrated is layer 17 of the graffiti site eastZ, featuring works by ZEROS, AWAKE, and anonymous artists.

10.14 W. Bradford Paley. *TextArc of "Alice's Adventures in Wonderland."* TextArc tool created by W. Bradford Paley, 2003.

displays the entire text of a book on a single screen and allows users to explore relationships between its words (10.14). Paley conceived TextArc as a tool that would allow a user to quickly gain some understanding of the contents of an unknown text—a business report, for example. In the illustration here, TextArc has displayed the text to Alice's Adventures in Wonderland. The entire text appears twice, in two concentric spirals. The outer spiral reproduces the book line-for-line. (The font is a single pixel in height.) The inner spiral consists of each word in the book at readable size. Words that appear more than once in the text are set in the inner oval-shaped field. Their exact position there is determined by where in the text they occur. Frequently used words are displayed brighter than less frequently used words, so that merely by loading Alice's Adventures in Wonderland into TextArc we would know that Alice, Hatter, Queen, Gryphon, Rabbit, and Duchess are important personages in the story. By selecting individual words or sentences and by working with a series of menus, we can envision the many verbal relationships of the novel. For example, selecting a word from the field causes orange lines to radiate from it to each place in the inner spiral of words where it belongs, and each line that it appears in turns green in the outer spiral. TextArc can also simply "read" the text from beginning to end, a slow but visually fascinating process that illuminates key words, associations, locations, and relationships as they pass by.

Graphic Design and Art

Graphic design is all around us, part of the look of daily life. Many art museums maintain collections of graphic design, which overlaps with art in interesting ways. Indeed, many artists have worked as graphic designers, and many graphic designers also make art.

One of the first artists to acknowledge the power of graphic design to become part of our personal world was Andy Warhol (10.15). His famous

10.15 Andy Warhol. *Black Bean*, detail, from the portfolio *Campbell's Soup I.* 1968. Color screenprint, image size $31\% \times 18\%$. Whitney Museum of American Art, New York

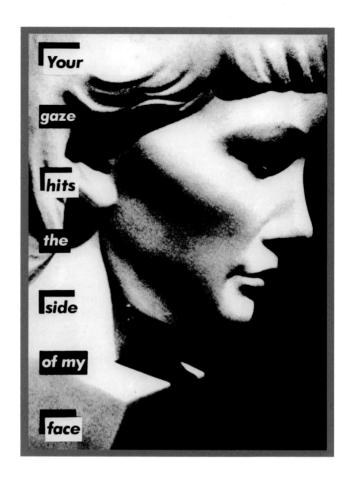

images of Campbell's soup cans are often talked about in the context of the history of art, for they signaled the arrival of a new kind of subject matter. Some viewers have seen them as a criticism of mass production and consumer culture; other viewers have seen them as a celebration of those same things. But one thing they certainly are is a collection of affectionate portraits of a very successful graphic design, the Campbell's soup label.

Campbell's first unveiled its red-and-white label in 1898. The gold medal was added in 1900, after the product won a gold medal at an international exhibition. For almost a century afterward, the label remained unchanged, a visual fact of daily life that accompanied several generations of Americans from childhood through old age. When asked why he painted the soup cans, Warhol answered, "I just paint things I always thought were beautiful—things you use every day and never think about." Campbell's finally changed their soup labels in 1999, twelve years after Warhol's death. From now on, viewers coming into contact with Warhol's paintings for the first time will have to be told that soup cans really looked like that once.

Whereas Warhol painted portraits of graphic design, Barbara Kruger appropriated its methods. Kruger worked for years as a graphic designer and art director for glossy magazines, where she became expert in the ways that words and images are used together to influence readers. She made use of her experience in works such as *Untitled* (*Your Gaze Hits the Side of My Face*) (10.16), which combines words and images in the manner of a poster or an advertisement. The image is a found photograph of a sculpture of a woman's head (note the block base). It can neither see nor speak. Passive and motionless, it exists only to be looked at. The words, in contrast, are visually more dynamic. Every other word punches outward toward us, asserting itself and disrupting our reading. The woman's face is a natural focal point, and each time we are drawn back to it we enact the statement: Again and again, our gaze hits the side of her face until we become aware of our looking as a kind of aggression.

Kruger uses the familiar look of graphic design to convey unexpected and often unsettling messages. Nathalie Miebach takes the content of graphic

10.16 Barbara Kruger. *Untitled* (Your Gaze Hits the Side of My Face). 1981. Photograph, 55 × 41". © Barbara Kruger. Courtesy Mary Boone Gallery, New York

10.17 Nathalie Miebach. *Antarctic Tidal Rhythms*. 2006. Reed, wood, Styrofoam, data; 8 × 6 × 3'.

© Nathalie Miebach. Image courtesy the artist

design-data that we would normally expect to see presented through charts and graphs-and gives it an unfamiliar visual form (10.17). Antarctic Tidal Rhythms embodies a year's worth of data concerning the gravitational influence of the sun and the moon on the Antarctic environment. At the core of the work is a basketry form. Like a graph, a basket is made of horizontal and vertical elements. By assigning values to those elements, as one would to the horizontal and vertical axes of a graph, Miebach allows data to direct her weaving and to determine the form the basket takes. In Antarctic Tidal Rhythms, the basket is woven according to rising and setting times for the moon and the sun over the course of a year. It grows from a circular base that represents twenty-four hours, with each weave representing an hour. Miebach refers to her baskets as "temporal landscapes," for they make visible the shape of data over a length of time. Onto this temporal landscape, she plots additional sets of data using color-coded elements such as wooden beads, blocks, and stakes. Here, wooden stakes and Styrofoam spheres chart tide readings, phases of the moon, solar noon readings, and the molecular structure of ice.

Miebach wants her sculptures to reveal the beauty of complexity and to inspire viewers to think about the differences between the visual vocabulary they associate with science and the visual vocabulary they associate with art. If beyond that they become interested in the data that underlies her work,

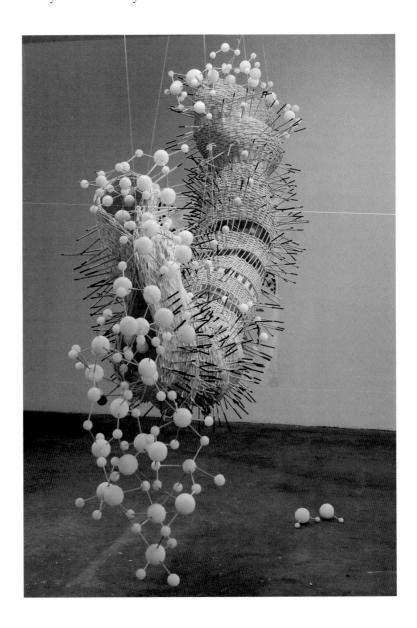

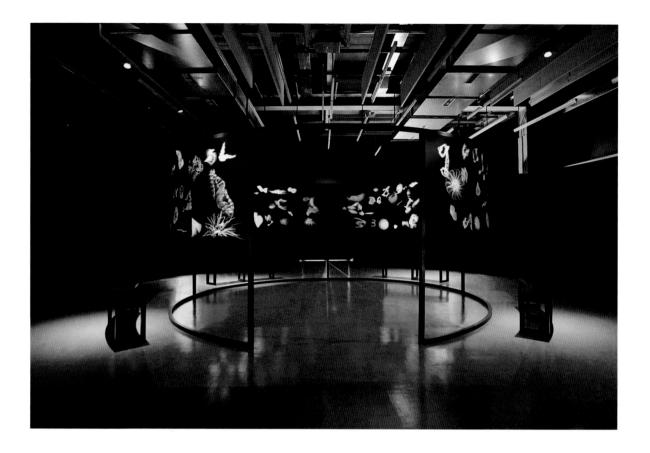

so much the better. "When you present the viewer with graphs and charts and data sheets full of numbers about climate change, say, that's an incredibly intimidating thing," she says. "But you present that same information through this weird, almost roller-coaster-y looking organic form, it lures them in."²

Designers working with digital motion graphics move with particular ease between design assignments and the expanding field of new media art, where digital technologies are turned to expressive ends. For example, Universal Everything, the design firm behind the Audi video we looked at earlier (see 10.12), often draws on an international network of designers, performers, and musicians to create animated digital works for museum settings. 1000 Hands, illustrated here (10.18), was a crowd-sourced audio-visual installation based in a downloadable mobile app that Universal Everything developed and made available for free. The app opens to a musical soundtrack composed for the project. Users draw a line with their finger, any kind of line, which the app automatically transforms into a three-dimensional animated linear form that pulsates and twists and shifts its colors to the beat of the music. Users could customize their creation, adjusting its complexity, energy level, and color, then submit it to join the dancing throng of drawings projected on the circular screen in the gallery, all moving to the beat of the music, each in its own way. The exhibition is over, but as of this writing the app is still available, and drawings can be submitted to an online gallery that Universal Everything maintains on its site.

We have come to accept the idea that a work of art may inspire many interpretations and hold many meanings. But it was not always this way. As we have seen, before our modern ideas about art were in place, artists often worked for clients who expected them to convey a message, whether about religious doctrine, a historical event, the power of a great ruler, or an episode from a favorite tale. Graphic designers continue that task, bending new technologies to the principles of communicative clarity and visual elegance that have been at the core of graphic design since scribes first developed writing.

10.18 Universal Everything. *1000 Hands*. 2013. Downloadable mobile app. Crowd-sourced installation at Media Space, London, September 21, 2013–February 7, 2014.

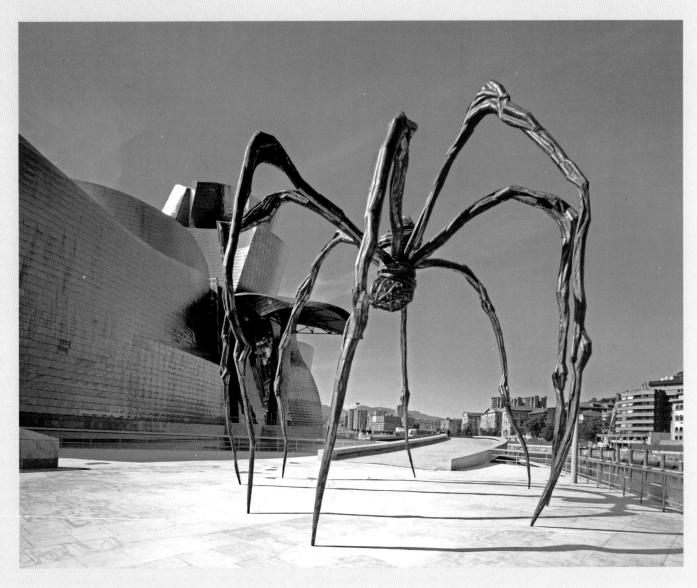

11.1 Louise Bourgeois. *Maman*. 1999, cast 2001. Bronze, marble, and stainless steel, height 29'4%". Edition 2/6 + A.P. Guggenheim Museum Bilbao, Bilbao, Spain

PART FOUR

Three-Dimensional Media

11

Sculpture and Installation

isitors arriving at the Guggenheim Museum Bilbao find it guarded by a very strange and unsettling presence: a 30-foot-tall bronze sculpture of a spider (11.1). Even less expected is the spider's name: *Maman*, French for "mom." For the artist Louise Bourgeois, *Maman* is a metaphor for her own mother as seen through a child's eyes—awesomely tall, protective, patient, and skilled. Perhaps the association of mother and spider was born from the strange logic of dreams. Bourgeois' mother wove and repaired tapestries for a living; a female spider spins a web to provide for herself and a cocoon to protect her young. Viewers make their own associations and explore their own feelings as they circle the bronze figures, or wander into the open cage of *Maman*'s cascading legs, or gaze upward at the compact body with its clutch of eggs suspended high overhead.

Maman is a sculpture in the round—a freestanding work that can be viewed from any angle, for it is finished on all sides. Not all sculpture is finished in the round. This work from Cambodia, for example, is a relief sculpture (11.2)—a sculpture in which forms project from but remain attached to a background surface. A relief is meant to be viewed frontally, the way we view a painting. Artists in many cultures have animated the surfaces of important objects and

11.2 The Churning of the Sea of Milk (detail), from the gallery of bas-reliefs, Angkor Wat, Angkor, Cambodia. 12th century. Sandstone.

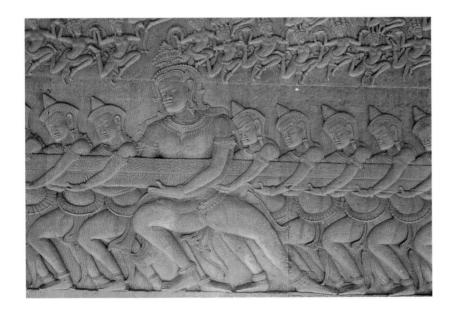

11.3 Durga Fighting the Buffalo Demon, Mahishamardini Cave, Mamallapuram, Tamil Nadu, India. 7th century.

architecture with relief sculpture. The carving illustrated here is a detail of a narrative relief at Angkor Wat, a vast temple built in the 12th century by Suryavarman II, king of the Khmer Empire (see 19.11). The relief depicts an episode from Hindu mythology wherein the god Vishnu convinces demons and gods to cooperate in their efforts to produce an elixir of immortality, which they both desire. Using the five-headed serpent Vasuki as a rope and Mount Mandara as a spindle, they pull back and forth for a thousand years—gods on one side, demons on the other—spinning the mountain to churn the Sea of Milk to obtain the elixir. The detail here shows part of the team of gods along with one of three giant figures who help them. Above, *apsaras*, beautiful celestial spirits, dance in the sky.

The Churning of the Sea of Milk is in low relief, sometimes called by the French name bas-relief, a technique in which the figures project only slightly from the background. Coins, for example, are modeled in low relief, as you can see by examining the portrait of Abraham Lincoln on the one-cent coin. A sculpture in which forms project more boldly from their background is called high relief. Forms modeled in high relief generally project to at least half their understood depth. Foreground elements may be modeled in the round, detaching themselves from the background altogether, as in this 7th-century monumental relief in a temple in Mamallapuram, India (11.3). The panel depicts a battle between the goddess Durga and the buffalo demon. To the left, eight-armed Durga, mounted on a lion, rushes forward with her victorious army. To the right, the buffalo demon and his supporters flee in defeat. The figures in this dynamic composition are all carved well away from the background, some considerably more than half-round. The panel belongs to an extraordinary Indian tradition in which entire temples were cut directly into cliffsides or carved from gigantic boulders. Interior and exterior—columns, doorways, arched ceilings, statues, and reliefs-were hewn from living rock, making of the temple itself a gigantic piece of walk-in sculpture.

In the round, low relief, and high relief are traditional categories for classifying sculpture. But as we shall see, sculpture today is anything but traditional. In addition to works in bronze, wood, and stone, we will encounter works in fiberglass, fabric, and fluorescent light. We will look at works meant to last

for eternity and works meant to last for a morning. And we will explore how an increasing awareness of sculpture's relationship to its surrounding space inspired artists to create spaces themselves as art, inaugurating a new artistic practice called installation.

Methods and Materials of Sculpture

There are four basic methods for making a sculpture: modeling, casting, carving, and assembling. **Modeling** and **assembling** are considered additive processes. The sculptor begins with a simple framework or core or nothing at all and *adds* material until the sculpture is finished. **Carving** is a subtractive process in which one starts with a mass of material larger than the planned sculpture and *subtracts*, or takes away, material until only the desired form remains. **Casting** involves a **mold** of some kind, into which liquid or semiliquid material is poured and allowed to harden.

Let us consider each of these methods in more detail and look as well at some of the materials they are used with.

Modeling

Modeling is familiar to most of us from childhood. As children, we experimented with play dough or clay to construct lopsided figures of people and animals. For sculpture, the most common modeling material is clay, an earth substance found in most parts of the world. Wet clay is wonderfully pliable; few can resist the temptation to squeeze and shape it. As long as clay remains wet, the sculptor can do almost anything with it—add on more and more clay to build up the form, gouge away sections, pinch it outward, scratch into it with a sharp tool, smooth it with the hands. But when a clay form has dried and been fired (heated to a very high temperature), it becomes hard. Fired clay, sometimes called by the Italian name **terra cotta**, is surprisingly durable. Much of the ancient art that has survived was formed from this material.

Gesturing exquisitely with one hand, the other hand posed on her knee, this graceful female figure was modeled of clay over a thousand years ago by

11.4 Figurine of a voluptuous lady. Maya, Late Classic period, 700–900 c.E. Ceramic with traces of pigment, height 8¾".

The Art Museum, Princeton University

an artist of the Mayan civilization in Mesoamerica (11.4). The figure was built up by hand, then sensitively worked with tools of stone and wood. (The Maya did not know metal.) Gentle, rounded forms predominate, from the masses of the head and body to the heavy ornaments and elaborate hairdo. Like much ancient art, this sculpture survived as part of a group of objects buried in a tomb.

In some ways modeling is the most direct of sculpture methods. The workable material responds to every touch, light or heavy, of the sculptor's fingers. Sculptors often use clay modeling in the same way that painters traditionally have used drawing, to test ideas before committing themselves to the finished work. As long as the clay is kept damp, it can be worked and reworked almost indefinitely.

Casting

In contrast to modeling, casting seems like a very *indirect* method of creating a sculpture. Sometimes the sculptor never touches the final piece at all. Metal, and specifically bronze, is the material we think of most readily in relation to casting. Bronze can be superheated until it flows, will pour freely into the tiniest crevices and forms, and then hardens to extreme durability. Even for a thin little projection, like a finger, there is no fear of its breaking off. Also through casting, the sculptor can achieve smooth rounded shapes and a glowing, reflective surface, such as we see in this Indian sculpture of the bodhisattva Avalokiteshvara (11.5). Cast in bronze and then gilded (covered with a thin layer of gold), the smooth, gleaming surfaces of the body contrast with the minutely detailed jewelry, hairstyle, and flowers, demonstrating the ability of metal to capture a full range of effects. In Buddhism, bodhisattvas are those

11.5 The Bodhisattva

Avalokiteshvara, from Kurkihar,
Bihar, Central India. Pala Dynasty,
12th century. Gilt bronze, height 10".
Patna Museum, Patna

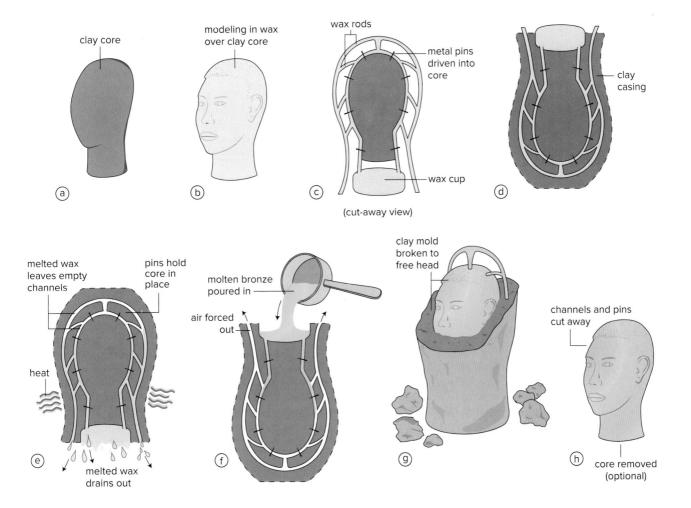

spiritually advanced beings who have chosen to delay their own buddhahood in order to help others. Avalokiteshvara is the most popular and beloved of these saintly presences. He is depicted here in princely garb, his hair piled high, seated in a relaxed and sinuous pose on a stylized lotus throne. Lotus blossoms, symbols of purity, twine upward beside him.

The most common method for casting metal is called the **lost-wax** process. Dating back to the third millennium B.C.E., the basic concept is simple and ingenious. We describe it here as it was practiced by the African sculptors of ancient Ife to create heads such as the one illustrated in Chapter 2 (see 2.16).

First, a core is built up of specially prepared clay (11.6; a). Over this core, the sculptor models the finished head in a layer of wax (b). When the sculpture is complete, wax rods and a wax cup are attached to it to form a sort of "arterial system," and metal pins are driven through the wax sculpture to the core inside (c). The whole is encased in specially prepared clay (d). When the clay has dried, it is heated so that the wax melts and runs out (hence "lost wax") and the clay hardens (e). The lost wax leaves a head-shaped void inside the block. Where the wax rods and block were, channels and a depression called a pouring cup remain. The pins hold the core in place, preserving the space where the wax was. Next, the mold is righted, and molten metal is poured into the pouring cup. The metal enters the mold through the channels, driving the air before it (f). When the metal bubbles up through the air channels, it is a sign that the mold is probably filled. Metal, therefore, has replaced the wax, which is why casting is known as a replacement method. When the metal has cooled, the mold is broken apart, freeing the head (g). The channels, now cast in metal as well, are cut away, the clay core is removed (if desired), holes or other flaws are patched or repaired, and the head is ready for smoothing and polishing (h).

11.6 The lost-wax casting process.

11.7 Jeff Koons. *Michael Jackson and Bubbles*. 1988. Porcelain, 42 × 70½ × 32½".

© Jeff Koons

A sculpture cast in this way is unique, for the wax original is destroyed in the process. Standard practice today is a variation called indirect or investment casting, which allows multiples to be made. In this method, the artist finishes the sculpture completely in clay, plaster, or other material. A mold is formed around the solid sculpture (today's foundries use synthetic rubber for this mold). The mold is removed from the sculpture in sections, then reassembled. Melted wax is painted or "slushed" inside the mold to build up an inner layer about threesixteenths of an inch thick. After it has hardened, this wax casting is removed from the mold and checked against the original sculpture for accuracy: it should be an exact duplicate, but hollow. The wax casting is fitted with wax rods, pierced with pins, then encased in solid plaster, which both fills and surrounds it, just as in Figure 11.6d. This plaster is called the *investment*. From this point on, the process is the same: the investment is heated so that the wax melts and runs out, metal is poured into the resulting void, and the investment is broken away to free the casting. The key difference is that the mold that makes the wax casting is reusable; thus, multiple wax versions of an original can be prepared and multiple bronzes of a sculpture cast. All but the simplest sculptures are cast in sections, which are then welded together. (Imagine two halves of an eggshell being cast separately in metal, then welded together to form a hollow metal egg.) As with prints (see Chapter 8), each casting is considered an original work of art, and a limited edition may be declared and controlled.

Although metal has historically been the most common material used for casting art objects, any material that can be poured and then hardened will do. For example, we cast small sculptures every time we make a tray of ice cubes, pouring water into a mold, freezing the water until it is solid, then unmolding the forms. Jeff Koons cast *Michael Jackson and Bubbles* in a ceramic blend consisting largely of porcelain (11.7). Ceramic is cast in a liquid form called slip, made by mixing powdered clay with water and a deflocculant, an ingredient that prevents the clay particles from clumping together. Similar in consistency to heavy cream, slip is poured into a mold made of plaster. Dry and porous, the plaster absorbs water from the slip, causing it to solidify first where the two are in contact. When a sufficiently thick wall of clay has set, the excess casting slip is poured out of the mold, leaving a hollow clay casting. When the casting is dry enough to handle safely, it is released from the mold and allowed to dry completely before being readied for firing and glazing. (For more about ceramics, see Chapter 12.)

Modeled from a photograph, Koons' sculpture depicts the pop star Michael Jackson holding his pet chimpanzee, Bubbles, on his lap. Red and blue in the photograph, their almost identical outfits have been transposed to white and gold, as have their skin tones, their hair, and the chimp's fur. Black eyes and

red lips focus our attention on their faces and suggest a bond between them. Flowers are strewn on the base of the sculpture as if in tribute. Historically, cast porcelain has been used for mass-produced figurines, and Koons relies on our knowing this. A few inches to a foot or so in height, figurines range from refined examples collected by aristocrats in the 18th century to sentimental knickknacks that have a popular following today. Koons presents Michael Jackson as a figurine on a monumental scale, a precious and fragile collectible.

The synthetic resins developed by modern chemistry have opened up new possibilities for sculptors. Synthetic resins are named for their resemblance to the natural resins secreted by plants such as pine trees and by certain insects. Amber, for example, is fossilized tree resin. Synthetic resin formulated for casting is a clear liquid that cures (solidifies permanently) through a chemical reaction triggered by mixing it with a second liquid, known as a catalyst or curing agent. Pigments can be added to the liquid resin, as can a variety of powdered fillers that give the finished casting the look of such traditional materials as bronze, wood, ceramic, and marble. Resin is cast in a rubber mold that has been sprayed with a release agent—a chemical that ensures that the resin will not stick to the mold as it hardens. The casting mixture—liquid resin, catalyst, and any colorants or fillers—is prepared at the last moment and poured into the mold, where it immediately begins to cure.

Rachel Whiteread's sculpture *Daylight* makes poetic use of synthetic resin (11.8). Whiteread is known for casting negative spaces such as the space under a table or a chair. She is especially interested in domestic spaces, and in the things we take for granted in them. She has cast spaces in plaster and concrete, transforming them by rendering them massive and opaque. More recently, she has worked with tinted resins, rendering spaces present yet still translucent. To create *Daylight*, Whiteread cast the shallow negative spaces held by an ordinary double-hung sash window—spaces cradled by the flat beds of the glass and the raised rims of the frames. She cast both sides of the window, then set the castings back-to-back, essentially turning the space around the window inside out. The result is a sculpture of a window made of the space a window holds. It is just enough of a shift to make a familiar object strange again, so we take the time to notice it. Tinted pale lilac, it seems to hold the memory of a particular light.

11.8 Rachel Whiteread. *Daylight*. 2010. Resin, $56\% \times 31\% \times 6\%$ ". © Rachel Whiteread. Courtesy the artist and Luhring Augustine, New York

11.9 Tilman Riemenschneider. Virgin and Child on the Crescent Moon. c. 1495. Limewood, height 34%". Museum für Angewandte Kunst, Cologne

Carving

Carving is more aggressive than modeling, more direct than casting. In this process, the sculptor begins with a block of material and cuts, chips, and gouges away until the form of the sculpture emerges. Wood and stone are the principal materials for carving, and both have been used by artists in many cultures throughout history.

Tilman Riemenschneider, one of the foremost German sculptors of the late Middle Ages, carved his Virgin and Child on the Crescent Moon in limewood (11.9). A soft wood with a close, uniform grain, limewood carves easily and lends itself well to Riemenschneider's detailed, virtuosic style. Mary stands in a gentle, informal S-curve, as though she might move at any moment. The infant Jesus is even more animated, and his body twists in a spiral motion. Like many artists of his time, Riemenschneider depicted Jesus unclothed and in motion to emphasize the completeness of his incarnation as a man.

Limewood was native to southern Germany, where Riemenschneider lived and worked. Northern German sculptors generally worked with oak, which was in plentiful supply in their own region. Ancient Olmec artists, in contrast, may have had more complex reasons for using basalt for their monumental stone carvings (11.10). Certainly they went to great lengths to quarry and transport it. Boulders weighing up to 44 tons seem to have been dragged for miles to the riverbank, then floated by barge to a landing point near their final destinations. Olmec sculptors shaped the hard stone using still harder stone tools, probably quartz blades. Carved in a broad style of plain surfaces and subtle modeling, the monumental sculptures are thought to represent Olmec rulers. Scholars believe that basalt was selected for its symbolic value. A volcanic stone spewn out in molten form from the Earth's interior, basalt was associated with the awesome powers of nature. It was thus a fitting material for rulers, who were believed to have the awesome power of journeying to the spirit world and back.

Assembling

Assembling is a process by which individual pieces or segments or objects are brought together to form a sculpture. Some writers make a distinction between assembling, in which parts of the sculpture are simply placed on or near each other, and constructing, in which the parts are actually joined together through welding, nailing, or a similar procedure. This book uses the term assemblage for both types of work.

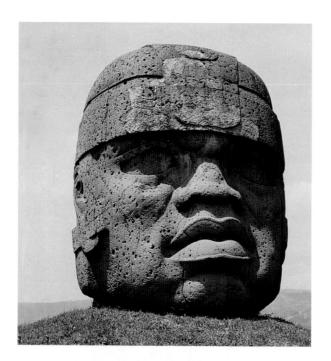

11.10 Colossal head. Olmec. 1500-300 B.C.E. Basalt, height approx. 8'. Museo de Antropología, Veracruz

The 20th-century American sculptor David Smith came to assemblage in an unusual way. While trying to establish himself as an artist, Smith worked as a welder. Later, when he began to concentrate on sculpture, he adapted his welding skills to a different purpose. His mature works broke new ground in both materials and forms (11.11). Smith's Cubi XXI is made of steel, a material closely identified with our modern era. Steel had been produced in small quantities since ancient times for such purposes as swords and armor, but only during the second half of the 19th century were technologies developed for mass-producing the metal, making steel widely and cheaply available for the first time. The architecture of the 20th century would not have been possible without it. Assembled from basic geometric shapes welded together, Cubi XXI seems to strike a precarious balance, as though a slight push could send its stacked elements tumbling. Smith wanted his sculptures to be displayed out of doors, and he polished their surfaces so that they would blaze in the sunlight. The wild scribbling of the polishing markings contrasts with the calm geometry of the forms that Smith favored.

11.11 David Smith. *Cubi XXI*. 1964. Stainless steel, height 9'11½". Gift of The Lipman Family Foundation, jointly owned by Storm King Art Center, Mountainville, New York and the Whitney Museum of American Art, New York

Roxy Paine also uses stainless steel for his outdoor sculptures, but in contrast to David Smith's vocabulary of geometric forms, Paine constructs organic forms—life-size, naturalistic trees he calls Dendroids (11.12). The pair of trees here lean toward each other, their branches joined at the tips. The longer we look, the less like any known trees they seem. Of course, they cannot grow, but are they dead? The branches seem a little too animated, like crooked whips or jagged bolts of lightning. The trunks and branches are not textured to imitate bark but, instead, are blatantly artificial—smooth, gleaming, cylindrical lengths of stainless steel welded together, the joints clearly evident. And where are the leaves? There is something magical about Paine's trees, as though we had stumbled onto a punishment in a fairy tale.

Martin Puryear assembled wooden elements to create *C.F.A.O.* (11.13). Puryear speaks freely about his experiences and influences, but he is normally quite reticent about what his sculptures might mean, preferring, he has said, to let viewers "puzzle things out." Nevertheless, for this sculpture he has furnished some clues. C.F.A.O. stands for Compagnie Française de l'Afrique Occidentale, the French West Africa Company, a trading company that sailed between France and West Africa beginning in the late 19th century, at a time when much of West Africa was under French colonial rule. Puryear first came into contact with the history of the company when he was teaching in West Africa with the Peace Corps. One of the firm's old warehouses still stood in the village where he lived. The base of the sculpture is an old, rustic French wheelbarrow. Its rough-hewn planks contrast with the smooth, elongated form it bears, an interpretation of a white mask danced by the Fang people. Like all African masks, it gives form to a spirit being. Puryear's elegantly carved version is much larger than an actual mask, and concave, like a shallow tub or coffin. The plain wooden scaffolding

11.12 Roxy Paine. *Conjoined*. 2007. Stainless steel and concrete, 40×45 '.

Modern Art Museum of Fort Worth. Courtesy of the artist and Marianne Boesky Gallery, New York, © Roxy Paine

11.13 Martin Puryear. C.F.A.O. 2006–07. Painted and unpainted pine and found wheelbarrow, $8'4\frac{1}{2}" \times 6'5\frac{1}{2}" \times 5'1"$. Courtesy the artist and Donald Young Gallery, Chicago

11.14 Huma Bhabha. *Bleekmen*. 2010. Clay, wood, wire, Styrofoam, plastic, cast iron, fabric, aluminum, acrylic paint, ink, paper, brass wire; $92\% \times 36 \times 31\%$ ". Courtesy the artist and Salon 94, New York

that supports it may be seen as a kind of bristling spiritual energy, like the halo of flames that rises up in back of the buddha Amida Nyorai in Figure 2.29.

Huma Bhabha makes sculptures from scavenged materials, a practice with its roots in her days as a young artist with not much money. Scraps of wood, pieces of metal and plastic, Styrofoam containers and packing pieces, chicken wire and sticks-all of these have served as building blocks for sculptures such as Bleekmen (11.14). The view illustrated here captures the side of Bleekmen that the artist covered roughly in clay, as though she were adding a skin over the sculpture's complicated innards, drawing it together into a recognizable figure—a head with an impassive face, like an African mask or a staring Easter Island statue (see 20.3). As viewers circle the work, the components it is made of come into view-pieces of wood, wire, metal, and Styrofoam, stacked in a composition that seems improvised and precarious. Whether the work represents a head is no longer so clear. From one side, it resembles nothing at all. Bhabha's sculptures appear before us like the charred survivors of some distant conflict. Yet there is a sort of humor to them as well, as though they were forever pulling themselves together, determined to go on. The title of Bleekmen is drawn from Philip K. Dick's 1964 science-fiction novel Martian Time-Slip, which tells of a human colony on Mars. The Bleekmen are Mars' original inhabitants. Described as wild and primitive, they nevertheless have discovered how to slip through time.

11.15 Jessica Stockholder. *Untitled*. 2006. Green plastic parts, black plastic parts, cushion, wooden element, red metal legs, fabric, cable, gray shelf, crocheted yarn, red skein of yarn, red electric cord, incandescent light fixture, tulle, various hardware and plastic parts and acrylic paint; 9'6" × 9' × 7'.

© Jessica Stockholder. Courtesy Mitchell-Innes and Nash, New York

Jessica Stockholder began her artistic career as a painter, and when she moved into the third dimension, she took her painter's love of color with her (11.15). As a sculptor, Stockholder takes color where she can find it, especially in the inexpensive, mass-produced objects that are everywhere around us—an orange plastic laundry basket, a pink shag rug, a set of green plastic dishes, a red extension cord, all are exploited for their formal values of line, shape, form, color, and texture. Sometimes an electric fan will appear, for movement, or a lamp, for light. Stockholder often paints on elements of her sculptures, adding human gestures to their manufactured surfaces. The result is a kind of paradox: a fundamentally nonrepresentational composition made of entirely recognizable objects. Like Katharina Grosse, whose work we looked at in Chapter 7 (see 7.14), Stockholder works at the intersection of installation, sculpture, and painting.

The Human Figure in Sculpture

A basic subject for sculpture, one that cuts across time and cultures, is the human figure. If you look back through this chapter, you will notice that almost all the representational works portray people. One reason, certainly, must be the relative permanence of the common materials of sculpture. Our life is short, and the desire to leave some trace of ourselves for future generations is great. Metal, terra cotta, stone—these are materials for the ages, materials mined from the Earth itself. Even wood may endure long after we are gone.

From earliest times, rulers powerful enough to maintain a workshop of artists have left images of themselves and their deeds. The royal tombs of ancient Egypt, for example, included statues such as the one illustrated here of the pharaoh Menkaure and Khamerernebty, his Great Royal Wife (11.16).

Portrayed with idealized, youthful bodies and similar facial features, the couple stand proudly erect, facing straight ahead. Although each has the left foot planted slightly forward, there is no suggestion of walking, for their shoulders and hips are level. Menkaure's arms are frozen at his sides, while his wife touches him in a formalized gesture of "belonging together." This formal pose is meant to convey not only the power of the rulers but also their serene, eternal existence. The pharaoh, after all, ruled as a "junior god" on Earth and, at death, would rejoin the gods in immortality. Egyptian rulers must have been pleased with this pose, for their artists repeated it again and again over the next two thousand years.

A second reason for the many human forms portrayed in sculpture is a little more mysterious. We might call it "presence." Sculpture, as pointed out earlier in this chapter, exists wholly in our world, in three dimensions. To portray a being in sculpture is to bring it into the world, to give it a presence that is close to life itself. In the ancient world, statues were often believed to have an ambiguous, porous relationship to life. In Egypt, for example, the Opening of the Mouth ceremony that was believed to help a dead person reawaken in the afterlife was performed not only on his or her mummified body but also on his or her statue. In China, the tomb of the first emperor was "protected" by a vast army of terra-cotta soldiers, buried standing in formation (see 19.14). A famous Greek myth tells of the sculptor Pygmalion, who fell so in love with a statue that it came to life.

Sculptors are often called on to memorialize the heroes and heroines of a community, people whose accomplishments or sacrifices are felt to be worthy of remembrance by future generations. Auguste Rodin's group of figures known as *The Burghers of Calais* (11.17) was commissioned in 1884 by the French city of Calais to honor six prominent townsmen of the 14th century, when France and England were engaged in the protracted conflict known as the Hundred Years War. The men had offered their lives to ransom Calais from the English, who had laid siege to it for over a year, starving its citizens. A famous chronicle of the time preserves the men's names, and Rodin, moved by it, imagined them as individuals, each facing death and defeat in his own way, whether in pride, anger, sorrow, resignation, or despair. Barefoot, with ropes around their necks and dressed only in their robelike shirts, as the English king had demanded, the men pace in an irregular circle, carrying the heavy key to the city gates. Sympathetic viewers must pace alongside them, for there is no angle from which all of their faces are visible.

11.16 Menkaure and Khamerernebty. Egypt, c. 2490–2472 B.C.E. Greywacke, height 4'6½". Museum of Fine Arts, Boston

11.17 Auguste Rodin.

The Burghers of Calais.

Modeled 1884–1917, cast 1919–21.

Bronze, 6'10½" × 7'10" × 6'3".

Rodin Museum, Philadelphia

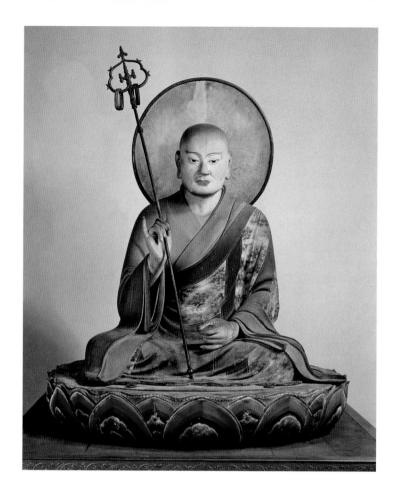

11.18 Kaikei. *Hachiman in the Guise of a Monk*. 1201. Polychrome wood, height 34½". Todai-ji temple. Nara

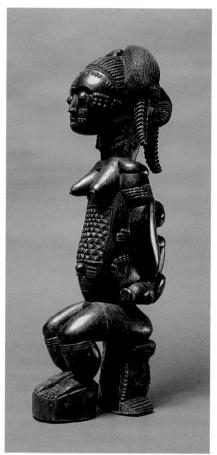

11.19 *Spirit Spouse*, from Ivory Coast. Baule, early 20th century. Wood, height 17%". University of Pennsylvania Museum, Philadelphia

Among the human images that artists are most often asked to make present in the world through sculpture are those connected with religion and the spirit realm. The Japanese sculptor Kaikei carved this image of the Shinto deity Hachiman in 1201 for a newly refurbished shrine (11.18). Patron and protector of warriors, Hachiman is often portrayed in the guise of a Buddhist monk. Kaikei has imagined him sitting cross-legged on a lotus pedestal, his long sleeves flowing gracefully over his knees. In his right hand he delicately holds a priest's walking staff made of bronze. The freely jangling rings at the top served to warn small creatures that someone was coming so they had time to get out of the way and avoid being stepped on. Cradled in his lap, his left hand originally held a rock-crystal rosary. The coloring heightens the realism of Kaikei's style, bringing the statue even closer to seeming capable of speech.

The human figure is also the most common subject of traditional African sculpture, but in fact the sculptures rarely represent humans. Instead, they generally represent spirits of various kinds. This masterful carving by a Baule sculptor of a seated woman carrying a child on her back depicts a spirit spouse (11.19). Once again, a formal pose and an impassive face are used to express the dignity of an otherworldly being. Baule belief holds that each person has, in addition to an earthly spouse, a spirit spouse in the Other World. If this spirit spouse is happy, all is well. But an unhappy or jealous spirit spouse may cause trouble in one's life. A remedy is to give the spirit spouse a presence in this world by commissioning a statue (called a "person of wood"). The statue is made as beautiful as possible to encourage the spirit to take up residence within it, and it is placed in a household shrine and tended to with gifts and small offerings.

Portrayals of rulers, heroes and heroines, and religious or spirit figures unite the many sculptural traditions of the world. Western culture, however, is

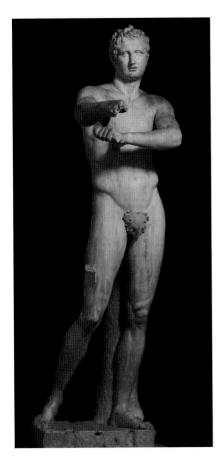

11.20 Apoxyomenos (Scraper). Roman copy of a bronze original by Lysippos, c. 320 B.C.E. Marble, height 6'83/4".

Musei Vaticani, Museo Pio Clementino, Rome

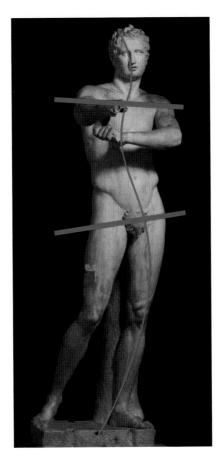

11.21 The dynamics of contrapposto.

marked as well by a tradition of sculpting the human figure for its own sake and of finding the body to be a worthy subject for art. This we owe ultimately to the ancient Greeks. Cultivating the body through gymnastics and sport was an important part of Greek culture, and they admired their athletes greatly. (The Olympics, after all, were a Greek invention.) Not surprisingly, perhaps, they came to believe that the body itself was beautiful. From the many athletic bodies on view, sculptors derived an ideally beautiful body type, governed by harmonious proportions. They gave these idealized, perfected bodies to images of gods and mythological heroes, who were usually depicted nude, and also to images of male athletes, who actually did train and compete unclothed. Finally, Greek artists developed a distinctive stance for their standing figures. Called contrapposto, it can be seen here in this statue of an athlete scraping himself off after a workout (11.20).

Contrapposto, meaning "counterpoise" or "counterbalance," sets the body in a gentle S-shaped curve through a play of opposites (11.21). Here, the athlete's weight rests on his left foot, so that his left hip is raised and his right leg is bent and relaxed. To counterbalance this, his right shoulder is raised. By portraying the dynamic interplay of a standing body at rest, contrapposto implies the potential for motion inherent in a living being. We can easily imagine that a moment earlier the athlete's weight was arranged differently, and that it will shift again a moment from now.

During the Renaissance, the study of Greek and Roman achievement brought the expressive, idealized body and the contrapposto stance back into Western art. We can see this clearly in such works as Michelangelo's *The Dying Slave* (11.22). The sculpture is one of a series of works that Michelangelo planned for the tomb of Pope Julius II, a project he never completed. We do

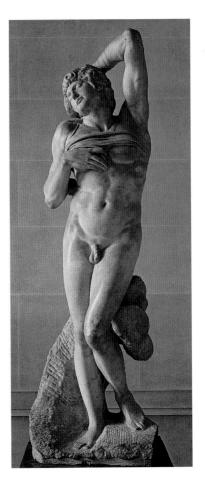

11.22 Michelangelo. *The Dying Slave*. 1513–16. Marble, height 7'6". Musée du Louvre, Paris

CROSSING CULTURES Primitivism

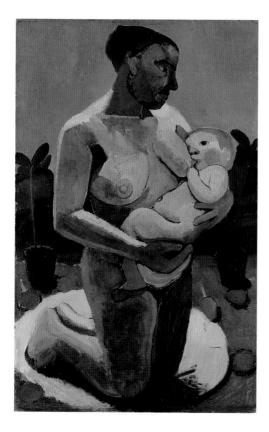

Why did artists start to "discover" African art during the early 1900s? How does the interest coincide with social events and cultural thinking of the time? What are some of the ways artists synthesized African style with European style in their works?

ooking back years later, the artists themselves disagreed on who was the first. Historians may never fully sort the matter out, but all agree that around 1906, in Paris, advanced young artists began to take an interest in African carvings. One of the first was the Fauve painter André Derain. Henri Matisse and Pablo Picasso quickly followed suit, along with Constantin Brancusi and many others. The artists purchased their first examples of African sculpture in flea markets and antique shops. European colonial rule over Africa, consolidated at the turn of the 20th century, resulted in hundreds of carvings being imported as "curiosities." When the artists wanted to see more, they went to the museum. Not an art museum, for African carvings were not then considered to be art, but to a museum of ethnography, where sculptures,

masks, utensils, weapons, ornaments, and other artifacts were jumbled together in dusty display cases. And yet, the young artists insisted, these carvings were art, and art of a very high order.

The "discovery" of African art was the culmination of several decades of interest in cultures outside the European mainstream, beginning with the Impressionists' fascination with Japanese prints in the 1860s. (See Crossing Cultures: Japanese Prints, page 99.) More recently, exhibitions had been held in Paris of Islamic art (1904) and ancient Iberian art (1906)—art from the region of present-day Spain from the 5th and 6th centuries B.C.E. The decorative patterns of Islamic art had a lasting influence on Matisse, while Picasso went through a brief "Iberian" phase. African art was the next step, the latest and most radical reach outside the West.

For artists seeking ways to break free of the tradition of European naturalism, African sculpture offered a seemingly limitless supply of ingenious solutions for abstracting the human face and form. Fascination with the beauty and power of African art quickly extended beyond Paris into advanced artistic circles across Europe, and it lasted for most of the first half of the 20th century. The interest in African art was more than formal, however. It was part of a larger, more complex, and more troubling phenomenon called primitivism. The word *primitive* refers to something that is less complex, less sophisticated, or less advanced than what it is being compared with—an earlier stage of it. Designating a culture as "primitive" excused European domination of it. Yet artists, at odds with the larger culture, admired all things primitive. Hoping to renew art by taking it back to its infancy, they looked to the "primitive" arts of Africa and Oceania, which they believed to be instinctive, unchanging, and primordial.

In *Kneeling Mother and Child*, Paula Modersohn-Becker portrays woman in her aspect of life-giver and nurturer, a basic force of nature itself. African sculptures often emphasize these female roles. The woman's monumentalized naked form has an earthbound, sculptural presence. The face especially is "primitivized"—painted in a purposefully unsophisticated, unbeautiful way.

The legacy of primitivism is complicated. Artists were instrumental in drawing serious attention to African and Oceanic art, but they were completely wrong in thinking of it as primitive. A century later, we are still struggling to see African art on its own terms.

Paula Modersohn-Becker. Kneeling Mother with a Child at Her Breast. 1907. Oil on canvas, $44\frac{1}{2} \times 29\frac{1}{8}$ ". Staatliche Museen zu Berlin, Preussischer Kulturbesitz, Nationalgalerie.

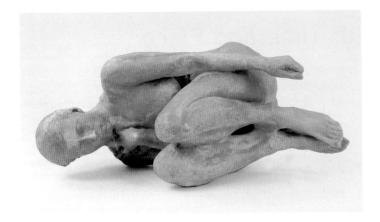

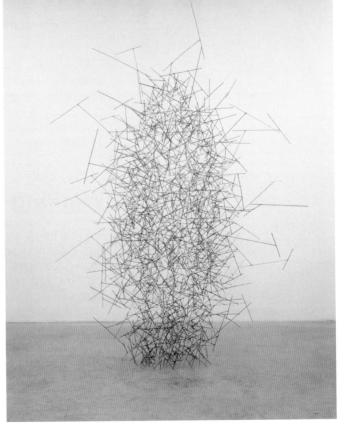

11.24 Antony Gormley. *Quantum Void III.* 2008. 2mm square section stainless steel wire, 8'4" \times 7'7 3 /4" \times 5'10 7 /8". © Antony Gormley. Photo © Stephen White, courtesy White Cube

not know what the figure represents: *The Dying Slave* is simply a name that has become attached to it over the centuries. A companion work depicting a muscular nude struggling against his bonds is known as *The Rebellious Slave*. The two statues may represent the arts in bondage after the death of Pope Julius, one of their great patrons. Less literally, they may also represent two reactions to the bondage of the soul, which longs for release from its earthly prison, the body. What is clear is that the figures are not meant to represent a specific person such as a saint or a martyr but, rather, to express an idea or an emotion through the body.

Since the Renaissance, the body has continued to serve as a subject through which sculptors express feelings and ideas about the human experience. For Kiki Smith, who came of age artistically during the decade around 1990, the body is a subject that connects the universal and the personal in a unique way. "I think I chose the body as a subject, not consciously, but because it is the one form that we all share," she has said. "It's something that everybody has their own authentic experience with."2 Honeywax depicts a woman, her knees and right hand drawn up to her chest, her left arm relaxed at her side, her eyes closed (11.23). It is hard to say whether she is retreating from the world or about to be born into it. Though Smith set the work on the floor, the figure's pose is that of a person suspended-in air, in fluid, in a dream. Translucent and easily injured, the wax surface suggests human skin, vulnerability, and impermanence. Within the history of sculpture, wax is the material of lost-wax casting, the material that will be discarded to make way for something else, something durable. "I feel I'm making physical manifestations of psychic and spiritual dilemmas," Smith has said. "Spiritual dilemmas are being played out physically."3 Her words might just as easily have been spoken by Michelangelo about his Dying Slave (11.22), and they demonstrate the continuing vitality of the human body as a vehicle for expressing the human experience.

The body at the center of Antony Gormley's *Quantum Void III* is an absence, a void within a field of energy (11.24). The photograph illustrated here makes the body-shaped void clear for purposes of documentation, but the experience of seeing the work in person is very different. Made of lengths of slender stainless steel bars welded each to the next in branching formation,

the sculpture dissolves in the sunlight into a formless dazzle. As viewers circle around it, the void at the heart of the work comes and goes, and only from certain angles does it seem to resolve itself into the form of a human body. "The body is central to my work," Gormley has written. "How does it feel to be alive? What is it to be conscious?" *Quantum Void III* can be understood as a visual response to those most basic and profound questions.

Working with Time and Place

We live in an environment sculpted by the forces of nature. Millions of years ago, drifting continents collided, the shock sending up towering mountain ranges. Glaciers advanced and retreated, gouging out lakes and valleys, creating hills and waterfalls, grinding down rock faces and distributing boulders. Rivers carved channels and canyons. Still today mountains are slowly being pushed upward, the ocean constantly rearranges the shoreline, and wind shifts the desert sands. Some shapings happen quickly, others take millions of years. Some last for centuries, others for only a moment.

People, too, have worked to sculpt the landscape. Often, the shaping is purely practical, like digging a canal to enable boats to penetrate inland, or terracing a hillside so that crops can grow. But just as often, we have shaped places for religious purposes or for aesthetic contemplation and enjoyment. When the Western category of art was first formulated, landscape gardening was often mentioned along with painting and sculpture. In Chapter 3, we looked at one of the most famous gardens in the world, the stone and gravel garden at Ryoan-ji Temple (see 3.24). We also looked at Robert Smithson's *Spiral Jetty*, a coil of rock and earth extending into the Great Salt Lake in Utah (see 3.25).

Spiral Jetty is an earthwork, a work of art made for a specific place using natural materials found there, especially the earth itself. Earthworks were one of the ways in which artists of Smithson's generation tried to move away from inherited ideas about art as an object that could be bought and sold. As with many developments of those years, earthworks built bridges of understanding to other world traditions. One of the most famous earthworks in the United States is the Serpent Mound, near Locust Grove, Ohio (11.25). For almost five thousand years, numerous Eastern American peoples built large-scale earthworks as burial sites and ceremonial centers. Serpent Mound was long thought to have been formed by the Hopewell people during the early centuries of our era. Recently, however, scientific methods have suggested a date of around 1070 c.E., long after the decline of Hopewell culture. Serpent Mound contains no burials, and one archaeologist has suggested that the mound may have been

11.25 Serpent Mound, near Locust Grove, Ohio. c. 1070 c.E. Overall length (uncoiled) approx. 1,300'.

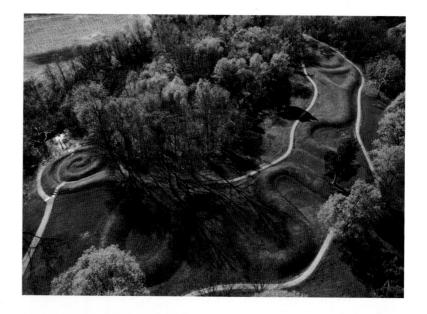

created in response to a celestial event, the sighting of Halley's comet, which flamed through the skies in 1066.⁵

Earthworks such as Serpent Mound and *Spiral Jetty* enter into the natural world and participate in its changes—the rain and snow that fall, the vegetation that grows and blossoms, even eventual decay. For artists such as Smithson, participating in natural processes was part of the art. He assumed that his work would change slowly over time, and he embraced those changes as part of the ongoing life of his sculpture. In the earthworks of Andy Goldsworthy, the element of time moves to center stage (11.26). Goldsworthy makes earthworks that are ephemeral, often from such fleeting materials as ice, leaves, or branches. Many of his works last no more than a few hours before the wind scatters them, or the tide sweeps them away, or, in the case of *Reconstructed Icicles*, *Dumfriesshire*, 1995, the sun melts them. Goldsworthy tries to go into nature every day and make something from whatever he finds. He documents his work in photographs, including photographs that record the work's disappearance over time, as nature "erases" it. "Time and change are connected to place," he has written. "Real change is best understood by staying in one place."

Photographs bring us views of Serpent Mound, *Spiral Jetty*, and *Reconstructed Icicles*, *Dumfriesshire*, by framing them in a two-dimensional composition and making them a focal point. In fact, such works are incidents in the landscape, like other incidents—a tree, a rock, a stream, a hill. We would experience them quite differently in person, with the land extending endlessly and our eyes free to look in any direction. Artists have more control over our experience in a shaped, delimited space such as a room. The art form known as installation, introduced in Chapter 2 (see 2.41), grew from this observation. Originally, "installation" referred to the placement of artworks in an exhibition space—where the pictures were hung or the sculpture was positioned. Gallery and museum workers speak of "installing a show," by which they mean setting the art in place. Often, an "installation shot" is made—a photograph documenting the exhibition.

Just as an installation shot gathers a space and everything in it into a single image, so artists began to conceive of a space and everything in it as a single work of art. This new approach came to be known as installation, or installation art. With installation art, an artist modifies a space in some way

11.26 Andy Goldsworthy. *Reconstructed Icicles, Dumfriesshire, 1995.* 1995. Icicles, reconstructed and refrozen.

and then asks us to enter, explore, and experience it. Some installations may remind us of places our mind invents in dreams. Others have been compared to sets for a play or a film—a place where something happened or is about to happen. Still others resemble places we are already familiar with, such as a hotel room, a gymnasium, a store, or an office.

The idea of a room remains at the heart of many installations. A room is a space set apart from the rest of the world. It may be a place of refuge, of discovery, of secrets, or even of imprisonment. The room in Ilya and Emilia Kabakov's *The Happiest Man* can be seen as all of those things (11.27). Offered a vast underground space to work with, the Kabakovs, husband and wife, transformed it into a darkened movie theater, complete with rows of folding theater seats and a large screen on which footage from old films played nonstop. Within this theater they constructed and furnished the room illustrated here. The presence of both a dining table and a bed tells us that this was a one-room living space. Whoever called it home would have shared a bathroom and probably a kitchen with other single-room tenants in what was formerly a spacious family apartment. The dark furniture is dowdy and old-fashioned but well cared for-the sort of inherited or second-hand belongings that someone living around 1955 might have possessed. The room's one unusual feature is its window, which looks out onto the movie screen. Indeed, the movie screen is all that can be seen through it.

The footage is from Soviet films of the 1930s, 40s, and 50s. The films were made during some of the bleakest years of Soviet history—years that witnessed famine, political persecutions, war, privation, repression, and censorship—yet the vision they present of Soviet society is radiant and optimistic, full of singing and dancing country folk from the Soviet Union's many distinct cultural regions. "At the beginning, we wanted to use a film from 1930s Hollywood, which was [essentially] a Cinderella story," the Kabakovs explained. "But we compared it to a film from 1930s Soviet Union which was about the happiness for all—the people in the film are simple people and they're all happy. It's a true utopia because everyone is happy." Visitors to the installation could sit in the theater to watch the films, or they could experience the view from the apartment where the happiest man lived, the man who could believe for a time that what he saw from his window was real.

11.27 Ilya and Emilia Kabakov. The Happiest Man. 2013. Installation at Ambika P3, University of Westminster, London.

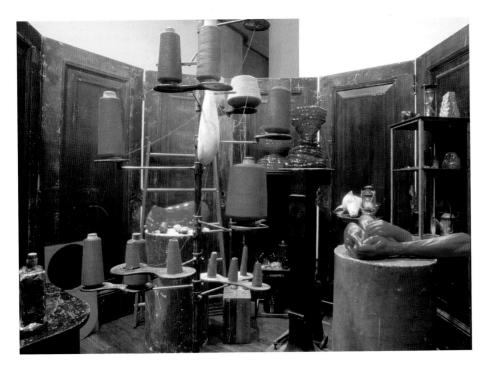

11.28 Louise Bourgeois. *The Red Room—Child*, interior. 1994. Installation, detail. Wood, metal, thread, glass, and wax; $6'11'' \times 11'7'' \times 9'$. Musée d'Art Contemporain de Montréal

11.29 Dan Flavin. *Untitled (to Karin and Walther)*, from the *European Couples* series. 1966–71. Fluorescent light fixtures with blue tubes, $8 \times 8'$. Courtesy Dia Art Foundation

In The Happiest Man, the Kabakovs created what they call a total installation, a work of art that can be entered so that viewers are immersed in the experience. In her installation The Red Room-Child, Louise Bourgeois turns this idea inside out, creating a place that viewers want to enter but cannot (11.28). The Red Room-Child is a chamber created by setting old wooden doors in a ring, each one hinged to the next. A window in one of the doors allows us to peer inside. The act feels somehow both shameful and fascinating, like secretly reading someone else's diary. Inside are many stands set with spools of red thread. Shelves and pedestals hold other red objects such as large and small forearms and hands. On one pedestal, a large hand seems to protect the small ones. On another, small hands imitate the large hands-learning how to do something, perhaps, something to do with the thread. The Red Room-Child was originally shown with a companion piece, a red room for the parents. Also defined by a ring of doors, this was clearly a marital bedroom, and so neat as to be almost sterile. Bourgeois' subject, as so often, is the psychological scarring of her own childhood, which was spent with a mother she adored and a father she hated for his infidelity to her mother. As viewers, we may be led to contemplate more generally the intense psychological bonds between parents and children.

Previous chapters have explored how light can be used to create a sense of place, as with the colored light that suffuses the Sainte-Chapelle in Paris (see 3.1). Another artist who devoted his career to exploring the effects of light on our perception of space was Dan Flavin. His means were simple, and they never varied: Flavin made constructions from standard, commercially available fluorescent light tubes and fixtures. At first he focused his attention on the lights themselves as sculptural objects, but he quickly came to realize, as he put it, that "the actual space of the room could be disrupted and played with" through light. ** Untitled (to Karin and Walther)* (11.29) consists of four blue fluorescent lights arranged in a square and standing on the floor in a corner. Two lights face inward, two outward. From these simple means a whole range of blues arises as light reflects off the white walls and radiates into the room.

Flavin was associated with **Minimalism**, an art movement of the 1960s. Like other movements of those years, Minimalism was part of an ongoing argument about the appropriate purpose, materials, and look of art in the modern era. Minimalist artists believed that art should offer a pure and honest aesthetic experience instead of trying to influence people through images or transmit the ego of the artist through self-expression. They favored materials associated more with industry or construction than with art, and they let those materials speak for themselves.

Tomás Saraceno's *in orbit* activated a space that we can normally only gaze at, the space held by the vast, vaulted glass cupola that covers a museum for contemporary art in Düsseldorf, Germany (11.30). The steel-and-glass structure replaced the original roof when the 19th-century building was converted into a museum, and it serves as a skylight for the interior atrium. Across this space Saraceno stretched three layers of netting made of slender, resilient steel wire. Looking like giant balloons, air-filled translucent plastic spheres up to 28 feet in diameter kept the layers apart, creating three distinct levels of undulating netting. Up to ten visitors at a time could enter the ethereal installation, passing freely from one level to the next.

From far below, the netting was barely visible, and so it seemed as though people were walking and lounging in the sky above. Inside the installation, the netting acted like a spider's web, with each new presence, each new footfall or shift in weight sending vibrations through the whole. Visitors became aware through their bodies that they were all connected. Suspended in mid-air, they experienced something close to weightlessness, something close to flying, something close to being able to inhabit the sky.

Several of the works we have examined in this section no longer exist, not because they were lost or destroyed, but because they were not meant to last in the first place. The idea of impermanent sculpture may surprise us at first, but in fact most of us not only are familiar with it but also have made it. An outdoor figure modeled in snow on a cold winter afternoon is destined to melt before spring, but we take pleasure in sculpting it anyway. Castles and mermaids modeled in wet sand by the shore will be washed away when the tide comes in, but we still put great energy and inventiveness into creating them. For festivals and carnivals the world over, weeks and even months are spent creating elaborate figures and floats, all for the sake of a single day's event.

11.30 Tomás Saraceno. *in orbit*. 2013. Installation at Kunstsammlung Nordrhein-Westfalen, Düsseldorf, summer 2013—autumn 2014. Steel wire, inflated polyvinyl chloride (PVC) spheres. Courtesy the artist and Tanya Bonakdar Gallery, New York

Since the 1960s, many artists have been intrigued by these kinds of events and activities—by the way they bring people together, focus their energy, and intensify life for a moment before disappearing. In their different ways, festivals and sandcastles suggested answers to such questions as how to bring art closer to daily life, and how to make art without making an object that could be sold and owned.

Among the most famous artists to work with these ideas were the husbandand-wife team of Christo and Jeanne-Claude. For over five decades, they planned and carried out vast art projects involving the cooperation of hundreds of people. The last work they completed together was The Gates (11.31), a project for New York City's Central Park. Hundreds of paid workers arrived from all over the country to help Christo and Jeanne-Claude set up 7,503 saffroncolored, rectangular gateways along the 23 miles of the park's footpaths. Rolled up and secured against the high horizontal beam of each gate was a saffroncolored banner of nylon fabric. On the opening day of the project, the workers went from gate to gate freeing the banners, which unfurled and began to billow in the wind as the pale winter sunlight played over and through them. The Gates remained in place for sixteen days, attracting four million visitors from all over the world. The American composer Aaron Copland once wrote an orchestral piece called Fanfare for the Common Man. In a similar spirit, The Gates were like a majestic ceremonial walkway for everyone. After sixteen days, the project was removed. The materials it was made of-steel, vinyl, and nylon fabric-were all recycled, and the park was left as pristine as it had been before.

Christo and Jeanne-Claude accepted no funding from outside sources for such projects, preferring instead to raise the money themselves by selling drawings and collages generated during the planning stages, as well as early artworks. They were careful to emphasize that their art was not just the end result, but the entire process from planning through removal, including the way it energizes people and creates relationships.

11.31 Christo and Jeanne-Claude. *The Gates.* 1979–2005. Installation in Central Park, New York City, February 12–27, 2005.

ARTISTS Christo (b. 1935) and Jeanne-Claude (1935-2009)

Why do the artists want to create works of large scale—gift packages—that the public cannot miss or ignore? Should they be allowed to manipulate the natural landscape, and if they change the landscape, why have works that are ephemeral?

any artists over time have worked on a grand scale, but none did so as consistently and as spectacularly as Christo and Jeanne-Claude. Their body of work consisted of "projects," most of which were colossal. Often, they wrapped things—large things—like giant gift packages. They wrapped a whole section of the Australian coast, cliffs and all, in woven erosion-control fabric. They wrapped a historic bridge in Paris with 10 acres of silky champagne-colored fabric. In 1995 they wrapped the Reichstag, the German Parliament building in Berlin, with more than a million square feet of shiny aluminum-hued cloth. No passerby could possibly miss these "projects" or ignore them.

Christo and Jeanne-Claude's art was very public, but the artists themselves remained something of a mystery. According to the brief and rather formal biography they used to release, Christo Javacheff was born in 1935 in Bulgaria, in eastern Europe. He studied at the Fine Arts Academy in Sofia, then traveled by way of Prague and Vienna to Paris. It was in Paris, in 1958,

that Christo began wrapping, at first on a modest scale. As he tells it, he began with small objects, such as chairs and tables and bottles. In Paris, too, Christo met Jeanne-Claude de Guillebon, born in Casablanca, Morocco, of a French military family, who became his partner.

The first of the large-scale wrapped projects was made in Cologne, Germany, in 1961, when Christo and Jeanne-Claude allowed their own art exhibition to spill outside a gallery beside the Rhine harbor onto the docks. A stack of barrels and other paraphernalia, plus rolls of industrial paper, became the *Dockside Packages*. Other ambitious wrappings followed, but the two artists had yet grander plans. The project that established their international reputation was not a wrapping but a *draping*. In 1972 Christo and Jeanne-Claude strung a 4-ton orange nylon curtain between two mountains in Colorado, an arrangement that held intact only long enough to be photographed. They called it *Valley Curtain*.

Two projects in particular transformed Christo and Jeanne-Claude into media celebrities. The first was Running Fence, in the mid-1970s, which set up a white nylon barrier 24½ miles long over the hills of northern California. The other was Surrounded Islands, in the early 1980s, for which eleven little islands in Florida's Biscayne Bay were circled with pink, floating, polypropylene cloth. Earlier projects had been remarkable, daring, extravagant-but these two were lovely. Even people who had objected to such manipulations of the landscape came to admire them. People had to admire quickly, though, for Christo and Jeanne-Claude's structures were meant to stand physically for only a few days or weeks. After a predetermined period, workers removed them, leaving no trace, and the materials were recycled. The projects live on afterward in preparatory sketches, photographs, books, and films.

Some observers have criticized the artists for the transitory nature of their works, but Christo had a ready reply: "I am an artist, and I have to have courage.... Do you know that I don't have any artworks that exist? They all go away when they're finished. Only the sketches are left, giving my works an almost legendary character. I think it takes much greater courage to create things to be gone than to create things that will remain."

Jeanne-Claude died in 2009. Christo continues to work on the projects they had planned together.

Christo and Jeanne-Claude at *The Gates*. 2005. Photo by Wolfgang Volz.

12

Arts of Ritual and Daily Life

s we saw in Chapter 2, our modern concept of art took shape during the 18th century. It was then that European philosophers separated painting, sculpture, and architecture from other kinds of skilled making and placed them together with poetry and music in a new category called the fine arts. More than two centuries separate us from that moment, and over that time the new grouping has come to seem natural to us, just part of the way the world is. Yet, in fact, the grouping is not natural but cultural.

In this chapter, we look at the context that "art" was lifted from, objects made with great skill and inventiveness, rewarding to contemplate and imbued with meaning. They were made to be touched, to be handled, to be used or worn in daily life or in ritual settings such as religious ceremonies. Because of that, they possess a special human intimacy. Even if we see them now in a museum, we know that they once were used by their owners, who took them into their lives.

We begin by introducing a range of widely used media—clay, glass, metal, wood, fiber, ivory, jade, and lacquer—illustrated with Western objects fashioned before our system of fine art arose, and with objects from cultures where that separation never occurred. We then look briefly at how Western thinking about these arts has changed and been challenged in the centuries since fine art was born.

Clay

Ceramics, from the ancient Greek word *keramakos*, meaning "of pottery," is the art of making objects from clay, a naturally occurring earth substance. When dry, clay has a powdery consistency; mixed with water, it becomes **plastic**—that is, moldable and cohesive. In this form it can be modeled, pinched, rolled, or shaped between the hands. Once a clay form has been built and permitted to dry, it will hold its shape, but it is very fragile. To ensure permanence, the form must be fired in a kiln, at temperatures ranging between about 1,200 and 2,700 degrees Fahrenheit, or higher. Firing changes the chemical composition of the clay so that it can never again be made plastic.

Nearly every culture we know of has practiced ceramics. The earliest known ceramics are from China and have been dated to as early as 20,000 years ago. Pottery almost as old has been discovered at sites in Japan. A major requirement for most ceramic objects is that they be hollow, that they have thin

walls around a hollow core. There are two reasons for this. First, many ceramic wares are meant to contain things—food or liquids, for instance. Second, a solid clay piece is difficult to fire and may very well explode in the kiln. To meet this need for hollowness, ceramists over the ages have developed specialized forming techniques.

One such technique is called slab construction. The ceramist rolls out the clay into a sheet, very much as a baker would roll out a pie crust, and then allows the sheet to dry slightly. The sheet, or slab, can then be handled in many ways. It can be curled into a cylinder, draped over a mold to make a bowl, shaped into free-form sculptural configurations, or cut into shapes that can be pieced together.

Another technique for making a thin, hollow form is coiling. The ceramist rolls out ropelike strands of clay, then coils them upon one another and joins them together. A vessel made from coils attached one atop the other will have a ridged surface, but the coils can be smoothed completely to produce a uniform, flat wall. The native peoples of the southwestern United States made extraordinarily large, finely shaped pots by coiling. During the 20th century, the tradition was revived by a few supremely talented individuals, including the famous Pueblo potter María Martínez (12.1).

Martínez worked with the local red clay of New Mexico. The distinctive black tonalities of her finished pots were produced by the firing process. After building, smoothing, and air-drying her pots, Martínez laboriously burnished them to a sheen with a smooth stone. Next, a design was painted on with slip (liquid clay). The pot was then fired. Partway through the firing, the flames were smothered, and the pot blackened in the resulting smoke. Areas painted with slip remained matte (dull), while burnished areas took on a high gloss.

By far the fastest method of creating a hollow, rounded form is by means of the potter's wheel. Potters in the ancient Near East were using a rotating disk, today called a slow wheel, to speed the making of coil pots by around 4000 B.C.E., but the true potter's wheel, known as the fast wheel, seems to have been invented first in China a little over a thousand years later. Despite some modern improvements and the addition of electricity, the basic principle

12.1 María and Julián Martínez. Jar. c. 1939. Blackware, height 11½". National Museum of Women in the Arts, Washington, D.C.

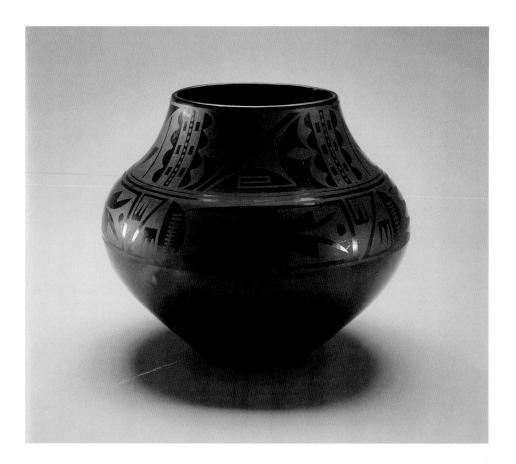

ARTISTS María Martínez (1881[?]-1980)

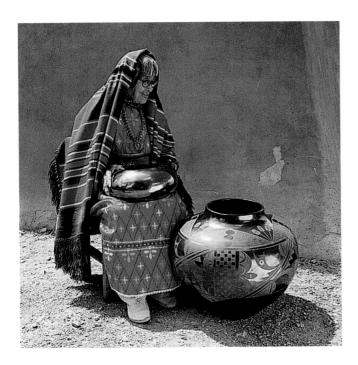

What is the method by which Martínez creates pottery? What aspects of the Pueblo culture does the artist showcase through her achievements?

t is a long way in miles and in time between the tiny pueblo of San Ildefonso in New Mexico and the White House in Washington, D.C. But the extraordinary ceramic artist María Martínez made that journey, and many others, in a long lifetime devoted to the craft of pottery making. María—as she signed herself and is known professionally—began her career as a folk potter and ended it six decades later as a first-ranked potter of international reputation.

A daughter of Pueblo people, María most likely was born in 1881, but there are no records. As a child, she learned to make pottery, using the coil method, by watching her aunt and other women in the community. Part of her youth was spent at St. Catherine's Indian School in Santa Fe, where María became friends with Julián Martínez. The couple married in 1904.

Although the husband worked at other jobs, the two Martínezes early formed a partnership for making

pottery—she doing the building, he the decorating. Between 1907 and 1910, he was employed as a laborer on an archaeological site near the pueblo, under the direction of Dr. Edgar L. Hewett. The amazing career of María Martínez was launched in a simple way; Dr. Hewett gave her a broken piece of pottery from the site and asked her to reconstruct a whole pot in that style using the traditional blackware techniques.

About 1919 the Martínezes developed the special black-on-black pottery that was to make them and the pueblo of San Ildefonso famous. The shiny blackware—created from red clay by a process of smothering the bonfire used for firing—was decorated with matte-black designs. This black-on-black ware was commercially quite successful. María Martínez and her husband became wealthy by the standards of the pueblo and, as was customary, shared that wealth with the entire community.

María bore four sons who survived. Eventually, they and their wives and children and grandchildren became partners in her enterprise. One shadow on her domestic life was her husband's serious alcoholism, which began early in their marriage and contributed to his death in 1943. After he was gone, Santana, María's daughter-in-law, took over much of the decorating of pots, later to be followed by María's son Popovi Da.

As María's fame spread, she traveled widely, giving demonstrations at many world's fairs. Among the awards she received were an honorary doctorate from the University of Colorado and the American Ceramic Society's highest honor for a lifetime of devotion to clay. Her visit to Washington during the 1930s was a highlight. President Franklin D. Roosevelt was not at home, but Mrs. Eleanor Roosevelt was, and she told María, "You are one of the important ones. We have a piece of your pottery here in the White House, and we treasure it and show it to visitors from overseas."

Undoubtedly, María's greatest achievement was in reviving and popularizing the traditions of fine pottery making among the Pueblo people. Not long before her death, according to her great-granddaughter, she said: "When I am gone, essentially other people have my pots. But to you I leave my greatest achievement, which is the ability to do it." 1

Photograph of María Martínez by Jerry D. Jacka.

of wheel construction remains the same as it was in ancient times. The wheel is a flat disk mounted on a vertical shaft, which can be made to turn rapidly either by electricity or by foot power. The ceramist centers a mound of clay on the wheel and, as the wheel turns, uses the hands to "open," lift, and shape the clay form—a procedure known as throwing. Throwing on the wheel always produces a rounded or cylindrical form, although the thrown pieces can later be reshaped, cut apart, or otherwise altered.

The Chinese vase illustrated on the facing page would have been thrown on a wheel by a specialist at one of the great ceramic centers of imperial China, where thousands of workers produced ceramics on an industrial scale using assembly-line methods (12.2). The vase is made of **porcelain**, a ceramic made by mixing kaolin, a fine white clay, with finely ground petunse, also known as porcelain stone. When fired at high temperature, elements in the mixture fuse into a glassy substance, resulting in a hard, white, translucent ceramic. The secret of porcelain was discovered and perfected in China, and for hundreds of years potters elsewhere tried without success to duplicate it.

After being shaped, the vase was dipped in a glaze. Ceramic glazes consist of powdered minerals in water. When fired, they fuse into a nonporous, glasslike coating that bonds with the clay body. Glazes may be formulated so that they yield a color when fired, but the classic glaze for white porcelain was transparent. It was probably made chiefly from very finely ground petunse, an ingredient in the porcelain itself. After firing, the brilliant white vase was decorated with enamel colors, yet another Chinese invention. Made from mineral pigments mixed with powdered glass, enamels offered ceramic artists a broader palette than glazes alone could provide. The vase was then fired again at a lower temperature to fuse the enamel colors, which could not have withstood the high heat needed to fire the porcelain itself.

The motif of nine peaches with peach blossoms carried a symbolic meaning for Chinese viewers. Peaches were emblems of longevity, and peach blossoms were used to decorate for the New Year. The number nine was associated with the idea of eternity. All in all, the vase was auspicious, visually wishing its owner a long life of many years.

Glass

If clay is one of the most versatile of materials, glass is perhaps the most fascinating. Few people, when presented with a beautiful glass form, can resist holding it up to the light, watching how light changes its appearance from different angles.

Although there are numerous formulas for glass, its principal ingredient is usually silica, or sand. The addition of other materials can affect color, melting point, strength, and so on. When heated, glass becomes molten, and in that state it can be shaped by several different methods. Unlike clay, glass never changes chemically as it moves from a soft, workable state to a hard, rigid one. As glass cools, it hardens, but it can then be reheated and rendered molten again for further working.

According to a legend recorded by the ancient Roman author Pliny, the secret of making glass was discovered accidentally by seafaring Phoenician traders. Debarking from their ships on the eastern Mediterranean shore, the traders made a fire on the beach and set their cooking cauldrons over it on lumps of "nitrum" from their cargo. (Nitrum was a valued substance that seems to have been either potash or soda.) The heat melted the nitrum, which fused with the sand to create a transparent liquid that cooled as glass. Delightful as the story is, archaeological evidence suggests that glass was first manufactured further inland, in the region today divided between eastern Syria and northern Iraq. From there, the technology spread throughout the ancient Near East, including Egypt, where this bottle in the shape of a pomegranate was made (12.3).

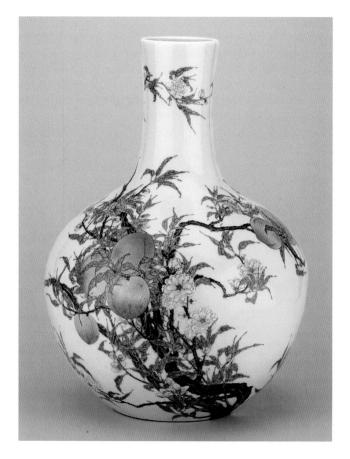

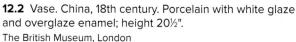

12.3 Bottle in the shape of a pomegranate. Egypt, c. 1550–1307 B.C.E. Sand-core glass, height 4". The Newark Museum, Newark, New Jersey

The most familiar way of shaping a hollow glass vessel such as a bottle is by blowing: the glass artist dips up a mass of molten glass at the end of a long metal tube and, by blowing into the other end of the tube, produces a glass bubble that can be shaped or cut while it is hot and malleable. The bottle here, however, was shaped by a more ancient method known as sand-core casting. In that method, a core of compacted clay and sand was made in the shape of the cavity of the intended vessel. Wrapped in cloth and set on the end of a long rod, the core was plunged into a vat of molten glass, then removed for further work such as smoothing and decoration. After the glass had cooled, the core was scraped out.

Glass was a luxury product in the ancient world. This bottle probably held pomegranate juice, which was appreciated as a beverage and also used for medicinal purposes. A red fruit filled with hundreds of edible, garnet-colored seeds, the pomegranate has been associated by many peoples with fertility and renewal. The ancient Egyptians were no exception, and they included pomegranates and images of pomegranates in their burials to help promote rebirth in the afterlife. This little bottle, then, would have taken part in a rich network of associations that gave it meaning beyond its humble function.

A special branch of glasswork, **stained glass** is a technique used for windows, lampshades, and similar structures that permit light to pass through. Stained glass is made by cutting sheets of glass in various colors into small pieces, then fitting the pieces together to form a pattern. Often, the segments are joined by strips of lead, hence the term *leaded* stained glass. The 12th and 13th centuries in Europe were a golden age for stained glass. In the religious philosophy that guided the building of the great cathedrals of that time, light

12.4 *Tree of Jesse*, west facade, Chartres Cathedral, France. c. 1150–70. Stained glass.

12.5 Pair of royal earrings. India (probably Andhra Pradesh), c. 1st century B.C.E. Gold, $1\frac{1}{2} \times 3 \times 1\frac{9}{6}$ ". The Metropolitan Museum of Art,

New York

was viewed as a spiritually transforming substance. The soaring interiors of the new cathedrals were illuminated by hundreds of jewel-like windows such as the one illustrated here from the Cathedral of Notre Dame at Chartres, France (12.4). The central motif is a branching tree that portrays the royal lineage of Mary, mother of Jesus. The tree springs from the loins of the biblical patriarch Jesse, depicted asleep at the base of the window. Growing upward, it enthrones in turn four kings of Judaea, then Mary, then Jesus himself.

Metal

Ever since humans learned to work metals, they have made splendid art, as well as functional tools, from this versatile family of materials. One distinctive aspect of metal is that it is equally at home in the mundane and the sublime—the bridge that spans a river or the precious ring on a finger; the plow that turns up the earth or the crown on a princess's head. Whatever the application, the basic composition of the material is the same, and the methods of working it are similar.

As discussed in Chapter 11, metal can be shaped by heating it to a liquid state and pouring it into a mold, a process known as casting (see 11.6). Another ancient metalworking technique is **forging**, in which metal is shaped by hammer blows. Some metals are heated to a high temperature before being worked with hammers, a technique known as hot forging. Iron, for example, is almost always hot-forged. Other metals can be worked at room temperature, a technique known as cold forging. Gold is an example of a metal that can be forged cold.

This pair of royal earrings from India testifies to the skills of early South Asian goldsmiths (12.5). The smooth, rectangular, budlike forms were fashioned from hammered gold. The elaborate decoration is made of gold granules, minute spheres of gold, applied in linear designs. Stylized leaf motifs (visible on the earring to the right), a winged lion (visible at left), and an elephant are worked in low relief on the broad surfaces of each earring. The two animals are royal emblems, suggesting that the earrings were probably a royal commission. The earrings are so heavy that they would have distended the wearer's earlobes

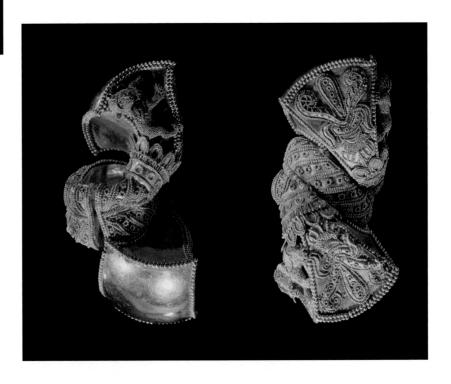

and come to rest on his or her shoulders, as depictions of early Indian rulers and deities in sculpture make clear. We may recall as well that the iconography of the Buddha figure, which developed around this same time, includes distended earlobes to remind us that in his youth he was a pampered Indian prince. This pair of earrings gives us a sense of the splendor he renounced.

A lion appears symbolically again in this medieval European aquamanile (12.6). Derived from the Latin for water (aqua) and hand (manus), an aquamanile held water used for ritual hand-washing. Aquamaniles were used by priests, who wash their hands at the altar before celebrating Mass (the central Roman Catholic rite of worship). They were also used in secular settings by aristocrats and wealthy merchants, whose dinner rituals included washing their hands in water perfumed with orange peel and herbs. Often fashioned in the form of animals, the fanciful metal vessels seem to have been an Iranian invention. Certainly they were used for centuries in the Islamic world before passing into the Christian culture of medieval Europe.

Modeled in wax and then cast in latten—an alloy of copper, like bronze and brass—the lion aquamanile here stands just over a foot tall. Water would have flowed into a waiting basin from the spigot issuing from the mouth of the dragon's head that juts from the lion's chest. Another dragon rises up on the lion's back to serve as a handle for lifting the vessel. The lion was a popular motif for European aquamaniles, perhaps because its symbolism could be adapted to both religious and secular settings. In a religious context, the lion could symbolize Jesus Christ. It was also the symbol of Saint Mark, one of the four gospel writers. In a secular context, the lion was a royal symbol suitable for the table of a noble family.

Wood

Widely available, renewable, and relatively easy to work, wood has been used by almost all peoples across history to fashion objects for ritual or daily use. As an organic material, however, wood is vulnerable—heat and cold can warp it, water can cause it to rot, fire will turn it to ash, and insects can eat away at it. We must assume that only a small fraction of the wooden objects made over the centuries have survived.

12.6 Lion aquamanile. Nuremberg, c. 1400. Latten alloy, height 13½". The Metropolitan Museum of Art, New York

12.7 Chair of Hetepheres. Egypt, Dynasty 4, reign of Sneferu, 2575–2551 B.C.E. Wood and gold leaf, height 315%6". Egyptian Museum, Cairo

12.8 Olowe of Ise. *Olumeye* bowl. Early 20th century. Wood, pigment, height 25%.

National Museum of African Art, Smithsonian Institution, Washington, D.C. The most common product of the woodworker's art is furniture. The basic forms of furniture are surprisingly ancient. The chair, for example, seems to have been developed in Egypt around 2600 B.C.E. Massive thrones for rulers and humble stools for ordinary people had existed earlier, but the idea of a portable seat with a back and armrests was an innovation (12.7). Miraculously preserved by the dry desert climate of Egypt, this chair, one of the oldest known, shows that artistic attention was lavished on furniture from the very beginning. The chair's legs are carved as the legs and paws of a lion, an emblem of royal power. Within the open frames of the armrests are carved bouquets of papyrus flowers, a symbol of Lower (northern) Egypt.

The repetition of the papyrus motif in numerous contexts across the centuries allowed scholars of Egyptian art to decipher its symbolic meaning. With the *Olumeye* bowl (12.8) by the great Yoruba sculptor Olowe of Ise, in contrast, much of the meaning is lost, for some of the iconographic elements are unique, and the original context in which the bowl was used is no longer known.

Olumeye is a Yoruba word meaning "one who knows honor." It refers to the kneeling woman Olowe depicted holding the lidded bowl. She is a messenger of the spirits, and she kneels in respect and devotion. Olumeye bowls were common in Yoruba culture. Often, they were used to store kola nuts, which were offered to guests as a sign of hospitality and to deities during worship. Of the many olumeye bowls to have come down to us, however, only this one includes a kneeling nude male among the small figures supporting the bowl, and only this one features four women dancing in a circle on the lid. Both subjects are unprecedented in Yoruba art.

If we knew who had commissioned the bowl from Olowe, or what context the bowl was used in, or what visual materials Olowe had been inspired by, we might be able to recover the meaning of these unusual elements or better explain their presence. As it is, we can only marvel at the mastery displayed in the carving itself. The lid is carved from a single piece of wood. Even more astonishing, the base—including the bowl, the *olumeye*, and the supporting figures—is also carved from a single piece. Olowe permitted himself a further bravura touch by carving a freely rolling head *inside* the cage formed by the supporting figures beneath the bowl. This, too, was an innovation, and its meaning is likewise unclear.

ARTISTS Olowe of Ise (18??-1938)

lowe of Ise was born in the Nigerian town of Efon Alaye, less than fifty miles from Ife, the holy city of the Yoruba. We do not know the date of Olowe's birth; since he was a respected elder at his death in 1938, he was probably born between 1850 and 1880. We also know little about his training as an artist, although we assume that he was apprenticed to an older sculptor before establishing himself as a master.

By the end of the 19th century, Olowe had moved to the royal city of Ise, where he became an emissary to the king. As an artist who was given commissions by kings and religious groups throughout the easternmost Yoruba lands, Olowe was well qualified for the position. Olowe also acted as court sculptor for the king of Ise, and he supervised a workshop in the palace that employed a dozen assistants.

During his lifetime, Olowe of Ise's work was known in England as well as in Nigeria. One of his elaborate wooden bowls with figures (similar to Figure 12.8) was brought back to England by a British visitor around 1900. In 1924 a pair of doors sculpted by Olowe and belonging to the king of Ikere were displayed at the British Empire Exhibition in London. They depicted the king receiving the British colonial officer who was helping to impose British rule over the formerly independent Yoruba kingdoms. The king was

persuaded to donate the doors to the British Museum, receiving in exchange an elaborate English chair he could use as a throne. He commissioned a new pair of doors from Olowe to replace them. Strange as it seems today, no one at the museum asked the king for the name of the artist who had carved the doors, and for

What aspects of the artist's character are shown in the carved roof support? How are artists viewed and respected by the Yoruba? Why do we know so little about Olowe of Ise?

the next twenty years they were attributed to an "unknown" Yoruba artist. Many European collectors of African art even assumed that Yoruba artists worked in complete anonymity. Such notions were not challenged until Olowe of Ise was interviewed by a British researcher shortly before his death.

Like many prosperous Yoruba men of his generation, Olowe of Ise married several wives and had many children. His fourth wife, Oloju-ifun Olowe, was interviewed more than fifty years after his death. She was able to recite a praise poem, or *oriki*, in his honor. It includes the following lines:

Olowe, my excellent husband . . . One who carves the hard wood of the *iroko* tree as though it were soft as a calabash.

One who achieves fame with the proceeds of his carving . . . My lord, I bow down to you.

Leader of all carvers . . .

There are no surviving photographs of Olowe of Ise, and no painted or sculpted artworks capture his physical likeness. Instead, the carved roof support illustrated here can be seen as revealing the basic character of this artist. Although it was once owned by a king, it is a metaphorical self-portrait of the artist as well as the patron, the visual and tactile equivalent of these descriptive lines from the *oriki* of Olowe of Ise:

Outstanding leader in war. Emissary of the king. One with a mighty sword. Handsome among his peers.

Olowe of Ise. Veranda Post with Mounted Hunter. Before 1938. Wood, pigment, height 7". Museum Fünf Kontinente, Munich.

Fiber

A fiber is a pliable, threadlike strand. Almost all naturally occurring fibers are either animal or vegetable in origin. Animal fibers include silk, wool, and the hair of such animals as alpacas and goats. Vegetable fibers include cotton, flax, raffia, sisal, rushes, and various grasses. Fibers lend themselves to a variety of techniques and uses. Some can be spun into yarn and woven into textiles. Others can be pressed into felt or twisted into rope or string. Still others can be plaited to create baskets and basketlike structures such as hats.

The art of basketry is highly valued by many Native American peoples, including the Pomo, whose ancestral lands are in present-day California (12.9). Legend tells that when a Pomo ancestor stole the sun from the gods to light the dark Earth, he hung it aloft in a basket that he moved across the sky. The daily journey of the sun reenacts that original event. Pomo baskets are thus linked to larger ideas about the universe and about the transfer of knowledge from gods to humans at the beginning of the world.

Traditionally a woman's art, basket weaving began with the harvesting of materials. This activity, too, was endowed with ritual significance, for it involved following ancestral paths into the landscape to find the traditional roots, barks, woods, rushes, and grasses. In the basket here, willow and bracken fern root were used to produce a pattern of alternating lights and darks. Feathers, clamshell beads, and glass beads procured through trade are woven into the surface. Somewhere in the basket, the weaver included a small, barely noticeable imperfection. Called *dau*, it serves as a spirit door, letting benevolent spirits into the basket and allowing evil ones to leave. Feather baskets were produced as gifts for important or honored persons, and they were usually destroyed in mourning when the person died.

Textile is the fiber art we are most intimately familiar with, for we clothe ourselves in it. The very first textiles were probably produced by felting, a technique in which fibers are matted and pressed together. Another ancient technique still in use today is weaving.

Weaving involves placing two sets of parallel fibers at right angles to each other and interlacing one set through the other in an up-and-down movement, generally on a loom or frame. One set of fibers is held taut; this is called the warp. The other set, known as the weft or woof, is interwoven through the warp to make a textile. Nearly all textiles, including those used for our clothing, are made by some variation of this process.

The ancient Incas, whose civilization flourished in the mountains of Peru during the 15th century, held textiles in such high regard that they draped gold and silver statues of their deities with fine cloth offerings. Textiles were

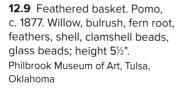

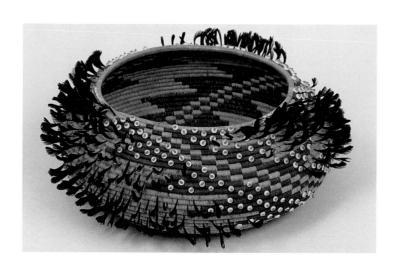

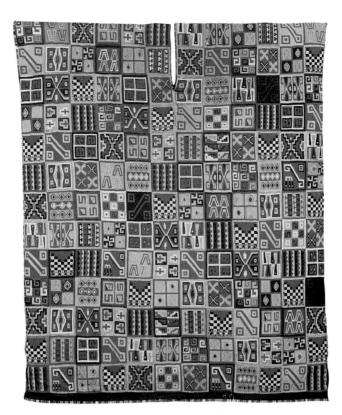

12.10 Tunic, from Peru. Inca, c. 1500. Wool and cotton, $35\% \times 30$ ". Dumbarton Oaks Research Library and Collections, Washington, D.C.

also accepted as payment for taxes, for they were considered a form of wealth. Standardized patterns and colors on Incan tunics instantly signaled the wearer's ethnicity and social status. Woven around 1500, the fascinating royal tunic illustrated here (12.10) is a virtual catalog of such patterns, although scholars have not yet succeeded in identifying them all. The black and white checkerboard pattern, for example, represents the Inca military uniform in miniature. By wearing this tunic, the king visually declared his dominance over all of Incan society.

Islamic cultures have focused a great deal of aesthetic attention on carpets and rugs. Among the most famous Islamic textiles is the pair of immense rugs known as the Ardabil carpets, of which we illustrate the one in the collection of London's Victoria and Albert Museum (12.11). Like most Islamic carpets, they were created by knotting individual tufts of wool onto a woven ground. The labor was minute and time-consuming: the London Ardabil carpet has over three hundred knots per square inch, or over twelve million knots in all!

The design features a central sunburst medallion with sixteen radiating pendants. Two mosque lamps, one larger than the other, extend from the medallion as well. Quarter segments of the medallion design appear in the corners of the rug. These elements seem to float over a deep blue ground densely patterned with flowers, making the carpet a sort of stylized garden. (In a similar figure of speech, we talk of a field in springtime as being "carpeted in flowers.") Paradise in Islam is imagined as a garden, and such flower-strewn carpets represent a luxurious, domesticated reminder of this ideal world to come.

Ivory, Jade, and Lacquer

A porcelain vase, a glass beaker, and a wool tunic might have been made as luxury items or intended for a social elite, but the materials they were made of—sand, clay, animal hair—were common enough. With ivory, jade, and lacquer, we arrive at rarer materials. Ivory and jade have been considered precious in themselves. Lacquer is unique to East Asia, where it has been the basis of an important artistic tradition for some three thousand years.

12.11 Ardabil carpet. Persia (Tabriz?), 1539–40. Wool pile on undyed silk warps, length 34'5³/₄". Victoria and Albert Museum, London

Technically, ivory may refer to the teeth and tusks of a number of large mammals. In practice, it is elephant tusks that have been the most widely sought-after and treasured form. Today considered an endangered species, Asian elephants once ranged from the coast of Iran through the Indian subcontinent, southern China, and Southeast Asia. African elephants once roamed much of the continent south of the Sahara desert. Trade in elephant tusks arose in ancient times and continued unchecked well into the 20th century, bringing raw ivory to cultures that did not have local access to it. Today the ivory trade in India is banned; the trade in Africa is restricted, monitored, and periodically suspended.

Ivory was treasured not only by cultures that obtained it through trade but also by cultures for whom elephants were a living presence. Many African peoples associated elephants symbolically with rulers, for they were seen to be mighty, powerful, wise, and long-lived. In the Yoruba city of Owe, in presentday Nigeria, only the king or titled chiefs would have been permitted to wear the armlet illustrated here (12.12). Carved from a single piece of ivory, it consists of two interlocking cylinders. The inner cylinder is finely pierced in an airy openwork pattern and punctuated by human heads carved in high relief. They may represent people over whom the wearer had power. The outer cylinder, which can shift slightly to the left or right, depicts kneeling hunchbacks, monkeys on leashes, and interlocking circles of crocodiles biting the heads of mudfish. Hunchbacks were associated with the deity Obatala, who had fashioned human bodies. He is said to have created hunchbacks while drunk, and he is thus their patron. Crocodiles and mudfish were royal symbols that linked rulers to Olokun, the deity of the sea who brought wealth and fertility. Scholars have suggested that such richly symbolic ornaments were worn at the festival of Ose, which celebrated the origins of Yoruba civilization.

Jade is a common name for two minerals, nephrite and jadeite. Ranging in color from white through shades of brown and green, the two stones are found principally in East and Central Asia and Central America. Although their underlying structures differ, they share the extreme hardness, the ice-cold touch, and the mesmerizing, translucent beauty that have caused jade to be treasured in cultures lucky enough to have access to it.

The ancient Olmecs, whose jade figure of a shaman we looked at in Chapter 2 (see 2.38), prized green jade. They associated its color with plant life—especially with corn, their most important crop—and its translucence with rainwater, on which agricultural bounty depended. In China, jade of all colors has been prized and carved for some six thousand years. In early Chinese belief, the stone was credited with magical properties.

12.12 Arm ornament. Yoruba, 16th century. Ivory, $51\%6 \times 4\%8 \times 4\%8$ ". National Museum of African Art, Smithsonian Institution, Washington, D.C.

crossing cultures Export Arts

How does the ivory vessel shown combine African and European forms and imagery? What room for personal creativity are artists given for export arts? What do these works reveal about our past and our values?

he magnificent ivory vessel illustrated here was carved during the late 15th or early 16th century by a sculptor of the Sapi culture, which flourished then along the West African coast in the region of present-day Sierra Leone. A lidded bowl atop an elaborate pedestal, it resembles a European chalice, though it was made to store salt. Male and female attendants ring the base, alternating with vigilant dogs that bare their teeth at snakes descending from above. Stylized roses adorn the lid.

A stunning example of African artistry, the vessel is intriguing for the way it mingles African and European forms and imagery. In fact, it was made to please Portuguese clients, who probably supplied the African artists with visual materials such as woodcut illustrations of roses, a flower that West Africans would not have known. Early Portuguese explorers had been deeply impressed by the skill of the ivory carvers they

encountered in Africa, and for a century or so they commissioned works such as this for European collectors.

Artworks made within one culture specifically for export to another are known as export art. Like this ivory salt cellar, they illustrate how artists adapt to foreign tastes and expectations. Many cultures have produced export arts. India, for example, has been known since ancient times for textiles, which it exported widely. An example is the patterned textile we know as chintz. Although today chintz is printed mechanically, the patterns were originally drawn and dyed by hand. Europeans conceived a passion for chintz during the 17th century, but they wanted the patterns modified to suit European tastes. Responding to this new market, Indian textile artists developed a hybrid style featuring flowering tree patterns derived from Indian, European, and Chinese sources.

During the 19th century, ceramists in Japan began to create porcelain especially for export to the West. Unlike porcelain produced for domestic clients, Japanese export porcelain often featured scenes or figures painted in traditional styles. The painted decoration allowed Western collectors to understand the objects as art, for painting was viewed as a fine art in the West, whereas ceramics were not.

Most export arts have been arts of daily life, the subject of this chapter. But paintings and sculptures have also been produced for export. In the late 18th and 19th centuries, for example, painters in China's port cities produced export watercolors depicting inland China, which was then off-limits to Western traders. To make their images more accessible, the painters adopted European conventions such as rectangular formats, linear perspective, and chiaroscuro modeling. European collectors took these images to be examples of Chinese art and faithful depictions of Chinese life. In fact, the images reflected what Chinese artists thought their European customers wanted to see.

Export arts are the ancestors of today's tourist arts, versions of "ethnic" art forms made as souvenirs for visitors. Often fashioned with great skill, tourist arts have been dismissed as inauthentic. Yet patronage, including outside patronage, has often played a key role in art. Moreover, over time, some forms that originated as tourist arts have come to seem traditional. We might better use these arts to examine our ideas about authenticity, what role it plays in our system of artistic values, and why.

Lidded saltcellar. Sapi artist, Sierra Leone, 15th–16th century. Ivory, height 11³/₄". The Metropolitan Museum of Art, New York.

12.13 Cong. Liangzhu, 5th–3rd century B.C.E. Jade, height 7¹¹/₆". Musée National des Arts Asiatiques – Guimet, Paris

12.14 Box. China, 1403–24. Carved red lacquer on wood core, diameter 10½". Freer Gallery of Art, Smithsonian Institution, Washington, D.C.

Among the oldest and most mysterious jade objects from China are the squared tubes called *cong* (12.13). Decorated along their four corners with a repeating linear pattern that sometimes includes a mask motif, the tubes were a particular specialty of the Liangzhu culture, a late-Neolithic culture that flourished in the Yangzi River valley, in eastern China. *Cong* were ritual objects—that much is clear—and they were included in great numbers in elite burials, usually in association with *bi*, flat jade disks with a circular hole at the center. Later Chinese writers associated *bi* with the dome of Heaven and *cong* with Earth, but we do not know what they meant to the people of the Liangzhu culture, which vanished suddenly long before the earliest Chinese dynasties.

Lacquer is made of the sap of a tree that originally grew only in China. Harvested, purified, colored with dyes, and brushed in thin coats over wood, the sap hardens into a smooth, glasslike coating. The technique demands great patience, for up to thirty coats of lacquer are needed to build up a substantial layer, and each must dry thoroughly before the next can be applied. Ancient Chinese artisans used lacquer to create trays, bowls, storage jars, and other wares that were lightweight and delicate-looking yet water-resistant and airtight. Exported along with other luxury goods over the long overland trade route known as the Silk Road, Chinese lacquerware was admired as far away as the Roman Empire.

Knowledge of lacquer spread early from China to Korea and Japan, as did cultivation of the sap-producing tree. Asian artists developed a variety of techniques for decorating lacquerware. In China, a favorite method was to apply layer after layer of red lacquer, building up a surface thick enough to be carved in relief (12.14). The scene carved on the lid of the red lacquer box illustrated here depicts two men meeting on a terrace overlooking a lake. They are attended by servants, one of whom enters through a pair of doors set in the arch of a large rock formation. In the sky, beneath scrolling clouds, a crane flies near a tall pine tree. Both are symbols of longevity, as are the large mushrooms growing at the lower left. The search for longevity and even immortality is a central concern of Daoism, an ancient Chinese philosophy that became a sort of popular religion. Daoist immortals were believed to dwell in a mountain paradise that was entered through a grotto. The arrangement of rocks with their doorway here may allude to it. One legendary immortal was carried off to heaven on the back of a white crane. The elderly man holding a curved scepter may be a Daoist sage and his visitor a disciple hoping to learn the secrets of immortality. Perhaps one day the crane will swoop down from the sky for him.

In Japan, artists perfected the art of decorating lacquerware with inlays of mother-of-pearl and sprinklings of gold and silver powder. The writing box illustrated here (12.15) features a motif of maple leaves much like the ones that Ernst Haas captured in his photograph of a park bench in Kyoto (see 1.11). The leaves are scattered around a *bugaku* hat, a hat worn in traditional court dances performed by members of the aristocracy. For a cultivated Japanese audience, the combination would bring to mind a famous episode from the *Tale of Genji*, a classic work of Japanese literature, in which the young, radiantly handsome Prince Genji dances before the emperor and his court as autumn leaves fall around him. As its name suggests, a writing box housed a set of writing implements. The inside, often decorated as well, was typically configured to hold an inkstone and ink stick, brushes, a water dropper, a small knife, and an ink stick holder.

Art, Craft, Design

When painting and sculpture were placed in the new category of fine art, the skilled activities they were formerly associated with—textiles, ceramics, metalwork, furniture making, and so on—were grouped together under various names, each of which suggested a contrast with fine art. They were referred to as decorative arts, suggesting that they were primarily ornamental; applied arts, suggesting that they were fundamentally utilitarian; and even minor arts,

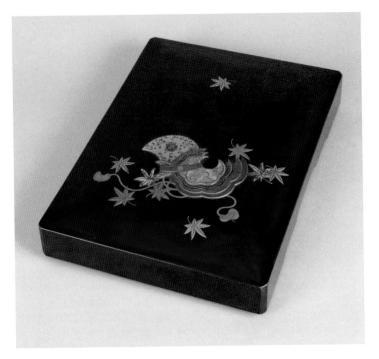

12.16 Gustav Stickley's Craftsman Workshop. Library Table. 1910–12. Oak, leather, and brass; $29\% \times 55\% \times 49$ ". Los Angeles County Museum of Art

suggesting that they were inherently less important. The English language offered up another word, craft, which, like the word "art," originally meant skill.

During that same historical period, the Industrial Revolution was transforming Western societies. The handmade world, which had existed since the beginning of human culture, was giving way to a world in which many objects used in daily life were mass-produced by machines. Small workshops were being replaced by large factories, and the nature of work itself was being transformed. Many social thinkers of the 19th century criticized those developments, and their criticism of industrialization went hand in hand with their criticism of the new distinction between fine art and craft. They pointed to the loss of dignity and of pride in one's work that factory labor entailed. They objected to the glorification of the fine arts over crafts and to the lower esteem in which people who worked with their hands were now held. They mourned the loss of the satisfaction to be had in making things by hand and the pleasure experienced in using them, and they worried about the effect it would have on the human spirit.

Criticism was especially strong in England, where the Industrial Revolution had begun. As the century wore on, many people grew determined to carve out a place for handmade objects in the new industrial order. They set up workshops and studios. They taught themselves and one another such skills as pottery, bookbinding, furniture making, and weaving. They held exhibits and formed societies, most famously, in 1887, the Arts and Crafts Exhibition Society. The Arts and Crafts movement, as it came to be known, quickly spread throughout Europe and to the United States, where its most vocal proponent was Gustav Stickley. In 1901 Stickley began to publish an influential magazine called *The Craftsman*, which introduced the ideals of the Arts and Crafts movement to a broad public. Several years later he founded the Craftsman Workshop, where the hexagonal library table illustrated here was built (12.16). Made of American oak, its simple lines, forthright construction, and unadorned surfaces epitomized the style that Stickley favored for what he called "a democratic art."

The Arts and Crafts movement began to wane after a few decades, but its influence can be felt to this day. One of its legacies is the vibrant presence of studio crafts in our cultural life, independent artists who practice such skills as woodworking, glassblowing, and weaving. An example is glass artist Toots

Zynsky, whose *Night Street Chaos* we illustrate here (**12.17**). After many years of experimenting with more traditional blowing and molding techniques, Zynsky turned to working with glass threads, long filaments pulled from heated rods of colored glass. To create a vessel such as *Night Street Chaos*, she first layers glass threads in a flat, circular formation. She fuses the arrangement in a kiln, then slumps it into a bowl-shaped steel mold. The glass is reheated and remolded several times, with each mold a little deeper and rounder than the one before. The final shaping Zynsky performs by hand, pushing and pulling at the symmetry of the molded vessel to create a sinuous, improvised, irregular form. Zynsky does not intend for her vessels to function as containers. ("The only thing they contain is my sort of fantasies and dreams," she has said.)² Rather, we might think of them as sculptural meditations on the beauty of vessels themselves, which have been the focus of so much aesthetic attention over the course of human history.

Jeroen Verhoeven enlisted the help of computer-aided design and manufacturing technology (CAD/CAM) to create *Cinderella*, a curvaceous table made of plywood (12.18). *Cinderella* was inspired by the forms of 17th- and 18th-century Dutch furniture. Verhoeven researched and drew example after example, simplifying their contours. He scanned his drawings into a computer and fused them using 3D morphing software to create a hybrid form, an elegant table turning into a bulbous cabinet, like an enchantment in a fairytale. The virtual design was digitally "sliced" like a loaf of bread into fifty-seven slices, which were cut and shaped individually by computer-driven woodworking machines, then glued together and finished by hand. Verhoeven issued *Cinderella* in a limited edition, as artists do for prints or cast sculptures.

"For me, it's a manifesto," Verhoeven said about his creation. "It's about showing what our high-tech tools would be capable of if they were fully utilized. We have at our disposal the most fantastic slaves whose possibilities we are completely wasting. We use them to mass-produce boring objects, whereas in fact these tools of the 21st century could produce art. Just like Cinderella, who was much more than a cleaning woman but whose talents remained hidden because they weren't used."

Another legacy of the Arts and Crafts movement has been a recurrent questioning of the distinction between fine art and craft. Beginning in the 1960s, many artists working with crafts media began to claim a place in the fine-art world, and many artists working in the fine-art system reached out to use materials and forms associated with crafts. In so doing, they have insisted

12.17 Toots Zynsky. *Night Street Chaos*, from the series *Chaos*. 1998. Fused and thermo-formed glass threads, $7\% \times 13 \times 7$ ". Courtesy the artist

12.18 Jeroen Verhoeven. *Cinderella* table. 2005. Plywood, $31\% \times 52 \times 40$ ". Courtesy of the artist and Blain/Southern

12.19 Merete Rasmussen. *Red Twisted Form.* 2012. Stoneware clay with colored slip, $21\% \times 35\% \times 35\%$. Victoria and Albert Museum, London. © Merete Rasmussen

12.20 Maria Nepomuceno. *Untitled*. 2010. Ropes, beads, and fabric, 14'5\%" \times 11'9\%". Installation, May 7–June 12, 2010, Victoria Miro, London N1.

Courtesy the artist and Victoria Miro, London. © Maria Nepomuceno

that we think harder about just what, if anything, distinguishes one category from the other, and they have built bridges of understanding to other cultures where such a division never arose.

Perhaps it should not surprise us that potters were among the first to practice their craft as an art. Clay, after all, had long led a double life, used at once for sculpture and for ceramics. Danish ceramist Merete Rasmussen uses the traditional coiling technique to build non-representational sculptural forms in stoneware. *Red Twisted Form* illustrates her special fascination with continuous surfaces (12.19). A single flowing ribbon with no beginning and no end, *Red Twisted Form* curls around itself, opening up negative spaces, delighting in the play between convex and concave surfaces, inviting us to take a visual ride on its roller coaster. "I work with the idea of a composition in three dimensions, seeking balance and harmony," Rasmussen writes. "The finished form should have energy, enthusiasm, and a sense of purpose."⁴

Ceramics had a comparatively easy time finding a place in the system of fine art, for clay had a long history as a sculptural medium. Fiber, on the other hand, faced greater resistance. The path was clearer in Europe, where the tradition of collaboration between artists and tapestry workshops had been kept alive. (For more about tapestry, see Chapter 7.) During the 1960s, exhibitions of contemporary tapestry included increasing numbers of ambitious, large-scale works in fiber by independent artists. Much of the new work abandoned tapestry's centuries-old link with painting. Made from rough, natural fibers and using such techniques as knotting, braiding, and crochet, it demanded to be understood as sculpture (see 22.21).

Among the many artists working with fiber today is the young Brazilian Maria Nepomuceno, who uses colorful rope and beaded necklaces to construct quirky biomorphic forms (12.20). Arranged on the floor as though they had propagated themselves there, they suggest a colony of brilliant anemones in a tropical coral reef. Cheerfully sensuous and uninhibited, their craters filled with beads like eggs or spawn, they overlap and touch and send out exploratory tendrils toward one another.

Nepomuceno's art was profoundly influenced by the experience of giving birth. She has compared the rope she works with to an umbilical cord through which life nourishes new life, the present connects to the future. She builds her forms by coiling the rope in spirals, a movement she associates with whirlpools, galaxies, and the DNA spiral of life itself. She speaks of the beads as fertile points capable of multiplying themselves into infinity. Themes of fertility and generation are clearly present in *Untitled*. Even if we can't put a name to these creatures, we know what they are up to.

12.21 El Anatsui. *Sasa*. 2004. Aluminum and copper wire, 21' × 27'6¾". Musée National d'Art Moderne, Centre Georges Pompidou. Paris

12.22 Marcus Amerman. Glass horse mask. 2008. Multicolored glass, $21\% \times 12\% \times 11\%$. National Museum of the American Indian, Smithsonian Institution, Washington, D.C.

In works such as *Sasa*, contemporary Ghanaian artist El Anatsui takes his formal inspiration from textiles, though the material he works with is not fiber but metal (12.21). *Sasa* is made of bottle caps and small food tins such as sardine cans, flattened and then stitched together with copper wire. It recycles materials imported into Africa, goods that flow from wealthier places into a poor continent. In its visual splendor, *Sasa* draws on the tradition of African royal textiles such as *kente* (see 1.7). *Kente*, too, was an art of recycling, for it was originally made of silk fabric imported from China. African weavers patiently separated the silk fabric into threads, which they then rewove in patterns that expressed their own culture. With *Sasa*, El Anatsui works even greater magic, for he transforms trash into something opulent, and uses the materials of poverty to evoke riches.

Made of pieces of colored glass fused and shaped in a kiln, the horse mask, by Choctaw artist Marcus Amerman, also presents us with a transformation (12.22). Masks were one component of the armor that Indians of the American West formerly dressed their horses in before battle. The spread of firearms rendered this armor obsolete—made of animal hides, it could protect a horse's flanks against arrows but not bullets. Masks, however, were never abandoned, for their purpose was not so much physical as mystical. Made of buffalo hide, animal skins, and cloth, ornamented with eagle feathers, animal horns, and symbolic motifs, horse masks served to intimidate the enemy and channel fearsome spirit powers, especially those of the Thunderbird, a sky deity whose merest glance produced bolts of lightning. The triangles that ring the eye holes of Amerman's glass creation can be found on many traditional horse masks, where they symbolize lightning flashing from the horse's eyes.

As we have seen, the Arts and Crafts movement heightened public awareness of the value of handmade objects and traditional skills in the face of industrialization. Yet most of the movement's leading voices fully recognized the value of mass production in making goods available to a greater number of people at affordable prices, and they appreciated the ability of machines to facilitate dull, repetitive tasks. In Austria and Germany especially, the ideals of the movement were interpreted to encourage cooperation between artists and manufacturers. In this new relationship, an artist's task was no longer to make an object but to design an object that could be made by industrial methods. Writing in *The Craftsman*, Gustav Stickley referred to such objects as industrial art. Within a few years, the field had become known as design.

One task of designers is to translate technological and scientific advances into functional, approachable, visually rewarding objects for our lives. A fascinating example of design at the forward edge of technology is Fractal.MGX (12.23), a coffee table created by the design firm WertelOberfell in collaboration with Matthias Bär and manufactured by MGX, the design division of a Belgian technology company. The designers took their inspiration from the Socotra dragon tree, whose branches repeatedly divide in two until they are dense enough to support an umbrella-like canopy of leaves overhead. This growth pattern is one of numerous patterns in nature that approximate fractals, fragmented geometric shapes that can be split into parts, each of which is a reduced version of the whole, a property known as self-similarity. Working with computer-aided design (CAD), the team used algorithms to generate a similar structure of faceted branches that divide repeatedly in four at decreasing intervals, eventually becoming so small and numerous that they form a quasi-surface. As the designers explain it, the structure starts out in a disorganized state at its base. As it rises, it becomes increasingly organized until it ends in a regular grid, thus enacting a progression from an approximate fractal, like the tree, to a fractal with exact self-similarity. Even without knowing all the details, we can sense that the design is somehow both organic and mathematical—a sort of petrified geometric forest.

Fractal.MGX was not constructed, carved, or molded. Rather, it was printed using stereolithography, a computer-driven, 3D-printing technology that employs an ultraviolet laser beam to cure and bond layer after ultra-thin layer of light-sensitive liquid resin. Imagine a rectangular tank as deep as Fractal.MGX is high. The tank houses a metal platform that can shift up and down. The printing begins with the platform at surface level. A blade sweeps over it, coating it with a layer of liquid resin just four-thousandths of an inch thick. A laser beam plays rapidly over the resin, drawing the first micro-layer of the design-in this case, the four shapes that the branching table will grow from. These shapes harden; the rest of the resin remains liquid. The platform shifts downward four-thousandths of an inch, another coating of resin is spread, and again the laser dances over it, this time drawing the second micro-layer and bonding it to the first. Fractal.MGX takes between seven and ten days to print. When it is finished, the platform returns to the surface, and the table rises up out of a pool of leftover liquid resin. After drying, it is cleaned, further hardened in an ultraviolet oven, and placed in a pigment bath for a day to tint it brown.

Fractal.MGX has been welcomed into the permanent collections of the Metropolitan Museum of Art in New York, the Montreal Museum of Fine Arts, and the Victoria and Albert Museum in London. The presence of design and craft objects in our art museums is a final legacy of the Arts and Crafts movement, ensuring that the category of art remains open to question and that it never floats too free of the objects that bring visual delight to our daily lives.

12.23 WertelOberfell, with Matthias Bär. *Fractal.MGX*. Manufactured 2007 by Materialise. Epoxy resin, $38\frac{5}{8} \times 22\frac{7}{8} \times 16\frac{7}{2}$ ". Victoria and Albert Museum, London

13

Architecture

rchitecture satisfies a basic, universal human need for a roof over one's head. More than walls, more than a chair to sit on or a soft bed to lie on, a roof is the classic symbol of protection and security. We've all heard the expression "I have a roof over my head," but it would be unusual to hear someone say, "I'm all right because I have walls around me." Of course, in purely practical terms a roof does keep out the worst of the elements, snow and rain, and in warm climates a roof may be sufficient to keep people dry and comfortable. The roof seems to be symbolic of the nature of architecture.

More than any of the other arts, architecture demands structural stability. Every one of us daily moves in and out of buildings—houses, schools, stores, banks, and movie theaters—and we take for granted, usually without thinking about it, that they will not collapse on top of us. That they do not is a tribute to their engineering; if a building is physically stable, it adheres faithfully to the principles of the particular *structural system* on which its architecture is based.

Structural Systems in Architecture

Since the time of the earliest human settlements, architects have tackled the challenge of erecting a roof over empty space, setting walls upright, and having the whole stand secure. Their solutions have depended upon the materials they had available, for, as we shall see, certain materials are better suited than others to a particular structural system. There are two basic families of structural systems: the shell system and the skeleton-and-skin system.

In the shell system one building material provides both structural support and sheathing (outside covering). Buildings made of brick or stone or adobe fall into this category, and so do older (pre-19th-century) wood buildings constructed of heavy timbers, the most obvious example being the log cabin. The structural material comprises the walls, marks the boundary between inside and outside, and is generally visible as the exterior surface. It may also serve for the ceiling of the building, and even, though more rarely, the roof.

The skeleton-and-skin system might be compared to the human body, which has a rigid bony skeleton to support its basic frame and a more fragile skin for sheathing. We find it in the tipi of the American Plains Indians, which consists of a conical skeleton of wooden poles covered with a skin made of

animal hides. We find it again in modern skyscrapers, with their steel frames (skeletons) supporting the structure and a sheathing (skin) of glass or some

other light material.

The task of any structural system is to channel the forces that act upon a building safely to the ground. Architects speak of these forces as *loads*. The first and most important of these loads is the building's own weight, which is caused by gravity. Gravity is constantly pulling the building toward Earth, as though daring it to fail. The building's weight is a permanent and unchanging load, but there are other loads that come and go, such as people moving through the building, furnishings placed in the building, snow that accumulates on the roof, wind that blows against the sides, earth that settles beneath its foundations, and even earth that trembles beneath it, as in an earthquake.

No matter what materials it is made of or how complicated its structure, a building handles these loads in just two ways: pushing and pulling. When an element is pushed, we say it is in *compression*. When an element is pulled, we say it is in *tension*. An element in compression becomes shorter. An element in tension lengthens. These changes are rarely visible to the naked eye, but they nevertheless occur.

You can get a sense of the forces of tension and compression by imagining yourself as a structural material. Two friends raise you up high overhead, their arms locked. One holds you by your ankles, the other braces your shoulders. You are horizontal, facing the floor, as rigid as you can be. The three of you have now formed an opening—a doorway, say, that people could pass through. The two people holding you up are in compression. Your weight is pushing down on them, and eventually their knees may buckle or their elbows give way if they are not strong enough. And you? Your situation is a little more complicated. Your front side is under tension, but your back side is under compression. You will feel this when you start to sag: your stomach muscles will make it clear that they are stretching, and your back will tell you that it is being scrunched.

To withstand the stresses induced by loads, then, structural materials must possess tensile strength (be able to withstand tension) and/or compressive strength (be able to withstand compression). Wood, stone, concrete, and steel, our most commonly used materials, all possess both tensile strength and compressive strength, though not always in equal measure. Stone and concrete have excellent compressive strength but little tensile strength. Wood is virtually equal in compressive and tensile strength, though it is not nearly as strong as steel, our strongest construction material.

With these basic concepts in mind, we can turn to some of the structural systems that architects have developed and look at some famous buildings that use them. We take up the systems roughly in the chronological order in which they were invented.

Load-Bearing Construction

Another term for load-bearing construction is "stacking and piling." This is the simplest method of making a building, and it is suitable for brick, stone, adobe, ice blocks, and certain modern materials. Essentially, the builder constructs the walls by piling layer upon layer, starting thick at the bottom, getting thinner as the structure rises, and usually tapering inward near the highest point. The whole may then be topped by a lightweight roof, perhaps of thatch or wood. This construction is stable, because its greatest weight is concentrated at the bottom and weight diminishes gradually as the walls grow higher.

Load-bearing structures tend to have few and small openings (if any) in the walls, because the method does not readily allow for support of material above a void, such as a window opening. Yet it would be a mistake to think that such basic methods must produce basic results. The Great Friday Mosque at Djenné, in Mali, is a spectacular example of monumental architecture created

post-and-lintel

from simple techniques and materials (13.1). Constructed of adobe (sun-dried brick) and coated with mud plaster, the imposing walls of this mosque have a plastic, sculptural quality. The photograph shows well the gentle tapering of the walls imposed by the construction technique as well as the small size of the windows that illuminate the covered prayer hall inside. The protruding wooden poles serve to anchor the scaffolding that is erected every few years so that workers can restore the mosque's smooth coating of mud plaster.

Post-and-Lintel

After stacking and piling, **post-and-lintel** construction is the most elementary structural method, based on two uprights (the posts) supporting a horizontal crosspiece (the **lintel**, or beam; see diagram). This configuration can be continued indefinitely, so that there may be one very long horizontal supported at critical points along the way by vertical posts to carry its weight to the ground. The posts are in compression; the lintel is in compression on its upper side and tension on its lower side—your situation when you were being lifted by your friends. The most common materials for post-and-lintel construction are stone and wood.

Post-and-lintel construction has been, for at least four thousand years, a favorite method of architects for raising a roof and providing for open space underneath. On a smaller scale, it is used to open up windows and doorways in load-bearing construction, the lintel bearing the weight of the material above and protecting the void below. The ruins of a portion of the ancient Egyptian temple of Luxor illustrate the majesty and also the limits of post-and-lintel construction in stone (13.2). Carved as bundles of stems capped by stylized papyrus-flower buds, the stone columns support rows of heavy stone lintels, with each lintel spanning two columns. The lintels would in turn have supported slabs of stone that served as both ceiling and roof. Because stone

13.1 Great Friday Mosque, Djenné, Mali. Rebuilt 1907 in the style of a 13th-century original.

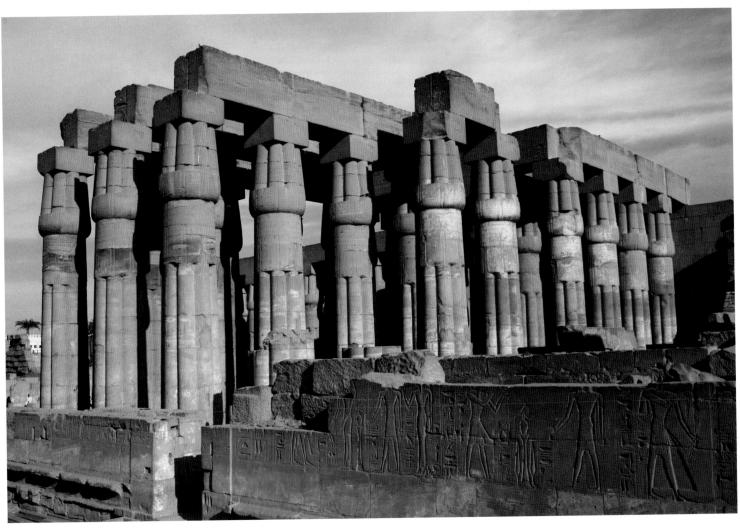

13.2 View of the hypostyle from the temple of Luxor, Egypt. Begun c. 1390 B.C.E. Height of columns 30'.

does not have great tensile strength, the supporting columns must be closely spaced. A large hall erected in post-and-lintel construction was thus a virtual forest of columns inside. We call such spaces **hypostyle** halls, from the Greek for "beneath columns." Ancient Egyptians associated hypostyle halls with the primal swamp of creation, where, according to Egyptian belief, the first mound of dry land arose at the dawn of the world. To make that connection clear, they designed their columns as stylized versions of plants that grew in the marshes of the Nile. Surrounded by load-bearing walls pierced high up by small windows, the hypostyle halls of Egyptian temples were dark and mysterious places.

In ancient Greece, the design of post-and-lintel buildings, especially temples, became standardized in certain features. Greek architects developed and codified three major architectural styles, roughly in sequence. We know them as the Greek **orders**. The most distinctive feature of each was the design of the column (13.3). By the 7th century B.C.E., the **Doric** style had been introduced. A Doric column has no base, nothing separating it from the floor below; its **capital**, the topmost part between the shaft of the column and the roof or lintel, is a plain stone slab above a rounded stone. The **Ionic** style was developed in the 6th century B.C.E. and gradually replaced the Doric. An Ionic column has a stepped base and a carved capital in the form of two graceful spirals known as **volutes**. The **Corinthian** style, which appeared in the 4th century B.C.E., is yet more elaborate, having a more detailed base and a capital carved as a stylized bouquet of acanthus leaves.

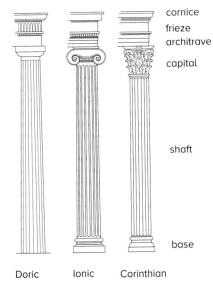

13.3 Column styles of the Greek orders.

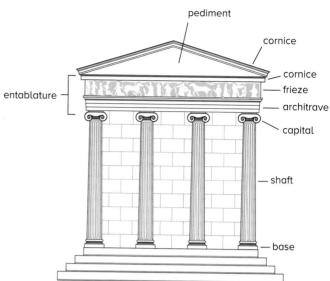

13.5 Elevation, Temple of Athena Nike.

The most famous and influential work of Greek architecture is certainly the Parthenon, a Doric temple that we will examine in Chapter 14 (see 14.26). Here, we look at the smaller Temple of Athena Nike (13.4), which stands nearby on the hilltop site in Athens known as the Acropolis. With their stepped bases and volute capitals, the columns indicate that this is an Ionic temple. The columns support a structure whose remains, reconstructed here in a line drawing (13.5), display other important elements of Greek architecture. The plain, horizontal stone lintels of Egypt are here elaborated into a compound structure called an entablature. The entablature consists of three basic elements. The simple, unadorned band of lintels immediately over the columns is the architrave. The area above the architrave is the frieze, here ornamented with sculpture in relief. The frieze is capped by a shelflike projection called a cornice. The entablature in turn supports a triangular element called a pediment, which is itself crowned by its own cornice. Like the frieze, the pediment would have been ornamented with sculpture in relief. If these elements look familiar to you, it is because they have passed into the vocabulary of Western architecture and form part of the basis of the style we refer to broadly as classical. For centuries, banks, museums, universities, government buildings, and churches have been built using the elements first codified and named by the Greeks, then adapted and modified by the Romans.

Many of the great architectural traditions of the world are based in postand-lintel construction. The architectural style developed in China provides a good contrast to that of Greece, for while its principles were developed around the same time, the standard material is not stone but wood. We know from terra-cotta models found in tombs that the basic elements of Chinese architecture were in place by the second century B.C.E. During the 6th century C.E., this architectural vocabulary was adopted by Japan along with other elements of Chinese culture. We illustrate it here with a Japanese building, the incomparable Byodo-in (13.6).

Built as a palace, Byodo-in was converted to a Buddhist shrine after the death of the original owner in 1052 c.e. Among the works of art it houses is Jocho's sculpture of the buddha Amida Nyorai, discussed in Chapter 2 (see 2.29). Our first impression is of a weighty and elaborate superstructure of gracefully curved roofs resting—lightly, somehow—on slender wooden columns. The effect is miraculous, for the building seems to float; but how can all of that weight rest on such slender supports? The answer lies in the cluster of interlocking

wooden brackets and arms that crowns each column (13.7). Called bracket sets, they distribute the weight of the roof and its large, overhanging eaves evenly onto the wooden columns, allowing each column to bear up to five times the weight it could support directly. Chinese and Japanese architects developed many variations on the bracket set over the centuries, making them larger or smaller, more elaborate or simpler, more prominent or more subtle.

The distinctive curving profile of East Asian roofs is made possible by a stepped truss system (13.8). (Western roofs, in contrast, are usually supported by a rigid triangular truss, as in the Greek pediment.) By varying the height of each level of the truss, builders could control the pitch and curve of the roof. Taste in roof styles varied over time and from region to region. Some roofs are steeply pitched and fall in a fancifully exaggerated curve, almost like a ski jump; others are gentler, with a subtle, barely noticeable curve.

The post-and-lintel system, then, offers potential for both structural soundness and grandeur. When applied to wood or stone, however, it leaves one problem unsolved, and that is the spanning of relatively large open spaces. The first attempt at solving this problem was the invention of the round arch.

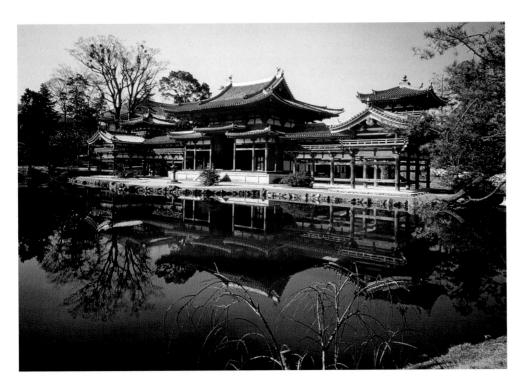

13.6 Hoodo (Phoenix Hall), Byodo-in Temple, Uji, Kyoto Prefecture, Japan. Heian period, c. 1053.

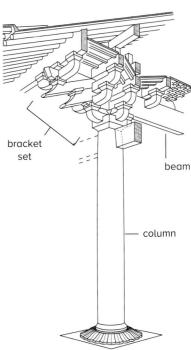

13.7 Bracket system.

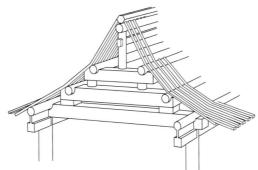

13.8 Stepped truss roof structure.

round arch

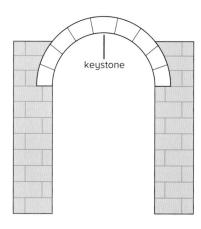

round arch with outward thrust contained

13.9 Pont du Gard, Nîmes, France. Early 1st century C.E. Length 902'.

Round Arch and Vault

Although the round **arch** was used by the ancient peoples of Mesopotamia several centuries before our common era (see 14.9), it was most fully developed by the Romans, who perfected the form in the 2nd century B.C.E. The arch is a compressive structure. Its components push against each other to achieve stability. This makes it particularly suited to stone, which has high compressive strength. An arch is not stable until it is complete, however. During construction, it must be supported from below by a temporary wooden framework called a centering. Once the centering is in place, wedge-shaped blocks of stone are set along its arch-shaped top, beginning from both ends simultaneously. When the topmost block, called the **keystone**, is wedged into place, the two sides of the arch meet and lean against each other. The centering can be removed, for the arch is now self-supporting. An arch exerts an outward thrust at its base. Unless the arch sits directly on the ground, this thrust must be countered or contained (see diagram).

The arch has many virtues. In addition to being an attractive form, it enables the architect to open up fairly large spaces in a wall without risking the building's structural soundness. These spaces admit light, reduce the weight of the walls, and decrease the amount of material needed. As utilized by the Romans, the arch is a perfect semicircle, although it may seem elongated if it rests on columns.

Among the most elegant and enduring of Roman structures based on the arch is the Pont du Gard at Nîmes, France (13.9), built about 15 c.e. when the empire was nearing its farthest expansion (see map, page 344). The Pont du Gard consists of three tiers of arcades—rows of arches set on columns or, as here, massive piers. It functioned as an aqueduct, a structure meant to transport water, and its lower level served as a footbridge across the river. That it stands today virtually intact after nearly two thousand years (and is crossed by cyclists on the route of the famous Tour de France bicycle race) testifies to the Romans' brilliant engineering skills. Visually, the Pont du Gard exemplifies the best qualities of arch construction. Solid and heavy, obviously durable, it is shot through with open spaces that make it seem light and its weight-bearing capabilities effortless.

When the arch is extended in depth—when it is, in reality, many arches placed flush one behind the other—the result is called a barrel vault. This vault

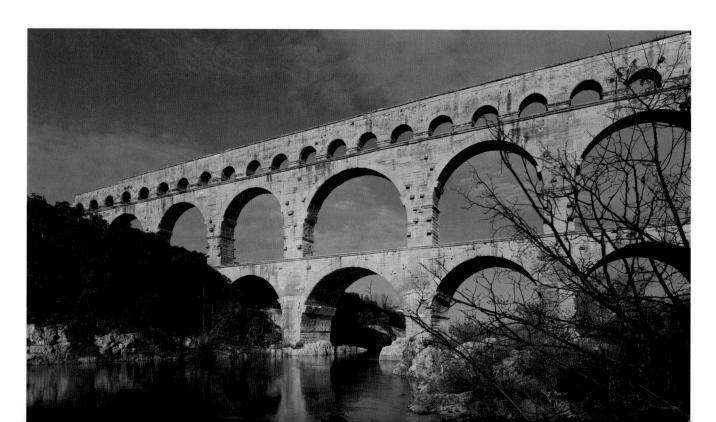

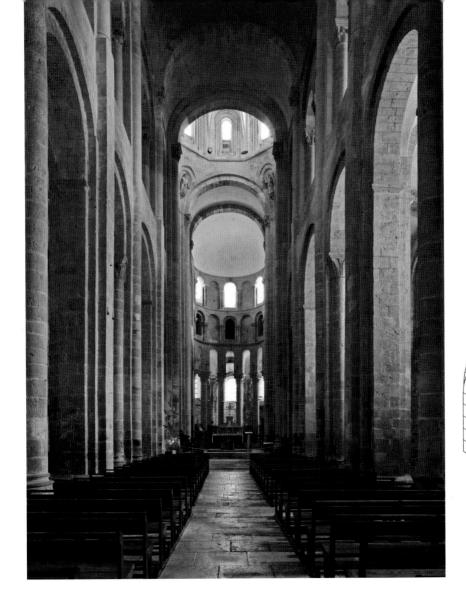

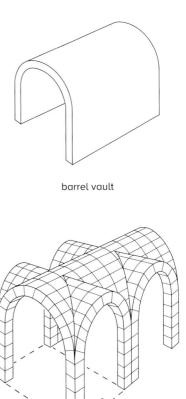

groin vault

13.10 Interior, Abbey Church of Sainte-Foy, Conques, France. c. 1050-1120.

construction makes it possible to create large interior spaces. The Romans made great use of the **barrel vault**, but for its finest expression we look many hundreds of years later, to the churches of the Middle Ages.

The church of Sainte-Foy (13.10), in the French city of Conques, is an example of the style prevalent throughout western Europe from about 1050 to 1200—a style known as Romanesque. Earlier churches had used the Roman round arch to span the spaces between interior columns that ultimately held up the roof. There were no ceilings, however. Rather, worshipers looked up into a system of wooden trusses and the underside of a pitched roof (see 15.2, 15.3). Imagine looking directly up into the attic of a house and you will get the idea. With the Romanesque style, builders set a stone barrel vault as a ceiling over the nave (the long central area), hiding the roof structure from view. The barrel vault unified the interior visually, providing a soaring, majestic climax to the rhythms announced by the arches below.

On the side aisles of Sainte-Foy (not visible in the photograph), the builders employed a series of **groin vaults**. A groin vault results when two barrel vaults are crossed at right angles to each other, thus directing the weights and stresses down into the four corners. By dividing up a space into rectangular segments known as **bays**, each of which contains one groin vault, the architects could cover a long span safely and economically. The repetition of bays also creates a satisfying rhythmic pattern.

Pointed Arch and Vault

Although the round arch and the vault of the Romanesque era solved many problems and made many things possible, they nevertheless had certain drawbacks. For one thing, a round arch, to be stable, must be a semicircle; therefore, the height of the arch is limited by its width. Two other difficulties were weight and darkness. Barrel vaults are both literally and visually heavy, calling for huge masses of stone to maintain their structural stability. They exert an outward thrust all along their base, which builders countered by setting them in massive walls that they dared not weaken with light-admitting openings. The **Gothic** period in Europe, which followed the Romanesque, solved those problems with the pointed arch.

The pointed arch, though seemingly not very different from the round one, offers two advantages. Because the sides arc up to a point, weight is channeled down to the ground at a steeper angle, and therefore the arch can be taller. The vault constructed from such an arch also can be much taller than a barrel vault. In addition, a pointed arch exerts far less outward thrust at its base than does a round arch. Architects of the Gothic period found they did not need heavy masses of material throughout the curve of the vault, as long as

13.11 Nave, Cathedral of Notre-Dame de Reims, France. 1211–c. 1290.

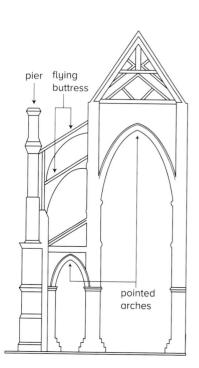

Elements of Gothic architecture

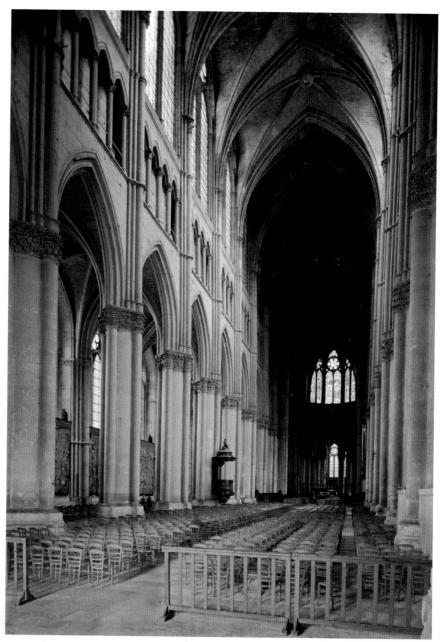

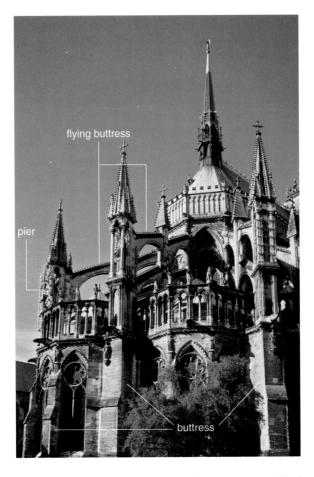

the major points of intersection were reinforced. These reinforcements, called **ribs**, are visible in the nave ceiling of Reims Cathedral (13.11).

The light captured streaming into the nave of Reims Cathedral in the photograph vividly illustrates another important feature of Gothic church architecture: windows. Whereas Romanesque cathedrals tended to be dark inside, with few and small window openings, Gothic builders strove to open up their walls for large stained glass windows. (Most of the stained-glass windows in Reims Cathedral have suffered damage and been replaced with clear glass, which is why the light is so evident in the photograph.) Fearing that the numerous window openings could disastrously weaken walls that were already under pressure from the outward thrust of arches, Gothic builders reinforced their walls from the outside with buttresses, piers, and a new invention, flying buttresses. The principles are easy to understand if you imagine yourself using your own weight to prop up a wall. If you stand next to a wall and press the entire length of your body against it, you are a buttress. If you stand away from the wall and press against it with outstretched arms, your body is a pier, and your arms are flying buttresses. The illustration here of the exterior of the cathedral shows the Gothic system of buttresses, piers, and flying buttresses, as well as the numerous windows that made them necessary (13.12).

13.12 East end, Cathedral of Notre-Dame de Reims.

Dome

A **dome** is a curved vault built to cover an interior space. The most common type of dome takes the form of a "shell of rotation"—that is, a form generated by rotating an arch about a vertical central axis. If the arch is a round Roman arch, a half-circle, then the shell of rotation will be a hemisphere, a half-globe, which is the form taken by many domes.

Sliced vertically, a dome is an arch form. Sliced horizontally, a dome is a complete circle. These two aspects are united in a single, continuous surface. Because of this, domes differ from arches in two significant ways. First, a dome

can be much thinner in relation to its span than an arch can. Second, a dome exerts far less outward thrust at its base, because the circles, called parallels, act like restraining hoops, preventing the dome from opening up. The upper portion of a dome is in compression. In the lower portion, however, the parallels are in tension, which increases as they near the base. Because domes are generally built of stone, brick, or concrete, all of which have low tensile strength, the base of a dome must be reinforced in some way to prevent cracks from developing. The base of the great dome of St. Peter's Basilica in Rome, for example, is encircled by embedded iron chains (see 16.11).

Like so many other architectural structures, the dome was perfected under the incomparable engineering genius of the Romans, and one of the finest domed buildings ever erected dates from the early 2nd century. It is called the Pantheon, which means a temple dedicated to "all the gods"-or, at least, all the gods who were venerated in ancient Rome (13.13, 13.14, 13.15). As seen from the inside, the Pantheon has a perfect hemispherical dome soaring 142 feet above the floor, resting upon a cylinder almost exactly the same in diameter-140 feet. The dome is made of concrete, which would have been applied over wooden centering erected in the interior, though exactly how this centering was constructed remains a mystery. The ceiling is coffered-ornamented with recessed rectangles, coffers, which lessen its weight. Only about 2 feet thick at its highest point, the dome increases dramatically in thickness toward its base as a series of step rings appear on the outer surface. The rings add weight to the base of the dome and increase its stability. At the very top of the dome is an opening 29 feet in diameter called an oculus, or eye, thought to be symbolic of the "eye of Heaven." This opening provides the sole (and

13.13 Pantheon, Rome. 118-26 C.E.

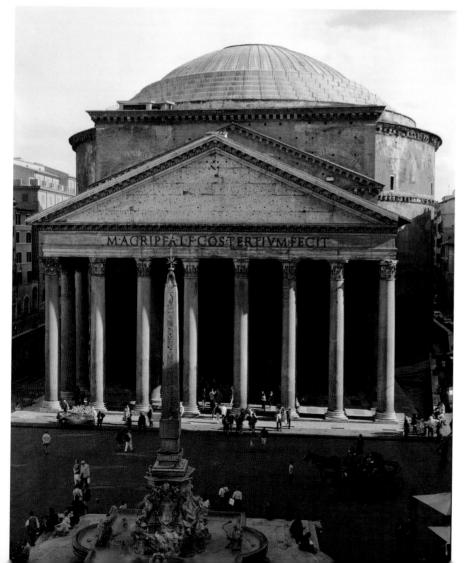

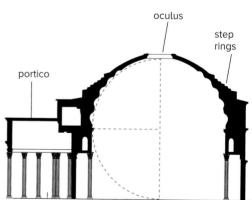

13.14 Section drawing of the Pantheon.

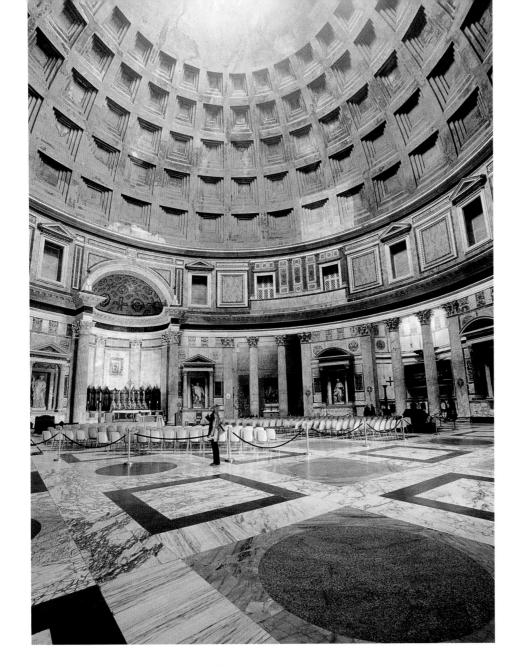

plentiful) illumination for the building. In its conception, then, the Pantheon is amazingly simple, equal in height and width, symmetrical in its structure, round form set upon round form. Yet because of its scale and its satisfying proportions, the effect is overwhelming.

The combined structural possibilities of the dome and the vault enabled the Romans to open up huge spaces such as the Pantheon without interior supports. Another important factor that allowed them to build on such a scale was their use of concrete. Whereas Greek and Egyptian buildings had been made of solid stone, monumental Roman buildings were made of thick concrete, tamped down into parallel brick walls as though into a mold, then faced with stone veneer to look as though they were made of solid stone. An important technological breakthrough, the use of concrete cut costs and enabled building on a grand scale.

Visitors enter the Pantheon through the rectangular **portico**, or porch, that is joined somewhat incongruously to it. Here we recognize the characteristic form of the Greek temple as inherited by the Romans: post-and-lintel construction, Corinthian order, entablature, and pediment. In Roman times, an approach to the building was constructed to lead to the portico while obscuring the rest of the temple. Thinking that they were entering a standard post-and-lintel temple,

13.15 Interior of the Pantheon.

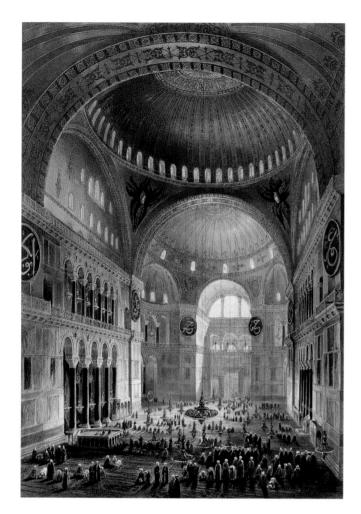

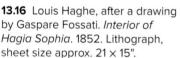

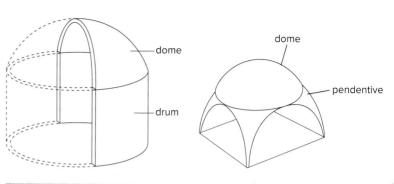

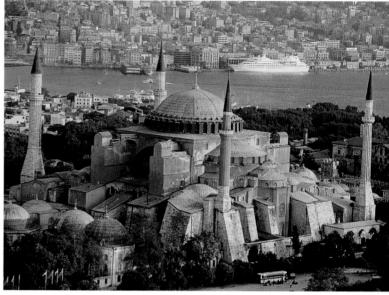

13.17 Hagia Sophia, Istanbul. 532-37.

visitors must have been stunned to see the enormous round space open up before their eyes. Tourists today experience the same theatrical surprise.

The Pantheon is a **rotunda**, a round building, and its dome sits naturally on the circular **drum** of the base. Often, however, architects wish to set a dome over a square building. In that case, a transitional element is required between the circle (at the dome's base) and the square (of the building's top). An elegant solution can be found in Hagia Sophia (the Church of the Holy Wisdom) in Istanbul (**13.16**, **13.17**). Designed by two mathematicians, Anthemius of Tralles and Isidorus of Miletus, Hagia Sophia was built as a church during the 6th century, when Istanbul, then called Constantinople, was the capital of the Byzantine Empire. When the Turks conquered the city in the 15th century, Hagia Sophia was converted for use as a mosque. It was at that time that the four slender towers, **minarets**, were added. The building is now preserved as a museum. In sheer size and perfection of form, it was the architectural triumph of its time and has seldom been matched since then.

The dome of Hagia Sophia rises 183 feet above the floor, with its weight carried to the ground by heavy stone piers—in this case, squared columns—at the four corners of the immense nave. Around the base of the dome is a row of closely spaced arched windows, which make the heavy dome seem to "float" upward. (The exterior view makes it clear that these windows are situated between buttresses that ring the base of the dome, containing its outward thrust and compensating for any structural weakening caused by the window openings.) Each of the four sides of the building consists of a monumental round arch, and between the arches and the dome are curved triangular sections known as **pendentives**. It is the function of the pendentives to make a smooth transition between rectangle and dome.

The domes of the Pantheon and the Hagia Sophia serve primarily to open up vast interior spaces. Seen from the outside, their hemispherical form is obscured by the buttressing needed to contain their powerful outward thrust. Yet the dome is such an inherently pleasing form that architects often used it for purely decorative purposes, as an exterior ornament to crown a building. In that case, it is often set high on a drum, a circular base, so that it can be seen from the ground. A famous example of a building crowned by an ornamental dome is the Taj Mahal, in Agra, India (13.18).

The Taj Mahal was built in the mid-17th century by the Muslim emperor of India, Shah Jahan, as a tomb for his beloved wife, Arjumand Banu. Although the Taj is nearly as large as Hagia Sophia and possessed of a dome rising some 30 feet higher, it seems comparatively fragile and weightless. Nearly all its exterior lines reach upward, from the graceful pointed arches, to the pointed dome, to the four slender minarets poised at the outside corners. The Taj Mahal, constructed entirely of pure white marble, appears almost as a shimmering mirage that has come to rest for a moment beside the peaceful reflecting pool.

The section drawing (13.19) clarifies how the dome is constructed. Over the underground burial chambers of Shah Jahan and his wife, the large central room of the tomb rises to a domed ceiling. Over this, on the roof of the building, sits a tall drum crowned by a pointed dome. A small entryway gives access to the inside for maintenance purposes, but it is not meant to be visited. The exterior is shaped in a graceful, bulging S-curve silhouette that obscures the actual drum-and-dome structure evident in the cutaway view.

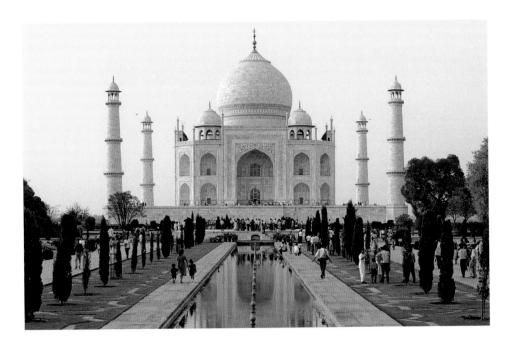

13.18 Taj Mahal, Agra, India. 1632-53.

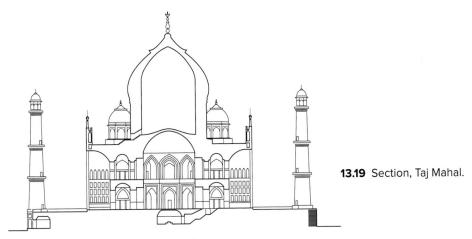

Corbelling

Islamic architects knew the use of the arch and the dome because Islam came of age in a part of the world that had belonged first to the Roman and then to the Byzantine Empire. When Islamic rulers settled in India, their architects brought these construction techniques with them, resulting in such buildings as the Taj Mahal. Indigenous Indian architecture, in contrast, does not make use of the arch or the dome but is based on post-and-lintel construction. To create arch, vault, and dome forms, Indian architects used a technique called **corbelling**. In a corbelled arch, each course (row) of stones extends slightly beyond the one below, until eventually the opening is bridged.

Just as a round Roman arch can be extended in depth to create a vault or rotated to create a dome, so corbelling can create vault forms and, as in the temple interior illustrated here, dome forms (13.20). Ornamented by band upon band of ornate carving and set with figures of the sixteen celestial nymphs, the corbelled dome rests on an octagon of lintels supported by eight columns. Pairs of stone brackets between each column provide additional support. The elaborate, filigreed carving that decorates every available surface testifies to the virtuosity of Indian stoneworkers, in whose skillful hands stone was made to seem as light as lace.

Although to the naked eye a corbelled arch may be indistinguishable from the round arch described previously, it does not function structurally as a round arch does, channeling weight outward and downward, and so does not enable the construction of large, unobstructed interior spaces.

13.20 Interior of the Jain temple of Dilwara, Vimala temple, Mount Abu, South Rajasthan, India. Completed 1032.

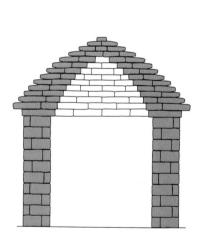

corbelled dome

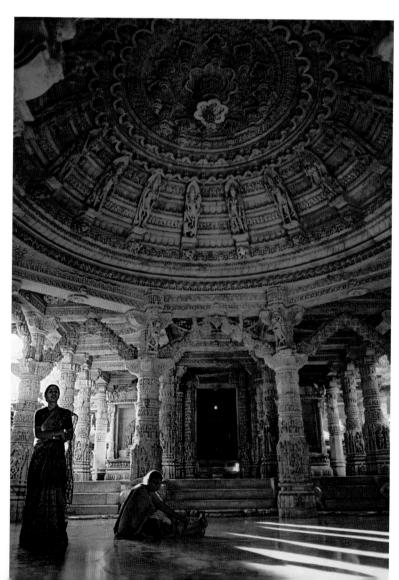

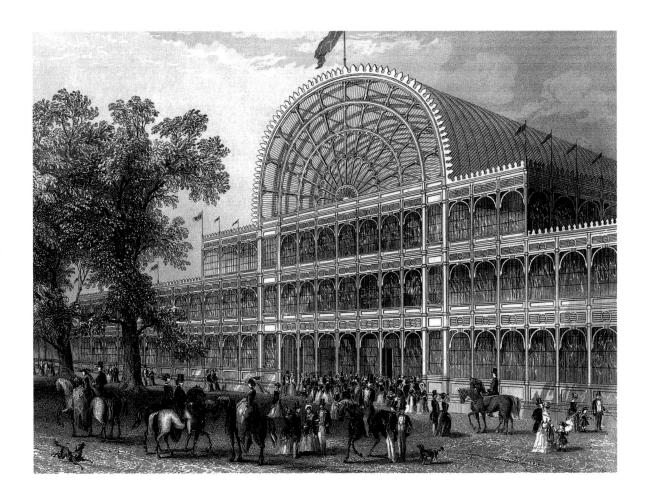

Cast-Iron Construction

With the perfection of the post-and-lintel, the arch, and the dome, construction in wood, stone, and brick had gone just about as far as it could go. Not until the introduction of a new building material did the next major breakthrough in structural systems take place. Iron had been known for thousands of years and had been used for tools and objects of all kinds, but only after the Industrial Revolution was it produced in sufficient quantity to be used as a building material. The structural value of iron was demonstrated brilliantly in a project that few contemporary observers took seriously.

In 1851 the city of London was planning a great exhibition, under the sponsorship of Prince Albert, husband of Queen Victoria. The challenge was to house under one roof the "Works of Industry of All Nations," and the commission for erecting a suitable structure fell to Joseph Paxton, a designer of greenhouses. Paxton raised in Hyde Park a wondrous building framed in cast iron and sheathed in glass—probably the first modern skeleton-and-skin construction ever designed (13.21). The Crystal Palace, as Paxton's creation came to be known, covered more than 17 acres and reached a height of 108 feet. Thanks to an ingenious system of prefabrication, the entire project was completed in less than 9 months.

Visitors to the exhibition considered the Crystal Palace a curiosity—a marvelous one, to be sure, but still an oddity outside the realm of architecture. They could not have foreseen that Paxton's design, solid iron framework clothed in a glass skin, would pave the way for 20th-century architecture. In fact, Paxton had taken a giant step in demonstrating that as long as a building's skeleton held firm, its skin could be light and non-load-bearing. Several intermediary steps would be required before this principle could be translated into today's architecture.

13.21 Joseph Paxton. Crystal Palace, Hyde Park, London. 1851. View of the exterior of the north transept. Engraving, 1851.

Another bold experiment in iron construction came a few decades later just across the English Channel, in France, and involved a plan that many considered to be foolhardy, if not downright insane. Gustave Eiffel, a French engineer, proposed to build in the center of Paris a skeleton iron tower, nearly a thousand feet tall, to act as a centerpiece for the Paris World's Fair of 1889. Nothing of the sort had ever been suggested, much less built. In spite of loud protests, the Eiffel Tower (13.22) was constructed, at a cost of about a million dollars—an unheard-of sum for those times. It rises on four arched columns, which curve inward until they meet in a single tower thrusting up boldly above the cityscape of Paris.

The importance of this singular, remarkable structure for the future of architecture rests on the fact that it was a skeleton that proudly showed itself without benefit of any cosmetic embellishment. No marble, no glass, no tiles, no skin of any kind—just the clean lines drawn in an industrial-age product. Two concepts emerged from this daring construction. First, metal in and of itself can make beautiful architecture. Second, metal can provide a solid framework for a very large structure, self-sustaining and permanent. Today the Eiffel Tower is the ultimate symbol of Paris, and no tourist would pass up a visit. From folly to landmark in a century—such is the course of innovative architecture.

Iron for structural members was not the only breakthrough of the mid-19th century. The Industrial Revolution also introduced a new construction material that was much humbler but equally significant in its implications for architecture: the nail. And for want of that simple little nail, most of the houses we live in today could not have been built.

Balloon-Frame Construction

So far in this chapter, the illustrations have concentrated on grand and public buildings—churches, temples, monuments. These are the glories of architecture, the buildings we admire and travel great distances to see. We should not forget, however, that the overwhelming majority of structures in the world have been houses for people to live in, or domestic architecture.

13.22 Alexandre Gustave Eiffel. Eiffel Tower, Paris. Completed 1889. Iron, height 934'.

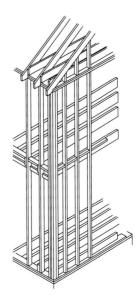

balloon-frame construction

Until the mid-19th century, houses were of shell construction. They were made of brick or stone (and, in warmer climates, of such materials as reeds and bamboo) with load-bearing construction, or else they were post-and-lintel structures in which heavy timbers were assembled by complicated notching and joinery, sometimes with wooden pegs. Nails, if any, had to be fabricated by hand and were very expensive.

About 1833, in Chicago, the technique of balloon-frame construction was introduced. Balloon-frame construction is a true skeleton-and-skin method. It developed from two innovations: improved methods for milling lumber and mass-produced nails. In this system, the builder first erects a framework or skeleton by nailing together sturdy but lightweight boards (the familiar 2-by-4 "stud"), then adds a roof and sheathes the walls in clapboard, shingles, stucco, or whatever the homeowner wishes (13.23). Glass for windows can be used lavishly, as long as it does not interrupt the underlying wood structure, since the sheathing plays little part in holding the building together.

When houses of this type were introduced, the term "balloon framing" was meant to be sarcastic. Skeptics thought the buildings would soon fall down, or burst just like balloons. But some of the earliest balloon-frame houses stand firm today, and this method is still the most popular for new house construction in Western countries.

The balloon frame, of course, has its limitations. Wood beams 2 by 4 inches thick cannot support a skyscraper ten or fifty stories high, and that was the very sort of building architects had begun to dream of late in the 19th century. For such soaring ambitions, a new material was needed, and it was found. The material was steel.

Steel-Frame Construction

Although multistory buildings have been with us since the Roman Empire, the development of the skyscraper, as we know it, required two late-19th-century innovations: the elevator and steel-frame construction. Steel-frame construction, like balloon framing, is a true skeleton-and-skin arrangement. Rather than piling floor upon floor, with each of the lower stories supporting those above it, the builders first erect a steel "cage" that is capable of sustaining the entire weight of the building; then they apply a skin of some other material.

13.23 Balloon-frame houses under construction.

But people could hardly be expected to walk all the way to the top of a ten-story building, to say nothing of a skyscraper. Hence, another invention made its appearance, the elevator.

What many consider to be the first genuinely modern building was designed by Louis Sullivan and built between 1890 and 1891 in St. Louis. Known as the Wainwright Building (13.24), it employed a steel framework sheathed in masonry. Other architects had experimented with steel support but had carefully covered their structures in heavy stone so as to reflect traditional architectural forms and make the construction seem reliably sturdy. Centuries of precedent had prepared the public to expect bigness to go hand in hand with heaviness. Sullivan broke new ground by making his sheathing light, letting the skin of his building echo, even celebrate, the steel framing underneath. Regular bays of windows on the seven office floors are separated by strong vertical lines, and the four corners of the building are emphasized by vertical piers. The Wainwright Building's message is subtle, but we cannot mistake it: the nation had stopped growing outward and started growing up.

Sullivan's design looks forward to the 20th century, but it nevertheless clings to certain architectural details rooted in Classical history, most notably the heavy cornice (the projecting roof ornament) that terminates upward movement at the top of the building. In a very few decades, even those backward glances into the architectural past would become rare.

Toward the middle of the 20th century, skyscrapers began to take over the downtown areas of major cities, and city planners had to grapple with

13.24 Louis Sullivan. Wainwright Building, St. Louis, 1890–91.

steel-frame construction

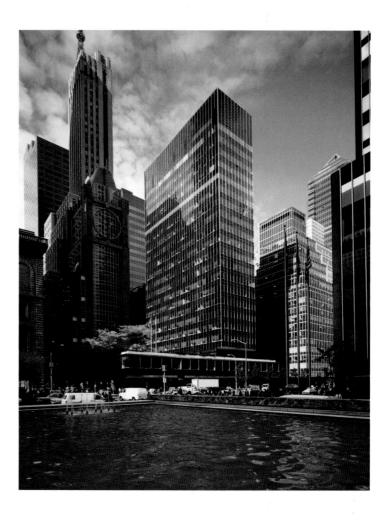

unprecedented problems. How high is too high? How much airspace should a building consume? What provision, if any, should be made to prevent tall buildings from completely blocking out the sunlight from the streets below? In New York and certain other cities, ordinances were passed that resulted in a number of look-alike and architecturally undistinguished buildings. The laws required that if a building filled the ground space of a city block right up to the sidewalk, it could rise for only a certain number of feet or stories before being "stepped back," or narrowed; then it could rise for only a specified number of additional feet before being stepped back again. The resultant structures came to be known as "wedding-cake" buildings. A few architects, however, found more creative ways of meeting the airspace requirement. Those working in the International style designed some of the most admired American skyscrapers during the 1950s and 1960s. International style architecture emphasized clean lines, geometric (usually rectilinear) form, and an avoidance of superficial decoration. The "bones" of a building were supposed to show and to be the only ornament necessary. A classic example of this pure style is Lever House.

Lever House in New York (13.25), designed by the architectural firm of Skidmore, Owings, and Merrill and built in 1952, was heralded as a breath of fresh air in the smog of look-alike structures. Its sleek understated form was widely copied but never equaled. Lever House might be compared to two shimmering glass dominoes, one resting horizontally on freestanding supports, the other balanced upright and off-center on the first. At a time when most architects of office buildings strove to fill every square inch of airspace to which they were entitled—both vertically and horizontally—the elegant Lever House drew back and raised its slender rectangle aloof from its neighbors, surrounded by free space. Even its base does not rest on the ground but rides on thin supports to allow for open plazas and passageways beneath the building. Practically no other system of construction except steel-frame could have made possible this graceful form.

13.25 Gordon Bunshaft of Skidmore, Owings, and Merrill. Lever House, New York. 1952.

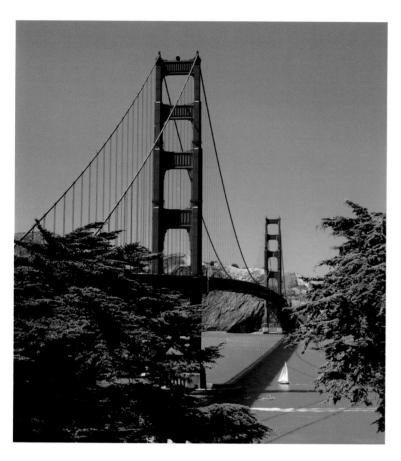

13.27 Foster and Partners. Millau Viaduct, Millau, France. 1993–2004.

Suspension and Cable-Stayed Structures

In the structural systems we have examined thus far, an elevated expanse such as a flat ceiling or a road over a river would be supported from below. Thus, arches support the footbridge on the lower level of the Pont du Gard (13.9), and columns support the lintels and stone slab ceiling of the temple of Luxor (13.2). With suspension and **cable-stayed** structures, such expanses are supported primarily from above, hung from a higher point by means of cables. We illustrate both systems here with bridges, their most common application, but they can also be used to support roofs and even floors.

The Golden Gate Bridge in San Francisco embodies the grace and power of suspension (13.26). Two thick, steel-wire cables are draped over twin towers set into the bed of the Golden Gate (the strait of water that links the Pacific Ocean to the San Francisco Bay) and anchored securely on either shore. These main cables in turn support vertical suspender cables attached to the deck below. The deck thus hangs from the main cables. Suspension bridges came into their own with the development of steel-wire rope in the 19th century, but the principle of suspension is far older. In Peru, for example, the ancient Inca constructed suspension bridges out of fiber rope to carry their mountain roads across gorges and canyons. Attached to stone anchors on either side of the void, the rope suspension system supported a wooden footpath.

Cable-stayed structures bear a superficial resemblance to suspension structures, but they operate on a different principle. With a suspension bridge, the suspender cables rise vertically to the main cables, which sag in a parabolic curve between the towers. These main cables are the primary load-bearing structure. With a cable-stayed bridge, the suspender cables rise on an incline and attach to the towers themselves. The towers are thus the primary load-bearing

structure. The Millau Viaduct, designed by English architect Norman Foster in collaboration with a team of French engineers, is a stunning example of a cable-stayed bridge (13.27). One of the tallest bridges in the world, the Millau Viaduct carries a four-lane highway for over one and a half miles across the valley of the River Tarn, near Millau, in the south of France. Seven concrete piers rise from the valley floor to the deck. A steel mast rises from each pier bearing eleven pairs of suspender cables, here called "stays," that reach down to the deck.

Reinforced Concrete

Concrete is an old material that was known and used by the Romans. A mixture of cement, gravel, and water, concrete can be poured, will assume the shape of any mold, and then will set to hardness. Its major problem is that it tends to be brittle and has low tensile strength. This problem is often observed in the thin concrete slabs used for sidewalks and patios, which may crack and split apart as a result of weight and weather. Late in the 19th century, however, a method was developed for reinforcing concrete forms by embedding mesh or rods made of iron or steel inside the concrete before it hardened. The metal contributes tensile strength, while the concrete provides shape and surface. Reinforced concrete has been used in a wide variety of structures, often in those with free-form, organic shapes. Although it may seem at first to be a skeleton-and-skin construction, reinforced concrete actually works more like a shell, because the metal and concrete are bonded permanently and can form structures that are self-sustaining, even when very thin.

Precast sections of reinforced concrete were used to create the soaring shell-like forms of the Sydney Opera House in Australia (13.28). The Opera House, which is really an all-round entertainment complex, is almost as famous for its construction difficulties as it is for its extraordinary design. So daring was its concept that the necessary technology virtually had to be invented as the project went along. Planned as a symbol of the great port city in whose

13.28 Joern Utzon. Sydney Opera House, Australia. 1959–72. Reinforced concrete, height of highest shell 200'.

13.29 Frank Lloyd Wright. Fallingwater, Mill Run, Pennsylvania. 1936.

harbor it stands, the Opera House gives the impression of a wonderful clipper ship at full sail. Three sets of pointed shells, oriented in different directions, turn the building into a giant sculpture in which walls and roof are one.

One type of structure facilitated by reinforced concrete is the **cantilever**, a projecting form supported at only one end. The American architect Frank Lloyd Wright made poetic use of the cantilever in one of his greatest works, the Edgar J. Kaufmann House, popularly known as Fallingwater (13.29). Wright designed Fallingwater for a wooded site beside a stream with a little waterfall. His clients, the Kaufmann family, assumed he would design a house with a view of the waterfall. Instead, Wright set the house over the falls, so that the sound of the water would become part of their lives. The vertical core of the house is made from stone quarried nearby, giving Fallingwater a conceptual as well as a visual unity with the landscape around it. Cantilevered terraces made of reinforced concrete project boldly outward from the core. Two of them seem to hover directly over the waterfall, rhythmically echoing the natural cantilever of its massive stone ledge.

Geodesic Domes

Of all the structural systems, probably the only one that can be attributed to a single individual is the geodesic dome, which was developed by the American architectural engineer R. Buckminster Fuller. Fuller's dome is essentially a bubble, formed by a network of metal rods arranged in triangles and further organized into tetrahedrons. (A tetrahedron is a three-dimensional geometric figure having four faces.) This metal framework can be sheathed in any of several lightweight materials, including wood, glass, and plastic.

The geodesic dome offers a combination of advantages never before available in architecture. Although very light in weight in relation to size, it is amazingly strong, because its structure rests on a mathematically sophisticated use of the triangle. Because it requires no interior support, all the space

ARTISTS Frank Lloyd Wright (1867–1959)

What are Wright's principles for "Prairie house"? How does Wright bring his "organic" approach to the Solomon R. Guggenheim Museum in New York and the Imperial Hotel in Tokyo? What parallels can be drawn between his philosophy and science?

any critics consider Frank Lloyd Wright to have been the greatest American architect of his time; certainly few would dispute the claim that he was the greatest designer of residential architecture. To see a Wright-designed building dating from the first decade of the 20th century is to be shocked by how remarkably modern it seems.

Wright received very little formal education. He attended high school in Madison, Wisconsin, but apparently did not graduate. Later, he completed the equivalent of about one year's coursework in civil engineering at the University of Wisconsin, while holding down a job as a draftsman. In 1887 he moved to Chicago and eventually found work in the architectural firm headed by Louis Sullivan, the great designer of early office buildings (see 13.24). Before long, Wright had assumed responsibility for fulfilling most of the residential commissions that came into the company, and in 1893 he opened a firm of his own.

During the next two decades, Wright refined the principles of the "Prairie houses" that are his trademark. Most are in the Midwest, and they echo that flat expanse of the Great Plains—predominantly horizontal, stretching out over considerable ground area but usually in one story. All expressed Wright's special interest in textures and materials; he liked whenever possible to build with materials native to the immediate surroundings, so that the houses blend with their environments. Interiors were designed in an open plan, with rooms flowing into one another (an unusual practice for the time), and the inside and outside of the house were also well integrated. These ingredients added up to what Wright always referred to as "organic" architecture.

For most of his long life, Wright's personal situation was far from tranquil. His parents seem to have had a bitterly unhappy marriage, and they divorced in 1885, when Wright was seventeen—an extraordinary event for that era. Wright himself had a troubled marital history. His first marriage ended when he eloped to Europe with Mamah Brothwick, the wife of a former client, leaving his own wife and six children behind. Five years later, back in Wisconsin, Brothwick was brutally murdered by a deranged servant while Wright was out of the house. This tragedy sent the architect off on a period of wandering through faraway parts of the world. A final marriage in the late 1920s lasted out his lifetime and appears to have given him his first real happiness.

Although he is best known for his domestic architecture, Wright also designed many large-scale commercial and public buildings, including the Solomon R. Guggenheim Museum in New York. His innovative design for the Imperial Hotel in Tokyo, planned to be stable in an area plagued by earthquakes, proved successful when the hotel survived without damage a devastating quake just a year after it was completed.

Wright was the author of several books on his theories of architecture, and always he focused on the organic nature of his work and on his own individuality. "Beautiful buildings are more than scientific. They are true organisms, spiritually conceived, works of art, using the best technology by inspiration rather than the idiosyncrasies of mere taste or any averaging by the committee mind."

Photograph of Frank Lloyd Wright.

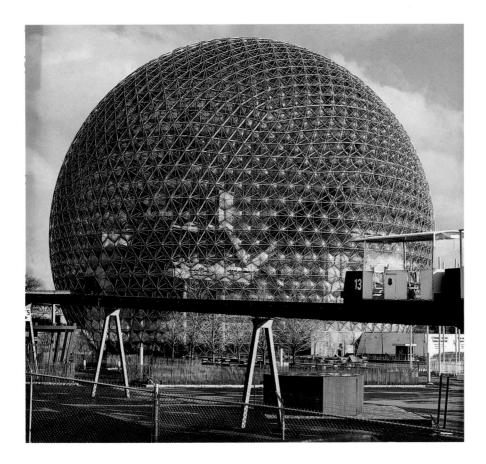

geodesic dome

13.30 R. Buckminster Fuller. U.S. Pavilion, Expo 67, Montreal. 1967. Geodesic dome, diameter 250'.

encompassed by the dome can be used with total freedom. A **geodesic dome** can be built in any size. In theory, at least, a structurally sound geodesic dome 2 miles across could be built, although nothing of that scope has ever been attempted. Perhaps most important for modern building techniques, Fuller's dome is based on a modular system of construction. Individual segments—modules—can be prefabricated to allow for extremely quick assembly of even a large dome. And finally, because of the flexibility in choice of sheathing materials, there are virtually endless options for climate and light control.

Fuller patented the geodesic dome in 1954, but it was not until thirteen years later, when his design served as the U.S. Pavilion at the Montreal World's Fair, that the public's attention was awakened to its possibilities. The dome at Expo 67 (13.30) astonished the architectural world and fairgoers alike. It was 250 feet in diameter (about the size of a football field rounded off) and, being sheathed in translucent material, lighted up the sky at night like a giant space-ship set down on Earth. After Expo 67, some people predicted that before long all houses and public buildings would be geodesic domes. That dream has faded considerably, but Fuller's dome has proved well suited for scientific research stations, homes, and even hotels in extremely cold and windy climates.

New Technologies, New Materials, Current Concerns

Like all areas of human creativity, architecture has been affected by the evolution of digital technologies. This section looks first at some of the possibilities opened up by using computers to link design and fabrication. Then it turns to examine how modern fabrics are being used to create lightweight, portable structures; how architects are responding to the needs of communities; and the ongoing challenge of developing environmentally responsible buildings.

Digital Design and Fabrication

Also known as computer-aided design and manufacturing (CAD/CAM), digital design and fabrication is very much what it sounds like: digital technology is used to help design an object; then digital design data is fed to computer-driven machinery (computer-numeric-controlled, CNC), which automatically fabricates the object.

Linking design and manufacturing by means of computers was pioneered in the 1960s by the electronics, aeronautic, and automotive industries, which could afford to invest in the large, mainframe computers of the day. With the development of personal computers during the years around 1980, digital technology was adopted in numerous work environments, including architecture studios. Many architects began to use two-dimensional drawing programs to help generate the thousands of drawings that guide construction. Today most architects work with more powerful three-dimensional modeling programs as part of the design process. Linked with the potential of digital fabrication, these programs have expanded the possibilities for the forms architecture can take.

One of the first architects to take advantage of digital design and fabrication was Frank Gehry. Gehry had become interested in complex curving forms, but he didn't know how to communicate them to a contractor so that they could be built. A search for solutions turned up a three-dimensional modeling program called CATIA, which had been developed for the French aerospace industry. The world got its first look at what CATIA could do for architecture when Gehry unveiled his next major project, the Guggenheim Museum Bilbao (13.31).

Gehry's design for the building began with gestural sketches on paper and proceeded to the construction of a wood-and-paper model. The model was scanned into CATIA, which mapped it in three dimensions. CATIA enabled Gehry's team to work within the construction budget by allowing them to follow every design decision through to its practical consequences in regard to construction methods and exact quantities of materials. In essence, the program built and rebuilt a virtual museum many times before the actual museum was begun. Information from CATIA then guided the digital fabrication of building components: CNC machines milled limestone blocks and cut glass for curved walls, cut the titanium panels that cover the exterior, and cut, folded, and bolted the underlying steel framework of the building.

13.31 Frank O. Gehry. Guggenheim Museum Bilbao, Bilbao, Spain. 1997.

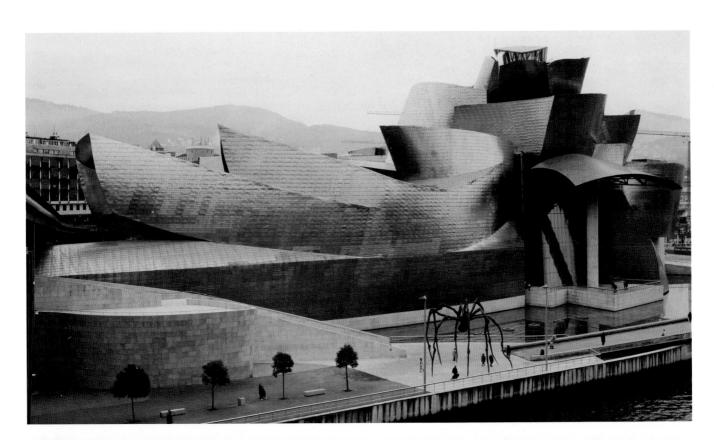

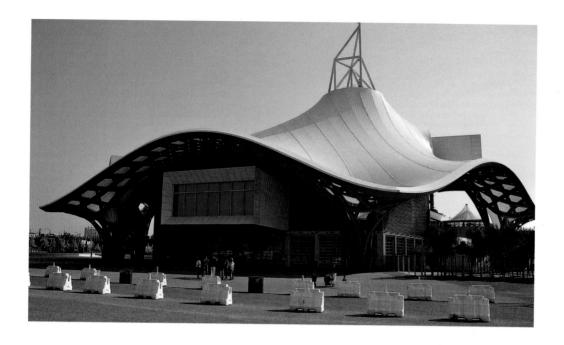

13.32 Shigeru Ban. Centre Pompidou-Metz, Metz, France. 2010.

The Guggenheim Museum Bilbao is a satellite museum of the Solomon R. Guggenheim Museum in New York. Another famous museum of modern and contemporary art, the Pompidou Center in Paris, recently opened its own satellite museum in Metz, France. Designed by Shigeru Ban, the Centre Pompidou-Metz is another example of the new architectural forms enabled by digital design and fabrication (13.32). The most spectacular element of the Pompidou-Metz is the undulating white canopy that shelters the center's galleries and atrium spaces. The canopy is supported by a structure made of laminated wooden ribs woven in an open, hexagonal pattern. To create the wooden structure, the curving geometry of the roof was digitally mapped. Sections (slices) were automatically derived to profile the rise and fall of each individual rib, then translated into instructions for CNC wood-milling machinery. All in all, some 1,800 double-curved segments of wood totaling over 59,000 running feet were individually fabricated to create the structure. Ban took his inspiration for the unusual roof from a Chinese woven bamboo hat that he had found. Weavers have produced such hats for thousands of years, but only with the development of CAD/CAM technology has an architect been able to imitate them.

Fabric Architecture

Shigeru Ban's ingenious wooden lattice is covered with Teflon-coated fiberglass fabric. The stain-resistant, self-cleaning membrane is translucent, allowing daylight to filter into the interior. In the evening, when the building is lit from within, the silhouette of the wooden structure shows through the membrane to the outside. The fabric Ban used is a modern invention, but the idea of fabric architecture is an ancient one. Stone Age peoples first made tents of tree branches covered with animal skins as early as 40,000 years ago. Later, as the first cities were raised up, nomadic peoples continued to live in tents. The yurts of Central Asia, made of felt over a wooden framework, and the tents of Middle Eastern Bedouin peoples, made of fabric woven from goat hair, are two examples of nomadic dwellings with roots in the distant past. Today interest in lightweight, portable structures and the development of stronger synthetic fabrics have inspired a new wave of fabric architecture.

The key to fabric architecture is tension: for fabric to bear weight and resist wind, it must be pulled tense. For that reason, fabric structures are also known as tensile structures or tensile membrane structures. One way to tense

fabric is to stretch it over a framework. The most familiar example of this principle is the umbrella: when you open an umbrella, the fabric is drawn taut by slender metal ribs, creating a portable roof that protects you from the rain. The tension of the fabric in turn prevents the ribs from buckling and constrains their movement, allowing them to be much thinner and lighter than they would otherwise need to be.

Zaha Hadid's innovative Burnham Pavilion is made of panels of fabric zipped tight over a framework of bent aluminum and steel tubing (13.33). Fabric is stretched over the inside of the pavilion as well, where it serves as a projection screen for videos. Light-emitting diodes (LED) set between the inner and outer fabric skins illuminate the pavilion at night so that it glows in a sequence of colors—green, orange, blue, violet. A product of computer-aided design, the curved form sits lightly on the ground, as though it had just touched down and might soon be off again. We could think of Burnham Pavilion as contemporary nomadic architecture. Built on-site for a centennial celebration in Chicago in 2009, it was designed so that it could be dismantled after the festival and erected elsewhere as desired.

Another way to tense fabric is with air pressure. Anyone who has ever inflated an air mattress will understand immediately how rigid and firm an air-filled structure can be. Air was first used as a structural support in the 19th century, with the invention of the inflatable rubber tire. The development of synthetic fabrics in the mid-20th century led visionary architects to experiment with inflatable structures during the 1960s. After a lull, inflatable architecture is today undergoing something of a revival.

13.33 Zaha Hadid Architects. Burnham Pavilion. Installation in Millennium Park, Chicago. 2009.

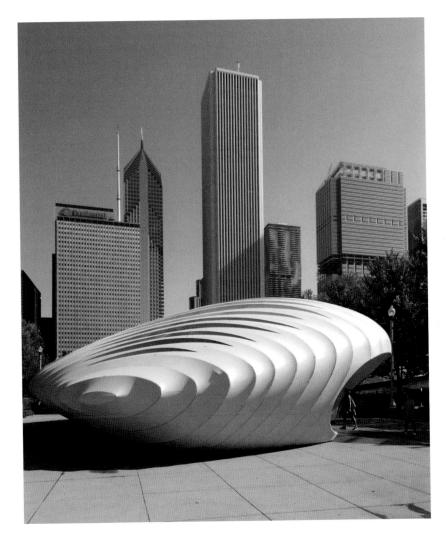

ARTISTS Zaha Hadid (b. 1950)

In some of her designs, how does Hadid capture "raw, vital, earthy quality"? Why did the architect have so much difficulty getting her projects realized early on in her career?

aha Hadid does not shy away from strong statements. "I don't design nice buildings," she told an interviewer. "I don't like them. I like architecture to have some raw, vital, earthy quality." Indeed, "nice" is a word that critics have never applied to Hadid's work, reaching instead for adjectives such as spectacular, visionary, futuristic, sensuous, and transformative. "Hadid is not merely designing buildings," wrote one critic, "she is reimagining domestic, corporate, and public space."

Zaha Hadid was born in Baghdad in 1950 into an intellectual and resolutely secular family. After schooling in Iraq and Switzerland, she attended the American University in Beirut, Lebanon, where she studied mathematics. Then it was on to London for advanced studies at the renowned Architectural Association School of Architecture. There, she became fascinated by the Russian avant-garde painters of the

early 20th century, and her conviction grew that modernism was an unfinished project. She took up painting as a design tool and adapted the formal vocabulary of the Russians she admired. Her paintings so little resembled traditional architectural renderings that many people had a hard time understanding them as buildings at all. Hadid insisted that they could be built and that her unusual technique allowed her to express more complex flows of space and the dynamism of fragmented and layered geometric forms, characteristic elements of the architecture she envisioned. After graduating, she worked for two years in the architectural firm of one of her teachers. Then, in 1980, she set up her own practice.

The decades that followed were difficult. Hadid's firm entered competition after competition, winning several, yet almost nothing was built. She reached the 21st century with only one significant building to her name and a reputation as a "paper architect"—brilliant in theory, but impractical and untested. Hadid looks back on this period philosophically: "During the days and years we were locked up in Bowling Green Lane with nobody paying attention to us, we all did an enormous amount of research, and this gave us a great ability to reinvent and work on things."

Then, finally, her luck turned. A series of commissions received during the late 1990s were completed, and the public got its first sustained look at the architecture of Zaha Hadid: the Bergisei Ski Jump in Austria (2002), the Center for Contemporary Art in Cincinnati (2003), the Phaeno Science Center in Wolfsburg, Germany (2005), and the BMW Central Building in Leipzig, Germany (2005). Hadid's buildings could indeed be built, and they were ravishing. In 2004 she was awarded the coveted Pritzker Architecture Prize, the first woman to be so honored.

Today Hadid has major projects under way in Europe, the United States, the Middle East, and Asia. Commissions pour in, and for the first time she has to contemplate the possibility of turning work down. She is as philosophical about her current popularity as she is about her years of neglect: "I think it's fantastic, and I'm very grateful for it, but I don't take it so seriously that it affects my life. I believe that when there are good moments, you have to recognize them and enjoy them, and that's it." Or, as she said in a less formal mood, "We're having fun now."

Zaha Hadid at a charity event, 2007.

Designed by Japanese architect Kengo Kuma for the grounds of a museum in Germany, this teahouse is an exquisite example of inflatable architecture (13.34). The tea ceremony developed in Japan during the 15th and 16th centuries in the cultural context of Zen Buddhism. Meant to create a moment of tranquility and aesthetic contemplation, to focus the mind and foster awareness of the body, the ceremony was performed in a small space created just for that purpose. A traditional freestanding teahouse is made in a simple, rustic style of wood and bamboo, with mud walls and a straw thatch roof. It consists of two rooms, each with its own entrance: a small room in which a few guests assemble, and an even smaller room in which the host prepares the utensils and the confections that will be served. The doorway is low so that guests must bend over deeply to enter; the ceiling is also low, and the windows are covered with rice paper, allowing light to filter in while blocking any view of the outside world.

Kuma interprets these ideas in a modern way in what he calls "breathing architecture." His teahouse is made of a double membrane of fine, soft, synthetic fabric. Fabric straps connect the inner and outer membranes; their pull dimples the surface when the structure is inflated. (In the illustration here, the strap locations show as dark dots.) The two rooms of a traditional teahouse are reimagined here as two elided bulbous forms, which earned the building the affectionate nickname "the Peanut" while it was being designed. The low entrance for guests is visible at the front. Zippers attach the membranes to either side of a channel that runs around the perimeter of a reinforced concrete foundation. LED lights set in the channel illuminate the membrane at night; during the day, sunlight filters through the translucent fabric. The structure takes only twenty minutes to inflate fully. "When a tea master comes to visit," writes the museum director, "we carry the shell out to the foundation in good weather, roll the trunk that holds the [air] pump into the park, and let the teahouse unfold before our eyes like a blossom."

Architecture and Community

Architecture plays an important role in nurturing and sustaining communities. Our sense of having a common life as citizens depends in part on our having public spaces that belong to everyone, places we can enjoy as equals. We need buildings to house the institutions of civic life—schools, courthouses, libraries, and hospitals. And of course we need dwellings, not only for our individual good, but for the common good of the community as a whole. In this section we look at a public space, a dwelling, and a civic building, with one twist: each project not only helps strengthen and sustain a community but also involved a community to make it happen.

13.34 Kengo Kuma. Teahouse, Museum Angewandte Kunst, Frankfurt. 2007.

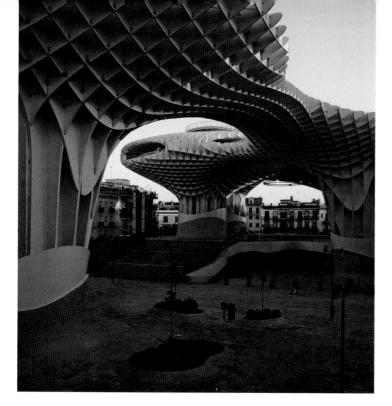

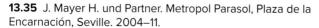

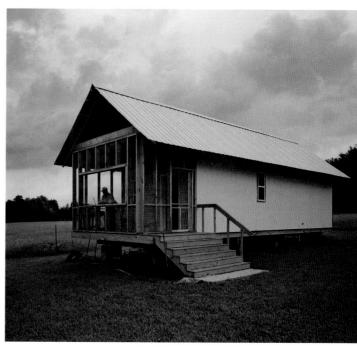

13.36 Rural Studio. \$20K House VIII (Dave's House), Newbern, Alabama. 2009.

The Spanish city of Seville is known for its magnificent Gothic cathedral, its beautiful royal palace, and its archive of priceless documents chronicling the Spanish Empire in the Americas and the Philippines. Designated as World Heritage Sites, all three are clustered around the intimate Plaza del Triunfo, where they draw over two million visitors to the city each year. The fate of a large square nearby, in contrast, had been far less glamorous. Uninspiring and unvisited, the Plaza de la Encarnación had at one time been the site of a large and bustling covered market. In 1973, however, the market was razed to make way for a parking lot. Later plans to move the parking lot underground had to be shelved when an archaeological dig turned up the remains of an ancient Roman colony beneath the square.

Looking to revitalize the plaza, the Seville Urban Planning Agency held an international competition to solicit ideas. The winner was Berlin architect Jürgen Mayer H., whose firm submitted plans for a sinuous wooden canopy called Metropol Parasol (13.35). Taking his inspiration from the vast vaulted spaces of the city's cathedral, Mayer envisioned Metropol Parasol as a cathedral without walls. Rising majestically from six large trunks, its billowing "mushrooms" meet overhead to form a continuous lattice that flows for almost 500 feet, providing shifting patterns of shade to the square below. At street level, the structure houses an indoor farmers' market and the entrance to an underground museum dedicated to the Roman excavation. Broad staircases that encourage lounging in the sun and serve as meeting places lead to an elevated terrace with cafés and restaurants. A walkway winds along the tops of the parasols, culminating in a panoramic viewing deck that overlooks the rooftops of Seville. Designed to serve as a contemporary landmark, Metropol Parasol responds to the needs of the local community and attracts tourists to a part of town they might otherwise have ignored.

Our next work involved the efforts of a different kind of community, a community of architecture students. Rural Studio is a satellite school for architecture students at Auburn University, in Alabama. It was founded in 1993 to provide hands-on experience and to expose students to the social and ethical dimensions of their profession. Living communally in one of the poorest

counties in the state, the students practice what one of the founders of the program called "an architecture of decency," designing and building houses for poor individuals and families, and civic structures such as community centers, chapels, sports facilities, learning centers, fire stations, and animal shelters for local communities in dire need.

An ongoing project at Rural Studio is the \$20K House. Each year, the students design a house that can be built for 20 thousand dollars-their estimate of the biggest mortgage that someone living on median social security could reasonably afford. \$20K House VIII (Dave's House) was designed and built in 2009 for local resident David Thornton (13.36). Set on an elevated foundation, \$20K House VIII is a plain, 600-foot-square box. The screened-in front porch opens onto an uninterrupted kitchen and living area. A wood-burning stove provides heat; a ceiling fan aids ventilation. Toward the rear of the house, an interior core encloses a bathroom and divides the living room from the bedroom at the rear. From the bedroom, a back door opens onto a small stoop. The roof is made of galvanized metal, which can eventually be recycled. The exterior of the house is also clad in metal, with the exception of the front porch wall. The wall Mr. Thornton and his visitors are likely to sit by, to look at, and to touch is made of wood. As an ultimate test, the house was erected by local contractors instead of by the students themselves. The cost: approximately \$12,500 for materials and \$7,500 for labor. Eventually, Rural Studio hopes to develop a catalog of inexpensive designs that can be adapted to different needs and made available for rural housing.

Our third project was built by the community itself, under the leadership of an architecture student who saw a need. Before beginning her professional studies, German architect Anna Heringer had spent a year volunteering for a nongovernmental development organization in Rudrapur, a village in Bangladesh. She returned to Rudrapur regularly as a student, and when it came time for her to develop a master's thesis, she decided to design a building for the village. A comprehensive study suggested that Rudrapur's long-term interests would be best served by a new school, and so Heringer set about designing

one, hoping that it might be realized.

The villagers wanted a school of brick or concrete, materials they associated with progress and viewed as far more stable than their own traditional earthen structures. But Heringer's studies in earth architecture suggested that local traditions needed only to be updated with more sophisticated construction techniques, such as a brick foundation, a layer of plastic to protect the mud walls from ground moisture, the addition of straw to the earth mixture for stability, and thicker walls. She designed a building made of bamboo and cob, a mixture of clay, earth, sand, straw, and water. Her proposal was accepted, and the result is the METI Handmade School (13.37).

Working under the direction of Heringer and three colleagues, the villagers built the school by hand. The water buffalo used to mix the cob were the only additional "equipment." The thick cob walls of the first story support

13.37 Anna Heringer and Eike Roswag. METI Handmade School, Rudrapur, Bangladesh. 2004–06.

a lightweight second story made of joined and lashed bamboo. Deep eaves provide shade and protect the walls from potentially damaging rains. Lengths of vibrantly colored, locally made fabric hang in the doorways and line the bamboo ceiling. Villagers can maintain the school themselves using the skills they learned while constructing it. Those skills have already been put to use on another project: Heringer returned to Rudrapur a year later to oversee a workshop that put local architecture students together with the newly skilled villagers to design and build several two-story cob houses. Heringer hopes that the young architects will carry what they learned to other regions of Bangladesh, and that this modern version of the region's traditional architecture will contribute to the country's ecological balance and economic development. "Architecture," she says, "is a tool to improve lives."

Sustainability: Green Architecture

For some 250 years, we have been living in the industrial age, which began when inventors discovered how to manufacture energy by harnessing the power of steam, which they created with heat generated by burning fossil fuels—coal and, later, oil. The steam engine was born, followed a century later by the internal combustion engine and the turbine.

During the 19th century, industry produced iron and steel in such large quantities that they became available as building materials. The Crystal Palace (13.21) and the Eiffel Tower (13.22) were conceived as showpieces for the kind of structures this made possible. Processing coal also produced coal gas, which was piped through cities and into buildings as fuel for street lamps and houselights, lighting the night on a large scale for the first time. But night was truly conquered when inventors discovered how to convert the energy into electricity, and then how to convert electricity into light with the incandescent lamp.

During the first decades of the 20th century, industrial methods for making sheet glass were developed, the advent of low-wattage fluorescent lamps made it practical to illuminate vast interior spaces artificially, and the triumph of air-conditioning allowed buildings to be sealed off from the natural environment around them. Lever House (13.25) epitomizes the aesthetic that developed around these new materials and technologies. Grids of concrete and steel sheathed in glass, their walls and ceilings hide pipes that invisibly deliver and remove hot and cold water, ducts that circulate air and regulate its temperature and humidity, and cables that make electricity available for lighting, appliances, and machines. Such buildings have since been erected all over the world.

Like other benefits of industrialization, these buildings come at a significant cost to the environment, and one that we cannot continue to pay indefinitely. The question of whether we can create a healthier and less wasteful human habitat is at the heart of green architecture. Green architecture

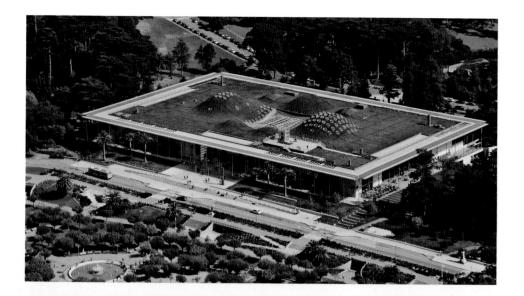

addresses the materials buildings are made of, the construction methods used to make them, and the technologies used to heat and cool them, to light their interior spaces, and to supply them with electricity and water. We have already seen these concerns at work in Anna Heringer's METI Handmade School, which favored local materials over brick and concrete, both of which are energy intensive—that is, much energy is needed to make them. For green concerns on a larger scale, we turn to Renzo Piano's California Academy of Sciences, in San Francisco's Golden Gate Park (13.38).

The aerial view illustrated here shows the building's distinctive green roof. It looks almost as though a rectangle of parkland had been lifted up and a building slipped under it. Planted entirely with native species, the roof provides natural insulation, keeping the building warm in the winter and cool in the summer. It also absorbs rainwater, preventing the runoff that carries pollutants from buildings into the ecosystem. The slopes of the mounds on the roof act as a natural ventilation system, funneling cool air down into the building's central atrium. The roof is framed by a glass canopy. Set with photovoltaic cells, the canopy generates up to 10 percent of the building's electricity while also providing cooling shade.

Inside the building, the extensive use of glass allows natural light to be the principal source of illumination. The glass is formulated for maximum clarity and to minimize heat absorption. Photosensors automatically adjust artificial lights in response to natural light levels. Office windows open so that employees can admit fresh air. In the visitor areas, an automated ventilation system regulates the building temperature: louvers open to let in cooling air from the park, and skylights on the roof open to allow hot air to escape. During the winter, radiant heat from hot-water pipes embedded in the concrete floors keeps warmth where it's needed. Reclaimed city water is used for the toilets, and low-flow fixtures throughout conserve water.

Attention to environmental concerns extended to the materials the building was made from, which include recycled steel and lumber harvested from sustainable yield forests. Much of the insulation is made from recycled blue jeans, and the concrete contains fly ash and slag—industrial by-products that formerly went to waste.

Increasing public awareness of environmental concerns has created a growing interest in healthy, green, efficient homes. To encourage innovation in green architecture, the United States Department of Energy hosts the Solar Decathlon, a competition in which teams of college students vie to design, build, and operate the most appealing, energy-efficient, and affordable solar-powered house. Held every other year, the popular event has inspired European and Chinese versions, creating a family of international Solar Decathlons. In 2013 the competition was held in Irvine, California, where top honors went to LISI House, by Team Austria (13.39).

13.39 Team Austria. LISI House, Irvine, California. October 10–13, 2013.

Designed as a dwelling for two people, LISI (for "Living Inspired by Sustainable Innovation") was quickly assembled on-site from prefabricated components scaled to fit neatly into standard international shipping containers. At the heart of the house is an open living area flanked on two sides by floor-to-ceiling sliding glass doors and on two sides by service cores that function as weight-bearing walls. One service core houses an open kitchen and numerous storage cupboards. The other, visible in the photograph, houses a bedroom, a bathroom, and a utility room for the automated systems that run the house. The glass doors open onto two patios north and south, effectively doubling the amount of living space when the weather permits. The entire plan—patios, living area, core units, and entrance ramp—is crowned by a cornice that supports a white textile facade. Filtering sunlight like a veil of foliage, the facade is essentially a wrap-around curtain that can be adjusted to enclose the house completely, shade selected areas as desired, or open the house to the world.

LISI House generates more energy than it needs from photovoltaic panels hidden on the roof. Two efficient air-water heat pumps provide hot water for domestic use and hot and cold water for space heating and cooling. The heating and cooling water is piped into a multifunctional system beneath the floor that regulates the indoor climate, adjusting the temperature and providing fresh air. An energy-recovery ventilation unit acts as a heat exchanger between exhaust air and fresh intake air to keep the living spaces comfortable and healthy. Automated screens and awnings provide shade to help maintain cool temperatures. An innovative shower tray recovers thermal energy from drain water through a heat exchanger, significantly lowering the net amount of energy used for daily hygiene. Everything happens invisibly, leaving the occupants to enjoy the handsome wood interior and generous outdoor spaces.

Over 90 percent of LISI House is made of wood, and not only the portions you might expect: in an effort to utilize every part of the tree, Team Austria used an insulation material made from wood fiber and cellulose and manufactured the chairs from bark. Wood is a renewable resource and our only carbon-neutral construction material—that is, the energy needed to transform trees into lengths of lumber is offset by the carbon dioxide that trees absorb as they grow. Often used for houses, it has always been considered too weak to support a large, multistory building. Lately, however, environment concerns have inspired architects to take another look at the potential of wood for larger structures.

One prominent advocate of wood construction is Michael Green, an architect in Vancouver, British Columbia. His recently completed Wood Innovation and Design Center was conceived as a showcase for the structural potential of timber (13.40). Rising to a height of 97 feet, it is as of this writing the tallest all-timber building in North America. The key to endowing wood with enough strength to replace steel and concrete is lamination, the gluing together of multiple thin layers

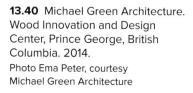

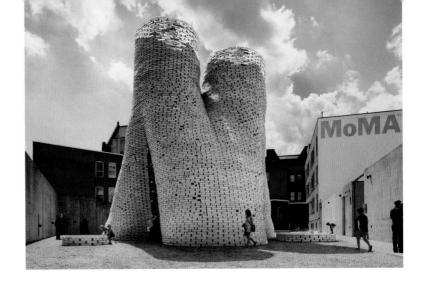

to form one thick one. Plywood is a familiar type of laminated wood product. Less familiar are cross-laminated timber, laminated strand lumber, laminated veneer lumber, and glue laminated timber. Collectively, these and other engineered wood products are known as massive timber, or mass timber. In the Wood Innovation and Design Center, mass timber serves for beams, flooring, and walls. With the exception of the ground floor slab and mechanical elements in the penthouse, there is no concrete in the building at all. Green purposefully kept the design simple so that it could be easily replicated by other architects and engineers.

The Wood Innovation and Design Center is eight stories tall, but far taller buildings are possible. In 2012, Green published a system for constructing mass-timber towers in seismically active areas such as Vancouver. His feasibility study projected towers up to thirty stories in height. "But we stopped at 30 stories only because at the time that was considered so beyond the comprehension of the public," he says. 9

Since the dawn of architecture, wood has been virtually the only organic material widely used for construction. Some architects believe that one path to a sustainable future lies in using biological or bio-engineering systems to manufacture new organic building materials. An architect involved in this line of research is David Benjamin, head of the Living Architecture Lab at Columbia University in New York and cofounder of The Living, a research and design studio.

Benjamin recently got an opportunity to put some new ideas into practice when The Living was selected as the winner of the Young Architects Program, an annual competition sponsored by the Museum of Modern Art and MoMA PS1, its affiliate institution. The Young Architects Program was founded to encourage and showcase innovation in architecture. Working within guidelines that address environmental issues such as sustainability and recycling, each year's winner must construct a temporary outdoor installation in the courtyard of MoMA PS1 that will provide shade, water, and seating for visitors. The Living responded with a circular tower called *Hy-Fi* (13.41).

Hy-Fi was built with organic bricks made from chopped corn husks and mycelium, a living mushroom-root material. Packed into a mold, the mixture self-assembles in a few days into a lightweight object. When it is completely dry, it is ready to use. The molds used to form the bricks for Hy-Fi can be seen at the top of the tower. Made of a new daylighting mirror film developed by the 3M Company, they served to reflect sunlight down into the interior. While it was in use, Hy-Fi created an agreeable micro-climate by drawing in cool air at the bottom and pushing out hot air at the top. Irregularly spaced openings between the bricks cast shifting sunspots on the walls and floor. When the installation was taken down, the molds were returned to 3M for use in further research and the bricks were sent to be composted. Hy-Fi is the first sizable structure whose construction involved almost zero carbon emissions. It arose from the earth and returned to the earth. It was a temporary building and now belongs to the past, but the ideas behind it will carry into the future.

13.41 The Living. *Hy-Fi*. 2014. Installation at MoMA PS1, Queens, New York, June 26–September 7, 2014.

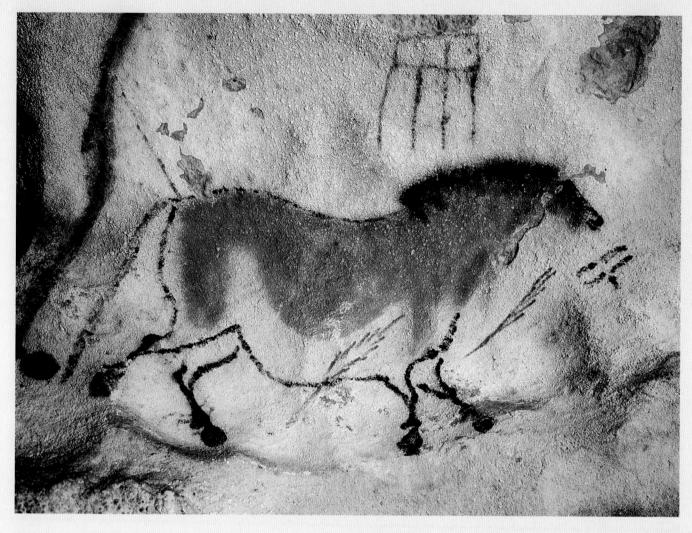

14.1 Horse and Geometric Symbol. Cave painting, Lascaux, France. c. 13,000 B.C.E.

PART FIVE

Arts in Time

14

Ancient Mediterranean Worlds

n important factor in understanding and appreciating any work of art is some knowledge of its place in time. When and where was it made? What traditions was the artist building on or rebelling against? What did society at that time expect of its artists? What sort of tasks

did it give them?

For that reason, the last part of this book is devoted to a brief survey of art as it has unfolded in time. As elsewhere, we focus mainly on the Western tradition, but we also examine the development of art in the cultures of Islam and Africa; of India, China, and Japan; and of Oceania, Australia, and the early Americas. Not only are these non-Western artistic traditions fascinating in their own right, but they also introduce us to other ways of thinking about art, other roles that art can play in society, and other formal directions that art can take. Many Western artists today draw as deeply on non-Western traditions as they do on Western ones, just as many contemporary artists beyond the West have been profoundly influenced by Western developments. More than at any other time in history, the entire range of humankind's artistic past nourishes its present.

The Oldest Art

The title of this chapter narrows our focus from the entire globe to the region around the Mediterranean Sea. It is here—in Africa, the Near East, and Europe—that the story of Western art begins. In these lands, beginning around 3000 B.C.E., numerous ancient civilizations arose, overlapped, and interacted; learned from one another and conquered each other; and finally faded into the world we know today.

These civilizations—the "worlds" of our title—were preceded by far older human societies about which we know very little. Scattered evidence of their existence reaches us over a vast distance of tens of thousands of years, fascinating, mysterious, and mute. In Chapter 1, we looked at a detail from the wall paintings in the Chauvet cave in present-day France (see 1.3). Dating from later in the Upper Paleolithic Period are the paintings of the caves at Lascaux, also in France (14.1). Until the discovery of the Chauvet cave in 1994, the images at Lascaux were the oldest known paintings in Europe. The horse illustrated has fascinated scholars because of its seemingly pregnant condition, the feathery forms near its forelegs, and the mysterious geometric symbol depicted above it.

RELATED WORKS

1.3 Lion panel, Chauvet cave

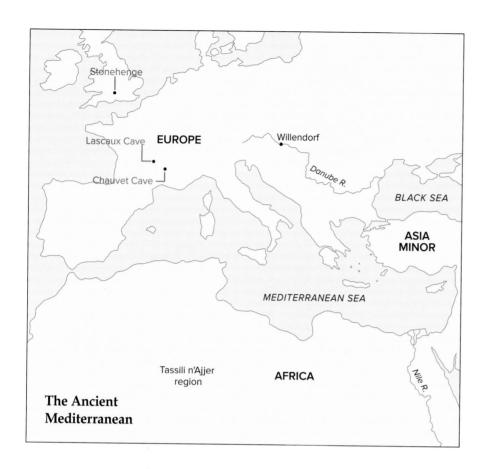

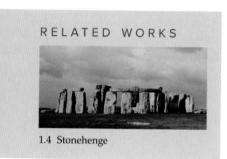

The paintings at Chauvet are even more finely executed, and they must surely be the result of a long tradition whose origins go back even further in time. As at Chauvet, the paintings at Lascaux are almost all of animals. Experts agree that the images are meaningful, although what their exact meaning is remains obscure.

The question of why a work of art was made arises also with ancient sculptures. Nearly as old as the Chauvet cave paintings is a little female statuette that often serves as an emblem of art history's beginnings. It is made of stone, was formed about 25,000 years ago, and was found near Willendorf, a town in present-day Austria (14.2). Less than 5 inches tall, the rounded figure is small enough to fit comfortably in the palm of a hand. Its face is obscured by a minutely detailed hairstyle that covers the entire head. Skinny arms bend at the elbows to rest on a pair of heavy breasts. The ballooning midsection tapers down to legs that end just below the knees.

Numerous Paleolithic female statuettes have been found across a broad region. Carved of wood, ivory, and stone, or modeled in clay, they were produced over a period of thousands of years and in a variety of styles. Scholars long assumed that they were fertility figures, used in some symbolic way to encourage pregnancy and childbirth. Today's more cautious experts suggest that it is unlikely that a single explanation can account for all of them. The most we can say is that they testify to a widely shared belief system that evolved over time.

Beginning around 9000 B.C.E. and continuing over the next four thousand years, the Paleolithic Period, or Old Stone Age, gradually gave way to the Neolithic, or New Stone Age. The Neolithic is named for new types of stone tools that were developed, but these tools were only one aspect of what in fact was a completely new way of life. Instead of gathering wild crops as they could find them, Neolithic people learned to cultivate fruits and grains. Farming was born. Instead of following migrating herds to hunt, Neolithic people learned to domesticate animals. Dogs, cattle, goats, and other animals served variously for

help, labor, meat, milk, leather, and so on. Dugout boats, the bow and arrow, and the technology of pottery—clay hardened by heat—vastly improved the standard of living. Settled communities grew up and, with them, architecture of stone and wood. The most famous work of Neolithic architecture in Europe is the monument known as Stonehenge, in England, which we discussed in

Chapter 1 (see 1.4).

Tantalizing glimpses of daily life in the Neolithic Period survive in the rock paintings of the Tassili n'Ajjer region of Algeria, in northern Africa (14.3). Today Tassili n'Ajjer is part of the Sahara, the world's largest desert. But at the time these images were painted, roughly between 5000 and 2000 B.C.E., the desert had not yet emerged. Instead, the region was a vast grassland, home to animals, plants, and the people we see depicted here—five women, gathered near their cattle. Other images painted on the rock walls at Tassili n'Ajjer depict women harvesting grain or occupied with children, men herding cattle, and enclosures that may represent dwellings.

The art that has come down to us from the Stone Age is fragmentary and isolated: ancient cave paintings; a small statue of a woman; a circular stone monument; paintings on rock walls in the desert. Our examples are separated from one another by thousands of years and thousands of miles. Each one must have been part of a long local artistic tradition that stretched back into the past and continued for many millennia afterward. Yet for each one, we are faced with questions: "What came before, what came after, and where is it?"

In studying art of the past, it is important to keep in mind that the cultures we examine most fully are not necessarily those in which the most art was made or the best art was made. They are, rather, the cultures whose art has been found or preserved. Art has been produced at all times and in all places and by all peoples. But for it to be available to future generations for study, it must survive—possibly even after the culture that produced it has disappeared. Certain conditions foster the preservation of art, and the ancient cultures that we are able to study in depth across time fulfill most of them.

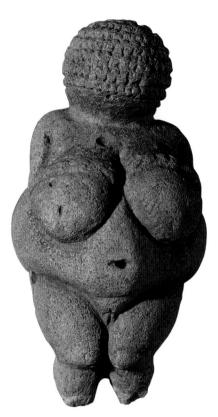

14.2 Female Figure from Willendorf. c. 23,000 B.C.E. Limestone, height 43/8". Naturhistorisches Museum, Vienna

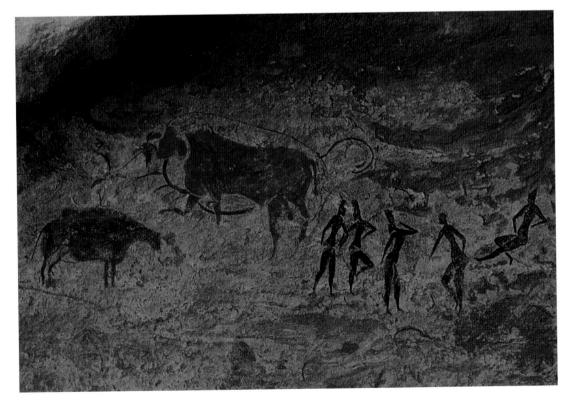

14.3 Women and Cattle. Rock painting at Tassili n'Ajjer, Algeria. Pastoralist style, after 5000 B.C.E.

First, the artists worked in durable materials such as stone, metal, and fired clay. Second, the local environment is not destructive to artworks; for instance, the hot, dry climate of Egypt provides an excellent milieu for preservation. Third, the culture was highly organized, with stable population centers. Great cities normally house the richest troves of artwork in any culture, for they are where rulers dwell, wealth is accumulated, and artists congregate. Fourth, the culture had a tradition of caching its artworks in places of limited or no accessibility. A huge portion of the ancient art that has survived comes from tombs or underground caves.

The first cultures of the ancient Mediterranean world to meet most of these conditions arose in Mesopotamia—a region in the Near East—and in Egypt, in northeastern Africa. Here, for the first time, we find a coherent, reasonably intact artistic production about which we have come to know a good deal. It is no accident that the civilizations of both Mesopotamia and Egypt developed along the banks of mighty rivers—the Tigris and Euphrates in Mesopotamia and the Nile in Egypt. Rivers provided both a means of transportation and a source of water. Water enabled irrigation, which in turn allowed for vaster and more reliable farming, which in turn supported larger and denser populations. Cities developed, and with them social stratification (the division of society into classes such as rulers, priests, nobles, commoners, and slaves), the standardization of religions and rituals, the creation of monumental architecture, and the specialization that allowed some people to farm, some to be merchants, and others to make art.

Our study of ancient Mediterranean worlds properly begins here, in the lands along the great rivers.

Mesopotamia

The region known to the ancient world as Mesopotamia occupied a large area roughly equivalent to the present-day nation of Iraq. Fertile soil watered by the Tigris and Euphrates Rivers made Mesopotamia highly desirable, but a lack of natural boundaries made it easy to invade and difficult to defend. Successive waves of people conquered the region in ancient times, and each new ruling group built on the cultural achievements of its predecessors. Thus, we can speak with some justice of a continuing Mesopotamian culture.

The first cities of Mesopotamia arose in the southernmost area, a region called Sumer. By about 3400 B.C.E., some dozen Sumerian city-states—cities that ruled over their surrounding territories—had emerged. The Sumerians were the first people to leave behind them not just artifacts but also words: the wedge-shaped marks that they pressed into damp clay to keep track of inventories and

14.4 Nanna Ziggurat, Ur (present-day Maqaiyir, Iraq). c. 2100–2050 B.C.E.

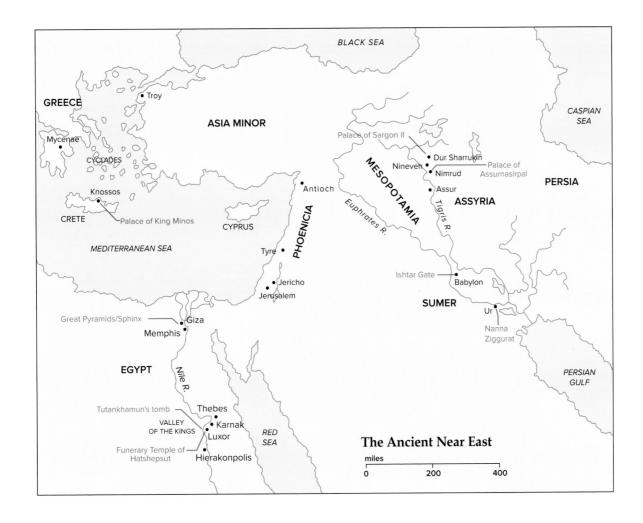

accounts developed over time into a writing system capable of recording language. Called cuneiform (Latin for "wedge-shaped"), it served as the writing system of Mesopotamia for the next three thousand years.

Lacking stone, the Sumerians built their cities of sun-dried brick. The largest structure of a Sumerian city was the **ziggurat**, a temple or shrine raised on a monumental stepped base (14.4). The example illustrated here, partially restored but still missing its temple, was dedicated to the moon god Nanna, the protective deity of the Sumerian city of Ur. In the flat land of Sumer, ziggurats were visible for miles around. They elevated the temple to a symbolic mountaintop, a meeting place for Heaven and Earth, where priests and priestesses communicated with the gods.

The refined and luxurious aspect of Sumerian art is evident in this small figure of a ram standing with its forelegs propped on a flowering tree (14.5). Crafted over a wooden core (now lost) of gold, silver, and a precious stone called lapis lazuli, the delicate figure probably served to support a small tray or tabletop.

14.5 Ram in Thicket, from Ur. c. 2600 B.C.E. Wood, gold foil, lapis lazuli; height 10". The University of Pennsylvania Museum, Philadelphia

By 2300 B.C.E., the Sumerian city-states had been conquered by their neighbors to the north, the Akkadians. Under their ruler Sargon I, the Akkadians established the region's first empire. Though it crumbled quickly, the empire seems to have extended all the way from the shores of the Mediterranean to the Persian Gulf. Sargon himself may be portrayed in the splendid Akkadian sculpture illustrated here (14.6). Certainly the expensive material and the fine workmanship suggest that it represents a ruler of some kind. The lifelike features—heavy-lidded eyes, strong nose, and sensitive mouth—argue that this is a naturalistic portrait of a real person and not a generic or idealized head. Such naturalism is extremely rare in early art.

A more stable and long-lived Mesopotamian empire was established by the Amorites, who consolidated their rule over the region by about 1830 B.C.E. and established a capital at Babylon. The most important legacy of the Babylonian empire is not artistic but legal: a set of edicts and laws compiled under the ruler Hammurabi (ruled c. 1792–1750 B.C.E.). Known as Hammurabi's Code, it is the only complete legal code to survive from the ancient world, and it has provided historians with valuable insights into the structure and concerns of Mesopotamian society.

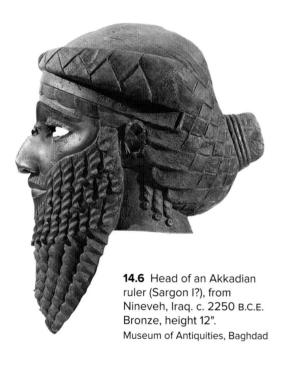

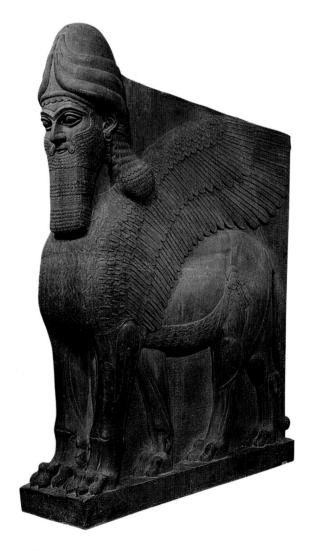

14.7 Human-headed winged lion. Assyrian, from Nimrud. 883–859 B.C.E. Limestone, height 10'2½". The Metropolitan Museum of Art, New York

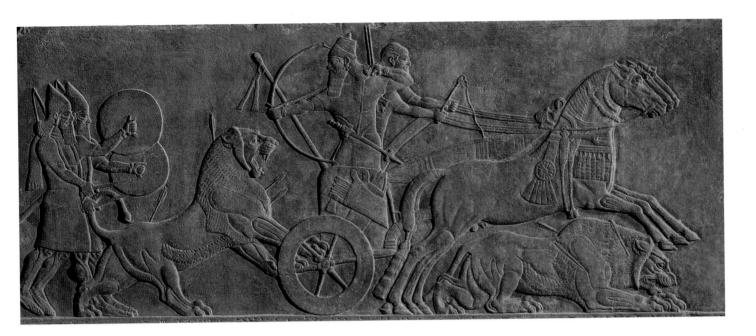

Mesopotamia's history was marked by almost continual warfare and conquest, and a major goal of architecture was the erection of mighty citadels to ensure the safety of temples and palaces. Such a citadel was that of the Assyrian ruler Assurnasirpal II, built at Nimrud in the 9th century B.C.E. Based in northern Mesopotamia, the Assyrians had been gathering power and territory since before 1100 B.C.E. Their military strength increased greatly under Assurnasirpal II, and within a few centuries they would amass the largest empire the region had yet seen. Assurnasirpal's palace had gates fronted by monumental stone slabs carved into enormous human-headed winged beasts, a bull and a lion. The lion (14.7) wears a horned cap indicating divine status. Its body has five legs, so that from the front it appears motionless but from the side it is understood to be walking. Visitors to the citadel were meant to be impressed—and no doubt intimidated—by these majestic creatures.

The walls of the palace were lined with alabaster reliefs depicting Assyrian triumphs and royal power. A popular subject is the lion hunt (14.8), in which the king is depicted slaying the most powerful of beasts. The ceremonial hunt was probably carried out as it is pictured here, with armed guards releasing captive animals into an enclosure for the king to kill from his chariot. Slaying lions was viewed as a fitting demonstration of kingly power. The lions' anatomy is beautifully observed, and the many overlapping figures show the sculptor's confidence in suggesting three-dimensional space.

When the Babylonians again came to power in Mesopotamia, late in the 7th century B.C.E., they formed a kingdom now called Neo-Babylonian. These "new" Babylonians surely must be ranked among the great architects of the ancient world. They developed a true arch before the Romans did and were masters of decorative design for architecture. Moreover, like their forebears, they had a formidable leader in the person of Nebuchadnezzar, an enthusiastic patron of the arts who built a dazzling capital city at Babylon.

A genuine planned city, Babylon was constructed as a square, bisected by the Euphrates River, with streets and broad avenues crossing at right angles. Because stone is scarce in this region of Mesopotamia, the architects made liberal use of glazed ceramic bricks. Babylon must have been a city of brilliant color. Its main thoroughfare was the Processional Way, at one end of which

14.8 Lion Hunt, from the palace complex of Assurnasirpal II, Kalhu (present-day Nimrud, Iraq). c. 850 B.C.E. Alabaster, height 39". The British Museum, London

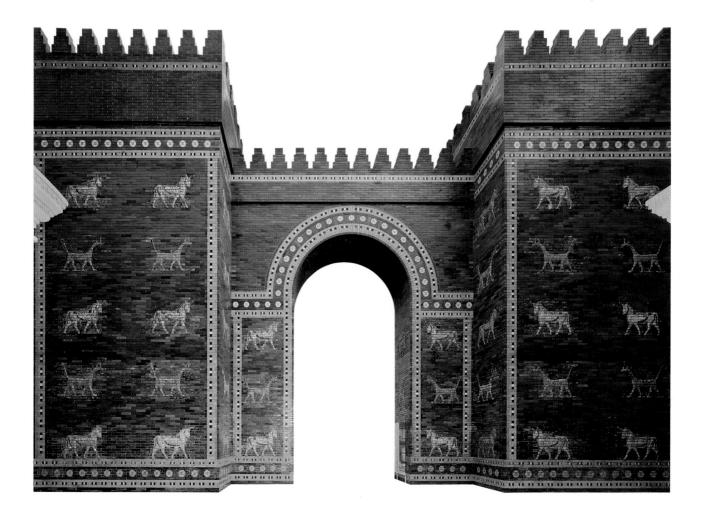

14.9 Ishtar Gate (restored), from Babylon. c. 575 B.C.E. Glazed brick, height 48'9". Staatliche Museen zu Berlin, Preussischer Kulturbesitz, Vorderasiatisches Museum

stood the Ishtar Gate (14.9), built about 575 B.C.E. and now restored in a German museum. The gate consists of thousands of glazed mud bricks, with two massive towers flanking a central arch. On ceremonial occasions, Nebuchadnezzar would sit under the arch in majesty to receive his subjects. The walls of the gate are embellished with more glazed ceramic animals, probably meant as spirit-guardians.

The history of Mesopotamia parallels in time that of its neighbor to the southwest, the kingdom of Egypt, with which it had regular contacts. In Egypt, however, we will find considerably less political turmoil. Protected to the south by a series of cataracts (rocky, unnavigable stretches of the Nile) and to the east and west by vast deserts, Egypt during much of its long history was spared the waves of immigration and invasion that continually transformed Mesopotamia.

Egypt

The principal message of Egyptian art is continuity—a seamless span of time reaching back into history and forward into the future. The Greek philosopher Plato wrote that Egyptian art did not change for ten thousand years; although that is an exaggeration, there were many features that remained stable over long periods of time. The Sphinx (14.10), the symbol of this most important characteristic of Egyptian art, is the essence of stability, order, and endurance. Built about 2530 B.C.E. and towering to a height of 66 feet, it faces into the rising sun, seeming to cast its immobile gaze down the centuries for all eternity.

The Sphinx has the body of a reclining lion and the head of a man, thought to be the pharaoh Khafre, whose pyramid tomb is nearby (see 3.5). Egyptian kings ruled absolutely and enjoyed a semidivine status, taking their authority from the sun god, Ra, from whom they were assumed to be descended. Both power and continuity are embodied in this splendid monument.

An even earlier relic from Egyptian culture, the so-called *Palette of Narmer* (14.11), illustrates many characteristics of Egyptian art. The palette (so named because it takes the form of a slab for mixing cosmetics) portrays a victory by the forces of Upper (southern) Egypt, led by Narmer, over those of Lower (northern) Egypt. Narmer is the largest figure and is positioned near the center of the palette to indicate this high status. He holds a fallen enemy by the hair and is about to deliver the death blow. In the lowest sector of the tablet are two more defeated enemies. At upper right is a falcon representing Horus, the god of Upper Egypt. In its organization of images the palette is strikingly logical and balanced. The central section has Narmer's figure just left of the middle, with his upraised arm and the form of a servant filling the space, while the falcon and the victim complete the right-hand side of the composition.

Narmer's pose is typical of Egyptian art. When depicting an important personage, the Egyptian artist strove to show each part of the body to best advantage so it could be "read" clearly by the viewer. Thus, Narmer's lower body is seen in profile, his torso full front, his head in profile, but his eye front again. This same pose recurs throughout most two-dimensional art in Egypt. It is not a posture that suggests much motion, apart from a stylized gesture like that of Narmer's upraised arm. But action was not important to Egyptian art. Order and stability were its primary characteristics, as they were the goals of Egyptian society. We see this in official sculptures, such as the double portrait of Menkaure and Khamerernebty in Chapter 11 (see 11.16), and also in less formal works.

RELATED WORKS

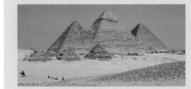

3.5 Pyramids at Giza

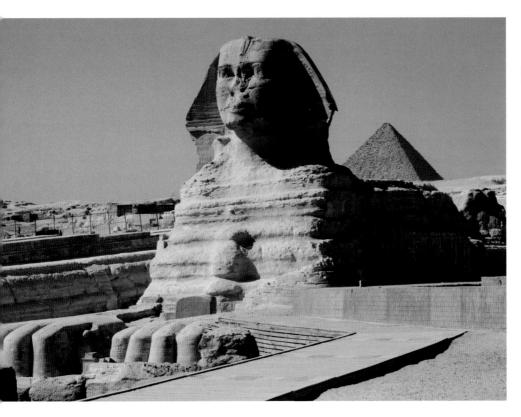

14.10 The Great Sphinx, Giza. c. 2530 B.C.E. Limestone rock, height 66'.

14.11 Palette of Narmer, from Hierakonpolis. c. 3100 B.C.E. Slate, height 25". Egyptian Museum, Cairo

A common sculpture type from the same period as the Menkaure figure is the *Seated Scribe* (14.12), depicting a high court official whose position might be explained as "professional writer." In an era when literacy was rare, the scribe played a vital role in copying important documents and sacred texts, and his work commanded much respect. This sculpture, although somewhat more relaxed than standing pharaoh portraits, is still symmetrical and reserved. The scribe's face shows intelligence and dignity, and his body is depicted realistically as thickening and rather flabby, no doubt a sign of his age and sedentary occupation, perhaps also an indicator of wisdom.

The most famous architectural creation of Egypt is the pyramid (see 3.5), but Egyptian architects also built homes, palaces, temples, shrines, and other structures. A pyramid, in fact, was only one element of a royal funerary complex, which also included a temple for the worship of the deceased ruler, who had rejoined the gods in immortality. One of the best-preserved and most innovative funerary temples is that of Hatshepsut, one of the few female rulers in Egypt's history (14.13). Rising in a series of three broad terraces, the temple continues *into* the steep cliffs behind it, from which an inner sanctuary was hollowed out. Over two hundred statues of Hatshepsut once populated the vast complex, which contained shrines to several Egyptian deities as well as to Hatshepsut and her father, the ruler Tuthmose I.

Egyptian painting reveals the same clear visual design and illustrative skill as the works in stone. A fragment of a wall painting taken from a tomb chapel in Thebes depicts a man named Nebamun posed very much like the figure of Narmer (14.14). Again we see the lower body with its striding legs in profile, the torso and shoulders full front but with a nipple in profile, the face in profile, the eye from the front again. Again he is larger than other figures, the most important person in the scene.

A mid-level official, Nebamun would have been buried in a sealed chamber dug somewhere beneath his painted chapel. He and his tawny cat are shown

14.12 Seated Scribe, from Saqqara. c. 2450 B.C.E. Painted limestone, with alabaster and rock crystal eyes; height 21".

Musée du Louvre, Paris

14.13 Funerary temple of Hatshepsut, Deir el-Bahri. c. 1460 B.C.E.

hunting birds in a marsh. Nebamun is young, handsome, and athletic, the form he hopes to have in eternity. He holds a throw stick in one hand and grasps three flapping egrets with the other. The small, elegant woman standing behind him on the papyrus skiff is his wife, Hatshepsut. The still smaller girl between his legs is their daughter. All are depicted in the formal, dignified poses suited to elite members of society. Birds and butterflies fill the air. The birds are shown in profile, the view that gives the most information. The same goes for the fish in the water below. All are depicted in such closely observed detail that we can identify many of the species.

The scene represents an elite ideal of Earthly leisure, now transposed to the afterlife. An inscription near Hatshepsut reads in part, "Taking enjoyment, seeing good things in the place of eternity." The scene also has more symbolic meanings. Nebamun's victorious pose proclaims his ability to triumph in the journey to the afterlife, which was thought to be fraught with peril. The marsh setting is also significant. It was in a marsh that the Egyptian goddess Isis prepared her husband Osiris for resurrection, and that life itself began at the time of creation. A marsh is thus a site where life renews itself, just as the man will renew himself by rising from death.

One brief period in the history of Egyptian culture stands apart from the rest and therefore has fascinated scholars and art lovers alike. This was the reign of pharaoh Amenhotep IV, who came to power about 1353 B.C.E. For a civilization that prized continuity above all else, Amenhotep was a true revolutionary. He changed his name to Akhenaten and attempted to establish monotheism (belief in one god) among a people who had traditionally worshiped many gods. He built a new capital at what is now called Tell el-Amarna, so historians refer to his reign as the Amarna period. Akhenaten was apparently quite active in creating a new style of art for his reign, and under his direction the age-old, rigid postures of Egyptian art gave way to more relaxed, naturalistic, and even intimate portrayals.

14.14 Fragment of a wall painting from the tomb of Nebamun, Thebes. c. 1450 B.C.E. Paint on plaster, height 32".

The British Museum, London

13.2 Temple of Luxor

14.15 *Queen Nefertiti.* c. 1345 B.C.E. Painted limestone, height 20". Staatliche Museen zu Berlin, Preussischer Kulturbesitz, Ägyptisches Museum

14.16 Akhenaten and His Family, from Akhetaten (modern Tell el-Amarna). c. 1345 B.C.E. Painted limestone relief, $12\% \times 15\%$ ". Staatliche Museen zu Berlin, Preussischer Kulturbesitz, Ägyptisches Museum

Nowhere is this new style more apparent than in the famous portrait bust of his queen, Nefertiti (14.15). While enchanted by Nefertiti's beauty, the modern viewer is perhaps even more taken by how contemporary she seems, how she appears to bridge the gap of more than three thousand years to our own world. With her regal headdress and elongated neck, Nefertiti presents a standard of elegance that is timeless.

Even more intimate is the charming domestic scene depicted in this lime-stone relief (14.16). Akhenaten and Nefertiti sit facing each other on cushioned thrones. Akhenaten tenderly holds one of their three daughters, who gestures toward her mother and sisters. Seated on Nefertiti's lap, the older daughter looks up at her mother as she points across to her father; the youngest daughter tries to get her mother's attention by caressing her cheek. Above, Akhenaten's god, Aten, the sun-disk, shines his life-giving rays upon them. The sculpture is an example of sunken relief. In this technique, the figures do not project upward from the surface. Instead, outlines are carved deep into the surface, and the figures are modeled within them, from the surface down.

Akhenaten's reforms did not last. After his death, temples to the old gods were restored and temples that had been built to Aten were dismantled. The city of el-Amarna was abandoned, and the traditional Egyptian styles of representation were reimposed. Thus it is that the immobile mask of eternity greets us again in the stunning gold burial mask of Akhenaten's son and successor, the young Tutankhamun (14.17).

From earliest times, Egyptians had buried their most lavish art in royal tombs. Rulers were sent into eternity outfitted with everything they would need to continue life in the sumptuous style they had known on Earth—furniture, jewelry, chariots, clothing, and artifacts of all kinds. From earliest times as well, grave robbers have coveted that buried treasure—and not for its artistic merits. Most of the royal tombs that have been discovered in modern times have been empty, their fabulous contents looted long ago. It was not until 1922 that modern eyes could assess the full splendor of ancient Egypt. In that year, the English archaeologist Howard Carter discovered the tomb of Tutankhamun, its treasures virtually intact after three thousand years.

Tutankhamun—quickly dubbed "King Tut" by the 1922 newspapers—was a relatively minor ruler. The tombs of the great would have been far more lavish. Yet even Tutankhamun's tomb was a virtual warehouse of priceless objects superbly crafted of alabaster, precious stones, and, above all, gold—gold in unimaginable quantities. Gold in Egyptian thought signified more than mere wealth. It was associated with the life-giving rays of the sun and with eternity itself. The flesh of the gods was believed to be gold, which would never decay. Tutankhamun's solid gold coffin, and the solid gold face mask that rested on the head and shoulders of his mummified body inside, were meant to confer immortality. Projecting over the young king's forehead are the alert heads of a cobra and a vulture, symbols of the ancient protective goddesses of Lower and Upper Egypt.

When Tutankhamun died, around 1323 B.C.E., Egyptian civilization was already ancient—a continuous culture that looked back confidently on some 1,700 years of achievement and power. Egypt would continue for 1,300 years into the future, but its years of supremacy were waning. Other, younger cultures were gathering force elsewhere around the Mediterranean. Two of these upstarts, Greece and Rome, would eventually conquer Egypt. We turn our attention to Greece next, after a brief look at some of the cultures that preceded it on the islands of the Aegean Sea.

RELATED WORKS

12.3 Bottle in the shape of a pomegranate

14.17 Burial mask of Tutankhamun. c. 1323 B.C.E. Gold, inlaid with blue glass and semiprecious stones; height 21¼".

Egyptian Museum, Cairo

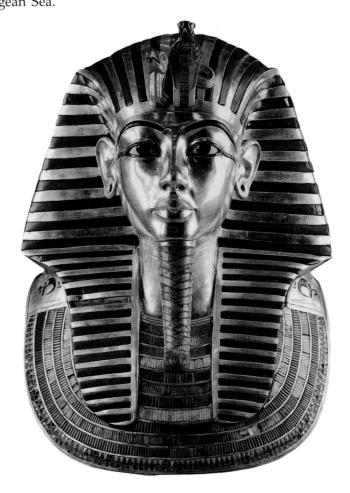

THINKING ABOUT ART Whose Grave?

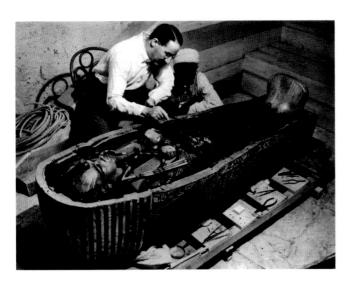

Why are the actions of Carter's team deemed acceptable? What are the motivations behind archaeological digs? Do such reasons justify Carter's actions and should graves be disturbed after thousands of years when relatives, and perhaps a culture, are no longer present?

hen Howard Carter and his party opened the tomb of the Egyptian king Tutankhamun in 1922, there was rejoicing around the world. The tomb was largely intact, not seriously pillaged by ancient grave robbers—it still contained the wonderful artifacts that had been buried with the young king more than three millennia earlier. Over the next several years, Carter and his team systematically photographed and cataloged the objects from the tomb, then transported them to the Cairo Museum.

There is a certain irony in this story that raises complex ethical questions. Why are Carter and his party not called grave robbers? Why are their actions in stripping the tomb acceptable—even praiseworthy—when similar behavior by common thieves would be deplored? No matter who opens a tomb and takes away its contents, that person is violating the intentions of those who sealed the tomb originally. No matter what the motivation, a human body that was meant to rest in peace for all time has been disturbed. Should that not make us feel uncomfortable?

At the time, some people were uneasy about the propriety of unearthing Tutankhamun's remains. When

Lord Carnarvon, Carter's sponsor, died suddenly from a mosquito bite, and several others connected with the project experienced tragedies, rumors arose about the "curse of King Tut." But Carter himself died peacefully many years later, and the talk subsided.

Perhaps it is the passage of time that transforms grave robbing into archaeology. Carter would no doubt have been outraged if, say, his grandmother's coffin had been dug up to strip the body of its jewelry. But after three thousand years, Tutankhamun has no relatives still around to protest.

Perhaps it is a question of the words we use to describe such ancient finds. We speak of Tutankhamun's "mummy," and mummy is a clean, historical-sounding word. Parents bring their children to museums to see the mummies and mummy cases. We can almost forget that a mummy is the embalmed body of a dead human being pulled out of its coffin so that we can marvel at the coffin and sometimes the body itself.

Or, perhaps the difference between grave robbing and archaeology lies in the motives of the perpetrators. Common thieves are motivated by greed, by their quest for money to be made by selling stolen objects. Carter and his team did not sell the treasures from Tutankhamun's tomb but stored them safely in the Cairo Museum, where art lovers from around the world can see them. They were, in effect, making a glorious gift to the people of our century and centuries to come (while at the same time, of course, acquiring significant glory for themselves).

The basic issue is a clash of cultural values. To the Egyptians, it was normal and correct to bury their finest artworks with the exalted dead. To us, the idea of all that beauty being locked away in the dark forever seems an appalling waste. We want to bring it into the light, to have it as part of our precious artistic heritage. Almost no one, having seen these magnificent treasures, would seriously propose they be put back in the tomb and sealed up.

In the end, inevitably, our cultural values will prevail, simply because we are still here and the ancient Egyptians are not. After three thousand years, Tutankhamun's grave really isn't his anymore. Whether rightly or wrongly, it belongs to us.

Howard Carter and an assistant unwrapping the innermost of Tutankhamun's three nested coffins. The third coffin is solid gold and contained the king's mummified body.

The Aegean

Between the Greek peninsula and the continent of Asia Minor (modern-day Turkey) is an arm of the Mediterranean Sea known as the Aegean (see map, page 337). Greek culture arose on the lands bordering this small "sea within a sea," but the Greeks were preceded in the region by several fascinating cultures that thrived on the islands that are so plentiful there.

The artistic cultures of the Aegean parallel in time those of Egypt and Mesopotamia, for the earliest begins about 3000 B.C.E. There were three major Aegean cultures: the Cycladic, centered on a group of small islands in the Aegean; the Minoan, based on the island of Crete at the southern end of the Aegean; and the Mycenaean, on the mainland of Greece.

Cycladic art is a puzzle, because we know almost nothing about the people who made it. Nearly all consists of nude female figures like the one illustrated here (14.18)—simplified, abstract, composed of geometric lines and shapes and projections. The figures vary in size from the roughly 2-foot height of our example to approximately life-size, but they are much alike in style. Most of the figures have been found in burial settings. This, together with the standardized iconography, suggests some sort of ritual use. It seems likely that the figures were associated with ideas about fertility; they may well represent a female deity. To modern eyes the Cycladic figurines seem astonishingly sophisticated in their sleek abstraction of the human figure. Indeed, 20th-century artists such as Alberto Giacometti (see 4.40) studied Cycladic art when they were forging their own abstract styles.

Centered in the great city of Knossos, Minoan culture can be traced to about 2000 B.C.E. We take the name from a legendary king called Minos, who supposedly ruled at Knossos and whose queen gave birth to the dreaded creature, half-human, half-bull, known as the Minotaur. Numerous frescoes survive at Knossos—some fragmentary, some restored—and from these we have formed an impression of a lighthearted, cheerful people devoted to games and sport. Among the finest wall paintings is a work known as the *Toreador Fresco* (14.19),

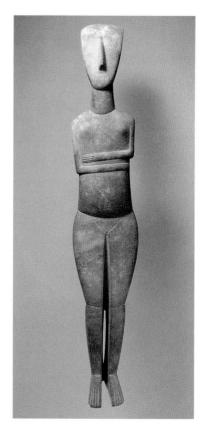

14.18 Statuette of a woman. Cycladic, c. 2600–2400 B.C.E. Marble, height 24³/₄". The Metropolitan Museum of Art, New York

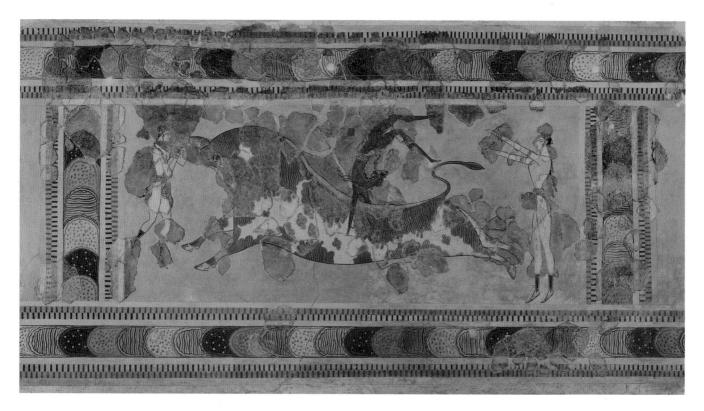

14.19 *Toreador Fresco*, from the palace at Knossos. c. 1500 B.C.E. Fresco, height approx. 32". Archaeological Museum, Herakleion, Crete

14.20 *Rhyton* in the shape of a lion's head, from Mycenae. c. 1550 B.C.E. Gold, height 8". National Museum, Athens

featuring the Minoans' special animal, the bull. This modern title suggests the Spanish sport of bullfighting (a toreador being a bullfighter), but we can see that the Minoans' game was unique to them. A young male acrobat vaults over the back of the racing bull; he will be caught in the waiting arms of the young woman at right. Another female player, at left, grasps the bull's horns; perhaps she is ready to take her turn somersaulting over the animal. Most striking here is the contrast between the hefty, charging bull and the lithe, playful flip of the acrobat. The composition is marvelously balanced, with the women at both sides serving as anchors, the tumbling male figure and the curving tail counterweighing the massive bull's head. Many graceful curves—of the bull's back, the bull's underbelly, the tumbler's arched body—reinforce our experience of motion, captured to the split second.

Mycenaean culture, so called because it formed around the city of Mycenae, flourished on the south coast of the Greek mainland from about 1600 to 1100 B.C.E. Like the Minoans, the Mycenaeans built palaces and temples, but they are also noted for their elaborate burial customs and tombs—a taste apparently acquired from the Egyptians, with whom they had contact. It seems probable that Egypt or Nubia was also the source of the Mycenaeans' great supplies of gold, for they alone among the Aegean cultures were master goldsmiths. Burial places in and around Mycenae have yielded large quantities of exquisite gold objects, such as the *rhyton*, or drinking cup, in the shape of a lion's head (14.20). The craftsmanship of this vessel is wonderful, contrasting smooth planar sections on the sides of the face with the more detailed snout and mane.

The Classical World: Greece and Rome

When we use the word "Classical" in connection with Western civilization, we are referring to the two cultures discussed next in this chapter—ancient Greece and ancient Rome. The term itself indicates an aesthetic bias, for anything "classic" is supposed to embody the highest possible standard of quality, to be the very best of its kind. If true, this would mean that Western art reached a pinnacle in the few hundred years surrounding the start of our common era and has not been equaled in the millennium and a half since then. This is a controversial idea that many would dispute vehemently. Few can deny, however, that the ancient Greeks and Romans *intended* to achieve the highest standards. Art and architecture were matters of public policy, and it was accepted that there could be an objective, shared standard for the best, the purest, the most beautiful.

Greece

No doubt, a major reason we so respect the ancient Greeks is that they excelled in many fields. Their political ideals serve as a model for contemporary democracy. Their poetry and drama and philosophy survive as living classics, familiar to every serious scholar. Greek philosophers, in fact, were the first to speculate on the nature and purpose of art, though they did not call it that. Sculpture, painting, and architecture were discussed as *techne*, roughly "things requiring a special body of knowledge and skill to make," a large category that included such products as shoes and swords. The idea survives in our words *technology* and *technique*.

Greek architecture and sculpture had an enormous influence on the later civilizations of Rome and, through Rome, Europe. We assume that Greek painting was equally brilliant, for ancient historians wrote vividly about it. Descriptions abound of such marvels as fruit painted so convincingly that even

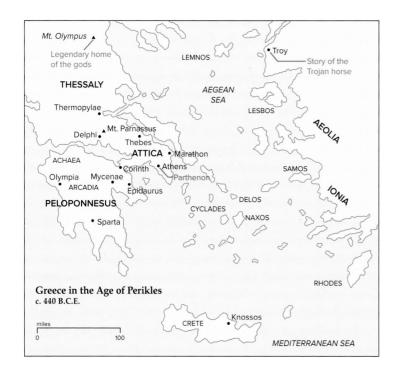

ravenous birds were fooled, and of rival artists striving to outdo one another in skill. But of the works themselves almost nothing has survived. Instead, we must content ourselves with images painted on terra-cotta vessels, which archaeologists have uncovered in large quantities.

An early example is the *krater* illustrated here (14.21). One of many standard Greek pottery shapes, a krater is a vessel used for wine. This krater dates from the 8th century B.C.E., when Greek culture first comes into focus. Stylistically it belongs to the Late Geometric period, when human figures begin to appear amid the geometric motifs that had decorated earlier Greek ceramics. In the upper register, a funeral ceremony is depicted. We see the deceased laid out on a four-legged couch. The checkerboard pattern above probably represents the textile that covered him. Wasp-waisted mourners stand to either side, slapping their heads and tearing their hair in grief. In the lower register, a procession of foot soldiers and horse-drawn chariots passes by. The highly abstracted figures are only beginning to break free from their geometric world. Notice, for example, the triangular torsos of the mourners and the squares framed by their arms and shoulders.

The krater not only depicts a funeral but also served as a grave marker itself. It was found in the Dipylon Cemetery, a burial ground near the entrance to ancient Athens. Other funerary vessels have been found with a hole punched through the base, suggesting that libations-offerings of wine and waterwere poured into them to pass directly into the earth of the grave beneath. Compared with the lavish burials of Egyptian pharaohs, the burial customs of the Greeks were bleak. Tombs of the Egyptian elite were fitted out for a luxurious life in eternity, since that is what they expected. The Greeks were not so optimistic. Death was death. The next world was imagined as a gray and shadowy place of little interest.

The sculptural tradition of Greece begins with small bronze figures of horses and men in styles much like the figures on the *krater* we just examined. At some point, however, Greek sculptors seem to have begun looking closely at the work of their neighbors the Egyptians, with whom they were in contact.

14.21 Hirschfeld Workshop (attr.). Krater. c. 750-735 B.C.E. Terra cotta, height 42%". The Metropolitan Museum of Art, New York

14.22 Kouros. c. 580 B.C.E. Marble, height 6'4". The Metropolitan Museum of Art, New York

Egyptian influence is clear in this life-size statue of a young man (14.22). Not only does the work reproduce the characteristic Egyptian pose—one leg forward, arms at the sides, hands clenched (see 11.16)—but it even follows the Egyptian grid system of proportions (see 5.18). Like Egyptian works, too, the block of original stone can still be sensed in the squared-off appearance of the finished sculpture.

In other respects, however, this figure is radically different from Egyptian works. Whereas Egyptian sculptors left their figures partially embedded in the granite block they were carved from, the Greek figure is released completely from the stone, with space between the legs and between the arms and the body. Whereas Egyptian men were depicted wearing loincloths, the Greek figure is nude. His neck ornament and elaborately braided hairstyle suggest that despite this nudity he is carefully groomed and appropriately dressed. His nudity, in other words, is a positive statement, not a temporary absence of clothing. Finally, whereas Egyptian statues depict specific individuals-rulers and other members of the elite—the Greek statue depicts an anonymous boy. Thousands of such figures were carved-perhaps as many as 20,000-all of them in the same pose, and all nude, broad-shouldered, slim-waisted, fit, and young. They were placed as offerings in sanctuaries to the gods and set as grave markers in cemeteries. Scholars refer to them generically by the Greek word for youths or boys, kouroi (singular kouros). Statues of maidens, korai (singular kore), were also carved, though these are fewer in number and always fully clothed.

Kouroi and korai were created largely during the 6th century B.C.E., in the Archaic period of Greek art, so called because what would later be leading characteristics can be seen in their early form. In the kouros depicted here, the earliest known example, the treatment of the body and the face is still fairly abstract. As the tradition evolved, sculptors aimed increasingly at giving their statues a lifelike, convincing presence. They observed human bodies more attentively and copied them more faithfully, leading eventually to a style we know as naturalism. One reason for this was that many statues depicted gods. The Greeks imagined their gods in thoroughly human form, many of them dazzlingly beautiful and eternally young. Every sanctuary contained a statue of the god or goddess it was dedicated to, and the more believable the statue was, the more present to believers the deity seemed.

Created only sixty years after the *kouros* we have been looking at, the amphora (storage vessel) illustrated next shows how rapidly Greek art evolved toward naturalistic representation (14.23). It also shows us something of the culture that made men's bodies available for direct observation. Created by the potter Andokides and a painter we recognize only as the "Andokides Painter," the vessel is one of the earliest examples of the red-figure style, which evolved toward the end of the Archaic period. In the red-figure style, the ground is painted black, while figures are left unpainted. The red that results is the natural color of fired earth. Earlier Archaic pottery had employed the reverse color scheme, with black figures painted on a red ground.

The amphora is decorated with a scene set in a gymnasium. From childhood on, exercise at the gymnasium was as much a part of Greek education as learning mathematics, music, and philosophy. Male citizens were in constant training, for they also formed their city's army. Greek athletes trained and competed in public in the nude. The scene on the amphora depicts two pairs of men wrestling. A trainer stands watching them, holding a flower up to his face. The flower, a symbol of beauty, indicates that the toned bodies of the athletes are to be as openly admired as their wrestling ability. Well-developed male bodies were on constant display, and their beauty was celebrated and depicted in art. There was an erotic component to this, but also a moral one, for beauty was felt to go hand in hand with nobility and goodness. Men in ancient Greece had public lives, and their bodies were public bodies. Women were largely confined to the domestic realm, and their bodies were not for public display, either in life or in art.

RELATED WORKS

11.20 Apoxyomenos, after Lysippos

The Greek concern with lifelike representation flowered fully in statues such as this bronze warrior (14.24). Here is an idealized, virile male body, its anatomy distilled from observing hundreds of athletic physiques. The warrior stands in a relaxed yet vigilant contrapposto-the pose the Greeks invented to express the potential for motion inherent in a standing human. (To review the principles of contrapposto, see page 255.) Bronze was the favored material for freestanding sculpture in ancient Greece, yet very few examples survive. The metal was too valuable for other purposes—especially weapons—and most ancient sculptures were melted down centuries ago. If it were not for marble copies of bronze works commissioned by later Roman admirers, we would know far less than we do about Greek art. The statue here is one of two lifesize warrior figures discovered off the coast of Riace, Italy, in 1972. They had escaped destruction only by being lost at sea.

The Riace warriors were created during the Classical period of Greek art, which dates from 480 to 323 B.C.E. Although all ancient Greek and Roman art is broadly known as Classical, the art produced during these decades was considered by later European scholars to be the finest of the finest. During this period, Greece consisted of several independent city-states, often at war among themselves. Chief among the city-states-from an artistic and cultural point of view, if not always a military one-was Athens.

14.23 Andokides and the "Andokides Painter." Amphora with gymnasium scene. c. 520 B.C.E. Terra cotta, height 2213/16". Staatliche Museen zu Berlin, Preussischer Kulturbesitz, Antikensammlung

14.24 "Warrior A," discovered in the sea near Riace, Italy. c. 450 B.C.E. Bronze, with bone and glass eyes, silver teeth, and copper lips and nipples; height 6'8". Museo Archaeologico Nazionale, Reggio Calabria, Italy

14.25 Reconstruction of the Acropolis, Athens.
Model by Roger Payne

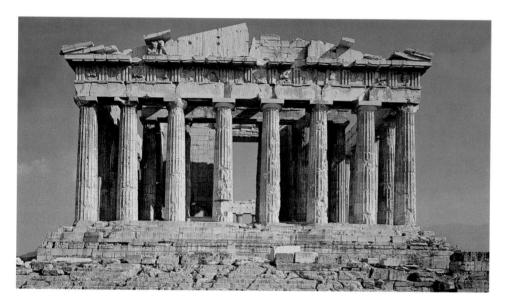

14.26 Iktinos and Kallikrates. Parthenon, Athens. 447–432 B.C.E.

Like many Greek cities, Athens had been built around a high hill, or acropolis. Ancient temples on the Acropolis had crumbled or been destroyed in the wars. About 449 B.C.E., Athens' great general Perikles came to power as head of state and set about rebuilding. He soon embarked on a massive construction program, meant not only to restore the past glory of Athens but also to raise it to a previously undreamed-of splendor.

Perikles' friend, the sculptor Phidias, was given the job of overseeing all architectural and sculptural projects on the Acropolis. The work would continue for several decades, but it took an amazingly short time given the ambitious nature of the scheme. By the end of the century, the Acropolis probably looked much like the reconstruction shown here (14.25). The large columned building at lower right in the photo is the Propylaea, the ceremonial gateway to the Acropolis through which processions winding up the hill would pass. At left in the photo, the building with columned porches is the Erechtheum, placed where Erechtheus, legendary founder of the city, supposedly lived.

But the crowning glory of the Acropolis was and is the Parthenon (14.26). Dedicated to the goddess Athena *parthenos*, or Athena the warrior maiden, the Parthenon is a Doric-style temple with columns all around the exterior and an inner row of columns on each of the short walls. The roof originally rose to a peak, leaving a pediment (visible in the reconstruction) at each end.

RELATED WORKS

13.4 Kallikrates, Temple of Athena Nike

THINKING ABOUT ART The Marbles and the Museums

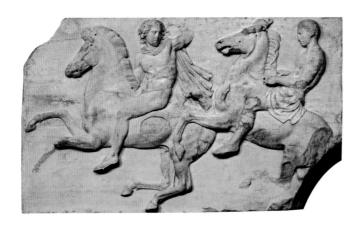

If the intentions of removing artifacts from their places of origin are for conservation and education, should such artifacts be returned when situations improve in the places of origin? How do politics, history, and technology factor into ownership of works of art?

ike most monumental buildings in antiquity, the Parthenon was originally ornamented with a rich program of sculpture. Only about half of the Parthenon sculptures survive today, and of those, half are in the British Museum. How they got there and whether they should be returned are the subjects of this essay.

To set the stage, we need to sketch in a quick history of Greece. The Parthenon was built in the city-state of Athens during the 5th century B.C.E. Three centuries later, Greece was subsumed into the growing empire of Rome. The western portion of the Roman Empire disintegrated during the 5th century C.E.; the eastern portion continued for a thousand more years as Byzantium, a Greek-speaking Christian empire ruled from Constantinople (present-day Istanbul). In 1453 Constantinople was conquered by Muslim forces, and Greece was absorbed into the Ottoman Empire, where it remained until modern times.

In 1799 Thomas Bruce, 7th Earl of Elgin, was appointed ambassador of England to the Ottoman court. By that time, the Parthenon was in ruins. Early Christians had converted it to a church, in the process destroying many of its sculptures. During the 17th century, invading Venetian forces had fired on the Parthenon, which the Ottomans were then using to store gunpowder. The resulting explosion caused severe damage. Lord Elgin arrived with a plan to make plaster copies of the remaining Parthenon sculptures

and send them back to England, but he quickly became convinced that the sculptures themselves needed to be removed to preserve them for posterity. As a diplomatic favor, the Ottoman court granted him a royal mandate to proceed. Detaching the sculptures from the building and shipping them to England took five years; Elgin paid for it out of his own personal fortune. Lord Elgin had intended to donate the marbles to the nation, but severe financial problems prompted him to ask for compensation. In the end, the British Museum, funded by Parliament, purchased the marbles for a fraction of what Elgin had spent to obtain them. The sculptures went on display to the public in 1817, and they have been on permanent display ever since, the object of scholarly research and conservation efforts.

Not long after Elgin shipped the Parthenon marbles off to England, Greece launched a war of independence against the Ottomans, which ended with a Greek victory in 1832. Almost immediately, Greek calls for the return of the marbles were heard. These calls have recurred regularly and with increasing frequency over the years. The British Museum has refused. The argument on both sides has taken many forms, but the trump card in the British response has always been this: How would you care for them? Indeed, sculptures left behind by Lord Elgin remained on the Parthenon until 1977, slowly decaying in the increasingly polluted air of modern Athens. Even after they were taken down, most were stored out of the public view, for Greek plans to build a state-of-the-art museum repeatedly came to naught-until recently.

In 2002 work began on a new museum designed by Swiss-born architect Benard Tschumi. Situated at the foot of the Acropolis, it opened to the public in June of 2009 and includes a large gallery designed especially to display the Parthenon marbles. As of this writing, the British Museum has said that it would consider loaning the marbles to Greece for a limited time on the condition that British ownership is officially recognized. The Greek government has refused to borrow the marbles on these terms and has suggested instead that negotiations be mediated by a third party, the United Nations Educational, Scientific and Cultural Organization (UNESCO). The British Museum has not responded. Should the marbles be returned?

Two Horsemen, from the west frieze of the Parthenon. c. 438–432 B.C.E. Marble, originally polychrome; height 393/6". The British Museum, London.

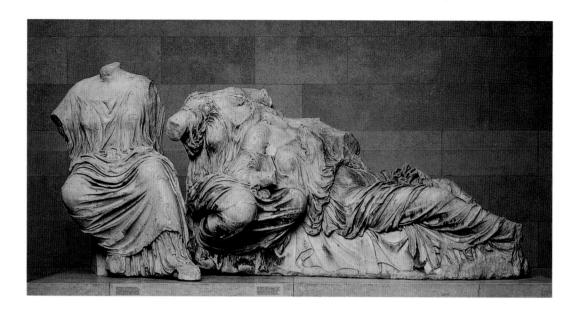

14.27 Three Goddesses, from the east pediment of the Parthenon. c. 438–432 B.C.E. Marble, over life-size. The British Museum, London

The pediments were decorated with sculptures, as was the frieze. (To review the vocabulary of Classical architecture, see pages 287–88.) In the manner of Greek temples, the Parthenon was painted in vivid colors, principally red and blue. The architects Iktinos and Kallikrates, directed by Phidias, completed the structure in just fifteen years.

The Parthenon has been studied in greater detail than perhaps any other building in the Western tradition, for it served generations of European architects as a model of perfection. Research has discovered numerous painstaking refinements that contribute to the temple's pleasing effect. First, a repeating ratio harmonizes its dimensions. The temple is a little more than twice as long as it is wide. The exact ratio is 9:4. This same ratio appears again when we compare the distance between the columns (measured from central axis to central axis) and the diameter of the columns. It appears for a third time in the dimensions of the facade: take away the steps and the pediment, and the widthto-height ratio of the facade is again 9:4. Legend claims there are no straight lines in the Parthenon, but that is probably a romantic exaggeration. Many of the lines we expect to be straight, however, are not. Instead, the builders adjusted the physical lines of the temple so they would appear to be straight. For example, tall columns that are absolutely straight may appear to bend inward at the center, like an hourglass, so the columns on the Parthenon have been given a slight bulge, known as entasis, to compensate for the visual effect. Also, a long horizontal, such as the Parthenon's porch steps, may appear to sag in the middle; to correct for this optical illusion, the level has been adjusted, rising about 2½ inches to form an arc higher at the center. A large building rising perpendicular to the ground may loom over the visitor and seem to be leaning forward; to avoid this impression, the architects of the Parthenon tilted the whole facade back slightly. Corner columns, seen against the sky, would have seemed thinner than inside columns, which have the building as a backdrop; therefore, the outside columns were made slightly heavier than all the others.

The inner chamber of the Parthenon once housed a monumental statue of the goddess Athena, made by Phidias himself of gold and ivory and standing 30 feet tall atop its pedestal. Contemporary sources tell us Phidias was an artist of unsurpassed genius, but we must take their word for it, since neither the Athena nor any of his other sculptures are known to survive. Other sculptures from the Parthenon have been preserved, however, and these were probably made by Phidias' students, under his supervision.

The Parthenon sculptures represent a high point in the long period of Greek experimentation with carving in marble. One existing sculpture group, now in the British Museum, depicts *Three Goddesses* (14.27). In Perikles' time this group stood near the far right side of the pediment; if you imagine the figures with their heads intact, you can see how they fit into the angle of the

triangle. Carved from marble and now headless, these goddesses still seem to breathe and be capable of movement, so convincing is their roundness. The draperies flow and ripple naturally over the bodies, apparently responding to living flesh underneath.

The last phase of Greek art is known as **Hellenistic**—a term that refers to the spread of Greek culture eastward through Asia Minor, Egypt, and Mesopotamia—lands that had been conquered by the Macedonian Greek ruler Alexander the Great. The beginning of the Hellenistic era is usually dated to Alexander's death in 323 B.C.E.

Hellenistic sculpture developed in several stylistic directions. One was a continuing Classical style that emphasized balance and restraint, as seen in one of the most famous of extant Hellenistic works, the *Aphrodite of Melos*, also known as the *Venus de Milo* (14.28). Venus was the Roman equivalent of Aphrodite, the Greek goddess of love, beauty, and fertility. Sculptors of the late Classical period had begun admitting female nudes into the public realm—though only as goddesses or mythological characters. This statue exemplifies the ideal of female beauty that resulted. Her twisting pose may be explained by the theory that her missing arms once held a shield propped up on her raised knee. She would have been admiring her own reflection in a mirror, her draperies slipping provocatively as she contemplated her beauty.

A second Hellenistic style overthrew Classical values in favor of dynamic poses and extreme emotions. One of the best-known examples of this style is the *Laocoön Group* (14.29), which we know from what is probably a Roman copy of a Greek bronze of the 2nd century B.C.E.

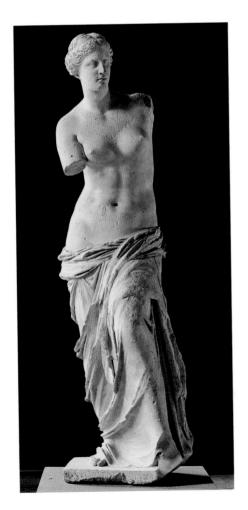

14.28 Aphrodite of Melos (also called Venus de Milo). c. 150 B.C.E. Marble, height 6'10".

Musée du Louvre, Paris

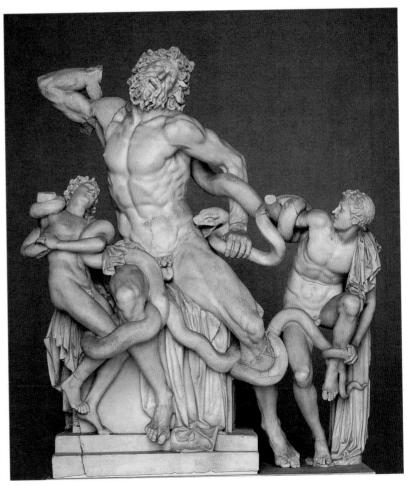

14.29 Laocoön Group. Roman copy, late 1st century B.C.E.—early 1st century C.E., of a Greek bronze(?) original, possibly by Agesander, Athenodorus, and Polydorus of Rhodes. Marble, height 8'.

Musei Vaticani, Rome

343

Laocoön was a priest of the sun god, Apollo, and his story involves one of the most famous events in Greek mythology. In the last year of the war between the Greeks and the Trojans, the Greeks devised a fabulous ruse to overrun the city of Troy. They built a giant wooden horse, concealed inside it a large number of Greek soldiers, and wheeled it up to the gates of Troy, claiming it was an offering for the goddess Athena. While the people of Troy were trying to decide whether to admit the horse, their priest, Laocoön, suspected a trick and urged the Trojans to keep the gates locked. This angered the sea god, Poseidon, who held bitter feelings toward Troy, and he sent two dreadful serpents to strangle Laocoön and his sons. The sculpture depicts the priest and his children in their death throes, entwined by the deadly snakes.

Compared with statues from the Classical period, such as the Riace *Warrior*, the *Laocoön Group* seems theatrical. Its subject matter, filled with drama and tension, would have been unthinkable three centuries earlier. The Classical sculptor wanted to convey an outward serenity, and thus showed the hero in perfection but not in action, outside time, not throwing the spear but merely holding it. Hellenistic sculptors were far more interested than their predecessors in how their subjects reacted to events. Laocoön's reaction is a violent, anguished one, and the outlines of the sculpture reflect this. The three figures writhe in agony, thrusting their bodies outward in different directions, pushing into space. Unlike earlier figures, with their dignified reserve, this sculpture projects a complicated and intense movement.

Rome

The year 510 B.C.E. is usually cited as the beginning of the Roman era, for it was then, according to ancient historians, that the Roman Republic was founded. There followed a long period of expansion and consolidation of territories

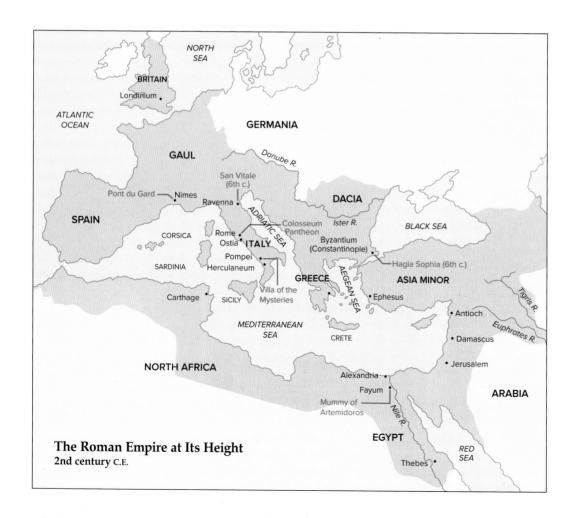

brought under Roman rule. Roman legions swept eastward through Greece into Mesopotamia, west and north as far as Britain, across the sea to Egypt, throughout the rim of northern Africa. In 27 B.C.E., when Augustus took the title of "caesar," Rome officially became an empire.

Rome came of age during the Hellenistic period, when the prestige of Greek culture was at its height in the ancient Mediterranean world. The Romans were great admirers of Greek achievements in the arts. Many works were taken from Greece and brought to Rome. Statues and paintings were commissioned from Greek artists, and copies were made in marble of Greek bronze originals, such as the *Laocoön Group* (14.29) illustrated earlier.

One aspect of Hellenistic art was a tendency toward realistic portrayals of individuals, as opposed to idealized portrayals of *types* of people. No longer forever young and perfect, an athlete such as a boxer might be portrayed as the survivor of years of physically punishing bouts, his face lined, his body thickening with the onset of middle age. Roman sculptors excelled at this realism in their portrait busts of ordinary citizens, who wanted to be remembered as individuals.

One such example is the *Double Portrait of Gratidia M. L. Chrite and M. Gratidius Libanus* (14.30). This is a funerary portrait, and it was once attached to a tomb. Mausoleums lined the main roads leading out of Rome, and portraits like this were set into their facades so that the dead seemed to be looking out of a window onto the living. The man is old. We see the folds of his sunken face and the lines on his brow, but also the laugh lines at the edges of his eyes. His wife's image seems more idealized. Perhaps she was younger, or perhaps this was a request. Their right hands are joined in a gesture from the Roman marriage ceremony. Her left hand rests affectionately on his shoulder; his left hand draws our attention to the heavy folds of his toga, a symbol of Roman citizenship. An inscription that was once nearby states that he was Greek in origin and suggests that he was the son of a freedman, an ex-slave. No wonder the right to wear the toga of a full citizen meant so much to him.

The greatest honor that could be bestowed on a Roman ruler was a portrayal in bronze on horseback. Equestrian statues of emperors crowded the Roman forum, their gilt surfaces gleaming. A description of Rome dating from around 320 c.e. speaks of twenty-three such statues. The Greeks, too, had honored their leaders with equestrian statues. Yet of all this only a single example has survived, the statue of Marcus Aurelius that we looked at in Chapter 3 (see 3.6). The equestrian statues of rulers and soldiers that ornament American and European cities are the direct descendants of this fine work.

14.30 Funerary Portrait of Gratidia M. L. Chrite and M. Gratidius Libanus. 10 B.C.E.—10 C.E. Marble with traces of color, height 23³/₄". Museo Pio Clementino, Musei Vaticani, Rome

RELATED WORKS

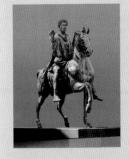

3.6 Equestrian statue of Marcus Aurelius

14.31 Wall painting, from Villa of the Mysteries, Pompeii. c. 50 B.C.E. Fresco.

The Romans were equally masterful at painting, but were it not for a tragedy that occurred in 79 C.E., we would know little more about Roman painting than we do about the Greek. In that year Mt. Vesuvius, an active volcano, erupted and buried the town of Pompeii, about a hundred miles south of Rome, along with the neighboring town of Herculaneum. The resulting lava and ashes spread a blanket over the region, and this blanket acted as a kind of time capsule. Pompeii lay undisturbed, immune to further ravages of nature, for more than sixteen centuries. Then, in 1748, excavations were undertaken, and their findings were made public by the famous German archaeologist Joachim Winckelmann. Within the precincts of Pompeii the diggers found marvelous frescoes that were exceptionally well preserved. Pompeii was not an important city, so we cannot assume that the most talented artists of the period worked there. In fact, there is some evidence to suggest that the fresco painters were not Roman at all, but immigrant Greeks. Nevertheless, these wall paintings do give some indication of the styles of art practiced within the empire at the time.

One fresco, from a house known as the Villa of the Mysteries (14.31), shows a scene believed to represent secret cult rituals associated with the Greek wine god, Dionysus, known to the Romans as Bacchus. The figures stand as though on a ledge, in shallow but convincing space, interacting only slightly with one another. Although the artist has segmented the mural into panels separated by black bands, the figures overlap these panels so freely that there is no strong sense of individual episodes or compartments. Rather, the artist has established two rhythms—one of the figures and another of the dividing bands—giving a strong design unity.

The floors of the finer houses at Pompeii were decorated with mosaics (14.32), a common practice in ancient Rome. The panel illustrated here graced the floor of a *triclinium*, or dining room. At the center, an octopus and a lobster are portrayed locked in combat. Around them swims a crowd of creatures that could have been fished up from the Mediterranean Sea, an appropriate subject for a house so near the shore. Pompeii's wealthier citizens probably dined regularly on many of the species pictured here in such vivid and accurate detail.

For all their production in sculpture and painting, the Romans are best known for their architecture and engineering. We saw two of their masterpieces, the Pont du Gard and the Pantheon, in Chapter 13 (see 13.9, 13.13, 13.15). But the most familiar monument—indeed, for many travelers the very symbol of Rome—is the Colosseum (14.33).

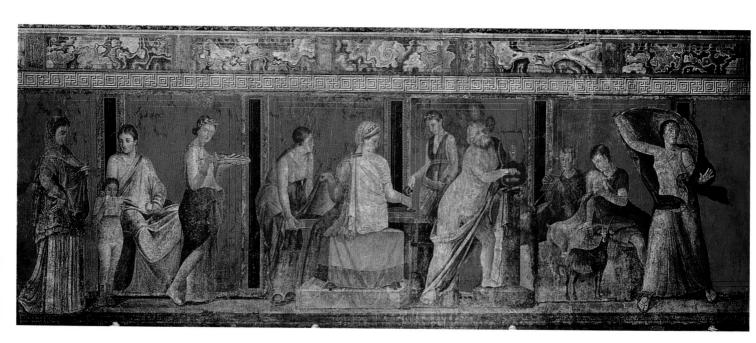

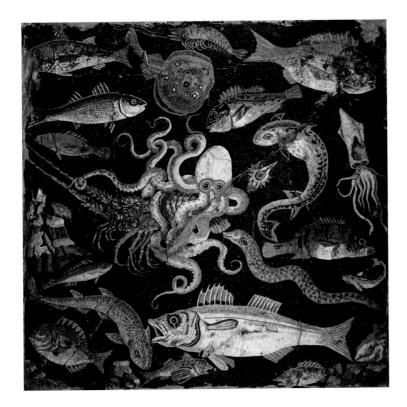

14.32 Floor mosaic depicting sea creatures, from Pompeii. 1st century C.E. $34\% \times 34\%$ ". Museo Archeologico Nazionale, Naples, Italy

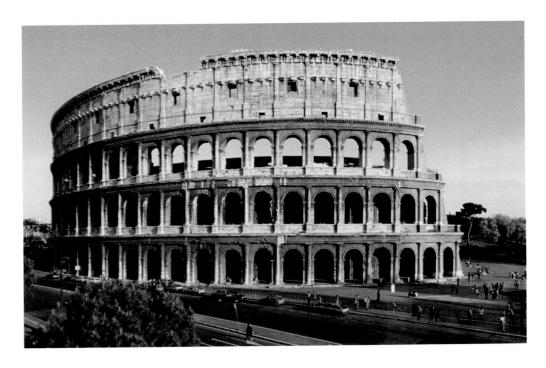

The Colosseum was planned under the emperor Vespasian and dedicated in 80 C.E. as an amphitheater for gladiatorial games and public entertainments. A large oval covering 6 acres, the Colosseum could accommodate some 50,000 spectators—about the same number as most major-league baseball stadiums today. Few of the games played inside, however, were as tame as baseball. Gladiators vied with one another and with wild animals in bloody and gruesome contests.

Even in its ruined state, this structure displays the genius of the Romans as builders. The Colosseum rises in four stories, each of which corresponds to a seating level inside. Archways on the first three stories open onto the barrel-vaulted corridors that ring the interior. The upper two tiers of arches once

14.33 Colosseum, Rome. 72–80 C.E.

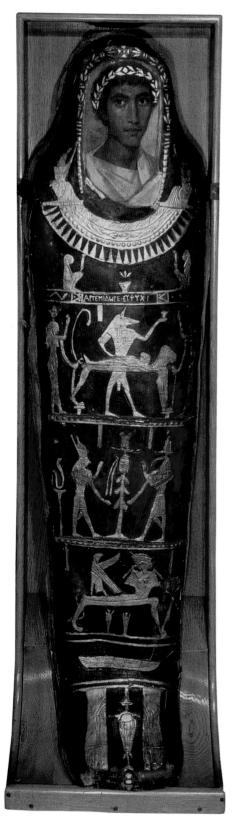

14.34 Mummy case of Artemidoros, from Fayum. 100–200 c.E. Stucco casing with portrait in encaustic on limewood with added gold leaf; height 5'7¼".

The British Museum, London

held statues; the street-level arches served as numbered entrances. (Some of the original numbers can still be seen.) The arches are framed by ornamental half-columns, with each tier distinguished by a different order: Tuscan on the first level, Ionic on the second, and Corinthian on the third. (The plain Tuscan order was a Roman addition to the Greek orders.) On the fourth level, the arches give way to small windows, which originally alternated with large bronze shields. Tall masts once ringed the top of the wall. They served to suspend a gigantic awning over the interior, shading at least some seats from the hot Roman sun. The arena consisted of a wooden stage covered with sand and fitted with trapdoors. Beneath it was a warren of stone corridors (still visible today), cells for animals, hoisting equipment, and a subterranean passageway that led to a nearby gladiator training camp. The building was fitted with an intricate drainage system for rainwater, and its massive foundations are set almost 40 feet into the ground. The Romans built things to last.

By the year 100 of our era, the Roman Empire ringed the entire Mediterranean Sea. It extended eastward through Asia Minor and into Mesopotamia, westward through Spain, northward into England, and south across North Africa and Egypt. Yet the many cultures that came under Roman rule did not cease to be themselves and suddenly become Roman. Instead, the empire extended its umbrella over a vast array of cultures, languages, and religions, all of which now mingled freely thanks to Roman rule and Roman roads.

Our last illustration gives us a glimpse of the multicultural world of late Rome (14.34). The illustration shows the mummy of a young man named Artemidoros, from Fayum, in Egypt. It dates from sometime in the 2nd century of our era. Egypt was then part of the Roman Empire, and Artemidoros was a Roman subject. Artemidoros, however, is a Greek name, and it is written in Greek letters on his mummy. Why a Greek in Egypt? Alexander the Great had conquered Egypt in 323 B.C.E. For the next three hundred years, Egypt was ruled by a Greek dynasty, the Ptolemies. Greeks constituted an elite part of the population, but though they preserved their own language, they adopted the Egyptian religion, with its comforting belief in an eternal afterlife. Thus, the body of Artemidoros, an Egyptian of Greek ancestry and identity, was mummified for burial, and on his mummy are depicted ancient Egyptian gods, including Anubis, the jackal-headed god of the dead, visible at the center just under Artemidoros' name.

Rome conquered Egypt from the last of the Ptolemies, the celebrated queen Cleopatra, in 31 B.C.E. Greek remained the principal administrative language of Egypt, even under Roman rule. Roman customs and fashions, however, were widely imitated by Egyptians who wanted to appear "up to date." One such custom was the funeral portrait, a commemorative painting of a recently deceased person. Thus, Artemidoros' mummy includes a funeral portrait, painted in encaustic on wood in a Greek-Roman style. (To review the technique of encaustic, see page 159.) What are we to call Artemidoros? Roman-Greek-Egyptian? After thousands of years of history, cultural identities could have many layers in the ancient Mediterranean world.

Influence flowed from Rome's conquests to Rome as well. Like the Greeks before them, the Romans were fascinated by Egyptian culture, which was so much older than their own. They imported many Egyptian statues to Rome, and Roman artists worked to satisfy a craze for new sculptures in the Egyptian style. Although Roman gods and goddesses remained the official deities of Rome, the worship of the Egyptian goddess Isis spread through the empire as far away as Spain and England. So did Mithraism, the worship of the sun god of the Persians, some of whose ancient territories also fell under Roman rule.

In these heady if sometimes perplexing times, who could have foreseen that the future would belong to a completely new religion that had only recently arisen in the eastern part of the vast empire? Based in the teachings of an obscure Jewish preacher named Jesus, it was called Christianity.

15

Christianity and the Formation of Europe

ccording to tradition, Jesus, known as the Christ or "anointed one," was born in Bethlehem during the reign of Emperor Augustus. In time his followers would become so influential in world affairs that our common calendar takes as its starting point the presumed date of Jesus' birth, calling it "year 1." As a matter of fact, the 6th-century calendar makers who devised this plan were wrong in their calculations. Jesus probably was born between four and six years earlier than they had supposed, but the calendar has nevertheless become standard.

The faith preached by the followers of Jesus spread with remarkable speed through the Roman Empire; yet, that empire itself was about to undergo a profound transformation. Overextended, internally weakened, and increasingly invaded, it would soon disintegrate. The western portion would eventually reemerge as western Europe—a collection of independent, often warring kingdoms united by a common religious culture of Christianity. The eastern portion would survive for a time as the Byzantine Empire, a Christianized continuation of a much-diminished Roman Empire. The Near East, Egypt, North Africa, and most of Spain, meanwhile, would become the heartlands of yet another new religious culture, Islam.

We will discuss the arts of Islam in Chapter 18. This chapter continues the story of the Western tradition with the rise of Christianity, the arts of Byzantium, and the formation of western Europe.

The Rise of Christianity

Christianity was but one of numerous religions in the late Roman Empire, but it quickly became one of the most popular and well organized. Rome's attitude toward this new cultural force within its borders varied. Often, the faith was tolerated, especially since it came to attract an increasing number of wealthy and influential people. At other times, Christians were persecuted, sometimes officially and sometimes by mobs. One reason for the persecutions was that Christians refused to worship the gods and goddesses of the state religion, including the emperor himself, in addition to their own god. Clearly, such people were a threat to the political stability and well-being of the empire.

Little art that is specifically Christian survives from these first centuries. Gathering places for the faithful were probably built in some of the major centers of the empire, but none survive. Most early worship took place in private

15.1 Christ as the Sun, detail of a mosaic under St. Peter's necropolis, Rome. Mid-3rd century.

homes, although only one such early house-church has been discovered. Some of the earliest Christian art has been preserved in underground burial chambers that were later forgotten. The portion of a mosaic illustrated here is from the vault of an underground necropolis (from the Greek for "city of the dead") in Rome (15.1). The mosaic was created around the same time as the mummy of Artemidoros discussed in Chapter 14 (see 14.34), and it offers a similarly fascinating mixture of imagery.

In depicting Christ in triumph, the artist has borrowed the iconography of the Greek sun god Helios, who was worshiped in the later Roman Empire as Sol Invictus, invincible sun. Patron of soldiers, he was often portrayed driving his chariot across the sky, light radiating from his head. Rays of light emanating from the head of this Christ-Helios are modified to suggest a cross. The grape leaves of the surrounding pattern were associated with the Greek god Dionysus, known to the Romans as Bacchus, the god of fertility and wine. Christians appropriated the grape leaf as a symbol, for Christ had spoken of himself as the true vine, whose branches (the faithful) would bear fruit (the kingdom of God on Earth). The benefit for artists was that the grape-leaf patterns they had learned as apprentices could serve for Christian clients as well as pagan ones.

Christianity's situation changed abruptly in the year 313, when the Roman emperor Constantine issued an edict of tolerance for all religions. Not only were all faiths now free to practice openly, but Constantine himself patronized Christianity, for he attributed his success in a key battle to the Christian God. Under his imperial sponsorship, architects raised a series of large and opulent churches at key locations in the empire. One of these was Old St. Peter's, built on the spot in Rome where it was believed that Peter, Jesus' first apostle, had been buried. This structure was demolished in 1506 to erect the "new" St. Peter's now in Rome (see 16.11), but contemporary descriptions and drawings have enabled scholars to make informed guesses about its design (15.2). A similar church built some sixty years later, St. Paul's Outside the Walls, stood intact until the 19th century, and an artist's rendering gives testimony to its grandeur (15.3).

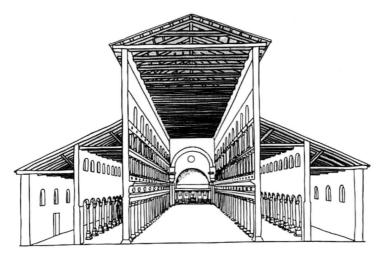

15.2 Reconstruction of Old St. Peter's, Rome. Begun c. 320.

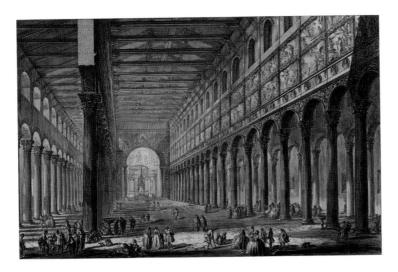

15.3 Giovanni Battista Piranesi. St. Paul's Outside the Walls, Rome, begun c. 385 from *Vedute di Roma* (*Views of Rome*). 1749. Etching, $15\frac{3}{6} \times 24$ ". Yale University Art Gallery

What should a church look like? Most Roman, Greek, and even Egyptian and Mesopotamian temples had essentially been conceived as dwelling places for the gods they were dedicated to. Priests might enter to perform rites of sacrifice and worship, but groups of ordinary people viewed those rites from outside, if they viewed them at all. Christianity from the beginning emphasized congregational worship, and so a fundamentally different kind of building was needed, one that could contain a lot of people. Roman architects already had such a structure in their repertoire of standard building types, a multipurpose meeting hall called a **basilica** (15.4, top).

As the plan shows, a basilica was basically a long rectangular hall. Entrances might be on the long or the short sides (here, they are on the long sides). At one or both ends (both, in this example) might be a curved section called an **apse**. To admit light, the open center space, called the **nave**, extended up higher than the surrounding **aisles**. This upward extension was called the **clerestory**, and it was pierced with windows called clerestory windows. If you look back at the drawing of Old St. Peter's (15.2), you can now clearly see the central nave with its clerestory windows and the lower side aisles that buttress it. In the distance, at the far end of the nave, is an apse.

A plan of Old St. Peter's (15.4, bottom) makes this clear and also shows an additional element. The basilica form is designed with the entry on one of the short sides. Inside we find the wide central nave flanked by narrower aisles. At the far end is the apse. A natural focal point for anyone entering the church,

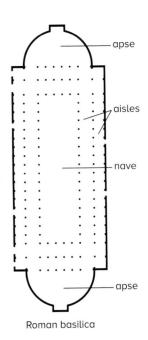

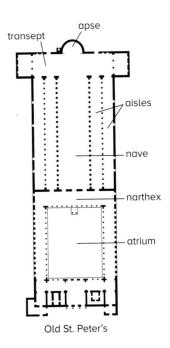

15.4 Plan of a Roman basilica (above, top) and plan of Old St. Peter's (below).

15.5 Constantine the Great. 325–26 C.E. Marble, height of head 8'6". Palazzo dei Conservatori, Rome

the apse provides a setting for the altar, the focal point of Christian worship. In addition, this far wall is extended slightly to each side of the building. The extensions create a lengthwise section perpendicular to the nave called a **transept**. Together, nave and transept form a cross, a fundamental Christian symbol. Preceding the church was an atrium. An open courtyard surrounded by a covered walkway, the atrium was a standard element of Roman domestic architecture. The arm of the walkway directly in front of the church served as an entry porch called a **narthex**. The elements here—nave, aisles, clerestory, apse, transept, and narthex—formed the basic vocabulary of church architecture in the West for many centuries. We will use them often in this chapter.

In 324 Constantine made another decision with far-reaching consequences: judging that the empire could be more securely ruled from the East, he ordered his architects and engineers to transform the ancient Greek colony of Byzantio, known in Latin as Byzantium, into a new capital city called Constantinople (present-day Istanbul, in Turkey). Six years later, he moved his administration there. As a symbol of his continuing presence in Rome, Constantine commissioned a 30-foot-tall statue of himself, portrayed seated in majesty, and had it installed in an apse added especially for that purpose to a prominent Roman basilica. Fragments of the statue have survived, including the massive head (15.5). The prominent nose and chin undoubtedly reproduce

Constantine's distinctive features. But the overall style of the image is far from the idealized naturalism of Greece and the realism of earlier Rome. Instead, exaggerated, stylized eyes stare out from geometric, semicircular sockets under an abstracted representation of hair. The stage is set for the art of Byzantium.

Byzantium

The actual territory ruled from Constantinople varied greatly over the centuries. At first, it was the entire Roman Empire. By the time the city was conquered by Islamic forces in 1453, it was a much-reduced area. But no matter the actual extent of their dominion, the title that Byzantine rulers inherited was "emperor of all the Romans." They viewed themselves as the legitimate continuation of the ancient Roman Empire, with one important difference: Byzantium was Christian. Whereas Constantine had extended his protection and patronage to Christianity, his successors went one step further: they made Christianity the official state religion. Church and state were intertwined in Byzantium, and its art marries the luxurious splendor of a powerful earthly kingdom—its gold and silver and jewels—with images that focus on an eternal, heavenly one.

The great masterpiece of early Byzantine architecture is the Hagia Sophia, which we examined in Chapter 13 (see 13.16, 13.17). A smaller gem of the early Byzantine style is San Vitale, built during the 6th century in Ravenna, Italy, which was then under Byzantine control (15.6, 15.7). San Vitale does not follow the cross plan that became standard for Western churches but, instead, uses a central plan favored in the East. Central-plan churches are most often square with a central dome, as is the Hagia Sophia. San Vitale, however, takes the unusual form of an octagon. Although an apse protrudes from one wall and a narthex is attached to two others, the fundamental focus of the building is at its center, over which rises a large dome. The major axis of a central-plan church is thus vertical, from floor to dome, or symbolically from Earth to the vault of heaven.

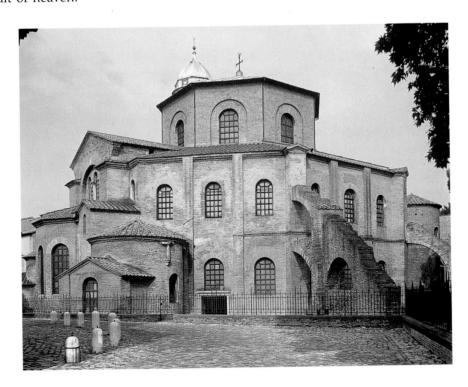

15.6 San Vitale, Ravenna. c. 527-47.

RELATED WORKS

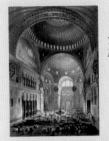

13.16 Interior of Hagia Sophia

13.17 Hagia Sophia

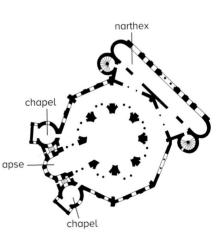

15.7 Plan of San Vitale.

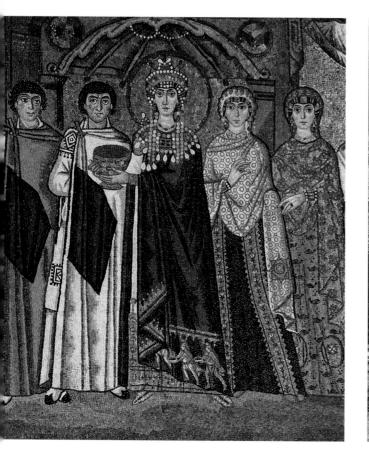

15.8 Empress Theodora and Retinue, detail. San Vitale, Ravenna. c. 547. Mosaic.

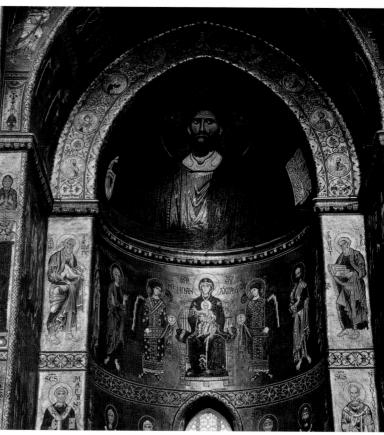

15.9 *Christ as Pantokrator.* Cathedral of Monreale, Sicily. Before 1183. Mosaic.

The interior of San Vitale is decorated in glittering mosaics, including portrayals of the emperor Justinian and the empress Theodora (15.8), under whose patronage the church was built. Like the statue of Constantine we examined earlier (see 15.5), the images conveyed the rulers' symbolic presence in this distant portion of their empire. Mosaic continued as a favored Byzantine technique, resulting in such masterpieces as the interior of the 12th-century Cathedral of Monreale, in Sicily (15.9). Set in the half-dome crowning the apse illustrated here is a large figure of Christ as *Pantokrator*, Greek for "Ruler of All." A standard element of later Byzantine iconography, the *Pantokrator* image emphasizes the divine, awe-inspiring, even terrifying majesty of Christ as opposed to his gentle, approachable, human incarnation as Jesus. Directly below Christ is Mary, the mother of Jesus, enthroned with the Christ child on her lap. She is flanked by angels and saints.

We can see here how Byzantine artists had moved away from the naturalism and realism of Greece and Rome toward a flattened, abstracted style. Like the artists of ancient Egypt, Byzantine artists strove to portray often complex religious doctrines and beliefs, not scenes from daily life. Their subject was not the impermanent Earthly world of the flesh but the eternal and sacred world of the spirit. By de-emphasizing the roundness, the weight, the "hereness" of human bodies in this world, they emphasize that what we are looking at is not in fact *here*, but *there*. The glittering gold background of the mosaics is typical, and it sets the figures in a Byzantine vision of heavenly splendor.

A distinctive form of Byzantine art is the **icon**, named after the Greek word for image, *eikon*. Within the context of Byzantine art, an icon is a specific kind of image, either a portrait of a sacred person or a portrayal of a sacred event. Icons were most commonly painted in tempera on gilded wood panels.

RELATED WORKS

7.17 Mausoleum of Galla Placidia

But other media were also used, including miniature mosaics, precious metals, and ivory (15.10). Ivory was a luxury material in Byzantium, and thus it is likely that this exquisitely carved image was made in Constantinople itself, perhaps for a member of the imperial court. The icon portrays Mary, called the Mother of God, enthroned in majesty, a subject that can also be seen in the mosaic we just examined. As in the mosaic, she displays her son Jesus, who blesses onlookers with his right hand. In his left hand he holds a scroll. Angels appearing from the sky in the upper corners marvel at the sight, spreading their hands in awe. Icons had a mysterious status in the Byzantine world. They were not images as we understand them but points of contact with the sacred realm. Divine power flowed through them into the world, and through them believers could address their prayers to the sacred presence they saw portrayed. Some icons were believed to have been miraculously created, others were believed to have worked miracles.

By the time this icon was carved, vast changes had occurred in the territories that Constantinople was built to rule. Constantine's vision of a unified Roman Empire did not prevail: the territory was simply too vast. His successors partitioned the empire into eastern and western halves, each with its own emperor. Within 150 years, the western empire had fallen, overwhelmed by a massive influx of Germanic peoples arriving from the north and east. Constantinople again claimed authority over the entire empire but could not enforce it. The western Church, based in Rome, preserved its imperial organization and religious authority, but true political and military power had passed to the local leaders of the newcomers, who settled throughout the lands of western Europe. It is to these peoples and their art that we now turn our attention.

The Middle Ages in Europe

The Middle Ages is the name that historians long ago gave to the period in Europe between the defeat of the last western Roman emperor in 476 and the beginnings of the Renaissance in the 15th century. To those early historians, the period was a dark one of ignorance and decline, an embarrassing "middle" time between one impressive civilization and another. Today we view the Middle Ages as a complex and fascinating period worthy of study in its own right. During these centuries, Europe was formed, and a distinctive Christian culture flowered within it. Far from ignorant, it was a time of immense achievement.

The Early Middle Ages

The kingdoms of the early Middle Ages in Europe were inhabited by descendants of migratory tribes that had traveled southward and westward on the continent during the 4th and 5th centuries. Ethnically Germanic, these peoples emerged, for the most part, from the north-central part of Europe, or what today we would call northern Germany and Scandinavia. The Romans referred to them as "barbarians" (meaning "foreigners"). They regarded them as crude, but they also admired their bravery and employed them increasingly as mercenaries. Nevertheless, the massive influx of barbarian tribes into Roman lands—sometimes as settlers, sometimes as invaders and conquerors—brought about the empire's ultimate collapse, near the end of the 5th century.

By the year 600, the migrations were essentially over, and kingdoms whose area roughly approximated the nations of modern Europe had taken form. Their inhabitants had steadily been converted to Christianity. For purposes of this discussion, we will focus initially on the people who settled in two areas—the Angles and Saxons in Britain, and the Franks in Gaul (modern France).

On the island of Britain northeast of London (then Londinium) was Sutton Hoo, where the grave of an unknown 7th-century East Anglian king has been

15.10 Plaque with Enthroned Virgin and Child. Byzantine (Constantinople?), c. 1050–1200. Ivory, with traces of red from original gilding; 10×6^{7} / $8^{"}$. The Cleveland Museum of Art

found. Objects discovered at the burial site include a superb gold-and-enamel purse cover (15.11), with delicately made designs. The motifs are typical of the animal style prevalent in the art of northwestern Europe at that time—a legacy, very likely, from the migratory herdsmen who were these people's ancestors. Animal-style images were often accompanied by interlace, patterns formed by intricately interwoven ribbons and bands. We can see interlace clearly in the upper-center medallion of the Sutton Hoo purse cover, where it is combined with abstracted animals.

Among the most important artistic products of the early Middle Ages were copies of Christian scriptures. In the days before the printing press, each book had to be copied by hand. During the early Middle Ages, this copying was carried out in monasteries, for monks, educated by the Church, were the only literate segment of the population. Monks not only copied texts but also **illuminated** them—furnished them with illustrations and decorations. The full-page illumination here (15.12) was probably made by Irish monks working in Scotland. It announces the beginning of the Gospel of Mark—one of the four accounts in the Bible of the life and works of Jesus—and it shows how the monks adapted animal style and interlace to a Christian setting. At the center of the page is Saint Mark's symbolic animal, the lion. Monks in Scotland could never have seen a lion, of course, and the fanciful creature they have come up with closely resembles the beasts on the cover of the Sutton Hoo purse. The borders of the illumination display the intricate interlace patterns that became a specialty of Irish illuminators.

In France, a different style of art was taking root, called **Carolingian** after the emperor Charlemagne. Charlemagne, or Charles the Great, was a powerful Frankish king whose military conquests eventually gave him control over most of western Europe. Like his father before him, Charlemagne was asked by the pope for military help against the Lombards, a Germanic tribe that had conquered Ravenna and besieged Rome. In 800, he intervened yet again on the pope's behalf, this time to restore order in Rome. On Christmas Day of that year, a grateful pope crowned Charlemagne *Romanorum Imperator*, Emperor of the Romans. It was the first time the title had been used in the West in over 300 years.

Even before being crowned emperor, Charlemagne was well aware of his preeminence among the rulers of Europe. Frankish kings had traditionally moved from palace to palace throughout their realm. Charlemagne, while continuing this custom, also decided to build a permanent and more magnificent capital in Aachen, in present-day Germany. With papal permission, he transported marble, mosaics, and other materials from buildings in Rome and Ravenna for his project. It is likely that he brought artisans as well, who worked side by side with their Frankish colleagues. The chapel from Charlemagne's

15.11 Purse cover, from the Sutton Hoo ship burial. 625-33. Gold with garnets and enamels; length $7\frac{1}{2}$ ". The British Museum, London

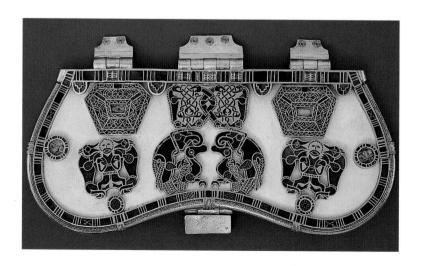

15.12 Page with lion, from the *Gospel Book of Durrow*. Scotland(?), c. 675. Ink and tempera on parchment, $9\frac{5}{8} \times 5\frac{11}{6}$ ". The Board of Trinity College, Dublin

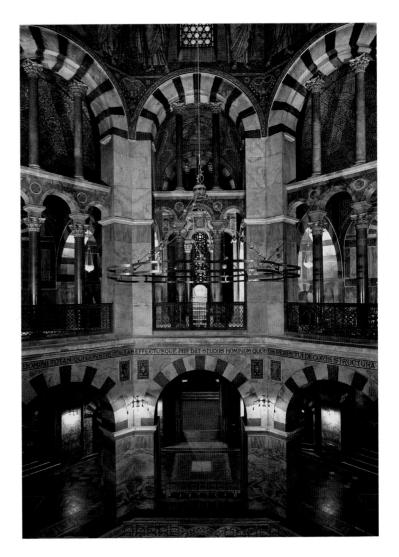

15.13 Interior, Palace Chapel of Charlemagne, Aachen. 792–805.

monumental palace complex has survived, for it was later incorporated into the Aachen Cathedral (15.13).

The basic plan of the chapel was probably inspired by San Vitale in Ravenna, which Charlemagne had visited several times (15.6). It was an appropriate choice for a ruler determined to revive the idea of the Roman Empire. Like San Vitale, the chapel consists of a domed octagonal core with a surrounding aisle and upper gallery. But Charlemagne's architects created a weightier and more rectilinear interior featuring Roman arches set on massive piers, and they covered the aisles with stone vaulting. The central plan of Charlemagne's chapel links it to the many central-plan churches of the Byzantine Empire to the east. The Roman arches, massive piers, and stone vaulting, in contrast, foretell the next style to emerge in Europe, the Romanesque.

The High Middle Ages

The Middle Ages was a time of intense religious preoccupation in Europe. It was during this era that most of the great cathedrals were built. Also, a major portion of the art that has come down to us is associated with monasteries, churches, and cathedrals.

Historians generally divide the art and architecture of the high Middle Ages into two periods: the Romanesque, from about 1050 to 1200, based in ancient Roman architecture, and the Gothic, from about 1200 into the 15th

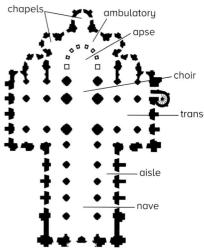

15.15 Plan of Sainte-Foy.

15.14 Aerial view of Sainte-Foy, Conques, France. c. 1050–1120.

century, which was created in northern France and spread from there. (The term "Gothic" derives from the Goths, who were among the many nomadic tribes sweeping through Europe during the 4th and 5th centuries. It was applied to this style by later critics in the Renaissance, who considered the art and architecture of their immediate predecessors to be vulgar and "barbarian.")

The Romanesque period was marked by a building boom. Contemporary commentators were thrilled at the beautiful churches that seemed to be springing up everywhere. Later art historians called the style of these buildings Romanesque, for despite their great variety they shared certain features reminiscent of ancient Roman architecture, including an overall massiveness, thick stone walls, round arches, and barrel-vaulted stone ceilings.

One reason for the sudden burst of building was the popularity of pilgrimages. In the newly prosperous and stable times of the 11th and 12th centuries, people could once again travel safely. Although some made the trip all the way to Jerusalem, in the Holy Land, most confined their pilgrimages to sites associated with Christian saints in Europe. Churches—and also lodgings and other services—arose along the most popular pilgrimage routes as way stations for these large groups of travelers.

The earliest Romanesque pilgrimage church still standing is the Abbey Church of Sainte-Foy, in France (15.14, 15.15). This aerial photograph makes clear the church's cross-form plan. Even from the exterior we can distinguish the nave, the slightly less tall aisles, and the transept. Two square towers flank the entry portal, and an octagonal tower marks the intersection of the transept and the nave. The round arches of the windows are continued in the interior, which has a barrel-vaulted nave and groin-vaulted aisles. The interior of Sainte-Foy is illustrated in Chapter 13 (see 13.10).

The plan (15.15) shows how Romanesque architects modified church design to accommodate large crowds of pilgrims. Aisles now line the transept as well as the nave and continue in a semicircle around the back of the

13.10 Interior, Sainte-Foy

apse, allowing visitors to circulate freely. The aisle around the apse is called an **ambulatory**, Latin for walkway. Small chapels radiate from the ambulatory. The apse itself is now preceded by an area called the choir. Together, apse and choir served as a small "church within a church," allowing monks to perform their rites even as pilgrims visited.

Pilgrims stopping at Sainte-Foy would have come to see the relics of Saint Foy herself, which were kept there in a statue made of gold hammered over a wooden core and set with gems (15.16). Saint Foy, known in English as Saint Faith, was supposed to have been put to death as a young girl, possibly in the

3rd century, for refusing to worship pagan gods. The reliquary statue of Saint Foy is a fine example of the treasures that were offered to and displayed in medieval churches. Another famous work of Romanesque art that was kept for centuries in a church treasury is the Bayeux Tapestry (15.17)-misnamed, because it is actually a work of embroidery. (In the past, large-scale fabrics, especially those hung in buildings, often were loosely called "tapestries," regardless of the construction method.) Embroidery is a technique in which colored yarns are sewn to an existing woven background; frequently the sewing takes the form of decorative motifs or images, as here. The Bayeux Tapestry is like a long picture book-20 inches high and 231 feet long-telling the story of the conquest of England by William of Normandy in 1066. The scene illustrated, one of seventy-two separate episodes reading from left to right, shows a group of Anglo-Saxons, who fought on foot, making a stand on a hill against a Norman cavalry assault. Soldiers and horses tumble spectacularly, and casualties from both sides fill the lower border. Scholars agree that the embroidery seems to have been produced by an English workshop, probably under the patronage of Odo of Bayeux, William's half-brother and Bishop of Bayeux, who is depicted in the tapestry a number of times.

We rarely know exactly where and how architectural styles started. Who "invented" the Romanesque style? Where did it first appear? With the Gothic style that followed it, however, we are in the unusual position of knowing where, when, and how it came about. A powerful French abbot named Suger wanted to enlarge and remodel his church, the Abbey Church of Saint-Denis, near Paris. Inspired by early Christian writings, he came to believe that an ideal church should have certain characteristics: It should appear to reach up to heaven, it should have harmonious proportions, and it should be filled with light. To fulfill those goals, his architects responded with pointed arches, ribbed vaulting, flying buttresses, and stained glass windows so large they seemed like translucent walls. (To review these architectural terms, see Chapter 13, pages 292–93.) Finished in two stages in 1140 and 1144, the graceful, light-filled interior of Saint-Denis immediately attracted attention and imitation.

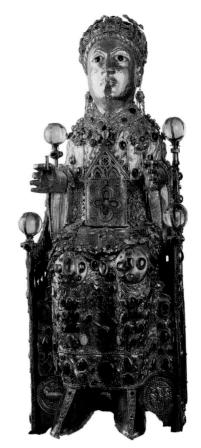

15.16 Reliquary statue of Saint Foy. Late 10th–early 11th century. Gold and gemstones over a wooden core, height 33½".

Cathedral Treasury, Conques, France

in Battle, detail of the Bayeux
Tapestry. Town Hall, Bayeux.
c. 1073–88. Wool embroidery on
linen; height 20", overall length 231'.
Reproduced with special authorization
of the City of Bayeux

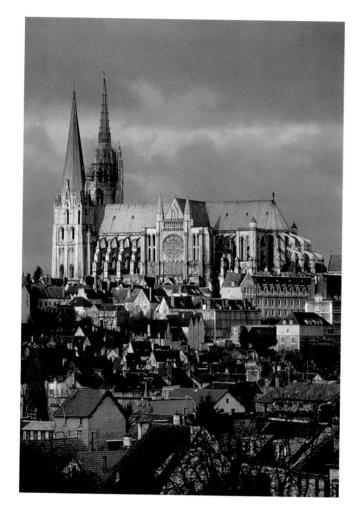

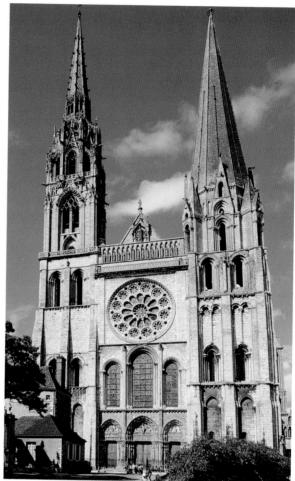

15.18 Chartres Cathedral, France. Begun 1134, completed c. 1260.

15.19 West facade, Chartres Cathedral.

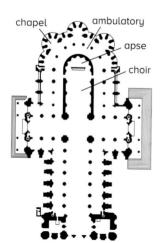

15.20 Plan of Chartres Cathedral.

Gothic style was born, the creation of a brilliant architect whose name the good abbot did not record.

The cathedral at Chartres, in France, shows the soaring quality of Gothic architecture (15.18). Here, the unadorned, earthbound masses of the Romanesque have given way to ornate, linear, vertical elements that direct the eye upward. Clearly visible are the flying buttresses that line the nave and apse to contain the outward thrust of the walls. Because portions of Chartres were built at different times, the cathedral also allows us to see something of the evolution of Gothic style. For example, the first thing most people notice about the facade of the cathedral (15.19) is the mismatched corner towers and spires. The north (left) tower was built first, between 1134 and 1150. Its plain, unadorned surfaces and solid masses are still fundamentally Romanesque. The south (right) tower and its spire were completed next, between 1142 and 1160. Designed in the very earliest Gothic style, they are conceived so that each level grows out of the one before, and all the elements work together to lead the eye upward.

The towers, south spire, and facade had originally been built as additions to an older Romanesque church that stood on the site. When a fire in 1194 burned this church to the ground, it was rebuilt over the course of the next sixty years in the Gothic style we see today. The plan (15.20) shows the familiar cross form, but the choir and ambulatory have taken on much larger proportions compared with those at Sainte-Foy. The soaring, open spaces of the interior were created with ribbed vaulting and pointed arches much like those we saw in Chapter 13 in the cathedral at Reims, built around the same time (see 13.11). The final addition to Chartres was the north (left) spire. Built in the early 16th century, it illustrates the last phase of Gothic style—a slender, elongated, and highly ornamental style called Flamboyant, French for "flamelike."

Sculpture in the Middle Ages was often created to embellish architecture. Over two thousand carved figures decorate the exterior of the Chartres Cathedral. Concentrated especially around principal entryways, they serve as a transition between the everyday world of the town and the sacred space within, forming a sort of "welcoming committee" for the faithful as they enter. Like the architecture itself, the sculptures were created at different times, and in them, too, we can appreciate the evolution of Gothic style.

Early Gothic style can be seen in the elongated and flattened bodies of these 12th-century carvings from the principal entry of the cathedral (15.21). In fact, it is difficult to believe that there are actual bodies under the draperies at all. The linear folds of the draperies are not so much sculpted as incised—drawn into the stone with a chisel. We can think of them as a sculptural equivalent of the garments in the Byzantine mosaic we looked at earlier (see 15.9), created around the same time.

Carved a mere hundred years later, this second group of figures (15.22) displays the mature Gothic style. Whereas the bodies of the earlier statues took the form of the columns they adorned, the bodies here are more fully rounded and have begun to detach themselves from their architectural supports. The three saints on the right still seem to float somewhat, as though suspended in midair, but the figure of Saint Theodore at the far left truly stands, his weight on his feet. A sense of underlying musculature is evident in armor covering his arms, and his garment, although not yet fully naturalistic, is carved with an awareness of a body underneath. It will remain for another era to conceive of the body first, and then figure out how clothing would drape over it.

15.21 Door jamb statues, west facade, Chartres Cathedral. c. 1145–70.

15.22 Saints Theodore, Stephen, Clement, and Lawrence, door jamb, south transept, Chartres Cathedral. 13th century.

15.23 Rose window and lancets, north transept, Chartres Cathedral. 13th century. Diameter of rose window, 42'.

The glory of Gothic cathedrals is their magnificent stained glass. Chartres contains over 150 stained glass windows. Their motifs include stories from the Bible, lives of the saints, signs of the zodiac, and donors from every level of society, from knights and nobles to tradespeople such as butchers and bakers. Among the most resplendent medieval windows are the great, radiating, circular groupings called rose windows (15.23). This rose window, one of three at Chartres, is dedicated to Mary, the mother of Jesus. She is depicted at its center enthroned as the Queen of Heaven. Radiating from her are windows portraying doves and angels, biblical kings, symbols of French royalty, and prophets. Like the gold of Byzantine mosaics, the gemlike colors of stained glass represent a medieval vision of heavenly splendor.

Although all art of the Middle Ages was imbued with Christian culture, not all of it was made for religious settings. Royal and noble households and, as the period drew to its close, wealthy middle-class families would have owned not only paintings and carvings of religious subjects for private devotion but also fine carved furniture, illuminated books, and objects to grace daily life such as the aquamanile illustrated in Chapter 12 (see 12.6). But the most treasured medieval possessions, more valuable by far than paintings, were tapestrieslarge woven hangings (15.24). Often created in cycles that told a story or followed a theme, sumptuous tapestries were hung in great halls and private chambers. The tapestry illustrated here is from a cycle of six hangings known as The Lady and the Unicorn, woven for a member of a wealthy French family named Le Viste toward the end of the 15th century. The unicorn is a mythical beast that, according to legend, can be tamed only by a beautiful young girl. Here, it also stands in for Le Viste himself in amorous pursuit. The lion, too, signals Le Viste's presence by holding up a standard bearing the family coat of arms. Five of the tapestries are devoted to the five senses. The subject of the tapestry here is smell: a servant offers a basket of flowers, while on the bench behind the lady, a monkey sniffs at a blossom he has stolen.

15.24 Smell, from The Lady and the Unicorn. Late 15th century. Wool and silk, $12''/2'' \times 10'63/4''$. Musée National du Moyen Age—Thermes de Cluny, Paris

15.25 Duccio. *Christ Entering Jerusalem*, detail of *Maestà Altar*. 1308–11. Tempera on panel, 40 × 21". Museo dell'Opera, Siena

Toward the Renaissance

The Gothic style lasted in northern Europe into the early 16th century. By that time, however, it was overlapping with far different ideas about art that had their origins in the south, in Italy. Living in the heart of what was the ancient Roman Empire, Italians were surrounded with the ruins of the Classical world. More treasures lay buried in the earth, awaiting excavation. All that was needed was an intellectual climate that encouraged an interest in such things. That climate eventually arose, and we call it the Renaissance. But the Renaissance did not happen all at once. Many developments prepared the way, some in scholarship, some in political thought, others in art.

The last two artists in this chapter were influential in making the shift from art styles of the Middle Ages to the quite different styles of the Renaissance. Duccio was an artist of Siena, in Italy. His masterpiece was the Maestà Altar, a multisection panel meant to be displayed on the altar of a church, of which we illustrate the part showing Christ Entering Jerusalem (15.25). What is most interesting about this painting is Duccio's attempt to create believable space in a large outdoor scene-a concern that would absorb painters of the next century. Christ's entry into the city, celebrated now on Palm Sunday, was thought of as a triumphal procession, and Duccio has labored to convey the sense of movement and parade. A strong diagonal thrust beginning at the left with Christ and his disciples cuts across the picture to the middle right, then shifts abruptly to carry our attention to the upper left corner of the painting—a church tower that is Christ's presumed goal. The architecture plays an important role in defining space and directing movement. This was Duccio's novel, almost unprecedented, contribution to the art of the period, the use of architecture to demarcate space rather than to act as a simple backdrop.

15.26 Giotto. *The Lamentation*, detail from the Scrovegni Chapel, Padua. c. 1303–05. Fresco.

Duccio's contemporary, a Florentine artist named Giotto, made an even more remarkable break with art traditions of the Middle Ages. In his most famous work, the cycle of frescoes on the walls of the Scrovegni Chapel, in Padua, Giotto used a grid of decorative bands to create three registers of rectangular picture spaces. In each picture space, he painted an episode from the life of the Virgin Mary. One episode is The Lamentation (15.26), which depicts Mary, Saint John, and others mourning the dead Christ. The scene has been composed as though it were on a stage and we the viewers are an audience participating in the drama. In other words, space going back from the picture plane seems to be continuous with space in front of the picture plane, the space in which we stand. Accustomed as we are now to this "window" effect in painting, it is difficult to imagine how revolutionary it was to medieval eyes, used to predominantly flat, decorative space in painting. Moreover, Giotto seems to have developed this concept of space largely on his own, with little artistic precedent. The figures in The Lamentation are round and full-bodied, clustered low in the composition to enhance the effect of an event taking place just out of our reach.

Giotto's grouping of the figures is unusual and daring, with Christ's body half-hidden by a figure with its back turned. This arrangement seems casual and almost random, until we notice the slope of the hill directing attention to Christ's and the Virgin's heads, which are the focal point. Yet another innovation—perhaps Giotto's most important one—was his interest in depicting the psychological and emotional reactions of his subjects. The characters in *The Lamentation* interact in a natural, human way that gives this and the artist's other religious scenes a special warmth.

Neither Duccio nor Giotto had an especially long career. Each did his most significant work in the first decade of the 14th century. Yet in that short time the course of Western art history changed dramatically. Both artists had sought a new direction for painting—a more naturalistic, more human, more engaging representation of the physical world—and both had taken giant steps in that direction. Their experiments paved the way for a flowering of all the arts that would come in the next century.

The Renaissance

hroughout the Middle Ages, painters were considered skilled crafts workers on a level with goldsmiths, carpenters, and other tradespeople. By the mid-16th century, in contrast, Michelangelo could claim that "in Italy great princes as such are not held in honor or renown; it is a painter that they call divine." From anonymous crafts workers to divinely talented individuals more honored and renowned than princes—what had happened?

The simplest answer is that Michelangelo lived and worked during the time that we call the Renaissance. Covering the period roughly from 1400 to 1600, the Renaissance brought vast changes to the world of art. The way art looked, the subjects it treated, the way it was thought about, the position of the artist in society, the identities and influence of patrons, the cultures that served as points of reference—all these things changed. We might even say that the Renaissance was the time when the concept of "art" began to take shape, for it was during these centuries that painting, sculpture, and architecture began to earn their privileged positions in Western thought.

The word *renaissance* means "rebirth," and it refers to the revival of interest in ancient Greek and Roman culture that is one of the key characteristics of the period. Scholars of the day worked to recover and study as many Greek and Latin texts as possible. Referring to themselves as humanists, they believed that a sound education should include not only the teachings of the Church and the study of early Christian writers but also the study of the liberal arts—grammar, rhetoric, poetry, history, politics, and moral philosophy—about which the pre-Christian world had much to teach.

Renaissance humanists believed in the pursuit of knowledge for its own sake. Above all, they held that humankind was not worthless in the eyes of God, as the Church had taught during the Middle Ages. Rather, humankind was God's finest and most perfect creation. Reason and creativity were God's gifts, proof of humankind's inherent dignity. People's obligation to God was thus not to tremble and submit but, rather, to soar, striving to realize their full intellectual and creative potential.

The implications of these ideas for art were tremendous. Artists became newly interested in observing the natural world, and they worked to reproduce it as accurately as possible. Studying the effects of light, they developed the technique of chiaroscuro; noting that distant objects appeared smaller than near ones, they developed the system of linear perspective; seeing how detail and color blurred with distance, they developed the principles of atmospheric perspective.

The nude reappeared in art, for the body was held to be the noblest of God's creations. "Who is so barbarous as not to understand that the foot of a man is nobler than his shoe," said Michelangelo, "and his skin nobler than that of the sheep with which he is clothed?" To portray the body with understanding, artists studied anatomy, even going so far as to dissect cadavers.

Under the influence of the ancient Greek philosopher Plato, whose works were newly available, beauty became equated with moral goodness. Renaissance artists sought an idealized beauty, one they created by taking the most beautiful features of numerous examples and combining them. "Be on the watch to take the best parts of many individual faces," wrote Leonardo da Vinci.³ And the German Renaissance painter Albrecht Dürer advised the same: "You, therefore, if you desire to compose a fine figure, must take the head from some, the chest, arm, leg, hand, and foot from others. . . . For from many beautiful things something good may be gathered, even as honey is gathered from many flowers."⁴

The ten-volume treatise on architecture by the Roman writer Vitruvius was read avidly in an attempt to understand Classical thought and practice, including ideas about beauty and harmonious proportions. Roman ruins still standing were studied in detail—described, measured, analyzed, and drawn. Excavations revealed still more examples, along with astonishing statues such as the *Laocoön Group* (see 14.29), which served as an inspiration and ideal for Renaissance artists.

Perspective and chiaroscuro, close observation of nature, the study of anatomy, theories of beauty and proportion—these established painting, sculpture, and architecture as intellectual activities allied with science, rhetoric, music, and mathematics. Artists were no longer mere crafts workers, but learned persons whose creative powers were viewed as almost miraculous. The greatest artists were considered a breed apart, constituting a class of their own that transcended the social class determined by birth—not nobility, not

bourgeoisie, not clergy, but a separate and elite category of people respected not because of who they were but because of what they could do. They lived in the courts of the nobles and the popes, they moved freely in good society, their company was sought after, their services in demand.

The character of art patronage reflected the changing times. Before the Renaissance, only two groups of people could afford to be art patrons—the nobility and the clergy. Both continued to be active sponsors of art, but they were joined in the 15th century by a new class of merchant-rulers, very rich, socially ambitious, fully able to support extravagant spending on art.

The Early and High Renaissance in Italy

Why did the Renaissance begin in Italy and not elsewhere? Scholars have offered many reasons. First, Italy had been among the first areas to recover economically from the chaos of the early Middle Ages. Powerful city-states engaged in extensive trade and banking had developed. Wealthy, independent, and fiercely competitive, the city-states would vie with one another to engage the finest artists, as would the merchant-princes whose fortunes sustained them. The Church, also an important patron of the arts, was centered in Italy as well. Humanism arose first in Italy, and it was in Italy that the first university position in Greek studies was established. Finally, Italians had long lived amid the ruins of ancient Rome, and they viewed themselves as the direct descendants of the citizens of the earlier civilization. If anyone could bring back its glories, surely it was they.

Among the first generation of Renaissance artists, the finest sculptor by far was Donatello. His statue of *St. Mark* (16.1), an early work, shows the characteristics of this new era, especially if we compare it with the statue of Saint Theodore from Chartres Cathedral, carved during the High Middle Ages (see 15.22). Whereas Gothic sculptors carved what they observed from the surface—face, clothing, limbs—Donatello thought methodically in the new way: the body provides the framework on which the fabric drapes, and therefore it must be considered first. Renaissance sculptors often created a full-scale model of a nude figure in clay, then draped clay-soaked linen about it to create garments, arranging the folds before the fabric dried. This model was then copied in marble. Scholars believe that Donatello was one of the first sculptors to use this method.

The statue is placed in a niche, but unlike most architectural sculptures from the Middle Ages, it does not depend on this framework for support. Rather, the fully rounded figure stands independently in true contrapposto, the weight on the right leg, left leg bent. The shoulders compensate: right shoulder lower, left shoulder higher. The clothing responds to the form underneath. Where the left knee bends outward, the robe falls back; where the right arm is pressed to the body, the sleeve wrinkles. We sense that if Saint Mark moved, the garments would move with him. The figure is as naturalistic as any ancient Greek statue, yet there is a stamp of individual personality in both face and body that may have come from Donatello's reading of Mark's Gospel.

Donatello's teacher was an artist named Lorenzo Ghiberti, who had established his reputation in 1401 by winning a competition to design a set of bronze relief sculptures for the doors of the baptistery of the cathedral in his native town of Florence. In 1425 a second set of doors was commissioned from Ghiberti. In between those two dates, the system of linear perspective had been discovered, described, and published. Ghiberti took full advantage of the possibilities opened up by the new discovery, as we can see in *The Story of*

16.1 Donatello. *St. Mark.* 1411–13. Marble, height 7'9". Or San Michele, Florence

RELATED WORKS

5.27 Alberti, Sant'Andrea

Jacob and Esau (16.2), one of the ten panels he executed for this second set of doors. The graceful, rounded figures in the foreground stand on a pavement whose converging lines begin a recession in space that is carried systematically through the architectural setting sculpted in low relief in the background. Renaissance artists used this new, rationally conceived space to bring clarity and order to their compositions, two qualities that Greek philosophy associated with beauty.

Artists had long used architectural settings to structure their compositions. Ghiberti's great innovation was to conceive of the architecture and the figures on the same scale instead of relying on the miniaturized, symbolic architecture of earlier artists such as Duccio (see 15.25). Ghiberti quite rightly

16.2 Lorenzo Ghiberti. *The Story of Jacob and Esau*, detail from the doors to the Baptistery of St. John, Florence ("The Gates of Paradise"). c. 1435. Gilt bronze, 31¼" square. Museo dell'Opera del Duomo, Florence

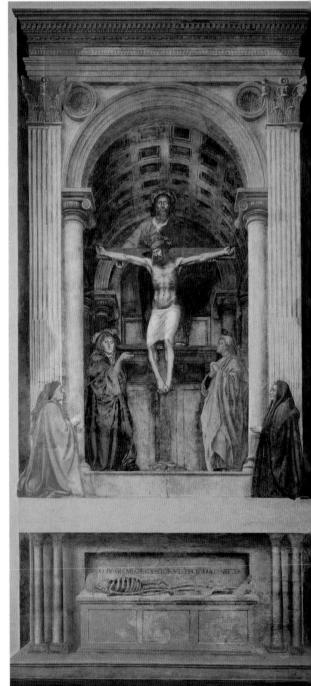

16.3 Masaccio. Trinity with the Virgin, St. John the Evangelist, and Donors. Santa Maria Novella, Florence. 1425. Fresco, 21'9" × 9'4".

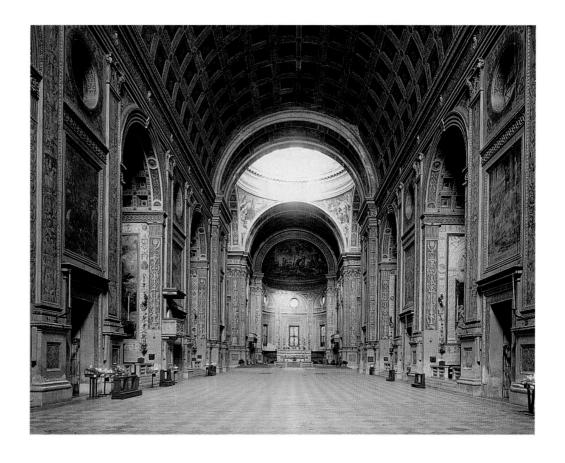

boasted of this in his *Commentaries*. "I executed this work with the most painstaking and loving care," he wrote, ". . . with the buildings drawn with the same proportions as they would appear to the eye and so true that, if you stand far off, they appear to be in relief. Actually they are in very low relief. The figures in the foreground look larger and those in the distance smaller, just as they do in reality."⁵

The youth of the great innovators of the Renaissance can sometimes astonish us. Donatello was twenty-five when he began work on *St. Mark*; Ghiberti was twenty-three when he won the competition for the baptistery doors. Our next artist, Masaccio, transformed the art of painting at age twenty-four with his fresco *Trinity with the Virgin, St. John the Evangelist, and Donors* (16.3) in the church of Santa Maria Novella in Florence. Masaccio does here for painting what Ghiberti did for sculpture in relief, using the new technique of linear perspective to construct a deep, convincing architectural space as a setting for his figures.

Masaccio has arranged the figures in a stable triangle that extends from the head of God the Father, who stands over the dead Christ, through the two donors who kneel to either side of the holy grouping and outside their sacred space. Triangular (or pyramidal) organization would remain a favorite device of Italian Renaissance artists. Earlier in this book, we noticed it in Raphael's *The Madonna of the Meadows* (see 4.16). Masaccio's composition is organized by a vanishing point located directly under the cross, at the midpoint of the ledge on which the donors kneel. Five feet above the floor, it is at the eye level of an average viewer. To visitors to the church, the painting thus is designed to present as convincing an illusion as possible that the sacred scene is really present before them.

Even the architectural setting that Masaccio has painted is in the new Renaissance style. We can see the sort of interior that inspired him in the church of Sant'Andrea in Mantua (16.4, 16.5), by the architect Leon Battista

16.4 Leon Battista Alberti. Interior, Sant'Andrea, Mantua. 1470–93.

16.5 Plan of Sant'Andrea.

Alberti. In Chapter 5, we examined the rhythms of the facade of this church (see 5.27). The photograph at 16.4 is taken looking up the nave toward the apse; the light in the middle distance is entering through the dome that rises over the intersection of the transept and the nave.

Sant'Andrea was Alberti's last work. Construction began in 1472, the year of his death. The facade and the nave were largely complete by 1488. The rest was constructed in stages, finally reaching completion over two centuries later. The interior allows us to see how Alberti developed the themes and elements announced by his facade. As in the facade, the square, arch, and circle dominate. The aisles of the standard basilica plan have given way to a procession of square, barrel-vaulted chapels along a majestic barrel-vaulted nave. This sequence of barrel-vaulted spaces placed at right angles to each other carries through the theme announced in the entryway while also preparing us for the grander right-angle crossing of the transept. The roundel (circular area) set in the pediment of the facade and again over its doors is repeated on the walls of the nave between the chapels and culminates with the great circular opening of the dome. The vast interior space composed of geometric volumes harks back to Roman examples such as the Pantheon (see 13.13).

In addition to Christian themes, **Renaissance** artists turned to stories of Greek and Roman gods and goddesses for subject matter, as did many Renaissance poets. An example is *The Birth of Venus* (**16.6**), by Sandro Botticelli. Born in 1445, Botticelli belonged to the third generation of Renaissance artists. Early in his career, he had the great fortune to enjoy the patronage of the Medici, the ruling merchant family of Florence, who probably commissioned this painting.

16.6 Sandro Botticelli. *The Birth of Venus*. c. 1480. Tempera on canvas, 6'7" × 9'2".
Galleria degli Uffizi, Florence

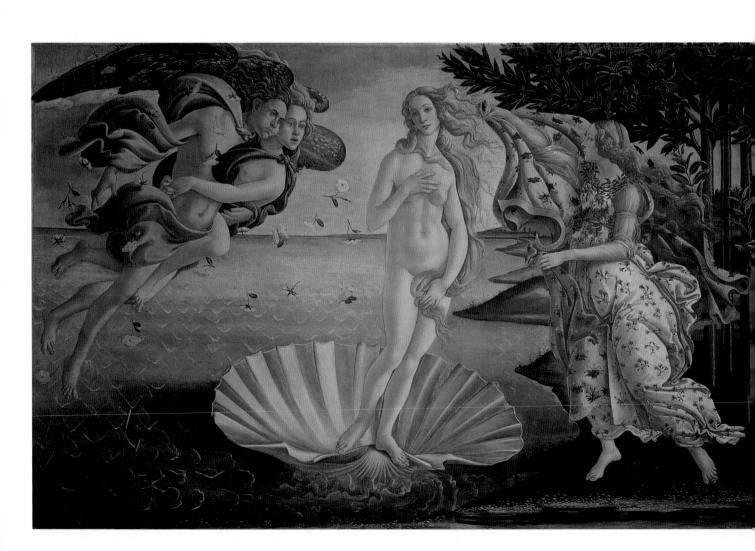

The Medici sponsored an Academy-a sort of discussion group-where humanist scholars and artists met to discuss Classical culture and its relationship to Christianity. The reconciliation of these two systems of thought gave rise to a philosophy known as Neo-Platonism, after the Greek philosopher Plato.

Venus was the Roman goddess of love and beauty. According to legend, she was born from the sea, and so Botticelli depicts her on a floating shell. The wind god Zephyr and his wife blow her gently toward the shore, where a figure representing spring waits ready to clothe Venus in a flowing garment. Botticelli paints the goddess in the nude, with strategically placed hands and a tress of hair the only concessions to modesty. Such a large-scale depiction of the female nude in art had been virtually unknown since Classical times. Venus' pose is modeled after a Roman sculpture of the goddess, which Botticelli had studied in the Medici collection, but her lightness, her fragile quality, her delicate beauty and billowing hair-these are Botticelli's own.

Although Botticelli's unusual linear style and shallow modeling was an exception to Renaissance norms, it was highly appreciated by the Medici circle. Venus, for example, looks as though she might be modeled in high relief, but not fully rounded. The implied space is shallow, with the sea and receding shoreline serving almost as a flat backdrop, as in a theatrical production. Medici intimates would also have understood the subtle Neo-Platonic overtones of the scene. In Neo-Platonic thought, Venus was identified with both Eve and the Virgin Mary; her birth from the water was related to the baptism of Christ by John the Baptist. Botticelli's work displays the rarefied and learned side of Renaissance art. It was painted not for a large public but for a cultivated audience of initiates.

We come now to a period known as the High Renaissance-a brief but glorious time in the history of art. In barely twenty-five years, from shortly before 1500 to about 1520, some of the most celebrated works of Western art were produced. Many artists participated in this brilliant creative endeavor, but the outstanding figures among them were unquestionably Leonardo da Vinci and Michelangelo.

The term "Renaissance man" is applied to someone who is very well informed about, or very good at doing, many different, often quite unrelated, things. It originated in the fact that several of the leading figures of the Renaissance were artistic jacks-of-all-trades. Michelangelo was a painter, sculptor, poet, architect-incomparably gifted at all. Leonardo was a painter, inventor, sculptor, architect, engineer, scientist, musician, and all-round intellectual. In our age of specialization, those accomplishments seem staggering, but during the heady years of the Renaissance nothing was impossible.

Leonardo is the artist who most embodies the term "Renaissance man"; many people consider him to have been the greatest genius who ever lived. Leonardo was possessed of a brilliant and inquiring mind that accepted no limits. Throughout his long life he remained absorbed by the problem of how things work, and how they might work. A typical example of his investigations is the well-known Study of Human Proportions (see 5.20), in which the artist sought to establish ideal proportions for the human body by relating it to the square and the circle. Above and below the figure is Leonardo's eccentric mirror writing, which he used in his notes and journals.

Leonardo's interest in mathematics is also evident from his careful rendering of perspective. In Chapter 4, we examined his masterpiece The Last Supper (see 4.45), which uses one-point linear perspective to organize the many figures in the composition and set them into deep space. Yet another interest, experimental painting techniques, served the artist less well in The Last Supper. Rather than employing the established fresco method, Leonardo worked in a medium he devised for the Last Supper project, thus dooming his work to centuries of restoration (page 107).

In spite of his vast accomplishments, Leonardo often had difficulty completing specific projects. Many of his most ambitious works were left unfinished, including this lovely painting of the Madonna and Child with St. Anne

RELATED WORKS

2.4 Leonardo, Mona Lisa

4.20 Leonardo, Virgin and St. Anne

4.45 Leonardo, The Last Supper

5.20 Leonardo, Study of Human Proportions

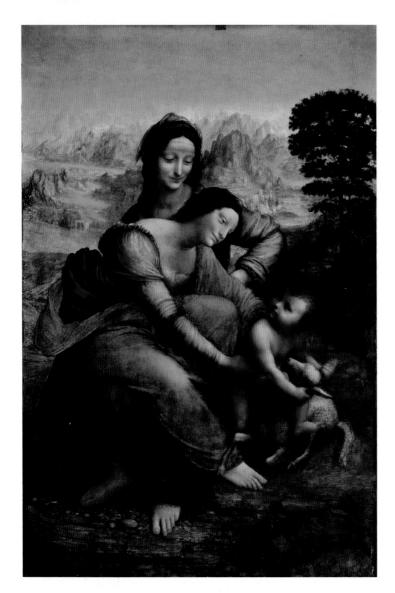

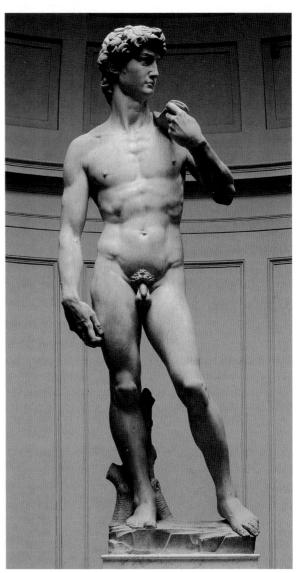

16.8 Michelangelo. *David*. 1501–04. Marble, height 18'. Galleria dell'Accademia, Florence

(16.7). Leonardo has arranged his figures in a triangular grouping by having the Virgin Mary, a grown woman, sit rather improbably on the lap of her mother, Saint Anne. As so often with Leonardo, the composition is not meant to be realistic but, rather, to suggest theological meanings. The three figures form a single unit because they are a single lineage. Looking at the image, our gaze falls across the generations, from Saint Anne to her daughter Mary to Mary's son Jesus. Jesus attempts to climb onto a lamb, a symbol of his future sacrifice. (The lamb was a sacrificial animal, and Jesus is thus referred to as the Lamb of God.) He exchanges a look with his mother, as though both know what his destiny holds. She tenderly holds him back, as if to say, "Yes, soon enough, but not yet." Leonardo destabilizes his triangular grouping by plunging the lower left corner into darkness, then restores the balance by placing a dark tree at the upper right, an allusion to the cross on which Jesus will die. In the background is an uninhabited, primal landscape of rocks and water, suggesting perhaps the creation of the world and the beginning of time. The entire scene is bathed in the gentle light of sfumato (derived from the Italian for "smoke"), Leonardo's specialty, in which layer upon layer of translucent glazes produce a hazy atmosphere, softened contours, and velvet shadows.

Leonardo was based in Florence at the time he painted *Madonna and Child with St. Anne.* Living there as well was Michelangelo, a quarter-century

younger yet already thought of as Leonardo's rival in greatness. Michelangelo had established his reputation as a sculptor by the age of twenty-five. A year later he received the commission for a colossal image of the biblical hero David (16.8), the young Hebrew shepherd who killed the giant Goliath with a single stone from his slingshot. The *David* statue reveals Michelangelo's debt to Classical sculptures. *David* is not, however, a simple restatement of Greek art. The Greeks knew how bodies looked on the outside. Michelangelo knew how they looked on the inside, how they worked, because he had studied human anatomy and had dissected corpses. He translated this knowledge into a figure that seems made of muscle and flesh and bone, though all in marble.

There are other characteristics that make *David* a Renaissance sculpture, not a copy of a Greek one. For one thing, it has a tension and an energy that are missing from Greek art. Hellenistic works such as the *Laocoön Group* (see 14.29) expressed these qualities through physical contortions, but to have this energy coiled within a figure standing quietly was new. David is not so much standing in repose as standing in readiness. Another Renaissance quality is the expression on David's face. Classical Greek statues tended to have calm and even vacant expressions. But David is young and vibrant—and angry, angry at the forces of evil represented by the giant Goliath. Contemporary Florentines found David a fitting emblem for their small but proud city, which had recently battled giants by expelling the ruling Medici family and then founding a republic. They placed the statue in the city square in front of the seat of the new government. (It has since been moved indoors.)

Not long after completing the *David*, Michelangelo embarked on the masterpiece that has become his best-known work, the ceiling frescoes of the Sistine Chapel in the Vatican, in Rome (16.9). He had been called to Rome by Pope Julius II, who wanted the artist to design his tomb, a large monument with numerous sculptures. Michelangelo set to work, but a year later Julius abandoned that project and proposed instead to use the artist's skills as a painter. Michelangelo, whose distaste for painting is well documented, resisted the plan, but in the end he was forced to capitulate.

16.9 Interior, Sistine Chapel, showing frescoes by Michelangelo (scenes from Genesis on the ceiling, 1508–12; the Last Judgment on the far wall, 1535–41) and by Pietro Perugino, Sandro Botticelli, Domenico Ghirlandaio and others (scenes from the lives of Moses and Jesus on the side walls, 1481–82).

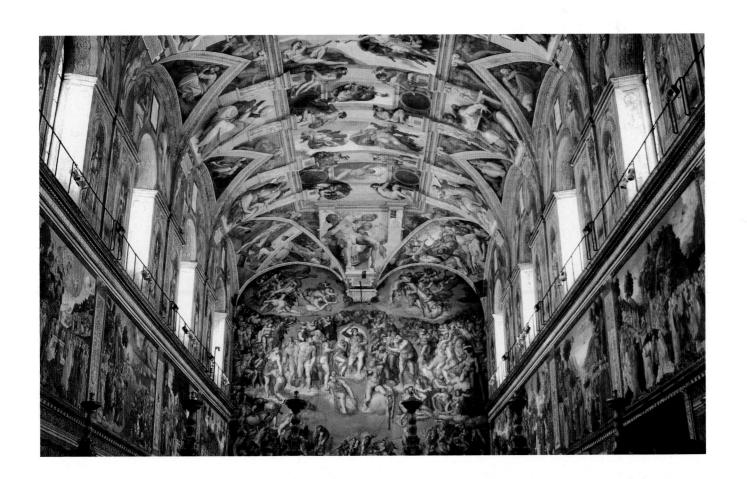

The Sistine Chapel, named after an earlier pope called Sixtus, has a high vaulted ceiling 128 feet long and 44 feet wide. Under Sixtus it had been decorated with a fresco of gilt stars on a deep blue ground. Along the sides were painted niches set with standing figures representing Christ, Saints Peter and Paul, and thirty popes that had been canonized as saints. All of this Julius wanted taken down and replaced with a new fresco. (To review the technique of fresco, see page 159.) Michelangelo signed the contract in 1508 and began work immediately—making detailed drawings, ordering pigments, overseeing the design and construction of the scaffolding, and assembling a team of a dozen or so assistants. The assistants would procure supplies, grind colors, prepare the plaster surface, prepare and transfer the cartoons, and paint repetitive or decorative elements, leaving Michelangelo free to paint everything else. Day after day for the next four years, Michelangelo and his assistants stood side by side on the scaffolding, painting the ceiling just overhead.

To tame the vast expanse of the ceiling vault, Michelangelo invented an illusionistic architecture (16.10). Painted to look like stone, its lintels, cornices, pedestals, and supporting sculptural figures create a large grid that divides the surface into discrete zones. In the niches thus created along the sides, Michelangelo portrayed Old Testament prophets and ancient Greek sybils—women gifted with prophecy. All were believed to have predicted the coming of Christ. Along the central spine of the ceiling, the painted architecture frames a series of nine pictorial spaces. Here, Michelangelo depicted scenes from Genesis, from the creation of the world through the story of Noah and the Flood. The detail of the ceiling illustrated here shows, from bottom to top: God, his hands

16.10 Michelangelo. Sistine Chapel ceiling, detail showing, from bottom to top: God Dividing the Waters from the Dry Land, with the Persian Sybil (left) and Daniel (right); The Creation of Adam; The Creation of Eve, with Ezekiel (left) and the Cumaean Sybil (right). 1508–12. Fresco.

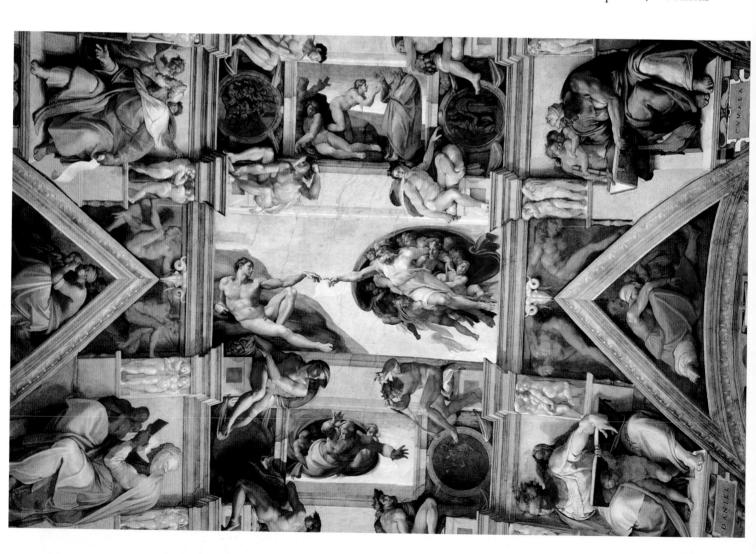

ARTISTS Michelangelo (1475-1564)

What are the benefits and the constraints of having patrons? How does Michelangelo depict the human figure through sculpture? Why the human body as a subject of intense study?

e is beyond legend. His name means "archangel Michael," and to his contemporaries and those who came after, his stature is scarcely less than that of a heavenly being. He began serious work as an artist at the age of thirteen and did not stop until death claimed him seventy-six years later. His equal may never be seen again, for only a particular time and place could have bred the genius of Michelangelo.

Michelangelo Buonarroti was born in the Tuscan town of Caprese. According to his devoted biographer and friend, Giorgio Vasari, the young Michelangelo often was scolded and beaten by his father for spending too much time drawing. Eventually, however, seeing his son's talent, the father relented and apprenticed him to the painter Domenico Ghirlandaio. At the age of fourteen, Michelangelo was welcomed into the household of the wealthy banker Lorenzo de' Medici, who operated a private sculpture academy for promising young students. There he remained until Lorenzo's death, after which Michelangelo, just seventeen years old, struck out permanently on his own.

He traveled to Venice and Bologna, to Florence, then finally to Rome, where he attracted the first of what would become a long list of patrons among the clergy. A *Pietà* (Virgin mourning the dead Christ) made in 1500 and now in St. Peter's established his reputation as a sculptor. Within a dozen years after that, he had completed the two works most closely associated with his name: the *David* statue and the ceiling frescoes in the Sistine Chapel.

From his teen years until his death, Michelangelo never lacked for highly placed patrons. He served—and survived—six popes, and in between accepted commissions from two emperors, a king, and numerous members of the nobility. All his life he struggled to keep a balance between the work he wanted to do and the work demanded of him by his benefactors. His relationships with these powerful figures were often stormy, marked by squabbles about payment, insults given and forgiven, flight from the scene followed by penitent return.

Michelangelo served these masters, at various times, as painter and architect, but he considered himself above all to be a sculptor. Much of his time was spent supervising the quarrying of superior stones for sculptural projects. His greatest genius lay in depictions of the human figure, whether in marble or in paint. Vasari writes that "this extraordinary man chose always to refuse to paint anything save the human body in its most beautifully proportioned and perfect forms." To that end, Michelangelo made extensive anatomical studies and dissected corpses to better understand the inner workings of the body.

Michelangelo formed a number of passionate attachments during his life. These inspired the artist, always a sensitive and gifted poet, to write numerous sonnets. One of his most poignant verses, however, was written as a commentary on his labors up on the scaffold under the Sistine Chapel ceiling. We might find it amusing if it were not so heartfelt:

I've grown a goiter by dwelling in this den—
As cats from stagnant streams in Lombardy,
Or in what other land they hap to be—
Which drives the belly close beneath the chin;
My beard turns up to heaven; my nape falls in,
Fixed on my spine; my breast-bone visibly
Grows like a harp: a rich embroidery
Bedews my face from brush-drops thick and thin. ⁶

Workshop of Frans Floris. *Portrait of Michelangelo Buonarroti*. 16th century. Oil on wood, diameter 11¾". Kunsthistorisches Museum, Vienna.

16.11 Michelangelo. St. Peter's Basilica, Vatican. c. 1546–64 (dome completed 1590 by Giacomo della Porta).

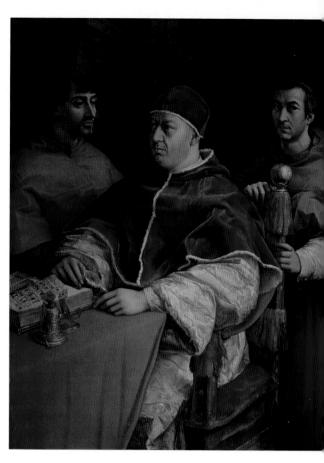

16.13 Raphael. *Pope Leo X with Two Cardinals*. c. 1518. Oil on wood, $5'\%'' \times 3'8\%''$. Galleria degli Uffizi, Florence

16.12 Plan of St. Peter's.

outstretched, his cloak billowing, looking down at the Earth as he separates the waters from the dry land; the creation of Adam, with the dynamic figure of God about to pass the spark of life to the languid first man; and God creating Eve as Adam slumbers. The Genesis scenes alternate rhythmically in size across the ceiling—large, small, large, small—creating the effect of a pulse or a heartbeat. The small scenes are framed by four nude youths holding garlands and ribbons that support bronze shields, painted as though decorated with reliefs illustrating still more biblical scenes. The youths are known by the Italian name for them, *ignudi*, and their meaning is much debated. They may be some kind of perfected beings, perhaps even angels.

The ceiling frescoes were an immediate success, and Michelangelo continued as a papal favorite, although his commissions were not always in his preferred line. Just as Pope Julius had urged the sculptor to work as a painter, one of Julius' successors, Pope Paul III, encouraged the sculptor to work as an architect. In 1546 Paul named Michelangelo the official architect of the new St. Peter's, one of the four most important churches in Rome. This structure would be erected on the site of *old* St. Peter's (see 15.2), dating from the early Christian era in the 4th century. By the time he began work on the project, Michelangelo was an old man, well into his seventies and physically tired, but his creative vigor was undiminished.

Construction on the new church had already begun, based on a plan by an architect named Bramante, who had died in 1514. Michelangelo revised Bramante's plan, gathering its elaborate fussiness into a bold and harmonious design (16.11, 16.12). Central and cross plans here merge in a new idea that relates the powerfully symbolic cross to the geometric forms that Renaissance artists loved, the square and the circle. Michelangelo did not live to see his church finished. The magnificent central dome was completed after his death

by another architect, who modified its silhouette. During the 17th century, the nave was lengthened and the facade remodeled. The photograph illustrated here, however, was taken from the rear of the church and shows the building that Michelangelo conceived. An organic whole with pulsating contours and a powerful upward thrust, it is the architectural equivalent of his muscular nudes.

The concentration of artistic energy in Rome during the Renaissance was such that while Michelangelo was working on the Sistine ceiling, his slightly younger rival Raphael was only a few steps away, painting his fresco *The School of Athens* (see 7.3) in the private library of the same pope, Julius II. In 1513 Julius was succeeded as pope by Giovanni de' Medici, whose family was now back in power in Florence. Raphael was increasingly in demand as a portraitist, and Giovanni de' Medici, now Pope Leo X, commissioned a likeness from him (16.13). Leo X was a passionate collector of books and manuscripts, and he eventually amassed a fine library. Raphael portrays him seated before one of his prized illuminated manuscripts, a magnifying glass in his left hand. Standing beside him are two nephews he had elevated to the office of cardinal (church officials next in rank to the pope). The rich fabrics, sumptuously painted, tell of the worldly splendor of the Church in Rome, while the keenly observed faces convey without flattery the aura of power and ambition that drove Leo X and his family.

After Rome and Florence, the third great artistic center of Italy was Venice, where Giovanni Bellini worked and taught (see 2.10). Bellini's two finest students, Giorgione and Titian, went on to become the greatest Venetian painters of the High Renaissance.

The iconography of Giorgione's painting *The Tempest* (**16.14**) is unknown. Even the artist's contemporaries seem not to have known what story he was

RELATED WORKS

4.16 Raphael, Madonna

7.3 Raphael, School of Athens

16.14 Giorgione. *The Tempest*. c. 1505. Oil on canvas, $32\frac{1}{4} \times 28\frac{3}{4}$ ". Gallerie dell'Accademia, Venice

RELATED WORKS

2.10 Bellini, Pietà

2.34 Titian, Assumption

5.30 Titian, Venus with a Mirror

depicting or to have been able to identify the nude woman nursing a child at right and the soldier (or shepherd) at left. Regardless of the meaning of its subject, *The Tempest* makes an important contribution to Renaissance art in the way it is composed. Artists of earlier generations would compose a scene by concentrating on the figures and painting the landscape as a kind of backdrop. Giorgione, however, has started by constructing a landscape and then placing his figures in it. This approach paved the way for the great landscape paintings of the centuries to follow.

In *The Tempest*, as the title implies, the subject is really the approaching storm, which closes in dramatically over the city while the two foreground figures are still bathed in sunlight. Giorgione's principal interest seems to have been the contrast of bucolic foreground against the city rendered in careful perspective, with the two drawn together by the violent effects of nature. The storm and the lush vegetation create a world in which nature dominates, not people, and the painting evokes a powerful, compelling mood of apprehension and anticipation.

Giorgione died in his early thirties; thus, we will never know what other wonders he might have accomplished. Titian, however, lived a long and productive life, and his career, like that of Michelangelo, allows us to witness the full arc of a great artist from youth through maturity to old age. We have seen the clarity of Titian's early style in the *Assumption* (see 2.34) and something of the opulence of his middle years in *Venus with a Mirror* (see 5.30). As Titian aged, his brushwork became freer and his colors grew more subdued and burnished. Contemporaries marveled that his paintings, seen up close, seemed nothing but a senseless frenzy of brush strokes. Yet as the viewer stepped back, there came into focus an image of unparalleled richness.

An example is *The Annunciation* (16.15), painted when the artist was seventy-five. The subject is the moment when an angel appears to Mary to tell her that she has been chosen to bear the Son of God. In Titian's imagining of the event, Mary turns quietly from her prayers and lifts her veil to look at her visitor. The angel arrives as though in a hurry, his cheeks still flush with the excitement of the news he brings. Mary does not see that behind her the air itself has opened with the force of an explosion, and from the golden light formed of endless cherubim descends the dove of the Holy Spirit. In this work, Titian produced a vision of heavenly glory as rhapsodic as the gold realm of Byzantium or the stained glass of the Middle Ages.

The Renaissance in the North

In the northern countries of western Europe—Switzerland, Germany, northern France, and the Netherlands—the Renaissance did not happen with the sudden drama that it did in Italy, nor were its concerns quite the same. Northern artists did not live among the ruins of Rome, nor did they share the Italians' sense of a personal link to the creators of the Classical past. Instead of the exciting series of discoveries that make the Italian Renaissance such a good story, the Northern Renaissance style evolved gradually out of the late Middle Ages, as artists became increasingly entranced with the myriad details of the visible world and better and better at capturing them.

We can see this fondness for detail in one of the most famous works of the late Middle Ages, the illuminated prayer book known as *Les Très Riches Heures* ("the very rich hours"). The book was created at the beginning of the 15th century by three artist brothers, the Limbourgs, for the duke of Berry, brother to the king of France.

Meant for daily religious devotion, the *Très Riches Heures* contains a calendar, with each month's painting featuring a typical seasonal activity of either the peasantry or the nobility. Our illustration shows the *February* page (16.16). At top in the lunette (half-moon shape), the chariot of the Sun is shown

16.15 Titian. *The Annunciation*. c. 1560. Oil on canvas, 13'2%" × 7'8½". Chiesa di San Salvador, Venice

16.16 Limbourg Brothers. February, from Les Très Riches Heures du Duc de Berry. 1416. Illumination, $8\% \times 5\%$ ". Musée Condé, Chantilly

making its progress through the months and signs of the zodiac. Below, the Limbourgs depict their notion of lower-class life in the year's coldest month.

This view of everyday life focuses on a small peasant hut with its occupants clustered around the fire, their garments pulled back to get maximum benefit from the warmth. With a touch of artistic license, the Limbourgs have removed the front wall of the hut so we can look in. Outside the cozy hut we see what may be the earliest snow-covered landscape in Western art. Sheep cluster in their enclosure, a peasant comes rushing across the barnyard pulling his cloak about his face to keep in the warm breath. From there the movement progresses diagonally up the slope to a man chopping firewood, another urging a donkey uphill, and finally the church at the top.

To appreciate the richness of details, we should bear in mind this is a miniature, barely 9 inches high. So acute is the Limbourgs' observation, on so tiny a scale, that we understand the condition of each player—the exertion of the woodcutter, the chill of the running figure, the nonchalant poses of the couple in the hut, and the demure modesty of the lady in blue.

The Limbourgs' manuscript marks a high point in a medieval tradition dating back hundreds of years (see 15.12). Within a few decades, however, the

16.17 Robert Campin. *Mérode Altarpiece*. c. 1426. Oil on panel, $25\%6 \times 24\%8$ " (center), $25\%8 \times 10\%4$ " (each wing). The Metropolitan Museum of Art, New York

printing press would be invented, and the practice of copying and illustrating books by hand would gradually die out. In the meantime, an increasing number of Northern artists were turning to painting on panel with the newly developed medium of oil paint. An early master of the medium was Robert Campin, a prominent artist in the Flemish city of Tournai, in present-day Belgium. The subject of his *Mérode Altarpiece* (16.17) is the Annunciation, the same event we saw depicted by Titian earlier in this chapter (see 16.15). Campin painted this work in 1426, right around the time that the principles of linear perspective were discovered in Italy. The Italian system did not make its way north for seventy-five more years. Campin relied instead on intuitive perspective, in which receding parallel lines converge unsystematically. He uses it here with charming inconsistency, tilting the tabletops toward us, for example, so we can get a look at everything that sits on them.

The Annunciation setting is replete with symbols, most of them referring to Mary's purity: the lilies on the table, the just-extinguished candle, the white linen, among others. At upper left, between two round windows, the tiny figure of a child carrying a cross flies down a light ray toward Mary's ear, signifying that the infant Jesus will enter Mary's womb through God's will, not through human impregnation. The right wing of the altarpiece shows Joseph, who will become Mary's husband, at work in his carpenter shop. By tradition, Joseph is making a mousetrap, symbolic of the soon-to-come Jesus' "trapping" the Devil, bringing good to banish evil. In the left wing, the donors, who commissioned the painting, kneel to witness the holy scene.

No recitation of this picture's details should overshadow its sheer beauty. Mary's face, modest above her crimson gown, is among the loveliest in all Renaissance art. The angel, with his luminous face and brilliant gold wings, displays an unearthly radiance. Both central figures wear robes that flow into rivers of sculptural folds. The *Mérode Altarpiece* is only about 2 feet in height. Its exquisitely rendered details, its clear colors, and the artist's skillful placement of light and shadow combine to give it a jewel-like quality.

Northern artists' preoccupation with decoration and surface and *things* derives naturally from their heritage. The North had a long tradition of painted miniatures, manuscript illuminations, stained glass, and tapestries—all decorative arts with a great deal of surface detail. Whereas the Italian masters were

RELATED WORKS

2.30 Van Eyck, Arnolfini Double Portrait

7.7 Christus, A Goldsmith in His Shop

obsessed with structure—accurate perspective and the underlying musculature of the body—Northern artists perfected their skill at rendering the precise outer appearance of their subjects. They were unsurpassed at capturing in paint the textures of satin or velvet, the sheen of silver and gold, the quality of skin to

its last pore and wrinkle.

In a fundamental way, Northern paintings are about looking. An apt example is Rogier van der Weyden's St. Luke Drawing the Virgin (16.18). At left is the Virgin Mary nursing the infant Jesus. At right is Saint Luke, author of one of the four Gospels in the Bible and patron saint of artists, drawing the mother and child in silverpoint. The two larger figures are carefully balanced in an architectural setting, behind which, through a window, we glimpse a land-scape in depth. Typical Northern touches include Rogier's minute attention to detail in the room—woodwork, tiles, canopy, window panes; wonderfully lavish drapery in the garments; rich colors; and faces so finely modeled and human we can think of them as portraits. There is great emotional warmth in this picture. The Virgin and the Child exchange tender glances, while Saint Luke, in his effort to capture their likeness, seems almost overcome with reverence and love. Everyone in the painting is caught up in looking, including the distant couple gazing out at the horizon.

Although Rogier's painting is gentle, religious art of the Northern Renaissance could also be harsh in its emotionalism—far harsher than that of Italy. Northern art abounds in truly grim Crucifixions, gory martyrdoms of saints, and inventive punishments for sinners. Italian artists did sometimes undertake

those subjects, but they never dwelt so fondly on the particulars.

Matthias Grünewald, a German artist active in the early 16th century, painted the Crucifixion of Christ as the center of his great masterpiece, the

16.18 Rogier van der Weyden. St. Luke Drawing the Virgin. c. 1435. Oil and tempera on panel, 4'6'/8" × 3'7⁵/8". Museum of Fine Arts. Boston

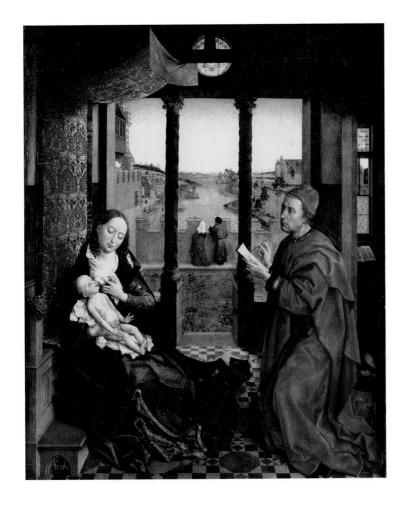

RELATED WORKS

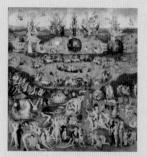

3.19 Bosch, Garden of Earthly Delights

8.8 Dürer, St. Jerome

16.19 Matthias Grünewald. *Isenheim Altarpiece* (exterior). 1515. Panel, 8'10" × 10'1". Musée d'Unterlinden, Colmar

Isenheim Altarpiece (16.19). Originally, the altarpiece reposed in the chapel of a hospital devoted to the treatment of illnesses afflicting the skin, including syphilis. This setting helps to explain the horrible appearance of Christ's body on the cross—pockmarked, bleeding from numberless wounds, tortured beyond endurance. Without question, the patients in the hospital could identify with Christ's sufferings and thus increase their faith.

In Grünewald's version of the Crucifixion, the twists and lacerations of the body speak of unendurable pain, but the real anguish is conveyed by the feet and hands. Christ's fingers splay out, clutching at the air but helpless to relieve the pain. His feet bend inward in a futile attempt to alleviate the pressure of his hanging body. To the left of the Cross, the Virgin Mary falls in a faint, supported by Saint John, and Mary Magdalene weeps in an agony that mirrors Christ's own. Opposite her, the Lamb of God, symbol of Christ, cradles a cross as blood flows from his breast into a chalice. To the right, John the Baptist directs our attention to the pitiful figure and says, "He must become greater, I must become less." Grünewald's interpretation of the Crucifixion is in keeping with a stark Northern tradition in which depictions of extreme physical agony were commonplace.

It was Albrecht Dürer (see 8.8) who more than any other artist attempted to fuse Italian ideas and discoveries with the Northern love of meticulous observation. Dürer had visited Italy as a young artist in 1494 and returned for a longer stay in 1505. He came to share the Italian preoccupation with problems of perspective, ideal beauty, and harmony. In Dürer's view, Northern art had relied too heavily on instinct and lacked a firm grounding in theory and science. Toward the end of his life he summarized his philosophy of art by writing and illustrating two important works, *Treatise on Measurement* and *Four Books on Human Proportions*.

An artist who matured in the climate of thought that Dürer had created was the German painter Hans Holbein. Although not as intellectual as Dürer, Holbein recognized the need to grapple with the issues that Dürer had introduced. He mastered perspective and studied Italian paintings. Under their

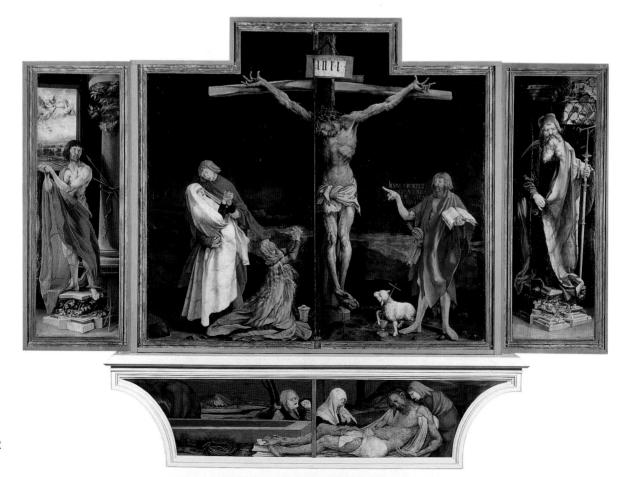

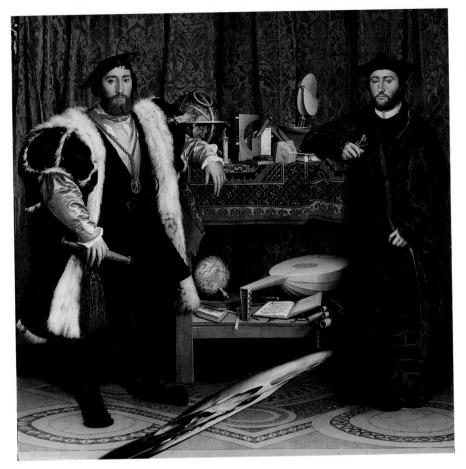

influence his modeling softened and his compositions grew more monumental. He did not lose the great Northern gift for detail, however, as his masterpiece known as *The Ambassadors* makes clear (16.20).

Holbein painted The Ambassadors in England, where his skills as a portraitist earned him the position of court painter to King Henry VIII. The painting was commissioned by the man on the left, Jean de Dinteville, the French ambassador to England. To the right is his friend Georges de Selve, a French bishop who also served as an ambassador. They look out at us from either side of a table richly laden with objects symbolizing the four humanist sciences-music, arithmetic, geometry, and astronomy. The imported Islamic rug speaks of contacts with the wider world, and the globe placed on the lower shelf reminds us that the Renaissance was also the age of European exploration and discovery. Close inspection reveals that the lute resting on the lower shelf has a broken string and that the book before it is open to a hymn by Martin Luther. The broken string symbolizes discord: Europe was no longer in harmony because of the difficult issues raised by Martin Luther's recent accusations against the Church in Rome. The movement Luther started, known as the Reformation, would very soon see Europe permanently divided into Protestant countries and Catholic countries. The religious unity that had characterized the Middle Ages would be gone forever.

The strangest element in the painting is the amorphous diagonal shape that seems to float in the foreground. Dinteville's personal motto was *memento mori*, Latin for "remember you must die." Holbein acknowledged this with a human skull, stretched as though made of rubber. The skull is painted to come into focus when the painting is viewed up close and at an angle. Death thus cuts across life and shows itself by surprise. Holbein's painting celebrates worldly splendor and human achievement even as it reminds us that death will eventually triumph. It stands as a portrait of two men, a portrait of a friendship, and a portrait of an era.

16.20 Hans Holbein the Younger. The Ambassadors. 1533. Oil on panel, $6'9\%" \times 6'10\%"$. The National Gallery, London

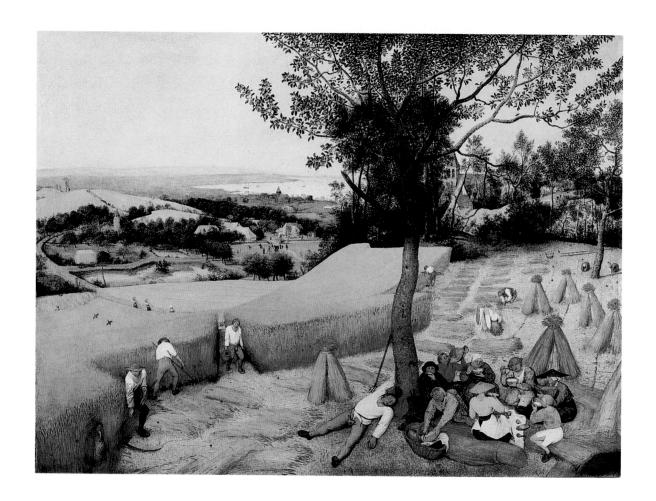

16.21 Pieter Bruegel the Elder. The Harvesters. 1565. Oil on panel, $3'10\%'' \times 5'3\%''$. The Metropolitan Museum of Art,

New York

Protestant reforms of the 16th century included an attitude toward religious images that ranged from wariness to outright hostility. Images of saints and other figures, reformers felt, had all too often been thought to possess sacred powers themselves. In their view, the Church in Rome had encouraged those beliefs, which amounted to idol worship. The walls of Protestant churches were bare: "The kingdom of God is a kingdom of hearing, not of seeing," said Martin Luther. One result was that Northern artists turned increasingly to the everyday world around them for subject matter, and one of the most fruitful subjects they began to explore was landscape.

We opened this brief survey of Northern Renaissance art with a manuscript page by the Limbourg brothers depicting a peasant household with a winter landscape in the background (16.16). The Harvesters (16.21), by the 16thcentury Netherlandish painter Pieter Bruegel the Elder, advances the season to late summer and shows us how far painting has come in 150 years. Like the February page from the Très Riches Heures, The Harvesters formed part of a cycle depicting the months of the year. In the foreground, a group of peasants have paused for their midday meal in the shade of a slender tree. No doubt, they have been working in the fields since dawn. The little group sits, chatting and eating. One man has loosened his breeches and stretched out for a nap. In the middle ground, the still unmowed portion of the field stretches out like a golden carpet. Some people are still at work, the men mowing with their scythes, the women stooping to gather the wheat into sheaves. Beyond there opens a vast panorama, a peaceful, domesticated landscape stretching as far as the eye can see. Landscape, which served the Limbourg brothers as a backdrop, has here become the principal theme, a grand setting in which humans take their appointed place, the rhythm of their work and lives falling in with the rhythm of the seasons and of creation.

The Late Renaissance in Italy

Scholars generally date the end of the High Renaissance in Italy to the death of Raphael in 1520. The next generation of artists came of age in the shadow of this great period and with two of its most intimidating artists, Titian and Michelangelo, still going strong. Of the various artistic trends that emerged, the one that has interested art historians most is known as **Mannerism**.

The word Mannerism comes from the Italian *maniera*, meaning "style" or "stylishness," and it was originally used to suggest that these painters practiced an art of grace and sophistication. Later critics characterized Mannerism as a decadent reaction against the order and balance of the High Renaissance. Today, however, most scholars agree that Mannerism actually grew out of possibilities suggested by the work of High Renaissance artists, especially Michelangelo, whose influence on the next generation was enormous.

Agnolo Bronzino's bizarre *Allegory* (16.22) illustrates some of the fascinating and unsettling characteristics of Mannerism. In an allegory, all the figures and objects also stand for ideas or concepts, and we should be able to "decode" their interaction, perhaps to draw a moral lesson. But the allegory here is so obscure that scholars have yet to reconstruct it. This fondness for elaborate or obscure subject matter is typical of Mannerist artists and the highly cultivated audience they painted for. Also typical is the "forbidden" erotic undercurrent. We recognize Venus and Cupid in the foreground. They are mother and son, but their interaction hints at a different sort of relationship, and both are clearly arranged for our erotic appraisal as well. The elongated figures and twisting S-shaped poses are part of the Mannerist repertoire, as is the illogical picture space—a shallow, compressed zone filled with an impossible number of people.

16.22 Agnolo Bronzino. *Allegory* (Venus, Cupid, Folly, and Time). c. 1545. Oil on wood, $5'1'' \times 4'8^{3}4''$. The National Gallery, London

Bronzino's painting is an extreme example of the highly artificial and self-conscious aspects of Mannerist art. But Mannerist elements can also be seen in less exotic works, such as Sofonisba Anguissola's lovely *Portrait of Amilcare, Minerva, and Asdrubale Anguissola* (16.23). The first woman artist known to have achieved celebrity among her contemporaries, Anguissola was born about 1535 in Cremona, the eldest of six sisters and one brother. She was well educated and was trained in painting; by about age twenty-two, she had attracted the admiring attention of Michelangelo.

The Portrait of Amilcare, Minerva, and Asdrubale Anguissola—the artist's father, sister, and brother—dates from around 1558. Sofonisba Anguissola here brought something new to the art of Renaissance portraiture, a feeling for family interaction, tenderness, and affection. Fate did not allow her to develop that gift, however. Her career took her to the court of Spain, where she had obtained a position as portrait painter and drawing instructor. Her departure, in fact, may have been what caused her to abandon work on this portrait, which remains unfinished. The Spanish court favored a far more stiff and formal style, and Anguissola, like all Renaissance artists, needed to please her patrons.

The Protestant Reformation in northern Europe drew large numbers of people away from the Roman Catholic Church. Deeply wounded, the Church of Rome regrouped itself and struck back. The Catholic Counter-Reformation, begun in the second half of the 16th century and continuing into the 17th, aimed at preserving what strength the Church still had in the southern countries and perhaps recovering some lost ground in the North. The concerns of the reformers extended to art, which they recognized as one of their strongest weapons. They insisted that all representations of sacred subjects conform strictly to the teachings of the Church and that artists arrange

16.23 Sofonisba Anguissola. *Portrait of Amilcare, Minerva, and Asdrubale Anguissola.* c. 1558. Oil on canvas, 5'1¾" × 4'. Nivaagaards Malerisamling, Niva

their compositions to make those teachings evident. They also understood and encouraged art's ability to appeal to the emotions, to engage the hearts of the faithful as well as their intellects.

The Last Supper (16.24) by the Venetian painter Tintoretto is an excellent example of the art encouraged by the Counter-Reformation. The greatest painter of the generation after Titian, Tintoretto developed his style from the virtuosic brushwork and dramatic lighting effects of Titian's late works (see 16.15). Tintoretto has chosen to portray the central theological moment of the Last Supper, when Christ breaks bread and gives it to his disciples to eat—the basis for the Christian sacrament of communion. The dramatic diagonal of the table sweeps our eyes into the picture and toward the figure of Christ, who stands near the very center of the canvas. His potentially obscure position in the distance is compensated for by the light that radiates from his head. Lesser glows of saintliness shine from the heads of his apostles, who sense the importance of the moment. Only Judas, who will soon betray Christ, does not emit the light of understanding. He is seated close to Jesus, but alone on the opposite side of the table, a symbolic placement that is both obvious and effective. Witnesses from heaven crowd into the scene from above, swirling in excitement. Though unseen by the servants, who go about their business, they are visible to us, who are left in no doubt that a miracle is taking place.

Comparing Tintoretto's version of *The Last Supper* with Leonardo's High Renaissance fresco (see 4.45), we can see that what was internalized, subtle, and intellectual has here become externalized, exaggerated, and emotional. Tintoretto's work prepares us well for the next era in art, for key elements of his *Last Supper*—the dramatic use of light, the theatricality, the heightened emotionalism, and even the diagonal composition—will play prominent roles in a style soon to be taken up across all of Europe during the Baroque.

16.24 Tintoretto. *The Last Supper.* 1592–94. Oil on canvas, 12' × 18'8". San Giorgio Maggiore, Venice

17The 17th and18th Centuries

he period encompassing the 17th and 18th centuries in Europe has often been called "The Age of Kings." Some of the most powerful rulers in history occupied the thrones of various countries during this time: Frederick the Great of Prussia, Maria Theresa of Austria, Peter the Great and Catherine the Great of Russia, and a succession of grand kings named Louis in France, to name but a few. These monarchs governed as virtual dictators, and their influence dominated social and cultural affairs of the time as well as political matters.

This same period could equally be called "The Age of Colonial Settlement." By the early 17th century, the Dutch, the English, and the French had established permanent settlements in North America. (Spain and Portugal had earlier laid claim to much of Central and South America.) The first successful English colony was at Jamestown, in Virginia, where a party led by John Smith arrived in 1607. Thirteen years later the plucky little ship *Mayflower* made landing in what is now Massachusetts. The settlers endured many hardships as they struggled through their first winters in the New World. At Jamestown the colonists went through a period still known as the "starving time." Ironically, the "starving time" in North America coincided exactly with a European style so opulent that its name is now synonymous with extravagance: the Baroque.

The Baroque Era

Baroque art differs from that of the Renaissance in several important respects. Whereas Renaissance art stressed the calm of reason, **Baroque** art is full of emotion, energy, and movement. Colors are more vivid in Baroque art than in Renaissance, with greater contrast between colors and between light and dark. In architecture and sculpture, where the Renaissance sought a classic simplicity, the Baroque favored ornamentation, as rich and complex as possible. Baroque art has been called dynamic, sometimes even theatrical. This theatricality is clearly evident in the work of the Baroque's leading interpreter, the artist Gianlorenzo Bernini.

Bernini would have been a fascinating character in any age, but if ever an artist and a style were perfectly suited for each other, this was true of Bernini and the Baroque. Largely for his own pleasure, he was a painter, dramatist, and composer. In architecture and sculpture, however, his gifts rose to the level of genius. Bernini's talents are on full display in the Cornaro Chapel in the

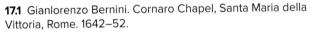

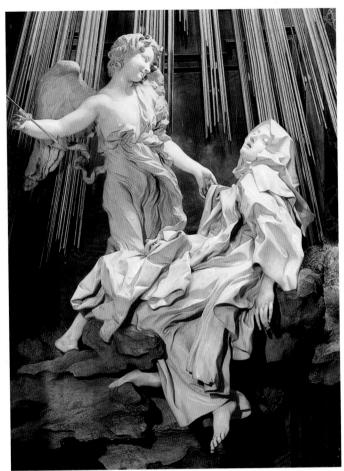

17.2 Gianlorenzo Bernini. *St. Teresa in Ecstasy*, from the Cornaro Chapel. 1642–52. Marble and gilt bronze, life-size.

church of Santa Maria della Vittoria in Rome (17.1). In this small alcove, the funeral chapel of Cardinal Federigo Cornaro, Bernini integrated architecture, painting, sculpture, and lighting into a brilliant ensemble. On the ceiling is painted a vision of heaven, with angels and billowing clouds. At either side of the chapel sit sculptured figures of the Cornaro family, donors of the chapel, in animated conversation, watching the drama before them as though from opera boxes. The whole arrangement is lighted dramatically by sunlight streaming through a yellow-glass window.

The centerpiece of the chapel is Bernini's sculptured group known as *St. Teresa in Ecstasy* (17.2). Teresa was a Spanish mystic, founder of a strict order of nuns, and an important figure in the Counter-Reformation. She claimed to be subject for many years to religious trances, in which she saw visions of Heaven and Hell and was visited by angels. It is in the throes of such a vision that Bernini has portrayed her. Teresa wrote:

Beside me, on the left hand, appeared an angel in bodily form, such as I am not in the habit of seeing except very rarely. . . . He was not tall but short, and very beautiful; and his face was so aflame that he appeared to be one of the highest rank of angels, who seem to be all on fire. . . . In his hands I saw a great golden spear, and at the iron tip there appeared to be a point of fire. This he plunged into my heart several times so that it penetrated to my entrails. When he pulled it out, I felt that he took them with it, and left me utterly consumed by the great love of God. The pain was so severe that it made me utter several moans. The sweetness caused by this intense pain is so extreme that one cannot possibly wish it to cease. . . . This is not a physical, but a spiritual pain, though the body has some share in it—even a considerable share.

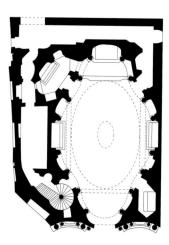

17.3 Plan of San Carlo alle Quattro Fontane.

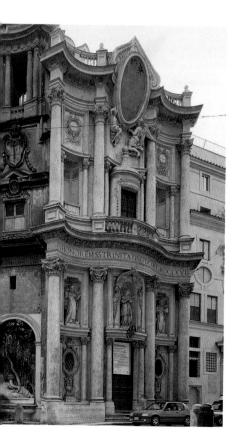

17.4 Francesco Borromini. Facade of San Carlo alle Quattro Fontane, Rome. 1665–67.

Just as Bernini transformed the chapel itself into a sort of theater complete with sculpted spectators, he has set the drama of Saint Teresa as if on a stage. We can imagine that the curtains have just parted, revealing Teresa in a swoon, ready for another thrust of the angel's spear. She falls backward, yet is lifted up on a cloud, the extreme turbulence of her garments revealing her emotional frenzy. The angel, wielding his spear, has an expression on his face of tenderness and love; in other contexts he might be mistaken for a Cupid. Master of illusions, Bernini has anchored the massive blocks of marble into the wall with iron bars so that the scene appears to float. The gilt bronze rods depicting heavenly rays of light are themselves lit from above by a hidden window: this little stage set has its own lighting. The deeply cut folds of the swirling garments create abrupt contrasts of light and shadow, dissolving solid forms into flamelike flickerings. As we stand before the chapel, our experience is also theatrical, for we can both watch the ecstasy and watch people watching the ecstasy; we are both caught up in the performance and aware of it as a performance.

One of the great projects of Baroque Rome was the completion of St. Peter's, which had been designed by Michelangelo (see 16.11, 16.12). During the early 17th century, an architect named Carlo Maderno lengthened the nave and created a new facade. Upon Maderno's death, Bernini continued the redecoration of the interior and designed a spectacular colonnade (row of columns) to enclose the vast square in front of the church. Interestingly, Bernini's architecture was more conservative than his sculpture. To fully appreciate the innovative daring of Italian Baroque architecture, we should turn to his principal rival, Carlo Maderno's nephew Francesco Borromini.

Like the architects of the Renaissance, Borromini worked his designs out logically so that every least detail reflected a guiding idea. But instead of basing his work in the square and the circle, he favored more subtle and dynamic forms such as the oval. Borromini's most influential building is a small church called San Carlo alle Quattro Fontane (Saint Charles at the Four Fountains). The domed interior, designed first, takes the form of an oval gently indented to suggest a cross (17.3). The resulting walls alternate between convex and concave curves, creating a softly undulating motion and an organic, almost pulsating space. The church became instantly famous, and requests for the plans flooded in from all over Catholic Europe.

The facade (17.4), designed twenty-five years later and completed after Borromini's death, carries the logic through to the exterior. Alternating convex and concave elements dominate, their curves describing sections of ovals. The interplay of surfaces is complex. Notice, for example, how the central portion of the facade is convex at the street level but becomes a concave setting for convex elements above, culminating in a framed oval held aloft by two angels that seem to hover in front of the building. The protrusion of the facade forward into the viewer's space is typical of Baroque architecture, as is the buildup of interest in the central portion and the overall sense of plasticity—the sense that a building can be modeled and sculpted almost like clay.

Unlike architecture or sculpture, a painting cannot literally project its figures into the viewer's space. Baroque artists, however, learned to create a similar effect by lighting their figures dramatically and plunging the backgrounds into shadow. Artemisia Gentileschi used this technique effectively in *Judith and Maidservant with the Head of Holofernes* (17.5). The artist took her subject from the biblical story of Judith. According to the scripture, Judith, a pious and beautiful Israelite widow, volunteered to rescue her people from the invading armies of the Assyrian general Holofernes. Judith charmed the general, accepted his invitation to a banquet, waited until he drank himself into a stupor, then calmly beheaded him, wrapped up his head in a sack, and escaped.

Other of Gentileschi's paintings show the decapitation in progress. Here, she focuses on the moments after the gory deed is done. She poses Judith tensely, caught in the wavering light from a single candle, one hand still clutching the bloody sword, the other poised in a gesture of silence. These Baroque

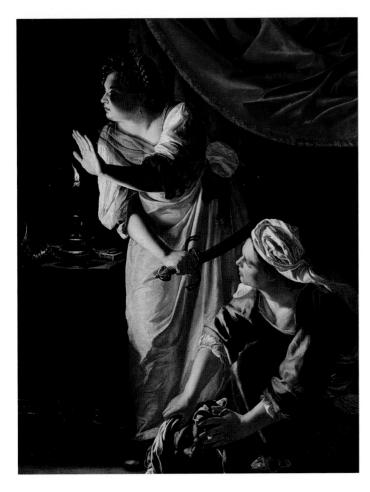

17.5 Artemisia Gentileschi. *Judith and Maidservant with the Head of Holofernes*. c. 1625. Oil on canvas, $6'\frac{1}{2}" \times 4'7^\frac{3}{4}"$. Detroit Institute of Arts

17.6 Caravaggio. *Entombment of Christ.* 1604. Oil on canvas, $9'9\%" \times 6'7^3\!4"$. Musei Vaticani, Pinacoteca, Rome

devices heighten the sense of danger, the urgency of deeds committed in the dark of night.

Gentileschi's dramatic way with light and dark was the influential invention of a painter named Caravaggio. His magnificent Entombment of Christ (17.6) is an example of the kind of painting that inspired Gentileschi and many other artists. The Entombment depicts the crucified Christ being lowered into an open grave. The body is held by two of Christ's followers-his disciple St. John and the Jewish ruler Nicodemus, to whom Christ had counseled that a man must be "born again" to enter Heaven. The group also includes the three Marys-Christ's mother, the Virgin Mary, at left; Mary Magdalene, center; and Mary Cleophas, at right-who look on in despair. Caravaggio's structure is a strong diagonal leading from the upraised hand at top right down through the cluster of figures to Christ's face. The light source seems to be coming from somewhere outside the top left edge of the picture. Light falls on the participants in different ways, but always enhances the sense of drama. Mary Magdalene's face, for example, is almost totally in shadow, but a bright light illuminates her shoulder to create a contrast with the bowed head. Light also catches the pathetic outstretched hand of the Virgin. Christ's body is the only figure lit in its entirety; the others stand in partial darkness.

The perspective of the painting places the viewer's eye level at the slab the grouping stands on. Set on a diagonal, the slab seems to project forward from the picture plane and into our space, involving us in the action. We may

ARTISTS Artemisia Gentileschi (1593-c. 1654)

How is Gentileschi able to achieve success as a woman? Compared with Michelangelo, how does Gentileschi depict the human figure in her works? In the small amount of her work we have access to, what subject matter does she tend to portray?

will show Your Most Illustrious Lordship what a woman can do," Artemisia Gentileschi wrote to a patron. She knew full well the prejudices that were arrayed against her. She also knew her own worth: "I have seen myself honored by all the kings and rulers of Europe to whom I have sent my works, not only with great gifts, but also with the most favored letters . . ." It was the simple truth. By dint of talent and ceaseless work, she had become successful, admired, and sought after, and this at a time when women artists were so unusual as to be curiosities.

Artemisia Gentileschi was born in Rome in 1593. Her father, Orazio, was a well-known painter. He was also in all likelihood her teacher. Orazio probably began teaching his daughter to paint subjects considered suitable for women, such as portraits and still life. But at

some point he must have recognized the extent of her talent, for the earliest painting we have from her hand depicts a biblical story, *Susanna and the Elders*, and features a large female nude. Mastery of the human form and an elevated literary subject signaled that Artemisia would stake her claim as a history painter, a true rarity for a woman. She was only seventeen years old.

The following year, Artemisia was raped by a friend of her father's, the painter Agostino Tassi. Afterward, Tassi promised to marry her, and because of this she consented to regular relations with him. When after a time he refused to fulfill his promise, Orazio dragged him to court. A transcript of the trial testimony survives, and it makes for disturbing reading. Artemisia recounts her version of events in detail and without flinching. Tassi denies all and hurls ugly accusations. In the end, he was found guilty. Artemisia quickly married a Florentine painter, Pietro Stiattesi. Her father found her a patron in Florence, proudly boasting in a letter that his daughter was so skilled that she was without peer. And so it was in Florence that Artemisia began her career.

Our knowledge of Artemisia's trajectory is spotty. She remained in Florence for six years. We find her next back in Rome, having separated from her husband and taken their daughter with her. Then Genoa and Venice, followed by a stretch of time in Naples. She was briefly summoned to London by the English court, then returned again to Naples for the rest of her days. She had two daughters, both of whom she trained as painters. She employed her younger brothers as couriers to deliver her paintings across Europe. Her brother Francesco also served as her business manager.

Our understanding of Artemisia Gentileschi's art is likewise incomplete, for only a fraction of her works have survived. Contemporary writers praised her skill at portraiture and still life, yet only one example of each has come down to us. The story of her rape has focused attention on her images of strong, assertive women, especially the several paintings of Judith slaying Holofernes, which have been seen as her psychological revenge on Tassi. Yet we have no entry into her thoughts, and such images form only a small part of her known output. We must finally fall back on Artemisia's own words to a patron: "The works will speak for themselves."

Artemisia Gentileschi. Self-Portrait as the Allegory of Painting. 1630. Oil on canvas, 38×29 ". The Royal Collection, Windsor Castle, England.

imagine ourselves standing in the grave that is about to receive Christ: perhaps that is why Nicodemus looks at us. Caravaggio painted this work to hang over an altar, and the head of a priest standing at the altar would have been at the ideal viewing level, the level of the slab. During the most solemn moment of the mass, the priest holds the communion bread aloft and repeats the words Christ spoke at the Last Supper, "This is my body." The raised bread would have been visibly juxtaposed with the body in the painting, restoring to the words an intense emotional impact.

We might compare Caravaggio's *Entombment* with a work painted just a few years later, *The Raising of the Cross* (17.7) by the Flemish artist Peter Paul Rubens. Although he spent most of his life in Antwerp (in modern Belgium), Rubens had traveled to Italy and studied the works of Italian masters, including Caravaggio. There are similarities between these two paintings—in the sharply diagonal composition and dramatic lighting—but we also find several differences in the two masters' styles. Caravaggio's figures seem almost frozen in a moment of anguish, but Rubens' painting teems with movement and energy, each of the participants balanced precariously and straining at his task. Although the Caravaggio group projects from the picture plane, its action is contained on four sides within the frame of the canvas. But Rubens' figures burst outside the picture in several directions, suggesting that the action continues beyond the painting. Rubens' heroic treatment of musculature recalls Michelangelo's paintings on the Sistine Chapel ceiling (see 16.10), but the writhing S-curve of Christ's body is typically Baroque.

17.7 Peter Paul Rubens.

The Raising of the Cross. 1610–11.
Oil on canvas, 15'2" × 11'2".

Antwerp Cathedral

17.8 Nicolas Poussin. *The Ashes of Phokion*. 1648. Oil on canvas, $3'9^{3/4}$ " \times 5'9 4 ".

Walker Art Gallery, National Museums Liverpool Although Baroque artistic principles were taken up across Europe, each country developed them in its own way. France, for example, favored a more restrained, "classical" version of Baroque style in which the order and balance of the Renaissance were retained, though infused with a new theatricality and grandeur.

Foremost among French painters of the 17th century was Nicolas Poussin, who actually spent most of his career in Rome. Steeped in the philosophy and history of the Classical past, he came to believe that art's highest purpose was to represent noble and serious human actions. An example is his painting *The Ashes of Phokion* (17.8). Phokion was a famous Athenian general of the 4th century B.C.E. In his old age, he was unjustly accused of treason, tried, and sentenced to death. The cremation or burial of his remains was outlawed. His friends and supporters dared not defy the court to accord him an honorable funeral. Only his widow did not desert him, arranging for cremation and performing the rites herself. She is shown here gathering up her husband's ashes outside the city walls. Her virtuous act was much admired by the ancient Roman Stoic philosophers, who taught that virtue was the only good, vice the only evil, and that the triumphs and sufferings of life were to be accepted calmly and without passion.

Poussin's visual response to this story and its Stoic setting inspired a composition that is far removed from the emotionalism of Caravaggio or the energy of Rubens. In place of their active diagonals, calm verticals and horizontals dominate. Only the manipulation of light marks the painting as Baroque. Zones of light and shadow alternate across the canvas, and the white of the widow's clothing is lit as if with a spotlight, drawing our attention to the principal actor on this vast stage. In the foreground, wind-tossed trees watch over Phokion's widow and her anxious servant. The trees are linked by visual rhymes to the mountain and clouds in the distance, emphasizing that her courageous act answers to a higher law than that of the city: the natural law of instinct.

To grasp fully the flavor of the Baroque in France, we should look at a king who for all time exemplifies the term "absolute monarch"—Louis XIV. Louis ascended the throne of France in 1643, at the age of four. He assumed

total control of the government in 1661 and reigned, in all, for seventy-two years. During that time, he made France the artistic and literary center of Europe, as well as a political force to be reckoned with. Showing the unerring instincts of a master actor, he created an aura around his own person that bolstered the impression of divinity. Each day, for example, two ceremonies took place. In the morning, half the court would file into Louis' chambers, in full pageantry, to participate in the king's *lever*—the king's "getting up." At night, the same cast of characters arrived to play ritual roles in the king's *coucher*—his "going to bed."

A life in which the simple act of climbing in and out of bed required elaborate ceremony surely also needed an appropriate setting, and Louis did not neglect this matter. He summoned Bernini from Rome to Paris to work on completion of the Louvre Palace (although the final design of the building was the work of others). But Louis' real love was the Palace of Versailles, in a suburb of the capital, which he substantially rebuilt and to which he moved his court in 1682. It was from this remarkable structure that the power of

kingship flowed forth.

In all, Versailles occupies an area of about 200 acres, including the extensive formal gardens and several grand châteaux. The palace itself, redesigned and enlarged during Louis' reign, is an immense structure, more than a quarter of a mile wide (17.9). The view here was painted in 1722, not long after the completion of Louis XIV's final addition, the chapel visible at the right. His great-grandson, who had succeeded him as Louis XV, would take up residence in the palace that year. The new king's golden carriage is depicted in the foreground, drawn by a team of black horses.

17.9 Pierre-Denis Martin. View of the Palace at Versailles from the Parade Ground in 1722. 1722. Oil on canvas, 4'6¾" × 4'11". Musée National du Château de Versailles

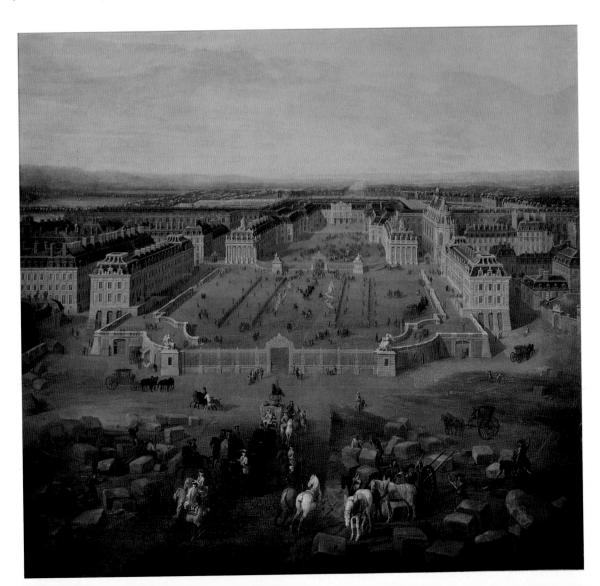

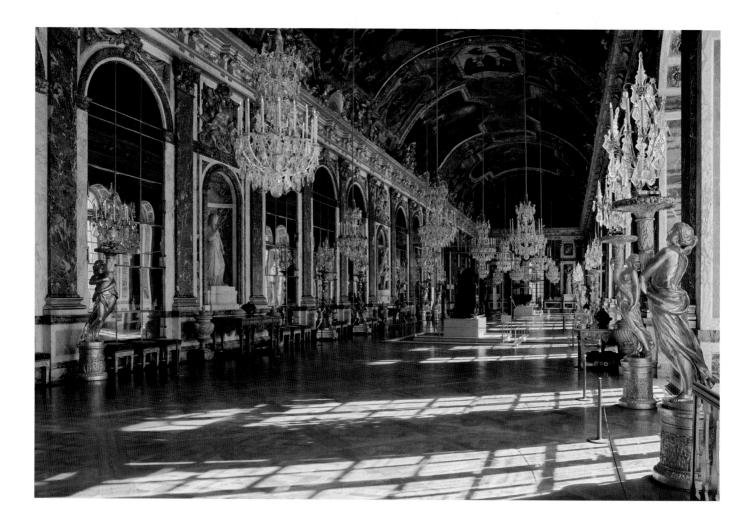

17.10 Jules Hardouin Mansart and Charles Le Brun. Hall of Mirrors, Palace of Versailles. c. 1680.

If the exterior of the palace reflects the continuing Classical tendencies of France, the interior revels in full Baroque splendor. As in Bernini's Cornaro Chapel (see 17.1), though on a much grander scale, architecture, sculpture, and painting are united, creating a series of lavish settings for the pageantry of Louis XIV and his court. Of the countless rooms inside, the most famous is the Hall of Mirrors (17.10), 240 feet long and lined with large reflective glasses. In Louis' time the Hall of Mirrors was used for the most elaborate state occasions, and even in the 20th century it served as the backdrop for momentous events. The treaty ending World War I was signed in the Hall of Mirrors.

The French court clearly was a model of pomp and pageantry, and the Spanish court to the south was eager to emulate that model. King Philip IV of Spain reigned for a shorter time than his French counterpart and could not begin to match Louis in either power or ability. Philip had one asset, however, that Louis never quite managed to acquire—a court painter of the first rank. That painter was one of the geniuses of Spanish art—Diego Velázquez.

In his capacity as court painter, Velázquez created his masterpiece, *Las Meninas* (*The Maids of Honor*) (17.11). At left, we see the artist, working on a very large canvas, but we can only guess at the subject he is painting. Perhaps it is the young princess, the *infanta*, who stands regally at center surrounded by her attendants (*meninas*), one of whom is a dwarf. Or perhaps Velázquez is actually painting the king and queen, whom we see reflected in a mirror on the far wall. Their participation is clear, but where are they standing? Possibly they are outside the picture, standing next to us, the observers. This ambiguity is part of the picture's fascination, as is the dual nature of the scene. Although it shows a formal occasion, the painting of an official portrait, Velázquez has given the scene a warm, "everyday" quality.

RELATED WORKS

7.19 Le Brun, Battle of the Granicus

Like Caravaggio, Velázquez uses light to create drama and emphasis, but light also serves here to organize and unify a complex space. The major light source comes from outside the top right corner of the painting, falling most brilliantly on the *infanta*, leaving the others in various degrees of shadow. Another light source illuminates the court chamberlain standing in the open doorway at back. Velázquez may have put him there to direct attention to the reflected images of the king and queen. Light also strikes the artist's face and the mirror reflection. What could have been a very disorderly scene has been pulled together by the device of spotlighting, much as a designer of stage lighting would control what the audience sees. The theatricality of the Baroque is more subtle in Velázquez than in Bernini, but it is no less skillful.

To end this discussion of 17th-century art, we move north, to the Netherlands. The Dutch Baroque, sometimes called the "bourgeois Baroque," is quite different from Baroque movements in France, Spain, and Italy. In the North, Protestantism was the dominant religion, and the outward symbols of faith—imagery, ornate churches, and clerical pageantry—were far less important. Dutch society, and particularly the wealthy merchant class, centered not on the Church but, instead, on the home and family, business and social organizations, the community. We see this focus in the work of two Dutch artists with very different styles—Rembrandt van Rijn and Judith Leyster.

Rembrandt's principal teacher, a painter named Pieter Lastman, had traveled in his youth to Italy, where he had come under the influence of

RELATED WORKS

1.14 Valdés Leal, Vanitas

17.11 Diego Velázquez. Las Meninas (The Maids of Honor). 1656. Oil on canvas, 10'5½" × 9'¾". Museo del Prado, Madrid

RELATED WORKS

8.11 Rembrandt, Christ Preaching

17.12 Rembrandt van Rijn. *Sortie of Captain Banning Cocq's Company of the Civic Guard (The Night Watch).* 1642. Oil on canvas, 12'2" × 17'7". Rijksmuseum, Amsterdam

Caravaggio. Returning to the Netherlands to establish his career, he brought with him the new kind of dramatic lighting that Caravaggio had invented. We can see how Rembrandt incorporated this lighting into his own personal style in the famous group portrait *Sortie of Captain Banning Cocq's Company of the Civic Guard* (17.12).

The painting portrays a kind of private elite militia. Such groups had played a prominent role in defending the city during the recent wars against Spanish domination, and although by Rembrandt's time their function was largely ceremonial, they were still widely respected, and all the most important men of the town belonged to one. Dutch civic organizations often commissioned group portraits, and painters usually responded by portraying the members seated around a table or lined up for the 17th-century equivalent of a class photograph. Rembrandt's innovation was to paint individual portraits within the context of a larger activity, a call to arms. He groups the figures naturally, in deep space, with Captain Cocq, resplendent in a red sash, at the center. The composition builds on a series of broad V-shapes, pointing upward and outward. The nested V-shapes make the picture seem to burst out from its core—and may have made its subjects feel they were charging off heroically in all directions, into battle. Lest this geometric structure seem rigid, Rembrandt has "sculpted" it into greater naturalness through his dramatic lighting of the scene. Light picks out certain individuals: Captain Cocq himself; the drummer at far right; the lieutenant at Cocq's side, awaiting orders; and especially the little girl in a golden dress, whose identity and role in the picture remain a mystery.

For many years Rembrandt's painting was known as *The Night Watch*, and it is still informally called by that name. The reason has nothing to do with the artist's intent. A heavy layer of varnish on top of the oil paint combined with smoke from a nearby fireplace had gradually darkened the picture's surface

ARTISTS Rembrandt van Rijn (1606–1669)

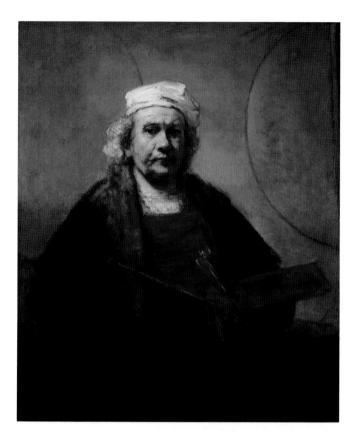

What do the numerous self-portraits tell us about the artist? What functions do light and darkness have in his art? How is Rembrandt's work accessible to us?

f the few artists classified as "greatest of the great," Rembrandt seems the most accessible to us. His life encompassed happiness, success, heartbreak, and failure—all on a scale larger than most of us are likely to know. Through his many self-portraits and his portraits of those he loved, we can witness it all.

Born in the Dutch city of Leiden, Rembrandt Harmensz. van Rijn was the son of a miller. At fourteen, he began art lessons in Leiden and later studied with a master in Amsterdam. By the age of twenty-two, he had pupils of his own. About 1631 he settled permanently in Amsterdam, having by then attracted considerable fame as a portrait painter. Thus began for Rembrandt a decade of professional success and personal happiness—a high point that would never come again in his life.

In 1634 Rembrandt married Saskia van Uijlenburgh, an heiress of good family, thus improving his own social status. The pair must have been rather a dashing couple-about-Amsterdam. The artist's portraits were in demand, his style was fashionable, and he had money enough to indulge himself in material possessions, especially to collect art. One blight on this happy period was the arrival of four children, none of whom survived. But in 1641 Rembrandt's beloved son Titus was born.

Rembrandt's range as an artist was enormous. He was master not only of painting but also of drawing and of the demanding technique of etching for prints. (It is said that Rembrandt went out sketching with an etcher's needle as other artists might carry a pencil.) Besides the many portraits, the artist displayed unparalleled genius in other themes, including landscapes and religious scenes.

In 1642 Rembrandt's fortunes again changed, but this time for the worse. Saskia died not long after giving birth to Titus. The artist's financial affairs were in great disarray, no doubt partly because of his self-indulgence in buying art and precious objects. Although he continued to work and to earn money, Rembrandt showed little talent for money management. Ultimately he was forced into bankruptcy and had to sell not only his art collection but even Saskia's burial plot. About 1649 Hendrickje Stoffels came to live with Rembrandt, and she is thought of as his second wife, although they did not marry legally. She joined forces with Titus to form an art dealership in an attempt to protect the artist from his creditors. Capping the long series of tragedies that marked Rembrandt's later life, Hendrickje died in 1663 and Titus in 1668, a year before his father.

Rembrandt's legacy is almost totally a visual one. He does not seem to have written much. Ironically, one of the few recorded comments comes in a letter to a patron, begging for payment—payment for paintings that are now considered priceless and hang in one of the world's great museums. "I pray you my kind lord that my warrant might now be prepared at once so that I may now at last receive my well-earned 1244 guilders and I shall always seek to recompense your lordship for this with reverential service and proof of friendship." ⁵

Rembrandt van Rijn. *Portrait of the Artist.* c. 1663–65. Oil on canvas, 45×37 ". Kenwood House, London.

RELATED WORKS 3.18 Vermeer, Woman Holding a Balance 4.38 Kalf, Still Life with Glass Goblet and

17.13 Judith Leyster. Carousing Couple. 1630. Oil on panel, $26\frac{3}{4} \times 22\frac{5}{8}$ ". Musée du Louvre, Paris

Porcelain

Bowl

until it seemed to portray a nighttime scene. No one alive could remember it any differently. It was only when the work was cleaned in the mid-20th century that the light-filled painting we know today reemerged. Even now, though, some members of the group can be seen more clearly than others, and viewers have often wondered how that could have been acceptable to the militia. Documents have revealed that each member contributed to the commission according to how prominently he would appear in the finished painting, and history records no complaints about the results.

The 17th century was the great age of Dutch **genre** painting—painting that focused on scenes of everyday life—and during her lifetime, Judith Leyster was highly regarded as a genre painter. After her death, however, she was virtually forgotten. Paintings from her hand made their way into important collections, but many seem to have been attributed to another (in our time, far better-known) Dutch painter, Frans Hals. Leyster had studied with Hals; thus, the confusion is not altogether surprising. Still, her disappearance from art history prevailed for some two centuries. Then, in 1893, a Dutch art historian who had just sold a "Hals" to the Louvre museum in Paris discovered Leyster's distinctive monogram on the canvas. Since then, other works by "Hals" have been reattributed to Leyster.

Carousing Couple (17.13) is Leyster's version of a standard genre subject, the "merry company" scene. Looking more than a little tipsy, a man grins blurrily at us as he plays a viol—probably none too steadily. His companion holds up a glass and lifts a tankard of wine, suggesting just one more. Merry company scenes look like great good fun, and they can leave us with the idea that 17th-century Holland was a rollicking place. But the scene would have carried a warning for its original audience. The young man is being led astray, and we are supposed to fear that he may give himself over to a life of pleasure instead of pursuing a life of good, productive work. It is difficult to say how

seriously artists and their audience took such stern moralizing, however. The woman here whose wiles are presumably to be condemned is in all likelihood a self-portrait of the artist!

The 17th century was also a great period for landscape painting in the Netherlands. Typical of Dutch landscape painting was the work of Jacob van Ruisdael. Van Ruisdael's *View of Ootmarsum* (17.14) shows not only the famed flatness of the Dutch landscape but also the artist's reaction to that flatness as an expression of the immense, limitless grandeur of nature. The artist makes a contrast between the land—where human order has been established in the form of buildings and cultivation—and the sky, with its billowing clouds, yielding to the wind, which mere people can never tame. The horizon line is set quite low, and, significantly, only the church steeple rises up in silhouette against the sky, perhaps symbolizing that humankind's one connection with the majesty of nature is through the Church.

Despite this emphasis on the church building, Van Ruisdael's art is essentially secular, as is that of Leyster and Rembrandt. Although religious subjects continued to appear in art—and do so even now—never again would religious art dominate as it did in the Renaissance and Italian Baroque periods. No doubt, this is largely because of the change in sponsorship; popes and cardinals became less important as patrons, while kings, wealthy merchants, and the bourgeoisie became more so. We can follow this increasing secularization of art as we move out of the 17th century into the 18th.

The 18th Century

The first half to three-quarters of the 18th century is often thought of as the age of **Rococo**—a development and extension of the Baroque style. The term "rococo" was a play on the word "baroque," but it also refers to the French words for "rocks" and "shells," forms that appeared as decorative motifs in architecture, in furniture, and occasionally in painting. Like the Baroque, Rococo is an extravagant, ornate style, but there are several points of contrast. Baroque, especially in the South, was an art of cathedrals and palaces;

17.14 Jacob van Ruisdael. *View of Ootmarsum.* c. 1660–65. Oil on canvas, $23\frac{1}{4} \times 28\frac{7}{8}$ ". Alte Pinakothek, Munich

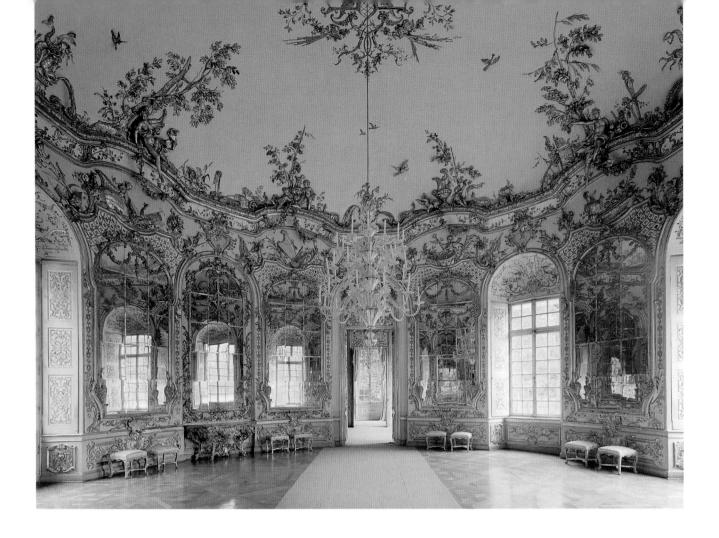

17.15 François de Cuvilliés the Elder. Mirror Room, Amalienburg, Nymphenburg Park, Munich. 1734–39.

Rococo is more intimate, suitable for the aristocratic home and the drawing room. Baroque colors are intense; Rococo leans more toward the gentle pastels. Baroque is large in scale, massive, dramatic; Rococo has a smaller scale and a lighthearted, playful quality.

The Rococo style of architecture originated in France but was soon exported. We find some of the most developed examples in Germany, especially in Bavaria. The Mirror Room of the Amalienburg, a little house in Nymphenburg Park near Munich (17.15), demonstrates amply why the word "rococo" has come to mean "elaborate and profuse." Designed by a Frenchman, François de Cuvilliés the Elder, the Mirror Room is a perfect riot of sinuous, twisting, almost visibly *growing* decorative forms. The line between walls and ceiling has been obscured deliberately to create the illusion of "sky" above the room. Large arched mirrors multiply the effect of playful design everywhere the eye might focus. Rococo was above all a sophisticated style, and the Amalienburg shows us the height of that sophistication.

Sophistication was paramount in painting as well. In Chapter 4, we looked at *The Embarkation for Cythera* by Jean-Antoine Watteau (see 4.10). Painted in 1718, it stands at the very beginning of the Rococo style. The dreamlike world Watteau invented must have appealed to French aristocrats weary of the formal grandeur of Versailles and the ceremonial character of daily life there. Even the new king, Louis XV, seems to have found his role exhausting, for he created within the palace a modest apartment that he could escape to and live, if only for a few hours, like a simple (if rather well-off) gentleman.

Just over half a century later, the aging king's mistress, the Countess du Barry, commissioned one of the last masterpieces of Rococo art, a set of four large paintings by Jean-Honoré Fragonard called *The Progress of Love*, of which we illustrate *The Pursuit* (17.16). Through a lushly overgrown garden on the grounds of some imaginary estate, an ardent youth chases after the girl who

RELATED WORKS

4.10 Watteau, Embarkation for Cythera

has captured his heart. He holds out to her a single flower, plucked from the abundance that surrounds them. She, surprised while sitting with her friends, flees, but so prettily that we know it is all a game. She will surely not run *too* fast. Above, a statue of two cupids seems to participate, watching over this latest demonstration of their powers to see how it will all turn out.

Madame du Barry had commissioned the paintings to decorate a new pavilion she had just had built on her estate. Although Fragonard never painted a lovelier set of works, his patron rejected them. She considered them too old-fashioned and sentimental. Rococo taste had run its course. Seriousness was now in vogue, together with an artistic style called **Neoclassicism** ("new classicism"). Since 1748, excavations at the Roman sites of Pompeii and Herculaneum in Italy had been uncovering wonders such as the wall paintings we looked at in Chapter 14 (see 14.31). Patrons and artists across Europe were newly fascinated by the Classical past, and their interest was encouraged by rulers and social thinkers hoping to foster civic virtues such as patriotism, stoicism, self-sacrifice, and frugality—virtues they associated with the Roman Republic.

17.16 Jean-Honoré Fragonard. The Pursuit, from The Progress of Love. 1771–73. Oil on canvas, height approx. 10'5".
The Frick Collection, New York

Among the many young artists who flocked to Italy to absorb the influence at first hand was a young painter named Jacques-Louis David. Upon his return to France, David quickly established himself as an artist of great potential, and it was none other than the new king, Louis XVI, who commissioned his first resounding critical success, *The Oath of the Horatii* (17.17).

The painting depicts the stirring moment when three Roman brothers, the Horatii of the painting's title, swear before their father to fight to the death three brothers from the enemy camp, the Curiatii, thus sacrificing themselves to spare their fellow citizens an all-out war. The subject combines great patriotism with great pathos, for as David's audience would have known, one of the Horatii was married to a sister of the Curiatii, and one of the Curiatii was engaged to a sister of the Horatii. David paints these two women at the right. They are overcome with emotion, knowing that tragedy is the only possible outcome. In fact, of the six brothers, only one, one of the Horatii, will survive the bloody combat. Arriving home, he finds his sister in mourning for her slain fiancé. Outraged at her sorrow, he kills her.

Gone are the lush gardens and pastel colors of the Rococo. In their place, David has conceived an austere architectural setting beyond which there is merely darkness. Spread across the shallow foreground space, the dramatically lit figures are portrayed in profile as though carved in relief. The creamy brush

17.17 Jacques-Louis David. *The Oath of the Horatii*. 1784–85. Oil on canvas, approx. 11 × 14'. Musée du Louvre, Paris

THINKING ABOUT ART Academies

Why would artists want to be accepted by academies? What are some of the accomplishments that academies encouraged? Are there limitations and labels which academies create that would hinder artistic expression?

he painting depicted here is a still life by the 18thcentury French artist Jean-Siméon Chardin. Chardin's career followed a typical path for his time and place. After completing his artistic training, he presented a group of his works for consideration by the Royal Academy of Painters and Sculptors, a powerful organization sponsored by the king. A committee judged his paintings worthy, and he was accepted into the Academy as a "painter of animals and fruits." As a member of the Academy, Chardin was entitled to show his paintings in a biennial exhibition called the Salon, thus gaining attention and attracting commissions. He became an officer of the Academy, and then its treasurer. Eventually, the king granted him a small yearly stipend along with a place to live in the Louvre Palace. Later in life he was even placed in charge of hanging the Salon show, a delicate task that required the skills of a diplomat.

Academies were one of the many ways in which Renaissance humanists had attempted to revive Classical culture. Their model was the celebrated Academy of the ancient Greek philosopher Plato, which earned its name from the park in Athens where the brilliant thinker met with his students, the Akademeia. Early Renaissance academies were private, informal gatherings that brought small groups of scholars and artists together to discuss ideas. In 1561, however, the artist Giorgio Vasari persuaded Cosimo de' Medici, a wealthy art patron, to sponsor a formal academy devoted to art, the Academy of Design, in Florence. By founding the first public academy, Vasari sought to underscore the prestige of art as an intellectual endeavor and to solidify the social status that artists had achieved during the Renaissance. Over the course of the next two centuries, art academies were founded across Europe. By the close of the 18th century, they were at the center of artistic life.

Academies were inherently conservative. Their aim was to maintain official standards of skill and taste by perpetuating models of greatness from the past, especially the Classical past. Although women artists could often be accepted as members, only men could enroll as students, for academic training revolved around mastering the human figure, and it was deemed improper for young girls to gaze upon naked models. Students began by copying drawings, then advanced to drawing fragments of Classical statues-isolated heads, feet, torsos. They learned to draw gestures, poses, and facial expressions that expressed all variety of dramatic situations and emotions. They studied anatomy. Eventually they progressed to drawing from live models. They came to know the human form so thoroughly that they could draw it from memory, creating complex compositions without recourse to models at all.

This emphasis on mastering the human form was linked to the belief that the greatest subject for art was history, including biblical and mythological scenes, historical events, and episodes from famous literary works. After history, portraiture had the most prestige. Then, in descending order, came genre, still life, and landscape. These beliefs had direct consequences for painters: upon his retirement, Chardin asked for a pension, pointing to his twenty years of service as treasurer. He was turned down. The new director of the Academy was an ambitious history painter who thought that Chardin had been far too amply rewarded already. After all, he was only a painter of animals and fruits.

Jean-Siméon Chardin. A Basket of Wild Strawberries. c. 1760. Oil on canvas, $12\% \times 16\%$ ". Private Collection.

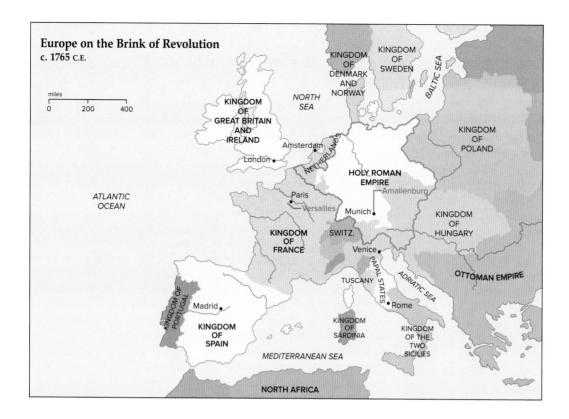

strokes and hazy atmosphere of Fragonard have given way to a smooth finish and a cool, clear light. Colors are muted except for the father's tunic, which flows like a river of blood next to the three gleaming swords.

Along with the stern "Roman family values" promoted by Neoclassicism, the late 18th century was under the spell of a new taste for simplicity and naturalness. One of the people most taken by the new informality was Louis XVI's queen, Marie-Antoinette. Another advocate of all that was unaffected was the queen's favorite portrait painter, Elisabeth Vigée-Lebrun. Inspired in part by the spareness of classical costume (note the women in David's painting) and in part by an ideal of the "innocent country girl," Vigée-Lebrun coaxed her highborn models into posing in airy white muslin dresses, their hair falling loosely about their shoulders, a straw bonnet tied with a satin ribbon on their head, and a flower or two in their hands.

The image confirmed the public's worst suspicions: their queen was frivolous and flirtatious. In an attempt to repair the queen's reputation, Vigée-Lebrun was asked to paint a different sort of portrait, *Marie-Antoinette and Her Children* (17.18). Here, Marie-Antoinette is portrayed as a devoted and beloved mother. She is a woman who knows that her place is in the home, not meddling in politics or advertising her charms. In a gesture meant to tug at viewers' heartstrings, her elder son, the heir to the throne, draws our attention to an empty cradle; his youngest sibling had recently died in infancy. The queen's formal velvet gown and the glimpse of the fabled Hall of Mirrors in the background are meant to convey that she is aware of the seriousness of her position and fully capable of the quiet dignity needed to fulfill it.

It was too late. Far too much damage had already been done for a single painting to repair. The nation was teetering on the brink of financial disaster. Popular opinion blamed the deficit on the queen's extravagant ways and suspected her as well of shocking personal vices. Vigée-Lebrun herself tells us that when the frame for the large canvas was carried into the Salon, where the painting was to be shown to the public for the first time, voices were heard saying, "There is the deficit."

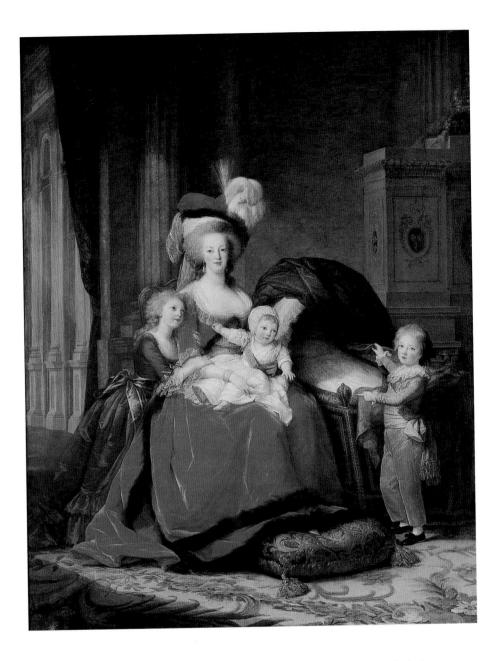

Although Vigée-Lebrun later made several copies of her own portraits of the queen, she never again painted Marie-Antoinette from life. Within two years, revolution had swept the country, ultimately destroying the monarchy and the aristocracy. The artist fled and took refuge outside France. The queen died by the guillotine.

17.18 Elisabeth Vigée-Lebrun. *Marie-Antoinette and Her Children.* 1787. Oil on canvas, 8'8" × 6'10". Palace of Versailles, France

Revolution

The leaders of the French Revolution continued to evoke the example of Rome and to admire Roman civic virtues. Neoclassicism became the official style of the Revolution and Jacques-Louis David its official artist. David served the Revolution as propaganda minister and director of festivals. As a deputy to the Convention of 1792, he was among those who voted to send his former patron Louis XVI to the guillotine. One of the events orchestrated by David was the funeral of the revolutionary leader Jean-Paul Marat. David staged the exhibition of Marat's embalmed cadaver to the public, and he memorialized

ARTISTS Elisabeth Vigée-Lebrun (1755-1842)

How does the artist display her steadfast and calm personality in her self-portrait? In her other works? What about her style attracts the attention of patrons and aristocratic clients?

rom her self-portrait she gazes directly at us, her viewers—calm, self-possessed, sure of her talent, sure of her place in the world. Her chalk is poised over the canvas; we have momentarily interrupted her work on a portrait. She will not be interrupted for long. Throughout her remarkable life, Elisabeth Vigée-Lebrun knew where she was going and remained steadfast on that path.

Born in Paris, the daughter of a portrait painter, Elisabeth Vigée was convent-educated and encouraged from an early age to draw and paint. At eleven she began serious art studies. After her father's untimely death, Elisabeth resolved to work as a painter, and by age fifteen she was her family's chief financial support. Patrons flocked to her studio, eager to have their portraits done by the young artist, and her fees multiplied.

One dark spot was her mother's remarriage, to a man who seems mainly to have coveted his stepdaughter's income. Because of this unpleasant circumstance, Elisabeth made the one real mistake of her life. Although she "felt no manner of inclination for matrimony," she succumbed to her mother's urgings and accepted the proposal of Jean-Baptiste-Pierre Lebrun, hoping "to escape from the torture of living with my stepfather." Alas for the twenty-year-old artist, she had merely "exchanged present troubles for others." Lebrun was "quite an agreeable person," but, his wife soon discovered, "his furious passion for gambling was at the bottom of the ruin of his fortune and my own." The happiest result of the union was Vigée-Lebrun's only child, her daughter Julie.

Neither marriage nor motherhood interfered with the artist's burgeoning career and social life. By all evidence she was lovely, witty, charming, and perfectly at home in any company. Quite independent of her husband, she entertained a growing circle of aristocratic friends, many of whom commissioned portraits. In 1779 a summons came from the Palace of Versailles. Marie-Antoinette sought her services, and Vigée-Lebrun made the first of some twenty portraits of the queen. The two women became friends—a splendid advantage for the artist initially, but a dangerous liability as resentment of the monarchy grew. When revolution came in 1789, Vigée-Lebrun fled the country, taking Julie with her. Lebrun was left behind forever.

Then commenced Vigée-Lebrun's twelve years of "exile" from France. And what an exile it was! She traveled first to Rome and Vienna, then to St. Petersburg and Moscow, spending six years altogether in czarist Russia. Wherever she went she was treated like visiting royalty, entertained lavishly, invited to join the local painters' academy. Wherever she went she was overwhelmed with portrait commissions. Kings and queens, princesses, counts, duchesses—she painted them all, in between the elaborate dinners and balls to which they invited her. In her memoirs she tells us she missed painting Catherine the Great because the empress died just before the first scheduled sitting.

In 1801, the furies of the revolution having abated, Vigée-Lebrun returned to Paris. She had not, however, quite satisfied her urge to travel. Only after a three-year stay in London and two visits to Switzerland did she finally settle down to write her memoirs and paint the survivors of the French nobility. She died in her eighty-seventh year, having painted more than 660 portraits. Her memoirs conclude with these words: "I hope to end peacefully a wandering and even a laborious but honest life." And she did.

Elisabeth Vigée-Lebrun. Self-Portrait. 1800. Oil on canvas, 31 \times 26 3 / a ". State Hermitage Museum, St. Petersburg, Russia.

the leader's death in what has become his most famous painting, The Death

of Marat (17.19).

A major figure in the Revolution, Jean-Paul Marat was the fiery voice of the radical political faction called the Jacobins. Because of a painful skin ailment, he spent his days in the bathtub, which was fitted out with a writing desk so he could work, and there he received callers. A woman named Charlotte Corday, who sympathized with a rival political faction called the Girondins, gained entry to his apartment and stabbed him to death.

In lesser hands Marat's demise could have been laughable—a naked man murdered in his tub. But David has invested the event with all the pathos and dignity of Christ being lowered into his tomb. (Compare Caravaggio's Entombment of Christ, 17.6.) Marat is shown, in effect, as a kind of secular Christ martyred for the Revolution. All the forms are concentrated in the lower half of the composition, and light bathes the fallen leader in an unearthly glow, both of these devices contributing to the sense of tragedy. Marat's face and body could be those of a fallen Greek warrior, sculpted in marble by an ancient master. David's purpose in this work was to transform a man whom many considered Satan himself into a sainted hero. He projected the image the leaders of the Revolution wished to have of themselves, just as Vigée-Lebrun's art had projected the image desired by the French monarchs.

Two other revolutions occurred at more or less the same time as that in France. One was the American Revolution, preceding the French by thirteen years. During the relatively brief period covered by this chapter, the American colonists had progressed from the "starving time" of Jamestown to a nation of people capable of independence and self-government. During that time also, the area that was to become the United States had developed its own artistic

17.19 Jacques-Louis David. The Death of Marat. 1793. Oil on canvas, 5'5" × 4'2½". Musée d'Art Ancien, Musées Royaux des Beaux-Arts, Brussels

styles. And by the eve of the Revolution, the colonies had their own master artist, born on home soil—John Singleton Copley.

Born in Boston, Copley would paint many people who later became heroes of the Revolution, including *Paul Revere* (17.20). Legend and poetry have preserved the image of Paul Revere taking his "midnight ride" on horseback, from Boston to Concord, to warn his fellow colonists that "the British are coming!" In his day, however, Revere was better known as a silversmith. The artist poses him with a silver teapot in one hand, the tools of his trade scattered elegantly on the table.

Copley's portrait is in much the same Neoclassical style as David's tribute to Marat. The subject sits quietly behind his table, gazing straight toward us. We as viewers might be seated just opposite him. Although he is dressed informally, Revere shows great dignity and an obvious pride in his work. Copley has rendered his subject's features, the garments, and the polished tabletop with wonderful fidelity. We sense fullness, a three-dimensional volume, in the body and especially in the hand clasping the teapot.

The third revolution of this time was not a political uprising but an economic and social upheaval. Many would argue that the Industrial Revolution, which began slowly in the last half of the 18th century, is still going on.

It is difficult to overestimate the impact—social, economic, and ultimately political—of the change from labor done by hand to labor done by machine. Within the space of a few decades, the machine drastically altered a way of life that had prevailed for millennia. People who had formerly worked in their homes or on farms suddenly were herded together in factories, creating a new social class—the industrial worker. Fortunes were made virtually overnight by members of another new class—the manufacturers. Naturally, all this upheaval was reflected in art. At the beginning of the 19th century, then, Western civilization faced a totally new world.

17.20 John Singleton Copley. *Paul Revere*. 1768–70. Oil on canvas, 35 × 28½". Museum of Fine Arts, Boston

18

Arts of Islam and of Africa

he ancient civilizations discussed in Chapter 14 culminated with the growth of the Roman Empire, which by 100 c.e. encompassed the entire Mediterranean region. Chapter 15 saw the empire divided into eastern and western halves after the death of the emperor Constantine. The eastern portion continued for a time as Byzantium. The western portion, after an unstable period, emerged as Europe, which we left in the last chapter on the brink of our own modern age. But what of the Roman lands along the southern shores of the Mediterranean, the lands of North Africa, Egypt, the Near East, and Mesopotamia? The answer is the religious culture of Islam, and thus it is with Islam that our brief exploration of artistic traditions beyond the West begins. (The story of Western art resumes with Chapter 21.)

Arts of Islam

Islam arose during the early 7th century C.E. on the Arabian Peninsula. There, according to Islamic belief, God—who had spoken through such prophets as Abraham, Moses, and Jesus—spoke directly to humanity for the last time. Through the angel Gabriel, He revealed His word to the Prophet Muhammad. Stunned by the revelations, Muhammad began to preach. At the heart of his message was *islam*, Arabic for "submission," meaning submission to God. Those who accepted Muhammad's teachings were called Muslims, "those who submit." Collected and set in order after his death, the revelations Muhammad recited make up the Qur'an ("recitation"), the holy book of Islam.

In 622 Muhammad emigrated from the city of Mecca northward to the city of Medina. Known as the *hijra*, this move marks the year 1 in the Islamic calendar, the beginning of a new era. Muhammad became a political leader in Medina as well as a spiritual one, and much of the Arabian Peninsula was brought into the Islamic community. After Muhammad's death in 632, his successors led Arab armies to victory after victory, and by the middle of the 8th century, Islamic rule extended from Spain and Morocco in the west to the

borders of India in the east.

Islam transformed the Arab peoples from a collection of warring tribes with a largely oral culture to a people united by faith, anchored by the written word, and sovereign over vast territories. These new conditions nurtured the growth of a new artistic culture. The need for places to worship and palaces for rulers inspired works of monumental architecture; the establishment of

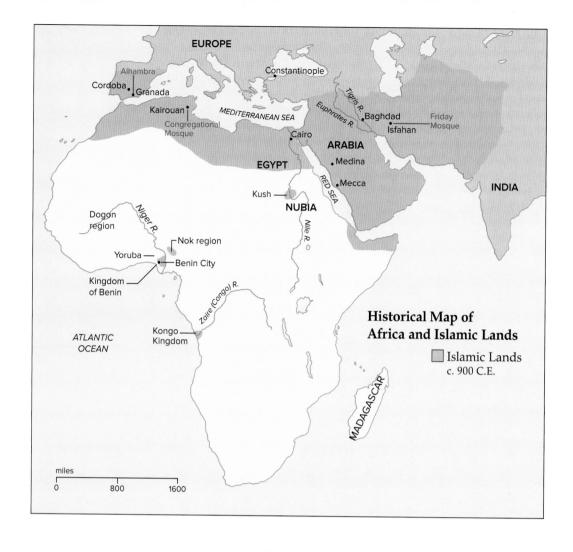

princely courts supported the production of luxury arts such as fine textiles and ceramics; and the centrality of the Qur'an led to a flowering of book arts, including calligraphy and illustration. Wherever Islam extended its influence, local artistic traditions were transformed by Islamic patronage. At the same time, converts from many lands transformed Islam itself into a true world religion. From its beginnings as an Arab faith, Islam became a spiritual and intellectual environment in which many cultures have thrived.

Architecture: Mosques and Palaces

One of the first requirements of Islamic rulers in new lands was a suitable place for congregational prayer, a mosque (from the Arabic *masjid*, "place for bowing down"). Early Islamic architects drew their inspiration from descriptions of the Prophet's house in Medina. Like most houses in Arabia, Muhammad's residence was built of sun-dried brick around a central courtyard. An open porch made of palm trunks supporting a roof of palm fronds ran along one wall, providing shade and shelter. There the Prophet had preached to the gathered faithful.

The Congregational Mosque at Kairouan, in Tunisia, shows how those elements were translated into monumental form (18.1). The shaded porch of Muhammad's house became a large prayer hall (the covered structure to the left). Just as the roof of Muhammad's porch was supported by rows of palm trunks, the roof of the hall is supported inside by rows of columns. The court-yard before the prayer hall is lined with covered arcades (rows of arches). Over the entry to the courtyard rises a large, square tower called a minaret. From its height a crier calls the faithful to prayer five times a day.

Two domes visible on the roof mark the prayer hall's center aisle. A worshiper entering from the courtyard and walking up this aisle would be walking toward the *mihrab*, an empty niche set into the far wall. This is the *qibla* wall, which indicates the direction of Mecca. Muhammad told his followers to face Mecca during prayer, and all mosques, no matter where in the world, are oriented toward that city. Inside every mosque, a *mihrab* marks the *qibla* wall, the wall Muslims face during prayer.

The minaret of the Kairouan Mosque was modeled on a Roman lighthouse, and the mosque's vocabulary of column, arch, and dome is based in Roman and Byzantine architecture. Cultural exchange between Islam and Byzantium can be seen again in the Great Mosque at Córdoba, in Spain. We looked at the interior of the prayer hall of this mosque in Chapter 3 (see 3.2). The illustration here shows the dome before the *mihrab* (18.2). Eight intersecting arches rising from an octagonal base lift a fluted, melon-shaped dome over the hall below. Light entering through windows opened up by the arches

18.1 Congregational Mosque, Kairouan. 836 and later.

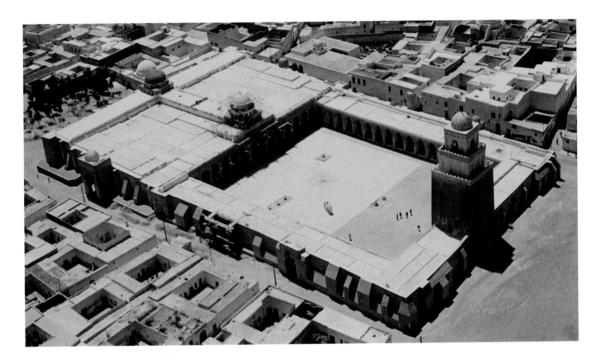

18.2 Dome in front of the *mihrab*, Great Mosque, Córdoba. c. 965. Mosaic.

3.2 Prayer hall, Great Mosque, Córdoba

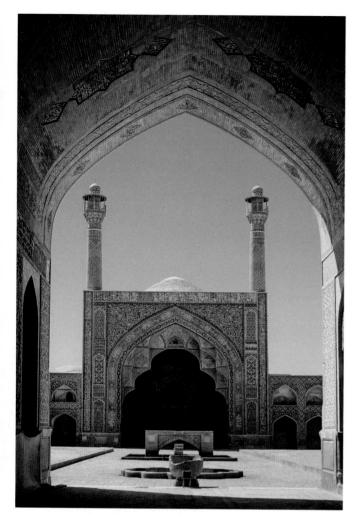

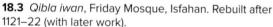

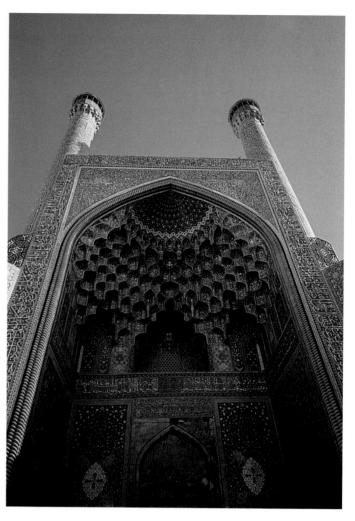

18.4 Entry portal, Shah Mosque, Isfahan. 1611–66.

plays over the glittering gold mosaics that cover the interior. Gold mosaics may remind you of Byzantine churches (see 15.9). In fact, the 10th-century ruler who commissioned the mosaics sent an ambassador to the Byzantine emperor requesting a master artisan to oversee the work. The emperor reportedly sent him not only the artisan but also a gift of 35,000 pounds of mosaic tesserae.

Whereas the mosaics in a Byzantine church might depict Jesus, Mary, and saints, the mosaics here do not portray any people, much less God himself. The Qur'an contains a stern warning against the worship of idols, and in time this led to a doctrine forbidding images of animate beings in religious contexts. As a result, artists working for Islamic patrons poured their genius into decorative geometric patterns and stylized plant forms—curving tendrils, stems, foliage, and flowers. Arabic script, too, became an important element of decoration. A passage from the Qur'an appears here in an octagonal band over the arches.

To the east, Islamic civilization was colored by the culture of Persia (present-day Iran), which had been Byzantium's great rival before its empire fell to Arab armies. During the 12th century, Persian architecture inspired a new form of mosque, illustrated here by one of the earliest and most influential examples, the Friday Mosque at Isfahan, in Iran (18.3). The photograph shows the view from the entrance to the courtyard. Directly ahead is a large vaulted chamber whose pointed-arch opening is set in a rectangular frame. This is an *iwan*, a form that served to mark the entry to a royal reception hall in Persian palaces.

Each side of the mosque's courtyard is set with an iwan. This four-iwan plan became standard in Persia, and its influence extended west to Egypt and east into Central Asia and India. The Taj Mahal in India, for example, is based in Persian architectural forms, and each of its four facades is set with an iwan (see 13.18). The photograph of the Friday Mosque at Isfahan was taken from the shade of the entry iwan, whose great pointed arch frames the view. Across the courtyard is the qibla iwan, oriented toward Mecca. Two slender minarets rise over its corners. The qibla iwan serves as a prayer hall, and the other three iwans are used as places for study, rest, or schooling. In back of the qibla iwan is a large domed chamber. Constructed for the private prayers of the ruler and his court, the domed chamber contains the milirab.

The interior of the qibla iwan seems to be formed of triangular scoops as though it had been hollowed out by a giant spoon. Added during the 14th century, these niche-like scoops, muqarnas, are one of the most characteristic of Islamic architectural ornaments. They appear in more typical form in the stunning entryway to the 17th-century Shah Mosque, also in Isfahan (18.4). Cascading downward from a sunburst motif at the top of the pointed arch, the tiers of clustered muqarnas seem to multiply into infinity, like honeycomb

or stalactites.

The blue glazed tile mosaic that blankets every surface of the entryway was a specialty of Persian artists. Glazed tile had been used to decorate buildings in the region since the ancient civilizations of Mesopotamia (see 14.9). An inscription flows around the perimeter of the frame, brilliant white on a deep blue ground; another band of calligraphy appears beneath the muqarnas. The rest is patterned in stylized flowering plants. Like the muqarnas, the patterns seem to multiply into infinity, as though a garden with blossoms as numerous as the stars had spread itself like a carpet over the building.

After roughly a century of unity under Arab leadership, Islamic lands were ruled by regional dynasties, and Arab dynasties took their place alongside dynasties founded by African, Persian, Turkish, and Central Asian groups. Little survives of the sumptuous palaces built for those rulers, for palaces were commonly destroyed or abandoned when a dynasty fell from power. A rare exception is the Alhambra, in Granada, Spain. Constructed largely during the 14th century under the Nasrid dynasty, the Alhambra was a royal city of gardens, palaces, mosques, baths, and quarters for artisans, all built within the protective walls of an older hilltop fortress. From the outside, the Alhambra looks every inch the forbidding fortress it began as. Once inside, however, visitors find themselves in a sheltered world of surpassing delicacy and refinement (18.5).

The Court of the Lions, shown here, takes its name from the stone lions supporting the fountain at its center. Water brought from a distant hill flows through the Alhambra in hidden channels, surfacing in fountains and pools. Indoor and outdoor spaces also flow into each other through open entryways, porches, and pavilions. Here, stucco screens carved in lacy openwork patterns and "fringed" with muqarnas are poised on slender columns, allowing light and air to filter through. The Nasrids were to be the last Islamic dynasty in Spain. Christian kings had already reclaimed most of the peninsula, and in 1492 Granada fell to Christian armies as well, ending almost eight hundred years of Islamic presence in western Europe.

Book Arts

Writing out the Qur'an-which Islamic scholars commonly memorize-is viewed as an act of prayer. Calligraphy thus became the most highly regarded art in Islamic lands, and great calligraphers achieved the renown Europeans accorded to painters and sculptors. As a religious text, the Qur'an was never illustrated with images of animate beings. Instead, artists ornamented manuscripts with geometric patterns and stylized plant forms, just as they did mosques. An example is this page from a Qur'an copied in 1307 by a famous calligrapher

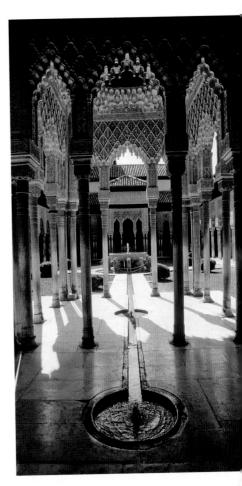

18.5 Court of the Lions, Alhambra Palace, Granada. Mid-14th century.

18.6 Ahmad al-Suhrawardi, calligrapher. Page from a copy of the Qur'an. Baghdad, 1307. Ink, colors, and gold on paper; $20\frac{3}{16} \times 14\frac{1}{2}$ ".

The Metropolitan Museum of Art, New York

18.7 Shaykhzada. Bahram Gur and the Princess in the Black Pavilion, from a manuscript of Hatifi's Haft Manzar. Bukhara, 1538.
Freer Gallery of Art, Smithsonian Institution, Washington, D.C.

named Ahmad al-Suhrawardi (18.6). The top and bottom bands of the painted frame are ornamented in gold with interlacing plant forms and a line of text in an archaic style of Arabic script called Kufic. Ahmad's own bold and graceful calligraphy fills the framed area. One of the most gifted students of an even more famous calligrapher named Yaqut al-Mustasimi, Ahmad lived and worked in Baghdad, which was a major center for book production and scholarship.

Although the Qur'an could not be illustrated with images, other books could. Books were the major artistic outlet for painters in Islamic culture. Working with the finest pigments and brushes that tapered to a single hair, artists created scenes of entrancing detail such as *Bahram Gur and the Princess in the Black Pavilion* (18.7). Bahram Gur was a pre-Islamic Persian king whose legendary exploits were often recounted in poetry. *Haft Manzar* ("seven portraits"), by the 16th-century Persian poet Hatifi, tells of Bahram Gur's infatuation with the portraits of seven princesses. He eventually wins them all and builds for each a pavilion decorated in a different color. The Russian princess is housed in a red pavilion, the Greek princess in a white one. Here, Bahram Gur visits the Indian princess in her black pavilion.

The complex, flattened architectural setting and strong colors mark the style of the artist Shaykhzada, whose signature appears on the work. Floor coverings piled pattern on pattern are tilted toward the picture plane, whereas the brass vessels set on them are seen in perspective. The king and his princess sit demurely on their individual carpets before a wall ornamented with glazed tile. The setting above resembles the square frame and arched opening of an *iwan*, the pervasive Persian architectural form that might well have graced a pavilion built for an Indian princess.

Arts of Daily Life

Western thinking about art has tended to relegate decorative art such as rugs and ceramics to "minor" status. Islamic cultures, though holding book arts in especially high esteem, have generally considered all objects produced with skill and taste to be equally deserving of praise and attention. Carpets and other textiles, for example, are an important facet of Islamic art. We saw one of the most famous of all Persian textiles in Chapter 12, the Ardabil carpet (see 12.11).

We end this look at Islamic arts with an example of ceramic art, a mosque lamp made during the 16th century in the Ottoman Empire (18.8). Based in Turkey, the Ottoman dynasty came to power in 1281. In 1453, Ottoman armies took Constantinople, putting an end to the Byzantine Empire. Constantinople, later called Istanbul, served as the Ottoman capital until the creation of the present-day nation of Turkey in the 20th century. The lamp was found in the Dome of the Rock, a 7th-century building in Jerusalem that is often called the first work of Islamic architecture. Ottoman rulers sponsored a renovation of that monument, and this lamp may have been made for it. Modeled after similar hanging lamps of glass, it probably served a symbolic function, for it would not have shed any light. The palette of blue, turquoise, and white, familiar from mosques at Isfahan (see 18.3, 18.4), points to the presence of Persian potters at the Ottoman court. The mixture of decorative motifs includes elements derived from Chinese ceramics, which were collected and admired in eastern Islamic lands. Finally, we see again the proud verticals and swirling ribbons of the Arabic script, writing made beautiful enough to carry God's word.

Arts of Africa

When Arab armies invaded Africa in the 7th century C.E., their first conquest was the Byzantine province of Egypt, the site of Africa's best-known early civilization. Chapter 14 introduced ancient Egypt in the context of the Mediterranean world, for its interactions with Mesopotamia, Greece, and Rome are an important part of Western art history. But it is useful to remember that Egyptian culture arose in Africa and was the creation of African peoples.

The Nile that nourished Egypt also supported kingdoms farther to the south, in a region called Nubia. Nubia was linked by trade networks to African lands south of the Sahara, and it was through Nubia that the rich resources of Africa—ebony, ivory, gold, incense, and leopard skins—flowed into Egypt. The most famous Nubian kingdom was Kush, which rose to prominence during the 10th century B.C.E. and lasted for over 1,400 years. The gold ornament illustrated here comes from a Kushan royal tomb, the pyramid of Queen Amanishakheto (18.9). A sensitively modeled ram's head protrudes from the center of the ornament, a symbol in Kush, as in Egypt, of the solar deity Amun. Over the ram's head, the disk of the sun rises before a faithful representation of an entryway to a Kushan temple.

18.8 Underglaze-painted mosque lamp from the Dome of the Rock in Jerusalem. Isnik, 1549. Height 15%". The British Museum, London

18.9 Ornament from the tomb of Queen Amanishakheto.
Kush, Meroitic period, 50–1 B.C.E.
Gold with glass inlay, height 2½".
Ägyptisches Museum, Staatliche
Museen zu Berlin

Carrying their conquests farther west across the Mediterranean coast of Africa, Arab armies quickly routed Byzantine forces from the Roman coastal cities. Far more difficult to subdue were the African people known as Berbers. Berber kingdoms were well known to the ancient Mediterranean world. In the days of the Roman Empire, Berbers mingled with the Roman population in Africa and occasionally rose to high rank in the Roman army. One Berber general became a Roman emperor. After the Islamic conquests, Berbers gradually converted to Islam, and Islamic Berber dynasties held sway in Morocco, Algeria, and Spain. Berber groups were also involved in the long-distance trade across the Sahara that linked the Mediterranean coast with the rest of the continent to the south. Along those ancient trade routes, Islam spread peacefully through much of West Africa, eventually resulting in such African Islamic art as the mosque at Djenné, in Mali (see 13.1).

The Africa that Islamic travelers found south of the Sahara was and is home to literally hundreds of cultures, each with its own distinctive art forms. More than any other artistic tradition, the arts of Africa challenge us to expand our ideas about what art is, what forms it can take, what impulses it springs from, and what purposes it serves. Much of the history of these arts is lost to us, in part for the simple reason that most art in Africa has been made of perishable materials such as wood. Nevertheless, excavations during the 20th century have revealed many fascinating works in stone, metal, and terra cotta, including sculptures such as this terra-cotta head (18.10).

The smooth surfaces and *D*-shaped eyes are characteristic of works from the culture known as Nok, named after the town in Nigeria where the first examples of its art were found. Scientific testing suggests that most Nok works were made between 500 B.C.E. and 200 C.E., or around the time of ancient Greece and Rome. Broken off at the neck, the life-size head here probably formed part of a complete figure. Judging by the few complete figures that have been recovered, its elaborate, sculptural hairstyle would have been complemented by lavish quantities of jewelry and other ornaments.

It seems likely that Nok culture influenced later cultures in the region, although we cannot say for sure. What is certain is that two of the most sustained art-producing cultures of Africa arose some centuries later not far from the Nok region. One is the kingdom of Benin, which began to take shape

18.10 Head, fragment of a larger figure. Nok, 500 B.C.E.— 200 C.E. Terra cotta, height 143/6". The National Commission for Museums and Monuments, Lagos

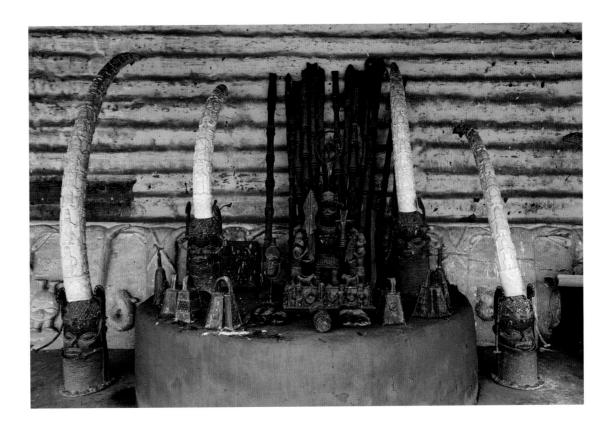

during the 13th century. Located in a region of Nigeria south of the Nok sites, Benin continues to the present day under a dynasty of rulers that dates back to the first century of its existence.

Like the rulers of ancient Egypt, the kings of Benin are viewed as sacred beings. Sacred kingship is common to many African societies, and art is often used to dramatize and support it. In Chapter 5, we looked at a brass altar to the Benin king's hand (see 5.19). The altar conveyed the king's centrality through symmetrical composition, his importance through hierarchical scale (he is larger than his attendants), and the symbolic role of his head through proportion (the head takes up one-third of his total height).

These elements can be seen again in the royal altars of the palace compound (18.11). Traditionally, each king upon assuming office commissioned and dedicated an altar to his father. The altar illustrated here is dedicated to Ovonramwen, who ruled toward the close of the 19th century. At the center of the altar is a brass statue depicting a standing king flanked by two attendants. As in the small altar to the hand, hierarchical proportion underscores the king's importance. This symmetrical composition stands at the center of a still larger symmetrical composition, the assemblage of the altar itself. Around the perimeter of the platform, ceremonial brass bells are displayed, three to the left, three to the right. Four large brass sculptures depicting heads of rulers are also set out symmetrically, each capped by an elephant tusk carved in relief with dozens of royal motifs.

In 1897, British forces attacked the Benin palace and took much of the art it contained—works in brass, ivory, terra cotta, and wood produced over a period of about four hundred years. As a result, objects like the ones shown in the photograph here can be found in museums around the world. Examining a brass head or a carved tusk from Benin is a rewarding experience, but these objects were not meant to be seen in isolation, much less in a museum. Rather, they were intended to take their place as elements in a larger, composite work of art—the assemblage of a sacred altar.

According to oral tradition, the current dynasty of Benin rulers was founded by a prince from the Yoruba city of Ife to the northwest. Yoruba rulers, too, were considered sacred, and artists sculpted portrait heads in their honor. We saw two of these sculptures in Chapter 2: a naturalistic work from

18.11 The palace altar to King Ovonramwen (r. 1888–97), Benin, Nigeria.

Eliot Elisofon Photographic Archives, National Museum of African Art, Washington, D.C.

crossing cultures Africa Looks Back

frican masquerades range from sacred and secret performances before a small group of initiates to public spectacles that verge on secular entertainment, though no masquerade is ever entirely secular. The largest masquerades may be performed in stages over many days and feature dozens of masks. Spirits of nature and natural forces; spirits of ancestors and of the recent dead; spirits of human types or social roles such as young maidens, blacksmiths, and farmers; spirits of abstract ideas such as beauty or fertility or wisdom-all may put in an appearance. Our knowledge of this rich and varied art form comes largely from Western researchers such as anthropologists and art historians, who over the past century have spent time "in the field"—that is, in various African communities, where they observe, photograph,

and document the performances. Yet the nature of masquerades is such that often the observers have found themselves to be the observed.

The masker illustrated here was photographed during a masquerade performed in an Igbo community. He is *onyeocha*, "white man." With his pith helmet, notepad, and pen, he may be a scholar who has come to do important research on these interesting Africans. While the other maskers in his troupe danced, he did not. Instead, he haughtily observed the goings on and took notes. Europeans, it is well known, are obsessed with writing everything down. But what can they hope to understand that way?

White-man masks depicting European government officers began to appear during the early 20th

What functions do masquerades play in African cultures? What depictions of Europeans do the Yoruba portray in their masquerades? What traditions do we have that are similar?

century, when colonial rule was imposed over the continent. Today, when tourism helps support many public masquerades, masks depicting tourists often appear. Armed with a carved wooden "camera," they elbow their way through the crowd, angling for a good view. One European couple portraved in a Yoruba masquerade actually danced, but what a dance! They began with a waltz, then switched to a disco number that got them so overheated they ended up writhing on the ground making love! To the Yoruba, the public displays of affection that Europeans commonly indulge in are shocking. Indeed, the European couple was followed in the performance by maskers portraying a dignified, well-behaved Yoruba couple for contrast. In a masquerade performed by the Dogon people, a white-man mask sat at a table and asked silly questions. He was an anthropologist, of course!

Europeans are not the only outsiders to have been incorporated into masquerades. Masks of Muslim scholars have appeared,

as have masks portraying irksome neighboring peoples. Most outside characters are portrayed satirically, often providing comic relief in a masquerade where genuinely powerful and sacred masks will also dance. The new masks demonstrate the vitality of this living art form, which easily absorbs new powers and presences into its view of the world. Yet the masks also bring us up short by questioning the limits of our ability to "study" another culture while it "holds still." "You do not stand in one place to watch a masquerade" goes an Igbo saying. Indeed, all cultures are always in motion, affecting each other through contact, both the observer and the observed.

Onyeocha ("white man") at an Igbo masquerade, Amagu Izzi, Nigeria, 1983.

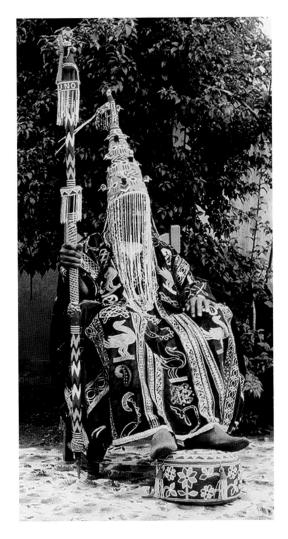

18.12 Ariwajoye I, ruler of Orangun-Ila, seated in state, 1977.

18.13 Display piece. Yoruba, early 20th century. Cloth, basketry, beads, fiber; height 41³/₄". The British Museum, London

the 13th century representing the ruler's outer, physical head and an abstract work representing his inner, spiritual head (see 2.16, 2.17). Although Yoruba artists no longer make such works, Yoruba kings are still regarded as sacred, and art still serves to dramatize their exceptional nature.

Taken in 1977, the photograph here shows the Yoruba ruler Ariwajoye I seated in his regal robes (18.12). His right hand grasps a beaded staff, and on his head is a cone-shaped beaded crown. Abstracted faces of the king's ancestors stare out from the crown; their dark, white-rimmed eyes are easily discernible. At the pinnacle of the crown is a beaded bird, and numerous bird heads protrude from the cone. The birds refer to the female ancestors whose powers the king must draw on. Known as Our Mothers, they are believed able to transform themselves into night birds. A beaded veil obscures the ruler's face, for his subjects are not allowed to gaze directly on a sacred being. The crown gives form to the idea that the living king is one with his godly ancestors, for in wearing it his head merges with theirs, and their many eyes look out.

Similar ideas are conveyed by a spectacular beaded display piece commissioned by a Yoruba king in the early 20th century (18.13). The base of the piece resembles the conical royal crown. As on the crown, faces of ancestors stare out from the front and back. Over this base rises the figure of a royal wife with a magnificent crested hairstyle and a child on her back. It is as though the bird at the pinnacle of Ariwajoye's crown had turned back into one of the female ancestors who guarantees his power. The woman carries an offering bowl with a small bird on its lid. Female attendants flock around her

18.14 Seated Couple. Dogon. Wood and metal, height 29". The Metropolitan Museum of Art, New York

18.15 Gwandusu (mother-and-child) display figure. Bamana. 13th–15th century. Wood, height 485%".
The Metropolitan Museum of Art, New York

body, while four protective male figures with guns ring the crown at the base. Male power is here seen as based in strength, whereas female power, greater and more mysterious, generates ritual (the offering) and new life (the child).

Complementary gender roles are also the subject of this elegant sculpture by an artist of the Dogon people, who live in present-day Mali (18.14). The sculpture portrays a couple seated side by side, rendered in a highly conventionalized, abstract manner. The stool they share links them physically and symbolically, as does the man's arm placed around the woman's shoulder. With their tilted heads, tubular torsos, angular limbs, horseshoe-shaped hips, and evenly spaced legs, the two bodies are almost mirror images of each other. Yet within this fundamental unity, differences appear. The man, slightly larger, speaks for the couple through his gestures, while the woman is quiet. His right hand touches her breast, suggesting her role as a nurturer. His left hand rests above his own genitals, signaling the idea of procreation. On her back, not visible here, she carries a child; on his back he carries a quiver. As often in African sculpture, abstraction is a clue here that the work does not represent specific people but spirits or ideas. He is the begetter, hunter, warrior, and

protector; she is the life-bearer, mother, and nurturer. Together with their child they form a family, the basic unit of a Dogon community. The four small figures beneath the stool may refer to the support they receive from ancestors or other spirits. The carving probably would have been kept in a shrine, where it served as a kind of altar—a site for communication between this world and the world of spirits, including spirits of ancestors.

In many African cultures, men's and women's organizations play important roles. Such associations may be in charge of initiations, preparing young boys and girls for their adult roles. Others help govern their communities or provide spiritual services and counseling. The dignified figure here belonged to a Gwan or Jo society (18.15). Formed among the Bamana, who live in Mali to the southwest of the Dogon, these associations help women generally, especially those who have had trouble conceiving, bearing, or rearing children. With her regal bearing and downcast eyes, the seated figure seems to summon up strength from within herself. On her head is a cap hung with amulets. The cap marks her as an exceptional woman, for such caps are usually worn only by powerful male hunters or sorcerers. On her lap she holds a baby, carved so that it melts into her form; perhaps it is being formed *from* her. Above the child's upraised arms, full breasts promise nourishing milk. Displayed in annual festivals, the statue embodies the central wish of those who come to Gwan or Jo for help.

Art in Africa often serves as an agent to bring about some desired state of affairs, usually through contact with spirit powers. Among the most well known and visually compelling works of spiritual agency are the power figures, *minkisi* (singular *nkisi*, "medicine"), of the Kongo and neighboring peoples of central Africa (18.16). *Minkisi* are containers. They hold materials that allow a ritual specialist to harness the powers of the dead in the service of the living. Almost any container can be a *nkisi*, but the most famous *minkisi* outside Africa are statues of ferocious hunters such as the one here. Called *minkondi* (singular *nkondi*), they hunt down and punish witches and wrongdoers.

18.16 *Nkondi* figure. Lower Congo. Before 1878. Royal Museum for Central Africa, Tervuren

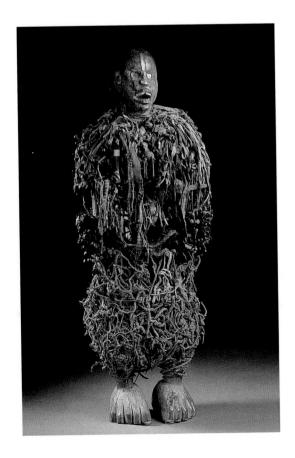

RELATED WORKS

2.40 Bwa masqueraders

18.17 Temne *nowo* masquerade with attendants, Sierra Leone, 1976.

A *nkondi* begins its life as a plain carved figure, commissioned from a sculptor like any other. In order to empower it, the ritual specialist adds packets of materials to its surface, materials linked to the dead and to the dire punishments the *nkondi* will be asked to inflict. Other materials may be added as well. Hunting nets tangled around the legs of the *nkondi* here remind him of his purpose, while mirrors in his eyes enable him to see approaching witches. Working on behalf of a client who has sought his help, or even a whole community, the specialist invokes and enrages the *nkondi* into action, particularly by driving iron nails or blades violently into it. Over the years, nails and other materials accumulate, offering visual testimony to the *nkondi*'s fearsome prowess.

The great African art of spiritual agency, and perhaps the greatest of African arts, is the masquerade. Involving sculpture, costume, music, and movement, a masquerade does not merely contact spirit powers to effect change; it brings the spirits themselves into the community. In Western museums, African masks are commonly exhibited and admired as sculpture. But in Africa a mask is never displayed in public as an isolated, inert object. It appears only in motion, only as the head or face of a spirit being that has appeared in the human community.

The mask photographed here is *nowo* (**18.17**), the guiding spirit of a Temne women's organization called Bondo, which regulates female affairs. Bondo prepares young girls for initiation into adult status and afterward presents them to the community as fully mature women. As in many African societies, young people deemed ready for initiation are taken from their families. Isolated together away from the community, they learn the secrets of adulthood and undergo physical ordeals. During this time, they are considered to be in a vulnerable "in between" condition, neither children nor adults. They need the protection, guidance, and sponsorship of spirits to make the transition successfully from one stage of life to the next.

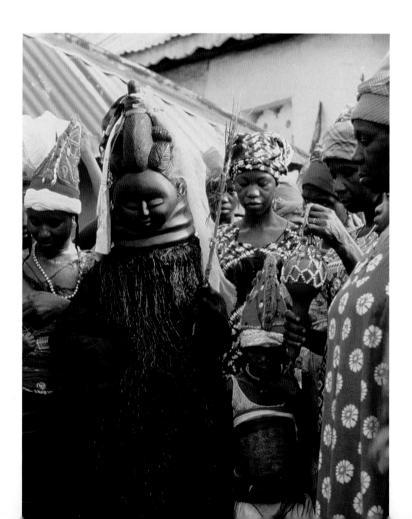

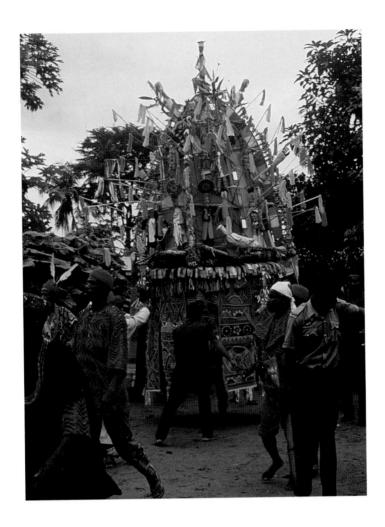

Nowo appears here accompanied by several attendants as part of a Bondo ceremony. The lustrous black mask represents a Temne ideal of feminine beauty and modesty. The rings around the base are compared to the chrysalis of a moth: just as the caterpillar emerges from its chrysalis transformed, so girls emerge from Bondo as women. The rings are also seen as ripples of water, for nowo is said to have risen out of the depths of a pool or river, where female spirits dwell. The white scarf tied to nowo's elaborate hairstyle indicates her empathy for the initiates under her care, whose bodies are painted white during their isolation as a sign of their "in between" state.

Even our preconceived ideas of what a mask is must be discarded when faced with the extraordinary spectacle of ijele (18.18). The most honored mask of the Igbo people of Nigeria, ijele appears at the funeral of an especially important man, welcoming his spirit to the other world and easing his transition from one stage of being to the next. The meanings of ijele are fluid and layered. In its towering aspect, ijele resembles an anthill—structures that in Africa may reach a height of 8 feet and which the Igbo regard as porches to the spirit world. Ijele is also a venerable tree, the symbol of life beneath whose branches wise elders meet to discuss weighty matters. Amid the tassels, mirrors, and flowers on ijele's "branches" are numerous sculpted figures of people, animals, and other masks—a virtual catalog of the Igbo and their world. Multiple large eyes suggest the watchfulness of the ever-present (though usually invisible) community of spirits. Majestic in appearance, ijele nevertheless moves with great energy, dipping, whirling, shaking, and turning. It is the great tree of meaning—of life itself—appearing briefly in the human community.

18.18 *ljele* masquerade at an Igbo second burial ceremony, Achalla, Nigeria, 1983.

19

Arts of Asia: India, China, and Japan

he previous chapter took us from the Mediterranean world into Asia with the spread of Islam to the east. This chapter continues our eastward journey with a brief look at three of the most influential civilizations of Asia: India, China, and Japan.

In truth, these civilizations have already appeared "behind the scenes" many times in this story of art. Chapter 14, for example, pointed out that the regions of Mesopotamia and Egypt were in contact with each other from early on. But Mesopotamia was also in contact with India to the east, where an impressive civilization had arisen in the Indus River Valley. Akkadian writings from around 2300 B.C.E. mention the presence of Indus merchants and ships in Mesopotamia, along with their valuable goods of copper, gold, ivory, and pearls. Later, during the days of the Roman Empire, a long network of

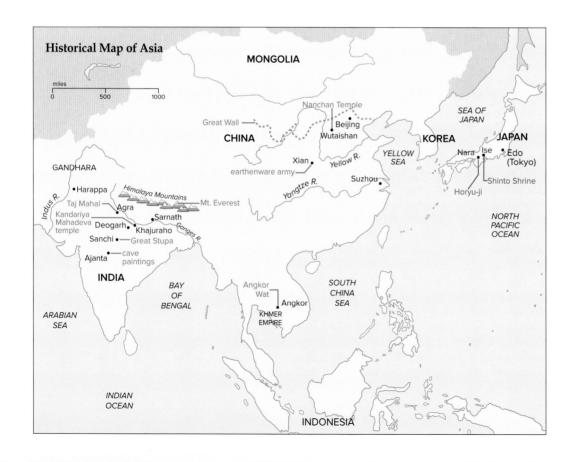

trade routes called the Silk Road allowed the citizens of Rome to enjoy the lacquerware and silk textiles of China. Rome had only the vaguest idea about where these exquisite products came from. China, more curious, avidly collected information about Rome and other Western lands. Still later, during the Renaissance, European explorers stumbled on the island nation of Japan. Japanese artists of the time delighted in recording the appearance of these exotic visitors from the West, whose customs were so strange.

Closer and more influential, however, were the contacts between these three Asian cultures themselves. China's greatest exports were writing, urban planning, administration, and philosophy, all of which it transmitted to Japan, together with styles of painting and architecture. India's greatest export was the religion of Buddhism, which travelers and missionaries brought over the Silk Road to China, and which then passed from China to Japan. With these paths of contact in mind, we begin our look at the arts of Asia.

Arts of India

The area of India's historical territories is so large and distinct that it is often referred to as a subcontinent. Another name for it is South Asia. Jutting out in a great triangle from the Asian landmass, South Asia is bordered along most of its northern frontier by the Himalaya Mountains, the tallest mountain range in the world. To the northwest, the mountain range known as the Hindu Kush gradually descends to the fertile valley of the Indus River, in present-day Pakistan.

19.1 Torso, from Harappa. Indus Valley civilization, c. 2000 B.C.E. Red sandstone, height 3¾". National Museum, New Delhi

Indus Valley Civilization

Like the Tigris and Euphrates in Mesopotamia and the Nile in Egypt, the Indus River provided water for irrigation and a central artery for transportation and travel. Cities arose along its length around 2600 B.C.E., or roughly the same time as Sumerian civilization developed in Mesopotamia. The engineering skills of the Indus architects were quite advanced. The most famous Indus city, Mohenjo-daro, was built on stone foundations, with straight, stone-paved streets laid out in a grid pattern. Houses constructed of fired brick were connected to a citywide drainage system.

The Indus people did not bury their dead with troves of precious objects, and thus we do not have an extensive record of their art. One of the most intriguing sculptures to have been found is this small sandstone torso (19.1). The softly modeled, rounded forms contrast dramatically with the armorlike musculature of ancient Mediterranean sculpture, reflecting a different way of thinking about the body. Later Indian sculpture will continue in this same vein. Scholars have interpreted the relaxed abdomen as a sign that the Indus people practiced the breathing exercises we know from later Indian culture as a component of yoga, the system of physical self-mastery that can be used to lead to spiritual insights.

A meditating yogi certainly seems to be the subject of this small, slightly damaged seal (19.2). Thousands of such seals have been found. Carved of steatite stone, they served to stamp an impression in wax or clay. At the top of the seal is an inscription. Scholars have not been able to decipher the Indus writing system, and anything it has to tell us about Indus culture must remain a mystery. His knees outspread, his feet tucked back and crossed, the yogi sits in the classic Indian pose of meditation familiar from later images of the Buddha. Other aspects of the image—the headdress with its curved horns and the small animals in the background—suggest the later Hindu god Shiva. We saw Shiva in his guise as Nataraja in Chapter 1 (see 1.9), but in another guise he is known as Lord of Beasts.

19.2 "Yogi" seal, from Mohenjodaro. Indus Valley civilization, 2300–1750 B.C.E. Steatite, $1\% \times 1\%$ ". National Museum, New Delhi

Indus culture began to disintegrate around 1900 B.C.E. Until recently, scholars believed that the cities were conquered by invaders entering the subcontinent from the northwest, a nomadic people who called themselves Aryas, "noble ones." New findings have overturned the idea of conquest, suggesting instead that Mohenjo-daro was abandoned after the Indus River changed its course and that other cities were ruined when a parallel river ran dry. During those same centuries, the Aryas began to arrive.

Buddhism and Its Art

Beginning around 800 B.C.E., urban centers again arose in northern India, and by the 6th century B.C.E., numerous principalities had taken shape. During this time, Aryan religious practice became increasingly complex. The priestly class of Aryan society, brahmins, grew powerful, for only they understood the complicated sacrificial rituals that were now required. Brahmins also began to impose rigid ideas about social order derived from the Vedas, their sacred texts. Disturbed by these developments, many sages and philosophers of the day sought a different path, preaching social equality and a more direct and personal access to the spiritual realm. Of these numerous leaders, the one who has had the most lasting impact on the world was Siddhartha Gautama, later known as the Buddha.

Gautama was born a prince of the Shaka clan in northern India, near present-day Nepal. His dates are traditionally given as 563–483 B.C.E., although recent research suggests that he lived slightly later, dying around 400 B.C.E. According to tradition, his life was transformed when a series of chance encounters brought him face-to-face with suffering, sickness, and mortality. These, he realized, were our common fate. What is to be done? Renouncing his princely comforts, he studied with the spiritual masters of the day and tried every accepted path to understanding, but to no avail. He withdrew into meditation until one day, finally, everything became clear. He was *buddha*, "awakened."

Buddha accepted the belief, current in the India of his day, that time is cyclical and that all beings, even gods and demons, are condemned to suffer an endless series of lives unless they can gain release from the cycle. His insight

19.3 Great Stupa, Sanchi, India. Sunga and early Andhra periods, 3rd century B.C.E.—1st century C.E.

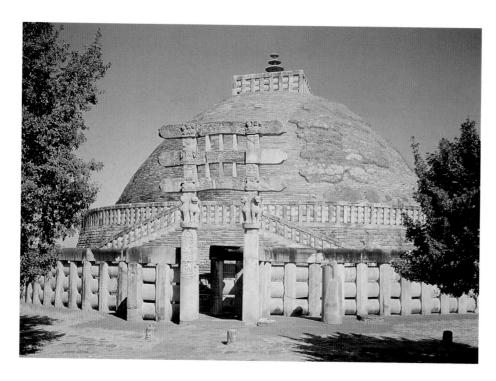

was that we are kept chained to the world by desire. His solution was to extinguish desire by cultivating nonattachment, and to that end he proposed an eightfold path of moral and ethical behavior. By following this path, we too may awake, see through the veil of illusion to the true nature of the world, and free ourselves from the cycle of life, death, and rebirth.

Buddha attracted followers from all walks of life, from beggars to kings, both men and women. After his death, his cremated remains were distributed among eight memorial mounds called **stupas**. During the 3rd century B.C.E., a Buddhist king named Ashoka called for these remains to be redistributed among a much larger number of stupas, including this one at Sanchi (19.3). A stupa is a solid earthen mound faced with stone. Over it rises a stylized parasol that symbolically shelters and honors the relics buried inside. Pilgrims come to be near the energy that is believed to emanate from the Buddha's remains. They visit the stupa by ritually walking around it. The two stone fences evident in the photograph, one at ground level and one higher up, enclose paths for circling the stupa.

Four gateways erected late in the 1st century B.C.E. punctuate the outer enclosure at Sanchi. Their crossbars are carved in relief with stories from the Buddha's life. Numerous figures ornament the gateways, including this voluptuous female (19.4). This is probably a *yakshi*, a nature spirit embodying ideas of fertility and abundance. The *yakshi* is not part of the Buddhist faith but belongs to older and more widespread Indian beliefs. The female form was considered auspicious in Indian thought. It was even held that women were able to cause trees to blossom or bear fruit. The *yakshi* here enlaces her arms in a mango tree, which has blossomed at the sound of her laughter. Together with her numerous companions on the other gateways, she showers blessings of abundance on the site and all who enter it.

Interestingly, the reliefs at Sanchi that narrate the story of the Buddha do so without showing the Buddha himself. Early Buddhist art avoided depicting the Buddha directly. Instead, sculptors indicated his presence through symbols.

19.4 Detail of east gate with *yakshi*. Great Stupa, Sanchi. Early Andhra period, 1st century B.C.E. Sandstone, height of figure approx. 5'.

19.5 Buddha Preaching the First Sermon, from Sarnath. c. 465–85 c.E. Sandstone, height 5'3". Archaeological Museum, Sarnath

19.6 The Bodhisattva Padmapani (The "Beautiful Bodhisattva"), detail of a fresco from Cave 1, Ajanta. c. 462–500 C.E.

A pair of footprints, for example, indicated the ground where he walked; a parasol indicated space he occupied. Nevertheless, the Buddhist community must eventually have felt the need for an image to focus their thoughts, for toward the end of the 1st century C.E. such images began to appear.

Several artistic centers in India were famous for images of the Buddha, and their styles are distinct. The statue here was carved in the 5th century C.E. in the workshops at Sarnath, in northern India (19.5). Typical of Sarnath style, the robe the Buddha wears molds itself discretely to the smooth, perfected surfaces of his body. The neckline and the hanging sleeves are almost the only signs that he is wearing a robe at all. Seated in the pose of meditation, the Buddha forms the *mudras* (hand gesture) that indicates preaching. He is understood to be preaching his first sermon, known as the Sermon at Deer Park. (Note the two deer carved in relief to either side of him.)

The workshops at Sarnath were patronized by the Gupta dynasty. Based in central India, these rulers had brought many of the regional kingdoms of the subcontinent into an empire. The Gupta period, which lasted from around 320 to 647 C.E., is regarded as a high point in Indian culture. During this time, Buddhism attained its greatest influence and often benefited from royal patronage, which enabled larger and more expensive projects to be undertaken. One of the most extraordinary projects was realized at Ajanta, in central India, where a series of halls, shrines, and residences for monks were hollowed out from an exposed cliff face. Murals ornamenting the walls of these sculpted caves are among the earliest examples of Indian painting to have come down to us. The detail illustrated here depicts the bodhisattva Padmapani, an image so lovely that it has become known as *The "Beautiful Bodhisattva"* (19.6).

crossing cultures The Early Buddha Image

What is the early depiction of Buddha in art? Why is that the case? How did the image of Buddha evolve? What is the Greek connection to the change? How is Buddha depicted today?

he early art of Buddhism did not include an image of its founder. Instead, in such works as the relief carvings at Sanchi (see 19.3, 19.4), the Buddha was represented by symbolic traces of his presence. Thus, an empty chair represented his seated presence, and a pathway represented him walking. That artists should have avoided depicting the Buddha directly is not so surprising. After all, the entire point of his teaching was that he was in his last earthly life. Henceforth, he would have no bodily form. Besides, the Buddha had lived 550 lives before his final one. Clearly, he had passed through many bodily forms.

So we may well wonder why images of the Buddha began to appear when and where they did, in northern India during the 1st century C.E. One of the reasons has to do with changes in Buddhism itself. By this time, the Buddha was no longer thought of as an exemplary man but as a god, and his followers now wanted an image to help them focus their devotion. Another reason was the artistic heritage of Greece.

What does Greece have to do with India? During the 4th century B.C.E., the Macedonian Greek conqueror Alexander the Great led his armies not only through Egypt and the Persian Empire but all the way to the Indus River in South Asia. For centuries afterward, regions bordering on India were part of the extensive Hellenistic world. Hellenistic culture was particularly vital in a region called Bactria, which bordered the mountains of the Hindu Kush. During the 1st century B.C.E., Bactria was conquered by a people of Chinese origin called the Kushans, who eventually established an empire that reached across northern India, where they encountered and embraced Buddhism. Having no monumental art of their own, the Kushans also embraced the Hellenistic culture of Bactria.

The Greeks had long envisioned their gods in sculpture as perfected humans. Under Kushan rulers, this Hellenistic heritage and the desire for an image of the Buddha merged in fascinating figures such as the one shown here. Modeled on statues of the Greek god Apollo, who was typically portrayed as a handsome youth, the Buddha stands in gentle contrapposto, the great contribution of the Greeks to art. His robe, reminiscent of a Roman toga, hangs in heavy folds over a naturalistically muscled body. The fragment of the relief illustrated to the right offers something even more surprising: a guardian of the Buddha dressed in a lion skin like the Greek hero Hercules and holding a thunderbolt like the Greek god Zeus! This fascinating Hellenistic-Indian hybrid style disappeared with the end of the Kushan Empire in the 3rd century C.E., but its effects were lasting. Contrapposto spread throughout India, where it is a prominent feature of later Hindu art. And the Buddha image was started on its long history.

⁽left) Standing Buddha, from Takht-i-Bahi, Gandhara. Kushan period, c. 100 C.E. Schist, height 35½". The British Museum, London. (right) Vajrapani, Guardian of the Buddha, as Hercules. Fragment of a relief from Gandhara. 1st century C.E. Stone, height 21½". The British Museum, London.

RELATED WORKS

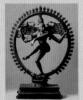

1.9 Shiva Nataraja

11.3 Durga Fighting the Buffalo Demon

3.10 Illustration from the Ramayana

Bodhisattvas are saintly beings who have delayed their own release in order to help others attain enlightenment. Padmapani is a special form of Avalokiteshvara, whom we met in Chapter 11 (see 11.5). Known as the Lotus-Giver, he is shown here holding a lotus blossom in his right hand and a begging bowl in his left. His hair is piled high, and he wears the jewels of a prince. His smooth, languorous body resembles that of the Buddha image from Sarnath (19.5), and it illustrates well the refined Gupta style in painting. The artist has given unforgettable form to the compassion a perfected being feels for the rest of humanity, still trapped in the world's illusions.

Hinduism and Its Art

The Gupta rulers who patronized Buddhist art so lavishly were Hindu, as was the local dynasty that sponsored the creation of the magnificent Ajanta caves. Hinduism would become the dominant religion of India over the coming centuries, and Buddhism, having already spread to China and Southeast Asia, would virtually disappear from the land of its birth.

Hinduism developed as the older Vedic religion, with its brahmins and its emphasis on ritual sacrifice, evolved in its thinking and mingled with local Indian beliefs, probably including those hinted at in ancient Indus art. Like Buddhism, Hinduism has at its core a belief in the cyclical nature of time, including the cosmic cycles of the creation, destruction, and rebirth of the world and the briefer cycles of our own repeating lives within it. The ultimate goal is liberation from these cycles into a permanent state of pure consciousness. This liberation will be granted to us by a god in return for our devotion. Strictly speaking, Hinduism is not one religion but many related faiths, each one taking its own deity as supreme. We have met two of the three principal deities of Hinduism in earlier chapters of this book, the god Shiva (see 1.9) and the goddess Devi or Shakti ("power"), whom we saw in her manifestation as Durga (see 11.3). The third principal deity is Vishnu.

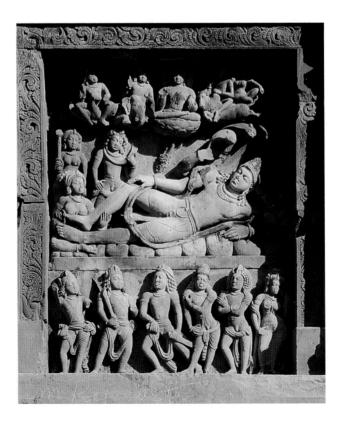

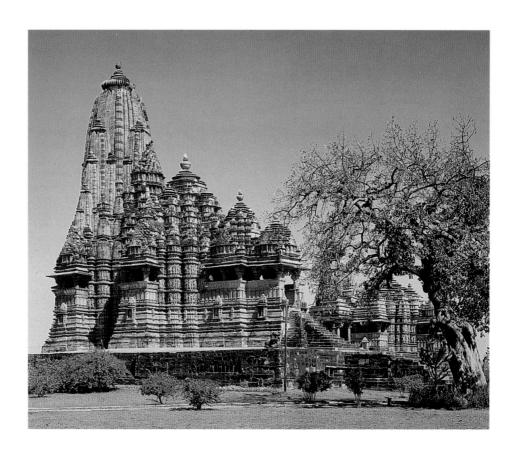

Carved in stone, the relief illustrated here depicts Vishnu dreaming the world into existence (19.7). Wearing his characteristic cylindrical crown, he slumbers on the coiled serpent of infinity, Ananta. The goddess Lakshmi holds his foot. She represents the female side of his energy. Moved by her, Vishnu dreams the god Brahma into existence. Brahma appears at the center of the uppermost row of figures, sitting in a meditative pose on a lotus blossom that is understood to grow from Vishnu's navel. Brahma in turn will create the world of space and time by thinking, "May I become Many." In the smooth surfaces of Vishnu's body, delicately set with jewelry, we see the Gupta style in a Hindu setting.

This relief appears on the exterior of one of the earliest surviving Hindu stone temples, a small structure dating from around 500 C.E. Temple architecture evolved rapidly over the ensuing centuries, and by 1000 C.E. monumental forms had been perfected. A masterpiece of the monumental temple as it developed in northern India is the Kandariya Mahadeva (19.8, 19.9). Dedicated to Shiva, the temple rests on a stone platform that serves to mark out a sacred area and separate it from the everyday world. Visitors climb the stairs, visible to the right, and proceed through a series of three halls, each of which is distinguished on the exterior by a pyramidal roof. These roofs grow progressively taller, culminating in a majestic curving tower called a *shikhara*. Conceived as a cosmic mountain ringed around with lesser peaks, the *shikhara* rises over the heart of the temple, a small, dark, cavelike chamber called a *garbhagriha* ("womb-house"). The *garbhagriha* houses a statue of the deity, a statue in which the god is believed to be truly present.

Indian architects worked with post-and-lintel construction techniques, and thus the interior spaces of Hindu temples are not large. They do not need to be, for Hindu religious practice is not based in congregational worship. Instead, devotees approach the deity individually with such gifts as flowers, food, and incense. These are offered as sacrifices by a brahmin, who receives them at the entrance to the *garbhagriha*.

19.8 Kandariya Mahadeva temple, Khajuraho, Madhya Pradesh, India. c. 1000 C.E.

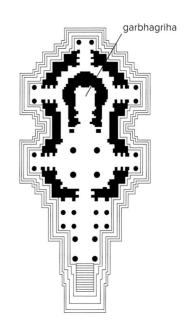

19.9 Plan of the Kandariya Mahadeva temple.

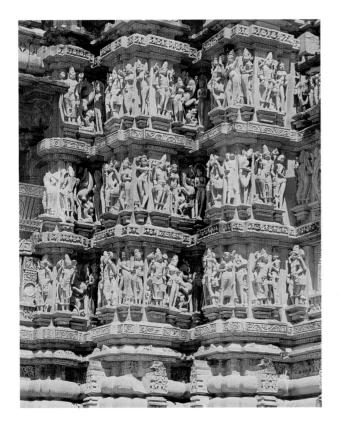

19.11 Central temple complex at Angkor Wat, Cambodia. c. 1113–50 C.E.

Like the form of the temple itself, the sculptures on its exterior represent the energies of the god radiating outward into the world. The myriad Hindu gods and goddesses in their many guises are favorite subjects. On northern temples such as the Kandariya Mahadeva, voluptuous women and sensuous loving couples are depicted as well (19.10). The presence of women is mandated in the texts that guided northern architects, and it demonstrates how belief in such auspicious presences as *yakshi* (19.4) found a place in Hinduism.

From as early as the 2nd century B.C.E., India exerted an influence on developing cultures in Southeast Asia. Kingdoms of Southeast Asia adopted both Buddhism and Hinduism, and they created their own styles of the art forms that came with them. Among the greatest architectural treasures of Southeast Asia is Angkor, the capital of the Khmer kingdom. The Khmer kingdom dominated the region of present-day Cambodia and much of the surrounding area between the 9th and 15th centuries. Taking the title *devaraja*, "god-king," Khmer rulers identified themselves with a deity such as Vishnu, Shiva, or the bodhisattva Lokeshvara. A temple erected to the deity was also thus a temple erected to the king, who was viewed as one of the deity's earthly manifestations. The finest and largest example is the beautiful temple complex known as Angkor Wat (19.11).

Built in the early 12th century under the patronage of the god-king Suryavarman II and dedicated to Vishnu, Angkor Wat consists of five shrines on a raised, pyramidal stone "mountain." Each shrine houses a *garbhagriha*, the womblike dwelling place of the deity. Colonnaded galleries connect and enclose the five shrines, their walls carved with reliefs depicting dancing figures, celestial beings, and the many guises and adventures of Vishnu (see 11.2). Visitors approach the complex by a long walkway that originally crossed over a surrounding moat. Like Hindu temples in India, the plan of Angkor Wat is based in a mandala, a diagram of a cosmic realm, and thus the entire site reflects the meaning and order of the spiritual universe.

RELATED WORKS

11.2 Relief from Angkor Wat

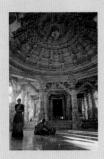

13.20 Interior, Jain temple

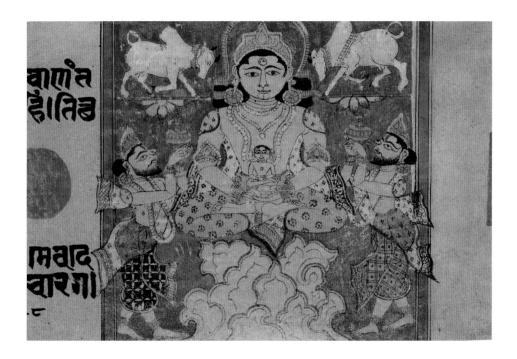

Jain Art

The Jain religion traces its beginnings to a sage named Mahavira, who lived during the 6th century B.C.E. Like the Buddha, Mahavira left the comforts of home in his youth to pursue spiritual wisdom. Upon achieving enlightenment, he became known as the Jina, or "victor." In the religion developed by his followers, Mahavira is considered to have been the last in a line of twenty-four Jinas. Unlike Buddhism, the Jain religion did not become a world faith, yet within India it has remained an important presence.

In Chapter 13, we looked at the interior of a Jain temple (see 13.20). The hundreds of Jain temples constructed between the 11th and 16th centuries testify to the wealth of the merchants and traders who were the primary adherents of the Jain faith. Jains also commissioned thousands of illuminated manuscripts for donation to temple libraries (19.12). The scene reproduced here is from a manuscript of the Kalpasutra, a work that narrates the lives of the Jain saints. The symmetrical composition depicts the bathing of Mahavira at his birth. The newborn Jina sits on the lap of the god Shakra, who seems to hover over a highly stylized depiction of Mount Meru, the sacred celestial mountain. Two attendant gods raise up vessels of water in preparation for the bath. Above, two water buffalo genuflect, recognizing the divine nature of the infant before them. The decorative flatness of the style, with its wiry, linear drawing and intense, bulging eyes, is typical of Jain manuscript painting.

19.12 Illustration depicting the Lustration of the Infant Jina Mahavira, detail of a folio from a manuscript of the Kalpasutra. Gujarat, late 14th century. Opaque watercolor on paper, folio size $3\frac{1}{2} \times 10^{15}\frac{1}{16}$ ". The Metropolitan Museum of Art.

Mughal Art and Influence

A new culture developed in India with the arrival of the Mughals, an Islamic people from Central Asia who established an empire on the subcontinent beginning in the 16th century. Like most Islamic groups from Central Asia, the Mughals were influenced by Persian culture. In India, Persian forms mingled with Indian elements to create a uniquely Indian form of Islamic art. The most beloved work of Mughal architecture is the Taj Mahal (see 13.18). In Chapters 13 and 18, we pointed out the Persian aspects of the monument: its iwan entryways, its central domed interior, and its crowning ornamental onion-shaped dome. (To review the form of an iwan, see 18.3.) Looking at the building again,

you can see that it rests on a stone platform in the manner of Hindu temples. The open, domed pavilions that sit on the roof and cap the four minarets are *chattri*, a traditional embellishment of Indian palaces.

Illustrated books were a second great Persian artistic tradition. The Mughal painting atelier was directed by Persian painters, who introduced new techniques, styles, subjects, and materials to the subcontinent. The influence of such Mughal masterpieces as the *Hamzanama* (see 2.7) was felt in Indian courts, where painters absorbed the Mughal love of detail and jewel-toned palette while retaining the decorative flatness and saturated color of earlier Indian manuscript painting (see 19.12). An example of the new style that resulted is *Maharana Amar Singh II*, *Prince Sangram Singh*, and Courtiers Watch the Performance of an Acrobat and Musicians (see 4.42).

Arts of China

Unlike India, China is not protected to the north by intimidating mountains. The vast and vulnerable northern frontier is one of the themes of Chinese history, for it resulted in a constant stream of influence and interaction. Peaceful contacts produced fruitful exchanges between China, India, Central Asia, and Persia. But repeated invasion and conquest from the north also shaped Chinese thinking and Chinese art.

Fundamental features of the Chinese landscape are the three great rivers that water its heartland, the Yellow in the north and the Yangtze and the Xi in the south. The Yellow River is traditionally spoken of as the "cradle of Chinese civilization." Advanced Neolithic cultures built settlements along the Yellow River from around 5000 B.C.E., but recent archaeological research has found Neolithic sites together with artifacts in jade and ceramic over a much broader area, giving us a more complicated and still incomplete picture of the early stages of Chinese culture. All we can say now is that over time these many distinct Neolithic cultures seem to have merged.

The Formative Period: Shang to Qin

The history of China begins firmly with the Shang dynasty (c. 1500-c. 1050 B.C.E.), whose kings ruled from a series of capitals in the Yellow River Valley. Archaeologists have discovered foundations of their palaces and walled cities, and excavations of royal tombs have yielded thousands of works in jade, lacquer, ivory, precious metals, and bronze. The illustration here shows a bronze jia, a vessel for wine (19.13). Valued and valuable possessions of elite families, bronze vessels were used at banquets for ritual offerings of food to ancestors. Visible on each side of the jia is the most famous and mysterious of Shang decorative motifs, the stylized animal or monster face known as taotie. Its two horns curling away from the raised center axis are clearly distinguishable, as are the staring eyes just beneath them. The taotie may relate to shamanism, the practice of communicating with the spirit world through animal go-betweens. Birds appear in a band above the taotie, the legs of the vessel are decorated with stylized dragons, and an animal of some kind sits on the lid. Whether directly associated with shamanism or not, animals both fantastic and real are a haunting presence in Shang art.

Around 1050 B.C.E., the Shang were conquered by their neighbors to the northwest, the Zhou, who ruled for the next eight hundred years. The first three hundred years of this longest dynasty were peaceful. During later centuries, however, the states over which the Zhou presided grew increasingly independent and treacherous, finally descending into open warfare. The deteriorating situation inspired much thought about how a stable society could be organized. One of the philosophers of the day was Confucius, who lived

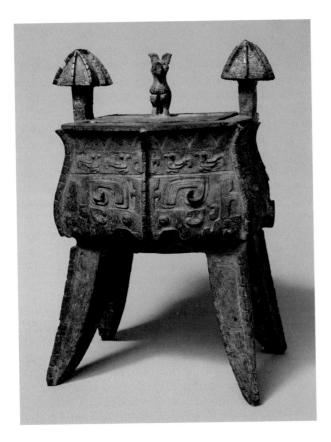

around the turn of the 5th century B.C.E. His ideas about human conduct and just rule would later be placed at the very center of Chinese culture.

In 221 B.C.E., the state of Qin (pronounced "chin") claimed victory over the other states, uniting all of China into an empire for the first time. The first emperor, Shihuangdi, was obsessed with attaining immortality. Work on his underground burial site began even before he united China and continued until his death. The mound covering the burial itself has always been visible, but the accidental discovery in 1974 of a buried terra-cotta army guarding it was one of the most electrifying moments in 20th-century archaeology (19.14). Row upon row the life-size figures stand in their thousands—soldiers, archers, cavalrymen, and charioteers—facing east, the direction from which danger was expected to come. Time has bleached them to a ghostly gray, but when they were new, they were painted in lifelike colors, for only by being as realistic as possible could they effectively protect the emperor's tomb behind them, about half a mile to the west.

Confucianism and Daoism: Han and Six Dynasties

Our name for China comes from the first dynasty, Qin. Chinese historians, however, reviled the Qin for their brutal rule. Ethnic Chinese instead refer to themselves as Han people, after the dynasty that overthrew the Qin. Han rule endured, with one brief interruption, from 206 B.C.E. to 220 C.E. During those centuries, many features of Chinese culture came into focus, including the central roles played by two systems of thought, Confucianism and Daoism.

The philosophy of Confucius is pragmatic; its principal concern is the creation of a peaceful society. Correct and respectful relations among people

19.14 Excavated figures from the terra-cotta army guarding the tomb of Shihuangdi, First Emperor of Qin (d. 210 B.C.E.). Xian, China.

19.15 Incense burner from the tomb of Prince Liu Sheng, Mancheng, Hebei. Han dynasty, 113 B.C.E. Bronze with gold inlay, height 10½". Hebei Provincial Museum, Shijiazhuang

are the key, beginning within the family, then extending outward and upward all the way to the emperor. Han rulers adopted Confucianism as the official state philosophy, in the process elaborating it into a sort of religion in which social order was linked to cosmic order.

Confucius urged people to honor ancestors and Heaven, as the Zhou deity was called. Apart from that, he had little to say about spiritual matters. For answers to questions about what lies beyond the physical world, the Chinese turned to Daoism. Daoism is concerned with bringing human life into harmony with nature. A *dao* is a "way" or "path." The Dao is the Way of the Universe, a current that flows through all creation. The goal of Daoism is to understand the Way and be carried along by it, and not to fight it by striving. The first Daoist text, the famous *Dao De Jing* ("the Way and its power") dates to around 500 B.C.E.; the materials it draws together are much older.

Among scholars, Daoism continued as a philosophy, but on a popular level it also became a religion; and in doing so it absorbed many folk beliefs, deities, and mystical concerns, including the search for immortality. The incense burner shown here, found in the tomb of a Han prince, portrays the Daoist paradise, the Isle of the Immortals in the Eastern Sea (19.15). A close look amid the crags of the mountainous island gradually reveals myriad small people, animals, and birds. They are the happy beings who have discovered the secret of immortality. Stylized waves inlaid in gold swirl around the base. Smoke from burning incense would have wreathed the island in clouds of fog, adding to its otherworldly appearance.

Not long after the end of the Han dynasty, invaders from inner Asia conquered the northern part of China. The imperial court fled to the south. For the next 250 years, China was divided. Numerous kingdoms—many under non-Chinese rulers—rose and fell in the north, while six weak dynasties succeeded each other in the south. For the educated elite, philosophical Daoism provided an escape route. To converse brilliantly, to wander the landscape, to drink, and write poetry—these were suitable occupations for those who were alienated by debased times. Nevertheless, Confucianism, with its stern emphasis on duty to society, remained the official ideal, and Confucian themes continued to appear in art.

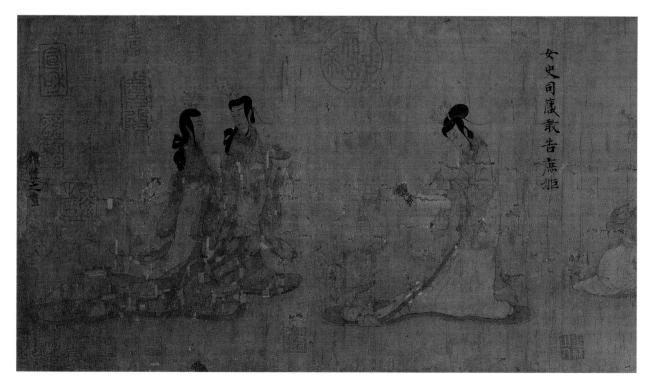

19.16 Admonitions of the Instructress to the Ladies of the Palace, detail. Tang (?) copy after a 4th-century C.E. original attributed to Gu Kaizhi. Handscroll, ink and color on silk; height 9¾". The British Museum, London

A famous example is the handscroll known as *Admonitions of the Instructress to the Ladies of the Palace*, attributed to the 4th-century painter Gu Kaizhi (19.16; to review the handscroll format, see page 110). *Admonitions* illustrates a series of Confucian lessons in correct behavior for court ladies. In the very last scene, shown here, the instructress is portrayed writing down her words of wisdom. To the left, two court ladies glide in to witness the event, their robes fluttering gracefully behind them. With its thin, even lines and sparing use of color, the style of the painting is typical of the 4th century. There is no hint of a setting, and only the sensitive placement of the figures suggests depth.

The Age of Buddhism: Tang

Buddhism had begun to filter into China during the Han dynasty, when missionaries from India arrived over the Silk Road. During the Six Dynasties period, it spread increasingly through the divided north and south. When China was reunited under the Sui dynasty (581–618 C.E.), the new emperor was a devout Buddhist; and during the first century of the Tang dynasty (618–906 C.E.), virtually the entire country adopted the Buddhist religion, and vast quantities of art were created for the thousands of monasteries, temples, and shrines that were founded.

The most popular form of Buddhism in China was the sect called Pure Land, named for the Western Paradise where the buddha Amitabha dwells. The fragment of a hanging scroll illustrated here (19.17) portrays a bodhisattva leading the soul of a fashionably plump, well-dressed little Tang lady to her eternal reward in the Western Paradise, imagined in the upper left corner as

8.2 Preface to the Diamond Sutra

19.17 Bodhisattva Guide of Souls. Tang dynasty, late 9th century C.E. Ink and colors on silk, height 31%". The British Museum, London

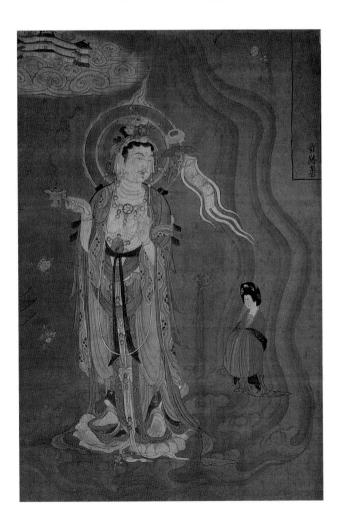

19.18 Nanchan Temple, Wutaishan, Shanxi. Tang dynasty, 782 C.E.

a Chinese palace. The magnificently attired bodhisattva is a Chinese fantasy of an Indian prince. In his right hand he holds an incense burner. His left hand holds a lotus flower and a white temple banner. Flowers fall about the couple, symbols of holiness and grace.

Much Buddhist art of the Tang dynasty was destroyed during the 9th century, when Buddhism was briefly persecuted as a "foreign" religion. One building that somehow escaped destruction is the Nanchan Temple (19.18). Little Chinese architecture has survived from before 1400, and thus the Nanchan Temple, though small, takes on added importance. Like all important buildings in China, the Nanchan Temple is raised above ground level by a stone platform. Wooden columns capped by bracket sets bear the weight of the tiled roof with its broad overhanging eaves. (To review the structural system of Chinese architecture, see pages 288–89.) The gentle curve of the roof draws our eyes upward to the ridge, where two ornaments based on upsweeping fishtails serve symbolically to protect the building from fire.

The same basic principles and forms served Chinese architects for temples, palaces, and residences. Multiplied a hundredfold, this pleasing, sturdy temple lets us imagine the grandeur of the multistoried palaces of the Tang just as the painted bodhisattva, multiplied into a cast of hundreds, lets us imagine the vanished murals that were the glory of Tang Buddhist art.

The Rise of Landscape Painting: Song

China again splintered after the fall of the Tang but was quickly reunited under the rulers of the Song dynasty (960–1279 C.E.). Artists during the Song continued to create works for Buddhist and Daoist temples and shrines. Sculpture played an important role in these contexts. The altar of a Buddhist shrine consists of figures from the Buddhist pantheon set on a platform and protected by a railing. A visitor to a large temple might find inside the entire assembly of Heaven—buddhas, bodhisattvas, lesser deities, guardians, and other celestial beings—carved as life-size figures and arranged to reflect the hierarchy of paradise.

The bodhisattva Guanyin, known in India as Avalokiteshvara (see 11.5), became the object of special affection in China. As Guanyin of the Southern Seas, he was believed to reside high on a mountain and offer his special protection to all who traveled the sea. Carved from wood and richly painted and gilded, the sculpture here depicts Guanyin atop his sacred mountain (19.19).

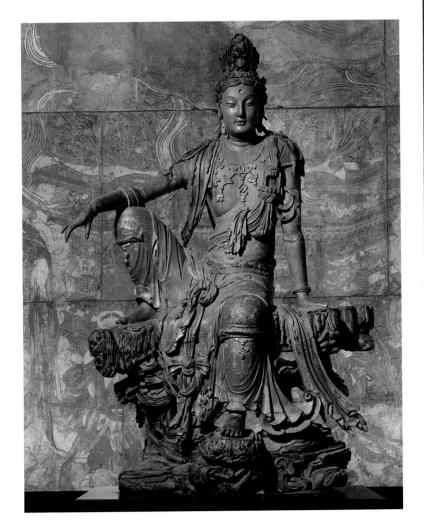

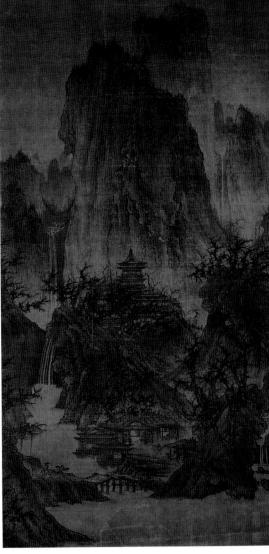

19.19 *Guanyin*. Song dynasty, c. 1100. Painted wood, height 7'11". The Nelson-Atkins Museum of Art, Kansas City, Missouri

Left leg dangling down, right leg drawn up, he sits in a position known as the pose of royal ease, as befits his princely nature. He would have been surrounded on his altar by attendants, making his high status even clearer. Cascading swags of drapery animate this serene figure, whose benevolent gaze is like a beacon of calm in the storm, saving us from shipwreck, both at sea and in life. The sculptor has given Guanyin a lithe, slightly feminized body. Chinese Buddhism gradually began to imagine Guanyin as a female deity, and later depictions often show her wearing flowing white robes.

We do not know who carved Guanyin with such virtuosity. Chinese thinking about art did not concern itself with sculpture and architecture but valued above all the "arts of the brush," calligraphy and painting. Often, paintings were preserved for future generations through the practice of copying. Many famous works of the Tang are known to us only through Song copies, such as Zhang Xuan's Court Ladies Preparing Newly Woven Silk (see 3.13). The Tang dynasty was viewed by later writers as the great age of figure painting, and Song copies help us see why. Song painters, in turn, cast their own long shadow over the future with landscape.

The Song style of monumental landscape was largely the creation of Li Cheng, whose *A Solitary Temple amid Clearing Peaks* is illustrated here (**19.20**). Li built on the work of his predecessors of the early 10th century, when landscape first became an independent subject for painting. In his hands, the

19.20 Li Cheng (attrib.). A Solitary Temple amid Clearing Peaks.

Northern Song dynasty, c. 960.

Hanging scroll, ink and slight color on silk; height 3'8".

The Nelson-Atkins Museum of Art, Kansas City, Missouri

elements they had explored—mobile midair perspective, monochrome ink, vertical format, flowing water, shrouding mists, and a buildup of forms culminating in towering mountains—were gathered into a newly harmonious and spacious whole. Typically, paths are offered for us to walk in and people for us to identify with. Entering the painting with the traveler on the donkey at the lower left, we can cross the rustic bridge to a small village where people are talking and working. A glimpse of a stepped path farther up gives us access to the temple in the middle distance. But, also typically, there is a limit to how high we can climb. Mists separate the middle distance from the towering presences that rise up suddenly in the background. At this point, we must leave the painting and draw back, and when we do, we see a totality that is hidden from us in daily life: the whole of nature and our small place in it. Yet in this view of nature we seem to distinguish an ordering principle, and our place, though small, is in harmony with it: the temple raises its tower upward, and the mountains continue the gesture.

Li Cheng's vision of nature ordered by some higher force and human life in harmony with it clearly echoes the ideas of Daoism. In fact, some art historians believe that such paintings may originally have been understood to portray the Daoist Isle of the Immortals (19.15). Yet we can also view the painting in a Confucian perspective as a mirror of the order of China itself, with the emperor towering above, surrounded by his officials, as well as through a Buddhist lens as the great example of the Buddha flanked by bodhisattvas.

Scholars and Others: Yuan and Ming

During the Song dynasty, a new social class began to make itself felt in Chinese cultural life, scholars. Scholars were the product of an examination system designed to recruit the finest minds for government service. Candidates spent many years studying for the grueling test, which became the gateway to political power, social prestige, and wealth. Scholars did not study anything so practical as administration, however. Their education was in the classic texts of philosophy, literature, and history; and its purpose was to produce the Confucian ideal of a cultivated person, right-thinking and right-acting in all situations. Among their other accomplishments, scholars were expected to write poetry and practice calligraphy. During the Song dynasty, they also took an interest in painting.

The ideals of scholar painting were formed within the refined and cultivated Song court. During the ensuing Yuan dynasty, however, a split developed between scholars and the government. The Yuan (1279–1368 C.E.) was a foreign dynasty founded by the Mongols, a Central Asian people who had conquered China. The Mongol court continued to sponsor art, as had all of China's past rulers, but scholars regarded everything connected with the court as illegitimate. They viewed themselves as the true inheritors of China's past.

Four scholar-painters of this time have come to be known as the Four Great Masters of Yuan. One was Ni Zan, whose best-known work is the beautiful, lonely *Rongxi Studio* (19.21). Typical of scholar paintings, *The Rongxi Studio* is painted in monochrome ink on paper. Vivid color and silk were both considered too pretentious, too professional. The brushwork is spare and delicate. Compared with the carefully drawn temple in Li Cheng's *A Solitary Temple amid Clearing Peaks* (19.20), Ni Zan's little studio is almost childlike. Like most scholar-painters, Ni Zan claimed that he painted merely to amuse himself, and that making a convincing likeness was the farthest thing from his mind. Also important is the inscription in Ni's own hand telling when, how, and for whom the picture was painted. Scholar-painters were not supposed to sell their work but to give it freely to one another as a token of friendship or in thanks for a favor. Their paintings almost always included an inscription and sometimes a poem as well. In their view, calligraphy and painting were closely related, for both consisted of brush strokes that revealed character.

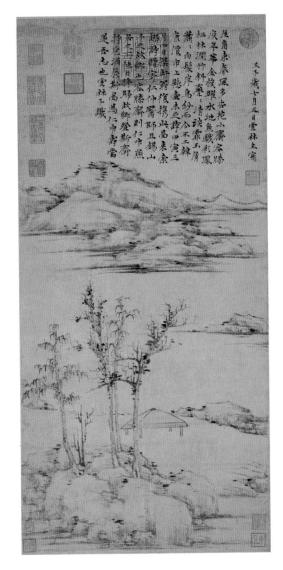

19.22 Zhao Mengfu. *Letter to Zhongfeng Mingben*, detail. 1321. Ink on paper, mounted as a handscroll; height 11%". Princeton University Art Museum

Calligraphy, in fact, was the art that scholars admired above all others. The example here is a part of a letter written by the scholar Zhao Mengfu (19.22). The content of such letters is viewed as unimportant. (This one thanks a monk for ceremonies conducted in memory of Zhao's deceased wife.) Rather, it was the visual style of the writing itself that was admired. The red elements are seals, personal stamps. Zhao Mengfu stamped his own seal after his signature, according to custom. The seals visible here are those of the many collectors who have owned this precious example of a great man's calligraphy over the centuries.

The Ming dynasty (1368–1644) returned Chinese rulers to the imperial throne. The scholar-painter ideal retained enormous prestige during this and the ensuing Qing dynasty (1644–1911), and Chinese writing about art focused on it almost exclusively. The writers, of course, were themselves scholars. In truth, scholar painting was only one of many types of art that were being made.

One lively sphere of artistic activity revolved around the large cities that had grown up during the late Song dynasty, especially in the south, and the wealthy middle-class patrons who lived in them. Another center of artistic patronage and production was the court itself. A beautiful example of Ming court taste in painting is *Mandarin Ducks and Hollyhocks*, a monumental hanging

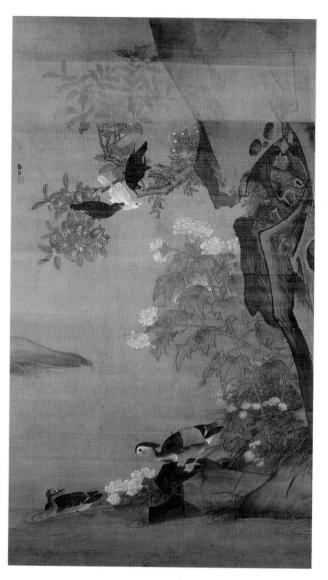

19.23 Lü Ji. *Mandarin Ducks and Hollyhocks*. Late 15th century. Hanging scroll, ink and colors on silk; image size 5'8" × 3'3". The Metropolitan Museum of Art, New York

scroll by Lü Ji (19.23). Born in southeastern China, Lü served with other court painters in the Hall of Benevolence and Wisdom and was eventually made a commander in the Imperial Guard. Lü specialized in bird-and-flower painting, a formerly intimate genre now conceived on a scale suitable for decorating the vast halls of the imperial palace. The brilliant colors, close observation, and meticulous detail of Lü's lively composition are pleasures in themselves, but as in much Chinese art, the objects depicted have symbolic value as well. Mandarin ducks were believed to mate for life, and so a pair of them, male and female, symbolizes marital fidelity. The nearby hollyhocks, furong, together with the branch of flowering cassia depicted above them, gui, allude to the phrase furong qigui, meaning "prosperous groom, honorable bride." Such a lavish painting would have made a suitable wedding gift within the rarefied circles of the imperial court.

Arts of Japan

Separated from the Asian landmass by the Sea of Japan, the islands of Japan form an arc curving northward from the tip of the Korean Peninsula. Neolithic cultures were established on the islands by 10,000 B.C.E. The ceramics

they produced are not only among the oldest known pottery in the world but some of the most fanciful as well, shaped with a seemingly playful streak that resurfaces regularly in Japanese art.

Japanese culture comes into clearer focus during the first centuries of our era. Large burial mounds from that time have yielded earthenware figures such as the horse illustrated here (19.24). Called *haniwa*, they embody a taste for simple forms and natural materials that is one of the themes of Japanese art. We can see these characteristics again in an early form of shrine architecture called *shinmei*. The most famous example of *shinmei* is a shrine complex at Ise (19.25). Erected during the first century C.E., the shrine at Ise has been ritually rebuilt on a regular basis since then, an unusual custom that allows this very early style to appear before our eyes in all its original freshness. The simple cylindrical shapes of the *haniwa* horse are echoed here in the wooden piles that raise the structures off the ground and the horizontal logs that hold the precisely trimmed thatch roofs in place. The buildings are left unpainted, just as *haniwa* were left unglazed.

Housed in the shrine, which can be entered only by members of the imperial family and certain priests, are a sword, a mirror, and a jewel—the three sacred symbols of Shinto. Shinto is often described as the native religion of Japan, but religion is perhaps too formal a word. Shinto involves a belief in numerous nature deities that are felt to be present in such picturesque sites as gnarled trees, imposing mountains, and waterfalls. A simple, unpainted wooden gate may be erected to mark a particularly sacred site. The chief deity of Shinto is female, the sun goddess. Purification through water plays an important role, as does the communion with and appeasement of spirits, including spirits of the newly dead. The constant presence of nature in Japanese art, together with the respect for natural materials simply used, reflects the continuing influence of these ancient beliefs.

19.24 Haniwa figure of a horse. Japan, 3rd–6th century C.E. Earthenware with traces of pigment, height 23½".

The Cleveland Museum of Art

19.25 Overhead view of the shrine complex at Ise showing the rebuilding of 2008–2013 nearing completion and the previous rebuilding not yet dismantled.

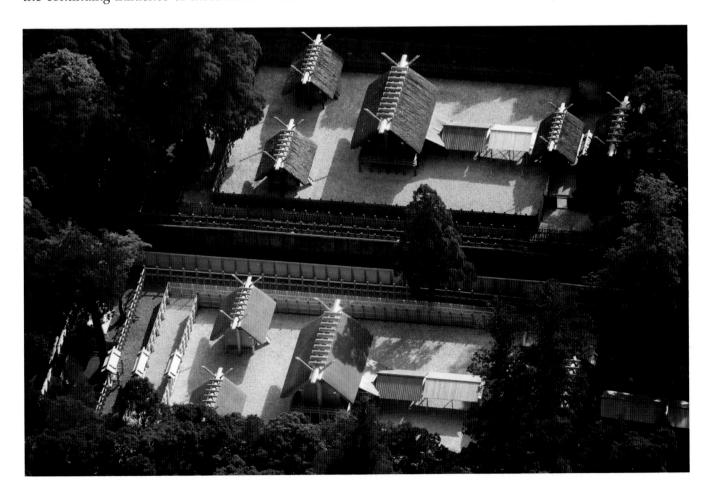

19.26 Horyu-ji Temple, Nara Prefecture. General view. Asuka period, 7th century C.E.

New Ideas and Influences: Asuka

Japan was profoundly transformed during the Asuka period (552–646 C.E.), when elements of Chinese culture reached the islands through the intermediary of Korea. One profound and lasting acquisition was the religion of Buddhism, accompanied by the art and architecture that China had developed to go with it. A perfected example of early Japanese Buddhist architecture is the temple compound Horyu-ji (19.26). Dating from the 7th century, Horyu-ji contains the oldest surviving wooden buildings in the world. The architecture reflects the elegant style of the Six Dynasties period in China. We could imagine that Gu Kaizhi's ethereal palace ladies (see 19.16) would feel at home here.

Inside the gateway and to the left stands a pagoda, a slender tower with multiple roof lines. The equivalent of an Indian stupa (see 19.3), a pagoda serves as a shrine for the relics of a buddha or saintly person. Its ancestors are the tall, multistoried watchtowers of Han-dynasty China. When Buddhism entered China, Chinese architects adapted the watchtower form to this new sacred purpose. To the right of the pagoda is the *kondo* ("golden hall"). Used for worship, the *kondo* houses devotional sculpture also based in Chinese models.

Buddhism did not eclipse Shinto, which continued to exist alongside it. Similarly, the earlier architectural ideas that produced the shrine at Ise were continued along with the newer Chinese-inspired forms. This ability to absorb and transform new ideas while keeping older traditions vital is one of the enduring strengths of Japanese culture.

RELATED WORKS

13.6 Phoenix Hall, Byodo-in Temple

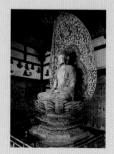

2.29 Jocho, Amida Nyorai

Refinements of the Court: Heian

At the beginning of the Asuka period, Japan was ruled by powerful aristocratic clans, each of which controlled its own region. Inspired by the highly developed bureaucracy of China, the country moved toward unification under a centralized government. In 646 C.E., the first imperial capital was established at Nara. During the 8th century, the capital was moved to Kyoto, marking the beginning of the Heian period (794–1185 C.E.).

A highly refined and sophisticated culture developed around the court at Kyoto. Taste was paramount, and both men and women were expected to be accomplished in several arts. Perhaps the most important art was poetry. Through the miniature thirty-one-syllable form known as *tanka*, men and women communicated their feelings for each other, but always indirectly.

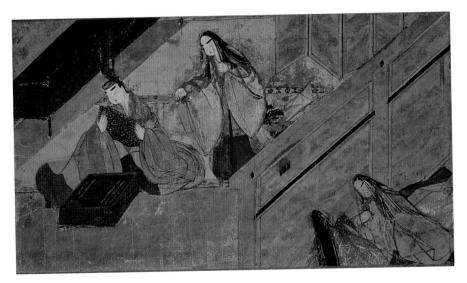

19.27 Illustration to chapter 39, "Yugiri" ("Evening Mist"), from the *Genji Monogatari Emaki* (*The Tale of Genji Illustrated Handscroll*). c. 1120–50. Handscroll, ink and color on paper; height 8%."

The Gotoh Museum, Tokyo. National Treasure

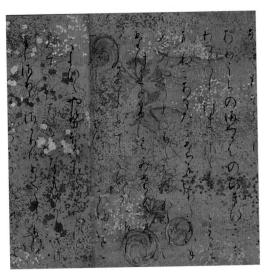

19.28 Detail of chapter 40, "Minori" ("Rites"), from the *Genji Monogatari Emaki* (*The Tale of Genji Illustrated Handscroll*). c. 1120–50. Handscroll, ink on dyed and decorated paper; height 8%."

The Gotoh Museum, Tokyo. National Treasure

The emphasis on literary accomplishment resulted in what many consider to be the greatest work of Japanese literature, *The Tale of Genji*, by Murasaki Shikibu. A lady of the court, Murasaki Shikibu wove aristocratic manners into a long narrative of love and loss that is often called the world's first novel.

Some of the earliest examples of secular painting in Japan survive in a copy of *The Tale of Genji* made during the 12th century (19.27). Written out and illustrated as a series of handscrolls (another imported Chinese idea), the monumental project brought together the specialized talents of several teams of artists. The illustration here depicts an episode from late in the tale. Yugiri, Genji's son, sits before a writing box, reading a letter he has just received. His wife, Kumoinokari, has crept up behind him and is about to snatch the letter from his hand, sure that it is from a woman he is in love with. On the opposite side of a partition, two anonymous ladies-in-waiting go about their duties, unseen by the protagonists though visible to us.

As in all the *Genji* illustrations, we are given a bird's eye view of an interior with the roof conveniently removed so we can see inside. At first glance, all of the characters seem to be wearing the same masklike face—two dashes for eyes, a bent line for a nose, two heavier dashes for eyebrows, a small red mouth. Emotion is never betrayed by expressions or gestures in the *Genji* paintings. Just as Heian aristocrats maintained a facade of flawless manners and communicated their feelings through poems, so the artists of the *Genji* scrolls conveyed emotion by other means. Here, the protagonists are hemmed in by their narrow architectural setting and the presence of the ladies-in-waiting, suggesting the emotional and social pressures that bear down on them.

The *Genji* illustrations were produced by professional artists working in teams. The lead artist would plan the composition, draw the fine outlines in black ink, and indicate how they were to be colored. Assistants would then apply layers of color, after which the lead artist would return to reinforce the outlines, make final adjustments, and add the facial indications. The text of the *Genji* scrolls, on the other hand, was written on opulently decorated paper by aristocrats selected for their exquisite calligraphy (19.28). The detail here illustrates the liquid grace of Heian calligraphy as it cascades down a piece of tinted paper sprinkled with gold and silver foil and stenciled motifs.

Buddhism remained central to Japanese life during the Heian period. Heian aristocrats at first favored esoteric Buddhism, an intellectually challenging

3.24 Stone and gravel garden, Ryoan-ji Temple 5.10 Sotatsu, The Zen Priest Choka 11.18 Kaikei, Hachiman in the Guise of a Monk

19.29 The Burning of Sanjo Palace, detail from Heiji Monogatari Emaki. Kamakura period, late 13th century. Handscroll, ink and color on paper; height 16¼", overall length 22'9". Museum of Fine Arts, Boston

faith that involved a hierarchy of deities as complicated as the hierarchy of the court itself. Later, as troubles grew, the simpler and more comforting message of Pure Land Buddhism became popular, as it had in China. In earlier chapters, we looked at two of the loveliest masterpieces of Heian Pure Land Buddhist art, the Byodo-in Temple (see 13.6) and the statue it houses, Jocho's *Amida Nyorai* (see 2.29). Amida is the Japanese name for Amitabha, the Buddha of the Western Paradise.

Samurai Culture: Kamakura and Muromachi

The last decades of the Heian period were increasingly troubled by the rise of regional warriors, samurai. During the 12th century, civil war broke out as powerful regional clans, each with its army of samurai, battled for control of the country. With the triumph of the Minamoto clan in 1185, a military government was installed. The office of emperor was retained, but true power resided with the commander-in-chief, the shogun. A military capital was established at Kamakura, far from the distractions of the Heian court.

One of the great works of the Kamakura period (1185–1392) is the *Heiji Monogatari Emaki* ("the illustrated story of the Heiji era"), a set of handscrolls that tell of the wars between the Minamoto and their great rivals, the Taira. *The Burning of Sanjo Palace* (19.29) portrays a dramatic episode of 1159 when Taira forces abducted the emperor in a surprise nighttime attack. Never have the cinematic possibilities of the handscroll format been employed more effectively! Scene after scene scrolls by like an epic film with a cast of thousands: marshaling forces, surprise attack, spectacular conflagration, wild-eyed horses, streaming warriors, bloody hand-to-hand combat, and the emperor and his retinue fleeing in terror and disarray. In the detail shown here, mounted samurai archers surge toward a gate, the palace in flames behind them. The event is captured in minute and realistic detail, though the anonymous artists could only have known it through stories.

Just as dramatic in its own way is this Buddhist painting of a subject called *raigo* (19.30). Instead of samurai streaming through a gate in the light of a burning palace, we see a buddha and his attendants streaming down from

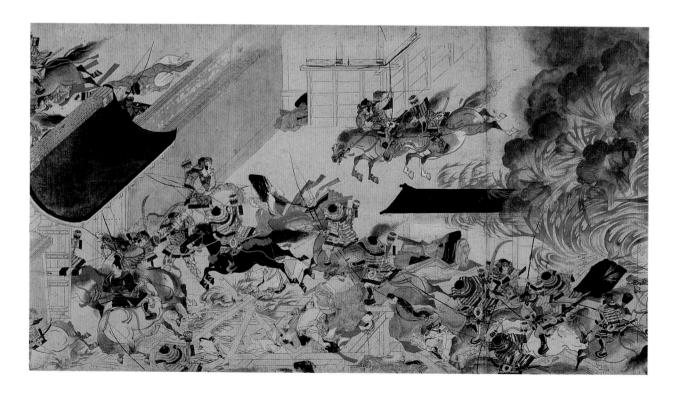

19.30 The Descent of Amida and the Twenty-five Bosatsu (Bodhisattvas). Kamakura period, early 13th century. Gold and color on silk, height 4'9".
Chion-in Temple, Kyoto

Heaven in the light of their own glory. They flow toward a small house where an old man lies dying. Literally "welcoming approach," raigo depicts the buddha Amida arriving to escort a believer's soul to the Western Paradise. The gold on this raigo has dimmed with age, but when the painting was new, the heavenly procession shimmered into view over flowering mountains painted blue and green. Amida is preceded by numerous bodhisattvas; behind him celestial musicians play. Tiny saints hover like lanterns around the old man's cottage, while in the upper right is a distant view of the Western Paradise itself. Raigo were taken to the homes of the dying in the hopes that the vision they depicted might come true.

Pure Land Buddhism continued to win the hearts of ordinary people during the Kamakura period. Also popular was the worship of the Shinto deity Hachiman, who was claimed by the Minamoto clan as an ancestor. We looked at a statue of Hachiman in Chapter 11, Kaikei's *Hachiman in the Guise of a Monk* (see 11.18), carved in the new realistic style of the time.

Toward the end of the 14th century, the Ashikaga family gained control of the shogunate, and the military capital was moved to the Muromachi district of Kyoto. During the Muromachi period (1392–1568), a new type of Buddhism, Zen, became the leading cultural force in Japan. Zen reached Japan from China, where it was already highly developed. Following the example of the historical Buddha, it stressed personal enlightenment through meditation. Centuries of accumulated writings and scripture were cast aside in favor of direct, one-on-one teaching, master to student. The best-known Zen teaching tools are *koan*, irrational questions designed to "short-circuit" logical thought patterns. "What is the sound of one hand clapping?" is a well-known *koan*. Zen training was (and is) spartan and rigorous, qualities that appealed to the highly disciplined samurai.

Enlightenment in Zen is above all *sudden*. Zen priest-painters embodied this sudden appearance of meaning out of chaos in a painting technique called *haboku*, "splashed ink." Sesshu Toyo's *Landscape* (19.31) is a masterpiece of this difficult technique—difficult because most attempts end in a mess. Sesshu drew together his "splashes" with a few expertly placed dark strokes, giving us all the clues we need to see a forested hillside by the water. A small house nestles at the foot of the hill, and on the water floats a lone boat. Although Sesshu Toyo was primarily a painter, he had trained as a Zen monk. He painted this work as a farewell gift for one of his pupils, and in the long inscription above he speaks of his own artistic path.

19.31 Sesshu Toyo. *Landscape* (in the *haboku* technique). 1495. Hanging scroll, ink on paper, width 12%".

Tokyo National Museum

Splendor and Silence: Momoyama

The shogun's control over regional lords and their samurai weakened during the Muromachi period, and devastating civil wars broke out. After the Ashikaga family fell from power in 1568, three strong leaders controlled the shogunate in succession. The decades of their rule are known as the Momoyama period (1568–1603).

For all its turbulence, the Momoyama period was a time of splendor for the arts. Fortified castles and great residences were built by powerful regional lords, and their interiors were decorated by the finest painters. One of the most influential artists of this time was Kano Eitoku, who developed a bold and highly colored decorative style that was much imitated in later Japanese art (19.32). *Cypress Trees* was originally painted to decorate the paper-covered sliding doors of a large interior. It was later remounted as a folding screen—a portable partition that serves to mark off space within a larger room. A venerable cypress, gnarled and twisted with age, reaches from its roots at the right across the entire width of the screen. Stylized clouds of gold leaf float behind it over a blue and green landscape.

Golden screens, as they are known, represent only one side of Momoyama taste. The other side is almost the exact opposite: a hushed and understated monochrome such as we see in Hasegawa Tohaku's *Pine Wood* (19.33). *Pine Wood* consists of a pair of six-panel folding screens, of which we show one. Painted with great simplicity in ink on paper, the ghostly trees appear through veils of mist. The paper itself, though technically blank, seems full of presences—trees we cannot see at the moment, or perhaps the edge of a lake. Tohaku's genius was to fashion monumental, decorative works from a fundamentally intimate style.

19.32 Kano Eitoku (attr.). *Cypress Trees*. Momoyama period, late 16th century. Color, gold leaf, and ink on paper; Eight-panel screen; 5'7" × 15'1½".

Tokyo National Museum

19.33 Hasegawa Tohaku. *Pine Wood*. Momoyama period, late 16th century. Ink on paper; One of a pair of sixpanel screens, height 5'1".

Tokyo National Museum

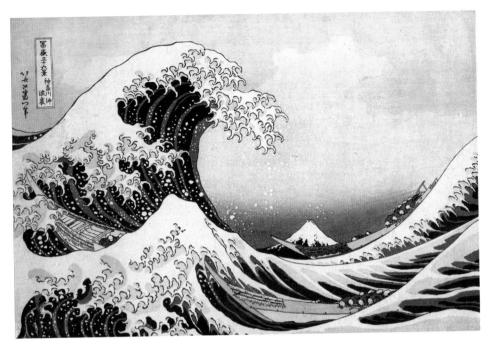

19.34 Katsushika Hokusai. *The Great Wave at Kanagawa*, from *Thirty-Six Views of Mount Fuji*. c. 1830–32. Polychrome woodblock print; ink and color on paper, 10½ × 14¹⁵/₁₆".

The Metropolitan Museum of Art, New York

Art for Everyone: Edo

Still another shift in the control of the shogunate signaled the beginning of the Edo period (1603–1868), named as before for the new capital city (present-day Tokyo). The many types of art that had been set in motion over the centuries continued during the Edo period. Decorative styles were carried on by such artists as Kaiho Yusho, whose golden screen painting is illustrated in Chapter 5 (see 5.25). The tradition of ink painting and the continuing influence of Zen produced such playful wonders as Nonomura Sotatsu's *The Zen Priest Choka* (see 5.10). But the great artistic event of the Edo period was the popularity of woodblock prints, a new form that made art available to everyone.

With theaters, tea houses, brothels, baths, wrestling matches, and other entertainments, the pleasure quarter and theater district of Edo became known as *ukiyo*, the floating world. Edo-era woodblock prints have become known as *ukiyo-e*, images of the floating world, for they had their roots in this new urban playground, where townspeople and samurai went to relax. Beautiful women, famous actors, scenes set in tea houses and bath houses, scenes from folk tales and ghost stories—these were some of the most popular subjects of *ukiyo-e*.

The production of woodblock prints was a team effort that brought together artists, block cutters, and printers. It was coordinated by a publisher, who marketed the results. In 1831, a publisher named Nishimuraya Yohachi announced the publication of a new series of prints, *Thirty-Six Views of Mount Fuji*, by "the old man Zen Hokusai Iitsu," one of the names used by Katsushika Hokusai. It would turn out to be one of the most popular series of prints ever produced. In the *Thirty-Six Views*, Hokusai left behind the traditional subject matter of *ukiyo-e* and turned his attention to a new subject, landscape. We meet pilgrims, laborers, merchants, farmers, fishermen, travelers, and sightseers, all going about their busy, fleeting lives, some in the countryside, others in town. Linking the scenes is the presence of Mount Fuji in the distance, occasionally admired, usually ignored.

The cowering fishermen of *The Great Wave at Kanagawa* (19.34) certainly cannot spare a second to gaze at the mountain. Yet there it is, calm and serene, its sloping sides leading up to a majestic snowcapped peak. What a contrast it provides with the angry wave rearing up with claws of foam, threatening to crush the slender boats below. A second wave in the foreground echoes the shape of Mount Fuji. But it will have this form for only a fraction of a second, whereas Fuji is eternal and unchanging. *The Great Wave at Kanagawa* has become an icon of Japanese art, famous around the world, thanks to Hokusai's

brilliant design.

RELATED WORKS

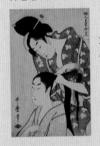

2.22 Utamaro, Hairdressing

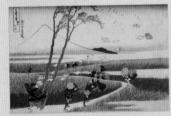

3.26 Hokusai, Ejiri in Suruga Province

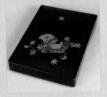

p.99 Hiroshige, Fireworks at Ryogoku

ARTISTS Katsushika Hokusai (1760-1849)

How can we describe Hokusai's character, and does that personality come out in his works? Why is it Hokusai never felt he had done enough and wanted more time?

ne of the most delightfully eccentric figures in the history of art is the Japanese painter and woodcut designer who has come to be known as Katsushika Hokusai. During his eighty-nine years, Hokusai lived in at least ninety different houses and used some fifty names. The name that stuck for posterity—Hokusai—means "Star of the Northern Constellation."

Hokusai was born in the city of Edo (now Tokyo), the son of a metal engraver. At the age of eighteen, he was sent as an apprentice to the print designer Katsukawa Shunsho. So impressed was the master with his pupil's work that he allowed the young man to adopt part of his own name, and for several years Hokusai called himself "Shunro." Later the two quarreled, and Hokusai changed his name.

Even in his early years, Hokusai always worked very quickly, producing huge quantities of drawings. As he finished a drawing, he would toss it on the floor, until there were papers scattered all over the studio, making cleaning impossible. When the house got too

filthy and disorderly, he would simply move to another, followed by his long-suffering wife.

Hokusai's first book of sketches was published in 1800 and showed various scenes in and around Edo. That same year the artist produced a novel, which he sent off to a publisher accompanied by the self-portrait shown here. (Hokusai's head is shaved in the manner of Japanese artists and writers of that time.) Both books achieved a popular success, but characteristically, Hokusai never bothered to open the packets of money sent by his publisher. If a creditor stopped by, he would hand over a packet or two without counting it. Throughout his life he remained indifferent to money and despite his great accomplishments was usually at the brink of starvation.

As Hokusai's fame spread, he was often invited to give public drawing demonstrations. Legends of his virtuosity abound. On one occasion, the story goes, he stood before the assembled crowd outside a temple and drew an immense image of the Buddha, using a brush as big as a broom. Another time, he drew birds in flight on a single grain of rice. Hokusai's sense of humor, never far below the surface, came bubbling out when he was asked to perform for the shogun (the military governor). As onlookers gathered at the palace, Hokusai spread a large piece of paper on the floor, painted blue watercolor waves across it, then took a live rooster, dipped its feet in red paint, and allowed it to run across the painting. Bowing respectfully, he announced to the shogun that his creation was a picture of red maple leaves floating down the river. 1

Though well aware of his own skill, Hokusai often amused himself by pretending modesty. In the preface to one of his books he wrote: "From the age of six I had a mania for drawing. At seventy-three I had learned a little . . . in consequence when I am eighty I shall have made still more progress, and when I am a hundred and ten, everything I do . . . will be alive." But the artist did not make it quite that far. As he lay on his deathbed, he cried out: "If Heaven would grant me ten more years!" And then: "If Heaven would grant me *five* more years, I would become a real painter." His grave is marked by a slab on which is carved the last of his names: Gwakio Rojin—Old Man Mad About Drawing.

Katsushika Hokusai. *Kamado Shogun Kanryaku no Maki (Self-Portrait)*, from *The Tactics of General Oven*. 1800. Woodcut, $8\frac{7}{16} \times 5\frac{7}{16}$ ". The Art Institute of Chicago.

20

Arts of the Pacific and of the Americas

ontinuing eastward around the world, we come to two regions that together cover almost half the globe: the vast ocean of the Pacific and the double continent of the Americas. We began the previous chapter by stressing the contacts that had linked India and China to the evolving Mediterranean world since ancient times. Here, we might do the opposite. From the end of the last Ice Age around 10,000 years ago, when rising waters submerged the land bridge that once linked Asia and Alaska, contact between Europe, Africa, and Asia on the one hand and the Americas and the Pacific Islands on the other was largely cut off.

In Chapter 16, there is a sign of the moment when one-half of the world rediscovered the other. If you look again at Hans Holbein's *The Ambassadors* (see 16.20), painted in 1533, you will notice a globe on the lower shelf. Globes were all the rage in the early 16th century, spurred by Columbus' accidental discovery in 1492 of lands across the Atlantic Ocean and Vasco da Gama's discovery in 1498 that it was indeed possible to sail all the way around Africa and arrive in India. Holbein's globe is placed so that Europe is facing us. If you were to turn it around, you would see an emerging idea of the rest of the world. In this chapter, we fill in Holbein's map with a look at art as it had been developing in the cultures of the Pacific and the Americas.

Pacific Cultures

The lands of the Pacific include the continent of Australia and the thousands of islands grouped together as Oceania, "lands of the ocean." Australia was settled by the ancestors of the peoples today known as Aborigines, who arrived by sea from Southeast Asia as early as 50,000 years ago. The neighboring island of New Guinea was settled around the same time. The peopling of the rest of the Pacific Islands was the result of centuries of maritime courage, as seafaring settlers set out across uncharted waters in search of land they could not have known existed. Among the first islands to be settled, beginning around 1500 B.C.E., were those to the east of New Guinea. These are grouped together with New Guinea as the cultural region of Melanesia. The last islands to be settled were the widely scattered islands of Polynesia, the easternmost cultural region of Oceania, which includes Hawaii (settled around 500 C.E.) and New Zealand (settled between 800 and 1200 C.E.).

The oldest examples of Pacific art are the earliest rock engravings of the Aborigines, some of which may date to 30,000 B.C.E. The meanings of these images are not known, but more recent Aboriginal art is intimately connected with the religious beliefs known as Dreamtime or the Dreaming. Dreamtime includes the distant past, when ancestral beings emerged from the Earth. Their actions shaped the landscape and gave rise to all forms of life within it, including humans. Dreamtime also exists in the present, and each individual is connected to it. With age a person draws closer to the realm of ancestors, and at death the spirit is reabsorbed into the Dreaming.

Ritual help for a spirit on its journey back to the Dreaming is the subject of Samuel Lipundja's *Djalambu* (20.1). Born in 1912, Lipundja was a member of the Yolngu, an Aboriginal people who live in East Arnhem Land, in northern Australia. The Yolngu have many ways of talking about the journey back to the Dreaming. Often, the soul is said to be carried by a current of water, in which case it may be thought of as a catfish that must avoid being eaten by diver birds. Catfish and diver birds are painted on Yolngu hollow-log coffins. During funerary rites, bullroarers (noisemakers) are whirled in the air to suggest diver birds in flight, while dancers painted as catfish scatter in fear. The central form of *Djalambu* is a log coffin, which is also understood to represent a catfish in the river. A diver bird and a long-necked tortoise appear near the base of the coffin-catfish, and seven bullroarers accompany it. The linear patterns of hatching and cross-hatching are characteristic of much Aboriginal art.

20.1 Samuel Lipundja. *Djalambu*. 1964. Earth pigments on bark, $53\% \times 29\%$ ".

National Gallery of Victoria, Melbourne

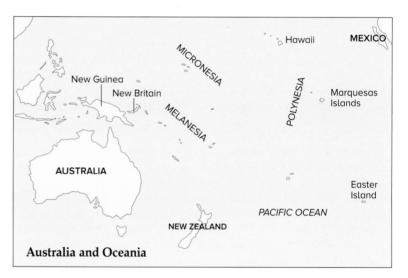

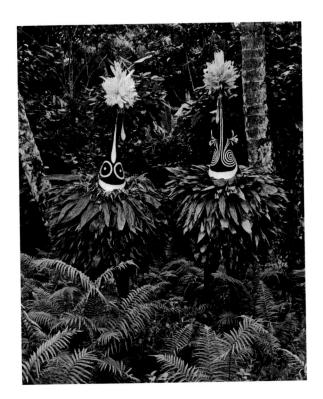

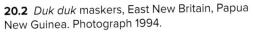

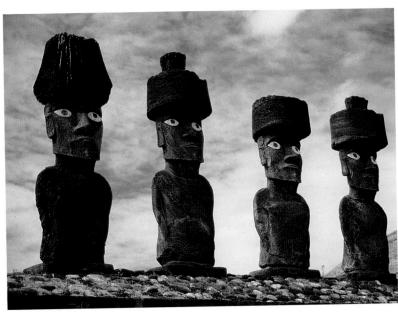

20.3 Stone figures on Ahu Nau Nau, Anakena, Easter Island (Rapanui), Chile.

The most haunting elements of *Djalambu* are the two circular eyes of the coffin, the alert and otherworldly gaze of an ancestor looking into this world from the Dreamtime. Eyes from another realm meet our own again in a mask from the Tolai people of New Britain, one of the islands of Melanesia (20.2). Masks and masquerades play important roles in many Melanesian cultures. As in Africa (see Chapter 18), masks are used to materialize spirit beings. These masks are *tubuan*, the female spirits of a society. *Duk duk* are male spirits, also danced by maskers, that punish lawbreakers at the bidding of the community's leaders. The male spirits are reborn each year from the *tubuan*, who are immortal. With their costume of leaves, *tubuan* represent nature and the natural order of things, and they lend their support to the authority of the human community's leaders. Yet all is not so simple, for the powers of the *tubuan* are volatile and potentially a force for chaos, and a true leader must show that he can control them.

Among the most well-known works of the Pacific are the monumental stone figures of Easter Island (Rapanui), the most remote and isolated island of Polynesia (20.3). Almost one thousand of the monolithic statues have been found. Scholars believe they were carved as memorials to dead rulers or other important ancestors. Whatever purpose the statues served, the islanders must have believed it to be vital to their community, for they went to heroic efforts to erect them. The stones were quarried and partially carved in the island's volcanic mountains. The average height of the figures is about 36 feet, and each one weighs tens of tons, yet somehow they were dragged for miles across the island and set upright on elevated stone platforms that probably served as altars.

Easter Islanders seem to have begun erecting the figures around 900 C.E. Six centuries later, conflicts apparently broke out on the island, and a period of warfare ensued. Most of the figures were knocked down and destroyed. The statues photographed here were restored in 1978, their heads crowned again with red stone topknots and their faces set with white coral eyes. Stones that had slumbered for centuries suddenly awoke. Lined up once more along the

20.4 Feather cloak. Hawaii. Feathers, fiber; height 5'9". The British Museum. London

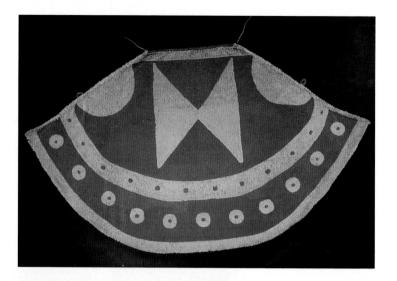

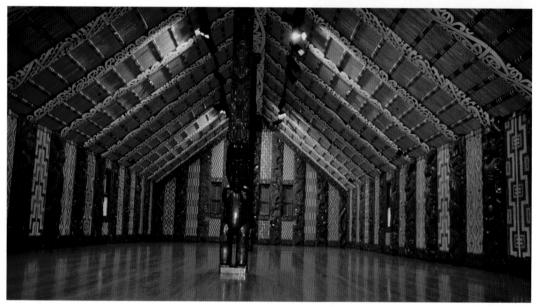

20.5 Interior of a Maori meeting house, Waitangi, North Island, New Zealand. Photograph 1999.

shoreline, they stare hypnotically inland in an eternal vigil whose purpose we may never fully understand.

Polynesian peoples believed that certain materials were sacred to the gods. Among those materials were feathers. Rulers and other high-ranking members of society traced their descent from the gods, and they adorned themselves with feathered garments as a sign of their status. With their bold geometric designs and brilliant colors, the feather cloaks of Hawaii are the most spectacular products of this unique art form (20.4). Although both men and women of the Hawaiian elite wore many types of feathered garments, majestic cloaks such as this, reaching from the shoulders to the ground, belonged exclusively to the highest-ranking men. The creation of such a cloak was itself a ritual activity limited to high-ranking men. As the makers wove and knotted the cloak's plant-fiber foundation, they chanted the names of the ancestors of the man who would eventually wear it. The names were thus captured in the cloak, imbuing it with protective spiritual power. Feathers were tied onto the completed fiber netting in overlapping rows. Feathers were collected by commoners, who offered them as part of their yearly tribute to their rulers.

The feather cloaks of Hawaii embody ideas about the order of society, the respective roles of men and women, the continuing presence of ancestors, and the protective power of the gods. Similar concerns are given architectural form in the men's meeting houses of the Maori people of New Zealand, the southernmost of the Polynesian islands (20.5). The house is understood as the

body of the sky father, the supreme deity of the Maori. The ridgepole is his spine, and the rafters are his ribs. His face is carved on the exterior, where other elements symbolize his embracing arms. Meetings thus take place within the god, which is to say within his protection, sanction, and authority.

The freestanding figures that support the ridgepole from inside portray ancestors. Their knees are bent in the aggressive posture of the war dance, reminding the living of their courage and great deeds. More stylized portrayals of snarling, powerful ancestors are carved in the series of reliefs that line the walls. Each relief panel meets a rafter whose lower portion is carved with still more ancestors. Everywhere, iridescent shell eyes gleam and glimmer as they catch the light. Ancestors were believed to participate in the discussions held in the house, and these sculptures make their watchful presence felt. The reliefs along the walls alternate with panels of lattice woven in symbolic patterns that relate to stories about Maori deities and heroes. The panels were woven by women. Women, however, are not permitted to enter the meeting house, and so they wove the panels from the back, standing outside.

The patterns that swirl over the surfaces of the rafter and carved poles of the meeting house echo the tattoo patterns that ornament the bodies of Maori men and women. All Polynesian peoples practiced tattoo, but nowhere was the art cultivated with greater virtuosity than among the inhabitants of the Marquesas Islands in the South Pacific (20.6). The illustration here shows two Marquesan men in different stages of the lifelong tattooing process. The mature man at the left is completely tattooed from head to foot, whereas the younger man at the right is only partially ornamented. If life granted him enough time, prestige, and wealth, he gradually had the remaining blank areas of his skin decorated.

Like all other arts, the act of tattooing was considered sacred by the Marquesans. It was performed ritually by a specialist, *tukuka*, who invoked the protective presence of specific deities. The designs were created using a bone tool that resembled a small comb with sharp, fine teeth. The specialist dipped the teeth in black pigment made of soot or ground charcoal, set them against his client's skin, then gave the tool a sharp rap with a stick to puncture the skin and insert the pigment. Because tattooing was expensive and painful, only a small area of the body was usually decorated during each session. Nearly all adult Marquesans both male and female wore tattoos, although only the wealthiest and most highly regarded chiefs and warriors reached the allover patterning of the man to the left in our illustration.

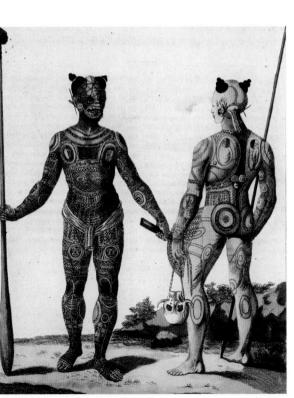

20.6 Inhabitants of the Island of Nuku Hiva. 1813. Hand-colored copperplate engraving after original drawings by Wilhelm Gottlieb Tilesius von Tilenau.

Bilderbuch für Kinder, vol. 8, Weimar 1813

The Americas

No one knows for sure when humans first occupied the double continent of the Americas or where those people came from. The most widely accepted theory is that sometime before 13,000 years ago—and possibly as early as 25,000 years ago—migrating peoples crossed over a now-submerged land bridge linking Siberia with Alaska, then gradually pushed southward, seeking hospitable places in which to dwell. Firm evidence of human presence at the tip of South America has recently been dated to about 12,500 years ago, indicating that by then both continents were populated, if only sparsely.

By 3000 B.C.E., we can identify developed cultures in three important centers: the Northwest Coast of North America, the fertile plateaus and coastal lowlands of Mesoamerica, and the Pacific Coast of South America. During the ensuing centuries, peoples in these and other territories created rich and sophisticated artistic expressions. Their early art has sometimes been called "pre-Columbian," meaning that it was created before Columbus' voyages to the Americas. The term acknowledges that the arrival of Europeans changed everything, and that the civilizations of the Americas were interrupted as decisively as if they had been hit by a meteor. Yet it is best to approach them on their own terms and not to think of them as "before" something else. After all, they did not think of themselves as coming "before" anything but, rather, after their many predecessors, whose achievements they knew and admired.

Mesoamerica

"Mesoamerica" describes a region that extends from north of the Valley of Mexico (the location of present-day Mexico City) through the western portion of modern Honduras. Mesoamerica is a cultural and historical designation as well as a geographical one, for the civilizations that arose in this region shared many features, including the cultivation of corn, the building of pyramids,

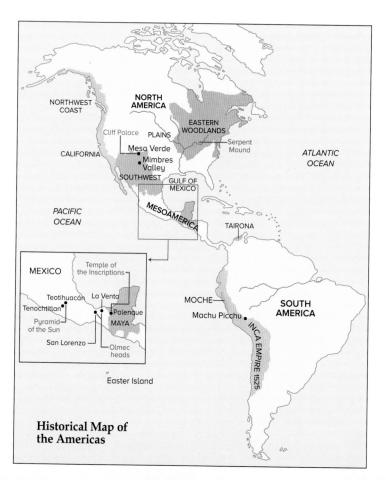

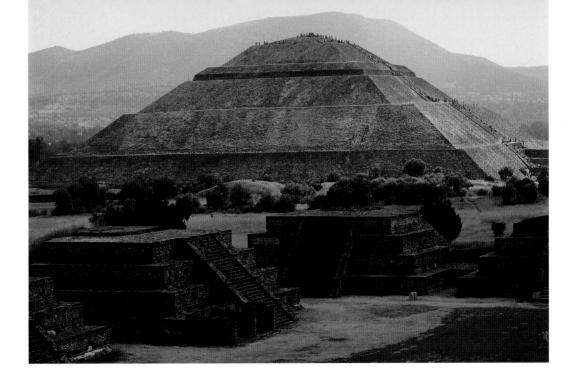

a 260-day ritual calendar, similar deities, an important ritual ball game, and a belief in the role of human blood in sustaining the gods and the universe. Mesoamerican peoples themselves were conscious of their common cultural background. Thus, the Aztecs, who were the most powerful culture in the region at the time of the Spanish conquests of the early 16th century, collected and admired jade sculptures by the Olmec, whose civilization had flourished over two thousand years earlier.

Olmec civilization, which flourished between about 1500 and 300 B.C.E., is often called the "mother culture" of Mesoamerica, for it seems to have institutionalized the features that mark later civilizations of the region. The principal Olmec centers were concentrated in a small region on the Gulf Coast of Mexico, but the influence of Olmec culture extended over a much broader area. Chapter 11 illustrated one of the colossal stone heads carved by Olmec sculptors (see 11.10). Chapter 2 included a finely worked Olmec jade depicting a shaman (see 2.38). Olmec leaders may have derived their power by claiming ability as shamans. Rulers in later Mesoamerican societies were also expected to have privileged access to the sacred realm.

A few centuries after the decline of the Olmecs, the city of Teotihuacán, located to the northeast of present-day Mexico City, began its rise to prominence. At its height, between 350 and 650 c.e., Teotihuacán was one of the largest cities in the world. Laid out in a grid pattern with streets at right angles, the city covered 9 square miles and had a population of around 200,000. Teotihuacán exerted great influence over the rest of Mesoamerica, though whether this was through trade or through conquest we do not know.

The heart of the city was its ceremonial center, a complex of pyramids and temples lining a 3-mile-long thoroughfare known as the Avenue of the Dead. To the Aztecs, who arrived in the region long after Teotihuacán had been abandoned, it seemed hardly possible that humans were capable of such wonders. They viewed the city as a sacred site where the gods had created the universe, and it was they who named its largest structure the Pyramid of the Sun (20.7). Made of stone and brick, the Pyramid of the Sun rises to a height of over 210 feet. A temple originally stood at its summit. Like the ziggurats of ancient Mesopotamia, Mesoamerican pyramids were symbolically understood as mountains. Excavations have discovered a tunnel leading to a natural cave containing a spring directly beneath the center of the Pyramid of the Sun. Perhaps it was this womblike source of water and life that was considered sacred by the city's original inhabitants.

20.7 Pyramid of the Sun, Teotihuacán, Mexico. 50–200 C.E.

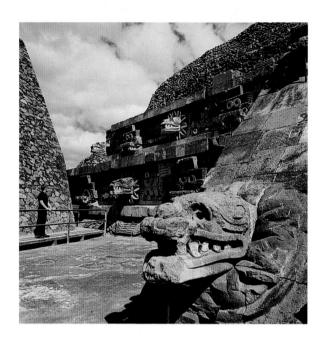

20.8 Temple of the Feathered Serpent, the Ciudadela, Teotihuacán, Mexico. 2nd century C.E.

Farther north along the Avenue of the Dead is a large sunken plaza surrounded by temple platforms. The focal point of this complex, the Temple of the Feathered Serpent, gives us our first look at a deity shared by many of the Mesoamerican civilizations (20.8). The Olmec pantheon included a feathered serpent, although its exact meaning is unclear. To the Aztecs, the feathered serpent was Quetzalcoatl, the god of windstorms that bring rain. Here, representations of the deity—its aggressive head emerging from a collar of feathers—alternate with the more abstract figure of the god of rain, distinguished by his goggle eyes. Rain and the wind that brought it were essential to the agricultural societies of Mesoamerica.

One of the most fascinating of all Mesoamerican civilizations was that of the Maya, which arose in the southeastern portion of Mesoamerica, primarily in the Yucatán Peninsula and present-day Guatemala. Mayan culture began to form around 1000 B.C.E., probably under the influence of the Olmecs. The Maya themselves come into focus just after the final decline of Olmec civilization around 300 B.C.E. Mayan civilization flourished most spectacularly between 250 and 900 C.E. It was still in existence when the Spanish arrived in the early 16th century, however, and speakers of Mayan languages live in the region today.

Among their other accomplishments (including astronomy, biology, and the mathematical concept of zero), the Maya developed the most sophisticated version of the Mesoamerican calendar and the most advanced of the region's many writing systems. Scholars began to crack the code of Mayan writing in the 1960s, and since then the steady deciphering of inscriptions has provided new insights into Mayan civilization, in the process overturning much of what earlier scholars assumed.

The Maya were not a single state but a culture with many centers, each ruled by a hereditary lord and an elite class of nobles. Warfare between the centers was common, and its purpose was not conquest but capture: prisoners of war were needed for the human sacrifices that were thought necessary to sustain the gods and maintain the universe. The official and ceremonial architecture of the Maya was meant to impress, and it does (20.9). The photograph illustrated here shows the structures known as the Palace and the Temple of the Inscriptions at Palenque, in the Chiapas region of Mexico. The royal dynasty of Palenque was founded in 431 C.E. and rose to prominence under Lord Pacal, who died in 683 C.E. He was buried in a small chamber deep beneath the Temple of the Inscriptions.

The Palace probably served as an administrative and ceremonial center. Set on a raised terrace, it is constructed on two levels around three courtyards.

RELATED WORKS

11.4 Maya figurine Like the Temple of the Inscriptions atop the pyramid, the buildings of the Palace take the form of long, many-chambered galleries. The square pillars of their open porches support massive stone ceilings with corbelled vaulting. (To review corbelling, see page 298.)

A series of murals discovered at Bonampak, in Mexico, help us imagine the kinds of ceremonies that took place in Mayan palaces (20.10). Painted in 800 C.E., the original murals are today badly faded and crumbling, and we appreciate them best in this careful copy that restores their original colors. The murals depict events surrounding the presentation of an heir to the throne. In the upper band, nobles and lords gather. We can see four of the lords clearly in this view, with their white capes and feather-crowned headdresses. Vertical panels of writing next to them record their names. The assembly continues

20.9 Palace and Temple of the Inscriptions, Palenque, Mexico. Maya, 7th century C.E.

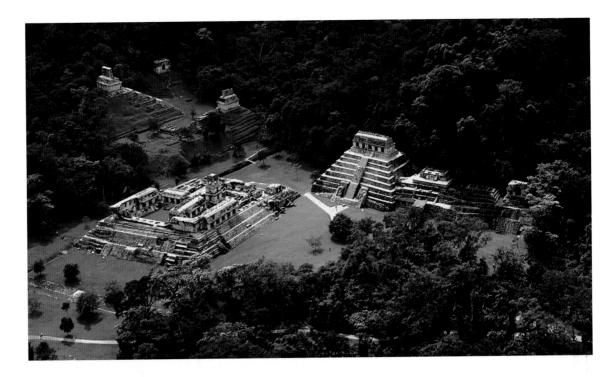

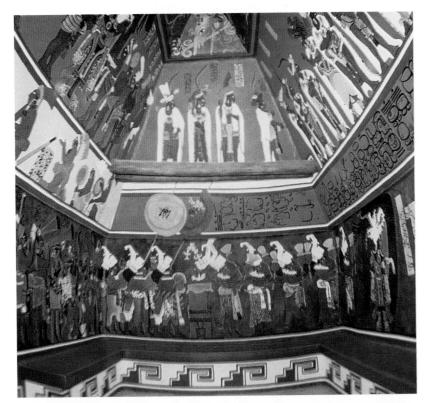

20.10 East wall, Room 1, Bonampak, Mexico. Maya, 800 C.E. Copy by Felipe Dávalos and Kees Grotenberg. Polychromed stucco. Courtesy Florida Museum of Natural History, Gainesville

around the wall to the right and culminates with a view of the young heir himself (not visible here). In the lowest band, a colorful and evidently noisy procession winds around the walls against a vivid blue background. The jaguar pelts, finely woven textiles, abundant jewelry, and feathered ornaments of the Maya have not survived, but this mural and others like it allow us to restore a sense of color and pageantry to the deserted ruins we study today.

The first scholars to study the Maya believed that their art was primarily sacred and depicted cosmic events such as stories of the gods. Thanks to our understanding of Mayan writing, we now realize that Mayan art is almost entirely concerned with history. Like the murals at Bonampak, it memorializes rulers and portrays important moments of their reigns. Preeminent among Mayan arts are narrative stone relief carvings such as this lintel from a building in Yaxchilan, in Mexico (20.11). The scene is the second in a sequence of three compositions that portray a royal bloodletting ceremony. Bloodletting was a central Mayan practice, and almost every ritually important occasion was marked by it. Lady Xoc, the principal wife of Lord Shield Jaguar, is seated at the lower right. The previous panel showed her pulling a thorn-lined rope through her tongue in the presence of Shield Jaguar himself. Here, she experiences the hallucinatory vision that was the ceremony's purpose. From the bowl of blood and ritual implements on the floor before her there rises the Vision Serpent. A warrior, possibly one of Shield Jaguar's ancestors, issues from its gaping jaws. Dated with the Mayan equivalent of October 23, 681 C.E., the ceremony probably marked the accession of Shield Jaguar as ruler. Bloodletting and the visions it produced seem to have been the Mayan rulers' way of communicating with the spirits and gods. This communication was their privilege, their duty, and the source of their power.

The last Mesoamerican empire to arise before the arrival of European conquerors was built by the Aztecs. According to their own legends, the Aztecs

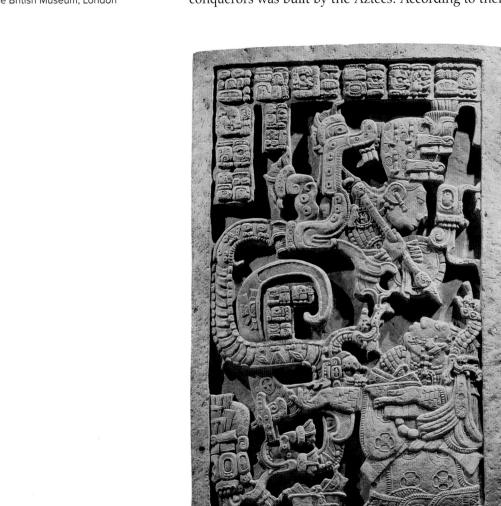

20.11 Lintel 25 (*The Vision of Lady Xoc*), Yaxchilan, Chiapas, Mexico. Maya, 725 c.E. Limestone, 513/6 × 34 × 4". The British Museum, London

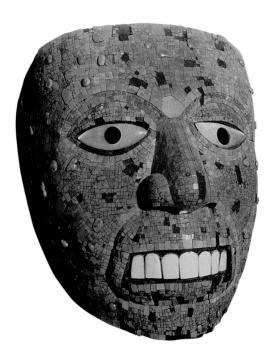

20.12 Ritual mask. Aztec, early 16th century C.E. Turquoise, pearl shell, $6\% \times 6 \times 5\%$ 6". The British Museum, London

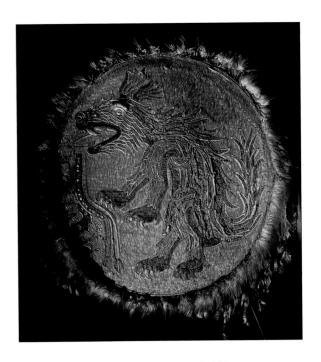

20.13 Ceremonial shield. Aztec, early 16th century. Feather mosaic and gold on wicker base; diameter 27½". Museum für Völkerkunde, Vienna

migrated into the Valley of Mexico during the 13th century C.E. from their previous home near the mythical Lake Aztlan (hence Aztec). They settled finally on an island in Lake Tezcoco, and there they began to construct their capital, Tenochtitlán. Tenochtitlán grew to be a magnificent city, built on a cluster of islands connected by canals and linked by long causeways to cities on the surrounding shores. Massive pyramids and temple platforms towered over the ritual precincts, and in the market squares goods from all over Mesoamerica changed hands. By 1500 Aztec power reached its height, and much of central Mexico paid them tribute.

Almost nothing remains of Tenochtitlán. Spanish conquerors razed its pyramids, and Mexico City has since been built on the same site. Aztec books were consigned to the fire, and their arts in precious metals were melted down for gold and silver. Yet the Spaniards were deeply impressed by the arts they found, and many objects were sent back to Europe. The mask illustrated here (20.12) was probably made by Mixtec artists living in Tenochtitlán. Mixtec artists also made gold and silver objects for the Aztecs, who greatly admired their work. (For Diego Rivera's portrayal of a Mixtec artistic community, see 7.4.) Mosaic of turquoise painstakingly applied in minute squares follows every curve of the face. Pearl shell serves for teeth and eyes. Such a mask would have been worn in one of the numerous ceremonies of song and dance that were central to Aztec life. Masks had a long history in Mesoamerica. The Aztecs collected jade masks carved by the Olmecs and in Teotihuacán. Maya artists also carved ritual masks of jade.

Featherwork was greatly prized in Mesoamerica, and a specialized group of weavers in Tenochtitlán produced featherwork headdresses, cloaks, and other garments exclusively for nobles and high officials. The ceremonial shield here (20.13) shows their vivid sense of design and color. The heraldic coyote depicted in blue feathers edged in gold is the Aztec god of war. From his mouth issues the symbol for "water burning," an Aztec term for war. Rich in metaphors, Aztec speech also referred to warfare as "the song of the shields" and "flowers of the heart upon the plain." Feather shields such as this were part of the lavish dance costumes worn by warriors in ritual re-creations of the warfare of the gods.

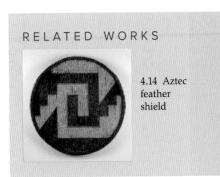

20.14 Stirrup vessel. Moche, 200–500 C.E. Earthenware with cream slip, height 9½". The Metropolitan Museum of Art, New York

South and Central America

Like Mesoamerica to the north, the region of the central Andes on the Pacific Coast of South America provided a setting in which numerous cultures developed. Pyramids, temple platforms, and other monuments have been found dating to the third millennium B.C.E., making them the oldest works of architecture in the Americas, contemporary with the pyramids of Egypt. Textiles of astonishing intricacy have also been found from this time.

Among the first South American peoples to leave a substantial record of art are the Moche, who dominated a large coastal area at the northern end of the central Andes during the first six centuries C.E. The Moche were exceptional potters and goldsmiths. Tens of thousands of Moche ceramics have been found, for one of their great innovations was the use of molds for mass production.

Kneeling warriors are a standard subject of Moche ceramic art (20.14). The large ear ornaments and elaborate headdress capped with a crescent-shaped element are typical of the costume on these figures. The warrior carries a shield and a war club; the heads of two more war clubs protrude from his headdress. His beaked nose probably links him to the barn owl, which was regarded as a warrior animal for its fierce and accurate nocturnal hunting abilities. Much of the finest Moche pottery takes the form of stirrup vessels, so called after the U-shaped spout (here attached to the warrior's back). The innovative spout pours well, can be carried easily, and minimizes evaporation. Yet such elaborate vessels cannot have been primarily practical.

One of the most spectacular archaeological sites in the world is the Inca city of Machu Picchu, in Peru (20.15). Beginning around 1430 and moving with amazing swiftness, the Incas created the largest empire of its time in the world. By 1500 Inca rule extended for some 3,400 miles along the Pacific Coast. Incan textiles are some of the finest in the long tradition of South American fiber work (see 12.10). Incan artists also excelled in sculptures and

20.15 Machu Picchu, Peru. Inca, 15th-16th centuries.

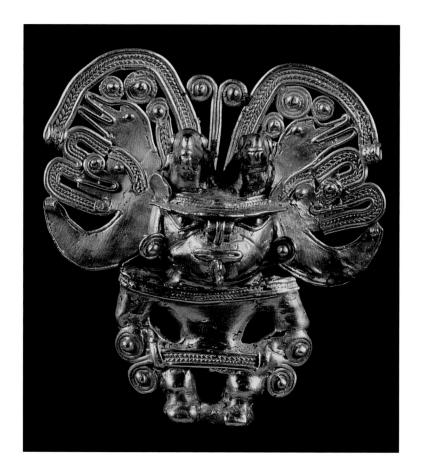

other objects of silver and gold. But the most original Incan genius expressed itself in stonework. Over 20,000 miles of stone-paved roads were built to speed communication and travel across the far-flung empire. Massive masonry walls of Incan buildings were constructed of large blocks of granite patiently shaped through abrasion until they fit together perfectly with no mortar.

Machu Picchu is set high in the Andes Mountains overlooking a hairpin turn in the Urubamba River thousands of feet below. Builders leveled off the site to create a small plateau and constructed terraces for houses and agriculture. Also visible at Machu Picchu is the wholly distinctive Incan sensitivity to the natural landscape. At the northern end of Machu Picchu, for example, a freestanding boulder was carved to resemble the silhouette of a peak that can be seen beyond it in the distance. Elsewhere a rounded building known as the Observatory accommodates a huge boulder into its walls and interior. Part of the boulder is subtly sculpted to create a staircase and chamber. The Inca believed stones and people to be equally alive and capable of changing into one another. This attitude seems to have resulted in their unique approach of relating architecture to its setting.

We end this section with an object made of the material that proved to be the Americas' undoing, gold (20.16). Fashioned of a gold and copper alloy called *tumbaga*, this pendant figure was made by artists of the Tairona culture, which flourished in northern Colombia after about 1000 C.E. The Tairona belong to the cultural region of Central America, which extends from the southern part of present-day Honduras into northwestern Colombia, where a mountain range called the Cordillera Oriental forms a natural boundary. The knowledge of extracting and working gold was first developed to the south, in Peru. Over generations it spread northward, with the goldsmith's art becoming increasingly refined and technically advanced.

Cast using the lost-wax technique, the pendant here portrays a ruler. He is probably also a shaman, and the birds that unfold like wings from either side of his head are the spirit alter egos that give him access to the other world. Tairona smiths added copper to the gold to lower its melting point and create

20.16 Pendant depicting a ruler. Tairona, 1000–1300 C.E. Copper and gold alloy, height 2¾". Museu Barbier-Mueller d'Art Precolombí, Barcelona

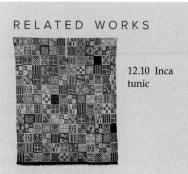

RELATED WORKS 11.25 Serpent Mound 12.9 Pomo basket

a harder, more durable object. After casting, the pendant was bathed in acids that removed the outermost layer of copper particles, leaving the impression of solid gold. The taste for ornaments in precious metals spread from Central America northward into Mesoamerica. There the finest artists in precious metals were the Mixtec, who supplied the Aztecs with their legendary and now lost works. Earlier cultures such as the Olmecs and the Maya had preferred jade.

North America

It might be expected that those of us who live in North America would have a clear picture of the history of art on our own continent, since we are, after all, right here where it happened. Unfortunately, we do not. In general, the ancient arts of North America are much less available to us than those of many other parts of the world—partly because the early inhabitants seem to have made their artifacts from perishable materials such as wood and fiber. Partly it is due to the absence of large urban centers. Patterns of life developed differently in the North.

Many arts of later North American peoples—Indians, as we have come to call them—are arts of daily life: portable objects such as baskets, clothing, and tools imbued with meanings that go far beyond their practical functions. In Chapter 12, we used as an example of such arts a basket from the Pomo of California (see 12.9). Pomo thought links the basket to the story of the sun's journey across the sky, and a flaw woven purposefully into the basket provides a way for spirits to enter and leave. The basket is thus connected to the sacred realm and to ritual. And yet it is also a basket.

The first clearly identifiable culture group of North America populated an area known as the Eastern Woodlands—in parts of what are now Ohio, Indiana, Kentucky, Pennsylvania, and West Virginia—starting about 700 B.C.E. Several Eastern Woodlands cultures are known collectively as the "mound builders," because they created earthworks, some of them burial mounds, in geometric forms or in the shapes of animals. The Serpent Mound in Ohio, illustrated in Chapter 11, is the most famous of the mounds still visible (see 11.25). Excavations of burial mounds have yielded beautifully crafted objects in sheet mica, copper, marine shell, silver, and obsidian—exotic materials obtained through an extensive trade network. Among the most compelling objects are hundreds of small stone pipes, their bowls carved as an effigy of an animal (20.17). The beaver here assumes a fighting pose, its tail tucked beneath its body. The bared incisors were carved from actual beaver teeth. Two freshwater pearls serve for eyes. Their reflective luster signaled the spirit-life of the effigy.

Tobacco was considered a sacred substance by many North American peoples. First domesticated in the Andes around 3000 B.C.E., it made its way north by way of Mexico some two thousand years later. In North America, smoking tobacco became viewed as a form of prayer. The rising smoke faded into the other world, bidding its spirits to come witness or sanction human

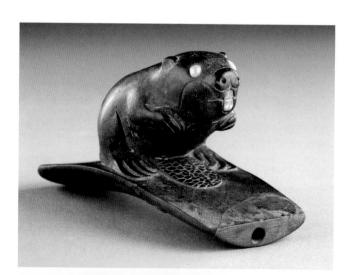

20.17 Beaver effigy platform pipe. Hopewell, 100 B.C.E.—200 C.E. Pipestone, pearl, and bone, length 4%6".

The Thomas Gilcrease Museum,

Tulsa, Oklahoma

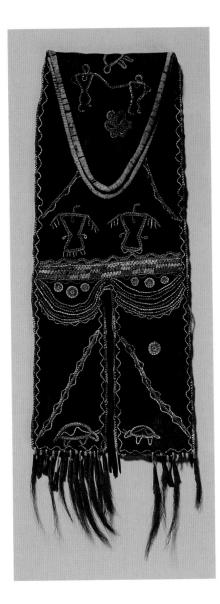

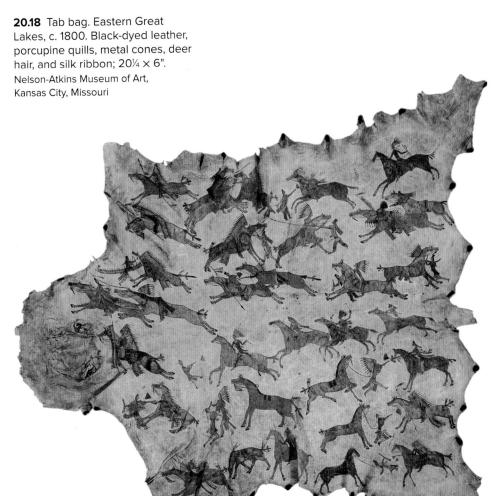

events. Interestingly, whereas knowledge of tobacco arrived from the South, the stone pipe itself is a North American invention.

Europeans arriving in America introduced such new materials as glass beads, and Indian beadwork became justifiably famous. An older Indian art, however, is quillwork (20.18). Quills from porcupine or birds were softened by soaking, then dyed to produce a palette of colors and worked into a surface of deerskin or birch bark. The quillwork on the deerskin bag illustrated here depicts elements of Eastern Woodlands cosmology. The broad horizontal band represents the Earth and its abundance. Above it are two mythical thunder-birds, powerful sky deities recognized by many Indian peoples. Below, two horned turtles represent underwater powers. Wavy lines everywhere indicate flows of spiritual energy. All are manifestations of manitou, the sacred force that was believed to pervade the universe.

Whereas Eastern Woodlands culture was based in a settled way of life, the Plains culture that formed to the west was nomadic, organized around the herds of buffalo that roamed the Great Plains. European explorers' greatest although accidental contribution to Plains culture was undoubtedly the horse, which was brought to America by Spanish colonists and spread throughout Indian cultures over the course of the 18th century.

Buffalo hides provided not only clothing but also shelter in the form of covering for tents, tipis (also spelled "tepees"). Hides provided a surface on which Plains men recorded their exploits as warriors (20.19). Drawn by Lakota warriors, the images here record a battle between the Lakota and the Crow,

20.19 Hide painted with scenes of warfare. Lakota, North or South Dakota, c. 1880. Hide and pigments, 8'2" × 7'9".

Thaw Collection, Fenimore Art Museum, Cooperstown, New York

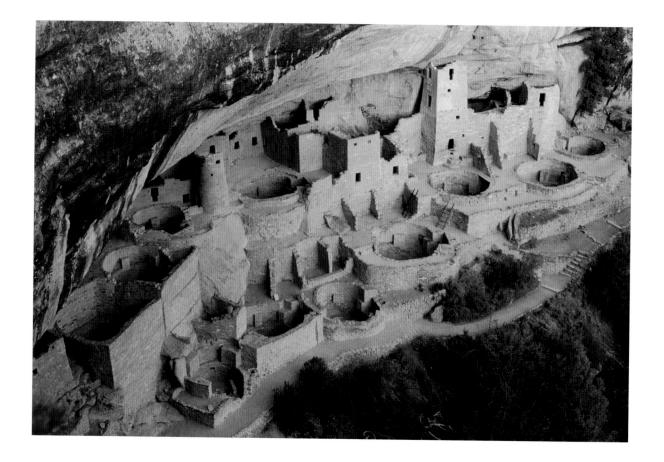

20.20 Cliff Palace, Mesa Verde, Colorado. Anasazi, c. 1200 C.E.

depicted with the vivid recall of participants. Such a hide would have been worn around the shoulders as a robe. Other garments such as shirts and leggings were also painted. Clearly visible are the feathered headdresses that were a distinctive feature of Plains costume. Headdresses were made from the tail feathers of eagles, which were identified with the thunderbird. Some offered protective spiritual power; others were merely finery. Only a proven warrior was permitted to wear one in battle, however.

Urban life was not entirely absent from North America. The people known to archaeologists as the Anasazi, who lived in the southwestern part of the continent, created ambitious communal dwelling sites. One such dwelling at Mesa Verde, in Colorado, has become known as Cliff Palace (20.20). The Anasazi had been present in the region from the first several centuries B.C.E. Around the 12th century C.E., they began clustering their buildings in protected sites on the undersides of cliffs. A complex system of handholds and footholds made access difficult. (Modern tourists have been provided an easier way in.) This arrangement allowed the Anasazi to ward off invaders and maintain a peaceful community life.

Cliff Palace, dated to about 1200 C.E., has more than two hundred rooms organized in apartment-house style, most of them living quarters but some at the back meant for storage. In addition, there are twenty-three *kivas*—large, round chambers, mostly underground and originally roofed, used for religious or other ceremonial purposes. The structures are of stone or adobe with timber, and so harmonious is the overall plan that many scholars believe a single architect must have been in charge. Cliff Palace was occupied for about a hundred years before being mysteriously abandoned in the early 14th century.

The Anasazi's neighbors in the Southwest were a people we know only as the Mogollon culture, which flourished in the Mimbres Valley of what is now New Mexico between the 3rd and 12th centuries C.E. Today the word *Mimbres* is associated with a type of ceramic vessel developed about 1000 C.E. Mimbres jars and bowls were decorated with geometric designs or with stylized figures of animals or humans. Often, these motifs appeared as paired figures (20.21). Although Mimbres ceramics were probably used in households in some way,

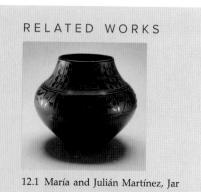

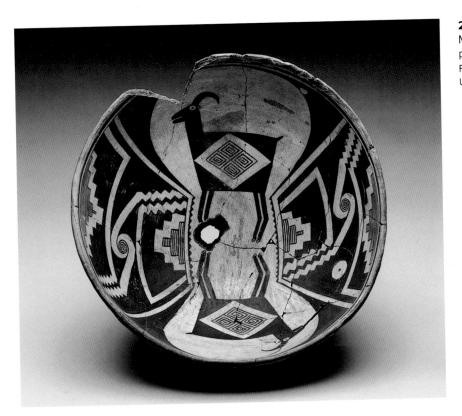

20.21 Bowl with Mountain Sheep. Mimbres, c. 1000–1150 C.E. Painted pottery, diameter 10½". Frederick R. Weisman Art Museum, University of Minnesota, Minneapolis

most examples that have come down to us have been recovered from burials. As grave goods the vessels often seem to have been ritually "killed," either by shattering or, as here, by being pierced with a hole. The act draws a parallel with the human body, which is a vessel for a soul. In death, the vessel is broken and the soul released.

Masks and masking played important roles in some Indian cultures. The Pueblo cultures of the Southwest acknowledge numerous supernatural beings called kachina (from the Hopi *katsina*). Danced by maskers, kachina enter into the community at important times to bring blessings. They may appear, for example, early in the year as auspicious presences so that rain will follow for the new crops. Later, after a successful growing season, they dance at harvest ceremonies. Over two hundred kachina have been identified, each with its own name, mask, character, dance movements, and powers.

Hopi and Zuni Indians make doll-size versions of kachina as educational playthings so that children may learn to identify and understand the numerous spirits (20.22). The kachina themselves often presented the dolls to the young members of the community during their appearances. The doll here portrays a kachina named tamtam kushokta. The spirit wears a white Hopi blanket around its waist and a coyote mask. A spectator who witnessed kachina maskers dancing in 1907 wrote, "In their right hands they carried a tortoise-shell rattle, which they shook with vigor when they danced, and in the left hand, a bundle of prayer sticks, tied up in corn husk, with a kind of handle attached by which it was held."² These handheld objects are faithfully represented on the doll. Kachina dolls were believed to contain some of the power of the spirit they represented. Early in the 20th century, admirers managed to purchase or commission kachina dolls, but that move caused great unease among the Zuni, who believed that letting the dolls out of the community would result in crop failures or other disasters. Selling the dolls to outsiders was a crime subject to severe punishment, although it seems that some were indeed sold.

Contact often led to cultural borrowing among Indian groups, as indeed it has with peoples all over the world throughout history. The Navajo people arrived in the Southwest between 1200 and 1500 c.e., after a long migration

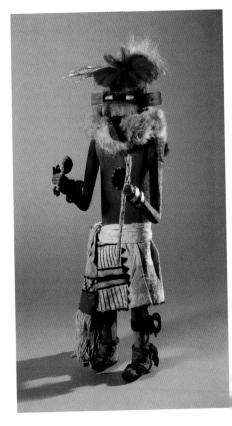

20.22 Kachina doll. Zuni, before 1903. Wood, pigments, hair, fur, hide, cotton, wool, yucca; height 19".

Brooklyn Museum of Art, New York

THE AMERICAS • 469

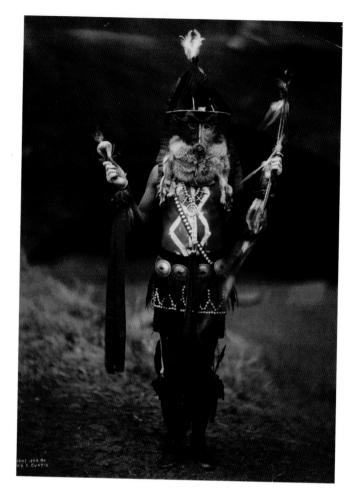

20.23 Edward S. Curtis. *Navajo Zahadolzha Masker*, from Volume 1 of *The North American Indian*. 1907. Photograph. Library of Congress, Washington, D.C.

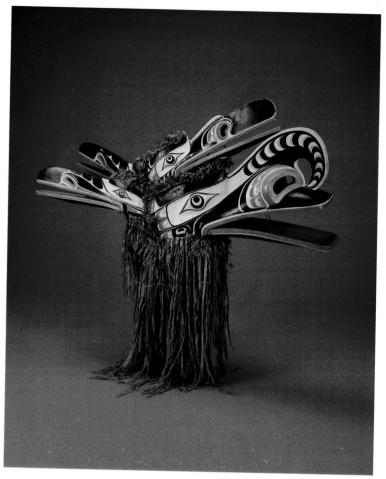

20.24 George Walkus. Four-headed hamat'sa mask. Late 19th century. Wood, paint, cedar bark, and string; height 17". Denver Art Museum

from their original lands in Alaska. Although they never quite adopted the settled life of their new Pueblo neighbors, they did adapt aspects of Pueblo arts and religious beliefs to their own use, including the practice of making spirit beings manifest through masks (20.23). As the photograph here shows, Navajo spirit masks resemble kachina, and indeed scholars believe that the two sets of deities may be distantly linked. The Navajo, however, call their spirits *Yei*, Holy People. Spirit masks such as this one might have appeared at the climax of a particularly elaborate healing ceremony, during which their powers had been invoked through a sand painting such as the one we looked at in Chapter 2 (see 2.37).

Masks are also danced by many peoples of the Pacific Northwest, including the Kwakiutl, or Kwakwaka'wakw, who live along the southern coast of British Columbia. The flamboyant Kwakiutl mask illustrated here makes manifest the four mythical Cannibal Birds who live at the north end of the world and eat human flesh (20.24). The largest of them is the fearsome Crooked Beak. During the winter, the four monsters ritually invade the human community. They kidnap young men of noble families and turn them into cannibals. This kidnapping and transformation take place within the larger ceremony of potlatch, in which a host generously feeds guests from numerous villages over the course of many days. On the final day, the elders of the gathering ritually cure the young man of his cannibalism. The four Cannibal Bird masks dance as part of this ritual, after which they are banished for another year. Usually the birds are danced individually. This mask is exceptional in making all four of them present at once.

Cannibal Bird masks are carved to this day, both for use and to be sold to collectors. Their tremendous formal variety shows how much room for creativity and individual expression an artist actually has within forms that are too often thought of as unchanging and "traditional."

21

The Modern World: 1800–1945

or 19th-century artists and writers, walking through the teeming city streets was the equivalent of today's channel surfing—one sensation followed quickly on another, offering fleeting glimpses of thousands of lives. They found it overwhelming—sometimes thrilling, sometimes disturbing—but they recognized it as new and they called it "modern." Modernity reflected the emergence of a new kind of society in the wake of the three revolutions discussed at the end of Chapter 17: the French Revolution, the American Revolution, and the Industrial Revolution. Driven by technological progress and characterized by rapid change, the 19th century gave birth to our industrialized middle-class culture of mass production, mass advertising, and mass consumption, including the mass consumption of leisure activities such as shopping, going to entertainments, or visiting art museums.

Art museums themselves were a development of the 19th century, and they made art available to the public (including artists) in a way we now take for granted. The first national museum was the Louvre in Paris. Opened in 1793 during the fervor of the French Revolution, it placed the art that had been the private property of the kings of France on public view in what used to be the royal residence. Like everything else that used to belong to aristocrats, art was now for everybody, but what kind of art did everybody want? What kind of art was suited to a society no longer dominated by the Church or by the nobility, but by the middle class and its leaders of finance and industry? Debates about art and modernity began during the 19th century and continued into the 20th, resulting in the ever-increasing number of "isms" that appear in art history from this point on: Realism, Impressionism, Pointillism, Fauvism, Cubism, Futurism, Surrealism-each one staking out a different viewpoint about what art can be, what subjects it can treat, and how it can look. During this time as well, photography revolutionized the making of images. From the Chauvet cave paintings of 30,000 B.C.E. until the first successful daguerreotype in 1837, images had been made by hand. Suddenly, there was another way, and it posed profound questions about the nature and purpose of art even as it opened up new possibilities.

The changes of modernity occurred everywhere in Europe, but the debates they provoked in the visual arts played out most dramatically in France, especially

in Paris, and this brief survey largely focuses there.

Neoclassicism and Romanticism

As we saw in Chapter 17, France's foremost Neoclassical painter, Jacques-Louis David, was an ardent supporter of the Revolution and portrayed several of its heroes (see 17.19). David went on to become the official painter to Napoleon, a position that gave him great influence over the artistic life of France. When Napoleon fell from power in 1815, David went into exile, but Neoclassical style was carried forward into the new century by his students, the foremost of whom was Jean-Auguste-Dominique Ingres.

The flawless finish that Ingres learned from David can be seen in *Jupiter and Thetis* (21.1). The subject is drawn from Homer's *Iliad*, the Greek epic of the Trojan War. The nymph Thetis is shown pleading with Jupiter, ruler of the gods, to intervene in the war on behalf of her son, the warrior Achilles. To the left, hidden in the clouds, Jupiter's jealous wife, Juno, spies on the encounter. With its clear contours, clean colors, and precise draftsmanship, the painting clearly shows Ingres' debt to his teacher.

Although today Ingres' portraits and nudes are among his most admired works, Ingres himself staked his reputation on paintings such as *Jupiter and Thetis*. He had inherited the view that great art can be made only from great subject matter, and that the greatest subject matter of all was history—a

21.1 Jean-Auguste-Dominique Ingres. *Jupiter and Thetis*. **1811**. Oil on canvas, 10'85%" × 8'65%". Musée Granet, Aix-en-Provence

category that included Classical mythology and biblical scenes. This viewpoint and the highly polished style that went with it became enshrined as academic art, the art that was encouraged by the official art schools and institutions of the 19th century.

The second dominant trend of the time, **Romanticism**, also had its roots in the preceding century. Romanticism was not a style so much as a set of attitudes and characteristic subjects. The 18th century is sometimes known as the Age of Reason, for its leading thinkers placed their faith in rationality, skeptical questioning, and scientific inquiry. Rebelling against those, Romanticism urged the claims of emotion, intuition, individual experience, and, above all, the imagination. Romantic artists gloried in such subjects as mysterious or awe-inspiring landscapes, picturesque ruins, extreme or tumultuous human events (see 4.8), the struggle for liberty (see 3.7 and 5.15), and scenes of exotic cultures.

Geographically, the closest "exotic" cultures to Europe were the Islamic lands of North Africa. To European thinking, these were part of "the Orient"—a realm imagined as sensuous and seductive, full of barbaric splendor and cruelty. Eugène Delacroix, the leading painter of the Romantic movement in France, spent several months in North Africa in 1832. Fascinated by all he saw, he filled sketchbook after sketchbook with drawings, watercolors, and observations. Later, he drew upon that material to create numerous paintings, including *The Women of Algiers* (21.2), which portrays three women and their servant in a harem, the women's apartment of an Islamic palace. Delacroix had apparently been allowed to visit an actual harem, a rare privilege for a man, not to mention a European. Compared with the cool perfection of Ingres' careful drawing and glazed colors, Delacroix's technique is freer and more painterly. Forms are built up with fully loaded brush strokes, contours are blurred, and colors are broken.

21.2 Eugène Delacroix. The Women of Algiers. 1834. Oil on canvas, 5'10½" × 7'6½". Musée du Louvre, Paris

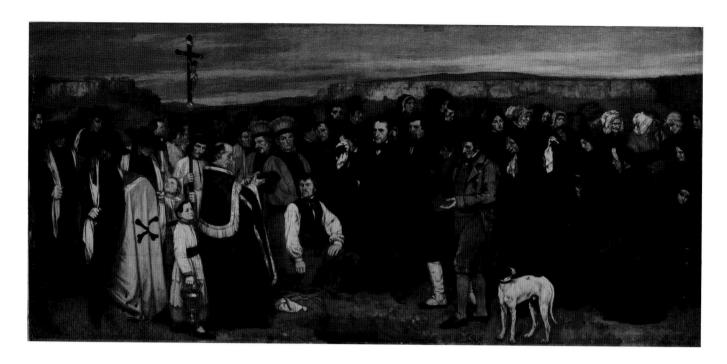

21.3 Gustave Courbet. *A Burial at Ornans*. 1849–50. Oil on canvas, 16'10³/₄" × 21'11".

Musée d'Orsay, Paris

Realism

The first art movement to be born in the 19th century was **Realism**, which arose as a reaction against both Neoclassicism and Romanticism. Realist artists sought to depict the everyday and the ordinary rather than the historic, the heroic, or the exotic. Critics who championed the Realist cause soon found their hero in a young painter named Gustave Courbet.

Courbet had grown up in Ornans, a small town in eastern France, near the Swiss border. He came to Paris at the age of twenty, and, in a sense, he brought his town with him: the people he knew there, the lives they led, and the landscape of its region were the subjects of his art. In 1849, after one of his paintings was awarded a gold medal at the Salon-the annual, state-sponsored exhibition of new art-Courbet decided that it was time for something truly ambitious. He returned to his hometown and worked through the winter on his first monumental painting, A Burial at Ornans (21.3). The subject is a burial-of whom we do not know. Courbet uses the event as a pretext for a group portrait of Ornans society. A priest, two red-robed beadles (lay officials in the Church), the mayor, a judge, male mourners, and a gravedigger have gathered around the open pit dug to receive the coffin, which is shown arriving at the left. Female mourners cluster to the right. A raised crucifix stands out clearly against the dull sky and distant chalk cliffs. Courbet persuaded the local authorities to pose for his painting: the mayor, judge, beadles, and priest are all portrayed as themselves. Courbet's friends and family are present, and most of the other figures have been identified as well.

When the painting was shown at the Salon of 1850, a critic later recalled, it was as though a tornado had blown through the room. Admirers held that Realism had produced its first masterpiece. Detractors thought that Courbet had pushed what they called "the cult of the ugly" about as far as it could go. The painting offended them on two counts. The first was its resolute refusal to beautify or sentimentalize the scene. The second was its scale: monumental formats were traditionally reserved for history paintings full of important personages. This painting was full of nobodies, taken seriously as people.

Courbet's "we the people" artistic agenda was linked to radical political ideas. In 1871 his participation in a bloody Paris uprising earned him a prison sentence; two years later, still in trouble, he fled the country for Switzerland, where he died in 1877.

Manet and Impressionism

In 19th-century France, the mark of an artist's success was acceptance at the annual Salon. Artists submitted their work for consideration by an official jury, whose members varied from year to year but tended to be conservative, if not downright stodgy. In 1863 the Salon jury rejected almost three thousand of the submitted works, which caused such an uproar among the spurned artists and their supporters that a second official exhibition was mounted-the "Salon des Refusés $^{''}$ ("showing of those who had been refused"). Among the works in the "refused" show-and very soon the most notorious among them-was Edouard Manet's painting Le Déjeuner sur l'herbe (21.4).

Luncheon on the Grass, as it is usually translated, shows a kind of outdoor picnic. Two men, dressed in the fashions of the day, relax and chat in a woodland setting. Their companion is a woman who has, for no apparent reason, taken off all her clothes. In the background another woman, wearing only a

filmy garment, bathes in a stream.

Manet seems to have wanted to accomplish two goals with this work. The first was to join Courbet and other artists in painting modern life. But the other was to prove that modern life could produce eternal subjects worthy of the great masters of the museums. His solution was to "update" two famous Renaissance images, Titian's Fête Champêtre and Raphael's The Judgment of Paris (see Related Works, this page). The public saw what Manet was doing: the Titian, after all, was in the Louvre Museum close by, and the Raphael was routinely copied by art students. They saw what he was doing, and they didn't like it. Surely Manet was making fun of them. In place of Titian's idealized and dignified nudes, he had painted what seemed to be a common woman of loose morals: Who else would sit there with no clothes on, meeting our gaze so frankly? The men in the painting, too, were completely undistinguished-not noble poets as in Titian, but ordinary students on holiday. One critic lamented that Manet was trying to achieve celebrity the easy way, by shocking his public. Others found the technique inept. Perhaps if Manet would learn something about perspective and drawing, they said, his taste might improve as well.

RELATED WORKS

Raphael, Judgment of Paris, detail

Titian, Fête Champêtre

21.4 Edouard Manet. Le Déjeuner sur l'herbe. 1863. Oil on canvas, $7' \times 8'10''$. Musée d'Orsay, Paris

Manet's painting is odd, and art historians still debate just what he meant by it. In modeling his figures, Manet focused on the highest and lowest values, all but eliminating the middle, transitional tones. As a result, the forms appear flattened, as though illuminated by a sudden flash of light. The perspective is off: contemporary viewers were quite right. The bather is as far away as the rowboat, but if you imagine her standing in it, you see that she is a giantess. It was evidently more important to Manet to have her form the apex of his triangle of figures than to place her correctly in perspective. This, too, flattens the painting, for the bather seems to move forward to join the rest of the figures, compressing the space between foreground and background. The spatial tension plays out in the landscape itself: on the left side of the painting, the ground recedes convincingly into the distance, but on the right side there is no recession-just flat bright green. Nor do we believe for a minute that these people are really sitting outdoors. Clearly, they are posing in a studio. The landscape is painted around them like a stage set or a photographer's backdrop. Finally, the borrowed composition feels borrowed, as though it were in quotation marks.

All these qualities—the public scandal, the flatness, the artificiality, the ambiguity, and the self-conscious relation to art history—have made the painting a touchstone of modern art. A painting in the modern era could no longer be a simple, transparent window on the world. It would also be increasingly conscious of itself *as* a painting.

During the years following Manet's sensation in the Salon des Refusés, young French artists increasingly sought alternatives to the Salon. One group in particular looked to Manet as their philosophical leader, although he never consented to exhibit with them. They thought of themselves as Realists, for like Manet and Courbet they believed that modern life itself was the most suitable subject for modern art. In 1874 they organized their first exhibition as The Anonymous Society of Artists, Painters, Sculptors, Printmakers, etc. A painting in the exhibit by Claude Monet called Impression: Sunrise, however, caught the attention of a critic named Jules-Antoine Castagnary, who used the title to explain what the artists had in common. They were not aiming for perfection, he wrote, but to capture an impression; they did not want to portray a landscape but the sensation of a landscape. All in all, he was quite taken with them: "I swear there's talent here, and a lot of it. These young people have a way of understanding nature that is neither dull nor banal. It's lively, nimble, light, ravishing. . . . It's admittedly sketchy, but how much of it rings true!" He titled his review "The Impressionists." The name stuck in the public imagination, and the artists themselves largely accepted it.

With Impressionism, art moved outdoors-not the artificial outdoors of Manet, but the true outdoors. Painting up until then had been a studio product, in part because of the cumbersome materials it involved. Thanks to the new availability of portable oil colors in tubes (as they are still manufactured today), many of the Impressionists took their canvases, brushes, and paints outside to be part of the shifting light they wanted to depict. Monet painted Autumn Effect at Argenteuil from a small boat that he would row out into the Seine River as it flowed by the little town of Argenteuil, where he had rented a house for himself and his family (21.5). Little dabs and flicks of paint indicate the dazzle of fall foliage, while small slabs and dashes of blue and white suggest the play of light on the moving water surface. The solid white forms of the village framed on the horizon find their counterparts in the cream-puff clouds overhead. Black has been banished from the palette, and shadows are indicated with blues and greens. Shown alongside Impression: Sunrise at the 1874 exhibition, the painting's brilliant colors must have produced an electric effect on a public accustomed to far more subdued harmonies.

The light in Pierre-Auguste Renoir's enchanting *Le Moulin de la Galette* (21.6) is a light we have not seen before in painting, the dappled, shifting light that filters through leaves stirred by a breeze. Traditional chiaroscuro required a steady and even source of light for modeling form. But light in nature wasn't

21.5 Claude Monet. Autumn Effect at Argenteuil. 1873. Oil on canvas, $21\% \times 29\%$ ". Courtauld Gallery, Courtauld Institute of Art, London

always like that. It moved, it shifted, it danced. Like his friend Monet, Renoir sought to capture such optical sensations through fluid brushwork, a lightened palette, and colored shadows. Renoir would later modify his style to embrace more rigorously planned compositions and fully modeled forms, but here he is in his full Impressionist glory, capturing a moment's pleasure with flickering strokes of paint that record sensations of light, color, and movement.

Le Moulin de la Galette was an establishment on the outskirts of Paris where working people gathered on their day off to relax and enjoy themselves. Renoir paints a group of his friends there, dancing and talking, drinking and flirting. The leisure activities of the middle class were a favorite subject

21.6 Pierre-Auguste Renoir. Le Moulin de la Galette. 1876. Oil on canvas, 4'3½" × 5'9". Musée d'Orsay, Paris

21.7 Berthe Morisot. Summer's Day. 1879. Oil on canvas, $18 \times 29\frac{1}{4}$ ". The National Gallery, London

of the Impressionists, and we may be forgiven if because of them we picture 19th-century France as a land where there is always time to stroll in the country, where a waltz is always playing under the trees.

Another founding member of the Impressionist group was Berthe Morisot. Born into a well-to-do family, Morisot received private art lessons intended to prepare her for life as an accomplished amateur painter, wife to a husband whose career would presumably take precedence. But her great talent and passionate interest took her far beyond anything her parents may originally have had in mind. While still in her early twenties, she took up the new practice of "open air" painting and began exhibiting successfully in the official Salon. In 1874 she contributed nine paintings to the first Impressionist exhibit, and she remained a dedicated member of the group for the rest of her life. Summer's Day is a lovely example of her style (21.7). Two fashionably dressed young women-probably models hired by Morisot-are having an outing on a lake in a Parisian park. One gazes out at us, a sky-blue parasol folded on her lap. The other turns to look at the ducks swimming alongside. A hired boatman would have been responsible for rowing such fine young ladies, though we don't see him. The palette is light, and the brushwork is varied and free, as though painting were the easiest thing in the world. As a sympathetic critic of the day wrote, "No one represents Impressionism with a more refined talent or with more authority than Madame Morisot."2

Post-Impressionism

The next generation of artists admired many aspects of Impressionism, especially its brightened palette and direct painting technique. But they reacted in various ways to what they perceived as its shortcomings. Their styles are so highly personal that we commonly group them together under the neutral term **Post-Impressionists**, meaning simply the artists that came after Impressionism. They include Georges Seurat, Vincent van Gogh, Paul Gauguin, and Paul Cézanne.

Seurat wanted to place Impressionism's intuitive recording of optical sensations on a more scientific footing. His reading of color theories led him to develop the technique of pointillism, in which discrete dots and dashes of pure color were supposed to blend in the viewer's eye (see 4.31).

Of all the Post-Impressionists, Seurat was the most faithful to the idea of painting modern life. For other Post-Impressionists, the industrialized modern world was not something that needed to be confronted but something that

THINKING ABOUT ART Presenting the Past

enerations of art lovers have enjoyed the story of the triumph of Impressionism. So familiar have many of these paintings become, so central to our idea of "great art," that we find it hard to believe that the public and most critics initially disliked them. Who could be so blind? Impressionism's important role in the history of modern art even earned the movement its very own museum in Paris, the intimate Jeu de Paume.

Many were horrified, then, when the French government announced in 1978 that it was going to move the Jeu de Paume's collection to the nearby Gare d'Orsay, a cavernous railway station that was to be renovated as a museum. There, the paintings would be united with works drawn from museums all over France and representing all the arts and artistic trends of the 19th century—not just progres-

sive styles, but conservative ones as well, not just painting and sculpture, but also architecture, photography, popular arts and illustration, decorative arts such as

furniture and porcelain, and exhibits about the political and social history of the time. Folded back into the larger context of the era, the Impressionists would hang alongside the academic painters and forgotten favorites of the Salon. "Just the people they'd been trying to get away from all their lives," grumbled one Parisian painter.³

One of those people was the arch-academic William-Adolphe Bouguereau, whose *The Birth of Venus* is illustrated here. Bouguereau began his career painting tormented Romantic themes, but he quickly discovered that what the public wanted was Venuses and Cupids, and that is what he gave them—slick, sentimental, and mildly titillating—until his death in 1905. It made him rich. Looking at this painting, with its clear contours

and flawless finish, we can better understand the artistic debates of the day. No wonder Impressionist works looked sketchy and even vulgar! Suddenly our own position becomes less clear: What would we have preferred ourselves? Venus, or some uncouth students at a picnic? Stylish escape, or raw modern life? Which, honestly, do we prefer now?

In 1986, after a widely publicized battle of powerful public officials, critics, patrons, and artists, the Gare d'Orsay reopened as the Musée d'Orsay, now one of the most popular and visited showplaces of art in Europe. By blurring distinctions between high and low, academic and avant-garde, its inclusive collection has challenged some of our most accepted understandings of art history, while its user-friendly design has democratized and made accessible the stuffy and exclusive space of the fine arts museum. For these reasons, it is perhaps the first exhibition hall of our own Postmodern era.

Why were Impressionist works so shocking when first introduced? Would we react similarly today to such style? What is the general preference in and reaction toward art nowadays? Would we be more ready to accept Venus, or some uncouth students at a picnic?

(top) Interior of the Musée d'Orsay, Paris. (center) William-Adolphe Bouguereau. *The Birth of Venus*. 1879. Oil on canvas, 9'10½" × 7'1¾". Musée d'Orsay, Paris needed to be escaped. Vincent van Gogh arrived in Paris from Antwerp in 1886, but he stayed for only two years—just long enough to catch up with the latest developments in art. Van Gogh settled instead in Arles, a small, rural town in the south of France, where he painted the landscape, people, and things closest to him. The high-key colors, agitated brushwork, and emotional intensity of such works as *The Starry Night* (see 1.10) and *Wheat Field and Cypress Trees* (see 2.1) would have an enormous influence on the next generation of artists.

Paul Gauguin worked in an Impressionist style early in his career, but he soon became dissatisfied. He felt the need for more substance, more solidity of form than could be found in optical perceptions of light. Beyond that, Gauguin was interested in expressing a spiritual meaning in his art. All these he sought on the sun-drenched islands of the South Pacific, where he journeyed to escape what he called "the disease of civilization." The brilliant high-keyed colors of Gauguin's Tahitian paintings reveal his debt to Impressionism. To this lightened palette he added his own innovations: flattened forms and broad color areas, a strong outline, tertiary color harmonies, a taste for the exotic, an aura of mystery, and a quest for the "primitive."

Te Aa No Areois (The Seed of the Areoi) (21.8) was painted about a year into Gauguin's first long stay in Tahiti, and it shows all these characteristics. Whereas Monet's painting is woven together out of distinct brush strokes like a piece of fabric, Gauguin's seems pieced, like a puzzle or a quilt. We can almost imagine assembling it by cutting the shapes from sheets of colored paper. The white motifs on the blue cloth dance free of their ground, as do the yellow palm trees in the background. In the midst of all this whirling brilliance, a golden brown woman sits in quiet dignity, holding a sprouting seed in the palm of her hand. Her pose—legs shown in profile, shoulders depicted frontally—is derived from Egyptian art. Gauguin believed that European art had been in thrall for too long to the legacy of Greece and Rome, and he looked to the

21.8 Paul Gauguin. Te Aa No Areois (The Seed of the Areoi). 1892. Oil on burlap, 36¼ × 28¾". The Museum of Modern Art, New York

21.9 Paul Cézanne. *Mont Sainte-Victoire*. 1902–04. Oil on canvas, $27\frac{1}{2} \times 35\frac{1}{4}$ ". Philadelphia Museum of Art

art of Egypt, Islam, and Asia to renew it. The woman's gesture is mysterious, yet we sense that there is some profound meaning to it, if only we could understand what she is offering us. Though he painted a paradise, Gauguin in fact was bitterly disappointed in Tahiti. He felt that European missionaries and colonists had already ruined it. In the end, he painted what he dreamed of finding, because what he found was that there was no escape.

In contrast to Gauguin's need for travel and exotic subjects, Paul Cézanne found everything he needed within walking distance of his home in the south of France. Cézanne admired the Impressionists' practice of working directly from nature, and he approved of their bright palette and their individual strokes of color. He was dissatisfied, though, with their casual compositions and their emphasis on what is transitory, such as the dappled sunlight on Renoir's spinning dancers. He felt that what had made painting great in the past was structure and order. He admired, for example, Nicolas Poussin's majestic structuring of nature in such paintings as The Ashes of Phokion (see 17.8). Could the brush strokes that the Impressionists used to register optical sensations be used to build something more solid and durable? Could an artist paint directly from nature and find in it the order and clarity of Poussin? These were the goals that Cézanne set for himself.

A favorite subject of Cézanne's last years was Mont Sainte-Victoire, a mountain near his home (21.9). Altogether he made seventy-five painted or drawn versions of the scene. The broad outlines of the composition are simple and noble: a rectangular band of landscape surmounted by the irregular pyramid of the mountain. This underlying geometry emerges clearly from hundreds of small, vivid patches of color. Each patch is composed of the terse, precise, parallel strokes that Cézanne used to register what he called his "little sensations before nature"-the impressions that colors shimmering in the hot southern sun made on his eyes. Near the foreground, the red tile roofs of farmhouses are like ready-made color patches. The roof of the isolated house near the center reproduces exactly the silhouette of the mountain. To the left, the upward diagonal of the ocher area around the group of three farmhouses is exactly parallel to the upward slope of the mountain. These echoes are a key to Cézanne's way of thinking: major structural lines are echoed everywhere. The line of the horizon, for example, is broken into segments, none of them quite horizontal. Segments of almost-horizontal lines appear throughout the painting, even in the sky, which is also painted in patches of color.

With paintings such as Mont Sainte-Victoire, Cézanne's treatment of nature grew increasingly abstract. Repetitions and echoes of key contour lines help unify the composition, but they have also begun to take on their own independent logic apart from the subject. Similarly, the terse strokes and color patches help unify the painting's surface, but they tend to fracture the image into facets. The next generation of painters would study these devices and

build on them.

Bridging the Atlantic: America in the 19th Century

Europe remained America's artistic touchstone during the 19th century, for America viewed itself then as a continuation of European culture. American artists often went to Europe for part of their training, not only to study with European teachers, but also to see the collections of the great museums. In Europe, they could absorb more easily the history of their art at first hand. There was no American substitute, for example, for wandering through the ruins of ancient Rome or visiting a Gothic cathedral. Some American artists remained in Europe and spent their careers there. Similarly, some European artists emigrated to America, where opportunity seemed greater.

RELATED WORKS

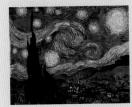

Van Gogh, The Starry Night

2.1 Van Gogh, Wheat Field and Cypress Trees

4.31 Seurat, Evening, Honfleur

Cézanne, Still Life with Compotier, Pitcher, and Fruit

21.10 George Caleb Bingham. *Fur Traders Descending the Missouri.* c. 1845. Oil on canvas, 29 × 36½". The Metropolitan Museum of Art, New York

Neoclassicism, Romanticism, Realism, and Impressionism were broad trends in America as they were in Europe, though without the intense battles they provoked in Paris.

Romanticism was a many-sided movement, and in America it expressed itself most clearly through an attitude toward landscape, an almost mystical reverence for the natural beauty of the unspoiled land itself. The broad vista and threatening storm of Thomas Cole's *The Oxbow* (see 3.22) display one aspect of American Romanticism. Cole was born in England, and his family emigrated to America when he was seventeen. His artistic training was in the United States, although he later spent two years looking at art in Europe.

In contrast to Cole, American-born George Caleb Bingham was largely self-taught. Bingham was the first major painter to live and work west of the Mississippi River. His *Fur Traders Descending the Missouri* (21.10), painted around 1845, portrays a French trapper and his son gliding down the Missouri River in a dugout canoe. The air is heavy with the golden light of dawn about to break. The son leans on their cargo, casually cradling a rifle. A duck he has recently shot lies in front of him. Father and son both look our way. The son's gaze is open; his father's more guarded. But the strangest and most haunting gaze in the painting is one we can't decipher at all: that of a bear cub chained to the prow of the canoe. Stock still, doubled by its lengthening reflection in the river, the bear has an eerie presence, reminding us of how mysterious and unknowable nature truly is.

Realism found its finest American practitioner in Thomas Eakins, whose *The Biglin Brothers Racing* is illustrated in Chapter 4 (see 4.6). Eakins had studied in Paris and toured the museums of Europe, but he returned to Philadelphia to paint American lives. Eakins had a distinguished career as a teacher. Among his students was Henry Ossawa Tanner, whose *Banjo Lesson* is illustrated in Chapter 5 (see 5.13). One of the first important African-American artists, Tanner moved to Paris in 1894, where he turned increasingly to religious subjects and exhibited regularly in the Salon.

Another American artist who traveled to Paris and remained there was Mary Cassatt. Whereas her artistic training in America had been conservative and academic, her natural inclination drew her toward scenes from daily life, especially intimate domestic scenes of mothers and children—a world men rarely depicted in art. Edgar Degas was impressed by the paintings she exhibited at the Salon during the 1870s, and he invited her to show with the Impressionists

RELATED WORKS

3.22 Cole, The Oxbow

4.6 Eakins, The Biglin Brothers Racing

5.13 Tanner, The Banjo Lesson

instead. "Finally I could work with absolute independence without concern for the eventual opinion of a jury," Cassatt later wrote. "I admired Manet, Courbet, and Degas. I detested conventional art. I began to live."

Painted in 1893, Cassatt's *The Boating Party* shows the joyous results of her artistic liberation (21.11). A well-to-do woman has hired a boatman to take her and her child on a pleasurable outing. The child, sprawled contentedly across her mother's lap, stares at the boatman with undisguised curiosity. The mother looks at him as well, pleasantly, but from a more polite distance. The bold, simplified forms and the broad areas of color reflect the influence of Japanese prints, which had been the subject of a major exhibition in Paris three years earlier. The straightforward color harmony of blue, yellow, and red is set singing by the boatman's deep blue clothing and the boat's brilliant white gunwale.

Into the 20th Century: The Avant-Garde

When you hear people talking about the newest, latest, most advanced art, you may hear them use the French term *avant-garde*. Avant-garde was originally a military term, referring to the detachment of soldiers that went first into battle. By the 1880s, younger artists began to refer to themselves as the avant-garde. They were the boldest artists, going first into uncharted territory and waiting for others to catch up. Their "battle" was to advance the progress of art against the resistance of conservative forces. Newness and change became artistic ideals. Each generation, even each group, believed it was their duty to go further than the one before. As the 20th century began, the idea of the avant-garde was firmly in place, and two of art's basic building blocks, color and form, were the focus of great innovation.

Freeing Color: Fauvism and Expressionism

Though it no longer wielded the power it once did, the annual Salon of Paris was still a conservative force in artistic life, and movements regularly arose against it. In 1903 a group of young artists founded the Salon d'Automne, the

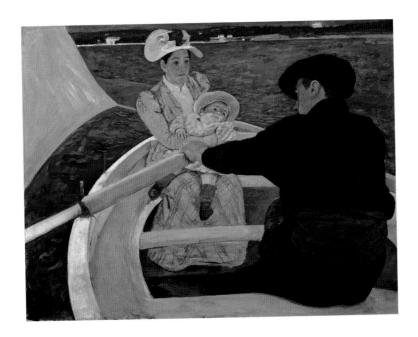

RELATED WORKS 4.34 Whistler, Nocturne in Blue and Gold 8.13 Cassatt, Woman Bathing

21.11 Mary Cassatt. The Boating Party. 1893–94. Oil on canvas, $35\% \times 46\%$ ". National Gallery of Art, Washington, D.C.

RELATED WORKS

2.25 Matisse, Piano Lesson

2.26 Matisse, Music Lesson

21.12 Henri Matisse.

The Joy of Life. 1905–06.

Oil on canvas, 5'8½" × 7'9¾".

The Barnes Foundation. Philadelphia

"autumn salon," as a progressive alternative. From the exhibits they organized, it was clear who their heroes were. In 1904 the artists of the Salon d'Automne organized a large exhibition of Cézanne. In 1906 they mounted a major retrospective of Gauguin. But the most notorious exhibit of the Salon d'Automne was the one they organized for themselves in 1905. It was then that a critic dubbed them *fauves*, "wild beasts."

The artist who emerged as the leader of this "wild" new trend in painting was Henri Matisse. Not long after his art first alarmed the critics, Matisse completed *The Joy of Life* (21.12), a major work that he exhibited when the Fauves showed again in 1906. Pink sky, yellow earth, orange foliage, blue and green tree trunks—in the Fauvist vision, color was freed from its supporting role in describing objects to become a fully independent expressive element. With its broad areas of pure color floating free, *The Joy of Life* radiates a sense of harmony and well-being. Gauguin had painted Tahiti as a paradise. For Matisse, color itself became a paradise, a place to be.

Fauvism did not last long. By 1908 its painters had begun to go their separate ways. Yet though brief, Fauvism was crucial for the development of modern art. Never again would artists feel they must confine themselves to replicating the "real" colors of the natural world.

Fauvism was part of a larger trend in Europe called expressionism, which arose as artists came to believe that the fundamental purpose of art was to express their intense feelings toward the world. **Expressionism**, broadly speaking, describes any style where the artist's subjective feelings take precedence over objective observation. Spelled with a capital E, it refers especially to an art movement that developed in Germany in the early 20th century, where

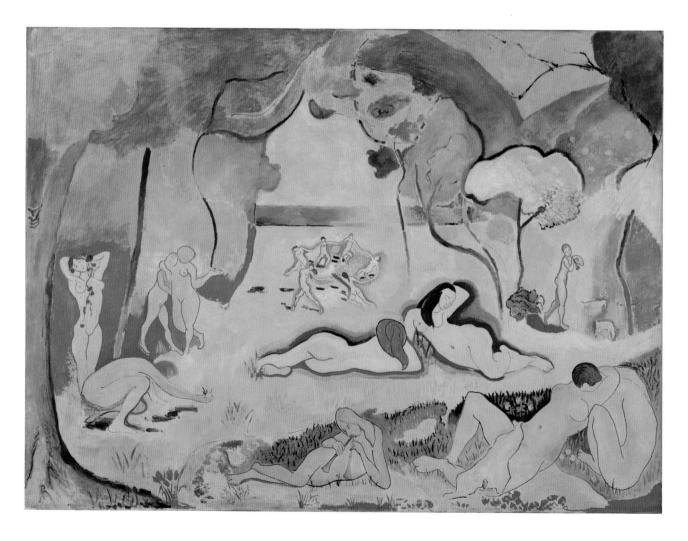

ARTISTS Henri Matisse (1869-1954)

Why did critics call Matisse a "wild beast"? Can we call him one? Why do his works not touch upon political or social issues?

ow ironic it is that Henri Matisse, of all people, should have provoked a critic to call him a "wild beast," for, though his art may indeed have seemed a bit wild at first, the artist himself could scarcely have been less so. Cautious, reserved, cheerful, hardworking, dedicated to his family, frugal, painstaking—these are the qualities that describe Matisse. His longtime friend and rival Picasso captured more of the headlines, but the steadfast Matisse created art no less innovative and enduring.

Matisse's father intended him to be a lawyer, but a severe case of appendicitis at the age of twenty-one changed his life—and changed the course of all modern art. Henri's mother bought him a box of paints as a diversion, and, for once, Matisse reacted strongly. Much later he said of this experience, "It was as if I had been called. Henceforth I did not lead my life. It led me."

Matisse enrolled at the Ecole des Beaux-Arts in Paris and studied with the painter Gustave Moreau, a brilliant teacher who is said to have told his young pupil, "You were born to simplify painting." After a period

of experimentation in various styles, Matisse exploded onto the Parisian art scene at the Salon d'Automne (autumn salon) in 1905, when he exhibited, along with several younger colleagues, works of such pure, intense, and arbitrary color that a critic labeled the artists fauves—wild beasts. In those early years, Matisse did not fare much better with the general public. However, he had the good fortune to attract the attention of certain wealthy Americans who have achieved fame as inspired collectors, including the Stein family (Gertrude and her brothers) and the eccentric Cone sisters of Baltimore.

Considering that the period in which he lived encompassed two world wars, Matisse kept himself remarkably outside the fray. His art did not touch upon politics or social issues. Throughout his life, his favorite subjects remained the human body (usually a beautiful female body) and the pleasant domestic interior. The joys of home life, of family, of cherished objects dominate his expression. In 1898 Matisse married Amélie Parayre, with whom he maintained a contented relationship for many years. Mme. Matisse was lovely, a willing model, charming and lively, and devoted to her husband's career. Their three children all chose art-related lives, Pierre becoming a prominent art dealer in New York.

We think of Matisse as a painter, but he worked in many fields—sculpture, book illustration, architectural design (of a small, jewel-like chapel near his home), and finally in *découpage*. By the early 1930s, Matisse had begun to use cut-up paper as a means of planning his canvases, and a decade later the cut paper had become an end in itself. When he was very old and could no longer stand at his easel, Matisse sat in his wheel-chair or in his bed, cutting segments of pre-painted paper and arranging them into compositions, some of mural size.

Perhaps it was at the end that he came nearest to his goal: "What I dream of is an art of balance, of purity and serenity, devoid of troubling or depressing subject matter, an art which might be for every mental worker, be he businessman or writer, like an appeasing influence, like a mental soother, something like a good armchair in which to rest from physical fatigue." 5

Matisse in his studio, 1909 or 1912. Photograph by Henri Monet(?). Pierre Matisse Gallery Archives, The Pierpont Morgan Library, New York

21.13 Ernst Ludwig Kirchner. *Street, Dresden.* 1908; dated 1907 on painting. Oil on canvas, $4'11\%'' \times 6'6\%''$. The Museum of Modern Art, New York

21.14 Vasili Kandinsky. *Black Lines No. 189.* 1913. Oil on canvas, 4'3" × 4'35%". Solomon R. Guggenheim Museum, New York

the expressive ideal had its greatest influence. Like the Fauves, Expressionist artists looked to Gauguin and Van Gogh as their predecessors. They admired as well the stark works of the Norwegian artist Edvard Munch, who was then living in Berlin (see 4.35).

One important Expressionist group was Die Brücke (The Bridge), founded in Dresden in 1905, the same year as the Fauve exhibit in Paris. The bridge the artists had in mind was one they would build through their art to a better, more enlightened future. One of the founders was Ernst Ludwig Kirchner, whose *Street, Dresden* we see here (21.13). The intense, arbitrary colors show Expressionism's link with Fauvism, and the wavering contours suggest the influence of Munch. To the right, a crowd moves toward us. Everyone seems to have a purpose—shopping, going to work, all the usual reasons that keep city streets teeming with people. To the left, a crowd walks in the other direction. In the center is the small figure of a child. She stands isolated from the crowds, her feet planted apart, resisting the flow. Perhaps she is a stand-in for the artist, who also questions all this coming and going, what purpose it serves, and why everyone is alone.

Another Expressionist group was Der Blaue Reiter (The Blue Rider), organized in 1911 by the Russian painter Vasili Kandinsky. Kandinsky had been teaching law in Moscow when an exhibit of Impressionist painting so moved him that he abandoned his career and moved to Germany to study art. Kandinsky's early paintings were intensely colored, Fauve-like works on Russian mystical themes. He never abandoned his idea that spirituality and art were linked. but he became increasingly convinced that art's spiritual and communicative power lay in its own language of line, form, and color, and he was one of the first painters to take the decisive step of eliminating representation altogether in such works as Black Lines No. 189 (21.14). In his own telling, Kandinsky discovered the power of nonrepresentational art when he was struck by the beauty of a painting he didn't recognize in his studio. It turned out to be one of his own works, set the wrong way up. He realized then that subject matter was only incidental to art's impact. About color, Kandinsky wrote, "Generally speaking, color influences the soul. Color is the keyboard, the eyes are the hammers, the soul is the piano with many strings. The artist is the hand that plays, touching one key or another purposively, to cause vibrations in the soul.

RELATED WORKS

4.35 Munch, The Scream

2.20 Delaunay, Electric Prisms

Shattering Form: Cubism

While artists associated with Europe's many expressionist tendencies were exploring the possibilities of color, two artists in Paris were reducing the role of color to a minimum to concentrate on the problem of representing form in space. One of those artists was a young Spanish painter, Pablo Picasso. In 1907, at age twenty-six, Picasso had already painted what is widely regarded as a pivotal work in the development of 20th-century art, Les Demoiselles d'Avignon (21.15).

Les Demoiselles d'Avignon was not Picasso's title but was given to the painting years later by a friend of his. It translates as "the young women of Avignon" and refers to the prostitutes of Avignon Street, a notorious district of Barcelona, Picasso's hometown. In early sketches for the painting, Picasso included a sailor entering at left to purchase a prostitute's services, but as the composition evolved, the sailor was eliminated. Instead, the prostitutes display themselves to us.

If these are prostitutes, then how extraordinary they are! They are far from enticing. Picasso has chopped them up into planes—flat, angular segments that still hint at three-dimensionality but have no conventional modeling. Figure and ground lose their importance as separate entities; the "background"—that is, whatever is not the five figures—is treated in much the same way as the women's bodies. As a result, the entire picture appears flattened; we have no sense of looking "through" the painting into a world beyond, as with Delacroix or even Manet.

To many people who see *Les Demoiselles* for the first time, the faces cause discomfort. The three at left seem like reasonable enough, if abstract, depictions of faces, except that the figure at far left, whose face is in profile, has an eye staring straight ahead, much as in an Egyptian painting. But the two faces at right are clearly masks—images borrowed from "primitive" art—and they create a disturbing effect when set atop the nude bodies of European females.

In Les Demoiselles Picasso was experimenting with several ideas that he would explore in his art for years to come. First, there is the inclusion of

21.15 Pablo Picasso. *Les Demoiselles d'Avignon*. 1907. Oil on canvas, 8' × 7'8". The Museum of Modern Art. New York

ARTISTS Pablo Picasso (1881-1973)

What are some of Picasso's "periods" of works? Why was he so successful early on? How should we interpret Picasso's insight into the nature of art? How is his interpretation carried out in his works?

he life of Picasso defies summary in a one-page biography. Few artists have lived so long; none has produced such an immense volume of work in so diverse a range of styles and media; and only a rare few can match him in richness and variety of personal history.

Pablo Ruiz y Picasso was born in the Spanish city of Málaga. He attended art schools in Barcelona and Madrid but became impatient with their rigid, academic approach and soon abandoned formal study. After two trips to Paris—where he saw the work of Van Gogh, Gauguin, and Toulouse Lautrec—he settled permanently in that city in 1904 and never again lived outside France.

Although Picasso worked in many different styles throughout his life, much of his art is classifiable into the well-known "periods": the "Blue" period, when

his paintings concentrated on images of poverty and emotional depression; the "Rose" period, whose paintings included depictions of harlequins and acrobats; the Cubist period, when he worked with the painter Georges Braque; and the "Neoclassical" period, in which the figures took on qualities resembling ancient Greek sculptures.

Success came early to Picasso. Except for brief periods when he was short of funds (usually because of some romantic entanglement), he lived well and comfortably and enjoyed a large circle of friends. His work was always in demand, whether in painting, sculpture, prints (of which he made thousands), theatrical design, murals, or ceramics. (He took up ceramic art in 1947 and decorated some two thousand pieces in a single year.)

It would be impossible to discuss Picasso's life without reference to the women who shared it, because they are a constant presence in his art. Picasso married only twice, but he maintained long, occasionally overlapping, liaisons with several other women. His attachments included Fernande Olivier; Eva Gouel; Olga Koklova, his first wife and the mother of his son Paulo; Marie-Thérèse Walter, mother of his daughter Maïa; Dora Maar; Françoise Gilot, who bore him Claude and Paloma, then later wrote a scandalous memoir of her years with the artist; and finally Jacqueline Roque, whom he married in 1961, in his eightieth year.

Despite his international celebrity, Picasso gave almost no interviews. One of the few took place in 1935 and included this insight into the nature of art: "Everyone wants to understand art. Why not try to understand the song of a bird? Why does one love the night, flowers, everything around one, without trying to understand them? But in the case of a painting people have to understand. If only they would realize above all that an artist works of necessity, that he himself is only a trifling bit of the world, and that no more importance should be attached to him than to plenty of other things which please us in the world, though we can't explain them. People who try to explain pictures are usually barking up the wrong tree."

Pablo Picasso. *Self-Portrait with Palette*. 1906. Oil on canvas, $36\frac{1}{4} \times 28\frac{3}{4}$ ". Philadelphia Museum of Art.

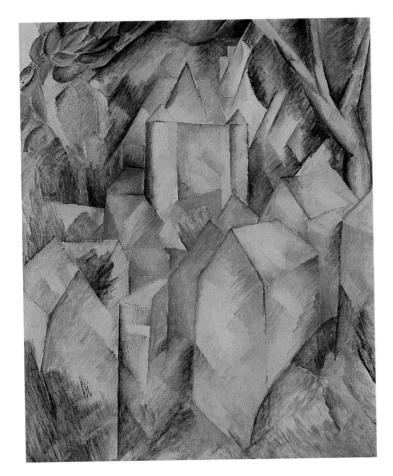

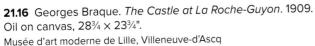

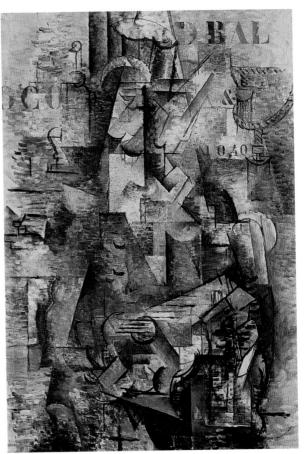

21.17 Georges Braque. Le Portugais (The Emigrant). 1911–12. Oil on canvas, 46×32 ". Kunstmuseum Basel

nontraditional elements. Picasso had recently seen sculptures from ancient Iberia (Spain before the Roman Empire), as well as art from Africa. In breaking with Western art conventions that reached back to ancient Greece and Rome, Picasso looked for inspiration from other, equally ancient, traditions. Second, there is the merging of figure and ground, reflecting the assumption that all portions of the work participate in its expression. And third, there is fragmenting of the figures and other elements into flat planes, especially evident in the breasts of the figure at upper right and the mask just below. This last factor proved especially significant for an artistic journey on which Picasso was soon to embark—the movement known as **Cubism**.

Picasso's partner in this venture was the artist Georges Braque. Braque was older than Picasso in years but younger as an artist. Picasso, after all, had been an artist since his early teens (see 2.12). He was one of the most naturally gifted artists in history, and his hand could produce any kind of style he asked it to. Braque was less precocious, but because of that more disciplined and determined. He developed an intense personal identification with Cézanne, who also progressed from awkward beginnings to mastery. Picasso grew to share this interest, and for a time he renounced his natural gifts to pursue together with Braque this new line of investigation. Both artists emerged stronger for it.

Picasso and Braque began working together in 1909, and by 1910 their experiments were so closely intertwined that their styles became virtually identical. For a time, they even ceased signing their works. "We were prepared to efface our personalities in order to find originality," Braque later recalled. Illustrated here are two paintings by Braque that demonstrate how Cézanne's methods led to something new, *The Castle at La Roche-Guyon* (21.16) and *Le Portugais* (*The Emigrant*) (21.17).

RELATED WORKS 6.13 Braque, Still Life on Table

The Castle at La Roche-Guyon depicts a hillside town of houses surmounted by a castle. Following Cézanne's advice, Braque has reduced the architecture to its simplest geometric forms: cube, cylinder, cone. (It was a painting of similar hillside houses that prompted a visiting friend to remark, "Look, little cubes," thus accidentally and misleadingly naming the style.) We recognize Cézanne's parallel brush strokes and color patches, which seem to break the surface into facets (see 21.9). Also learned from Cézanne is the way the principal linear motifs of the composition echo outward to influence everything around them. Here, the earth around the castle and the surrounding green of nature all partake of the angles and facets of the houses. Braque has reined in Cézanne's bright Impressionist palette to a restricted range of gray, ocher, and green, allowing the forms to interpenetrate more easily. Some of the forms seem solid, but others shade off into transparency.

In The Emigrant, a fully Cubist work, these discoveries are taken to their logical conclusion. The figure of a seated man playing his guitar is broken into facets based in simple geometric shapes-triangle, circle, line. Because the forms are so basic, they easily echo throughout, unifying the composition. Color is reduced to gray warmed with ocher, allowing the shards of the foreground and background to interpenetrate at will. The principal lines of the composition suggest a classic Renaissance pyramid such as Leonardo used for Mona Lisa (see 2.4). Visual cues help viewers orient themselves: the open hole and strings of the guitar, the player's mustache, the rope to the right that sets the scene on a dock. The addition of stenciled letters, an intrusion from the "real world," was Braque's innovation. As Cubism progressed, the two artists experimented with incorporating other elements such as newspaper, wallpaper, and fabric. The psychological tension of merging the "real" with the "not real" (the illusory world of paint on canvas) would have important applications for later 20th-century art. Picasso and Braque also realized that the geometric rhythms of an object could be assembled from multiple views. For example, if you look at a pitcher from the front, the side, the top, the bottom, you will see a number of versions, but your true understanding of a pitcher is the sum of all of these. With Cubism, this sum of viewpoints could be painted. Cubism thus followed up on another discovery implicit in much of Cézanne's work: the eye is always moving, and motion is how we assimilate the world.

The great beauty of Cubism was that, as with linear perspective, anyone could do it. Cubism offered the most original and powerful system for rethinking the representation of form and space since the Renaissance. Over the ensuing decade and more, many young artists in Europe passed through a Cubist phase to break free of the past.

Futurism and Metaphysical Painting

Cubism poured all its energy into formal concerns. The subjects that Braque and Picasso treated while working out their discoveries were so traditional as to be neutral—a still life on a tabletop, a seated figure with a musical instrument, a landscape with some houses. Any of those subjects could have been painted in the 17th century. Other innovators, however, believed that art would move forward only through exploring new subjects. One of the most original and influential of these artists was the Italian painter Giorgio de Chirico, who called his approach Metaphysical Painting. "It is most important that we should rid art of all that it has contained of *recognizable material* to date, all familiar subject matter, all traditional ideas, all popular symbols must be banished forthwith," he wrote. "To become truly immortal a work of art must escape all human limits: logic and common sense will only interfere. But once these barriers are broken it will enter the regions of childhood vision and dream."

Dreams are what come to mind in front of *The Disquieting Muses* (21.18). The hot afternoon sun casts long shadows across an open plaza. There are no trees, no people. Nothing of nature at all. In the background, banners snap in

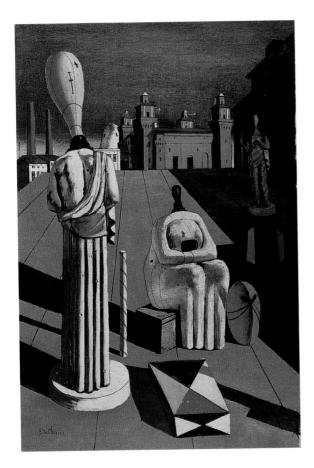

21.18 Giorgio de Chirico. *The Disquieting Muses*. 1916. Oil on canvas, $38\% \times 26$ ". Private Collection

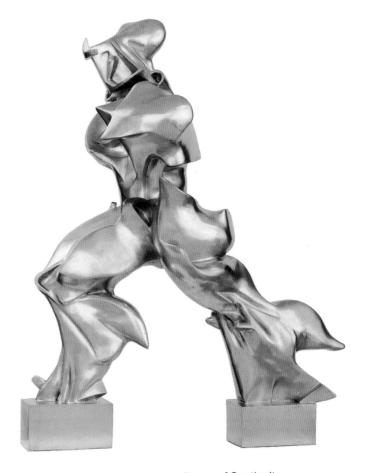

21.19 Umberto Boccioni. *Unique Forms of Continuity in Space*. 1913. Bronze, height 3'7%".

The Museum of Modern Art, New York

the wind over an early Renaissance fortress. Next to the fortress is a factory. In the shade, a statue in Classical garments stares (though her face is featureless) at the two presences in the foreground, the disquieting muses themselves: a pockmarked Classical column, a sculpture with a hatmaker's dummy for a head, a tailor's dummy seated nearby. The painting is composed of fragments of Italy's own past and present—ancient Rome, the Renaissance, the Industrial Revolution. How can we make any sense out of what history has left to us, it seems to ask? What do we do now?

In contrast to De Chirico's motionless dream world, a group of Italian artists calling themselves the **Futurists** decided that motion itself was the glory of the new 20th century, especially the motion of marvelous new machines. The view from an airplane, the feeling of racing through the countryside in an automobile—how could these new sensations not be reflected in art? Here, we see a work by the movement's foremost sculptor, Umberto Boccioni (21.19). *Unique Forms of Continuity in Space* represents a striding human figure as the Futurist imagined it to be in the light of contemporary science: a field of energy interacting with everything around it. "Sculpture," wrote Boccioni, "must give life to objects by making their extension in space palpable, systematic, and plastic, since no one can any longer believe that an object ends where another begins and that our body is surrounded by anything . . . that does not cut through it and section it in an arabesque of directional curves." "10"

World War I and After: Dada and Surrealism

P.11 Man Ray, Champs délicieux

In 1914 conflict broke out in the Balkan Peninsula. Soon, as the result of treaties and alliances, every major power in Europe was drawn into war. Soldiers with their heads full of gallant ideas about battle rushed headlong into the most horrible deaths imaginable. Trench warfare, poison gas, bombardment by air, machine guns, tanks, submarines—science and technology, in which the 19th century had put its faith, revealed their dark side. The ideal of progress was shown to be utterly hollow, and ten million people lost their lives in one of the bloodiest wars in history.

In 1916 a group of artists waiting out the war in Zurich, in neutral Switzerland, banded together as a protest art movement called Dada. What did Dada protest? Everything. Dada was anti. Anti art, anti middle-class society, anti politicians, anti good manners, anti business-as-usual, anti all that had brought about the war. In that sense, Dada was a big *no*. But Dada was also a big *yes*. Yes to creativity, to life, to silliness, to spontaneity. Dada was provocative and absurd. Above all, it refused to make sense or to be pinned down.

More an attitude than a coherent movement, Dada embraced as many kinds of art as there were artists. In Germany, Dada developed a biting political edge in the work of Hannah Höch and others (see 9.10). In France, its absurd and philosophical aspects came to the fore. Francis Picabia, a French artist who joined the Dada movement, delighted in the similarities between humans and machines, and he created paintings that looked like diagrams. *L'Enfant Carburateur (The Child Carburetor)* (21.20) would seem to offer a perfectly reasonable plan for constructing a child if the child you have in mind is part of an internal combustion engine. A carburetor is designed to produce an explosive mixture of fuel and air, and perhaps Picabia thought that children weren't so different. Labels point out such key areas as "Sphere of the Migraine" and "Destroy the Future." The materials include gold leaf, which gives the work a strangely precious and perhaps even sacred aura.

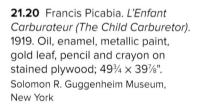

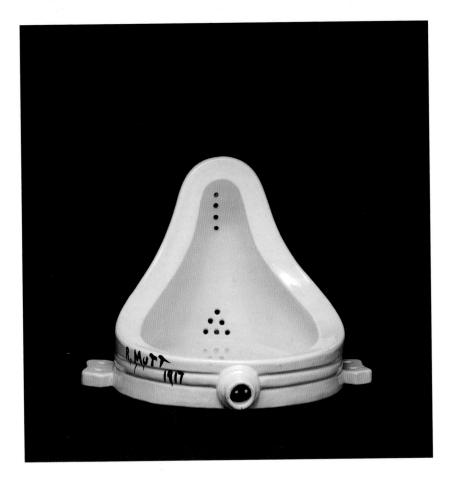

21.21 Marcel Duchamp. Fountain. 1917/1964 Edition Schwartz, Milan. Ceramic compound, height 14". Indiana University Art Museum, Bloomington

The Dadaist with the most lasting impact on American art in the 20th century was Marcel Duchamp, whose "ready-mades" probed the border between art and life in a way that later generations have returned to again and again. A ready-made is a work of art that the artist has not *made* but *designated*. Undoubtedly, the most notorious of Duchamp's ready-mades was *Fountain*, a work of 1917 shown here in a signed replica of 1964 (21.21). *Fountain* was an ordinary porcelain urinal set on its back. Duchamp entered it into a New York art exhibition under a pseudonym, R. Mutt, which he slopped on in black paint as a signature. Here, we see a replica because Duchamp never intended for his ready-mades to be permanent. His project was to find an object—he insisted that it be an object with no aesthetic interest whatsoever—and exhibit it as art. After the exhibition, the object was to be returned to life.

Fountain was pure provocation. The exhibition organizers had stated that all entries would be accepted, and Duchamp wanted to see whether they really meant it. Yet as Duchamp well knew, Fountain also raised interesting philosophical questions: Does art have to be made by an artist? Is art a form of attention? If we have spent our lives perfecting this form of attention on various acknowledged masterpieces, can we then bestow it on absolutely anything? If so, how is an art object different from any other kind of object? Does art depend on context, on being shown in an "art place" such as a museum or a gallery? Can something be art in one place and not another? Is Fountain still art today, or was it art only for the time that Duchamp said it was? Duchamp thought that art and life could regularly trade places, and he suggested helpfully that one could use a Rembrandt as an ironing board.

A movement that grew out of Dada was **Surrealism**, which was formulated in Paris in the 1920s. Like Dada, Surrealism was not a style but a way of life. Fascinated by the theories of Sigmund Freud, who was then setting out his revolutionary ideas in Vienna, the Surrealists appreciated the logic of dreams, the mystery of the unconscious, and the lure of the bizarre, the irrational, the incongruous, and the marvelous.

RELATED WORKS

5.17 Magritte, Delusions of Grandeur II

21.22 Meret Oppenheim. Object (Luncheon in Fur). 1936. Fur-covered cup, saucer, and spoon; overall height 27/8". The Museum of Modern Art, New York

A distinctive contribution of Surrealism to art was the poetic object—not a sculpture as it had traditionally been understood, but a *thing*. Surrealist objects often juxtapose incongruous elements to provoke a shiver of strangeness or disorientation. One of the most famous and unsettling Surrealist objects is Meret Oppenheim's *Object (Luncheon in Fur)* (21.22). Perhaps Oppenheim witnessed two ladies taking tea together in their best fur coats and melted them into a dreamlike object? Perhaps we really are supposed to imagine bringing the furry cup to our lips for lunch. Freud's theories famously claimed a large role for unconscious sexual desire, and Surrealist works often have erotic overtones.

Possibly the most famous of all Surrealist works is Salvador Dalí's *The Persistence of Memory* (21.23), a small painting that many people call simply "the melted watches." Dalí's art, especially here, offers a fascinating paradox: His rendering of forms is precise and meticulous—we might say *super-*realistic—yet the forms could not possibly be real. *The Persistence of Memory* shows a bleak, arid, decayed landscape populated by an odd, fetal-type creature (some think representative of the artist) and several limp watches—time not only stopped but also melting away. Perhaps in this work Dalí's fantasy, his dream, is to triumph once and for all over time.

Joan Miró's Carnival of the Harlequin (21.24) offers a Surrealist view of one of the most famous of all Spanish paintings, Las Meninas, by Velázquez (see 17.11). Miró's fantasy world is aswarm with odd little creatures—animals and fish and insects and perhaps a snake or two—as well as nameless abstract forms

21.23 Salvador Dalí. *The Persistence of Memory.* 1931. Oil on canvas, $9\frac{1}{2} \times 13$ ". The Museum of Modern Art, New York

that participate in the artist's madcap party. Much of Miró's imagery suggests a cheerful sexuality, as though the whole space of the universe were occupied with lighthearted erotic play and reproduction. In contrast to the utter stillness of Dalí's *The Persistence of Memory*, Miró's *Carnival* is all movement. There are even a few musical notes at the top to accompany the dance. As interpreted by Miró, Surrealism's dreams are lively ones.

21.24 Joan Miró. *Carnival of the Harlequin*. 1924–25.
Oil on canvas, 26 × 36⁵/₈".
Albright-Knox Art Gallery, Buffalo, N.Y.

Between the Wars: Building New Societies

Surrealism offered a personal solution to life during the years following the trauma of World War I. But in the view of many artists, society, and possibly even human nature itself, had to be transformed so that such a horror would not happen again. That art could play a central role in bringing about a better society was a 19th-century idea, yet it found renewed application after World War I in a collective approach. It was not through the personal insights of individual artists that the world would change, but through the cooperative endeavors of artists, designers, and architects. Together, they could create a new environment for living, one that was completely modern, purged of associations with the past, and comfortable with the new spirit of the machine age.

Even more radical opportunities presented themselves in Russia and Mexico, where successful revolutions had toppled older governments. In these countries, new societies were being formed that embraced lofty ideals of social and economic equality for all and a concern for ordinary workers. In Chapter 7, we looked at a fresco commissioned from Diego Rivera by the revolutionary Mexican government (see 7.4). Before the Mexican Revolution, Rivera had been living in Paris and painting in an advanced Cubist style. On his return to Mexico, he developed a more accessible style for his murals, and he stayed with it for the rest of his career. His great desire was to communicate with everyone, to leave no one out. The demands of the European avant-garde must have seemed far away.

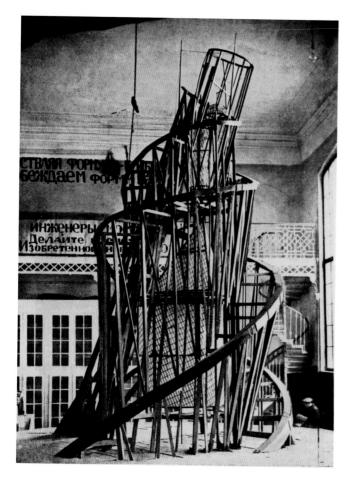

21.25 Vladimir Tatlin. Model for the Monument to the Third International. 1919–20. Wood, iron, and glass. Destroyed.

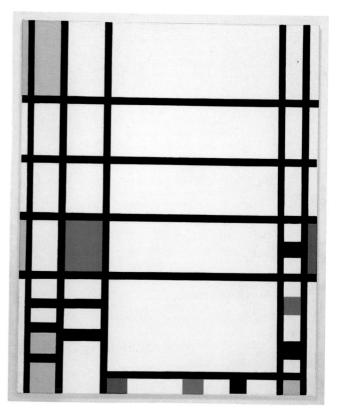

21.26 Piet Mondrian. *Trafalgar Square*. 1939–43. Oil on canvas, 4'9½" × 3'11½".

The Museum of Modern Art, New York

The Soviet government of Russia would eventually demand that its artists similarly turn their backs on modern tendencies, but during the first few years after the Russian Revolution of 1917, many artists believed that only the most revolutionary art could bring about a new world. One important movement was Constructivism, which had been founded by Vladimir Tatlin in 1913. Tatlin believed that advanced ideas about art should be put to practical use, and that artists should apply their talents to architecture, graphic design, theatrical productions, textiles, monuments, festivals, and all other visual forms. Tatlin's own design for the Monument to the Third International demonstrates what he thought could be done (21.25). Designed to house the Russian congress, the monument was never built, but what a work of architecture it would have been! An open steel framework would support the building from the outside, its spiral combining the industrial look of the Eiffel Tower (see 13.22) with a Futurist sense of motion. Suspended inside would be four chambers in pure geometric forms: a cube, a pyramid, a cone, and a sphere. The various branches of the government would meet in these rooms, which would rotate at speeds varying from one revolution per year (the large cube at the bottom) to one revolution per hour (the small sphere at the top).

When Constructivism was condemned by the Soviet regime in 1922, many of its artists left the Soviet Union to spread its ideals elsewhere. One of the European movements touched by Constructivist ideas was De Stijl, in the Netherlands. The most famous artist associated with De Stijl was Piet Mondrian. Beginning as a painter of flowers and landscapes, Mondrian distilled his art to what he considered to be the most universal signs of human order: vertical and horizontal lines, and the primary colors of red, yellow, and blue (21.26). To Mondrian, these formal elements radiated a kind of intellectual beauty that was humanity's greatest achievement. Nature, with its irrationality

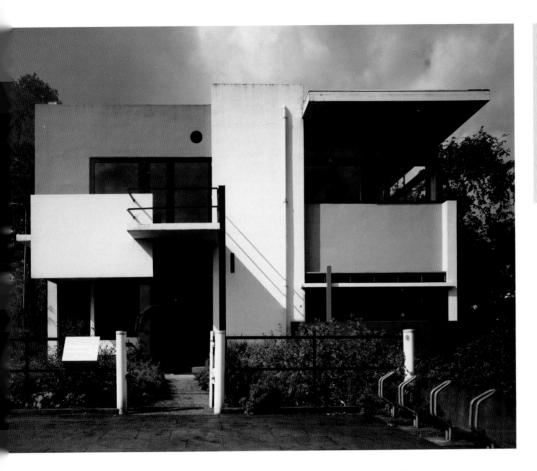

RELATED WORKS

5.26 Klee, Landscape with Yellow Birds

21.27 Gerrit Rietveld. Schroeder House, Utrecht, The Netherlands. 1924.

and irregularity, encouraged humankind's primitive, animal instincts, resulting in such disasters as war. In Mondrian's vision of the world, people would be surrounded by rational beauty and thus become balanced themselves.

Mondrian thought of his canvases as places where we could turn to stabilize ourselves and restore our calm. He also believed that they would not be necessary—no art would be necessary—in a future where people lived in environments such as Gerrit Rietveld's Schroeder House (21.27). Rietveld was the foremost architect of De Stijl, and Schroeder House looks very much like a Mondrian painting projected into three dimensions. Schroeder House is like an inhabitable sculpture—a construction in space of intersecting vertical and horizontal planes, color-coded inside and out in primary colors. As in Mondrian's painting, symmetrical elements are placed in subtle asymmetrical balance. No art hangs inside. Instead, the floor of one room is painted red, the wall of another is painted blue, and so on. Movable partitions allow the interior space to be reconfigured, and spaces flow into each other rather than being clearly separated.

Construction by intersecting planes in space is also the principle behind Marcel Breuer's famous armchair, designed in 1928 (21.28). Breuer was a teacher and a former student at the **Bauhaus**, a school of design founded in Germany in 1919 by the architect Walter Gropius. The Bauhaus was yet another incarnation of the ideal of collective artistic endeavor in the years following World War I. Students studied a variety of disciplines, and their education was designed to eliminate traditional divisions between painters, sculptors, architects, craft artists, graphic designers, and industrial designers. The word *Bauhaus* translates roughly as "building house," and its leaders sought to "build" new guiding principles of design compatible with 20th-century technology. Structures, rooms, furniture, and everyday household objects were stripped of superficial

21.28 Marcel Breuer. Armchair. c. 1928. Chrome-plated tubular steel with canvas slings. The Museum of Modern Art, New York

embellishment and pared down to clean lines. Breuer's armchair, made of canvas panels and steel tubing, was supposed to be economical to manufacture, making good design available to everyone. After the Nazis closed the Bauhaus in 1933, several of its key members emigrated to the United States, and the school's influence continued to be felt in all design disciplines for decades.

The Bauhaus and De Stijl both sought to create harmony between individual lives and modern industry and technology. A man who painted visions of what this might be like was Fernand Léger. Woman and Child is a grand, symphonic composition like those of the 19th century, but this is a modern symphony, with straight lines, right angles, clear shapes, and forthright colors (21.29). Léger forged a painting style that has the honest surfaces of industrial production—even the bodies seem to be made of manufactured parts. Yet the effect is not alienating at all. The woman and child are content in their calm, ordered, well-lit world. In a lecture titled "The Machine Aesthetic," Léger praised the beauty of industrial products and the dedication of those who made them. "A worker would never dare deliver a product other than clear-cut, polished, burnished," he later said. "The painter must aim at making a clear-cut picture, clean, with finish." Léger had painted in a radical Cubist style before the war. After the war, he was not the only artist to step back from the avant-garde in what one French critic called "the return to order."

In the United States, the period following World War I also saw the flowering of art dedicated to building a better society. One of the most vibrant movements of the time arose in the New York neighborhood called Harlem. Harlem is the northeast section of Manhattan Island. It was and is home to many black Americans, of all economic classes. During the decade of the 1920s, Harlem served as a magnet for some of the greatest talents of that generation—artists, musicians, composers, actors, writers, poets, scientists, and educators. Louis Armstrong came to Harlem, and so did Duke Ellington. The writer Langston Hughes and the poet Countee Cullen were in residence. Creative energy was in the air, and for a time it seemed as though almost every Harlemite was doing something wonderful—a book, a play, a Broadway show,

21.29 Fernand Léger. Woman and Child. 1922. Oil on canvas, 5'7/4" × 7'11". Öffentliche Kunstsammlung, Kunstmuseum, Basel

a sculpture series, a jazz opera, a public mural. This phenomenon came to be called the Harlem Renaissance.

Much of the spirit embodied in the Harlem Renaissance had to do with merging three experiences: the rich heritage of Africa, the ugly legacy of slavery in America (ended barely more than fifty years earlier), and the realities of modern urban life. There is no single style associated with artists of the Harlem Renaissance, but the work of the painter and illustrator Aaron Douglas is representative of the spirit and aspirations of the group. Douglas, who was born in Kansas, moved to Harlem in 1924. During the Harlem Renaissance years, he gradually developed a style he called "geometric symbolism." He worked prolifically through the twenties but is perhaps most noted for a series of murals done a few years later, for the 135th Street branch of the New York Public Library. The series is called Aspects of Negro Life. Our illustration shows the segment that Douglas called From Slavery Through Reconstruction (21.30).

To the right, figures rejoice at the reading of the Emancipation Proclamation, the 1863 executive order that freed slaves in rebelling states. Light radiates from the document in concentric circles. At the left, men pick cotton in the fields as members of the Ku Klux Klan loom up menacingly in the background. Founded in the South at the end of the Civil War in 1865, the Klan terrorized newly free African Americans in a bid to restore white supremacy. At the center, a man points toward the Capitol building, depicted high on a hill in the distance. In his left hand he holds another light-radiating document. It is a voting ballot. Voting rights had been granted to African Americans by constitutional amendment in 1870. However, they still were not secure when Douglas painted his mural, and they would not be for over thirty more years.

The Harlem Renaissance, as a movement, lasted only a decade: its momentum was stopped by the stock market crash of 1929 and the ensuing Great Depression of the 1930s. Aaron Douglas' vision of a better society was actually painted during the early years of the Depression, as the dream of the Harlem Renaissance faded. It is nevertheless a vision of hope. Other artists continued to believe that art had a social mission during those difficult times. Dorothea Lange documented the dignity of ordinary people faced with extraordinary adversity in photographs such as Migrant Mother (see 9.6). Rockwell Kent produced a stirring call to action in Workers of the World, Unite! (see 8.5). The Depression was, in fact, worldwide. In Europe, severe hardship fueled nationalist resentments against the unjust settlement of World War I. Anger swept the fascist regimes of Hitler and Mussolini into power in Germany and Italy. In 1939 the world was plunged again into war.

21.30 Aaron Douglas. From Slavery Through Reconstruction from Aspects of Negro Life. 1934. Oil on canvas, $5' \times 11'7''$. Schomburg Center for Research in Black Culture, The New York Public Library

22

From Modern to Postmodern

he most lethal conflict in history, World War II was brought to a terrifying end on August 9, 1945, when the United States dropped an atomic bomb on the Japanese city of Nagasaki. Tens of millions of people had lost their lives over the course of the six-year conflict, most of them civilians. Many European cities lay in ruins.

In the aftermath of the war, the horrors of the Nazi death camps were brought to light. The United Nations was founded to promote peace. Yet already the United States and the Soviet Union, which had emerged from the war as the two dominant "superpowers," were entering into the prolonged, nuclear-armed standoff known as the Cold War.

As artistic life resumed in this new international climate, it gradually became clear to many observers that the most interesting new art was no longer originating in Paris. Rather, it was found in New York. The center of energy had shifted. Several developments had paved the way for this flowering of advanced art in America. One was the founding of the Museum of Modern Art in New York City in 1929. The first Western museum dedicated exclusively to modern art, the Museum of Modern Art began to assemble an important collection, and it mounted exhibitions of Cubism, nonrepresentational art, Dada, and Surrealism—all the important European trends. A number of progressive European artists spent the war years in exile in New York, including key members of the Surrealist movement. With them, there arrived an adventurous American collector and gallery owner named Peggy Guggenheim, who had been living in Paris and London. In New York, Guggenheim opened a gallery called Art of This Century, where she showed not only avant-garde European artists but also promising young Americans she discovered.

In short, New York now had many of the features of earlier European art capitals: direct contact with the latest directions in art, keen and engaged critics, forums for viewing and discussing new work, collectors ready to purchase, a national press prepared to trumpet artistic achievement, a confidence born of economic and political strength, and, most of all, the ability to attract talented and ambitious young artists.

Within a few decades, New York would become merely one important art center among many. But for a time, the story of Western art can be continued by looking at what happened there.

The New York School

Painters associated with the first major postwar art movement are commonly referred to as the New York School. Not a school in the sense of an institution or of instruction, the New York School was a convenient label under which to lump together a group of painters also known as the **Abstract Expressionists**. Primary among them were Jackson Pollock and Willem de Kooning. Abstract Expressionism had many sources, but the most direct influence was Surrealism, with its emphasis on the creative powers of the unconscious and its technique of automatism as a way to tap into them. The painters of the New York School developed highly individual and recognizable styles, but one element their paintings had in common was scale: Abstract Expressionist paintings are generally quite large, and this is important to their effect. Viewers are meant to be engulfed, to be swept into the world of the painting the way we may be swept into a film by sitting so close that the screen fills our entire field of vision.

The quintessential Abstract Expressionist was Jackson Pollock, who by the late 1940s had perfected his "drip technique." To create such works as *Number* 1, 1949 (22.1), Pollock placed the unstretched canvas on the floor and painted on it indirectly, from above, by casting paint from a brush in controlled gestures or by dripping paint from a stir-stick. Layer after layer, color after color, the painting grew into an allover tangle of graceful arcs, dribbled lines, spatters, and pools of color. There is no focal point, no "composition." Instead, we find ourselves in front of a field of energy like the spray of a crashing wave. A critic of the time coined the term **action painting** to describe the work of Pollock and others, for their paintings are not images in the traditional sense but traces of an act, the painter's dance of creation. Pollock said that his method of working allowed him to be "in" the painting, to forget himself in the act of painting, and that is also the best way to look at his works, to lose ourselves in them.

Strictly speaking, Pollock's painting is not abstract but nonrepresentational. As always, the terminology of art evolved haphazardly and inconsistently as people grasped for terms to speak about what was new. Critics and artists of the day used *abstract* and *nonrepresentational* interchangeably, and in casual speech and writing *abstract* is still the more common term. De Kooning's *Woman IV*

RELATED WORKS

13.25 Bunshaft, Lever House

22.1 Jackson Pollock. *Number 1,* 1949. 1949. Enamel and metallic paint on canvas, 5'3" × 8'6". Museum of Contemporary Art, Los Angeles

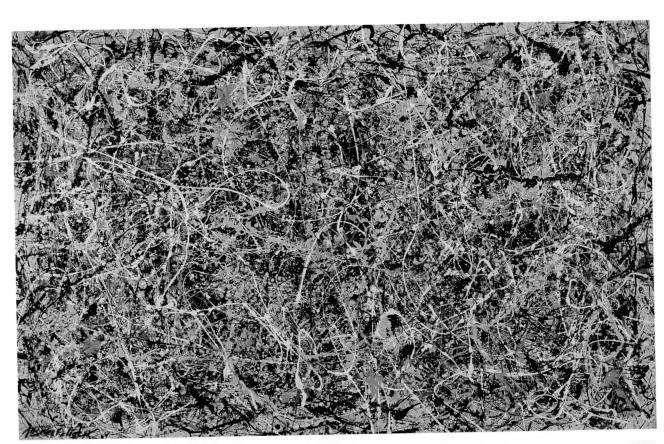

ARTISTS Jackson Pollock (1912–1956)

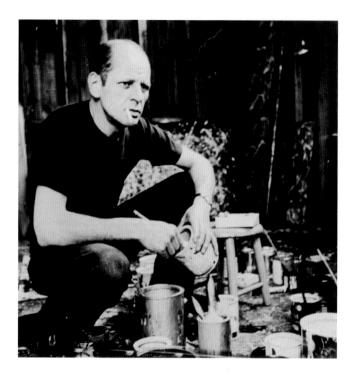

What did Pollock learn from Benton that made him the artist he became? What is Pollock's style? Why was the general public slow to accept Pollock's creation, and why did he become unsure of where he wanted his art to go?

ackson Pollock was born on a sheep ranch in Cody, Wyoming, the youngest son in a family of five boys. During his youth, the family moved around a good deal and led a fairly unstable existence. By the age of fifteen, Jackson had begun to show signs of the alcoholism that would plague him all of his life.

In 1930 Pollock went to New York to study at the Art Students League. His principal teacher there was Thomas Hart Benton, a realistic painter of regional Americana, best known for his murals. Later, Pollock would say he was glad to have had the experience with Benton, because he then had to struggle all the harder to make art so very different from that of his mentor.

Money was a critical problem throughout the early years in New York. By 1935 Pollock was employed on the Federal Art Project of the Works Progress Administration—a Depression-era program meant to provide employment for artists. He was required to turn out, every four to eight weeks, one painting suitable for

installation in public buildings, for which he was paid a stipend of about \$100 a month. Frequent alcoholic binges often interfered with this work, and in 1937 Pollock began psychotherapy in an attempt to overcome his addiction.

Pollock's work was first exhibited in 1942, as part of a group show that also included the work of painter Lee Krasner. Krasner and Pollock soon formed a close relationship, and they were married in 1945. Gradually, Pollock's work began to change, to be freer and more spontaneous, to contain fewer and fewer figural elements. During the late 1940s, he began exhibiting works in his mature style.

Some critics praised Pollock as the greatest of all American artists, but the general public was very slow to accept his revolutionary art. *Time* magazine epitomized the bewilderment of the popular press, dubbing him "Jack the Dripper." Nevertheless, some collectors were willing to invest, so finances became less pressing.

The years 1948 to 1952 were the artist's prime, when he was at the height of his creative powers. After that, he seemed less sure where to go with his art, and even the sympathetic critics were not so responsive to the work. Pollock began to paint less and drink more. On the night of August 11, 1956, Pollock—along with two young women friends—was driving his convertible near his home when he lost control of the car and rammed into a clump of trees at high speed. Pollock and one of the women were killed instantly. The artist was only forty-four years old.

Pollock drunk could be violent and brutish; Pollock sober was shy, introverted, and uncommunicative. Few ever succeeded in getting him to talk about his art, but there is one quote, reprinted many times, that gives voice to his truly remarkable vision: "On the floor I am more at ease. I feel nearer, more a part of the painting, since this way I can walk around it, work from the four sides and literally be in the painting. . . . When I am in my painting, I am not aware of what I'm doing. It is only after a sort of 'get acquainted' period that I see what I have been about. I have no fears about making changes, destroying the image, etc., because the painting has a life of its own. I try to let it come through. It is only when I lose contact with the painting that the result is a mess. Otherwise there is pure harmony, an easy give and take, and the painting comes out well."

Jackson Pollock in his studio. 1950, photographed by Rudolph Burckhardt.

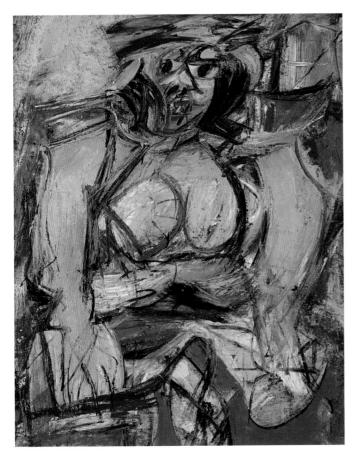

22.2 Willem de Kooning. *Woman IV.* 1952–53. Oil, enamel, and charcoal on canvas, $4'10\frac{1}{2}" \times 3'9\frac{1}{8}"$. The Nelson-Atkins Museum of Art, Kansas City, Missouri

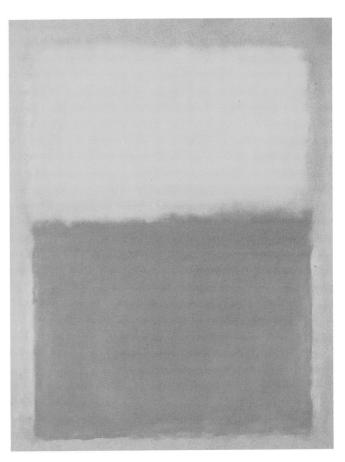

22.3 Mark Rothko. *Orange and Yellow*. 1956. Oil on canvas, 7'7" \times 5'11". Albright-Knox Art Gallery, Buffalo, N.Y.

is abstract in our strict sense (22.2). Like Pollock, de Kooning had developed a nonrepresentational, gestural style during the 1940s. During the next decade, however, he returned to the human figure, most notoriously in the *Women* series.

Even today the *Women* paintings retain their power to disturb. De Kooning admitted that he began each painting from a magazine photograph of a beautiful woman; yet, as he worked, they mutated into grimacing monsters. The artist was dismayed, for that wasn't his goal at all. We can see the paintings as reflecting de Kooning's conscious and unconscious feelings toward women. Yet they also record a struggle between two ways of thinking about art. Forceful gestures keep trying to establish a painting about the act of painting, but against this effort the image keeps reasserting itself, demanding to be recognized. Hovering in the background are the spirits of such great painters of human flesh as Rembrandt and Titian, who also used paint in an intensely physical way.

Whereas Pollock and de Kooning developed styles that exploit the visual impact of gestures—lively, often forceful movements of brush, hand, and arm—other Abstract Expressionists downplayed the drama of the gesture in favor of broad areas, or "fields," of color. This variety of Abstract Expressionism is sometimes known as **color field painting**. Few traces remain of the gestures that Mark Rothko used to apply paint to canvas in *Orange and Yellow* (22.3). Instead, we see two, soft-edged, horizontal fields of color floating on the larger color rectangle of the canvas. Almost all of Rothko's mature paintings consist of variations on this simple but fertile compositional idea: soft-edged horizontal fields of color on a vertical color ground; the rectangle of the canvas and its echoes. Where de Kooning emphasized the physicality of paint, Rothko did the opposite, thinning his colors so much that the pigment powder barely holds to the canvas.

Rothko's paintings have a luminous, meditative quality. A similarly contemplative mood infuses Louise Nevelson's wood assemblage *Sky Cathedral* (22.4).

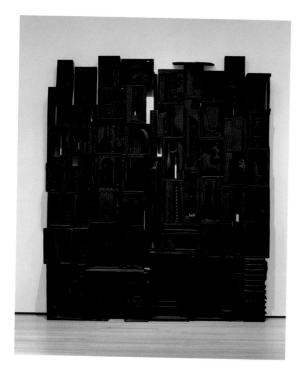

22.4 Louise Nevelson. *Sky Cathedral*. 1958. Painted wood, $11'3\frac{1}{2}" \times 10'\frac{1}{4}" \times 18'$. The Museum of Modern Art, New York

22.5 Helen Frankenthaler. *Mauve District*. 1966. Polymer on unprimed canvas, $8'7" \times 7'11"$. The Museum of Modern Art, New York

Nevelson was one of several New York-based sculptors whose work was associated with Abstract Expressionism. She began working with wood during the years of World War II, at a time when her colleagues such as David Smith were using iron and steel (see 11.11). She said later that welding metal reminded her too much of the war. Her son was in the war; everyone's son was in the war. She turned to cast-off bits of wood—odd scraps of lumber, fragments of furniture, broken pieces of architectural details. It was with these materials that she found her voice as an artist and created her most characteristic works, the monumental, monochromatic assemblages often referred to as wall sculptures. *Sky Cathedral* is made of shallow wooden boxes filled with bits of scavenged wood, the whole painted black. At 11 feet in height, it shares the Abstract Expressionists' sense of scale. The monochrome paint unifies the diverse elements, emphasizing their formal qualities over their "previous lives," now muted.

The next generation of painters did not find much room to breathe in the heroic gestural style of action painting. Its famous practitioners were perhaps a little too famous to follow. The energies of color field painting, in contrast, were carried forward by a new generation of artists, who explored and extended its possibilities. First and foremost among these was Helen Frankenthaler, who pioneered a staining technique. To create such paintings as *Mauve District*, Frankenthaler poured thinned paint onto unprimed canvas spread on the floor and manipulated its flow in various ways (22.5). The colors soaked into the canvas like dyes, binding with the fabric. *Mauve District* illustrates well the kind of airy, open composition that Frankenthaler excelled at. The white shape pushes at the border of the canvas, while the colors seem to expand outward.

RELATED WORKS 11.11 Smith, Cubi XXI

Into the Sixties: Assemblage and Happenings

By the middle of the 1950s, Abstract Expressionism had been the "new" style for fifteen years. Many artists felt it was time to move on. One of the most influential voices of the time was the composer John Cage, whose writings and

speeches suggested a different path for art to follow. Music and art, Cage said, should be "an affirmation of life—not an attempt to bring order out of chaos nor to suggest improvements in creation, but simply a way of waking up to the very life we're living." Like the Dadaists of forty years earlier, young artists began mixing art back up with life as they found it, sometimes literally and often humorously. Critics called the trend Neo-Dada ("new Dada").

Robert Rauschenberg's Winter Pool suggests that art and life aren't so far removed from each other by including a ladder for passage back and forth (22.6). Things from the paintings can step down into our world; we can climb into the art. Some things in the painting already look quite familiar, now that we come to think of it: newspaper clippings, a handkerchief, some sandpaper, a piece of wood, a metal frame with a handle that turns out to be an old handheld bellows. Bits of this and that that someone might have had lying around. Well, don't throw them away! Put them into the art! The right wing of the painting is assembled from gestures and color fields, like a sampler of Abstract Expressionism. The ladder opens up a white void between the two paintings. Could we see it as an emptied, snow-covered swimming pool? The title asks us to make that connection, and when we do, we start paying more attention to the negative spaces. The rungs of the ladder frame four white rectangles, like four monochromatic compositions. The paintings themselves are full of rectangles and echoing whites. The painting on the left is as wide as the ladder; the painting on the right is as wide as the intervals of the rungs. The potentially chaotic world in which anything can find itself in a painting turns out to be ordered by rhythm and repetition.

Rauschenberg referred to his works as combine paintings, but a more general term is **assemblage**. Another artist who made assemblages was Rauschenberg's friend Jasper Johns. Johns chose as his subjects some of the most familiar images one could imagine: the American flag, a map of the United States, numerals, letters of the alphabet, and targets (**22.7**). He said that by choosing

RELATED WORKS

7.2 Johns, Numbers in Color

22.6 Robert Rauschenberg. *Winter Pool.* 1959. Combine painting: oil, paper, fabric, wood, metal, sandpaper, tape, printer paper, printed reproductions, handheld bellows, and found painting, on two canvases, with ladder; $7'5'2'' \times 4''10'2'' \times 4''$. The Metropolitan Museum of Art, New York

22.7 Jasper Johns. *Target with Four Faces*. 1955. Assemblage: encaustic on newspaper and collage on canvas with objects, 26" square, surmounted by four tinted plaster faces in wood box with hinged front; overall dimensions with box open $33\% \times 26 \times 3$ ". The Museum of Modern Art, New York

22.8 Allan Kaprow. *Courtyard*. 1962. Happening at the Mills Hotel, New York.

Courtesy of the Library, Getty Research Institute, Los Angeles (980063). Photo: © Lawrence Shustak. Courtesy Allan Kaprow Estate and Hauser & Wirth these motifs, the work of composition had already been done for him, and he could concentrate on "other things." What other things? Paradoxes, for one. Painted in encaustic over newsprint, the target is textured, sensuous, and unique. Yet the idea of a target exists potentially in endless multiples. Above the target are portions of four faces. Johns took the casts from the same person, making a series of anonymous mechanical multiples from a unique individual. Like all of Johns' favorite motifs, a target is not only familiar but also two-dimensional, abstract, and symbolic. Is the painting a representation of a target or a target? What is the difference? It also teases us into thinking about aesthetics and emotional distance. For example, if we appreciate the painting as an abstract composition of concentric circles, does that spare us from thinking about it as a target and the blindfolded victims of a firing squad?

Cage had also suggested that visual art look to the lively art of theater for renewal. The composer's friend Allan Kaprow followed through on that suggestion by eliminating the art object and staging events he called **happenings**. Kaprow's *Courtyard* (22.8) happened in the courtyard of a seedy hotel. Kaprow and his assistants erected a five-story "mountain" of scaffolding covered with black paper. On a platform atop it they set an "altar" of mattresses. Over the mattresses was suspended a large dome, also covered in black paper. After audience members helped sweep the space clean, black paper scraps were showered down from above. A woman in white danced around the base of the mountain and then climbed up to the mattresses. She was followed by photographers who took pictures of her as she continued to dance. Accompanied by shrieks, sirens, and thunder effects, the dome was lowered over them.

Among the spectators at *Courtyard* was Hans Richter, one of the original members of Dada. None other than Marcel Duchamp, then living in New York, had drawn his attention to it. The Dadaists, too, had staged provocative events. "A Ritual!" Richter wrote. "It was a composition using space, color and movement, and the setting in which the Happening took place gave it a nightmarish, obsessive quality. . . . "³ The Dadaists recognized their successors clearly. Just as Dada had created both art and anti-art as "shock therapy" for the complacent, conformist society that had produced World War I, this later generation was producing art and anti-art to jolt into awareness the complacent, conformist society of prosperous, postwar America.

RELATED WORKS

2.39 Beuys, How to Explain Pictures to a Dead Hare

Art of the Sixties and Seventies

Does art exist in its own aesthetic realm apart from life? Is it important for us to have art as an alternative to our social experience, a refuge from everyday concerns that keeps us in touch with spiritual or abstract matters? Or is art deeply involved with life? Is it important for us to see the lives we live, the issues that concern us, our sense of what it is like to be in the world here and now given form through art? These questions have animated the history of art since the beginning of the modern era. As viewers, we have the luxury of appreciating all types of art, but artists have to choose one path or the other. During the sixties and seventies, the directions that had been set out in the previous decade were continued, questioned, and complicated by new trends.

Pop Art

Even the name is breezy: "pop," for popular. The artists of **Pop** found a gold mine of visual material in the mundane, mass-produced objects and images of America's popular culture—comic books, advertising, billboards, and packaging; the ever-expanding world of home appliances and other commodities; and photographic images from cinema, television, and newspapers. Like Neo-Dada, Pop drew art closer to life, but life as it had already been transformed into images by advertising and the media.

An example is Andy Warhol's *Gold Marilyn Monroe* (22.9). A glamorous but troubled film star, Monroe took her own life in August of 1962. Warhol began a series of works devoted to her almost immediately. Significantly, the image is not a direct portrait of the actress herself but, rather, a silkscreen reproduction of one of her black-and-white publicity photographs. Warhol used the image in dozens of works, sometimes printing it multiple times across the canvas, like newspapers rolling off the press. He colored the image with silkscreen, garishly and clumsily. Monroe is at once debased by the crude,

22.9 Andy Warhol. *Gold Marilyn Monroe*. 1962. Silkscreen ink on synthetic polymer paint on canvas; 6'11'/4" × 4'9".

The Museum of Modern Art, New York

ARTISTS Andy Warhol (1928-1987)

How is Warhol two people, and why does he have two sides to his personality? How does such a personality explain his description of himself as a "machine"? Why is Pop art a fit with Warhol's character, and what are some of the themes he chose to emphasize?

hen friends recall the most visible and colorful of the Pop artists, they often remark that he was two people. There was Andy Warhol—media celebrity, high priest of commercial and show-business imagery, wearer of bizarre white wigs, leader to an entourage of quirky New York types, maker of sexually explicit cult films. Then there was Andrew Warhola—child of struggling Czech immigrants, devout Roman Catholic, prolific worker, introvert often paralyzed by shyness, adoring son who, as an adult, brought his mother to live with him for twenty years.

Warhol, born Warhola, grew up in Pittsburgh and attended Carnegie Institute of Technology. After

graduation in 1949 he moved to New York, where he launched what would become a highly successful career as a commercial artist. Over the next ten years, his employers included most of the chic fashion magazines and elegant Fifth Avenue stores, for which he designed advertisements, promotional pieces, and window displays. He was also—ironically, in view of his later adventures—one of the illustrators for the first edition of *Amy Vanderbilt's Complete Book of Etiquette*.

By 1960 the artist and his style had found each other. Warhol, the gifted commercial artist, slipped into Pop, the "fine art" style of commercial images, without missing a beat. For a decade, Pop would remain a dominant art wave in the United States, and Warhol sailed on the crest of that wave. The themes with which he is most closely associated appeared repeatedly in prints and paintings: Marilyn Monroe, Elizabeth Taylor, Jackie Kennedy, and, of course, the famous Coke bottles and Campbell's soup cans.

A turning point in Warhol's career occurred in 1963, when the artist moved into a new studio in New York. A friend decorated the entire space in silver paint and aluminum foil, a large group of acquaintances and admirers and hangers-on converged, and thus was born—the Factory. At the Factory, Warhol continued his enormous output of prints, paintings, and sculptures. At the Factory, he directed the production of many avant-garde (some would say outlandish) films, featuring actors with names such as Viva, Ultra Violet, and International Velvet. And at the Factory, in 1968, a woman who announced herself as the founder of SCUM (Society for Cutting Up Men) shot Warhol and nearly killed him.

Many observers felt that Warhol ran out of steam after the shooting, that his art no longer showed the edge and excitement it once had. Nevertheless, he worked steadily, developing his familiar themes and some new ones, until his death at age fifty-eight, of complications following gallbladder surgery.

Warhol often liked to say he was a "machine." He claimed to be devoid of emotion or feeling, just a machine that produced a product, called art, in a place called a Factory. One of his much-quoted statements sums this up. "If you want to know all about Andy Warhol, just look at the surface: of my paintings and films and me, and there I am. There's nothing behind it."

Photograph of Andy Warhol, 1986.

22.10 Roy Lichtenstein. *Blam.* 1962. Oil on canvas, 5'8" × 6'8". Yale University Art Gallery, New Haven

22.11 Frank Stella. *Harran II.* 1967. Polymer and fluorescent polymer paint on canvas, 10 × 20'. Solomon R. Guggenheim Museum, New York

commercial treatment and glorified by the gold setting, like a sacred presence in a Byzantine icon (see 15.9, 15.10). It is not quite her we see but the mask of her fame. Son of eastern European immigrants, Warhol was brought up in the Eastern Orthodox faith, where the tradition of icons has been perpetuated. An astute observer, he noticed what images circulated with a similar force in American culture.

Roy Lichtenstein based his early paintings on hand-drawn advertising (then known as "commercial art") and comic-book imagery. He was intrigued by the conventions that these forms had developed for depicting the world standardized ways for representing eyes, hair, glass, smoke, explosions, water, and even dripping brush strokes. Blam is adapted from a frame in the comic series All-American Men of War (22.10). Lichtenstein cropped the original image, rotated it 45 degrees, reduced the color scheme to the three primary colors, and simplified the depiction of the explosion to underscore its abstract quality. Most important, he enlarged it to over 5 feet in height, in the process enlarging the dot pattern of the printing. (Comic books then were printed on newsprint using a system that permitted a palette of up to sixty-four colors, all printed with four colors of dots; the background tint of Blam is made of painted dots.) By isolating images from their original context and dramatically shifting their scale, Lichtenstein draws our attention to the elements they are made of—black lines, flat colors, dots. Lichtenstein stopped drawing directly on comics within a few years, but he continued to work in his streamlined version of their style-cool, detached, seemingly mechanical-for the rest of his life.

Abstraction and Photorealism

While the artists of Pop turned their attention to imagery, other artists continued to explore the possibilities of nonrepresentational art. One direction that attracted many painters was **hard-edge painting**, a variation of color field painting in which areas of flat color are separated by sharp, precise edges, as in Frank Stella's *Harran II* (22.11). *Harran II* is one of the first works in Stella's *Protractor* series, a large group of paintings in which the shape of the canvas

22.12 Chuck Close. *Phil.* 1969. Acrylic and graphite pen on canvas, $9'\frac{1}{4}" \times 7'$.

Whitney Museum of American Art, New York

2.15 Hanson,
Housepainter III

1.15 Flack,
Wheel of
Fortune
(Vanitas)

and the division of the color areas within it are derived from the shape of a protractor, a semicircular drafting tool used to measure angles. Stella began the series by establishing thirty-one formats and three principles for designing the color areas within them: interlace, rainbow, and fan, indicated in the titles by I, II, and III, respectively. The format of *Harran II* is made of four protractor shapes: two placed back-to-back, and two overlapping these at 90-degree angles. The interior of the painting is articulated in bands of color, all the same width, that reiterate the arcs of the protractors and the angles used to fit them together.

Like Johns and Rauschenberg, Stella did not conceive of his painting as a visual field that viewers see *into* but as an object that viewers look *at*. *Harran II* does not offer a window onto a deep Renaissance perspective, or a shallow Cubist space, or an Abstract Expressionist infinity of tangled lines. Instead, it presents itself as a shaped surface that bears a design about the shape of the surface. "All I want anyone to get out of my paintings," Stella said, "is the fact that you can see the whole idea without any confusion. . . . What you see is what you see."⁵

Pop art's focus on imagery in the mass media inspired artists to look more closely at photographs. In a trend called **Photorealism**, they began to paint what they saw there. Chuck Close's *Phil* is indirectly a portrait of a man named Phil, but it is primarily a monumental painting of a photograph that Close took of a man named Phil (**22.12**). Close's subject was faces and how photography recorded them. He asked friends to pose for his camera so that he could have faces to paint. He drew a grid over the resulting photograph, then a grid with the same number of squares over a much larger canvas (*Phil* measures 9 feet in height). He copied each square of the photograph independently, one at a time, ignoring the larger image and focusing exclusively on the information in the square. The image emerged as a by-product of this activity. Different aspects of photography captivated different painters. Close was interested in the medium's subtle distortions and shifts in focus—now sharp and detailed, now soft and blurred

Minimalism and After

Frank Stella's "what you see is what you see" program for painting was echoed by a number of sculptors. Like Stella, they wanted to rid art of representation and personal expression once and for all, and to allow viewers to see "the whole idea without any confusion." Critics tried to categorize their work in many ways—Primary Structures, Reductive art, Literalism—but the label that stuck, despite the artists' objections, was Minimalism.

Donald Judd's *Untitled (Stack)* embodies many of the characteristics associated with Minimalism (22.13). It is made of galvanized iron, a common industrial and construction material. The material is used literally; it does not try to depict or suggest anything else. The sculpture has the impersonal look of industrial fabrication; there is no trace of the artist's "hand" or "touch." In fact, *Untitled (Stack)* was manufactured by a metal workshop according to Judd's specifications. The composition consists of repeating units of simple geometric shapes, precisely positioned—in this case, boxes 9 inches in height displayed at 9-inch intervals. There is no particular focal point, no areas of greater or lesser interest. The sculpture is attached to the wall rather than exhibited on a pedestal, as traditional sculpture had been. Other Minimalist works were set on the floor.

Minimalist art did not reward the kind of looking skills that viewers had been taught were important, skills such as analyzing the composition (this was quickly done), appreciating the use of formal elements (there weren't many), or sensing the artist's physical and emotional involvement (the work had been manufactured). It was almost as though appreciating Minimal art required different looking skills. Judd himself suggested what these might be. "A work

22.13 Donald Judd. *Untitled* (Stack). 1967. Lacquer on galvanized iron, twelve units, each $9 \times 40 \times 31$ ", installed vertically with 9" intervals. The Museum of Modern Art, New York

RELATED WORKS

7.13 Benglis painting on the floor

of art needs only to be interesting," he wrote in 1965. "It isn't necessary for a work to have a lot of things to look at, to compare, to analyze one by one, to contemplate. The thing as a whole, its quality as a whole is what is interesting."

Minimalism provoked strong reactions, not only among critics and the public, but also among artists. In a variety of interrelated trends, artists variously reacted against aspects of it or developed possibilities that it suggested. Collectively, these trends are known as **Postminimalism**, which unfolded from the mid-1960s through the mid-1970s. Neither styles nor movements in the traditional sense, the diverse trends of Postminimalism dramatically expanded—permanently, it seems—the ways in which art could be made, the materials it could be made from, and the kinds of objects and activities that could be offered and interpreted as art.

PROCESS ART A composition of repeating rectangular units links Eva Hesse's *Contingent* to Minimalism (22.14). Almost everything else about the work, however, stakes out a distance. Whereas Minimalism favored tough industrial materials associated with construction, *Contingent* consists of panels of flimsy cheesecloth, hung from the ceiling like banners. Each panel is encased in transparent fiberglass, and its center portion is painted with latex. In place of Minimalism's precise geometries and manufactured look, the rectangles of *Contingent* are casual and varied, and the piece is clearly handmade. And whereas Minimalist works were pointedly about nothing but their own clarity, *Contingent* feels more personal, intuitive, and intimate. Many viewers have sensed allusions to the human body in Hesse's works.

Hesse is one of a number of artists associated with **Process art**. In Process art, the meaning of a work embraced what it was made of and how it was made. Process artists were attracted to unconventional materials. They were

22.14 Eva Hesse. *Contingent*. 1969. Cheesecloth, latex, polyester resin, fiberglass; eight units, dimensions variable, $12'4" \times 20'8" \times 3'7"$.

National Gallery of Australia, Canberra

22.15 Bruce Nauman. *Green Light Corridor*. 1970. Painted wallboard and fluorescent light fixtures with green lamps, dimensions variable, approx. $10 \times 40 \times 1$ '. Solomon R. Guggenheim Museum, New York

willing to surrender complete control, to embrace chance and unpredictability, and to create ephemeral or temporary works. The panels of *Contingent*, for example, "are the way they are and the way the material and fiberglass worked out," Hesse said. "They are all different sizes and heights, but I said 'Well, if it happens, it happens'." The latex has yellowed and grown brittle over the years, as Hesse knew it would; that her work would not have a long life was a trade-off she made for its impact in the moment.

INSTALLATION Minimalist sculptures were shown carefully positioned in the architectural spaces of a museum or gallery. In the words of one artist, a Minimalist sculpture was "one of the terms" in the space, all of which was interesting. As the sculptors intended, viewers became conscious of their own bodily presence in the same space and attentive to their experience as they looked at the sculpture. Taking those ideas a step further, artists created installations—spaces conceived of as works of art for viewers to enter and experience. Bruce Nauman's *Green Light Corridor* asks viewers to enter a long, narrow corridor lit with green fluorescent light (22.15). The corridor is only a foot wide, so viewers must work their way down it sideways. When they emerge from this claustrophobic experience, their eyes have been so saturated with green light that they produce a complementary afterimage, coloring everything magenta for a time.

Installation art had numerous precedents. The Surrealists had sometimes exhibited their paintings in galleries decorated to look like a Surrealist painting come to life. Allan Kaprow, whose Happening we looked at earlier (see 22.8), had also created places he called "environments"—rooms that viewers entered and explored. But it was in the climate of Postminimalism that the practice of creating spaces became widespread and that the name "installation" became standard.

BODY ART AND PERFORMANCE Many installations were temporary works: an existing space was transformed for the length of an exhibition, then returned to its original condition. Temporary installations were an attempt to move art away from the influence of the art market, which emphasized portable objects that could be bought and sold like luxury products. By making works that could not be sold, artists wanted to disrupt the association of art and money. A more radical move away from making objects was **Body art**, a practice in which artists made art using their own body as a material or medium. In Chapter 9, for example, we looked at a frame from a film that Bruce Nauman made to document his *Dance or Exercise on the Perimeter of a Square* (see 9.21).

Body art was a subcategory of a broader form called **Performance art**, in which the artist appears "live and in person." Performance had been a recurring presence in 20th-century art, beginning with events staged by Futurist and Dada artists in the first decades of the century and continuing through Allan Kaprow's happenings (see 22.8). During the Postminimal years, such actions, events, and happenings became more formalized, and the name Performance art came into general use.

Much of the Performance art of the 1970s concerned the relationship between artist and spectator. An example is *Imponderabilia*, which the artist Marina Abramović performed with her then-partner Ulay in a museum in Italy (22.16). The two stood facing each other in a narrow doorway, naked, eyes locked, immobile, and expressionless. Anyone wanting to enter the museum had to get by them, squeezing through sideways, brushing up against their bodies. Which way would the spectators face? Where would they look? How would they hold their hands? It is easy to imagine their discomfort, but it is almost frightening to consider the extreme vulnerability of the artists, who were forbidden by the rules of the work to move or speak. Many of Abramović's works put her in a vulnerable position, and in some cases, the spectators grew menacing. We do not know what might have happened here, for after ninety minutes, the police were called to put an end to *Imponderabilia*.

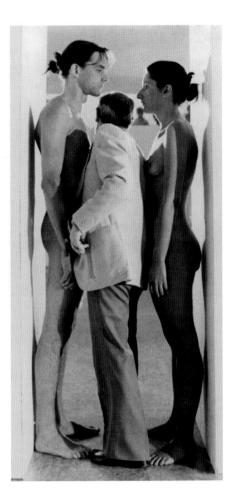

22.16 Marina Abramović and Ulay. *Imponderabilia*. 1977. Performance at the Galleria Comunale d'Arte Moderna, Bologna, Italy. Courtesy Marina Abramović Archives and Sean Kelly Gallery, New York

22.17 Walter De Maria.

The Lightning Field,
Quemado, New Mexico. 1977.
Long-term installation, western
New Mexico. Four hundred pointed steel rods, 1 mile × 1 kilometer.
Courtesy Dia Art Foundation, New York

RELATED WORKS

5.24 Lin, Storm King Wavefield

3.25 Smithson, Spiral Jetty

LAND ART Also known as Earth art, Land art was yet another way in which Postminimalist artists sought to separate art from issues of money and ownership, to escape from urban exhibition spaces such as galleries and museums, and to open up alternatives to the weighty traditions of painting and sculpture. In Land art, the artist intervenes in some way in a landscape. This can be as simple as aligning a sequence of found stones or as elaborate as creating a pathway that launches bravely out into a lake and then coils in on itself, as Robert Smithson did in Spiral Jetty (see 3.25). One of the most famous works of Land art is Walter De Maria's The Lightning Field (22.17). Located in New Mexico in a remote region of high desert, The Lightning Field consists of four hundred highly polished steel poles arranged in a rectangular grid measuring 1 mile by just over 1 kilometer. The poles are set so that their pointed tips describe a horizontal plane-that is, the artist explained, so that they would evenly support an imaginary sheet of glass. Their average height is over 20 feet. At dawn and dusk they are clearly visible in the raking light; at mid-day, with the sun directly overhead, they seem to vanish.

De Maria chose the location for its high incidence of lightning, and images such as the spectacular photograph illustrated here have captured the public's imagination. The poles do attract lightning when it occurs, yet their larger purpose is to provide a framework for visitors to have a heightened experience of light, space, landscape, and solitude. "The land is not the setting for the work but a part of the work," De Maria insisted. He believed that isolation was essential to Land art, and he intended for *The Lightning Field* to be experienced alone or in the company of just a few people over a period of at least twenty-four hours. The foundation that owns the work is faithful to his wishes: up to six visitors at a time are driven to the site, dropped off at a small cabin that has been made ready for them, and picked up the next day. If they have been wise, they will have separated to wander through the field, alone with their thoughts and alive to their sensations.

CONCEPTUAL ART Conceptual art is art in which ideas are paramount and the form that realizes those ideas is secondary—often lightweight, ephemeral, or unremarkable. Arising in the mid-1960s as yet another echo of Dada, Conceptual art is especially indebted to Marcel Duchamp, whose self-proclaimed goal was to eliminate what he called the "retinal aspect" of art—its appeal solely to the eye—in favor of an engagement with ideas. Duchamp's ready-mades such as *Fountain* (see 21.21) can be considered as Conceptual works, though they made their appearance before the term was invented.

RELATED WORKS

2.42 Gonzalez-Torres, "Untitled"

In itself, *Fountain* has no particular visual interest. But the shift brought about by calling a urinal *Fountain* and exhibiting it as art is food for thought.

Conceptualism is not a style but a way of thinking about art, and artists have put it to many different uses. Many Conceptual artists worked with language, for words, when written, take on a double life as image and idea. For example, Joseph Kosuth, one of the foremost practitioners and theorists of Conceptual art, made a work called *One and Three Chairs* by juxtaposing three elements: a chair, a black-and-white photograph of the same chair enlarged to life-size, and a photographic enlargement of a dictionary definition of the word "chair." In true Conceptual fashion, the form is secondary, for the style of chair doesn't matter, any dictionary definition will do, and the three elements can be arranged in many ways. *One and Three Chairs* could thus take many forms. The work is not illustrated here, but it doesn't really need to be: you know all you need to know from the description.

In Kosuth's *Five Words in White Neon* (22.18), the form does matter, but it matters in a particular way. *Five Words in White Neon* is from Kosuth's *Tautology* series. A tautology is a restatement of the same idea in different terms. "The runners crossed the finish line one after the other in succession" is an example of a tautology, where "in succession" means the same thing as "one after the other." In logic, a tautology is a compound statement that is necessarily true, such as "it will rain tomorrow or it will not rain tomorrow." Kosuth's work is tautological in that it represents the phrase "five words in white neon" with five words in white neon.

Conceptual art also had strong links to Minimalism. Sol LeWitt, whose sculptures are often discussed as Minimal art, preferred to refer to his work as Conceptual, for it was primarily about ideas. "The idea becomes a machine that generates the art," he famously wrote. LeWitt created hundreds of such "machines" in the form of instructions for wall drawings to be executed by other people. The illustration here depicts a detail from an installation of *Wall Drawing #122* (22.19). The instructions are: A 36" (90 cm) grid covering the wall. All combinations of two lines crossing, placed at random, using arcs from corners and sides, straight, not straight, and broken lines. Each 36" (90 cm) square contains one combination (150 possibilities).

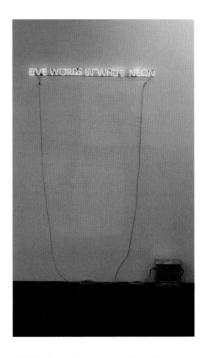

22.18 Joseph Kosuth. *Five Words in White Neon*. 1965. Glass tubing, neon, and transformer; length of phrase 4'11".

Private Collection

22.19 Sol LeWitt. *Wall Drawing #122*, detail. First installation: Massachusetts Institute of Technology, Cambridge, MA, January 1972. This image: Installation at the Paula Cooper Gallery, New York, May 7–August 11, 2011. Black pencil grid, blue crayon arcs and lines; dimensions variable.

22.20 Joan Jonas. *Glass Puzzle*. 1973. Black-and-white video, 17:23 min. Performers: Joan Jonas

Courtesy Electronic Arts Intermix, New York, and Yvon Lambert, Paris

and Lois Lane. Music: The

Liquidators.

LeWitt's wall drawings are not intended to be permanent. They are realized as temporary installations, usually by a team of artists, left on view for a time, and then painted over. Every time the idea is made manifest, it looks a little different, and no single manifestation can be considered definitive.

New Media: Video

Portable video cameras were first made available to the general public in 1965, and the first two works of video art quickly followed within weeks of each other. One was by Andy Warhol, who had been asked by a magazine to experiment with one of the new devices. The other was by Nam June Paik (see 9.22), who recorded from a taxi his view of the papal motorcade during the Pope's historic 1965 visit to New York. He showed the video that very evening at a café popular with artists.

Video was ideally suited to an era that questioned whether artworks needed to be objects, in which performance had assumed an important role, and in which the power of television had begun to show its full force. Joan Jonas' *Glass Puzzle* illustrates the experimental nature of early video art (22.20). The video captures an unrehearsed performance by Joan Jonas and another artist, Lois Lane. A mobile video camera operated by filmmaker Babette Mangolte fed the live performance to a monitor. A second video camera was trained on the monitor, recording the video display. The second camera also captured the reflections of the room in the monitor's glass screen, creating a complex, puzzling space in which actions happening simultaneously appear to be layered over one another-one fed to the monitor by the mobile camera, the other visible in the reflection of the room in the glass. Glass Puzzle is an enigmatic work. The two women wear intimate clothing-short slips, a satin dressing gown, a white unitard. In some sequences, they appear together, one mimicking the other's gestures (as illustrated). In others, they appear to be waiting, marking time, or displaying themselves. One dances. The video records ambient sounds (traffic passing outdoors, dancing feet, rustling clothes, music being played), but the women do not speak.

Reconsidering Craft

The 1960s also saw the beginnings of a long reconsideration of the division between art and craft that had been in place for some two hundred years. Was there really such a clear difference between them, and, if so, what defined it? Materials? Techniques? Forms? Context? Already in the preceding decade, artists trained in ceramics had begun to make sculptures. Clay, however, had always enjoyed a sort of dual citizenship, used for both sculpture and pottery. Far more radical were the claims of the next craft medium that demanded a place in the system of fine art, fiber.

Through the European tradition of tapestry, fiber had long been associated with two-dimensional images. The revival of hand-weaving during the Arts and Crafts movement of the late 19th century had launched a slender but persistent new tradition of loom-woven hangings by artists who often also designed textiles for industrial production. But it was in three dimensions that fiber finally captured the attention of the art world, as younger artists abandoned the loom to create bold sculptural forms such as *Abakan Red*, by the Polish artist Magdalena Abakanowicz (22.21).

Suspended in space, over 10 feet in height, *Abakan Red* is one of a series of large fiber sculptures, all called *Abakans*, that the artist made during the 1960s and early 1970s. Heavy and roughly textured, they were made using sisal that Abakanowicz recycled from nautical rope. "I collected all the ropes rejected by the ships," she said. "I was absolutely not interested in learning how to weave. I pulled out the sisal threads from the ropes, washed them and added dyes, cooking them like a soup in a big pot. Then, I built a wooden frame and on it I crossed the different ropes and cords to get the wanted surfaces."¹¹

Feminism and Feminist Art

If you had been reading a book like this around 1968, the chapters of Part Five, "Arts in Time," would most likely not have introduced you to Sofonisba Anguissola (16.23), Artemisia Gentileschi (17.5), Judith Leyster (17.13), Elisabeth Vigée-Lebrun (17.18), Berthe Morisot (21.7), or Mary Cassatt (21.11). Art historians knew of works by these women; they just didn't make an effort to

22.21 Magdalena Abakanowicz. *Abakan Red.* 1969. Sisal and metal, approx. 13'3½" × 12'6½" × 13'1½". Tate Modern, London. © Magdalena Abakanowicz, courtesy Marlborough Gallery

RELATED WORKS

10.16 Kruger, Untitled

22.22 Judy Chicago.

The Dinner Party. 1979.

Mixed media, each side 48'.

Brooklyn Museum of Art, New York

include them in their telling of the history of art. It was quite possible to come away from a course in art history or a visit to a museum believing that women had played little or no role in the art of the past. If you look forward in this book to the art of the eighties and nineties, you will find not only many more women but greater diversity in general. This diversity accurately reflects the makeup of the contemporary art world, and it is due in large measure to the impact of feminism and related social and political movements of the 1970s.

Feminist organizations had originally been formed around such issues as equal rights and equal pay. Because images are powerful and pervasive in contemporary society, visual culture quickly became a feminist concern, both in art and in the media. Women art professionals organized to recover women's art of the past, to push for more equitable representation in museums and galleries, and to nurture contemporary women artists. During this first phase of feminism, a project that intrigued many artists was the creation of a specifically female art, rooted in the biological, psychological, social, and historical experience of women.

Judy Chicago's *The Dinner Party* is perhaps the most important work from this time (22.22). A collaborative work, *The Dinner Party* was executed with the help of hundreds of women and several men. Arranged around a triangular table are thirty-nine place settings, each one created in honor of an influential woman, such as the Egyptian ruler Hatshepsut and the novelist Virginia Woolf. The names of an additional 999 important women are written on the tile floor. By using such craft techniques as ceramics, weaving, needlepoint, and embroidery, Chicago demanded artistic equality for media that had long been associated with "women's work." Confined to the domestic sphere, the vast majority of women throughout history had been limited to these expressive outlets—including the expressive outlet of setting and decorating a table—and *The Dinner Party* honors them. The thirteen places on each side of the triangle intentionally evoke the seating arrangement of Leonardo's *Last Supper*, a central work in the history of Western art, and one that depicts an all-male gathering.

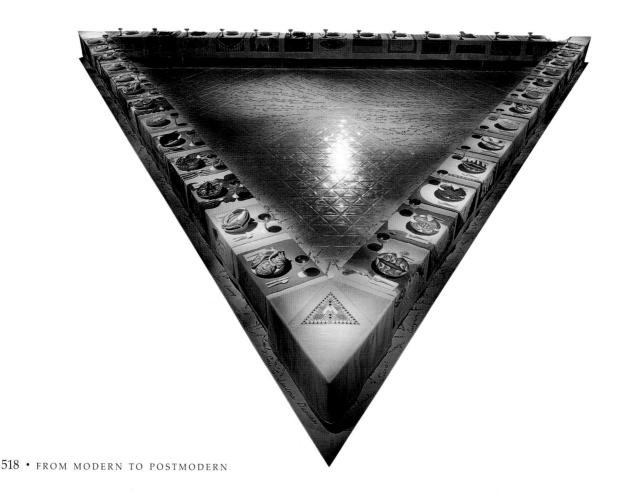

Art of the Eighties and Nineties: Postmodernism

Over the course of the seventies, it became clear to many people that ideas about art that seemed to have been in place for much of the modern era were eroding and that something different was taking their place. This new climate of thought came to be called Postmodernism.

The term postmodern was first used to describe architecture such as Renzo Piano and Richard Rogers' Georges Pompidou National Center of Art and Culture (22.23). Designed in 1971 and completed six years later, the Pompidou Center created a sensation. Encased in scaffolding, pipes, tubes, and funnels-all color-coded according to function-it looks like a building turned inside out. The architects themselves likened it to "a Jules Verne spaceship that can't fly." The Pompidou Center was one of many buildings of the time that turned away from the International style that had dominated Western architecture after World War II (see 13.25). The International style had grown from the thinking of early 20th-century Modernist movements such as De Stijl and the Bauhaus (see pages 496-97). Its industrial materials, clean lines, and rectilinear forms sought not only to express the modern age but also to create a luminous, rational environment in which humanity itself would progress. By the mid-sixties, however, many began to find International style buildings oppressive and sterile. A new direction was called for, but instead of building on Modernist ideas and progressing forward, architects reached both backward-adapting ornaments and forms from traditions as distant as ancient Egypt-and outward-looking seriously at common, everyday architecture. Instead of the rational order of International style, they often emphasized other, equally human qualities such as playfulness, curiosity, and eccentricity.

22.23 Renzo Piano and Richard Rogers. Georges Pompidou National Center of Art and Culture, Paris. 1977.

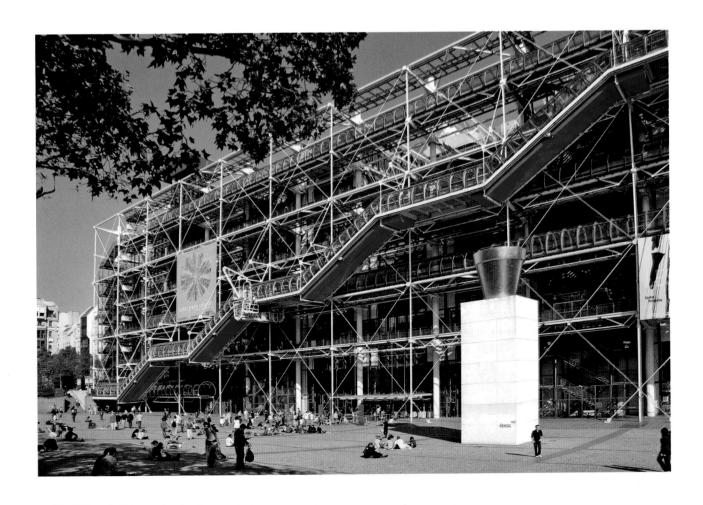

22.24 Sherrie Levine. *Fountain* (after Marcel Duchamp: A. P.). 1991. Bronze, 14½ × 14¼ × 25". Collection Walker Art Center, Minneapolis

The notion that there may be no such thing as "progress" in art is part of the web of related ideas that make up Postmodernism. Another is a more complex view of history. Feminism had clearly shown that within art history as it was usually told lay other histories that were untold. Art history was not the straightforward progression of one style to another that it had been made to seem. Rather, each historical moment was full of multiple directions, contradictions, and debates. Perhaps a fairer way to study history would be to study everything that happened, not just the "winners" whose style seemed to be part of "progress." This way of thinking led to the creation of museums such as the Gare d'Orsay in Paris. (See "Thinking about Art: Presenting the Past," page 479.) Applying these ideas to the present moment logically leads to pluralism, the idea that art can take many directions at the same time, all of them equally valid. Historians of the future should no longer select one as "correct" and sweep the rest under the carpet. Pluralism in turn recognizes that there is no longer any single leading artistic center. Rather, the world of art consists of many centers and has many levels.

Sherrie Levine's 1991 Fountain (after Marcel Duchamp) may be the ultimate Postmodern statement (22.24). Fountain was the most notorious of Duchamp's ready-mades, an ordinary porcelain urinal that he contributed to an art exhibit in 1917 (see 21.21). Levine presents a gleaming bronze version. Levine created a number of "after" works, restating images made originally by such artists as Constantin Brancusi, Man Ray, and the photographer Walker Evans. She has said that what interests her is the "almost-same"-Duchamp's Fountain, but with a slightly different urinal and cast in bronze; Brancusi's sculpture of a newborn, but cast in glass; a photograph of a photograph by Walker Evans. In exploring ideas about authorship and originality by repeating other artists' imagery, Levine was employing a postmodern practice known as appropriation. Loosely, appropriation refers to the artistic recycling of existing images. In this sense, it acknowledges that images circulate in such vast quantities through our society that they have become a kind of public resource that anyone can draw on. More strictly, appropriation is linked to Duchamp himself, who presented the creations of others (a urinal) as his own and in doing so gave them a new meaning. In music, many of the same ideas lie behind the practice of sampling-taking bits of music from prerecorded songs and giving them new meaning by placing them in a new context. Both appropriation and sampling form part of larger theories that doubt whether any artist is the sole creator of his or her work or the final authority about what it means. All artists borrow ideas in one way or another, and the meaning of a work is unstable and varies from viewer to viewer. The creation of meaning, and thus of art, is a communal project.

These, then, are some of the ideas that inspired Postmodernism. Constantly debated, they provided the climate for much of the art that was made toward the end of the 20th century.

The Painterly Image

For many observers, art history seemed to stop running forward in the mid-1970s, when one artist after another began to make paintings—not the cool, impersonal surfaces of Photorealism (22.12) or the silkscreened ironies of Andy Warhol (22.9), but paintings where paint was freely manipulated as a sensuous material in order to make a recognizable, expressive image. That kind of painting was supposed to be over.

During the early 1980s, some of these artists became known as Neo-Expressionists, for their work recalled the sincerity and emotional intensity of the Expressionist movement of early 20th-century Europe (see page 484). German artist Anselm Kiefer became one of the most talked-about of this group, for his work often dealt directly with the great trauma of his country's past: the horrors of Nazi power under Adolf Hitler and the atrocities of

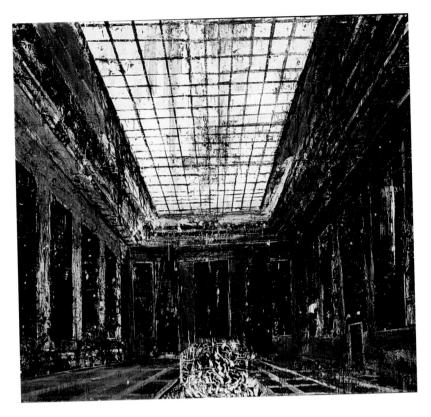

22.25 Anselm Kiefer. *Interior*. 1981. Oil, paper, and straw on canvas; $9'5\% \times 10'2\%$ ". Stedelijk Museum, Amsterdam

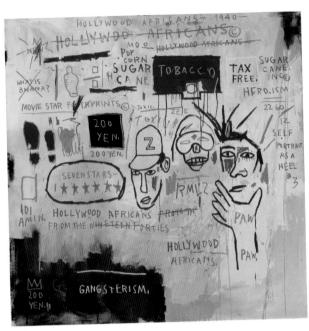

22.26 Jean-Michel Basquiat. *Hollywood Africans*. 1983. Acrylic and oil stick on canvas, 7×7 . Whitney Museum of American Art, New York

World War II. *Interior* (22.25) was based on a photograph of Hitler's Chancellery (office of state), a building designed by the ambitious Nazi architect Albert Speer. In Kiefer's work the Chancellery, rendered in dramatic perspective, is abandoned and decaying. A fire burns in the center of the room; perhaps it will destroy the building and the regime it represents. Most critics have read Kiefer's work as a kind of exorcism—an attempt to drive out the evil spirits of Germany's past. And, to be sure, the artist's vast theatrical spaces, almost like stage sets, are empty. The actors are gone.

In New York, a number of young artists drew their energy from street life, the punk scene, the early years of hip hop, and the graffiti images that then were appearing on subways, storefronts, and almost every urban surface. One of these painters was Jean-Michel Basquiat. Born in Brooklyn of Afro-Caribbean heritage, Basquiat grew up speaking English, Spanish, and French. Though he drew avidly from a young age, he first attracted attention in his teens with brief graffitied phrases-critical, cryptic, poetic, philosophical-tagged SAMO©. Many of the sayings were spray-painted on walls near art galleries and directed at the art world. In 1980 he participated as SAMO in a sprawling exhibition that brought together underground artists and graffiti writers. The following year he was invited to contribute work to a similarly sprawling exhibition about the crossover between new music and visual art. In the corridor devoted to graffiti, he spray-painted a mural and signed it SAMO; in another room he exhibited a group of paintings under his real name for the first time. People noticed. From that moment until his death from a drug overdose seven years later, Basquiat blazed with amazing intensity. Paintings seemed to pour out of him in a torrent of words and images.

Hollywood Africans displays Basquiat's potent mix of drawing, painting, symbol, and text (22.26). On a ground of broadly brushed color, he portrays himself with two friends, the artist and hip-hop musician Rammellzee and the

artist Toxic. Basquiat had flown them out to join him in Los Angeles, where he was making new work for an upcoming exhibition. Amid the glamour of their new surroundings, the three began calling themselves Hollywood Africans. Words and phrases written on the painting link the three friends to historical Hollywood Africans, black actors who were confined to such stereotypical roles as plantation workers (sugar cane, tobacco) and "native" servants of white explorers ("what is bwana?"). Bringing the stereotypes up to the present day, Basquiat adds urban thugs to the repertoire (gangsterism), suggesting that things haven't progressed very far. The painting was finished in time for the opening of his exhibition. Important people in Hollywood were going to be there, and he wasn't about to miss an opportunity to make them a little uncomfortable.

Words and Images, Issues and Identities

In works such as *Still Life on Table: "Gillette"* (6.13) and *The Emigrant* (21.17), Cubist artists at the beginning of the 20th century imported words into art. With the growth of advertising in the form of posters and newspapers, words had taken on a new visual presence in the environment, and Cubist paintings were the first to acknowledge this. During the 1960s, Conceptual art often took the form of words, as in the work of Joseph Kosuth (see 22.18). By the 1980s, it had become clear to many that advertising was the prevalent visual reality of our time, and a number of artists adopted its techniques, most commonly to address political and social issues.

22.27 Jenny Holzer. *Protect Me From What I Want* from *Survival*. 1983–85. Installation at Caesar's Palace, Las Vegas, Nevada, September 2–8, 1986, organized by Nevada Institute for Contemporary Art. Daktronics double-sided electronic sign.

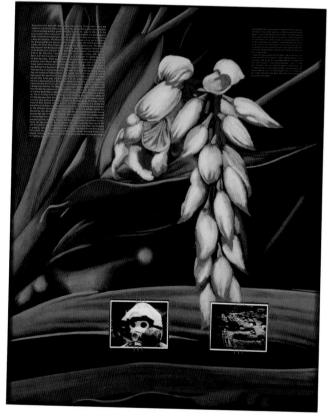

22.28 David Wojnarowicz. *Americans can't deal with death.* 1990. Acrylic and photograph on board, 5×4 . Courtesy of the Estate of David Wojnarowicz and P.P.O.W. Gallery, New York

Jenny Holzer's *Protect Me From What I Want* (22.27) is one of a series of works in which the artist inserted words that closely resembled advertising slogans into public places. The photograph here shows the work installed at Caesar's Palace, a famous hotel and casino in Las Vegas. The photograph gives some idea of the dense advertising environment the sign was part of. Advertising, of course, is precisely about wanting, about creating desire. How many people noticed Holzer's prayerlike slogan shouting its warning amid the dazzling display of neon signs promoting hotels, casinos, restaurants, and other temptations? ("Win \$5000 dollars!" reads a sign in the lower right.) We have no way of knowing, of course, but those who did may have paused for a moment.

One of the most highly charged issues of the 1980s was the AIDS epidemic, which forced deep-lying prejudices to the surface of public life. In the works of his final years, David Wojnarowicz used the formal means of advertising to channel his emotions as the disease ravaged his body (22.28). In *Americans can't deal with death* Wojnarowicz sets blocks of printed text over a painting of an exotic flower. Openings cut into the painting frame two small black-and-white photographs attached to the surrounding canvas with stitches. One depicts a man wearing a gas mask, the other skeletons in an excavated burial ground. The texts are printed in type so small that the viewer has to draw very close to decipher them, and even then the colors do not make them easy to read.

In the longer text, Wojnarowicz recalls a visit to a museum exhibit about the atomic bomb. The tourists with their cameras, the beaming matronly guide, and the aerial photographs of destruction with no hint of human casualties make him dizzy, it all seems so abstract in the museum's telling. "I'm thinking if I owned the museum I'd hook the constant smell of rotting flesh into the air-conditioning unit," he writes. In the shorter text, Wojnarowicz relates a dream in which he recognizes that an unknown boy is ill and needs to see a doctor. The boy closes his eyes as though he could block out the news. Later, a strange man arrives, claiming to know Wojnarowicz or someone close to him. Wojnarowicz recognizes him as Death and tries to steer him away. "He reappears in the distance but far away isn't far enough," the artist writes. He turns to find the boy silently weeping.

Artists associated with the feminist movement of the 1970s and the gay activism of the 1980s were instrumental in opening the art world to works that addressed human difference, just as American culture in general became more aware of the many identities it embraced and, all too often, silenced. Perhaps the most complicated location of difference in America is race, most especially blackness and ideas about blackness both within and outside of the African American community.

American community. One of the most thoughtful artists to work with historical and personal questions of blackness is Glenn Ligon. Ligon began as a nonrepresentational painter with a lush, gestural style, but he grew dissatisfied with the gap between the kinds of things he was becoming interested in communicating and the painterly means he was using. He began experimenting with ways to make paintings using words, eventually finding his answer in inexpensive, store-bought plastic stencils. The first works in his mature style were based in phrases drawn from Zora Neale Hurston's 1928 essay "How It Feels to Be Colored Me," including Untitled (I Do Not Always Feel Colored) (22.29). Ligon repeats the phrase again and again down the surface of the painting using black oil stick (oil paint in stick form). Each letter must be positioned and stenciled individually, and so details such as line breaks and letter spacing take on an expressive force. Paint that accumulates on the stencil begins to rub off onto the surface, interfering with the letters and making the text increasingly difficult to decipher. "The act of painting is putting my voice in the text, but I think the act of the viewer is putting his voice there too," Ligon says. "And also the fact that I'm quoting, it's not my voice directly. It's always words that are out in the world-edited, public, open-that allow other people's voices to speak them."13

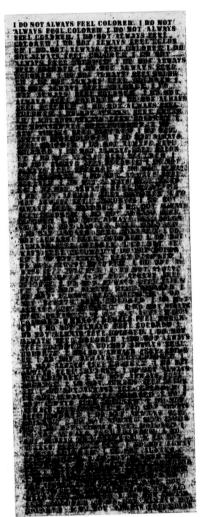

22.29 Glenn Ligon. *Untitled* (I Do Not Always Feel Colored). 1990. Oil stick, gesso, and graphite on wood, 80 × 30".
Whitney Museum of American Art, New York. Courtesy Regen Projects, Los Angeles. © Glenn Ligon

New Media: The Digital Realm

The rapid development of digital technologies during the final two decades of the 20th century allowed images and sounds to be encoded and transmitted as patterns of numbers. Raw information—streams of numbers—came to flow rapidly around the world, decoded by machines into forms that have meaning for us, into text, into still and moving images, and into sound. During the 1990s, all those functions became concentrated in personal computers, which in turn were linked to the Internet and through it to the World Wide Web.

The Internet and the World Wide Web began to be colonized by artists almost as soon as they were up and running. Artists circulated e-mails, created Web sites, and wrote software programs as art. Coding gradually became recognized as a new medium, as necessary to making art for the Internet as learning how to use oil paint had been to making art during the Renaissance. Incorporeal and often ephemeral, Internet art exists for a time on the Internet, and although it can be commissioned or sponsored (and often is), it cannot truly be owned or sold.

One of the first pieces of Internet art to earn widespread recognition was a black-and-white, interactive, browser-based work by Olia Lialina called *My Boyfriend Came Back from the War* (22.30). Lialina created the work in 1996, the year that frames were added to HTML (HyperText Markup Language, the standard language used to create Web sites). Frames allowed designers to partition a Web page so that it could display more than one HTML document at a time. Lialina created *My Boyfriend Came Back from the War* to take advantage of the storytelling possibilities that this new feature opened up. Through images and short sentences displayed in four independent frames, *My Boyfriend Came Back from the War* evokes the awkward conversation of a couple trying to reconnect

22.30 Olia Lialina. *My Boyfriend Came Back from the War.* 1996. Hyper Text Markup Language (HTML), frames.

THINKING ABOUT ART The Guerrilla Girls

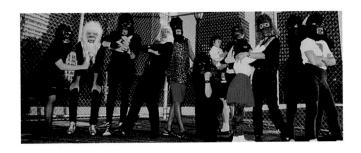

Who are the Guerrilla Girls, and what is their mission? How successful are they in their campaign? Why do the members choose to be anonymous?

ho are they? That's a secret. How many of them are there? That's a secret, too. How do you find them? You don't. You leave a message and, if they wish, they'll find you. If you are fostering sexism or racism in the art world, they'll find you whether you like it or not. They strike without warning, often by night, in the manner of guerrilla fighters, wearing the fierce, menacing head masks of gorillas. Each of them is a working artist, and together they have become a force to be reckoned with. They are the Guerrilla Girls.

The Guerrilla Girls came into being in 1985, shortly after the opening of a huge exhibition at New York's Museum of Modern Art. The show, titled "International Survey of Contemporary Painting and Sculpture," included works by 169 artists, fewer than 10 percent of whom were women. One April morning, residents of lower Manhattan, where many artists live and work, awakened to find copies of a distinctive poster plastered on outdoor walls. In bold type the poster inquired, "WHAT DO THESE ARTISTS HAVE IN COMMON?" Underneath were the names of forty-two prominent artists—all male. The poster text continued, "They all allow their work to be shown in galleries that show no more than 10 percent women or none at all."

More posters followed. One asked, "DO WOMEN HAVE TO BE NAKED TO GET INTO THE MET. MUSEUM?" Another cataloged "THE ADVANTAGES OF BEING A WOMAN ARTIST," a sweetly sarcastic list that included such benefits as "Working without the pressure of success" and "Seeing your ideas live on in the work of others." Prime targets for the Guerrilla Girls' scorn were art critics, museums, and galleries that concentrate attention on white male artists, all but ignoring women and minority artists. The posters

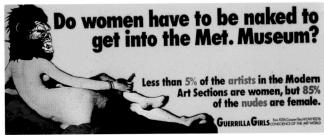

achieved almost instant chic, partly because of their excellent graphic design, partly because of the Guerrilla Girls' aura of mystery.

From posters, the Guerrilla Girls progressed to on-site appearances. Let a museum present a maledominated exhibition, and the Guerrilla Girls were sure to turn up—wearing their gorilla masks (often with short skirts and lacy stockings), waving bananas, making street theater for an appreciative audience. Given such a cleverly designed campaign, media attention was inevitable. Scores of articles about the Guerrilla Girls have been published in newspapers and magazines. They have been interviewed on television and often speak at colleges. They maintain a Web site, www.guerillagirls.com, and have published several books, including *The Guerrilla Girls' Art Museum Activity Book* (2004).

For ease of communication, each of the Guerrilla Girls has taken the name of a noted woman artist who is dead. (Material for this essay was supplied to the author by "Alice Neel.") It is believed that several members of the group are quite well-known artists, but this cannot be proved, because the women never appear in public as Guerrilla Girls without their masks.

The gorilla masks serve a double purpose. Of course, they protect the wearers' identities, but they also put everybody else at a disadvantage. We know these are women, so it is more than a little disconcerting to be confronted with a ferocious, toothy ape face. This effect is no doubt intended. Individually, women artists may lack clout, but the Guerrilla Girls, as a group, know a thing or two about power.

There is no way to determine how much influence the Guerrilla Girls have had in improving prospects for women and minority artists. Still, as every reformer knows, the first step toward making a change is getting attention, and that has been taken care of. The Guerrilla Girls have a great many secrets. Just possibly, one of them may be the secret of success.

Some Guerrilla Girls (left) and one of their posters (right).

RELATED WORKS

10.13 Curtis, Graffiti Archaeology

4.55 Steinkamp, Dervish

9.26 Lialina, Summer

3.27 Wall, A Sudden Gust of Wind

after having been separated. Users cause the conversation to unfold by clicking on the frames. The low speed of the early Internet caused the frames to load slowly and haltingly, expressing a tentative, painful exchange full of silences.

One effect of the new technologies was to expand the possibilities available to video artists. Newly developed digital video projectors allowed videos to be shown at cinematic scale on gallery walls, and digital editing programs gave artists far more control over the final image. One artist quick to take advantage of the new technologies was Bill Viola. In 1992 Viola began to shoot the footage for his works using a high-speed film camera. When footage shot at high speed is projected at a normal rate, it produces the illusion of perfectly smooth slow motion. Viola transfers the slowed film images to high-definition digital video, which he then edits on the computer. The finished video is copied to a disk for projection on a large scale in a gallery or museum installation. One of the first results of this process was *The Greeting* (22.31). In real time, the encounter it captures took 45 seconds. Projected in slow motion, it lasts for 10 minutes, allowing us to savor every detail.

The Greeting begins with two women standing in conversation. A younger woman arrives and is greeted joyfully by one of the first two as the other looks on. The woman who arrives looks as though she is pregnant, and we might assume that this has something to do with the happiness of the occasion. Viola based *The Greeting* on a painting by the Italian Renaissance artist Pontormo that also depicts a gathering of women in voluminous, vibrantly colored

22.31 Bill Viola. *The Greeting*. 1995. Video/sound installation. Color video projection on large vertical screen mounted on wall in darkened space; amplified stereo sound; 14' × 22'8" × 25'7". Performers: Angela Black, Suzanne Peters, Bonnie Snyder. Production still. Photo: Kira Perov

drapery against a dark background with indistinct buildings. The subject of Pontormo's painting is the Visitation, the name for an episode described in the Gospel of Saint Luke when Mary, pregnant with Jesus, visits her older cousin Elizabeth, who will soon give birth to John the Baptist. The Visitation was a standard subject in Renaissance art, and many painters imagined it. By calling his video *The Greeting*, Viola distances it from its specifically Christian model. Yet with painterly lighting and slowed motion he lifts his scene out of the ordinary, suggesting that we are witnessing a sacred moment.

Taking the digital realm as a subject, Terry Winters searched for a way to express in paint the invisible, unquantifiable, overwhelming, abstract entity that has become the central reality of our time: information. *Color and Information* defies conventional categories of representation and abstraction (**22.32**). Winters developed a linear visual language whose basic markings of "I" and "O" reflect the on/off, if/then binary logic of computers. Just as streams of these simple choices generate complicated programs, so Winters used them to create dense, layered paintings that seem to allude at once to a satellite photograph of a city, the twin lobes of the human brain, the circuitry of a computer, the explosion of a galaxy being born, the intricate maze of the World Wide Web, pure energy expanding outward. "I believe it is the first Millennium picture I have seen," wrote one critic when the works were first shown in 1999. ¹⁴ Painting, long written off as dead, suddenly seemed uniquely suited to carry us into the future.

22.32 Terry Winters. *Color and Information*. 1998. Oil and alkyd resin on canvas, 9×12 '. Courtesy the artist and Matthew Marks Gallery, New York

Opening Up to the World

eginning in the 19th century and continuing through the 20th, transportation and communications technologies made possible by science and industry opened up new possibilities for human interaction, compressing our experience of distance and quickening the pace of daily life. "All distances in time and space are shrinking," wrote the German philosopher Martin Heidegger in 1950, referring to the new phenomenon of air travel. "Man now reaches overnight, in planes, places which formerly took weeks and months of travel." Astonished passengers had voiced similar sentiments about rail travel a century earlier. During the 1960s, when television took its place in homes alongside radio and the telephone, the phrase "global village" was proposed to characterize a worldwide community linked by electronic media. Two decades later, "globalization" came into common use to describe an intensified awareness that the world is being woven into a single place, a sensation reinforced on the most intimate level by the personal computer, the Internet, and the World Wide Web.

Over the course of the same centuries, Western ideas about art were taken up and adapted by many cultures around the world. As the countries of Latin America gained their independence across the 19th century, for example, they retained cultural ties with Europe, including artistic exchange. The key movements of European modernism were absorbed and local modern movements flourished, just as they did in the United States. In Japan, renewed contact with the West split Japanese art into two distinct strains for much of the 20th century, one that continued Japan's own traditions, another that developed imported Western concepts. Colonial presences also left Western ideas about art in their wake, as countries in Africa, South Asia, and Southeast Asia achieved independence during the decades following World War II.

As the 20th century drew to a close, the art world—a term that embraces artists, curators, dealers, collectors, journalists, critics, and other professionals—began to expand its international reach. Galleries, museums, and artists established presences on the Internet, and online magazines, newsletters, and blogs about art proliferated. Exhibition spaces opened in such newly energized centers as Tokyo, New Delhi, and Beijing, sometimes linked to galleries in established art-market centers such as New York and London. The venerable and prestigious international biennial exhibitions of new art hosted by Venice (since 1895) and São Paulo (since 1951) were joined by similarly ambitious events in cities such as Sydney, Istanbul, Dakar, Singapore, Shanghai, Moscow, Seoul, and Berlin, creating an expanded network in which art from many points of origin circulates and becomes known. We close this brief survey of

the arts in time by looking at the work of eleven contemporary artists of the globalizing world.

The Nigerian-British artist Yinka Shonibare, MBE, is known for installations featuring headless mannequins dressed in 18th- or 19th-century-style clothing made of colorful "African" cloth (23.1). Cake Man bends under the weight of a tall stack of elaborately decorated cakes that he carries on his back. The gesture he makes with his left hand suggests that he has just tossed the last cake up there. Will the stack topple, or will he try for more? In place of a head he has a smooth black globe that tracks the rise and fall of a skittish stock market. Buy. Sell. Buy. Sell. "Cake Man is essentially about greed, the burden of carrying wealth and never having enough," Shonibare says. "Even though it weighs you down, you still want more."²

The textiles that Shonibare favors have an intriguing history. Though widely used in West Africa for clothing, they are not African in origin. They were first produced around 1900 by the Dutch, who developed them in imitation of the batik cloth made in Indonesia, which was at that time part of their colonial empire. The British soon began producing similar textiles, and both countries marketed them to West Africa, then part of the British and French colonial empires, where they became part of "traditional" dress. Still today, these "typical African" fabrics are made in England and the Netherlands. "Even things that were supposed to represent authentic Africa didn't turn out to fulfill the expectation of authenticity," says Shonibare.³ The textiles invite us to meditate on the complex back-and-forth of these relationships, which destabilize simple ideas about cultural authenticity and national identity. More generally, they serve as the artist's visual marker. "I use the fabric to connect with my audience," he says. "When they see it, they know it's me talking to them, it's like a voice."

Yinka Shonibare is well positioned to explore issues of cultural influence and cross-influence. Born in London to Nigerian parents, he moved to Nigeria

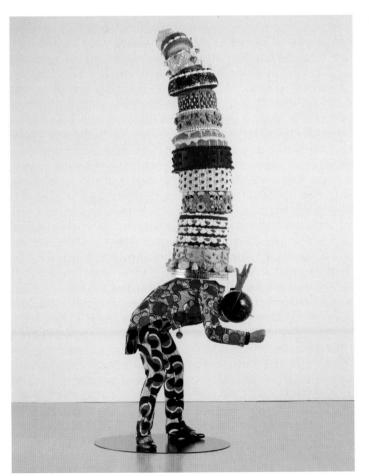

23.1 Yinka Shonibare, MBE. *Cake Man*. 2013. Fiberglass mannequin, Dutch wax-printed cotton textile, plaster, polystyrene, pocket watch, globe, leather, and steel baseplate; height 10'4".

Courtesy Stephen Friedman Gallery and Pearl Lam Galleries

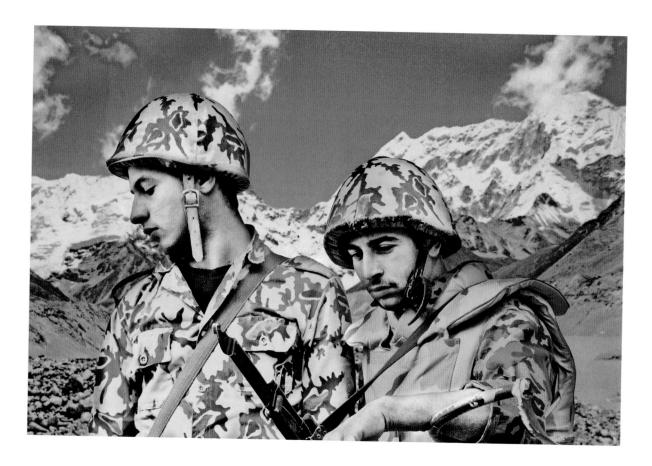

23.2 Nermine Hammam.

Armed Innocence II, from
Cairo Year One: Upekkha. 2011.
Digital print, 24\% × 33\%".
The Deutsche Bank Collection, Berlin

with his family at the age of three, five years after the country had won its independence from Great Britain. Growing up, he spoke Yoruba at home and English at school; the academic year was spent in Africa, but summers were spent in England. "I think those who have actually had that colonial experience shouldn't necessarily be forced to choose one side, because their identity is formed from that mixture," he says. "I see it as making a new kind of global person."

Taking up Shonibare's phrase, our next artist is also a new kind of global person. Born in Egypt, Nermine Hammam was educated in the United Kingdom and the United States before returning to Cairo to live and work. In January of 2011, during the early days of the Egyptian Revolution, Hammam went to Tahrir Square to photograph the arrival of the Egyptian army, which had been called in to guarantee order. Along with the protestors occupying the square, she watched with apprehension as the tanks and military vehicles arrived. But when the hatches opened and the vehicles emptied, what emerged were not the fierce, seasoned fighters she had imagined but soldiers who were little more than boys—wide-eyed, slender, nervous, disoriented.

During the following weeks, as the protests continued under the protection of the army, Hammam photographed the soldiers in unguarded moments of daydreaming, vulnerability, flirtation, and kindness. "By the end of February, the exhaustion on their youthful faces was tangible," she writes. "I wanted to embrace them, to reassure them that everything would be ok. So I transported them to places in which they might find solace. . . . As an act of homage to these gentle youths, I stuck their images on postcards from all the pleasant destinations in the world." Hammam titled her series of photographs *Upekkha*, after the Buddhist practice of equanimity, of maintaining mental serenity in the face of events so as to see things clearly (23.2). In light of subsequent events, the early weeks of solidarity between the army and the protestors is hard to recall, Hammam says. Nevertheless, those moments were real, and with her photographs she wants to project them into the future, so that we may all see clearly.

Issue-driven installations, digitally manipulated photography, performance, video, and conceptually inspired projects have been taken up by artists around the world as part of the global vocabulary of contemporary art. Just as important, however, are artists who continue to work with local cultural forms, renewing them to express contemporary concerns. In Pakistan, students at the National College of Arts in Lahore are required to study traditional Mughal miniature painting for one semester. Some of them become hooked, often to their own surprise.

Imran Qureshi entered the National College of Arts planning to study printmaking, but his professors convinced him that he was unusually gifted for miniature painting, and so he entered the school's rigorous two-year training program. For the first year and a half, students absorb the techniques and visual conventions of Mughal court painting by copying examples from the past. They learn how to make their own brushes and paper and process their own paints. Only during the final months of the program are they allowed to experiment with their own creative direction. In *Blessings Upon the Land of My Love*, Qureshi employs the conventions and techniques of Mughal painting to portray what at first glance appears to be the aftermath of a violent incident (23.3). Something awful has occurred, a suicide bombing or a massacre. A closer look, however, reveals that the pools of blood are composed of radiating petals, like flowers.

23.3 Imran Qureshi. *Blessings Upon the Land of My Love*, detail. 2011. Diptych: gouache and gold leaf on wasli paper; each painting $16\% \times 13\%$ ".

Courtesy the artist and Corvi-Mora, London

23.4 Subodh Gupta. Dada.
2010–14. Stainless steel and stainless steel utensils,
22'3"%" × 30'6%" × 30'6%",
dimensions variable.
Installation view, "Subodh
Gupta. Everything is Inside,"
National Gallery of Modern Art,
New Delhi, India, 2014.
Courtesy the artist and Hauser & Wirth

The painting transposes into other terms an installation of the same name that Qureshi created for a biennial held in the emirate of Sharjah, where he covered a large courtyard with red splatters transformed into blossoms. The immediate inspiration for the works was the brutal murder of two young Pakistani boys, beaten to death by an angry mob in broad daylight as a crowd that included members of the local police looked on. Captured on video, the sickening incident sparked a national outcry. The public's reaction seemed to Qureshi a sign of hope, that some good might come of the violence, that flowers might grow from the bloodshed.

From earliest times in India, the blessings of abundance have been celebrated and embodied in art. Sculptors carved voluptuous *yakshi*, sensuous fertility spirits whose touch causes trees to blossom and bear fruit (see 19.4). The facades of Hindu temples swarm with thousands of carved figures of gods and goddesses, radiating spiritual energy into the world (see 19.8). In works such as *Dada* (23.4), Indian artist Subodh Gupta perpetuates his culture's generous aesthetic of abundance in purely secular terms. Named for the Hindu word for "grandfather" as well as the anarchic European art movement, *Dada* depicts a banyan tree, the national tree of India, bristling with stainless steel pails, canisters, pots, pitchers, bowls, colanders, tiffin carriers, cups, spoons, ladles, and more. Stainless steel vessels are ubiquitous in India, seen in the streets transporting food, used at home for cooking and serving everyday meals. Replacing earlier vessels of pottery or copper, they are shining symbols of progress and rising living standards.

Gupta makes his flamboyant, entertaining art from the everyday objects of Indian culture. "There are times when there is nothing other than what is around us that makes us who we are," he writes. "For me, the great thinkers are the common people, with their everyday existence; their hurried lives and makeshift settlements. You must see this as the place I look to be inspired."

Gupta insists that his sculpture is universal in its appeal, and we can certainly enjoy it purely for the spectacle it offers. Nevertheless, a little knowledge about contemporary India adds a layer of meaning, enriching our experience. In the same way, a little knowledge of Chinese history can enrich our experience of Feng Mengbo's *Long March: Restart* (23.5). The Long March was a famous event in 20th-century Chinese history, an episode from the prolonged civil war that pitted the Red Army of the Chinese Communist Party against the Kuomintang, the army of the Chinese Nationalist Party, for control of the

country. In 1934, encircled by the Kuomintang and certain that an attack was imminent, the Red Army decided on a tactical retreat. Breaking through the encirclement, they headed first west and then north, covering some 8,000 miles of often difficult terrain in 370 days. The march marked the rise to prominence of Mao Zedong, who established the People's Republic of China when the Red Army, now called the People's Liberation Army, finally triumphed in 1949.

Long March: Restart is an interactive video game installation based on the Long March—but not too closely. The player character, a Red Army soldier, uses such unconventional weapons as Coca-Cola cans and faces such unhistorical enemies as space aliens, demons, and fireball monsters. Projected on an enormous screen approximately 20 feet in height and 80 feet long, Long March: Restart dwarfs the gamer and onlookers, who have to dash to keep up with the soldier as he zips along from one challenge to another. Feng Mengbo created Long March: Restart using the 8-bit technology of the side-scrolling video games of the 1980s. East meets West and communism meets capitalism as icons, scenes, and characters drawn from popular video games of the time mingle with Chinese landmarks, slogans, and characters and famous historical images such as Red Square in Moscow and the American moon landing. Long since superseded, the primitive 8-bit technology is by now an object of nostalgia, giving Long March: Restart the look of an archaic, if much-loved, game from the past.

The past is a difficult subject in Cambodia, where almost a quarter of the population died of starvation, overwork, torture, or execution during the brutal four-year rule of the Khmer Rouge. Cambodian sculptor Sopheap Pich was a young child when the Khmer Rouge came to power in 1975. Four years later his family fled to a refugee camp on the Thai border, and in 1984 they came as refugees to the United States. Pich eventually studied art, earning a

Master's degree in 1999. In 2002 he moved back to Cambodia.

Pich had been a painter in America, but when he returned to Cambodia, paint and contemporary painting no longer seemed so relevant. He turned instead to two of the most common materials of Cambodian village life, rattan and bamboo, and he began weaving them into sculptural forms. "I sensed I was free from the art history that I knew," he recalls. "Working slowly, I gave up notions of what the final work should be like and what the forms meant." Pich's first woven sculptures were based on the forms of inner organs, reflecting his time as a pre-med student, before he turned to art. He has made Buddhist images as well as memory sculptures of things he saw as a child during the Khmer Rouge years, but he resists pressure to address that time more directly in his work. "I don't believe I went through or saw the trauma the others did," he says simply. "I don't have an adult reading of it . . ."

9.27 Cao Fei, i.Mirror 4.41 Do Ho Suh, Reflection 10.10 SenseTeam, poster for X Exhibition

23.5 Feng Mengbo. Long March: Restart. 2008. Video game (color, sound), custom computer software, wireless game controller; dimensions and duration variable. The Museum of Modern Art, New York. © Feng Mengbo, courtesy Hanart TZ Gallery

More recently, Pich has been making nonrepresentational works that hover between painting and sculpture. An example is *Fertile Land* (23.6). Made of bamboo from the countryside and rattan harvested in the mountains, its grid crossings secured with tight twists of wire, *Fertile Land* is painted with earth pigments that Pich gathers on travels around Cambodia and mixes with such materials as charcoal, warmed wax, and resin made by boiling sap. Burlap from used rice bags adds texture. Works such as *Fertile Land*, says Pich, "represent for me a kind of distillation of emotion, of remembrance, of reflections on what has influenced me, or the places I have been."

Like many artists today, Japanese artist Kohei Nawa works in series, each generated by a particular idea or strategy. For his series *PixCell (Beads)*, Nawa begins by searching Internet auction sites and purchasing an object. He thus knows the object only as a two-dimensional image made of pixels on the computer screen. When he receives the object, now quite real, he covers it with glass, crystal, and acrylic spheres of various sizes (23.7). Like mutant, three-dimensional pixels, the spheres transpose the object back into unreality. We can still sense its broad contours, but detail disappears under the distorting power of the spheres that multiply over the surface. In Nawa's words, the existence of the object is now replaced with a "husk of light" that shows a new vision, the cells of an image, for which he invented the word PixCells.¹¹

Nawa's *PixCell (Beads)* series includes toys, musical instruments, shoes, and numerous taxidermy animals. The animals carry a special charge, since they were once alive, and even as taxidermy they retain a lifelike presence and texture. In the context of traditional Japanese culture, *PixCell-Deer* is especially evocative. In Shinto belief, deer appear as messengers of the *kami*, nature spirits and natural phenomena that are worshiped as sacred beings. Deer are also associated with the Buddha, who gave his first sermon at Deer Park.

As a child, Mexican artist Damián Ortega used to get his older brother in trouble by pestering him to take apart household appliances. As the family toaster lay in dozens of pieces on the counter and his brother was being

23.6 Sopheap Pich. Fertile Land. 2012. Bamboo, rattan, wire, burlap, plastics, beeswax, damar resin, earth pigment, charcoal, oil paint; $7'7'' \times 7'7'' \times 3''$. Courtesy the artist and Tyler Rollins Fine Art, New York

23.7 Kohei Nawa. *PixCell-Deer#24*. 2011. Stuffed deer and artificial crystal glass, height 6'81%6". The Metropolitan Museum of Art, New York

THINKING ABOUT ART IS IT Over?

What does it mean for art to be over? Do you agree? Does it matter? What are the consequences for artists?

In 1984, the American philosopher Arthur Danto published an essay with the provocative title "The End of Art." Almost simultaneously, the German art historian Hans Belting published a slender book called *The End of the History of Art?* Belting's next book, translated into English as *Likeness and Presence*, bore the tantalizing subtitle *A History of the Image Before the Era of Art.* Danto went on to refine his thinking in a series of essays collected as *After the End of Art: Contemporary Art and the Pale of History*.

To judge by the titles, these two prominent thinkers agreed that art arose at a certain moment, lasted for a number of centuries, and then in some sense came to

an end, even though art continues to be made. How are we to understand these assertions?

In his preface to Likeness and Presence, Belting admits that readers may be puzzled by the notion of an "era of art." Readers of this book, however, will understand quite well, for the idea that our modern concept of art has its roots in the Renaissance is now widely acknowledged (see Chapters 2, 12, and 16). According to Belting, whose topic was the sacred images, icons, of Christian Rome, Byzantium, and the Middle Ages, the Renaissance brought a new type of image and a new way of relating to images. Icons had functioned as portals to the sacred realm. The saints and other holy figures they depicted were believed to be literally present. Some icons were believed to be able to work miracles; others were thought to have miraculous origins. The new images of the Renaissance, in contrast, were understood as human creations, works formed by the skill and imagination of artists fluent in the new scientific techniques of perspective and chiaroscuro. The era of art began, and with it the history of art.

In what way can this era be said to be over? Danto often spoke of his encounter with Andy Warhol's *Brillo Box* sculptures, shown for the first time in 1964. Pondering the significance of these works, he came to the conclusion that "What is the essence of art?," the question that had driven modern art since the Post-Impressionists, was not the correct philosophical question to be asking. The deeper question was, "What makes an object a work of art when something that looks virtually identical to it is not a work of art?" What does it mean that Warhol's *Brillo Boxes* are art whereas the Brillo boxes in the storeroom of a supermarket are not?

As Danto points out, the question could not have been asked until it was historically possible for there to be a work of art such as *Brillo Boxes*. But by bringing the question to philosophical consciousness, Warhol effectively brought the history of art to an end: there was no further direction for the history of art to take, no "next" step. Art could henceforth be anything artists and patrons wanted it to be. All that remained was to define it, and that task fell to philosophers.

Art will always be made, for it responds to fundamental human needs. But the story of art as a phenomenon unfolding in history is over. Today's pluralistic art world, with its many simultaneous directions and no clear dominant trend, is a direct result of the end of art.

Andy Warhol. *Brillo Boxes*. 1964. Acrylic paint and silkscreen on wood, each box $17\frac{1}{2} \times 17 \times 14$ ". Museum of Modern Art, New York.

23.8 Damián Ortega. *Harvest*. 2013. Steel sculptures and lamps, dimensions variable.
Courtesy Gladstone Gallery, New York and Brussels

RELATED WORKS

11.30 Saraceno, in orbit

2.21 Donovan, Untitled

scolded, Ortega would be looking at the pieces, fascinated by the idea that these objects that lay before him were also a toaster. Ortega's taste for taking things apart accompanied him into adulthood. Most famously, he dismantled an entire car, a Volkswagen Beetle, and suspended the parts from the ceiling in relative position, as though the car had exploded outward in all directions at once.

Ortega takes apart not only objects but also ideas and systems, always to see how they are made. "I like to think that the importance of objects lies in what they could generate as ideas," he has written. "I once read that, in Sanskrit, the concept of 'thing' is understood as an equivalent of 'event.' I found this incredibly interesting, because it implies playing down the importance of the object to emphasize the importance of its function, its production system, the technology employed in it, and its implications as a cultural and historical product." 12

Harvest finds the artist thinking about language and its representation (23.8). Suspended from the ceiling, close to the floor, twenty-five lengths of steel turn and twist in the air, fragments, it seems, of some disaster that has left them broken and deformed. Each one is lit independently from above. Only if we shift our attention from the sculptures to the shadows they cast does sense begin to emerge: each shadow takes the form of a letter of the alphabet. Ortega asked his mother, a school teacher, to write out the alphabet for him in the beautiful penmanship of her generation and profession. His sculptures reproduce it, but only in shadow. Critics have pointed out the Latin verb for to read, legere, also means to harvest or to gather. In reading, we harvest meaning from symbols, but only after we have the keys we need to decode them. How long might this new alphabet of writhing forms have resisted our attempts to make sense of it? Or might we even have decided that there was no meaning to be found?

Control Room (23.9), by the German photographer Thomas Demand, seems at first glance to be much more straightforward than Ortega's sculpture. And then, suddenly, not. There's something suspicious about it. The texture is everywhere the same—light reflects from all the surfaces in the same way. The monitors on the wall are as matte as the photocopy machine in the foreground. The instruments and gauges have no demarcations or numbers on them. The signs on the wall are blank, mere horizontal stripes of color. An entire layer of decipherable information has been stripped away, leaving us with a composition of colored shapes and forms, strangely familiar yet fundamentally strange.

In fact, *Control Room* is a photograph of a life-size model of a control room constructed entirely of paper. It was built purely to be photographed. Once the photograph was made, the model was destroyed. Demand constructs his three-dimensional paper models after photographs, then translates them back into two dimensions through photography. Unlike the original photographs, which have no definitive size, Demand's works have the scale and force of paintings, sometimes even of murals. *Control Room*, for example, is over 6 feet in height.

For a number of years, Demand selected photographs of rooms in which something historically important had happened, or rooms that appeared in the news. *Control Room*, for example, was based on a news photograph of the interior of the Fukushima Daiichi nuclear power plant taken in 2010, after a meltdown triggered by a tsunami forced workers to evacuate. Lately, with the explosion of private, casual photographs that circulate on the Internet and through social media, Demand has turned his attention to these kinds of images as well, seeing in them a kind of banal, everyday note-taking.

Looking back to the art of the Renaissance, the painter Willem de Kooning once said that "flesh was the reason oil painting was invented." Oil paint is uniquely suited to capturing the luminosity, the translucence, the sensual presence of human skin. An admirer of de Kooning, the young British painter

23.9 Thomas Demand.

Kontrollraum/Control Room. 2011.
C-print/Diasec, 6'6¾" × 9'10".
Courtesy Sprüth Magers

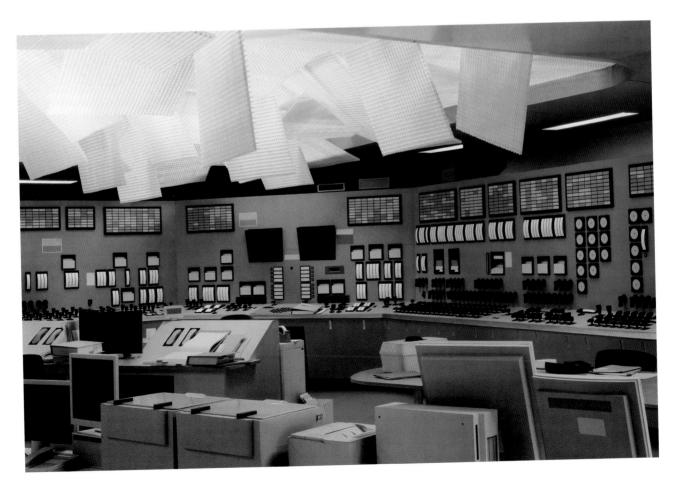

Jenny Saville cites his remark with approval. Flesh is her subject (23.10). Working in a loose, painterly style, Saville paints bodies, women's bodies. She paints them as landscapes of flesh shaped by time, pain, love, desire, illness, deformity, and violence. "I'm trying to find bodies that manifest in their flesh something of our contemporary age," she has said. "I'm drawn to bodies that emanate a sort of state of in-betweeness: a hermaphrodite, a transvestite, a carcass, a half-alive/half-dead head. If they are portraits, they are portraits of an idea or sensation." 14

Saville prefers working from photographs to working from a live model. She collects vast numbers of photographs, some of which she has taken herself, others of which she culls from medical textbooks, forensic science books, and the media. She has observed surgeons at work to understand what it is to cut into and enter a body. Her monumental paintings are often as disturbing as they are compelling. Their scale engulfs the viewer, and Saville intends this. She hopes that viewers will approach until the image dissolves in an intense, all-encompassing awareness of the sensuous physicality of the paint itself and the varied markings and densities on the surface.

Brazilian sculptor Ernesto Neto has said that the space he would most like to create a work for, his ideal interior, would be a cave. Looking at *Leviathan Thot*, a sculpture he was invited to create for temporary installation in the Pantheon in Paris, we can see why he might feel that way (23.11). *Leviathan Thot* transformed the Pantheon's cavernous Neoclassical interior into a sensuous,

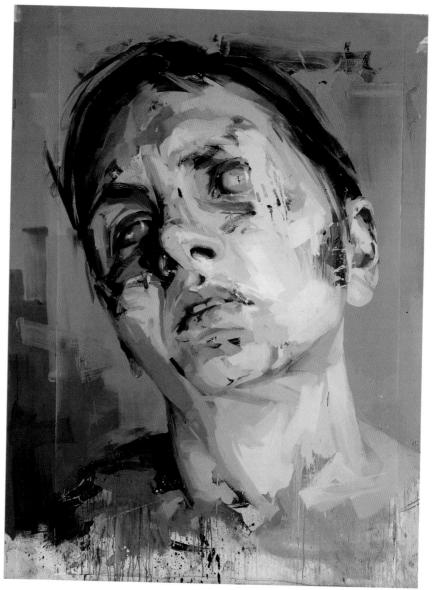

23.10 Jenny Saville. *Rosetta 2*. 2005–06. Oil on watercolor paper, mounted on board; 8'3½" × 6'1¾". © Jenny Saville. Courtesy of Gagosian Gallery, New York

23.11 Ernesto Neto. *Leviathan Thot*. Installation at the Pantheon, Paris, September 15—December 31, 2006. Lycra tulle, polyamide fabric, Styrofoam balls. Courtesy the artist; Tanya Bonakdar

Gallery, New York; and Galeria Fortes

Vilaçca, São Paulo

mysterious place filled with pendulous, organic forms. Weighted by sand and white plastic beads, elongated nylon sacks hung like soft, translucent stalactites from an openwork fabric membrane overhead, stretching it, tugging at it, opening it up in space, here like a web, there like a tent. "Leviathan" names a sea monster. Perhaps it has swallowed us up. The building has become a body, and we are inside.

Neto refers to the sacks in this work as columns, suggesting that we think of them in relation to the building's own columns, some of which are visible in the photograph shown here. The Pantheon's columns push upward against gravity, lifting the load of the vaulted ceilings and the central dome to open up an interior space. Neto's sculpture works with gravity, is created by gravity, which pulls the elements earthward and gives the work form. "Every work I make is always about a relationship," he says. "One element interferes with the other element . . . and the result is a sociability from one to the other, so you should have an interaction that achieves a limit—a precise balance before equilibrium is lost." Neto thinks of his work as a dance, another art of gravity, grace, balance, and interaction. "I always have a plan, but it's like the plan for a journey," he explains. "Once you're on the road, you change things. If nothing changes, if you end up with something that's just as you planned it, then you haven't created art." "16"

Pronunciation Guide

This guide offers pronunciations for names and foreign terms appearing in the text. It uses the sounds available in standard North American English to approximate the original languages. The phonetic system includes the following conventions:

> ah-spa, hurrah air-pair, there an-plan, tan aw-thaw, autumn ay-play, say

dj-jump, bridge i-mirage, barrage eh-pet, get er-her, fur

oh-toe, show

ow-cow, how uh-bus, fuss ye-pie, sky

Aachen AHK-en

Abakanowicz, Magdalena MAG-dah-LAY-nuh

ah-bah-kah-NOH-vitch

Abramović, Marina mah-REE-nuh ah-BRAH-moh-vitch

Akan AH-kahn

Akhenaten AH-keh-NAH-ten

Alberti, Leon Battista LAY-on bah-TEES-tuh ahl-BAIR-tee

Alhambra ahl-AHM-bruh

Alvarez Bravo, Manuel mahn-well AHL-vah-rez BRAH-voh

Amida Nyorai ah-MEE-duh nyoh-RYE

Anatsui, El el ah-nah-TSOO-ee

Andokides ahn-doh-kee-dayz

Angkor Wat ANG-kohr WAHT; also, VAHT

Anguissola, Sofonisba soh-foh-NEEZ-bah ahn-gwee-SOH-lah

Antoni, Janine jah-NEEN an-TOH-nee

Aphrodite ah-froh-DYE-tee

Apoxyomenos ah-PAHK-see-oh-MEN-ohs

Ariwajoye ah-ree-wah-DJOH-yay Arnolfini ahr-nohl-FEE-nee

Artemidoros ar-teh-mee-DOR-ohs

Asante ah-SAHN-tay

Athena Nike uh-THEE-nuh NYE-kee

Aurelius, Marcus aw-REE-lee-oos

auteur oh-TER

Avalokiteshvara ah-vah-loh-kih-TESH-vahr-uh

avant-garde AH-vawn GARD

Badi'uzzaman bah-dee-ooz-(ah)-mahn

Baldessari, John bahl-duh-SAHR-ee

Ban, Shigeru shee-GEH-roo BAHN

Bartholl, Aram BAR-tohl

Basquiat, Jean-Michel ZHAWN-mee-SHELL BAHS-kyah

bas-relief BAH ruh-LYEF

Baule BOW-lay Bayeux bye-YE(r)

Bellini, Giovanni djoh-VAHN-ee bell-EE-nee

Benin beh-NEEN

Bernini, Gianlorenzo djahn-loh-REN-zoh bayr-NEE-nee

Beuys, Joseph YOH-sef BOYZ

Bilbao bil-BAH-oh

Boccioni, Umberto oom-BAIR-toh boh-CHOH-nee

bodhisattva boh-dih-sur-vuh

Borromini, Francesco frahn-CHESS-koh boh-roh-MEE-nee

Bosch, Hieronymus heer-AHN-ih-mus BAHSH Botticelli, Sandro SAN-droh bot-ee-CHEL-ee

Bourgeois, Louise boor-IWAH

Brancusi, Constantin KAHN-stan-teen BRAHN-koosh;

also, brahn-KOO-zee

Braque, Georges jorj BRAHK

Breuer, Marcel mahr-SELL BROY-er

Bronzino, Agnolo AHN-yoh-loh brahn-zee-noh Bruegel, Pieter PEE-tur BROO-g'l; also, BROY-g'l

Bruggen, Coosje van KOHSH-yuh fahn BRUHK-en

buon fresco boo-ohn fres-koh

Byodo-in BYOH-doh-een

camera obscura KAM-er-uh ob-SKOOR-uh

Campin, Robert KAHM-pin

Cao Fei tsow fay

Caravaggio kah-rah-vah-djoh

Cartier-Bresson, Henri awn-ree KAR-tee-ay bress-AWN

Cézanne, Paul POHL say-ZAHN

Chartres SHAR-tr'

Chauvet cave shoh-VAY

chiaroscuro kee-AH-roh-SKOOR-oh

Cimabue chee-mah-BOO-av

contrapposto trah-POH-stoh

Copley, John KAHP-lee

Córdoba KOR-doh-buh

Courbet, Gustave goos-TAHV koor-BAY

Cuvilliés, François de FRAWN-swah koo-veel-yay

Daguerre, Louis Jacques Mandé loo-ee JAHK

mahn-DAY dah-GAIR

Dalí, Salvador sal-vah-DOHR DAH-lee

Dasavanta duh-shuh-vuhn-tuh

David, Jacques-Louis jahk loo-ee dah-veed

De Chirico, Giorgio DJOR-djoh deh-KEER-ee-koh

Degas, Edgar ed-GAHR deh-GAH

de Kooning, Willem VILL-um duh KOON-ing

Delacroix, Eugène uh-ZHEN duh-lah-KWAH

Delaunay, Sonia SOH-nya deh-low-nay

Demand, Thomas DAY-mahnt

De Maria, Walter dih-MAH-ree-uh

diptych DIP-tik

dipylon DIH-pih-lon

Dogon doh-GAWN

Donatello dohn-ah-TELL-oh

Duccio DOO-choh

Duchamp, Marcel mahr-SELL doo-SHAWM

Dürer, Albrecht AHL-brekt DOOR-er

Eakins, Thomas Ay-kins

facade fuh-SAHD

Fante FAHN-tay

Fauve fohv

Feng Mengbo fung mung-boh

Flavin, Dan FLAY-vin

Fragonard, Jean-Honoré jawn AW-nor-ay FRA-goh-nahr Francesco di Giorgio Martini frahn-CHES-koh dee

DJOR-djoh mahr-TEE-nee

Frankenthaler, Helen FRANK-en-thahl-er

fresco secco FRES-koh SEK-oh

Gauguin, Paul POHL goh-GAN

Genji Monogatari GEHN-jee mohn-oh-geh-TAHR-ee

Gentileschi, Artemisia ahr-tuh-MEE-zhuy djen-teel-ESS-kee

Géricault, Théodore tay-oh-DOHR jay-ree-KOH Ghiberti, Lorenzo loh-REN-zoh gee-BAIR-tee Giacometti, Alberto ahl-BAIR-toh jah-koh-MET-ee

Giorgione djor-DJOH-nay

Giotto DJOH-toh

Godard, Jean-Luc jaw(n)-look goh-dahr Gonzales-Torres, Felix gawn-zah-layss toh-rayss

gouache gwahsh

Goya, Francisco de frahn-siss-koh day Goy-ah

Grien, Hans Baldung GREEN

grisaille gree-ZYE

Grosse, Katharina kah-tah-REE-nah GROH-suh

Grotjahn, Mark GROHT-djahn

Grünewald, Matthias mah-TEE-ess GROON-eh-vahlt

Guanyin gwahn-YEEN Guernica GWAIR-nih-kuh Gu Kaizhi goo kye-IR

Gupta, Subodh soo-bohd GOOP-tuh Hadid, Zaha ZAH-hah hah-DEED Hagia Sophia HYE-uh soh-FEE-uh Hamzanama HAHM-zah-NAH-mah

Hammam, Nermine nair-MEEN hah-MAHM Haruka Kojin HAH-roo-kah KOH-djin

Hasegawa Tohaku HA-suh-gah-wuh TOH-hah-koo

Hatoum, Mona hah-TOOM

Heian hay-AHN

Heiji Monogatari HAY-djee mohn-oh-geh-TAHR-ee

Heringer, Anna ah-nah HAIR-ring-ger

Hesse, Eva AY-vuh HESS

Hiroshige, Ando AHN-doh heer-oh-SHEE-gay Hokusai, Katsushika kat-s'-SHEE-kah HOH-k'-sye

Holbein, Hans HAHNS HOHL-byne

Hon'ami Koetsu HOH-nah-mee ko-EH-tsoo

Horyu-ji hor-yoo-djee Huizong hway-DZUNG hypostyle HYE-poh-styel

Ife EE-fay ijele ee-JAY-lay Inca ING-keh Iktinos IK-tin-ohs

Ingres, Jean-Auguste-Dominique jawn oh-GOOST

dohm-een-EEK ANG-gr' intaglio in-TAHL-yoh

Iraj EE-raj Ise EE-say

iwan EE-wahn

Jacquette, Yvonne ee-VAHN dja-KET

Jahangir ja-HAHN-GEER

Jain DJAYN

Inanadakini ee-NUH-nuh-DUH-kee-nee

Iocho DIOH-CHOH

Kabakov, Ilya and Emilia EEL-yah and ay-MEEL-yah

кан-boh-kawf

Kaiho Yusho kah-ee-hoh yoo-shoh

Kaikei kye-kay Kairouan KAIR-wahn Kalf, Willem VIL'm KAHLFF Kallikrates kah-LIK-rah-teez

Kandariya Mahadeva kahn-DAHR-yuh mah-hah-DAY-vuh

Kandinsky, Vasili vah-SEE-lee kan-DIN-skee

Kano Eitoku KAH-no ay-TOH-koo

kente KEN-tay

Khamerernebty kah-mair-air-NEB-tee

Khurd, Madhava MAH-duh-vuh KOORD-(uh)

Khusrau koos-ROW

Kiefer, Anselm AHN-zelm KEE-fur

Kirchner, Ernst Ludwig AYRNST LOOT-vik KEERSH-nur

Klee, Paul KLAY

Klimt, Gustav Goos-tahv KLEEMT

Knossos NAW-sos

Kollwitz, Käthe KAY-tuh KOHL-vitz

Kruger, Barbara KROO-ger

Kuma, Kengo KENG-goh KOO-mah Kusama, Yayoi yah-yoy k'-SAH-mah

Lakshmana LAHK-shmah-nah

lav-AH-coh-un

Lascaux las-COH

Le Brun, Charles sharl le-bru(N)H Le Corbusier luh KOHR-boo-(zee)-AY

Léger, Fernand fayr-NAHN lay-JAY

Leonardo da Vinci lay-oh-NAHR-doh dah VEEN-chee Leyster, Judith YOO-dit LYE-stur

Lialina, Olia OH-lee-ah lee-ah-LEE-nah Li Cheng lee CHENG

Ligon, Glenn LYE-gun Limbourg lam-BOOR

Lippi, Filippino fee-lee-PEE-noh LEEP-pee

Louvre LOOV-r' Lysippos lye-sip-os

Machu Picchu MAH-choo PEEK-choo Magritte, René reh-NAY ma-GREET

Mahavira mah-hah-VEE-ruh

Manet, Edouard ayd-WAHR mah-NAY

Manohar mah-NOH-hahr

Mapplethorpe, Robert MAY-p'l-thorp

Martínez, María & Julian mah-REE-uh & HOO-(lee)-ahn

mahr-TEE-nez

Masaccio mah-ZAH-choh

Matisse, Henri ahn-REE mah-TEES

Maya MAH-yah

Mehretu, Julie MAIR-eh-too Menkaure men-kow-ray Mesa Verde MAY-suh VAIR-day Messager, Annette MESS-ah-JAY

mezzotint MET-zoh-tint

Michelangelo mye-kel-AN-jel-oh; also, mee-kel-AHN-jel-oh

mihrab MI-hrahb

Milhazes, Beatriz bay-ah-TREEZ meel-YAH-zess

Mimbres MIM-bres

Miró, Joan HWAHN meer-OH

Moche MOH-chay

Modersohn-Becker, Paula MOH-der-zun BEK-er

Mondrian, Piet PEET MOHN-dree-ahn Monet, Claude CLOHD moh-NAY Morisot, Berthe BAYR-t' mohr-ee-ZOH Muafangejo, John MOO-fahn-geh-joh

Mughal MOO-gahl

Munch, Edvard ED-vahrd MOONK

Murakami, Takashi tah-KAH-shee moo-ruh-KAH-mee

Muromachi MOOR-oh-MAH-chee

Mutu, Wangechi wang-GAY-shi moo-too Muybridge, Eadweard ED-werd MY-bridj Mycenae my-seen-ay, or my-seen-ee

Nefertiti NEF-er-TEE-tee

Nepomuceno, Maria nap-oh-moo-SAY-noh

Neto, Ernesto NET-toh

Nicéphore Niépce, Joseph NEE-say-for n'YEPS

Ni Zan nee DZAHN

nkisi nkondi en-KEE-see en-KOHN-dee

Noguchi, Isamu EE-sah-moo noh-GOO-chee

Notre-Dame-du-Haut NOH-tr' DAHM doo OH

Ofili, Chris oh-FEE-lee

Oldenburg, Claes klahs

Olmec OHL-mek

Olowe of Ise OH-loh-way of EE-say

Osorio, Pepón pay-POHN oh-ZOH-ree-oh

Paik, Nam June nahm djoon PYEK

Palenque pah-LENG-kay

Pantokrator pan-TAW-kruh-ter

Pettibon, Raymond PEH-tee-bahn

Piano, Renzo PYAH-noh

Picabia, Francis frahn-SEES pee-KAH-byuh

pointillism PWAN-tee-ism; also, POYN-till-izm

Pollock, Jackson PAHL-uck

Pompeii pahm-PAY

Pont du Gard pohn doo GAHR

Poussin, Nicolas nee-coh-LAH poo-SAN

qibla KIB-luh

Qur'an koor-'AHN

Rae, Fiona fee-OH-nuh RAY

raigo rye-GOH

Rama RAH-mah

Raphael RAHF-yell; also, RAF-fye-ell

Rathnasambhava ruht-nuh-SUHM-buh-vuh

Rauschenberg, Robert ROW-shen-burg

Renoir, Pierre-Auguste pyair oh-GOOST rehn-WAHR

Rheims RANS

rhyton RYE-ton

Riemenschneider, Tilman TEEL-mahn REE-men-shnye-der

Rietveld, Gerrit GAY-rit REET-velt

Rivera, Diego dee-AY-goh ree-VAIR-uh

Rococo roh-coh-coh

Rodin, Auguste oh-GOOST roh-DAN

Romero, Betsabeé bet-sah-BAY roh-MAIR-roh

Rongxi rong-HSEE

Rousseau, Henri (le Douanier) ahn-REE roo-SOH

(luh dwahn-YAY)

Ruscha, Ed roo-SHAY

Ryoan-ji RYOH-ahn-djee

Sainte-Chapelle sant shah-PELL

Sainte-Foy sant FWAH

San Vitale san vee-TAHL-ay

Sassetta sah-seh-tuh

Saville, Jenny SA-vil

Sesshu SESS-yoo

Seurat, Georges jorj sur-RAH

sfumato sfoo-MAH-toh

Shiva Nataraja SHEE-vuh NAH-tah-rah-juh

Shonibare, Yinka YING-kuh shoh-nee-BAHR-ay

Shravana SHRUH-vuh-nuh

Sikander, Shahzia SHAHZ-yuh sik-AN-dur

Singh, Raghubir RAH-goo-beer SING

Sotatsu, Nonomura noh-noh-moor-ah soh-taht-s'

Stieglitz, Alfred STEEG-litz

stupa STOO-puh

Suh, Do Ho doh hoh suh

al-Suhrawardi, Ahmad AHK-mahd ah-soo-rah-WAHR-dee

Sze, Sarah zee

Taj Mahal tahj meh-HAHL

tathagata tah-tah-GAH-tah

Teotihuacán tay-OH-tee-hwah-CAHN

Titian TISH-an; also, TEE-shan

Todai-ji toh-DYE-djee

Toulouse-Lautrec, Henri de awn-REE duh too-LOOZ

loh-TREK

trompe-l'oeil tromp-LOY

Tufte, Edward TUHF-tee

Tutankhamun toot-an-KAH-mun

Utamaro, Kitagawa kee-TAH-gah-wuh oo-TAH-mah-roh

Utzon, Joern yern oot-suhn

Valdés Leal, Juan de (hoo)-AHN day vahl-DAYS lay-AHL

Van der Weyden, Rogier roh-JEER van dur VYE-den

Van Eyck, Jan YAHN van IKE

Van Gogh, Vincent van GOH; also, van GAWK

Van Ruisdael, Jacob YAH-cub van ROYS-dahl

Velázquez, Diego DYAY-goh vay-LASS-kess

Vermeer, Johannes yoh-HAH-ness vair-MAYR; *also*, vair-MEER

Verrocchio, Andrea del ahn-DRAY-ah del veh-ROH-kyo

Versailles vair-SYE

Vigée-Lebrun, Elisabeth ay-leez-eh-BETT vee-JAY

leh-BRUN

Vishnu VISH-noo

Wang Jian wang JYAHN

Watteau, Antoine ahn-TWAHN wah-TOH; also, vah-TOH

Willendorf VILL-en-dohrf

Wojnarowicz, David voy-nyah-ROH-vitz

Xoc shawk

Yoruba YAW-roo-buh

Yucatán yoo-cuh-TAN

Zahadolzha zah-ha-DOHL-jah

Zhao Mengfu jow meng-FOO

Zhou Dynasty JOH

ziggurat zig-oor-aht

Zynsky, Toots ZIN-skee

Suggested Readings

ON THE INTERNET

Many of the museums credited in the captions to the images in this book maintain Web sites. The most extensive museum sites offer a variety of resources such as online collections, thematic tours, timelines, informative texts and essays, glossaries, artists' biographies, video clips, and podcasts. Sites worth exploring in depth include those of the Metropolitan Museum of Art (metmuseum.org), the Museum of Modern Art (moma.org), the museums of the Smithsonian Institution (si.edu), the Art Institute of Chicago (artic.edu), the Nelson-Atkins Museum of Art (nelson-atkins.org), and the J. Paul Getty Museum (getty.edu). Links to museums around the world can be found at artcyclopedia.com under "Art Museums Worldwide."

Most of the galleries credited in the captions maintain Web sites where recent works by contemporary artists can be viewed. Articles and press releases about the work may also be featured. Many individual artists maintain Web sites, as do a number of periodicals, including *Artforum*, *Art in America*, and *ARTnews*.

YouTube and other video-sharing sites feature numerous interviews with artists, tours of installations and works of architecture, and clips of video art. Particularly noteworthy is the United Nations Educational, Scientific, and Cultural Organization channel (UNESCO TV, www.youtube.com/user/unesco), which features videos of designated World Heritage properties such as the Alhambra and the Taj Mahal, and videos of Intangible Heritage such as African masquerades.

The Google Art Project (googleartproject .com) brings together more than 32,000 works from over 150 participating institutions. Images labeled "gigapixel" can be enlarged to show details so fine they escape the naked eye. Many of the institutions can also be explored room by room, showing how artworks are installed in their galleries.

GENERAL REFERENCE

- Barnet, Sylvan. *A Short Guide to Writing about Art*, 11th ed. Upper Saddle River, NJ: Pearson, 2015.
- Chilvers, Ian. The Oxford Dictionary of Art and Artists, 4th ed. Oxford: Oxford University Press, 2009.
- Clarke, Michael. *The Concise Dictionary of Art Terms*, 2nd ed. Oxford: Oxford University Press, 2010.
- Nelson, Robert S., and Richard Shiff, eds. *Critical Terms for Art History,* 2nd ed. Chicago: University of Chicago Press, 2003.
- Turner, Jane, ed. *The Dictionary of Art.* 34 volumes. Oxford: Oxford University Press, 2003. Also available online by subscription at www.oxfordartonline.com.

PART 1

INTRODUCTION

- Anderson, Richard L. *Calliope's Sisters: A Comparative Study of Philosophies of Art,*2nd ed. Upper Saddle River, NJ:
 Pearson, 2004.
- Arnheim, Rudolf. Visual Thinking. 1969. Berkeley: University of California Press, 2004.
- Carroll, Noel, ed. *Theories of Art Today*. Madison: University of Wisconsin Press, 2000.
- Dissanayake, Ellen. *Homo Aestheticus: Where Art Comes From and Why.* Seattle:
 University of Washington Press, 1995.
- Dutton, Denis. *The Art Instinct: Beauty, Pleasure, and Human Evolution*. New York:
 Bloomsbury Press, 2009.
- Eldridge, Richard. An Introduction to the Philosophy of Art. Cambridge: Cambridge University Press, 2003.
- Freeland, Cynthia. Art Theory: A Very Short Introduction. Oxford: Oxford University Press, 2007.
- Shiner, Larry. *The Invention of Art: A Cultural History*. Chicago: University of Chicago Press, 2001.
- Shipps, Steve. (Re)Thinking "Art": A Guide for Beginners. Oxford: Blackwell, 2008
- Staniszewski, Mary Anne. Believing Is Seeing: Creating the Culture of Art. New York: Penguin Books, 1995.

PART 2

THE VOCABULARY OF ART

- Albers, Josef. Interaction of Color, 1963. New Haven: Yale University Press, 2006. Arnheim, Rudolf. The Power of the Center: A Study of Composition in the Visual Arts. 1988. Berkeley: University of California Press, 2009.
- Elam, Kimberly. Geometry of Design: Studies in Proportion and Composition, 2nd ed. New York: Princeton Architectural Press, 2011.
- Gage, John. Color and Meaning: Art, Science, and Symbolism. Berkeley: University of California Press, 1999.
- Puttfarken, Thomas. *The Discovery of Pictorial Composition*. New Haven: Yale University Press, 2000.

PART 3

TWO-DIMENSIONAL MEDIA

- Baldwin, Gordon. Looking at Photographs: A Guide to Technical Terms, rev. ed. Los Angeles: J. Paul Getty Museum, 2009.
- Barsam, Richard. *Looking at Movies: An Introduction to Film, 4th ed. New York: Norton, 2012.*
- Clarke, Graham. *The Photograph*. Oxford: Oxford University Press, 1997.
- Doherty, Tiama, and Anne T. Woollett. Looking at Paintings: A Guide to Technical Terms, 2nd ed. Los Angeles: J. Paul Getty Museum, 2009.
- Eskilson, Stephen J. *Graphic Design: A New History*, 2nd ed. New Haven: Yale University Press, 2012.
- Fuga, Antonella. Artists Techniques and Materials. Oxford: Oxford University Press, 2006.
- Greene, Rachel. *Internet Art.* London: Thames & Hudson, 2004.
- Hirsch, Robert. Seizing the Light: A Social History of Photography, 2nd ed. New York: McGraw-Hill, 2008.
- Krug, Margaret. An Artist's Handbook: Materials and Techniques. London: Laurence King, 2012.
- Lambert, Susan. *Prints: Art and Techniques.* London: V&A Publications, 2001.
- Paul, Christin. *Digital Art*, 2nd ed. London: Thames & Hudson, 2008.
- Rush, Michael. *New Media in Art*, 2nd ed. London: Thames & Hudson, 2005.

THREE-DIMENSIONAL MEDIA

- Ballantyne, Andrew. Architecture: A Very Short Introduction. Oxford: Oxford University Press, 2002.
- Beardsley, John. *Earthworks and Beyond: Contemporary Art in the Landscape,*4th ed. New York: Abbeville Press, 2006.
- Bishop, Claire. *Installation Art: A Critical History*. New York: Routledge, 2005.
- Ching, Francis D. K. A Visual Dictionary of Architecture, rev. and expanded ed. Hoboken, NJ: Wiley, 2011.
- Cooper, Emmanuel. *Ten Thousand Years of Pottery*, 4th ed. Philadelphia: University of Pennsylvania Press, 2010.
- Fariello, M. Anna, and Paula Owen, eds., Objects and Meaning: New Perspectives on Art and Craft. Lanham, MD: Scarecrow Press, 2004.
- Gissen, David, ed. Big & Green: Toward Sustainable Architecture in the 21st Century. New York: Princeton Architectural Press; Washington, D.C.: National Building Museum, 2002.
- Harris, Jennifer, ed. 5000 Years of Textiles. 1993. Washington, DC: Smithsonian Books. 2011.
- Iwamoto, Lisa. Digital Fabrications: Architectural and Material Techniques. New York: Princeton Architectural Press, 2009.
- Kaplan, Wendy. The Arts and Crafts Movement in Europe and America: Design for the Modern World. New York: Thames & Hudson in association with the Los Angeles County Museum of Art, 2004.
- Keverne, Roger, ed. *Jade*. Leicester: Annessa, 2010.
- Magliaro, Joseph, and Shu Hung, eds., *By Hand: The Use of Craft in Contemporary Art*. New York: Princeton Architectural

 Press, 2007.
- Mills, John W. *Encyclopedia of Sculpture Techniques*. London: B. T. Batsford, 2005.
- Raizman, David. *History of Modern Design,* 2nd ed. Upper Saddle River, NJ: Pearson, 2010.
- Salvadori, Mario. *Why Buildings Stand Up*. New York: Norton, 2002.
- Schoesser, Mary. World Textiles: A Concise History. London: Thames & Hudson, 2003.
- Shepheard, Paul. What Is Architecture? An Essay on Landscapes, Buildings, and Machines. Cambridge, MA: The MIT Press, 1994.
- Stang, Alanna, and Christopher Hawthorne.

 The Green House: New Directions in

 Sustainable Architecture. New York:

 Princeton Architectural Press, 2005.
- Tait, Hugh. Five Thousand Years of Glass, rev. ed. Philadelphia: University of Pennyslvania Press, 2004.
- Trench, Lucy, ed. *Materials and Techniques in the Decorative Arts: An Illustrated Dictionary.* Chicago: University of Chicago Press, 2000.

- Williams, Arthur. The Sculpture Reference Illustrated: Contemporary Techniques, Terms, Tools, Materials, and Sculpture. Gulfport, MS: Sculpture Books Publishing, 2005.
- Yonemura, Anne. Lacquer: An International History and Illustrated Survey. New York: Abrams, 1984.

PART 5

ARTS IN TIME

- Adams, Laurie Schneider. Art across Time, 4th ed. New York: McGraw-Hill, 2010.
- Arnason, H. H., and Elizabeth Mansfield. History of Modern Art, 7th ed. Upper Saddle River, NJ: Pearson, 2012.
- Arnold, Dieter, *The Encyclopedia of Ancient Egyptian Architecture*. Princeton: Princeton University Press, 2003.
- Aruz, Joan, ed. Art of the First Cities: The Third Millennium B.C. from the Mediterranean to the Indus. New York: The Metropolitan Museum of Art, 2003.
- Bahn, Paul G. *The Cambridge Illustrated History of Prehistoric Art.* Cambridge, UK:
 University of Cambridge Press, 1998.
- Bailey, Gauvin. *Baroque & Rococo*. London: Phaidon, 2012.
- Beard, Mary, and John Henderson. Classical Art: From Greece to Rome. Oxford: Oxford University Press, 2001.
- Berlo, Janet. *Native North American Art*. Oxford: Oxford University Press, 1998
- Blair, Sheila, and Jonathan Bloom. *The Art* and Architecture of Islam, 1250–1800. New Haven; London: Yale University Press, 1994.
- Blier, Suzanne. *The Royal Arts of Africa: The Majesty of Form.* New York:
 Abrams, 1998.
- Bradley, Richard. *Image and Audience:*Rethinking Prehistoric Art. Oxford: Oxford
 University Press, 2009.
- Brend, Barbara. *Islamic Art.* Cambridge, MA: Harvard University Press, 1991.
- Britt, David. ed. *Modern Art: Impressionism to Post-Modernism.* London: Thames & Hudson, 2008.
- Brown, David Blayney. *Romanticism*. London: Phaidon, 2001.
- Camille, Michael. *Gothic Art: Glorious Visions*. New York: Abrams, 1996.
- Chipp, Hershell B. *Theories of Modern Art:*A Source Book by Artists and Critics.
 Berkeley: University of California
 Press, 1984.
- Clark, T. J. The Painting of Modern Life: Paris in the Art of Manet and His Followers, rev. ed. Princeton, NJ: Princeton University Press, 1999.
- Clunas, Craig. *Art in China*, 2nd ed. Oxford: Oxford University Press, 2009.

- Curatola, Giovanni, et al. *The Art and Architecture of Mesopotamia*. New York: Abbeville Press, 2007.
- D'Alleva, Anne. *Art of the Pacific*. London: Weidenfeld and Nicolson, 1998.
- Dawtrey, Liz, et al., eds. *Investigating Modern Art*. New Haven: Yale University
 Press in association with the Open
 University, 1996.
- Dehejia, Vidya. *Indian Art.* London: Phaidon, 1997.
- Eisenmann, Stephen. *Nineteenth-Century Art: A Critical History*, 4th ed. London: Thames & Hudson, 2011.
- Elsner, Jas. *Imperial Rome and Christian Triumph*. Oxford: Oxford University Press, 1998.
- Ettinghausen, Richard, Oleg Graber, and Marilyn Jenkins-Madina. *Islamic Art and Architecture*, 650–1250. New Haven; London: Yale University Press, 2001.
- Gale, Matthew. *Dada and Surrealism*. London: Phaidon, 1997.
- Godfrey, Tony. *Conceptual Art.* London: Phaidon, 1998.
- Harris, Ann Sutherland. Seventeenth Century Art and Architecture, 2nd ed. Upper Saddle River, NJ: Pearson, 2008.
- Hopkins, David. *After Modern Art,* 1945–2000. Oxford: Oxford University Press, 2000.
- Irwin, David. *Neoclassicism*. London: Phaidon, 1997.
- Kraske, Matthew. Art in Europe, 1700–1830. Oxford: Oxford University Press, 1997.
- Lowden, John. Early Christian & Byzantine Art. London: Phaidon, 1997.
- Mason, Penelope. *History of Japanese Art*, 2nd ed. Upper Saddle River, NJ: Prentice Hall, 2005.
- Miller, Mary Ellen. *The Art of Mesoamerica*, 5th ed. London: Thames & Hudson, 2012.
- —— and Megan O'Neil. *Maya Art and Architecture*, 2nd ed. London: Thames & Hudson, 2014.
- Miller, Rebecca Stone. *Art of the Andes: From Chavin to Inca*, 3rd ed. London: Thames & Hudson, 2012.
- Mitter, Partha. *Indian Art*. Oxford: Oxford University Press, 2001.
- Morphy, Howard. *Aboriginal Art.* London: Phaidon, 1998.
- Nash, Susie. *Northern Renaissance Art.* Oxford: Oxford University Press, 2008.
- Osborne, Robin. Archaic and Classical Greek Art. Oxford: Oxford University Press, 1998.
- Paoletti, John, and Gary M. Radke. *Art in Renaissance Italy*, 4th ed. Upper Saddle River, NI: Pearson, 2011.
- Pasztory, Esther. *Aztec Art.* Norman: University of Oklahoma Press, 1998.
- Penny, David W. *Native American*Art. New York: Hugh Lauter Levin,
 1994.

- Robins, Gay. *The Art of Ancient Egypt*, rev. ed. Cambridge, MA: Harvard University Press, 2008.
- Sekules, Veronica. *Medieval Art.* Oxford: Oxford University Press, 2001.
- Snyder, James, rev. L. Silver and H. Luttikhulzen. *Northern Renaissance Art*, 2nd ed. Upper Saddle River, NJ: Pearson, 2005.
- Stanley-Baker, Joan. *Japanese Art*, rev. and expanded ed. London: Thames & Hudson, 2000.
- Stokstad, Marilyn, and Michael W. Cothren. *Art History*, 5th ed. Upper Saddle River, NJ: Pearson, 2010.
- Sullivan, Michael. *The Arts of China*, 5th ed., rev. and expanded. Berkeley: University of California Press, 2009.
- Taylor, Brandon. *Contemporary Art: Art Since* 1970. London: Laurence King, 2012.
- Thapar, Bindia. *Introduction to Indian Architecture*. Singapore: Periplus Editions, 2004.
- Thompson, Belinda. *Impressionism: Origins, Practice, Reception.* London: Thames & Hudson, 2000.
- Visonà, Monica, et al. A History of Art in Africa. 2nd ed. Upper Saddle River, NJ: Pearson, 2008.
- White, Randall. *Prehistoric Art: The Symbolic Journey of Humankind*. New York: Abrams, 2003.
- Zanker, Paul. *Roman Art.* Los Angeles: The J. Paul Getty Museum, 2010.

Notes to the Text

CHAPTER 1

- 1. Quoted in Friedrich Teja Bach, "Brancusi: The Reality of Sculpture," *Brancusi* (Philadelphia Museum of Art, 1995), p. 24.
- 2. Quoted in Liz Dawtrey et al., *Investigating Modern Art* (London: Yale University Press in association with The Open University, 1996), p. 139.
- All quotations in this essay are from Maya Lin, Boundaries (New York: Simon & Schuster, 2000).
- 4. Quoted in Marilyn Stokstad, *Art History* (New York: Abrams, 1995), p. 1037.
- 5. Mark Roskill, ed., *The Letters of Vincent van Gogh* (New York: Atheneum, 1977), p. 188.
- 6. For details about these experiments and for information about creativity in general, see R. Jung et al., "White Matter Integrity, Creativity, and Psychopathology: Disentangling Constructs with Diffusion Tensor Imaging," PLoS ONE, vol. 5, no. 3 (March 2010), www.plosone.org, article ID e9818; Po Bronson and Ashley Merryman, "The Creativity Crisis," Newsweek, July 10, 2010, www.thedailybeast.com/newsweek; Patricia Cohen, "Charting Creativity: Signposts of a Hazy Territory," The New York Times, May 8, 2010, www.nytimes.com; Robert J. Sternberg, "What Is the Common Thread of Creativity? Its Dialectical Relation to Intelligence and Wisdom," American Psychologist, vol. 56, no. 4 (April 2001), pp. 360-62; Mihaly Csikszentmihalyi, "The Creative Personality," Psychology Today, July 1, 1996, www.psychologytoday.com.
- 7. Kelley's account, necessarily truncated here, is well worth reading in its entirety. It can be found in Mike Kelley, *Kandors* (Cologne: Jablonka Galerie; Munich: Hirmer Verlag, 2010), pp. 53–60.

CHAPTER 2

- 1. Letter 489, c. May 19, 1888, from *The Complete Letters of Vincent van Gogh* (London: Thames & Hudson, 1958); quoted in A. M. and Renilde Hammacher, *Van Gogh* (New York: Thames & Hudson, 1982), p. 157.
 - 2. Letter 557, October 24, 1888, ibid., p. 169.
- 3. A thorough examination of the painting undertaken at the museum in 2004 revealed that the panel had indeed been lightly trimmed but that the painted surface is intact, still separated from the edge of the panel by an unpainted margin. There never were any columns. The copyists who added them may have wanted to correct an aspect of the painting that they found strange.
- 4. Quoted in Dore Ashton, *Picasso on Art:* A Selection of Views (New York: Viking, 1972), p. 109.

- 5. Ibid.
- 6. Quotations in this essay are taken from the texts collected in Louise Bourgeois, *Death of the Father, Reconstruction of the Father: Writings and Interviews, 1923–1997* (London: Violette, 1998)
- 7. Cited in Stanley Baron and Jacques Damase, *Sonia Delaunay: The Life of an Artist* (London: Thames & Hudson, 1995), p. 199.
- 8. For the first theory, see Erwin Panofsky, Early Netherlandish Painting, Its Origins and Character (Cambridge MA: Harvard University Press, 1953); for the second, see Edwin Hall, The Arnolfini Betrothal (Berkeley: University of California Press, 1994); for the identity of the sitters, see Lorne Campbell, "Portrait of Giovanni(?) Arnolfini and His Wife," National Gallery Catalogues: The Fifteenth Century Netherlandish Paintings (London: National Gallery Company, Ltd., 1998), pp. 174–211; for the fourth theory, see Margaret L. Koster, "The Arnolfini Double Portrait: A Simple Solution," Apollo, September 2003, pp. 3–14.
- 9. Quoted in "Interview: Dennis Cooper in Conversation with Tom Friedman," *Tom Friedman* (London: Phaidon, 2001), p. 39.

CHAPTER 3

- 1. Robert Rauschenberg, An Interview with Robert Rauschenberg by Barbara Rose (New York: Elizabeth Avedon Editions, 1987), p. 59. Information in this biography is adapted from Robert Rauschenberg (Washington, D.C.: National Collection of Fine Arts, 1976).
- 2. Quoted in "Mexican Autobiography," *Time*, April 27, 1953.
- 3. Quoted in Jud Yalkut, "Polka Dot Way of Life: Conversations with Yayoi Kusama," *NY Free Press* 1, no. 8 (February 15, 1965), p. 9.
- 4. Yayoi Kusama, interview with Brady Turner in *BOMB*, no. 66 (Winter 1999), bombsite.com.
- 5. Yayoi Kusama, interview with Akira Tatehata in *Yayoi Kusama* (London: Phaidon Press, 2000), p. 18.
 - 6. Ibid., p. 28.
- 7. Transcribed from Baldessari's recorded account of this work at www.moma.org/explore/multimedia/audios/34/800.

CHAPTER 4

- 1. Quoted in Jori Finkel, "Shining a Light on Light and Space Art," *Los Angeles Times*, September 18, 2011, www.latimes.com.
- 2. Cited in Henri Dorra and John Rewald, Seurat: L'oeuvre peint, biographie et catalogue critique (Paris: Les Beaux-Arts, 1959), pp. l-li.

- 3. Van Gogh, letter to his brother Theo, September 8, 1888, vangoghletters.org, letter 677.
- 4. J. Gill Holland, ed. and transl., *The Private Journals of Edvard Munch: We Are Flames Which Pour Out of the Earth* (Madison: The University of Wisconsin Press, 2005), pp. 64–65.
- 5. Quoted in Urs Steiner and Samuel Herzog, "'Es kommt auf die Idee an': Ein Gespräch mit der palästinensisch-britischen Künstlering Mona Hatoum," Neue Zürcher Zeitung, November 20, 2004, www.nzz.ch.
- 6. John McCoubrey, ed., American Art, 1700–1960: Sources and Documents (Englewood Cliffs, N.J.: Prentice Hall, 1965), p. 184.
- 7. Quoted in Kynaston McShine, "A Conversation about Work with Richard Serra," in Kynaston McShine and Lynne Cooke, *Richard Serra Sculpture: Forty Years* (New York: The Museum of Modern Art, 2007), p. 33.
- 8. Quoted in Jori Finkel, "I Sing the Clothing Electric," *The New York Times*, April 5, 2009, www.nytimes.com.

CHAPTER 5

- 1. Exhibition catalogue statement, Anderson Galleries, January 29, 1923; quoted in Laurie Lisle, *Portrait of an Artist: Georgia O'Keeffe* (New York: Seaview Books, 1980), p. 66.
- 2. For interpretations based in these and other points of view, see T. J. Clark, *The Painting of Modern Life*, rev. ed. (Princeton: Princeton University Press, 1999); Bradford Collins, ed., 12 Views of Manet's Bar (Princeton: Princeton University Press, 1996); and Novelene Ross, Manet's Bar at the Folies-Bergère and the Myths of Popular Illustration (Ann Arbor: University of Michigan Press, 1982).

CHAPTER 6

- 1. Quoted in Robert Wallace and the Editors of Time-Life Books, eds., *The World of Leonardo* (New York: Time Incorporated, 1966), p. 17.
- 2. Quoted in Sharon F. Patton, *African-American Art* (Oxford: Oxford University Press, 1998), p. 188.
- 3. Taken from the artist's statement in *Slash: Paper Under the Knife* (New York: Museum of Arts and Design, 2009), p. 172.

CHAPTER 7

1. Akbar cited in Vidya Dehejia, *Indian Art* (London: Phaidon, 2000), p. 309; Zhang cited in Richard Barnhardt et al., *Three Thousand Years of*

Chinese Painting (New Haven: Yale University Press, 1997), p. 10; Leonardo cited in Thomas Puttfarken, The Invention of Painting (New Haven: Yale University Press, 2000), p. 105; Calderón de la Barca cited in Anita Albus, The Art of Arts (Berkeley: University of California Press, 2000), p. vii.

- 2. Black Mountain College Records, 1946; quoted in Ellen Harkins Wheat, *Jacob Lawrence: American Painter* (Seattle: Seattle Art Museum, 1986), p. 73.
- 3. Quoted in Ati Maier, "Katharina Grosse," *BOMB*, no. 115 (Spring 2011), www.bombsite.
- 4. Transcribed from Mark Bradford talking about *Black Venus* at pinocchioisonfire.org, a microsite associated with his retrospective exhibition at the Wexner Center for the Arts, Ohio State University, Columbus, Ohio, 2010. (Domain no longer in use.)
- 5. Transcribed from Mark Bradford's audio tour of his retrospective exhibition at the Wexner Center for the Arts, Ohio State University, Columbus, Ohio, 2010.
- 6. This and subsequent quotes are transcribed from *Made in L.A. 2014: Lessons from Channing Hansen's Crib*, a video produced by the Hammer Museum, Los Angeles. As of this writing, it can be found on vimeo.com.
- 7. Quoted in Diana Kamin, "Pae White," 2010: Whitney Biennial (New York: Whitney Museum of American Art, 2010), p. 122.

CHAPTER 8

- 1. Martha Kearns, *Käthe Kollwitz: Woman and Artist* (Old Westbury, N.Y.: Feminist Press, 1967), p. 48.
 - 2. Ibid., p. 164.
- 3. Robert Goldwater and Marco Treves, eds., *Artists on Art: From the Fourteenth to the Twentieth Century* (New York: Pantheon, 1972), p. 82.
- 4. Quoted in Carol Wax, The Mezzotint: History and Technique (New York: Abrams, 1990), p. 15.
- 5. Fiona Rae, "Artist Fiona Rae on How She Paints," *The Observer*, September 19, 2009. Online as "Artist Fiona Rae Loves to Show Off in Paint," www.guardian.co.uk.
- 6. Quoted in Peter Crimmins, "Nothing Virtual About Philagrafika Arts Festival," WHYY News and Information, January 28, 2010, www.whyy.org.
- 7. Quoted in "Cut & Paste, an interview with Swoon," destroythee.wordpress.com, March 27, 2013.
- 8. Quoted in "Swoon: Beauty of Urban Decay," freshnessmag.com, undated (www.freshnessmag.com/content/features/files/1104/swoon).

CHAPTER 9

- 1. Cited in Graham Clarke, *The Photograph* (Oxford and New York: Oxford University Press, 1997), p. 151.
- 2. Raghubir Singh, "River of Colour: An Indian View," in *River of Colour: The India of Raghubir Singh* (London: Phaidon, 1998), p. 15.

- 3. Richard Huelsenbeck's "Dadaist Manifesto" quoted in Matthew Gale, *Dada & Surrealism* (London: Phaidon, 1997), p. 121.
- 4. Quoted in Neal David Benezra, "Surveying Nauman," in Robert C. Morgan, ed., *Bruce Nauman* (Baltimore: Johns Hopkins University Press, 2002), p. 122.
- 5. Quoted in Dorothy Spears, "I Sing the Gadget Electronic," *The New York Times*, May 19, 2011, www.nvtimes.com.
- 6. Quoted in Ossian Ward, "No-Win Ten-Pin Bowling with Cory Arcangel," *Time Out London*, February 10, 2011, www.timeout.com.
- 7. Quoted in Michael Connor, "Olia Lialina, 'Summer' (2013)," *Rhizome*, August 8, 2013, www.rhizome.org.
- 8. From the artist's text about *Map* on his Web site, datenform.de/map.html.

CHAPTER 10

- 1. Quoted in "The Slice of Cake School," *Time*, May 11, 1962, p. 52.
- 2. Quoted in Amy Wallace, "Science to Art, and Vice Versa," *The New York Times*, July 9, 2011, www.nytimes.com.

CHAPTER 11

- 1. Quoted in Peter Boswell, "Martin Puryear," in Martin Friedman et al., Sculpture Inside Outside (New York: Rizzoli, 1988), p. 197.
- 2. Quoted in Helaine Posner, *Kiki Smith/Helaine Posner;* interview by David Frankel (Boston: Bulfinch, 1998), p. 12.
 - 3. Ibid., p. 32.
- 4. Antony Gormley, "The Body Is the Most Potent and Intelligent Object," *The Guardian*, April 22, 2004.
- 5. The suggestion was made by Bradley Lepper. See David Hurst Thomas, Exploring Ancient Native America: An Archaeological Guide (New York: Macmillan, 1994), p. 133.
- 6. Andy Goldsworthy, "Time, Change, Place," *Time* (New York: Abrams, 2000), p. 7.
- 7. Quoted in Arifa Akbar, "From Totalitarianism, to Total Installation," *The Independent*, March 27, 2013, www.independent.co.uk.
- 8. Cited in David Batchelor, *Minimalism* (Cambridge: Cambridge University Press, © 1997 Tate Gallery), p. 55.
- 9. Steven R. Weisman, "Christo's Intercontinental Umbrella Project," *The New York Times*, November 13, 1990, p. C13.

CHAPTER 12

- 1. Susan Peterson, *The Living Tradition of María Martínez* (New York: Kodansha International, 1977), p. 191.
- 2. In conversation with Tina Oldknow in "Meet the Artist: Toots Zynsky," a podcast from the Corning Museum of Glass, April 17, 2007. Available for download at www.cmog.org.
- 3. Quoted in Valérie Bougault, "La Table Cendrillon de Jeroen Verhoeven," *Connaissance des Arts*, September 2009, p. 102. Translation by the author.

4. From the artist's statement on her Web site, www.mereterasmussen.com.

CHAPTER 13

- 1. Frank Lloyd Wright, A Testament (New York: Horizon Press, 1957), p. 64.
- 2. Quoted in Jonathan Glancey, "'I Don't Do Nice,'" *The Guardian*, October 9, 2006, www.guardian.co.uk.
- 3. Quoted in Richard Morrison, "Forever Thinking Outside the Boxy," *The Times*, June 27, 2007, www.timesonline.co.uk.
- 4. Hans Ulrich Obrist, ed., Zaha Hadid/Hans Ulrich Obrist: The Conversation Series (Köln: Verlag der Buchhandlung Walther König, 2007), p.
 - 5. Ibid., p. 91.
- 6. Quoted in Steve Rose, "Profile of Zaha Hadid," *The Guardian*, October 17, 2007, www.guardian.co.uk.
- 7. Ulrich Schneider, "Breathing Architecture—Building for Nomads?" in Volker Fischer and Ulrich Schneider, eds., Kengo Kuma: Breathing Architecture: The Teahouse of the Museum of Applied Arts Frankfurt (Frankfurt: Museum of Applied Arts, 2008), p. 28.
- 8. Anna Heringer, www.anna-heringer.com, home page.
- 9. Quoted in Henry Fountain, "Towers of Steel? Look Again," *The New York Times*, September 23, 2013, www.nytimes.com.

CHAPTER 16

- 1. Quoted in R. Goldwater and M. Treves, eds., Artists on Art: From the Fourteenth to the Twentieth Century (New York: Pantheon, 1972), p. 69.
 - 2. Ibid., p. 70.
 - 3. Ibid., p. 52.
 - 4. Ibid., p. 82.
 - 5. Ibid., p. 30.
 - 6. Ibid., pp. 60-61.
- 7. Quoted in Hans Belting, Likeness and Presence: A History of the Image before the Era of Art (London and Chicago: University of Chicago Press, 1994), p. 465.

CHAPTER 17

1. The Book of Judith is one of the so-called deuterocanonical books, books that do not appear in the Hebrew Bible, the Tanakh. Often cited by the early church fathers, the Book of Judith has officially been considered canonical by the Catholic Church since the Council of Carthage in 397, and thus was included by Saint Jerome in the Vulgate, the Latin translation of the Bible that came to be considered definitive. In shaping the Protestant Bible, Martin Luther moved the deuterocanonical books to the Apocrypha, a collection of adjunct, noncanonical texts. Later Protestant Bibles either follow his example or omit the book altogether. Reacting to the Protestant challenge, the Council of Trent reaffirmed the canonical status of the Book of Judith in 1546. For Gentileschi as for other

Catholic artists—including Michelangelo, who depicted Judith with the head of Holofernes on the Sistine ceiling, and Caravaggio, who painted a particularly gory version of the beheading—the Book of Judith was biblical.

- 2. Artemisia Gentileschi, letter to Don Antonio Ruffo, January 30, 1649, in Mary D. Garrard, *Artemisia Gentileschi: The Image of the Female Hero in Italian Baroque Art* (Princeton: Princeton University Press, 1989), pp. 390–91.
- 3. Artemisia Gentileschi, letter to Galileo Galilei, October 9, 1625, in Garrard, pp. 383–84.
- 4. Artemisia Gentileschi, letter to Don Antonio Ruffo, March 13, 1649, in Garrard, pp. 391–92.
- 5. Joan Kinnier, *The Artist by Himself* (New York: St. Martin's, 1980), p. 101.
- 6. Memoirs of Madame Vigée-Lebrun, trans. Lionel Strachey (New York: Braziller, 1989), pp. 20, 21, 214.

CHAPTER 19

- 1. Elizabeth Ripley, *Hokusai: A Biography* (Philadelphia: Lippincott, 1968), p. 24.
 - 2. Ibid., pp. 62, 68.

CHAPTER 20

- 1. Though widely used by archaeologists since the 1930s, the name Anasazi is problematic, for it was originally a Navajo word meaning an ancient foreign or enemy people. Modern Pueblo peoples have objected to having their probable ancestors named in this way, but they have not yet agreed on an alternative from the numerous Pueblo languages now spoken. Some scholars have suggested referring to the culture as Ancestral Pueblo or Ancient Pueblo, but these, too, are problematic, since pueblo is a Spanish word and thus also imposes an identity from outside, in this case one framed by the region's conquerors and colonizers. Until a suitable alternative has been agreed on, Anasazi will probably remain the standard term, even if we are uneasy with it.
- 2. Quoted in Diana Fane, Objects of Myth and Memory: American Indian Art at the Brooklyn Museum (Brooklyn, N.Y.: The Museum in association with the University of Washington Press, 1991), p. 107.

CHAPTER 21

- 1. Jules-Antoine Castagnary, "Exposition du boulevard des Capucines: Les Impressionnistes," *Le Siècle*, April 29, 1874.
- 2. Gustave Geoffroy, "L'exposition des artistes indépendants," La Justice, April 19, 1881.
- 3. Simon Hantaï, in a conversation reported to the author.

- 4. Quoted in Ian Dunlop, *Degas* (New York: Galley Press, 1979), p. 168.
- 5. Robert Goldwater and Marco Treves, eds., Artists on Art: From the Fourteenth to the Twentieth Century (New York: Pantheon, 1972), p. 413.
- 6. Quoted in Hershel B. Chipp, Theories of Modern Art: A Source Book by Artists and Critics (Berkeley: University of California Press, 1968), pp. 154–55.
 - 7. Goldwater and Treves, p. 421.
- 8. Quoted in William Rubin, Picasso and Braque: Pioneering Cubism (New York: The Museum of Modern Art, 1989), p. 19.
 - 9. Quoted in Chipp, pp. 401-02.
 - 10. Ibid., p. 300.
- 11. Quoted in Christopher Green, *Cubism and Its Enemies* (New Haven and London: Yale University Press, 1987), p. 147.

CHAPTER 22

- 1. Quoted in Irving Sandler, The Triumph of American Painting: A History of Abstract Expressionism (New York: Harper & Row, 1976).
- 2. John Cage, "Experimental Music" (1957), in *Silences* (Middletown, Conn.: Wesleyan University Press, 1961), p. 12.
- 3. Hans Richter, *Dada: Art and Anti-Art* (New York and Toronto: McGraw-Hill Book Company, 1965), p. 213.
- 4. Gretchen Berg, "Andy: My True Story," Los Angeles Free Press March 17, 1967, p. 3; quoted in Andy Warhol: A Retrospective, ed. Kynaston McShine (New York: Museum of Modern Art, 1989), p. 460.
- 5. Frank Stella, "Questions to Stella and Judd," interview with Bruce Glaser, *Art News*, vol. 65, no. 5 (September 1966), pp. 55–61.
- 6. Donald Judd, "Specific Objects," Arts Yearbook 8 (New York, 1965), pp. 74–82.
- 7. Eva Hesse, "A Conversation with Eva Hesse" (1970), interview with Cindy Nemser, reprinted in Mignon Nixon and Cindy Nemser, Eva Hesse (Cambridge, Mass.: The MIT Press, 2002), pp. 21–22.
- 8. Robert Morris, "Notes on Sculpture" (1966), reprinted in Gregory Battcock, ed., *Minimal Art: A Critical Anthology* (Berkeley: University of California Press, 1995), p. 234.
- 9. Walter De Maria, ""The Lightning Field': Some Facts, Notes, Data, Information, Statistics and Statements," *Artforum*, vol. 18, no. 8 (April 1980), p. 52.
- 10. Sol LeWitt, "Paragraphs on Conceptual Art" (1967), reprinted in Gary Garrels, ed., Sol LeWitt: A Retrospective (San Francisco Museum of Modern Art, 2000), pp. 369–71.
- 11. Quoted in Rita Reif, "The Jackboot Has Lifted. Now the Crowds Crush," *The New York Times*, June 3, 2001, www.nytimes.com.
- 12. Quoted in Alan Riding, "Showcasing a Rise from Rebellion to Respectability," *The New York Times*, March 5, 2000.

- 13. "Get the Picture, an interview with Marie de Brugerolle," in Glenn Ligon, Yourself in the World: Selected Writings and Interviews, ed. Scott Rothkopf (New Haven: Yale University Press in association with the Whitney Museum of American Art, New York, 2011), pp. 78–86.
- 14. Ronald Jones, "Notebook," in *Terry Winters: Graphic Primitives* (New York: Matthew Marks Gallery, 1999), p. 44.

CHAPTER 23

- 1. Martin Heidegger, "The Thing" (1950), trans. Albert Hofstadter in *Poetry, Language, Thought* (New York: Harper & Row, 1971), p. 165.
- 2. Quoted in Stephanie Bailey, "Let Them Eat Cake: Interview with Yinka Shonibare," *ArtAsiaPacific*, Blog, January 3, 2014, artasiapacific/blog.
- 3. Quoted in Richard Lacayo, "Decaptivating," *Time*, July 6, 2009, www.time.com.
- 4. Quoted in Coline Milliard, "Yinka Shonibare MBE: Same But Different," Catalogue, issue 1 (September 2009), www.cataloguemagazine.com.
 - 5. Quoted in Bailey.
- 6. From "Uppekha: Artist Statement," downloadable on Hamman's Web site, www.nerminehammam.com.
- 7. Quoted in Subodh Gupta: The Imaginary Order of Things (Málaga: CAC Málaga, 2013), p. 121.
- 8. Quoted in Lisa Pollman, "Interview with Cambodian Artist Sopheap Pich: Sculpting with Bamboo," May 28, 2014, www.theculturetrip.com.
- 9. Quoted in Claire Knox, "Going against the grid: moving art away from the Khmer Rouge," *The Phnom Penh Post*, November 30, 2012, www.phnompenhpost.com.
- 10. Quoted in the press release for the exhibition "Sopheap Pich: Reliefs," Tyler Rollins Fine Art, April 18–June 14, 2013.
- 11. From the artist's description of the project on his Web site, www.kohei-nawa.net.
- 12. Quoted in Damián Ortega and Jessica Morgan, *Do It Yourself: Damián Ortega* (New York: Skira Rizzoli, with Institute of Contemporary Art, Boston, 2009), p. 168.
- 13. Willem de Kooning, "The Renaissance and Order," a lecture given at Studio 35 in 1950 and published in *trans/formation*, vol. 1, no. 2 (New York, 1951), pp. 85–87.
- 14. Simon Schama, "Interview with Jenny Saville," in *Jenny Saville* (New York: Rizzoli, 2005), p. 124.
- 15. "Artworker of the Week #63: Ernesto Neto," an interview with Erin Mann, Kulture-flash, No. 187, December 12, 2006, www.kulture-flash.net.
- 16. Quoted in Dan Horch, "In the Studio: Ernesto Neto," *Art* + *Auction*, May 2008, p. 70.

Glossary

Words in *italics* are also defined in the glossary. Numbers in **bold-face** following the definitions refer to the numbers of figures in the text that illustrate the definitions.

- abstract Descriptive of art in which the forms of the visual world are purposefully simplified, fragmented, or otherwise distorted. Compare representational, naturalistic, stylized, nonrepresentational. (2.14)
- Abstract Expressionism An American art movement of the mid-20th century characterized by large ("heroic") scale and nonrepresentational imagery. An outgrowth of Surrealism, Abstract Expressionism emphasized the artist's spontaneous expression as it flowed from the subconscious, which in turn was believed to draw on primal energies. See also action painting. (22.1)
- acrylic A synthetic plastic resin used as a binder for artists' paints. Also used in the plural to refer to the paints themselves: acrylics. (7.12)
- **action painting** *Nonrepresentational* painting in which the physical act of applying paint to a *support* in bold, spontaneous gestures supplies the expressive content. First used to describe the work of certain *Abstract Expressionist* painters. **(22.1)**
- adobe Sun-dried (as opposed to furnace-baked) brick made of clay mixed with straw. (13.1)
- **aesthetics** The branch of philosophy concerned with the feelings aroused in us by sensory experiences such as seeing and hearing. Aesthetics examines, among other things, the nature of art and the nature of beauty.
- **afterimage** An image that persists after the visual stimulus that first produced it has ceased. The mechanics of vision cause an afterimage to appear in the *complementary* hue of the original stimulus. **(4.30)**
- **aisle** Generally, a passageway flanking a central area. In a *basilica* or cathedral, aisles flank the *nave*. **(15.4)**
- alla prima Italian for "at first." In oil painting, the technique of of painting directly in opaque colors, as opposed to constructing the image gradually by layering underpainting, opaque colors, and glazes over a detailed drawing. Also known as "direct painting" or "wet-on-wet." (7.8)
- **ambulatory** In church architecture, a vaulted passageway for walking (ambulating) around the *apse*. An ambulatory allows visitors to walk around the altar and choir areas without disturbing devotions in progress. **(15.15)**
- analogous harmony The juxtaposition of hues that contain the same color in differing proportions, such as red-violet, pink, and yellow-orange, all of which contain red. (4.29)
- animal style A style in European and western Asian art in ancient and medieval times based in linear, stylized animal forms. Animal style is often found in metalwork. (15.11)
- appropriation A Postmodern practice in which one artist reproduces an image created by another artist and claims it as his or her own. In Postmodern thought, appropriation is felt to challenge traditional ideas about authenticity and individuality, the location of meaning within a work of art, and copyright issues involving intellectual property. (22.24)

- **apse** The semicircular, protruding niche at one or both ends of the *nave* of a Roman *basilica*. In basilica-based church architecture, an apse houses the altar and may be elongated to include a choir. **(15.4)**
- aquatint An *intaglio* printmaking method in which areas of tone are created by dusting resin particles on a plate and then allowing acid to bite around the particles. Also, a *print* made by this method. (8.12)
- arcade In architecture, a series of arches carried on columns or piers. (13.9)
- arch In architecture, a curved structure, usually made of wedge-shaped stones, that serves to span an opening. An arch may be semicircular or rise to a point at the top. (13.9)
- Archaic In the history of ancient Greece, the period between the 8th and the 6th centuries B.C.E., when what would later be leading characteristics of Greek art can be seen in their earliest form. (14.22)
- architrave In Classical architecture, the lowest band of the entablature. (13.5)
- assembling The technique of creating a sculpture by grouping or piecing together distinct elements, as opposed to *casting*, *modeling*, or *carving*. An assembled sculpture may be called an assemblage. (11.13)

asymmetrical Not symmetrical. (5.9)

atmospheric perspective See perspective. (4.48)

- **auteur** French for "author," the word describes a filmmaker, usually a director, who exercises extensive creative control over his or her films, imbuing them with a strong personal style. **(9.19)**
- Baroque The period of European history from the 17th through the early 18th century, and the styles of art that flourished during it. Originating in Rome and associated at first with the Counter-Reformation of the Catholic Church, the dominant style of Baroque art was characterized by dramatic use of light, bold colors and *value* contrasts, emotionalism, a tendency to push into the viewer's space, and an overall theatricality. Pictorial composition often emphasized a diagonal axis, and sculpture, painting, and architecture were often combined to create ornate and impressive settings. (17.1)

barrel vault See vault. (13.10)

basilica In Roman architecture, a standard type of rectangular building with a large, open interior. Generally used for administrative and judicial purposes, the basilica was adapted for early church architecture. Principal elements of a basilica are *nave*, *clerestory*, *aisle*, and *apse*. (15.4)

bas-relief See relief. (11.2)

- **Bauhaus** A school of art and architecture in Germany from 1919 to 1933 whose influence was felt across the 20th century. Bauhaus instructors broke down the barriers between art, craft, and design, and they believed that artists could improve society by bringing the principles of good design to industrial mass production. **(21.28)**
- bay In architecture, a modular unit of space, generally cubic and generally defined by four supporting *piers* or columns. **(13.10)**
- **binder** A substance in paints that causes particles of *pigment* to adhere to one another and to a *support*.

- **Body art** A trend in *Postminimalism* in which the artist's body was used as a medium or material. Body art is a variety of *Performance art.* (9.21)
- buttress, buttressing In architecture, an exterior support that counteracts the outward thrust of an arch, dome, or wall. A flying buttress consists of a strut or arch segment running from a freestanding *pier* to an outer wall. (13.12)
- **cable-staying** In architecture, a structural system in which a horizontal element is supported from above by means of cables that rise diagonally to attach to a vertical mast or tower. **(13.27)**
- **calligraphy** From the Greek for "beautiful writing," handwriting considered as an art, especially as practiced in China, Japan, and Islamic cultures. (19.22)
- cantilever In architecture, a horizontal structural element supported at one end only, with the other end projecting into space. (13.29)
- **capital** In architecture, the decorative sculpted block surmounting a column. In *Classical* architecture, the form of the capital is the most distinctive element of the various *orders*. **(13.3)**
- Carolingian The period in medieval European history dominated by the Frankish rulers of the Carolingian dynasty, roughly 750–850 C.E. In art, the term refers especially to the artistic flowering sponsored by Charlemagne (ruled 800–814). (15.13)
- **cartoon** A full-scale preparatory drawing for a *fresco* or *mural*.
- **carving** 1. In sculpture, a subtractive technique in which a mass of material such as stone or wood is shaped by cutting and/or abrasion. 2. A work made by this method. Compare *modeling*. **(11.9)**
- **casting** The process of making a sculpture or some other object by pouring a liquid into a *mold*, letting it harden, and then releasing it. Common materials used for casting include bronze, plaster, clay, and synthetic resins. **(11.6)**
- ceramic Made of baked ("fired") clay. See also terra cotta. (12.1) chiaroscuro Italian for "light-dark." In two-dimensional, representational art, the technique of using values to record light and shadow, especially as they provide information about three-dimensional form. See model. (4.20)

chroma See intensity. (4.26)

- Classical Most narrowly, the "middle" period of ancient Greek civilization, beginning around 480 B.C.E. and lasting until around 323 B.C.E. More broadly, the civilizations of ancient Greece and ancient Rome, and the centuries during which they flourished. Most generally, and with a lowercase *c*, any art that emphasizes rational order, balance, harmony, and restraint, especially if it looks to the art of ancient Greece and Rome for models. (14.24)
- **clerestory** The topmost part of a wall, extending above flanking elements such as *aisles*, and set with windows to admit light. In a *basilica* or church, the clerestory is the topmost zone of the *nave*. **(15.2)**
- coffer A recessed, geometrical panel in a ceiling, often used in multiples as a decorative element. (13.15)
- collage From the French for "glue," the practice of pasting shapes cut from such real-world sources as magazines, newspapers, wallpaper, and fabric onto a surface. Also, a work of art made in this way. (6.13)
- **color field painting** A style of nonrepresentational painting featuring broad "fields" or areas of color. Arising in the 1950s after *Abstract Expressionism*, it shared that movement's fondness for large *scale* as well as its desire to transcend the visible world in favor of universal truths viewed as unconscious or spiritual. **(22.3)**
- **color wheel** A circular arrangement of hues used to illustrate a particular color theory or system. The most well-known color wheel uses the spectral *hues* of the rainbow plus the intermediary hue of red-violet. **(4.24)**

- complementary colors Hues that intensify each other when juxtaposed and dull each other when mixed (as pigment). On a color wheel, complementary hues are situated directly opposite each other. (4.24, 5.11)
- **composition** The organization of lines, shapes, colors, and other art elements in a work of art. More often applied to two-dimensional art; the broader term is *design*.
- Conceptual art Art created according to the belief that the essence of art resides in a motivating idea, and that any physical realization or recording of this idea is secondary. Conceptual art arose during the 1960s as artists tried to move away from producing objects that could be bought and sold. Conceptual works are often realized physically in materials that have little or no inherent value, such as a series of photographs or texts that document an activity. They are often ephemeral. (22.17)
- Constructivism A Russian art movement of the early 20th century. Based in the principles of geometric abstraction, Constructivism was founded around 1913 by Vladimir Tatlin and condemned in 1922 by the Soviet government. (21.25)
- **content** What a work of art is about, its meaning.
- context The personal, social, cultural, and historical setting in which a work of art was created, received, and interpreted.
- **contour** The perceived edges of a three-dimensional form such as the human body. *Contour lines* are lines used to indicate these perceived edges in two-dimensional art. **(4.4)**
- **contrapposto** A pose that suggests the potential for movement, and thus life, in a standing human figure. Developed by sculptors in ancient Greece, contrapposto places the figure's weight on one foot, setting off a series of adjustments to the hips and shoulders that produce a subtle S-curve. **(11.21)**
- cool colors Colors ranged along the blue curve of the color wheel, from green through violet. (4.24)
- **corbelling** In architecture, a construction technique in which each course of stone projects slightly beyond the one below. Corbelling can be used to create space-spanning forms that resemble the *arch*, the *vault*, and the *dome*, though they do not bear weight in the same way. **(13.20)**

Corinthian order See order. (13.3)

- **cornice** In *Classical* architecture, the uppermost element of an *entablature*; a raking cornice frames the upper, slanting edges of a *pediment*. More generally, a horizontal, projecting element, usually molded and usually at the top of a wall. **(13.5)**
- cross-hatching See hatching.
- Cubism A movement developed during the early 20th century by Pablo Picasso and Georges Braque. In its most severe "analytical" phase, Cubism abstracted the forms of the visible world into fragments or facets drawn from multiple points of view, then constructed an image from them which had its own internal logic. A severely restricted *palette* (black, white, brown) and a painting technique of short, distinct "touches" allowed shards of figure and ground to interpenetrate in a shallow, shifting space. (21.17)
- Dada An international art movement that emerged during World War I (1914–18). Believing that society itself had gone mad, Dada refused to make sense or to provide any sort of aesthetic refuge or comfort. Instead, it created "anti-art" that emphasized absurdity, irrationality, chance, whimsy, irony, and childishness. Deliberately shocking or provocative works, actions, and events were aimed at disrupting public complacency. (21.21)
- daguerreotype The first practical photographic process. Invented by Jacques Louis Mandé Daguerre and made public in 1839, it produced a single permanent image directly on a prepared copper plate. (9.3)

design The organization of visual elements in a work of art. In two-dimensional art, often referred to as *composition*.

dome In architecture, a convex, evenly curved roof; technically, an *arch* rotated 360 degrees on its vertical axis. Like an arch, a dome may be hemispherical or pointed. **(13.13)**

Doric order See order. (13.3)

drum In architecture, a cylindrical wall used as a base for a dome.
(13.18)

drypoint An intaglio printmaking technique similar to engraving in which the design is scratched directly into a metal plate with a sharp, pointed tool that is held like a pen. As it cuts through the metal, the tool raises a rough edge called a burr, which, if left in place, produces a soft, velvety line when printed. Also, a print made by this method. (8.9)

Earth art See Land art. (5.24)

earthwork See Land art. (5.24)

easel painting A portable painting executed on an easel or similar support. (1.10)

edition In printmaking, the total number of *prints* made from a given plate or block. According to contemporary practice, the size of an edition is written on each print, and the prints are individually numbered within it. The artist's signature indicates approval of the print and acts as a guarantee of the edition.

embroidery A technique of needlework in which designs or figures are stitched into a textile ground with colored thread or varn. (15.17)

encaustic Painting *medium* in which the *binder* is wax, which is heated to render the paints fluid. **(7.1)**

engraving An *intaglio* printmaking method in which lines are cut into a metal plate using a sharp tool called a burin, which creates a clean, V-shaped channel. Also, a print resulting from this technique. (8.8)

entablature In Classical architecture, the horizontal structure supported by capitals and supporting in turn the pediment or roof. An entablature consists of three horizontal bands: architrave, frieze, and cornice. (13.5)

entasis In Classical architecture, the slight swelling or bulge built into the center of a column to make the column seem straight visually. (14.26)

etching An *intaglio* printmaking method in which the design is bitten into the printing plate with acid. Also, the resultant print. To create an etching, a metal plate is covered with an acid-resistant *ground*. The design is drawn with a sharp, penlike tool that scratches the ground to reveal the metal beneath. The plate is then submerged in acid, which bites into the exposed metal. The longer the plate remains in contact with the acid, the deeper the bite, and the darker the line it will print. (8.11)

Expressionism An art movement of the early 20th century, especially prevalent in Germany, which claimed the right to distort visual appearances to express psychological or emotional states, especially the artist's own personal feelings. More generally, and with a lowercase *e*, any art style that raises subjective feeling above objective observation, using distortion and exaggeration for emotional effect. **(21.13)**

Fauvism A short-lived but influential art movement in France in the early 20th century that emphasized bold, arbitrary, expressive color. **(21.12)**

figure See figure-ground relationship.

figure-ground relationship In two-dimensional images, the relationship between a *shape* we perceive as dominant (the figure) and the background shape we perceive it against (the ground). Figure shapes are also known as **positive shapes**, and the shapes of the ground are **negative shapes**. Psychologists have identified

a list of principles we use to decide which shapes are figure and which ground. When none of those conditions is met, figure and ground may seem to shift back and forth as our brain organizes the information first one way and then another, an effect known as figure-ground ambiguity. (4.12, 4.13, 4.14)

flying buttress See buttress. (13.12)

foreshortening The visual phenomenon whereby an elongated object projecting toward or away from a viewer appears shorter than its actual length, as though compressed. In two-dimensional *representational* art, the portrayal of this effect. **(4.46)**

forging The technique of shaping metal, especially iron, usually by heating it until it softens and then beating or hammering it.

form 1. The physical appearance of a work of art—its materials, style, and *composition*. 2. Any identifiable shape or mass, as a "geometric form."

fresco A painting medium in which colors are applied to a plaster ground, usually a wall (*mural*) or a ceiling. In *buon fresco*, also called **true fresco**, colors are applied before the plaster dries and thus bond with the surface. In *fresco secco* ("dry fresco"), colors are applied to dry plaster. (7.4)

frieze Generally, any horizontal band of *relief* sculpture or painted decoration. In *Classical* architecture, the middle band of an *entablature*, between the *architrave* and the *cornice*, often decorated with relief sculpture. (13.5)

Futurism Art movement founded in Italy in 1909 and lasting only a few years. Futurism concentrated on the dynamic quality of modern technological life, emphasizing speed and movement. **(21.19)**

genre The daily lives of ordinary people considered as subject matter for art. Also, **genre painting**, painting that takes daily life for its subject. **(17.13)**

geodesic dome An architectural structure invented by R. Buckminster Fuller, based on triangles arranged into tetrahedrons (four-faceted solids). **(13.30)**

gesso A brilliant white undercoating made of inert *pigment* such as chalk or plaster and used as *ground* for paint, especially for *tempera*

glaze In oil painting, a thin, translucent layer of color, generally applied over another color. (For example, blue glaze can be applied over yellow to create green.) In ceramics, a liquid that, upon firing, fuses into a vitreous (glasslike) coating, sealing the porous clay surface. Colored glazes are used to decorate ceramics. (12.2)

Gothic Style of art and architecture that flourished in Europe, especially northern Europe, from the mid–12th to the 16th century. Gothic architecture found its finest expression in cathedrals, which are characterized by soaring interiors and large stained glass windows, features made possible by the use of the pointed *arch* and the *flying buttress*. **(15.18)**

grisaille A painting executed entirely in gray-scale values, often as a foundation for colored glazes.

groin vault See vault.

ground 1. A preparatory coating of paint, usually white but sometimes colored, applied to the *support* for a painting or drawing. 2. An acid-resistant coating applied to a metal plate to ready it for use in *etching*. 3. The information that is perceived as secondary in a two-dimensional image; the background. See *figure-ground relationship*.

happening An event staged or directed by artists and offered as art. Coined in 1959 and widely used during the 1960s, the term has generally been replaced today by *Performance art*. Compared with contemporary Performance art, happenings were more open to spontaneity and often encouraged audience participation. (22.8)

hard-edge painting A style of nonrepresentational painting popular in the late 1950s and 1960s featuring areas of flat color with sharply defined borders. (22.11)

hatching Closely spaced parallel lines that mix optically to suggest *values*. Hatching is a linear technique for modeling *forms* according to the principles of *chiaroscuro*. To achieve darker values, layers of hatching may be superimposed, with each new layer set at an angle to the one(s) beneath. This technique is called **cross-hatching**. (4.21)

Hellenistic Literally "Greek-like" or "based in Greek culture."

Descriptive of the art produced in Greece and in regions under Greek rule or cultural influence from 323 B.C.E. until the rise of the Roman Empire in the final decades of the 1st century B.C.E. Hellenistic art followed three broad trends: a continuing classicism; a new style characterized by dramatic emotion and turbulence; and a closely observed realism. (14.28, 14.29)

hierarchical scale The representation of more important figures as larger than less important figures, as when a king is portrayed on a larger scale than his attendants. (5.19)

high relief See relief. (11.3)

hue The "family name" of a color, independent of its particular value or saturation. (4.24)

hypostyle An interior space filled with rows of columns that serve to support the roof. **(13.2)**

icon In Byzantine and later Orthodox Christian art, a portrait of a sacred person or an image of a sacred event. (15.10)

iconography The identification, description, and interpretation of subject matter in art. **(2.29)**

illumination 1. The practice of adding hand-drawn illustrations and other embellishments to a manuscript. 2. An illustration or ornament thus added. **(15.12)**

impasto From the Italian for "paste," a thick application of paint. (2.1)

Impressionism A movement in painting originating in the 1860s in France. Impressionism arose in opposition to the academic art of the day. In subject matter, Impressionism followed *Realism* in portraying daily life, especially the leisure activities of the middle class. Landscape was also a favorite subject, encouraged by the new practice of painting outdoors. In technique, Impressionists painters favored *alla prima* painting, which was put into the service of recording fleeting effects of nature and the rapidly changing urban scene. (21.5)

installation An art form in which an entire room or similar space is treated as a work of art to be entered and experienced. More broadly, the placing of a work of art in a specific location, usually for a limited time. (2.41)

intaglio Printmaking techniques in which the lines or areas that will take the ink are incised into the printing plate, rather than raised above it (compare relief). Aquatint, drypoint, etching, mezzotint, and photogravure are intaglio techniques. (8.7)

intensity The relative purity or brightness of a color. Also called *chroma* or *saturation*. (4.26)

interlace Decoration composed of intricately intertwined strips or ribbons. Interlace was especially popular in medieval Celtic and Scandinavian art. (15.12)

intermediate colors Also known as *tertiary colors*. Colors made by mixing a primary color with a secondary color adjacent to it on the color wheel (for example, yellow and orange). **(4.24)**

International style A style that prevailed after World War II as the aesthetic of earlier Modernist movements such as de Stijl and the Bauhaus spread throughout the West and beyond. International style buildings are generally characterized by clean lines, rectangular geometric shapes, minimal ornamentation, and steel-and-glass construction. (13.25)

in the round In sculpture, a work fully finished on all sides and standing free of a background. Compare *relief.* (16.8)

Ionic order See order. (13.3)

isometric perspective See perspective. (4.50)

keystone The wedge-shaped, central stone in an arch. Inserted last, the keystone locks the other stones in place. **(13.9)**

kinetic Having to do with motion. Kinetic art incorporates (rather than depicts) real or apparent movement. Broadly defined, kinetic art may include film, video, and *Performance art*. However, the term is most often applied to sculpture that is set in motion by motors or air currents. **(4.52)**

kore Greek for "maiden" or "girl," used as a generic name for the many sculptures of young women produced during the Archaic period of Greek civilization.

kouros Greek for "youth" or "boy," used as a generic name for the numerous sculptures of nude youths produced during the Archaic period of Greek civilization. (14.22)

Land art Also known as *Earth art*. Art, generally large in scale, made in a landscape from natural elements found there, such as rocks and dirt. Land art arose during the 1960s as a way to bypass conventional urban exhibition spaces and to make art that could not be sold as a commodity. A work of Land art may be referred to as an *earthwork*. (3.25)

layout In graphic art, the disposition of text and images on a page, or the overall design of typographic elements on page, spread, or book.

linear perspective See perspective. (4.43)

linocut A *relief* printmaking technique in which the printing surface is a thick layer of linoleum, often mounted on a wooden block for support. Areas that will not print are cut away, leaving raised areas to take the ink. **(8.6)**

lintel In architecture, a horizontal beam or stone that spans an opening. See *post-and-lintel*. (13.2)

lithography A *planographic* printmaking technique based on the fact that oil and water repel each other. The design to be printed is drawn in greasy crayon or ink on the printing surface—traditionally a block of fine-grained stone, but today more frequently a plate of zinc or aluminum. The printing surface is dampened, then inked. The oil-based ink adheres to the greasy areas and is repelled by the damp areas. **(8.15)**

logotype See wordmark. (10.5)

lost-wax casting A technique for *casting* sculptures or other objects in metal. A model of the object to be cast is created in wax, fitted with wax rods, then encased in a heat-resistant material such as plaster or clay, leaving the rods protruding. The ensemble is heated so that the wax melts and runs out (is "lost"), creating a mold. Molten metal is poured into the mold through the channels created by the melted wax rods, filling the void where the wax original used to be. When the metal has cooled, the mold is broken open to release the casting. **(11.6)**

low relief See relief. (11.2)

mandala In Hinduism and especially Buddhism, a diagram of a cosmic realm, from the Sanskrit for "circle." (5.8)

Mannerism From the Italian *maniera*, meaning "style" or "stylishness," a trend in 16th-century Italian art. Mannerist artists cultivated a variety of elegant, refined, virtuosic, and highly artificial styles, often featuring elongated figures, sinuous contours, bizarre effects of scale and lighting, shallow pictorial space, and intense colors. (16.22)

mass Three-dimensional *form*, often implying bulk, density, and weight. **(4.12)**

matrix In printmaking, a surface (such as a block of wood) on which a design is prepared before being transferred through pressure to a receiving surface (such as a sheet of paper).

medium 1. The material from which a work of art is made.2. A standard category of art such as painting or sculpture.3. A liquid compounded with *pigment* to make paint, also called a *vehicle* and often acting as a *binder*.

megalith A very large stone. (1.4)

metalpoint A drawing technique in which the drawing medium is a fine metal wire. When the metal employed is silver, the technique is known as **silverpoint**. **(6.6)**

Metaphysical painting An Italian art movement of the early 20th century that expressed the mystery of reality through enigmatic, dreamlike images. Based in the work of Giorgio de Chirico, it had an important influence on Surrealism. **(21.18)**

mezzotint An *intaglio* printmaking technique in which the printing plate is first roughened with a special tool called a rocker, which creates a fine pattern of burrs. Inked and printed at this point, the plate would print a velvety black. *Values* are created by smoothing away the burrs in varying degrees (smoothing the plate altogether creates a nonprinting area, or white). Also, the resultant print. **(8.10)**

minaret A tower forming part of a mosque and serving as a place from which the faithful are called to prayer. (18.1)

Minimalism A broad tendency during the 1960s and 1970s toward simple, primary forms. Minimalist artists often favored industrial materials (sheet metal, bricks, plywood, fluorescent lights), and their sculptures (which they preferred to call objects) tended to be set on the floor or attached to the wall rather than placed on a pedestal. (22.13)

modeling 1. In sculpture, manipulating a plastic material such as clay or wax to create a *form*. 2. In figurative drawing, painting, and printmaking, simulating the effects of light and shadow to portray optically convincing *masses*. (11.4, 4.20)

mold A casing containing a shaped void in which liquid metal, clay, or other material may be *cast*. **(11.6)**

monochromatic Having only one color. Descriptive of work in which one *hue*—perhaps with variations of *value* and *intensity*—predominates. **(4.28)**

monotype A *planographic* printmaking method resulting in a single impression. A typical technique is to paint the design in oil paint on a plate of glass or metal. While the paint is still wet, a piece of paper is laid over it, and pressure is applied to transfer the design from the plate to the paper. **(8.18)**

mosaic The technique of creating a design or image by arranging bits of colored ceramic, stone, glass, or other suitable materials and fixing them into a bed of cement or plaster. (7.17)

mural Any large-scale wall decoration in painting, fresco, mosaic, or some other medium. (20.10)

narthex In early Christian architecture, the porch or vestibule serving as an entryway to a church. **(15.4)**

naturalistic Descriptive of an approach to portraying the visible world that emphasizes the objective observation and accurate imitation of appearances. Naturalistic art closely resembles the forms it portrays. Naturalism and *realism* are often used interchangeably, and both words have complicated histories. In this text, naturalism is construed as a broader approach, permitting a degree of idealization and embracing a stylistic range across cultures. *Realism* suggests a more focused, almost clinical attention to detail that refuses to prettify harsh or unflattering matters. **(2.12)**

nave In an ancient Roman *basilica*, the taller central space flanked by *aisles*. In a cruciform church, the long space flanked by *aisles* and leading from the entrance to the *transept*. (15.4)

negative shape See figure-ground relationship.

Neoclassicism Literally "new classicism," a Western movement in painting, sculpture, and architecture of the late 18th and

early 19th centuries that looked to the civilizations of ancient Greece and Rome for inspiration. Neoclassical artists worked in a variety of individual styles, but in general, like any art labeled *Classical*, Neoclassical art emphasized order, clarity, and restraint. (17.17)

neutral Descriptive of colors that cannot be classified among the spectral hues and their intermediaries on the *color wheel*: black, white, gray, and the browns and brownish grays produced by mixing complementary colors. **(4.24)**

nonobjective Descriptive of art that does not represent or otherwise refer to the visible world outside itself. Synonymous with *nonrepresentational*. Compare *abstract*, *stylized*. **(2.20)**

nonrepresentational See nonobjective. (2.21)

oculus A circular opening in a wall or at the top of a *dome*. (13.14) open palette See *palette*. (1.8)

optical color mixture The tendency of the eyes to blend patches of individual colors placed near one another so as to perceive a different, combined color. Also, any art style that exploits this tendency, especially the *pointillism* of Georges Seurat. (4.31)

order In Classical architecture, a system of standardized types. In ancient Greek architecture, three orders pertain: Doric, Ionic, and Corinthian. The orders are most easily distinguished by their columns. **Doric:** the shaft of the column may be smooth or fluted. It does not have a base. The capital is a rounded stone disk supporting a plain rectangular slab. **Ionic:** the shaft is fluted and rests on a stepped base. The capital is carved in graceful scrolling forms called *volutes*. **Corinthian:** the shaft is fluted and rests on a more detailed stepped base. The elaborate capital is carved with motifs based on stylized acanthus leaves. **(13.3)**

palette 1. A surface used for mixing paints. 2. The range of colors used by an artist or a group of artists, either generally or in a specific work. An open palette is one in which all colors are permitted. A restricted palette is limited to a few colors and their mixtures, tints, and shades. (4.25, 21.17)

pastel 1. A drawing medium consisting of sticks of color made of powdered *pigment* and a relatively weak *binder*. 2. A light-value color, especially a *tint*. **(6.9)**

pediment In *Classical* architecture, the triangular element supported by the columns of a *portico*. More generally, any similar element over a door or window. **(13.5)**

pendentive In architecture, a curving, triangular section that serves as a transition between a *dome* and the four walls of a rectangular building. **(13.16)**

Performance art An event or action carried out by an artist and offered as art. In widespread use since the 1970s, *Performance art* is an umbrella term that embraces earlier practices such as the *happenings* of the 1960s and the events staged by *Dada* artists in the 1920s. Performances may range from improvisatory to highly scripted, and from actions of daily life to elaborately staged spectacles. **(22.16)**

perspective A system for portraying the visual impression of three-dimensional space and objects in it on a two-dimensional surface. Linear perspective is based on the observation that parallel lines appear to converge as they recede from the viewer, finally meeting at a vanishing point on the horizon. Linear perspective relies on a fixed viewpoint. Atmospheric perspective is based on the observation that distant objects appear less distinct, paler, and bluer than nearby objects because of the way moisture in the intervening atmosphere scatters light. Isometric perspective uses diagonal lines to convey recession, but parallel lines do not converge. It is principally used in Asian art, which is not based in a fixed viewpoint. (4.44)

photogravure In intaglio printmaking, a method for printing a continuous-tone photographic image. To create a photogravure, a full-size positive transparency of the photographic image is placed over a piece of light-sensitized gelatin paper and exposed to ultraviolet light. Beginning at the surface and extending gradually downward, the gelatin hardens in proportion to the amount of light that reaches it through the transparency. Pale tones allow more light to pass through; dark tones allow less. After exposure, the gelatin tissue is attached face down to a copper plate. The plate is set in a bath of warm water, causing the paper backing to float free and the unhardened gelatin to dissolve. The hardened gelatin remains attached to the plate, where it reproduces the photographic image in relief, with lighter areas thicker and darker areas thinner. The gelatin surface is then dusted with resin, as for aquatint, and set in an acid bath, as for etching. The acid eats around the resin particles, through the gelatin, and into the plate, biting it to various depths according to the thickness of the gelatin. The plate is then removed from the acid and the gelatin layer cleaned away. When the plate is inked and printed, deeply bitten areas produce dark tones; lightly bitten areas produce pales tones. (8.14)

Photorealism A movement in painting and sculpture of the 1960s and 1970s that imitated the impersonal precision and wealth of minute detail associated with photography. Photorealist sculptors sometimes clothed their figures in real clothing, and painters sometimes took an actual photograph for their subject, faithfully depicting the effects of depth of field (sharp detail giving way to blurred areas), forced perspective, and other characteristics of the technology. (22.12)

picture plane The literal surface of a painting imagined as window, so that objects depicted in depth are spoken of as behind or receding from the picture plane, and objects in the extreme foreground are spoken of as up against the picture plane. A favorite trick of *trompe-l'oeil* painters is to paint an object that seems to be projecting forward from the picture plane into the viewer's space.

pier A vertical support, often square or rectangular, used to bear the heaviest loads in an arched or vaulted structure. A pier may be styled to resemble a bundle of columns. (13.12)

pigment A coloring material made from various organic or chemical substances. When mixed with a *binder*, it creates a drawing or painting *medium*.

plane A flat surface. See picture plane.

planography Printmaking techniques in which the image areas are level with the surface of the printing plate. *Lithography* and *monotype* are planographic methods. **(8.1)**

plastic 1. Capable of being molded or shaped, as clay. 2. Any synthetic polymer substance, such as *acrylic*.

pointillism A quasi-scientific painting technique of the late 19th century, developed and promulgated by Georges Seurat and his followers, in which pure colors were applied in regular, small touches (points) that blended through optical color mixture when viewed at a certain distance. (4.31)

Pop art An art style of the 1960s, deriving its imagery from popular, mass-produced culture. Deliberately mundane, Pop art focused on the overfamiliar objects of daily life to give them new meanings as visual emblems. **(22.9)**

porcelain A *ceramic* ware, usually white, fired in the highest temperature ranges and often used for fine dinnerware, vases, and sculpture. (12.2)

portico A projecting porch with a roof supported by columns, often marking the entrance to a building. (13.13)

positive shape See figure-ground relationship.

post-and-lintel In architecture, a structural system based on two
 or more uprights (posts) supporting a horizontal crosspiece
 (lintel or beam). (13.6)

Post-Impressionism A term applied to the work of several artists— French or living in France—from about 1885 to 1905. Although all painted in highly personal styles, the Post-Impressionists were united in rejecting the relative absence of *form* characteristic of *Impressionism*. The group included Vincent van Gogh, Paul Cézanne, Paul Gauguin, and Georges Seurat. **(1.10)**

Postminimalism An umbrella term for the diverse trends that followed in the wake of *Minimalism,* including *Process art, Body art, Performance art, Installation, Land art,* and *Conceptual art.* Postminimalism was prevalent from the mid-1960s to the mid-1970s **(22.14)**

primary color A *hue* that, in theory, cannot be created by a mixture of other hues. Varying combinations of the primary hues can be used to create all the other hues of the spectrum. In pigment, the primaries are red, yellow, and blue. **(4.24)**

primer A preliminary coating applied to a painting *support* to improve adhesion of paints or to create special effects. A traditional primer is *gesso*, consisting of a chalky substance mixed with glue and water. Also called a *ground*.

print An image created from a master wood block, stone, plate, or screen, usually on paper. Prints are referred to as multiples, because as a rule many identical or similar impressions are made from the same printing surface, the number of impressions being called an *edition*. See *relief*, *intaglio*, *lithography*, screenprinting. (8.3)

Process art A trend in *Postminimalism* in which the subject of a work of art was what it was made of (materials) and how it was made (processes). **(7.14)**

proportion Size relationships between parts of a whole, or between two or more items perceived as a unit; also, the size relationship between an object and its surroundings. Compare scale. **(5.19)**

Realism Broadly, any art in which the goal is to portray forms in the natural world in a highly faithful manner. Specifically, an art style of the mid-19th century, identified especially with Gustave Courbet, which fostered the idea that everyday people and events are fit subjects for important art. Compare *naturalism.* **(21.3)**

refraction The bending of a ray of light, for example, when it passes through a prism. **(4.23)**

registration In printmaking, the precise alignment of impressions made by two or more printing blocks or plates on the same sheet of paper, as when printing an image in several colors. **(8.4)**

relief Anything that projects from a background. 1. Sculpture in which figures are attached to a background and project from it to some degree. In low relief, also called bas-relief, the figures project minimally, as on a coin. In high relief, figures project substantially from the background, often by half their full depth or more. In sunken relief, outlines are carved into the surface and the figure is modeled within them, from the surface down. 2. In printmaking, techniques in which portions of a block meant to be printed are raised. See woodcut, linocut, wood engraving. (16.2, 8.1)

Renaissance The period in Europe from the 14th to the 16th century, characterized by a renewed interest in *Classical* art, architecture, literature, and philosophy. The Renaissance began in Italy and gradually spread to the rest of Europe. In art, it is most closely associated with Leonardo da Vinci, Michelangelo, and Raphael. **(16.9)**

representational Descriptive of a work of art that depicts *forms* in the natural world. **(2.12)**

restricted palette See palette. (21.17)

rib In architecture, a projecting band on a ceiling or a vault. (13.11)

Rococo A style of art popular in Europe in the first three quarters of the 18th century. Rococo architecture and furnishings emphasized ornate but small-scale decoration, curvilinear forms, and pastel colors. Rococo painting, also tending toward the use of pastels, has a playful, lighthearted, romantic quality and often pictures the aristocracy at leisure. (17.15)

Romanesque A style of architecture and art dominant in Europe from the 10th to the 12th century. Romanesque architecture, based on ancient Roman precedents, emphasizes the round arch and the barrel vault. (13.10)

Romanticism A movement in Western art of the late 18th and early 19th century, generally assumed to be in opposition to Neoclassicism. Romantic works are marked by intense colors, turbulent emotions, complex composition, soft outlines, and sometimes heroic or exotic subject matter. (21.2)

rotunda An open, cylindrical interior space, usually covered by a dome. (13.15)

saturation See intensity. (4.26)

scale Size in relation to some "normal" or constant size. Compare proportion. (5.16)

screenprinting A printmaking method in which the image is transferred to paper by forcing ink through a fine mesh in which the areas not meant to print have been blocked; a stencil technique. (8.17)

secondary color A hue created by combining two primary colors, as yellow and blue mixed together yield green. In pigment, the secondary colors are orange, green, and violet. (4.24)

serigraphy See screenprinting. (8.17)

sfumato From the Italian word for "smoke," a technique of painting in thin glazes to achieve a hazy, cloudy atmosphere, often to represent objects or landscape meant to be perceived as distant from the picture plane. (16.7)

shade A color darker than a hue's normal value. Maroon is a shade of red. (4.26)

shape A two-dimensional area having identifiable boundaries, created by lines, color or value changes, or some combination of these. Broadly, form. (4.14)

silkscreen See screenprinting. (8.17)

silverpoint See metalpoint.

simultaneous contrast The perceptual phenomenon whereby complementary colors appear most brilliant when set side by side. (2.5)

slip In ceramics, a liquid mixture used for casting consisting of powered clay, water, and a deflocculant.

stained glass The technique of creating images or decorations from precisely cut pieces of colored glass held together with strips of lead. (12.4)

still life A painting or some other two-dimensional work in which the subject matter is an arrangement of objects-fruit, flowers, tableware, pottery, and so forth-brought together for their pleasing contrasts of shape, color, and texture. Also, the arrangement of objects itself. (5.14)

stippling A pattern of closely spaced dots or small marks used to create a sense of three-dimensionality on a flat surface, especially in drawing and printmaking. See also cross-hatching, hatching. (4.22)

stop out In printmaking, to protect selected areas of a plate from the bite of acid by coating them with a resistant varnish.

stupa A shrine, usually dome-shaped, associated with Buddhism. (19.3)

style A characteristic, or a number of characteristics, that we can identify as constant, recurring, or coherent. In art, the sum of such characteristics associated with a particular artist, group, or culture, or with an artist's work at a specific time.

stylized Descriptive of representational art in which methods for depicting forms have become standardized, and can thus be repeated without further observation of the real-world model. Compare abstract. (2.18)

subject matter In representational or abstract art, the objects or events depicted. (2.25, 2.26)

sunken relief See relief. (14.16)

support The surface on which a work of two-dimensional art is made; for example, canvas, paper, or wood.

Surrealism A movement of the early 20th century that emphasized imagery from dreams and fantasies. (21.22)

suspension In architecture, a structural system in which a horizontal element is supported from above by means of slender vertical cables attached to a thick main cable that describes a parabolic curve between two towers. (13.26)

symbol An image or sign that represents something else, because of convention, association, or resemblance. (10.1)

symmetrical Descriptive of a design in which the two halves of a composition on either side of an imaginary central vertical axis correspond to each other in size, shape, and placement. (5.7)

tapestry An elaborate textile meant to be hung from a wall and featuring images and motifs produced by various weaving techniques. (7.19)

tempera Paint in which the pigment is compounded with an aqueous, emulsified vehicle such as egg yolk. (7.5)

tensile strength In architecture, the ability of a material to withstand tension and thus to span horizontal distances without continuous support from beneath.

terra cotta Italian for "baked earth." A ceramic ware, usually reddish, fired in the low temperature ranges and somewhat porous and fragile; earthenware. (11.4)

tertiary colors See intermediate colors. (4.24)

tessera (pl. tesserae) In mosaic, a small, usually cubic piece of colored ceramic, stone, or glass used as the basic unit of composition.

tint A color lighter than a hue's normal value. Pink is a tint of red. (4.26)

transept The arm of a cruciform church perpendicular to the nave. The transept often marks the beginning of the apse. (15.15)

triadic harmony A color scheme based in three hues equidistant from one another on the color wheel, such as yellow-orange, blue-green, and red-violet. (21.8)

triptych A composition consisting of three panels side by side, generally hinged in such a way that the outer two panels can close like shutters over the central one. (16.17)

trompe l'oeil French for "fool the eye," representational art that mimics optical experience so faithfully that it may be mistaken momentarily for reality. (2.15)

typeface In graphic design, a style of type. (10.6)

typography In graphic design, the arrangement and appearance of printed letter forms (type). (10.7)

value The relative lightness or darkness of a hue, or of a neutral varying from white to black. (4.26)

vanishing point In linear perspective, the point on the horizon where parallel lines appear to converge. (4.44)

vault An arched masonry structure or roof that spans an interior space. A barrel vault is a half-round arch extended in depth. A groin vault is formed by the intersection of two barrel vaults of equal size at right angles. A **ribbed vault** is a groin vault in which the lines marking the intersection of the vaults are reinforced with a raised rib. (13.10)

- **vehicle** Another term for *medium,* in the sense of a liquid compounded with *pigment* to make paint.
- **visual weight** The apparent "heaviness" or "lightness" of the forms arranged in a composition, as gauged by how insistently they draw the viewer's eye. **(5.8)**
- **volute** In architecture, a spiral, scroll-like ornament such as the *capital* of a column in the *lonic order*. **(13.4)**
- warm colors Colors ranged along the orange curve of the color wheel, from red through yellow. (4.24)
- wash Ink or watercolor paint thinned so as to flow freely onto a support. (6.10)
- **watercolor** A painting *medium* in which the *binder* is gum Arabic. (7.10)
- **woodcut** A *relief* printmaking method in which a block of wood is carved so as to leave the image areas raised from the background. Also, the resultant *print*. **(8.3)**
- wood engraving Similar to *woodcut*, a *relief* printmaking process in which the image is cut on the end grain of a wood plank, resulting in a "white-line" impression. (8.5)
- wordmark In design, a logo that consists of text—generally the name of a company, an institution, or a product—given a distinctive graphic treatment. Also known as *logotype*. (10.5)
- **ziggurat** In ancient Mesopotamian architecture, a monumental stepped structure symbolically understood as a mountain and serving as a platform for one or more temples. **(14.4)**

Photographic Credits

Abbreviations:

ADAGP - Société des auteurs dans les arts graphiques et plastiques, Paris akg - akg-images, London AR - Art Resource, New York ARS, NY - @ 2015 Artists Rights Society (ARS), New York BI - Bridgeman Images BL − © The British Library Board BPK - Bildarchiv Preussischer Kulturbesitz, Berlin BM − © The Trustees of the British Museum CA − © Cameraphoto Arte, Venice EL/akg - Erich Lessing/akg-images Freer - Freer Gallery of Art, Smithsonian Institution, Washington, D.C. LOC - Library of Congress Prints and Photographs Division Washington, D.C. MMA/Scala — Image © The Metropolitan Museum

of Art/Art Resource/Scala, Florence MNAM/RMN — Photo © Centre Pompidou, MNAM-CCI, Dist. RMN-Grand Palais/image Centre Pompidou, MNAM-CCI.

MoMA/Scala — Digital image, © The Museum of Modern Art, New York/Scala, Florence Nelson-Atkins — The Nelson-Atkins Museum of Art, Kansas City, Missouri

NG/Scala – © The National Gallery, London/ Scala, Florence

NGA — Image courtesy of the Board of Trustees, National Gallery of Art, Washington, D.C. Pirozzi — © Vincenzo Pirozzi, Rome fotopirozzi@ inwind.it

RMN — Réunion des Musées Nationaux, Paris. Photo © RMN-Grand Palais

Scala – Scala, Florence

Scala — MBA - Photo Scala, Florence – courtesy of the Ministero Beni e Att. Culturali

VAGA – Licensed by VAGA, New York, NY Whitney – Whitney Museum of American Art, New York

Cover Image: © Markus Linnenbrink. Photo: Annette Kradisch, Nuremberg; Installation view: Kunsthalle Nürnberg, Nuremberg

Front matter: Photographs of the author: Photographs by Jim Whitaker, courtesy the author

p. iv Michel Denancé/Renzo Piano/Artedia.
© 2015 ARS, NY/ADAGP; p. iv The Phillips
Collection, Washington, D.C. Gift of Agnes Gund
and Daniel Shapiro and Gifford and Joann Phillips,
2006. © 2015 The Murray-Holman Family Trust/
ARS, NY; p. v © Shahzia Sikander. Image courtesy
Sikkema Jenkins & Co., New York; p. vi Photo
Erika Barahona-Ede. Art GMB2001.1. © The
Easton Foundation/VAGA; p. vii © Hans Hinz/
Artothek; p. ix Scala - MBA; p. ix MMA/Scala.
Gift of Paul and Ruth W. Tishman, 1991.435a,b.;
p. ix EL/akg.

Chapter 1: 1.1 Michel Denancé/Renzo Piano/ Artedia. © 2015 ARS, NY/ADAGP; 1.2 MNAM © 2015 ARS, NY/ADAGP; 1.3 Courtesy of the French Ministry of Culture and Communication, Regional Direction for Cultural Affairs - Rhône-Alpes, Regional Department of Archaeology; 1.4 Alvis Upitis/Getty Images; 1.5 Courtesy of Institute of Archaeology and Cultural Relics of Shandong Province. © Cultural Relics Publishing House, Beijing; 1.6 © Catherine Karnow/Corbis; 1.7 The Newark Museum 97.25.11. AR/Scala; 1.8 BM, 1920,0917,0.2; 1.9 Rijksmuseum, Amsterdam. AK-MAK-187; 1.10 MoMA/Scala. Acquired through the Lillie P. Bliss Bequest, 472.1941; 1.11 Ernst Haas/Getty Images; 1.12 Courtesy Rex Jung, Brain & Behavioral Associates, PC; 1.13 Photo Fredrik Nilsen, Courtesy Gagosian Gallery. Art © Mike Kelley Foundation for the Arts. All Rights Reserved/VAGA; 1.14 Wadsworth Atheneum, Hartford. The Ella Gallup Sumner and Mary Catlin Sumner Collection Fund, 1939.270; 1.15 Collection Louis K. Meisel Gallery, New York; 1.16 Philadelphia Museum of Art. Purchased with funds contributed by Mr. and Mrs. W. B. Dixon Stroud, 1995-55-1. Courtesy of the artist and Gladstone Gallery, New York and Brussels.

p. 8 Jackie Johnston/AP Photo.p. 11 Scala.

Chapter 2: 2.1 NG/Scala; 2.2 Robert Watts Estate, New York; 2.3 © 2015 The Andy Warhol Foundation for the Visual Arts, Inc./ARS, NY; 2.4 RMN (musée du Louvre)/Michel Urtado; 2.5 Museum of Fine Arts, Boston. Bequest of Anna Perkins Rogers (21.1331). Photograph © 2015 Museum of Fine Arts, Boston; 2.6 © Quattrone, Florence; 2.7 © MAK/Georg Mayer, B. I. 8770/9; 2.8 Photo Smithsonian American Art Museum/AR/Scala; 2.9 MoMA/Scala. Gift of T. J. Maloney, 123.1952.1. © 2015 Center for Creative Photography, Arizona Board of Regents/ ARS, NY; 2.10 CA; 2.11 Image © Museo Nacional del Prado. Photo MNP/Scala; 2.12 Museo Picasso, Barcelona/Giraudon/BI. © 2015 Estate of Pablo Picasso/ARS, NY; 2.13 Scala. © 2015 Estate of Pablo Picasso/ARS, NY; 2.14 Photo Christopher Burke. Art © The Easton Foundation/VAGA; 2.15 Courtesy Mrs. Duane Hanson. Art © Estate of Duane Hanson/VAGA; 2.16 Werner Forman Archive/BM; 2.17 André Held/akg; 2.18 MMA/Scala. Gift of Stanley Herzman, in memory of Adele Herzman, 1991, 1991.253.54; 2.19 BL/Robana/Scala; 2.20 Davis Museum at Wellesley College, Wellesley, MA, Gift of Mr. Theodore Racoosin, 1956.16 © Pracusa 2015090; 2.21 Courtesy Pace Gallery. Photo Gordon R. Christmas; 2.22 LOC. FP 2 - JPD, no. 2191; 2.23 MMA/Scala. H. O. Havemeyer Collection. Bequest of Mrs. H. O. Havemeyer, 1929, 29.100.35; 2.24 Courtesy Sperone Westwater, New York © 2015 Susan Rothenberg/ARS, NY; 2.25 MoMA/ Scala. Mrs. Simon Guggenheim Fund, 125.1946. © 2015 Succession H. Matisse/ARS, NY; 2.26 The Barnes Foundation, Philadelphia, Pennsylvania/ BI. © 2015 Succession H. Matisse/ARS, NY; 2.27 EL/akg; 2.28 Installation view (The Museum of

Contemporary Art, Los Angeles) © Janine Antoni. Courtesy of the artist and Luhring Augustine, New York; 2.29 © Sakamoto Photo Research Laboratory/Corbis; 2.30, 2.31 NG/Scala; 2.32 © abm - archives barbier-mueller, inv. 1009-31. Photo Pierre-Alain Ferrazzini; 2.33 Photo Professor Herbert M. Cole; 2.34 CA; 2.35 © Thomas Struth; 2.36 Courtesy of the artist; 2.37 © Horace Bristol/ Corbis; 2.38 The Collection of Robin B. Martin, The Guennol Collection, Brooklyn Musuem of Art, New York. Photo © Justin Kerr K4838; 2.39 Photo Walter Vögel. Courtesy Ronald Feldman Fine Arts, New York. © 2015 ARS, NY/VG Bild-Kunst, Bonn; 2.40 Carol Beckwith/Angela Fisher, Robert Estall Photo Library; 2.41 Photo Jason Wyche. Art © 2015 Kara Walker; 2.42 © The Felix Gonzalez-Torres Foundation, Courtesy of Andrea Rosen Gallery, New York. Photo Paul Jeramias, The Solomon R. Guggenheim Foundation, New York. ARG# GF1995-1.

p. 26 Photo Michael Gray/courtesy GRACE.
p. 31 Photo © Sylvia Plachy.

p. 47 Freer. Gift of Charles Lang Freer, F1899.34.

Chapter 3: 3.1 Photo © RMN; 3.2 Scala; 3.3 Los Angeles County Museum of Art. From the Nasli and Alice Heeramaneck Collection, Museum Associates Purchase (M.78.9.2); 3.4 © Quattrone, Florence; 3.5 Spectrum/Heritage Images/Scala; 3.6 © Vanni Archive/AR; 3.7 RMN (musée du Louvre)/Hervé Lewandowski; 3.8 Museo Nacional Centro de Arte Reina Sofia, Madrid, Spain. © 2015 Estate of Pablo Picasso/ARS, NY; 3.9 NG/ Scala; 3.10 BL MS. Add. 15297(1), fol. 34r; 3.11 The Museum of Contemporary Art, Los Angeles. Gift of Peter and Eileen Norton, Santa Monica, California, 89.28. Photo Paula Goldman. © 2015 ARS, NY/ADAGP; 3.12 Scala; 3.13 Photograph © 2015 Museum of Fine Arts, Boston. Special Chinese and Japanese Fund 12.886; 3.14 MoMA/ Scala. Mrs. Simon Guggenheim Fund. 577.1943; 3.15 akg. Art © Robert Rauschenberg Foundation/ VAGA; 3.16 Museum of African American History, Boston and Nantucket; 3.17 akg. © 2015 Banco de Mexico Diego Rivera Frida Kahlo Museums Trust, Mexico, D. F./ARS, NY; 3.18 NGA. Widener Collection 1942.9.97; 3.19 Scala; 3.20 MoMA/ Scala. Gift of Nelson A. Rockefeller, 252.1954; 3.21 © Yayoi Kusama. Courtesy of David Zwirner, New York; Ota Fine Arts, Tokyo/Singapore; Victoria Miro, London; KUSAMA Enterprise; 3.22 MMA/Scala. Gift of Mrs. Russell Sage, 1908, 08.228; 3.23 Freer. Purchase F1956.27; 3.24 © Vanni Archive/AR; 3.25 Photo George Steinmetz. Art © Holt Smithson Foundation/ VAGA; 3.26 Honolulu Museum of Art, Gift of James A. Michener, 1991, 21941; 3.27 Photo courtesy Marian Goodman Gallery, New York. © Jeff Wall; 3.28 MoMA/Scala. Gift of Jerry I. Spever and Katherine G. Farley, Anna Marie and Robert F. Shapiro, and Marie-Josée and Henry R. Kravis. Courtesy the artist and Marian Goodman Gallery.

p. 54b © Syed Jan Sabwoon/epa/Corbis.
p. 64 © Richard Schulman/Corbis.
p. 70 © Yayoi Kusama. Courtesy of David Zwirner, New York; Ota Fine Arts, Tokyo/Singapore; Victoria Miro, London; KUSAMA Enterprise.

p. 54a © Charles & Josette Lenars/Corbis

Chapter 4: 4.1 The Phillips Collection, Washington, D.C. Gift of Agnes Gund and Daniel Shapiro and Gifford and Joann Phillips, 2006. © 2015 The Murray-Holman Family Trust/ARS, NY; 4.2 Scala/BPK. © Keith Haring Foundation. Used by permission; 4.3 Courtesy of the Artist and Victoria Miro, London. © Sarah Sze. Photo © Sarah Sze and Frank Oudeman; 4.4 Courtesy Regen Projects, Los Angeles © Jennifer Pastor; 4.5 © Henri Cartier-Bresson/Magnum Photos; 4.6, 4.7 NGA. Chester Dale Collection, Gift of Mr. and Mrs. Cornelius Vanderbilt Whitney 1953.7.1; 4.8, 4.9 RMN (musée du Louvre)/Michel Urtado; 4.10, 4.11 © Blauel/ Artothek; 4.12 UBC Museum of Anthropology, Vancouver, Canada. Photo Bill McLennan; 4.13 Saint Louis Art Museum. Museum Shop Fund. 37:1991. © Emmi Whitehorse; 4.14 Landesmuseum Württemberg, Stuttgart/Photo H. Zwietasch; 4.16 KHM-Museumsverband GG 175; 4.17 Photo by Fulvio Orsenigo © 2015 Doug Wheeler; courtesy David Zwirner, New York/London; 4.18 Museum of Fine Arts, Houston, Texas. Gift of Michael Charles/BI; 4.20 NG/Scala; 4.21 Photo Darryl Allan Smith. © 1979 The Charles White Archives; 4.23a © Andrzej Wojcicki/Science Photo Library/ Corbis; 4.25 Sterling and Francine Clark Art Institute, Williamstown, Massachusetts, 1955.827/ BI; 4.28 Courtesy the Artist, Victoria Miro, London and 303 Gallery, New York © Inka Essenhigh; 4.29 © Diana Cooper; 4.31 MoMA/Scala. Gift of Mrs. David M. Levy. 266.1957; 4.32, 4.33 Courtesy of the artist; 4.34 Photo © Tate N01959; 4.35 Nasjonalgalleriet, Oslo/BI. © 2015 ARS, NY; 4.36 Photo Aurelien Mole. Courtesy GALLERIA CONTINUA San Gimignano/Beijing/Les Moulins and White Cube; 4.37 MoMA/Scala. The Philip L. Goodwin Collection, 97.1958.a-e. © 2015 ARS, NY/ADAGP; 4.38 akg; 4.39 © Samuel Fosso. Courtesy Jack Shainman Gallery and Galerie Jean Marc Patras; 4.40 Collection Fondation Alberto & Annette Giacometti/BI. Art © Alberto Giacometti Estate/Licensed by VAGA and ARS, New York, NY; 4.41 Courtesy Lehmann Maupin Gallery, New York. © Do Ho Suh, 2004; 4.42 MMA/ Scala. Gift of Mr. and Mrs. Carl Bimel, Jr. 1996, 1996.357; 4.44 Scala/BPK. Photo Jörg P. Anders; 4.45 © Quattrone, Florence; 4.46 NGA. Gift of W.G. Russell Allen 1941.1.100; 4.47 Rijksmuseum, Amsterdam RP-P-OB-1492; 4.48 MMA/Scala. Bequest of Maria DeWitt Jesup, from the collection of her husband, Morris K. Jesup, 1914. 15.30.61; 4.49 MMA/Scala. Gift of Douglas Dillon, 1979. 1979.75.1; 4.51 Topkapi Palace Library, Istanbul. MS. H. 1517, folio 108v. Photo © Hadive Cangökce, Istanbul; 4.52 Courtesy Storm King Art Center, Mountainville, New York. Photo Jerry Thompson. © 2015 Calder Foundation, New York/ARS, NY; 4.53 Photo Lorenz Kienzle. © 2015 Richard Serra/ ARS, NY; 4.54 Courtesy Nick Cave and the Jack Shainman Gallery, New York. Photo James Prinz Photography, Chicago; 4.55 Courtesy of the Artist and Lehmann Maupin Gallery, New York.

p. 99a Brooklyn Museum, Gift of Anna Ferris, 30.1478.76.

p. 99b Rijksmuseum, Amsterdam AK-MAK-1612.p. 107a Photo Eric Vandeville.

p. 107b EL/akg.

Chapter 5: 5.1 MoMA/Scala. Mrs. Simon Guggenheim Fund, 224.1968. © 2015 Succession H. Matisse/ARS, NY; 5.2 @ Yayoi Kusama. Courtesy of David Zwirner, New York; Ota Fine Arts, Tokyo/Singapore; Victoria Miro, London; KUSAMA Enterprise; 5.3 Courtesy the artist and Marian Goodman Gallery. © 2015 ARS, NY/ ADAGP; 5.4 Courtesy of The Noguchi Museum, New York. Photographed by Michio Noguchi. © 2015 The Isamu Noguchi Foundation and Garden Museum, New York/ARS, NY: 5.5 Courtesy the artist and SCAI the Bathhouse, Tokyo; 5.6 Museum of Fine Arts. Boston. Gift of the William H. Lane Foundation, 1990.432. Photograph © 2012 Museum of Fine Arts, Boston. Art. © 2015 Georgia O'Keeffe Museum/ARS, NY; 5.7 The Metropolitan Museum of Art. Purchase, Lita Annenberg Hazen Charitable Trust Gift, 1987, 1987.16. MMA/Scala; 5.9 EL/akg; 5.10 © The Cleveland Museum of Art. Norman O Stone and Ella A. Stone Memorial Fund 1958.289; 5.11 Philadelphia Museum of Art. The John H. McFadden Collection, 1928, M1928-1-41. Photo Graydon Wood. Photo The Philadelphia Museum of Art/AR/Scala; 5.12 @ Samuel Courtauld Trust, The Courtauld Gallery, London/BI: 5.13 Collection of Hampton University Museum, Hampton, Virginia US 919-H; 5.14 The Barnes Foundation, Philadelphia, Pennsylvania/BI; 5.15 EL/akg; 5.16 Collection Fundação de Serralves, Porto, Portugal. Purchase financed by funds donated by João Rendeiro, European Funds and Fundação de Serralves. © 2001 Claes Oldenburg and Coosje van Bruggen; 5.17 Hirshhorn Museum and Sculpture Garden, Smithsonian Institution, Gift of Joseph H. Hirshhorn, 1966. HMSG 66.3199. © 2014. Image Bank ADAGP/Scala. Art © 2015 C. Herscovici/ ARS, NY; 5.18 BM, EA579; 5.19 BM, Af1897,1011.2; 5.20 Scala - MBA; 5.22 © Fondation Le Corbusier/© F.L.C./ADAGP/ARS, NY 2015. Plan FLC 21007; 5.23 © Paul M.R. Maevaert, © F.L.C./ ADAGP/ARS, NY 2015; 5.24 Courtesy Storm King Art Center, Mountainville, New York. Photo Jerry Thompson. © Maya Lin Studio, Inc., courtesy The Pace Gallery; 5.25 Freer. Gift of Charles Lang Freer, F1900.24; 5.26 © Hans Hinz/ Artothek. © 2015 ARS, NY/VG Bild-Kunst, Bonn; 5.27 Andrea Jemolo/akg; 5.28 MoMA/Scala. Gift of Mrs. Simon Guggenheim. © 2015 Estate of Pablo Picasso/ARS, NY; 5.29 EL/akg; 5.30 NGA. Andrew W. Mellon Collection. 1937.1.34. NGA. Chester Dale Collection, Andrew W. Mellon Collection 1937.1.34; 5.31 MoMA/Scala. Gift of Mrs. Simon Guggenheim. © 2015 Estate of Pablo Picasso/ARS, NY.

p. 120 MMA/Scala. Gift of Georgia O'Keeffe through the generosity of The Georgia O'Keeffe Foundation and Jennifer and Joseph Duke, 1997, 1997.61.34. © 2015 Georgia O'Keeffe Museum/ ARS, NY.

p. 125 © Bibliothèque nationale de France, Paris.

Chapter 6: 6.1 © Shahzia Sikander. Image courtesy Sikkema Jenkins & Co., New York; 6.2 Museo Nacional Centro de Arte Reina Sofia, Madrid. © 2015 Estate of Pablo Picasso/ARS, NY; 6.3 Royal Collection Trust © Her Majesty Queen Elizabeth II, 2015/BI; 6.4 Courtesy the artist and Blum & Poe. © Mark Grotjahn; 6.5 MoMA/Scala. Gift of David Teiger and the Friends of Contemporary Drawing, 393.1999. Courtesy the Artist, Victoria Miro, London © Chris Ofili; 6.6 MMA/Scala. Harris Brisbane Dick Fund, 1936, 36.101.1; 6.7 Hirshhorn Museum and Sculpture Garden, Washington,

D.C. HMSG 83.153 Courtesy DC Moore Gallery, New York, NY; 6.8 © The Cleveland Museum of Art. Leonard C. Hanna, Jr. Fund 1958.344; 6.9 MMA/Scala. Bequest of Stephen C. Clark, 1960, 61.101.7; 6.10 MMA/Scala. H. O. Havemeyer Collection, Bequest of Mrs. H. O. Havemeyer, 1929, 29.100.939; 6.11 Seattle Art Museum, Gift of the ContemporaryArtProject, Seattle, 2002.30. Courtesy Marian Goodman Gallery, New York. © Julie Mehretu; 6.12 MoMA/Scala. Gift of the Friends of Contemporary Drawing. 249.2000. Courtesy the artist, David Zwirner, New York/ London and Regen Projects, Los Angeles; 6.13 MNAM/RMN. © 2015 ARS, NY/ADAGP; 6.14 Photograph © 2015 Museum of Fine Arts, Ellen Kelleran Gardner Fund 1971. 63. Art © Romare Bearden Foundation/VAGA; 6.15 Photo Gene Ogami. Courtesy of the artist and Susanne Vielmetter Los Angeles Projects; 6.16 Courtesy Courtesy Galerie Chantal Crousel. Photo Florian Kleinefenn. Art © Mona Hatoum; 6.17 © Mia Pearlman.

p. 143 Scala - MBA.
p. 145 New York Public Library. Spencer Collection, Persian ms. 41, folios 21b, 22a.

Chapter 7: 7.1 EL/akg; 7.2 Albright Knox Art Gallery/AR/Scala. Gift of Seymour H. Knox, Ir., 1959. Art © Jasper Johns/VAGA; 7.3 Scala; 7.4 Bob Schalkwijk/AR/Scala. © 2015 Banco de México Diego Rivera Frida Kahlo Museums Trust, Mexico, D.F./ARS, NY; 7.5 MMA/Scala. Robert Lehman Collection, 1975, 1975.1.27. Photo Malcolm Varon; 7.6 MoMA/Scala. Gift of Mrs. David M. Levy, 28.1942.10. © 2015 The Jacob and Gwendolyn Knight Lawrence Foundation, Seattle/ARS, NY; 7.7 MMA/Scala. Robert Lehman Collection, 1975, 1975.1.110; 7.8 Image courtesy Sikkema Jenkins & Co., New York. Art © 2015 Amy Sillman; 7.9 MMA/Scala. Purchase, Joseph Pulitzer Bequest, 1915, 15.142.2; 7.10 MoMA/Scala. Inter-American Fund 140.1945. © 2015 ARS, NY/ADAGP; 7.11 MMA/Scala. The Lin Yutang Family Collection, Gift of Hsiang Ju Lin, in memory of Taiyi Lin Lai, 2005, 2005.510.5. © The Estate of Chang Dai Chien; 7.12 © Beatriz Milhazes. Courtesy James Cohan Gallery, New York/Shanghai; 7.13 Henry Groskinsky/The LIFE Picture Collection/Getty Images. Courtesy Cheim & Read, New York. Art © Lynda Benglis/VAGA; 7.14 Photo Arthur Evans. © 2015 ARS, NY/VG Bild-Kunst, Bonn; 7.15 © Mark Bradford. Image courtesy of Sikkema Jenkins & Co. Photo Jason Dewey; 7.16 Courtesy of the artist and Marc Selwyn Fine Art, Beverly Hills. Photo Heather Rasmussen; 7.17 CA/akg; 7.18 Photo James and Karla Murray. Courtesy Galerie Lelong, New York. Art © The Nancy Spero and Leon Golub Foundation for the Arts/ VAGA; 7.19 KHM-Museumsverband KK V 2; 7.20 © Pae White. Courtesy the artist, Greengrassi and Neugerriemschneider, Berlin.

p. 164 National Academy Museum, New York 1977.15. © 2015 The Jacob and Gwendolyn Knight Lawrence Foundation, Seattle/ARS, NY.

Chapter 8: 8.2 BL, Or.8210/p.2; 8.3 MoMA/ Scala. Gift of the Arnhold Family in memory of Sigrid Edwards, 470.1992.4. © 2015 ARS, NY/ VG Bild-Kunst, Bonn; 8.4 Photograph courtesy of the Denver Art Museum. Asian Art Department Acquisition Fund, 2004.41; 8.5 LOC. Rights Courtesy Plattsburgh State Art Museum, State University of New York, USA; 8.6 © 1995 John Muafangejo Trust; 8.8 Rijksmuseum, Amsterdam RP-P-OB-66.97; 8.9 MoMA/Scala. Gift of the artist, 338.2003. Photo Christopher Burke. Art $\ \odot$ The Easton Foundation/VAGA; 8.10 Photo Smithsonian American Art Museum/AR/Scala. © 2015 Susan Rothenberg/ARS, NY; 8.11 Rijksmuseum, Amsterdam RP-P-1961-1022; 8.12 Rijksmuseum, Amsterdam RP-P-1921-2060; 8.13 NGA. Chester Dale Collection 1963.10.253; 8.14 Whitney; purchase with funds from the Print Committee 93.94. Photo Sheldan C. Collins. © Lorna Simpson; 8.15 Publisher and printer Gemini G.E.L., Los Angeles. Edition: 50. MoMA/Scala. Gift of Edward R. Broida, 729.2005; 8.16 Moore Energy Resources Elizabeth Catlett Collection. Art © Catlett Mora Family Trust/VAGA; 8.17 MoMA/Scala. John B. Turner Fund, 1386.1968. Photo Robert McKeever. © Ed Ruscha. Courtesy Gagosian Gallery; 8.18 Courtesy the artist and Koenig & Clinton, New York.Private Collection, New York; 8.19 Photo courtesy Pace Editions/Pace Gallery. © Fiona Rae; 8.20 Courtesy the Artist and Ronald Feldman Fine Arts, New York. Photo Greenhouse Media; 8.21 Courtesy the Artist and ACME, Los Angeles; 8.22 Photo © Jaime Rojo.

p. 181 akg. © 2015 ARS, NY/VG Bild-Kunst, Bonn.p. 186 © Blauel/Gnamm/Artothek.

Chapter 9: 9.1 NGA. Gift of The Circle of the National Gallery of Art; 9.3 © Corbis; 9.4 MMA/ Scala. Purchase, Joseph Pulitzer Bequest, 1996, 1996.99.2; 9.5 Special Collections, University of Nevada, Reno Library, UNRS-P2710/810; 9.6 LOC, LC-USF34-T01-009058-C; 9.7 Photo © 2015 Succession Raghubir Singh; 9.8 MMA/Scala. Alfred Stieglitz Collection, 1933, 33.43.39. © 2015 The Estate of Edward Steichen/ARS, NY; 9.9 MoMA/Scala. Provenance unknown. 436.1986. © 2015 Georgia O'Keeffe Museum/ARS, NY; 9.10 Scala/BPK. Photo Jörg P. Anders. © 2015 ARS, NY/VG Bild-Kunst, Bonn; 9.11 MNAM/RMN/ Bertrand Prévost. © Man Ray Trust/Artists Rights Society (ARS), NY/ADAGP 2015; 9.12 Courtesy of the artist and Metro Pictures Gallery, New York; 9.13 A. Gursky Edition of 6. © 2015 Andreas Gursky/ARS, NY/VG Bild-Kunst, Bonn; 9.14 © 2015 ARS, NY/VG Bild-Kunst, Bonn; 9.15 LOC, LC-USZ62-52703; 9.16 Melies/The Kobal Collection/Picture Desk; 9.17 Mc Cay/The Kobal Collection/Picture Desk; 9.18 Goskino/The Kobal Collection/Picture Desk; 9.19 © Impéria/ Courtesy Photofest; 9.20 Andy Warhol Museum, Pittsburgh. © 2015 The Andy Warhol Museum, Pittsburgh, PA, a museum of Carnegie Institute. All rights reserved. © 2015 The Andy Warhol Foundation for the Visual Arts, Inc./ARS, NY; 9.21 Courtesy Electronic Arts Intermix (EAI), New York. © 2015 Bruce Nauman/ARS, NY; 9.22 Stedelijk Museum, Amsterdam. © Estate Nam June Paik; 9.23 Courtesy the artist and Cristin Tierney Gallery, New York; 9.24 © Shirin Neshat. Courtesy Gladstone Gallery, New York and Brussels; 9.25 © Cory Arcangel; 9.26 © Olia Lialina; 9.27 Courtesy of the artist and Lombard Freid Projects, NY; 9.28 Photo Anne Fourès. © Aram Bartholl.

p. 211 © Copyright The Robert Mapplethorpe Foundation. Courtesy Art + Commerce. MAP # 1860.

Chapter 10: 10.2 © Cook and Shanosky Assocs Inc.; 10.3a Paul Rand Archives, Yale University; 10.3b Paul Rand Archives, Yale University;

10.3 c © American Broadcasting Companies, Inc.; 10.4a © AngiePhotos/iStock; 10.4b ©American Broadcasting Companies, Inc.; 10.5 Courtesy AOL; 10.6 J. Paul Getty Museum, GRI Digital Collections 1385-140; 10.7 © Joan Dobkin; 10.8a Courtesy Metro North Railroad; 10.8b Reprinted by permission, Edward R. Tufte, Envisioning Information (Graphics Press, Cheshire, CT USA, 1990); 10.9 MMA/Scala. Harris Brisbane Dick Fund, 1932, 32.88.12; **10.10** © SenseTeam; **10.11** Justin Sullivan/Getty Images; 10.12 © Universal Everything; 10.13 Courtesy Cassidy Curtis. Photo © Cassidy Curtis; 10.14 Courtesy TextArc. org; 10.15 Printed by Salvatore Silkscreen Co., Inc., New York; Published by Factory Additions, New York. Whitney; purchase with funds from the Friends of the Whitney Museum of American Art 69.13.2. Digital Image © Whitney Museum of American Art. © 2015 The Andy Warhol Foundation for the Visual Arts, Inc./ARS, NY; 10.16 Photo courtesy Mary Boone Gallery, New York. © Barbara Kruger; 10.17 © Nathalie Miebach, image courtesy the artist; 10.18 © Universal Everything.

Chapter 11: 11.1 Photo Erika Barahona-Ede. Art GMB2001.1. © The Easton Foundation/VAGA; 11.2 Hervé Champollion/akg; 11.3 © Massimo Borchi/Atlantide Phototravel/Corbis; 11.4 The Art Museum, Princeton University. Gift of Gillett G. Griffin. Photo © Justin Kerr K2845; 11.5 © Dirk Bakker/BI; 11.7 © Jeff Koons; 11.8 © Rachel Whiteread. Courtesy of the artist and Luhring Ausustine, New York; 11.9 Museum für Angewandte Kunst, Cologne. Sammlung Wilhelm Clemens. A 1156 CL. Photo © Rheinisches Bildarchiv Köln, rba_c017585; 11.10 Werner Forman Archive/Anthropology Museum, Veracruz University, Jalapa; 11.11 Photo James Whitaker. Art © The Estate of David Smith/VAGA; 11.12 Modern Art Museum of Fort Worth, Texas, museum purchase. Originally commissioned by the Madison Square Park Conservancy. Photo David Wharton, Fort Worth. Courtesy of the artist and Marianne Boesky Gallery, New York © Roxy Paine; 11.13 Courtesy the artist and Donald Young Gallery. Chicago; 11.14 Collection MoMA. Photo Sherry Griffin. Courtesy the artist and Salon 94, New York; 11.15 © Jessica Stockholder. Courtesy Mitchell-Innes & Nash, New York; 11.16 Photograph © 2015 Museum of Fine Arts, Harvard University-Boston Museum of Fine Arts Expedition 11.1738; 11.17 The Philadelphia Museum of Art/AR/Scala; 11.18 DeAgostini Picture Library/Scala; 11.19 University of Pennsylvania Museum. Purchased from J. Laporte, 29-12-68; 11.20, 11.21, 11.22 Scala; 11.23 Milwaukee Art Museum, Gift of Contemporary Art Society. M1996.5 © Kiki Smith, courtesy The Pace Gallery; 11.24 Photo © Stephen White Courtesy White Cube. Art © Antony Gormley; 11.25 © Richard A. Cooke/Corbis; 11.26 © Andy Goldsworthy. Courtesy Galerie LeLong, New York; 11.27 © 2015 ARS, NY, VG Bild-Kunst, Bonn; 11.28 Musée d'Art Contemporain de Montréal. Photo Richard-Max Tremblay. Art © The Easton Foundation/VAGA; 11.29 Courtesy Dia Art Foundation. Photo Cathy Carver. © 2015 Stephen Flavin/ARS, NY; 11.30 Courtesy the artist and Tanya Bonakdar Gallery, New York. Photography by Studio Tomás Saraceno ©2013; 11.31 Volz/LAIF/Camera Press. © Christo and Jeanne Claude 2005; 12.1 National Museum of Women in the Arts, Washington, D.C. Gift of Wallace and Wilhelmina Holladay.

- p. 256 Scala/BPK. Photo Jörg P. Anders.p. 264 Volz/LAIF/Camera Press.
- p. 267 © Jerry D. Jacka Photography.

Chapter 12: 12.2 BM, 1936,0413.44; 12.3 Photo The Newark Museum/AR/Scala. Gift of Mrs. Eugene Schaefer, 1950, 50.1249; 12.4 © Sonia Halliday Photographs; 12.5 MMA/Scala. Gift of The Kronos Collections, 1981, 1981.398.3-4; 12.6 MMA/Scala. The Cloisters Collection, 1994, 1994.244; 12.7 Werner Forman Archive/Egyptian Museum, Cairo; 12.8 National Museum of African Art, Smithsonian Institution. Bequest of William A. McCarty-Cooper. 95-10.1. Photo Franko Khoury; 12.9 The Philbrook Museum of Art, Tulsa, Oklahoma, Gift of Clark Field 1948.39.37; 12.10 Dumbarton Oaks Research Library and Collections, Washington, D.C. Photo © Justin Kerr K4311.1; 12.11 © Victoria and Albert Museum, London; 12.12 National Museum of African Art, Smithsonian Institution, Washington D.C. Gift of Walt Disney World Co., a subsidiary of The Walt Disney Company. D.C. Photo Jerry L. Thompson/ AR; 12.13 RMN (musée Guimet, Paris)/Thierry Ollivier; 12.14 Freer. Purchase F1953.64a-b; 12.15 MMA/Scala. The Howard Mansfield Collection, Purchase, Rogers Fund, 1936, 36.100.141a-e; 12.16 Los Angeles Country Museum of Art. Gift of Max Palevsky and Jodie Evans in honor of the museum's twenty-fifth anniversary M.89.151.14; 12.17 Photo courtesy of the artist. © Toots Zynsky; 12.18 Image courtesy of the Artist and Blain | Southern. Photo Matthew Hollow, 2013; 12.19 Courtesy the artist. Photo © Merete Rasmussen; 12.20 Courtesy the Artist and Victoria Miro, London. © Maria Nepomuceno; 12.21 MNAM/RMN/Georges Meguerditchian. © El Anatsui, courtesy October Gallery; 12.22 National Museum of the American Indian, Smithsonian Institution, Washington D.C. Photo Ernest Amoroso. © Marcus Amerman; 12.23 © Victoria and Albert Museum, London.

p. 273 Museum Fünf Kontinente, Munich, 98-319-711.

p. 277 MMA/Scala. Gift of Paul and Ruth W. Tishman, 1991.435a,b.

Chapter 13: 13.1 © Gavin Hellier/JAI/Corbis; 13.2 © Prisma Archivo/Alamy; 13.4 © Aristidis Vafeiadakis/ZUMA Press/Corbis; 13.6 © Sakamoto Photo Research Laboratory/Corbis; 13.7 from A Pictorial History of Chinese Architecture by Lian Ssu-ch'eng, forward by Wilma Fairbank, originally published by MIT 1984; 13.9b © Paul M.R. Maeyaert; 13.10a © Achim Bednorz, Cologne; 13.11b Scala; 13.12 © Ruggero Vanni/Corbis; 13.13 Pirozzi; 13.15a © John and Lisa Merrill/ Corbis; 13.16 © Historical Picture Archive/Corbis; 13.17 Harvey Lloyd/Image Bank/Getty Images; 13.18 Monique Pietri/akg; 13.20b John Henry Claude Wilson/Robert Harding; 13.21 IAM/akg; 13.22 © Art on File/Corbis; 13.23a © Bill Varie/ Corbis; 13.24a © James Caulfield Photography, Chicago; 13.25 © Angelo Hornak/Corbis; 13.26 © Wes Thompson/Corbis; 13.27 © Martial Colomb/Photographer's Choice RF/ Getty Images; 13.28 Album/Raga/Prisma/ akg; 13.29 © Richard A. Cooke/Corbis; 13.30 © Gardner/Halls/Architectural Association Photograph EXHIB120-49E; 13.31 Album/Miguel Angel Manzano/akg; 13.32 © Jörg Fischer/dpa/ Corbis; 13.33 Zaha Hadid Architects. Photo Michelle Litvin; 13.34 Photo Museum Angewandte Kunst, Frankfurt-am-Main; 13.35 © Ferenandi Alda, Seville; 13.36 © Timothy Hursley, 2009;

13.37 Photo by Kurt Hörbst. Courtesy Anna Heringer; 13.38 © Proehl Studios/Corbis; 13.39 Jason Flakes/U.S. Department of Energy Solar Decathlon; 13.40 Courtesy Michael Green Architecture. Photo Ema Peter; 13.41 © David Benjamin. Photo Amy Barkow.

 p. 307 © Bettmann/Corbis.
 p. 312 PA Archive/Press Association Images/Fiona Hanson.

Chapter 14: 14.1 © Hans Hinz/Artothek; 14.2 EL/ akg; 14.3 Jack Jackson/Photoshot; 14.4 © Erwin Böhm, Mainz; 14.5 University of Pennsylvania Museum. British Museum/University Museum Expedition to Ur, Iraq, 30-12-702; 14.6 Scala; 14.7 MMA/Scala. Gift of John D. Rockefeller, Jr., 1932, 32.143.2; 14.8 BM, 1849,1222.19; 14.9 Scala/ BPK. Photo Olaf M. Tessmer; 14.10 © pius99/ iStock; 14.11 \odot Jurgen Liepe, Berlin; 14.12 EL/akg; 14.13 © Radius Images/Corbis; 14.14 BM, EA37977; 14.15 Scala/BPK. Photo Margarete Buesing; 14.16 Scala/BPK; 14.17 Scala; 14.18 MMA/ Scala. Gift of Christos G. Bastis, 1968, 68.148; 14.19 © Craig & Marie Mauzy, Athens mauzy@otenet.gr; 14.20 akg; 14.21 MMA/Scala. Rogers Fund, 1914, 14.130.14; 14.22 MMA/Scala. Fletcher Fund, 193.2 32.11.1; 14.23 Scala/BPK. Photo Ingrid Geske; 14.24 Scala - MBA; 14.25 Roger Payne/Private Collection/© Look and Learn/BI; 14.26 Scala; 14.27 BM, 1816,0610.405; 14.28 EL/akg; 14.29 Nimatallah/akg; 14.30 © Vanni Archive/AR; 14.31 Scala; 14.32 Scala - MBA; 14.33 Adam Woolfitt/ Robert Harding; 14.34 BM, 1888,0806.8 21810.

p. 334 Scala/BPK.p. 341 BM, 1816,0610.47.

Chapter 15: 15.1 Scala; 15.3 Yale University Art Gallery, The Arthur Ross Collection 2012.159.11.16; 15.5 Pirozzi; 15.6 Heiner Heine/akg; 15.8 CA; 15.9 BI; 15.10 \odot The Cleveland Museum of Art. Gift of J. H. Wade 1925.1293; 15.11 BM, 1939,1010.2.a-l; 15.12 The Board of Trinity College Dublin. Library of Trinity College, Dublin, MS. 57, fol. 191v; 15.13 © Achim Bednorz, Cologne; 15.14 EL/akg; 15.16 © Paul M.R. Maevaert; 15.17 Musee de la Tapisserie, Bayeux/BI; 15.18 © Adam Woolfitt/Corbis; 15.19 John Elk III/Bruce Coleman, Inc./Photoshot; 15.21 Schütze/Rodemann/akg; 15.22 Peter Willi/BI; 15.23 © Angelo Hornak, London; 15.24 RMN (musée de Cluny - musée national du Moyen-Âge)/Michel Urtado; 15.25 Photo Opera Metropolitana Siena/Scala; 15.26 De Agostini Picture Library/A. Dagli Orti/BI.

Chapter 16: 16.1 Scala; 16.2, 16.3 © Quattrone, Florence; 16.4 Scala; 16.6 © Quattrone, Florence; 16.7 RMN (musée du Louvre)/René-Gabriel Ojéda; 16.8 © Quattrone, Florence; 16.9, 16.10 Javier Larrea/Robert Harding; 16.11 © James Morris, Ceredigion; 16.13 © Quattrone, Florence; 16.14 © Quattrone, Florence; 16.15 EL/akg; 16.16 RMN (domaine de Chantilly)/René-Gabriel Ojéda; 16.17 MMA/Scala. The Cloisters Collection, 1956, 56.70; 16.18 Photograph © 2015 Museum of Fine Arts, Gift of Mr. and Mrs. Henry Lee Higginson 93.153; 16.19 Musee d'Unterlinden, Colmar/Bl; 16.20 NG/Scala; 16.21 MMA/Scala. Rogers Fund, 1919, 19.164; 16.22 NG/Scala; 16.23 EL/akg; 16.24 CA.

p. 375 EL/akg.

Chapter 17: 17.1 Pirozzi; 17.2 Scala/Fondo Edifici di Culto - Min. dell'Interno; 17.4 Scala; 17.5 Detroit

Institute of Arts/Gift of Mr Leslie H. Green/BI; 17.6 Scala; 17.7 Onze Lieve Vrouwkerk, Antwerp Cathedral, Belgium/Peter Willi/BI; 17.8 © Walker Art Gallery, National Museums Liverpool/BI; 17.9 Photo © Château de Versailles, Dist. RMN-Grand Palais/Jean-Marc Manaï; 17.10 © Corbis; 17.11 Image © Museo Nacional del Prado. Photo MNP/ Scala; 17.12 Rijksmuseum, Amsterdam SK-C-5; 17.13 RMN (musée du Louvre); 17.14 © Blauel/ Gnamm/Artothek; 17.15 © Paul M.R. Maeyaert; 17.16 © The Frick Collection, New York. Henry Clay Frick Bequest 1915.1.45; 17.17 RMN (musée du Louvre)/Gérard Blot/Christian Jean; 17.18 RMN (Château de Versailles)/Gérard Blot; 17.19 © Royal Museums of Fine Arts of Belgium, Brussels/photo J. Geleyns/Ro scan; 17.20 Photograph © 2015 Museum of Fine Arts, Gift of Joseph W. Revere, William B. Revere and Edward H. R. Revere 30.781.

p. 392 Royal Collection Trust © Her Majesty Queen Elizabeth II, 2015/BI.
p. 399 The Iveagh Bequest, Kenwood House, London/© English Heritage Photo Library/BI.
p. 405 EL/akg.
p. 408 Scala.

Chapter 18: 18.1 © Roger Wood/Corbis; 18.2 Institut Amatller d'Art Hispànic/Arxiu MAS, Barcelona; 18.3 © Daniel Boiteau/Alamy; 18.4 Robert Harding Productions; 18.5 © Eddi Boehnke/Corbis; 18.6 MMA/Scala. Rogers Fund 1955, 55.44; 18.7 Freer. Purchase F1956.14 folio 22r; 18.8 BM, 1887,0516.1; 18.9 Scala/BPK. Photo Margarete Buesing; 18.10 © Dirk Bakker/ BI; 18.11 Eliot Elisofon Photographic Archives, National Museum of African Art. Photo Eliot Elisofon, 1970. Image no. EEPA EECL 7590; 18.12 Photo © John Pemberton III; 18.13 © The Trustees of the British Museum; 18.14 MMA/Scala, Gift of Lester Wunderman, 1977, 1977.394.15; 18.15 MMA/Scala. The Michael C. Rockefeller Memorial Collection. Bequest of Nelson A. Rockefeller, 1979, 1979.206.121; 18.16 © RMCA Tervuren, EO.0.0.7943. Photo Plusj; 18.17 Photo Frederick Lamp; 18.18 Photo courtesy Elizabeth Evanoff Etchepare. Image number UCSB 88-8751.

p. 420 Photo Professor Herbert M. Cole.

Chapter 19: 19.1 National Museum of India, New Delhi/BI; 19.2 National Museum of India, New Delhi/BI; 19.3 Scala; 19.4 © rchphoto/iStock; 19.5 © Oronoz, Madrid; 19.6 © Dinodia Photos/Alamy; 19.7 Giraudon/BI; 19.8, 19.10 © Borromeo/AR: 19.11 © Paul Miller/Black Star; 19.12 MMA/Scala. Cynthia Hazen Polsky and Leon B. Polsky Fund, 2005, 2005.35; 19.13 Nelson-Atkins. Purchase William Rockhill Nelson Trust, 34-66; 19.14 Julia Hiebaum/Robert Harding; 19.15 Courtesy of Institute of Archaeology and Cultural Relics of Shandong Province. © Cultural Relics Publishing House, Beijing; 19.16 BM, 1903.4-8.1; 19.17 BM, 1919,0101,0.46; 19.18 Courtesy of Institute of Archaeology and Cultural Relics of Shandong Province. © Cultural Relics Publishing House, Beijing; 19.19 Nelson-Atkins. Purchase: Nelson Trust. 34-10. Photo Robert Newcombe; 19.20 Nelson-Atkins. Purchase: Nelson Trust, 47-71. Photo Robert Newcombe; 19.21 Photo © National Palace Museum, Taipei, Taïwan, Dist. RMN-Grand Palais/image NPM; 19.22 Princeton University Art Museum. Bequest of John B. Elliot Class of 1951, 1998-54. Photo Bruce M. White. @ 2012 Photo Trustees of Princeton University; 19.23 MMA/

Scala. Ex coll. C. C. Wang Family, Gift of the Oscar L. Tang Family, 2005, 2005.494.2; 19.24 © The Cleveland Museum of Art. The Norweb Collection 1957.27; 19.25 The Asahi Shimbun/Getty Images; 19.26 © DAJ/Getty Images; 19.27, 19.28 Photo The Gotoh Museum, Tokyo; 19.29 Photograph © 2015 Museum of Fine Arts, Fenollosa-Weld Collection 11.4000; 19.30 © Sakamoto Photo Research Laboratory/Corbis; 19.31 Tokyo National Museum. National Treasure A282/DNP; 19.32, 19.33 Fine Art Images/Heritage Images/Scala; 19.34 MMA/Scala. H. O. Havemeyer Collection, Bequest of Mrs. H. O. Havemeyer, 1929, JP1847.

p. 431a BM, 1899,0715.1.

p. 431b BM.

 p. 358a Rijksmuseum, Amsterdam AK-MAK-1612.
 p. 452 Photography © The Art Institute of Chicago. Martin A. Ryerson Collection, 30793 (4-1-43).

Chapter 20: 20.1 National Gallery of Victoria, Melbourne. Purchased through The Art Foundation of Victoria with the assistance of Esso Australia Ltd, Fellow, 1989. © 2015 ARS, NY/ VISCOPY, Australia; 20.2 © Chris Rainier/Corbis; 20.3 Georgia Lee, Rapa Nui Journal-Easter Island Foundation, CA; 20.4 BM, Oc, HAW.133; 20.5 © Earl & Nazima Kowall/Corbis; 20.6 akg; 20.7 Getty Images/Moment/Nils Axel Braathen; 20.8 SEF/AR; 20.9 © Danny Lehman/Corbis; 20.10 Courtesy Florida Museum of Natural History, Gainesville; 20.11 Photo © Justin Kerr K2888; 20.12 Werner Forman Archive/BM; 20.13 EL/akg; 20.14 MMA/Scala. Gift of Nathan Cummings, 1963, 63.226.8; 20.15 N.J. Saunders/Werner Forman Archive; 20.16 © abm - archives barbiermueller, inv. 531-3. Photo Pierre-Alain Ferrazzini; 20.17 Thomas Gilcrease Museum, Tulsa, OK/ © Dirk Bakker/BI; 20.18 Nelson-Atkins. Purchase: the Donald D. Jones Fund for American Indian Art, 2004.17. Photo Jamison Miller; 20.19 Photo John Bigelow Taylor, New York; 20.20 © Kevin Fleming/Corbis; 20.21 Frederick R. Weisman Art Museum at the University of Minnesota, Minneapolis. 1992.22.416; 20.22 Brooklyn Museum of Art, New York. Museum Expedition 1903, Museum Collection Fund, 03.325.4653; 20.23 LOC. LC-USZC4-464; 20.24 Denver Art Museum. Native Arts acquisition fund, 1948.229 © Denver Art Museum.

Chapter 21: 21.1 EL/akg; **21.2** RMN (musée du Louvre)/Thierry Le Mage; 21.3 RMN (musée d'Orsay)/Gérard Blot/Hervé Lewandowski; 21.4 RMN (musée d'Orsay)/Hervé Lewandowski; 21.5 © Samuel Courtauld Trust, The Courtauld Gallery, London/BI; 21.6 RMN (musée d'Orsay)/ Hervé Lewandowski; 21.7 NG/Scala; 21.8 MoMA/Scala . The William S. Paley Collection. SPC14.1990; 21.9 Philadelphia Museum of Art, George W. Elkins Collection. E'1936-1.1/AR/Scala. Photo Graydon Wood; 21.10 MMA/Scala. Morris K. Jesup Fund, 1933, 33.61; 21.11 NGA. Chester Dale Collection 1963.10.94; 21.12 The Barnes Foundation, Philadelphia, Pennsylvania/BI. © 2015 Succession H. Matisse/ARS, NY; 21.13 MoMA/ Scala. Purchase 12.1951; 21.14 © The Art Archive/ AR/The Solomon R. Guggenheim Foundation/ Solomon R. Guggenheim Museum, New York. Solomon R. Guggenheim Founding Collection, by gift. Photo David Heald. © 2015 ARS, NY; 21.15 MoMA/Scala. Acquired through the Lillie P. Bliss Bequest. © 2015 Estate of Pablo Picasso/ ARS, NY; 21.16 Musée d'art moderne d'art contemporain et d'art brut, Lille Métropole,

Villeneuve d'Ascq, Gift of Geneviève and Jean Masurel in 1979. © Muriel Anssens. © 2015 ARS, NY/ADAGP; 21.17 Kunstmuseum Basel, Gift of Raoul La Roche, 1952. © Hans Hinz/Artothek. © 2015 ARS, NY/ADAGP; 21.18 Scala. © 2015 ARS, NY/SIAE, Rome; 21.19 MoMA/Scala. Acquired through the Lillie P. Bliss Bequest, 231.1948; 21.20 © The Art Archive/AR/The Solomon R. Guggenheim Foundation/Solomon R. Guggenheim Museum, New York. Solomon R. Guggenheim Founding Collection, by gift. Photo David Heald. © 2015 ARS, NY; 21.21 Indiana University Art Museum. Partial gift of Mrs. William Conroy. © Succession Marcel Duchamp/ADAGP/ARS, NY 2015; 21.22 MoMA/ Scala. Purchase, 130.1946.a-c. © 2015 ARS, NY/ProLitteris, Zurich; 21.23 MoMA/Scala. Given anonymously, 162.1934. © Salvador Dalí, Fundació Gala-Salvador Dalí, ARS, NY 2015; 21.24 Albright-Knox Art Gallery, Buffalo, New York, Room of Contemporary Art Fund, 1940/AR/ Scala. © Successió Miró/ARS, NY/ADAGP 2015; 21.26 MoMA/Scala. Gift of Mr. and Mrs. William A.M. Burden, 510.1964; **21.27** © VIEW Pictures Ltd/Alamy; 21.28 MoMA/Scala; 21.29 Offentliche Kunstsammlung, Kunstmuseum, Basel. Gift of Raoul La Roche, 1956. © Hans Hinz/Artothek. © 2015 ARS, NY/ADAGP; 21.30 Schomburg Center, NYPL/© AR. Art © Heirs of Aaron Douglas/VAGA.

p. 475a Marcantonio Raimondi after Raphael, The Judgment of Paris. NGA. Gift of W.G. Russell Allen 1941.1.63.

p. 475b EL/akg.

p. 479a Robert O'Dea/akg.

p. 479b EL/akg.

p. 485 Pierre Matisse Gallery Archives. the Pierpont Morgan Library, New York, MA 5020/ AR/Scala

p. 488 The Philadelphia Museum of Art/AR/Scala. A.E. Gallatin Collection, 1950-1-1, 4266. Photo Graydon Wood. © 2015 Estate of Pablo Picasso/ ARS, NY.

Chapter 22: 22.1 The Museum of Contemporary Art, Los Angeles. The Rita and Taft Schreiber Collection Given in loving memory of her husband, Taft Schreiber, by Rita Schreiber, 89.23. Photo Fredrik Nilsen. © 2015 The Pollock-Krasner Foundation/ARS, NY; 22.2 Nelson-Atkins. Gift of Willian Inge, 56-128. Photo Jamison Miller. © 2015 The Willem de Kooning Foundation/

ARS, NY; 22.3 Albright-Knox Art Gallery, Buffalo, New York, Gift of Seymour H. Knox Jr., 1956/AR/ Scala. © 1998 Kate Rothko Prizel & Christopher Rothko/ARS, NY; 22.4 MoMA/Scala. Gift of Mr. and Mrs. Ben Mildwoff, 136.1958.1-57. © 2015 Estate of Louise Nevelson/ARS, NY; 22.5 MoMA/ Scala. Mrs. Donald B. Straus Fund, 2668.1967. © 2015 Helen Frankenthaler Foundation, Inc./ ARS, NY (ARS), New York; 22.6 MMA/Scala. Gift of Steven and Alexandra Cohen, and Purchase, Lila Acheson Wallace Gift, Bequest of Gioconda King, by exchange, Anonymous Gift and Gift of Sylvia de Cuevas, by exchange, Janet Lee Kadesky Ruttenberg Fund, in memory of William S. Lieberman, Mayer Fund, Norman M. Leff Bequest, and George A. Hearn and Kathryn E. Hurd Funds, 2005, 2005.390a-c. Art © Robert Rauschenberg Foundation/VAGA; 22.7 MoMA/ Scala. Gift of Mr. and Mrs. Robert C. Scull, 8.1958. Art © Jasper Johns/VAGA; 22.8 Courtesy The Getty Research Institute, Los Angeles, 980063. Photo Lawrence Shustak; 22.9 MoMA/Scala. Gift of Philip Johnson, 316.1962. © 2015 The Andy Warhol Foundation for the Visual Arts, Inc./ARS, NY; 22.10 Yale University Art Gallery, Gift of Richard Brown Baker, B.A. 1935, 1995.32.9. © Estate of Roy Lichtenstein/DACS 2015; 22.11 The Art Archive/AR/The Solomon R. Guggenheim Foundation/Solomon R. Guggenheim Museum, New York. Gift, Mr. Irving Blum, 1982. © 2015 Frank Stella/ARS, NY; 22.12 Whitney; purchase with funds from Mrs. Robert M. Benjamin 69.102. Photo Sheldan C. Collins. © Chuck Close, courtesy Pace Gallery; 22.13 MoMA/Scala. Helen Acheson Bequest (by exchange) and gift of Joseph Helman. Art © Judd Foundation. VAGA; 22.14 National Gallery of Australia, Canberra. Purchased 1973, 1974.395 A-H. © The Estate of Eva Hesse. Courtesy Hauser & Wirth; 22.15 Solomon R. Guggenheim Museum, New York. Panza Collection, Gift, 1992, 92.4171. Photo Erika Barahona Ede $\ensuremath{\mathbb{C}}$ The Solomon R. Guggenheim Foundation, New York. © 2015 Bruce Nauman/ARS, NY; 22.16 Photo Giovanna dal Magro. © 2015 Marina Abramovic. Courtesy of Sean Kelly Gallery/(ARS), New York; 22.17 Dia Art Foundation. Photo John Cliett. © Walter de Maria; 22.18 Private Collection/BI; 22.19 Courtesy Paula Cooper Gallery, New York. Photo Cathy Carver. © 2015 The LeWitt Estate/ARS, NY; 22.20 Courtesy Electronic Arts Intermix (EAI), New York, and Yvon Lambert Paris; 22.21 Photo © Tate T12979. Art © Magdalena Abakanowicz; 22.22 Brooklyn Museum of Art, New York, Gift of The

Elizabeth A. Sackler Foundation. Photo © Donald Woodman. © 2015 Judy Chicago/ARS, NY; 22.23 © Maria Breuer/imagebroker/Alamy; 22.24 Walker Art Center, Minneapolis. T.B. Walker Acquisition Fund, 1992. Courtesy of the artist and Paula Cooper Gallery, New York; 22.25 Photo AR/Scala. © Anselm Kiefer; 22.26 Whitney; gift of Douglas S. Cramer 84.23. Digital Image © Whitney Museum of American Art. © The Estate of Jean-Michel Basquiat/ADAGP/ARS, New York 2015; 22.27 © Jenny Holzer, Photo Thomas Holder. Courtesy Jenny Holzer/AR/. © 2015 Jenny Holzer, member ARS, NY; 22.28 Courtesy of the Estate of David Wojnarowicz and P.P.O.W Gallery, New York; 22.29 Whitney; Gift of The Bohen Foundation in honor of Thomas N. Armstrong III. 2001.275. Courtesy Regen Projects, Los Angeles © Glenn Ligon; 22.30 © Olia Lialina; 22.31 Courtesy Bill Viola Studio LLC; 22.32 Courtesy of the artist and Matthew Marks Gallery, New York.

p. 502 © Rudolph Burckhardt/Sygma/Corbis.
p. 508 © LGI Stock/Corbis.
p. 525a&b Copyright © by Guerrilla Girls. www. guerrillagirls.com.

Chapter 23: 23.1 Image courtesy Stephen Friedman Gallery and Pearl Lam Galleries. Photo Stephen White. © Yinka Shonibare MBE. All Rights Reserved, DACS/ARS, NY 2015; 23.2 Courtesy and © Nermine Hammam; 23.3 Courtesy the artist and Corvi-Mora, London; 23.4 Courtesy the artist and Hauser & Wirth. Photo Rahm Rahman. © Subodh Gupta; 23.5 MoMA/Scala, 1168.2008. Photo Mattthew Septimus. © Feng Mengbo, courtesy Hanart TZ Gallery; 23.6 Courtesy the artist and Tyler Rollins Fine Art, New York; 23.7 MMA. Purchase, Acquisitions Fund and Peggy and Richard M. Danziger Gift, 2011, 2011.493a-j. Photo Nobutada OMOTE, courtesy SCAI The Bathhouse, Tokyo, 23.8 © Damian Ortega. Courtesy Gladstone Gallery, New York and Brussels; 23.9 © 2015 ARS, NY/VG Bild-Kunst, Bonn; 23.10 © Jenny Saville. Courtesy of Gagosian Gallery; 23.11 Courtesy the artist, Tanya Bonakdar Gallery, New York; and Galeria Fortes Vilaçca, Såo Paulo.

p. 535 MoMA/Scala. Gift of Doris and Donald Fisher, 357.1997 and 358.1997. © 2015 The Andy Warhol Foundation for the Visual Arts, Inc./ ARS, NY.

Index

All references are to page numbers. Numbers in **boldface** indicate an illustration on that page

Abakan Red (Abakanowicz) 517, 517 Abakanowicz, Magdalena: Abakan Red 517, 517 Aboriginal art 453-454, 454 Abramović, Marina: Imponderabilia 513, 513 abstract art 30, 33, 34, 36, 207, 501 Abstract Expressionism 501, 501, 503, 503-504, **504**, 505, 510 academies 405 Acropolis (Athens) 340, 340 acrylic paint 169, 169-170 action painting 501 Admonitions of the Instructress ... (Gu Kaizhi, attr.) 438, 438-439 adobe 286 advertising 232-234, 233, 234, 522, 523 Aegean cultures 335, 335-336, 336 aesthetics 4, 22, 25, 47, 208, 258 Afghanistan 54, 54 African art 417-425; artist profile 273, 273; Asante culture 9, 9, 43, 43, 421; Bamana culture 422, 423; Benin 130, 130-131, 418-419, 419; Berber culture 418; collage 156, 156; contemporary 101, 101, 156, 156, 183, 183-184, 529, 529-530; and context 43, 43-44; Dogon culture 422, 422-423; European interest in 256, 256; and export arts 277, 277; Igbo culture 420, 420, 425, 425; ivory 276, 276, 277, 277; kente cloth 9, 9, 421; Kush 417, 417; linocut 183, 183-184; masquerades 48, 48-49, 113, 420, 420, 424, 424-425, 425; nkondi figures 423, 423-424; Nok culture 418, 418; Nubia 417, 417; primitivism 256, 256; and proportion 130, 130-131; sculpture 254, 254; wood 272, 272, 273, 273; Yoruba culture 32-33, 33, 272, 272, 273, 273, 276, 276, 419, 420, 421, 421-422. See also Egyptian art; Islamic art African-American art: artist profile 163, 163; collage 155, 155; Harlem Renaissance 163, 498-499, 499; and human experience themes 65, 65-66; lithography 192, 192; photogravure 190, **190**; tempera 162, **162** afterimage 94, 94 Aiken, Gayleen: A Beautiful Dream 26, 26 aisles 351, 351, 358 Akan culture 43-44, 44 Akbar 158 Akhenaten (pharaoh) 331 Akhenaten and His Family 332, 332 Alberti, Leon Battista: Sant'Andrea (Mantua) 135, 135, 368, 369, 369-370 ALGO 54 1.0 (Hansen) 173, 173 Alhambra Palace (Granada) 415, 415 alla prima 165 Allegory (Bronzino) 385, 385-386 Altar to the Chases High School (Boltanski) 61, 61 Alvarez Bravo, Manuel: The Visit 87-88, 88

Amalienburg: Hall of Mirrors (Cuvilliés the Elder)

The Ambassadors (Holbein) 383, 383

ambulatories 358, 359, 360

523 Americas. See Mesoamerican art; North American peoples; South/Central American art Amerman, Marcus: Horse mask 282, 282 Amida Nyorai (Jocho) 40-41, 41, 288, 446, 448 Amnesty International leaflet (Dobkin) 230, 230 - 231amphora (Greece) 338, 339 analogous color harmonies 93 Anasazi culture 468, 468 Anatsui, El: Sasa 282, 282, 529 Andokides and the "Andokides Painter" 338, 339 Angkor Wat (Cambodia) 241, 242, 434, 434 Anguissola, Sofonisba 517; Portrait of Amilcare. Minerva and Asdrubale Anguissola 386, 386 animal style 356 animation 114, 215-216 The Annunciation (Titian) 378, 379 Antarctic Tidal Rhythms (Miebach) 237-238, 238 Antoni, Janine: Gnaw 40, 40 AOL wordmark (Wolff Olins) 229, 229 Aphrodite of Melos 20, 343, 343 Apoxyomenos (Lysippos) 255, 255, 338 appropriation 520 apses 351, 351, 358, 360 aquatint 184, 188-190 Aquila, Abruzzi, Italy (Cartier-Bresson) 80, 80 Arcangel, Cory: Various Self Playing Bowling Games Architectural Perspective (Francesco, attr.) 105, architecture 284-319; Baroque 388-389, 389, 390, 390, 395, 395-396, 396; and bio-engineering 319, 319; Byzantine 296, 296, 297, 298, 353, 353-354, 413, 414; China 288, 440, 440; and Christianity 52, 52, 351, 351-352, 362; and community 313-316; digital design and fabrication 309, 309-310, 310; Egypt 55, 55-56, 62, 62, 286-287, 287, 295, 329, 329, 330, 330; fabric 310-311, 311, 313, 313; and golden section/rectangle 131, 131-132, 342; Gothic **292**, 292–293, **293**, 357–358, 359–362, **360–362**; Greece 287, 287-288, 288, 295, 340-342, 340-343; green 316-319, 316-319; Inca culture 464, 464-465; India 297, 297, 298, 298, 428, 429, 429, 433, 433-434, 434; Islamic 52, 52, 285-286, 286, 296, 296, 297, 297, 298, 412-415, 413-415; Japan 288-289, 289, 445, 445, 446, 446; Mesoamerica 459, 459-461, 460, 461, 464, 464-465; Mesopotamia 290, 325, 325, 327-328, **328**; Neolithic 5–6, **6**, **322**, 323; postmodern 519, 519; Renaissance 369, 369-370, 376, 376; Rococo 402, 402; Roman 290, 290-291, 292, 293, 294-296, 295, 346, 346-348, 347, 413; Romanesque 291, 291, 292, 357, 357, 358, 358; and sacred themes 52; space shaped by 102; De Stijl 497, 497; structural systems in 284-306, 286-306, 308; and sustainability 316-319, 316-319; and time/motion 112, 113; in wood 318, 318-319 architraves 286, 288 arch/vault construction 290-293, 290-293

American Revolution 409-410

Americans can't deal with death (Wojnarowicz) 522,

Ardabil carpet (Persia) 275, 275, 416, 417 Arena Chapel frescoes (Giotto) 107, 364, 364 Ariwajoye I (Yoruba ruler) 421, 421 arm ornament (Yoruba) 276, 276, 421 armchair (Breuer) 497, 497, 498 Armed Innocence II (Hammam) 530, 530 Arnolfini Double Portrait (van Eyck) 41-43, 42, 380 Artemidoros mummy case (Egypt) 348, 348 Artemis, Acrobats ... (Spero) 175, 175 artist profiles: Bourgeois 31, 31; Christo and Jeanne-Claude 264, 264; Dürer 186, 186; Gentileschi 392, 392; Hadid 312, 312; Hokusai 452, 452; Kollwitz 181, 181; Lawrence 163, 163; Leonardo da Vinci 143, 143; Lin 8, 8; Martínez 267, 267; Matisse 485, 485; Michelangelo 375, 375; O'Keeffe 120, 120; Olowe of Ise 273, 273; Picasso 488, 488; Pollock 502, 502; Rauschenberg 64, 64; Rembrandt 399, 399; van Gogh 11, 11; Vigée-Lebrun 408, 408; Warhol 508, 508; Wright 307, 307 Artistry of the Mentally Ill (Prinzhorn) 26 artists' roles or functions 7, 9-10, 12 Arts and Crafts movement 279-280, 282, 283 arts of ritual and daily life 265-283; ceramics 265-268; and design 282-283, 283; and export arts 277, 277; fiber 274, 274-275, 275; glass 268-270, 269, 270; and industrialization 279; ivory 275-276, 276, 277, 277; jade 275, 276, 278, 278; lacquer 278, 278, 279; metal 270, 270-271; wood 271-273, 272, 273. See also specific kinds Asante culture 9, 9, 43, 43-44, 421 The Ascent of the Prophet Muhammad (Sultan Muhammad, attr.) 34, 34, 415 The Ashes of Phokion (Poussin) 394, 394, 481 Aspects of Negro Life (Douglas) 499, 499 assemblage 248-252, 249-252, 505, 505-506 Assumption (Titian) 44, 44-45, 378, 378 Asta su Abuelo (Goya) 189, 189 Asuka period (Japan) 446, 446 asymmetrical balance 122, 122-124, 126 atmospheric perspective 109-110 audience 22-25 Aurelius, Marcus 56, 56, 345, 345 auteur concept 218 Autumn Colors among Streams and Mountains (Shen) 110, 110, 154, 442 Autumn Effect at Argenteuil (Monet) 94, 476, 477 avant-garde 483-491, 484, 486-489, 491 Aztec culture 38, 85, 85, 459, 462-463, 463

В

Badi'uzzaman Fights Iraj ... (Dasavanta, Shravana, and Madhava Khurd) 24, 24
Bahram Gur and the Princess in the Black Pavilion (Shaykhzada) 416, 416
balance 118–119, 121–124, 126; asymmetrical 122, 122–124, 126; symmetrical 118–119, 126; and visual weight 118
Baldessari, John: Six Colorful Inside Jobs 75, 75
balloon-frame construction 300–301
Bamana culture 422, 423
Ban, Shigeru: Pompidou-Metz 310, 310, 534
The Banjo Lesson (Tanner) 126, 126–127, 482, 482

402, 402

Bär, Matthias (WertelOberfell): Fractal.MGX 283, 283 A Bar at the Folies-Bergère (Manet) 124, 124, 125, 476 Barcilon, Pinan Brambilla 107, 107 Baroque art 388-401; architecture 388-389, 389, 390, **390**, **395**, 395–396, **396**; France 394–396; Italy 388-393; Netherlands 397-401; painting 390-394, **391-394**, 396-401, **397-401**; sculpture 389, 389-390; Spain 396-397 barrel vaults 290-291, 291 Bartholl, Aram: Map 225, 225 basilicas 351, **351** A Basket of Wild Strawberries (Chardin) 405 basketry 274, 274 Basquiat, Jean-Michel 521; Hollywood Africans 521, 521-522 bas-relief **241**, 242 The Battle of the Granicus (Le Brun) 176, 176-177, 396 Battleship Potemkin (Eisenstein) 217, 217 Bauhaus 497-498, 519 Baumgarten, Alexander 47 Bayeux Tapestry 359, 359 bays (architecture) 291, 291 Bearden, Romare: Mysteries 155, 155 A Beautiful Dream (Aiken) 26, 26 beauty 25, 27-29, 186 Bellini, Giovanni: Pietà 27, 27-28, 378 Belmondo, Jean-Paul 218, 219 Belting, Hans 535 Benglis, Lynda 170, 170-171, 512 Benin 130, 130-131, 418-419, 419 Benjamin, David (The Living) 319 Berber culture 418 Bernini, Gianlorenzo: Cornaro Chapel 388-389, 389, 396; St. Peter's Basilica 390; St. Teresa in Ecstasy 389, 389-390 Beuys, Joseph: How to Explain Pictures to a Dead Hare 48, 48, 506 Bhabha, Huma: Bleekmen 251, 251 The Biglin Brothers Racing (Eakins) 81, 81-82, 482, 482 binders 146, 158 Bingham, George Caleb: Fur Traders Descending the Missouri 482, 482 bio-engineering and architecture 319, 319 biographical point of view 125 Bird in Space (Brancusi) 2, 3 The Birth of Venus (Botticelli) 370, 370, 371 The Birth of Venus (Bouguereau) 479, 479 Black Bean (Warhol) 237, 237, 507 Black Lines No. 189 (Kandinsky) 486, 486 Black Venus (Bradford) 172, 172 Blam (Lichtenstein) 509, 509 Der Blaue Reiter 486 Bleekmen (Bhabha) 251, 251 Blessings Upon the Land of My Love (Qureshi) 531, 531-532 Blond Negress, II (Brancusi) 100, 100 The Boating Party (Cassatt) 99, 483, 483 Boccioni, Umberto: Unique Forms of Continuity in Space 491, 491 The Bodhisattva Avalokiteshvara (Kurkihar, Bihar) **244**, 244–245 Bodhisattva Guide of Souls (Tang) 439, 439

The Bodhisattva Padmapani (Ajanta) 430, 430, 432

book arts 356, 357, 415-416, 416, 435, 435, 436

Borromini, Francesco: San Carlo alle Quattro

Boltanski, Christian: Altar to the Chases High School

Bosch, Hieronymus: The Garden of Earthly Delights

Botticelli, Sandro 370-371; The Birth of Venus 370,

Body art 513

Fontane 390, 390

68, 68, 382

370, 371

bottle in shape of pomegranate 268-269, 269, 333 Bouguereau, William-Adolphe: The Birth of Venus 479, 479 Le Boulevard du Temple (Daguerre) 201, 201-202 Bourgeois, Louise: artist profile 31, 31; Maman 240, 241; Personages series 30, 30, 32; The Red Room-Child 261, 261; Spider 185, 185; Woman with Packages 30, 30, 33, 35 bowl (Chinese) 33, 33 bracket system 288-289, 289 Bradford, Mark: Black Venus 172, 172 Brancusi, Constantin 3, 256; Bird in Space 2, 3; Blond Negress, II 100, 100; studio of 2, 3 Braque, Georges 488; The Castle at La Roche-Guyon 489, 489-490; collage 154, 154-155; Le Portugais (The Emigrant) 489, 489, 490, 522; Still Life on Table: "Gillette" 154, 489, 522 Breathless (Godard) 218, 219 Breuer, Marcel 497; armchair 497, 497, 498 Brillo Boxes (Warhol) 535, 535 Bronzino, Agnolo: Allegory 385, 385-386 Die Brücke 486 Bruegel, Pieter, the Elder: The Harvesters 384, 384 brush and ink 153-154 Buddha (standing) (Gandhara) 431 Buddha of Bamiyan (Afghanistan) 54, 54 Buddha Preaching the First Sermon (Sarnath) 430, 430 Buddhism 428-429, 431, 530; and architecture 313, 428, 429, 429; and Chinese art 33-34, 439, 439-440, 440; and contemporary art 221, 221; and iconoclasm 54, 54; and iconography 40-41, 41; and Indian art 244, 244-245, 428-431, 428-432; and Japanese art 47, 47, 446, 447-448, 449, 449, 451; and mandalas 121, 121, 126; and natural world 73, 73; and paper 145; and printmaking 179, 179; and sculpture 244, 244-245, 254, 254; and similarity in sacred images 53, 53, 55 Buick, Malcolm (Wolff Olins): AOL wordmark 229, 229 Bunshaft, Gordon (Skidmore, Owings, and Merrill): Lever House 303, 303, 316, 501 buon fresco 159 The Burghers of Calais (Rodin) 253, 253 A Burial at Ornans (Courbet) 474, 474 Burnham Pavilion (Hadid) 310, 311, 538 The Burning of Sanjo Palace (Japan) 448, 449 The Burning of the Houses of Parliament (Turner) 93, 123, 123-124 buttresses 292, 293, 293 Bwa masquerade (Burkina Faso) 48, 48-49, 424 Byodo-in Temple (Kyoto) 288-289, 289, 446 Byzantine art 54, 296, 296, 297, 298, 353, 353-355, 353-355, 413, 414, 535 Byzantium 341, 352, 413

cable-stayed structures 304, 304-305 CAD/CAM (computer design and manufacturing technology) 280, 280, 283, 283 Café-concert (Seurat) 149-150, 150, 151 Cage, John 64, 504-505, 506 Cai Lun 145 Cake Man (Shonibare) 529, 529 Calder, Alexander 112; Southern Cross 112, 112 Calderón de la Barca, Pedro 158 California Academy of Sciences (Piano) 316, 317 calligraphy 145, 415-416, 416, 443, 443, 447, 447 Cambodian art 533-534, 534. See also Angkor Wat camera obscura 200, 200-201 Cameron, Julia Margaret: Julia Jackson 202, 203 Campbell's Soup I (Warhol) 237, 237 Campin, Robert: Mérode Altarpiece 380, 380 Campus, Peter: Third Tape 221, 221-222, 516

Cabbage Leaf (Weston) 27, 28, 43

Candles Un-burn, Suns Un-shine, Death Un-dies (Robleto) 197, 197 Cannibal Bird masks (Kwakiutl) 470, 470 cantilevers 306 Cao Fei: i.Mirror 224-225, 225, 533 capitals (columns) 287, 287 Caravaggio 397; Entombment of Christ 391, 391, 393, 409 Carnival of the Harlequin (Miró) 494-495, 495 Carolingian art 356 Carousing Couple (Leyster) 400, 400-401 carpet (Persia) 275, 275, 416, 417 Carter, Howard 334 Cartier-Bresson, Henri: Aquila, Abruzzi, Italy 80, 80 cartoons (fresco) 159 carving 39, 248, 248 Cassatt, Mary 482-483, 517; The Boating Party 99, 483, 483; Woman Bathing 189, 189-190, 483 casting 244-247, 244-247 cast-iron construction 299, 299-300, 300 The Castle at La Roche-Guyon (Braque) 489, 489 Catlett, Elizabeth: Singing Their Songs 192, 192 Cave, Nick: Soundsuit 113, 113, 517 cave paintings 4-5, 5, 107, 146, 320, 321-322, 471 censorship 211 ceramics: arts of ritual and daily life 265-268, 267, 269; casting 246, 246-247; China 6, 6, 9, 33, 33, 265, 266, 268, 269; as fine art 281; Greece 146, 265, 337, 337, 338, 339; Islamic 417, 417; Japan 47, 47, 265; North American peoples 266, 266, 267, 468-469, 469; South American peoples 464, 464 ceremonial shield (Aztec) 463, 463 Cézanne, Paul 478; Mont Sainte-Victoire 480, 481; Still Life with Compotier, Pitcher, and Fruit 127, 127-128, 481 C.F.A.O. (Purvear) 250-251, 251 chair of Hetepheres (Egypt) 272, 272, 330 chalk 151 Champs délicieux, second rayogram (Man Ray) 209, 209, 492 Chang Dai Chien: Mountains Clearing After Rain 167-168, 168 Chanter (Whitehorse) 84, 84, 85 charcoal 148 Chardin, Jean-Siméon 405; A Basket of Wild Strawberries 405 Chartres cathedral (France) 270, 270, 360-362, 360-362 Chauvet cave paintings 4, 5, 321, 321, 322, 471 chiaroscuro 88, 104 Chicago, Judy: The Dinner Party 518, 518 The Chief (Fosso) 101, 101, 529 Chinese art 436-444; architecture 288, 440, 440; perspective 110, 110; brush and ink 154; and

arts of ritual and daily life 276; and atmospheric Buddhism 33-34, 439, 439-440, 440; ceramics 6, 6, 9, 33, 33, 265, 268, 269; and Confucianism 437-439, 438, 442; contemporary 532-533, 533; and daily life themes 62, 62-63; and Daoism 438, 438, 442; and export arts 277; Han dynasty 437-438, 438; ink stick 167-168, 168; jade 278, 278; lacquer 278, 278, 444; Longshan culture 6, 6; map 426; Ming dynasty 443-444, 444; and natural world 72, 72-73; painting 62, 62-63, 72, 72-73, 110, 110, 438, 438-439, 439, 441, 441-442, 442, 443-444, 444; and paper 145, 145; Qin dynasty 436, 437, 437; scrolling clouds 33, 33-34; sculpture 33-34, 437, 437, 440-441, 441; Shang dynasty 436, 437; Song dynasty 440-442, 441; stylization 33, 33-34; and symbolism 227, 227; Tang dynasty 439, 439-440, 440; woodcuts 179, 179, 180; Yuan dynasty 442-443, 443; Zhou dynasty 436

Christ as Pantokrator (Santa Maria la Nuova) 354, 354

Christ as the Sun (mosaic) 350, 350 Crane, Jordan (Wolff Olins): AOL wordmark globalization 528-529; and graphic design Christ Preaching (Rembrandt) 188, 188, 398 229, 229 233-236, 239; Internet art 223-225, 524, **524**, Christianity: and architecture 52, 52, 351, 351-352, cravons 149-150 526; and photography 210, 212, 212-213; post-362; and Byzantine art 353-355, 353-355; creativity 12-14 Internet art 225; and Postmodernism 524, 524, and iconoclasm 54; and metal 271; Protestant cross-hatching 89, 89 526-527; and printmaking 179, 195, 233-234; Reformation 383, 384, 386-387; rise of 349-353; Crow Camp, 1910 (Throssel) 203, 203 and video 220, 222, 234-235, 516, **516**, **526**, and similarity in sacred images 53, 53, 55; and Crystal Palace (Paxton) 298, 299, 316 526-527 stained glass 269-270, 362, 362; and stories as Cubi XXI (D. Smith) 249, 249, 504 The Dinner Party (Chicago) 518, 518 themes **59**, 59-60. *See also* medieval art Cubism 29, 207, 487, 488, 489–490, 510, 522 Dinteville, Jean de 383 Christo: artist profile 264, 264; The Gates 263, 263 Curtain (Guston) 191, 191-192 Christus, Petrus: A Goldsmith in His Shop 164, directional lines 80-82 Curtis, Cassidy: Graffiti Archaeology 235, 235, 526 display piece (Yoruba) 421, 421-422 164-165, 380 Curtis, Edward S.: Navajo Zahadolzha Masker 470 The Disquieting Muses (de Chirico) 490-491, 491 chroma 92 Cut with the Kitchen Knife Dada ... (Höch) 208, Djalambu (Lipundja) 454, 454-455 Church of the Frari, Venice (Struth) 44, 45 208, 492 D-N SF 12 PG VI 14 (Wheeler) 87, 87 The Churning of the Sea of Milk (Angkor Wat, Cute Motion!! (Rae) 195, 195, 538 Dobkin, Joan: Amnesty International leaflet 230, Cambodia) 241, 242 Cuvilliés, François de, the Elder: Hall of Mirrors 230-231 Cimabue: Madonna Enthroned 53, 53, 55, 363 (Amalienburg) 402, 402 Dogon culture 422, 422-423 Cinderella table (Verhoeven) 280, 280 Cycladic culture 335, 335 domes 293–297, **294–297**, 413; geodesic 306, circular shield (Aztec) 85, 85, 463 cylindrical head (Yoruba) 32-33, 33, 419, 421 308, 308 clerestories 351, 351 Cypress Trees (Kano, attr.) 450, 450 Donatello: St. Mark 367, 367, 369 Cliff Palace (Anasazi) 468, 468 Dong Yuan 72 Close, Chuck: Phil 510, 510 Donovan, Tara 35; Untitled (Mylar) 35, 35, 536 coffered ceilings 294, 295 door jamb statues 361, 361 Cole, Thomas: The Oxbow 71, 71, 482, 482 Dada 208, 208-209, 492, 492-493, 493, 505, 506 Doric style 287, 287, 288 collage 154-156, 208 Dada (Gupta) 532, 532 Dormiente (Hatoum) 98, 98, 100, 530 color 89-98; color theory 90-91; emotional effects Daguerre, Louis Jacques Mandé: Le Boulevard du of 96-98; harmonies 93-94; light vs. pigment 92, Double Portrait ... (Roman) 345, 345 Temple **201**, 201–202 Douglas, Aaron 499; Aspects of Negro Life 499, 499 92; optical effects of 94-96; photography 209; daguerreotype 201, 201-202, 471 Draftsman Drawing a Reclining Nude (Dürer) properties of 92; psychological effects of 89-90 daily life themes 61-63, 65 108, 108 Color and Information (Winters) 527, 527 Dalí, Salvador 494; The Persistence of Memory 494, drawing 141-157; liquid media 151-154; media color field painting 503, 503 494, 495 color wheel 90, 91 146-154; painting vs. 153-154; paper as medium Dance or Exercise ... (Nauman) 220, 220, 513 154-157; reasons for 141-142, 144; surfaces for Colossal head (Olmec) 248, 248, 459, 459 Danto, Arthur 535 Colosseum (Rome) 346-348, 347 Daoism 438, 438, 442 The Dream (Rousseau) 69, 69 Commentaries (Ghiberti) 369 Dasavanta: Hamzanama 24, 24, 436, 436 drums (domes) 296, 296 community and architecture 313-316 David (Michelangelo) 211, 372, 373 drypoint 184, 185 complementary color harmonies 93 David (Verrocchio) 23, 23, 373 du Barry, Countess 402, 403 composition 115. See also design principles David, Jacques-Louis 407, 472; The Death of Marat Duccio: Maestà Altar 363, 363 computer design and manufacturing technology 409, 409; The Oath of the Horatii 404, 404, 406 Duchamp, Marcel 493, 506, 514; Fountain 493, 493, (CAD/CAM) 280, 280, 283, 283 Daylight (Whiteread) 247, 247, 538 computer technology. See digital technology de Chirico, Giorgio 490; The Disquieting Muses Conceptual art 514–515, **515**, 522 duk duk masters (Melanesia) 455, 455 490-491, **491** Dürer, Albrecht 382; artist profile 186, 186; conceptual unity 117 de Kooning, Willem 501, 503, 537; Woman IV Draftsman Drawing a Reclining Nude 108, 108; concrete 295, 305. See also reinforced concrete 503, 503 St. Jerome in His Study 184-185, 185, 382; Self-Confucianism 437-439, 438, 442 De Maria, Walter 514; The Lightning Field 514, 514 Portrait at Age 28 186; and typography 230, 230 Congregational Mosque (Kairouan) 412-413, 413 Death and Life (Klimt) 122, 122, 126 Durga Fighting the Buffalo Demon (Mahishamardini Conjoined (Paine) 250, 250 The Death of Marat (David) 409, 409 conservation 107 Cave) 242, 242, 432 decorative arts. See arts of ritual and daily life Dutch Baroque art 397-401 Constantine (Roman emperor) 350, 352-353 Deer's Skull with Pedernal (O'Keeffe) 119, 119, 121 The Dying Slave (Michelangelo) 255, 255, 257, 373 Constantine the Great (Roman) 352, 352-353 Degas, Edgar: Nude Woman Having Her Hair Constructivism 496, 496 Combed **36,** 37; The Singer in Green 150, conté crayons 149-150 content 39 Le Déjeuner sur l'herbe (Manet) 475, 475–476 Eakins, Thomas: The Biglin Brothers Racing 81, context 43-45 Delacroix, Eugène 473; Liberty Leading the People 57, 81-82, 482, 482 Contingent (Hesse) 512, 512, 513 57, 473; The Women of Algiers 473, 473 earthworks 73, 73, 258, 258-259 continuous-motion photography 214 Delaunay, Sonia: Electric Prisms 35, 35, 486 Easter Islanders 455, 455 Delusions of Grandeur II (Magritte) 129, 129, 494 Eastern Woodlands cultures 258, 258-259, 466, contrapposto 255, 255, 257, 339, 339, 367, 367, 431 Demand, Thomas 537; Kontrollraum/Control Room 466-467, 467 Cook, Roger: signage systems 228, 228 Eastman, George 202-203, 214 cool colors 91 Les Demoiselles d'Avignon (Picasso) 487, 487, 489 Edison, Thomas: Fred Ott's Sneeze 214 Cooper, Diana: The Site 93, 93 Densatil Monastery artists (Tibet): Thirteen Deity editing (film) 217 Copland, Aaron 263 Jnanadakini Mandala 121, 121, 126 Copley, John Singleton: Paul Revere 94, 410, 410 editions (prints) 178 depth cues 103-104. See also perspective Edo period (Japan) 451, 452 corbelling 298, 298 Derain, André 256 Edouard Manet, Une Marchande de Consolation Corinthian style 287, 287, 347, 348 Dervish (Steinkamp) 114, 114, 526 Cornaro Chapel (Bernini) 388-389, 389, 396 (Stop) 125, 125 The Descent of Amida and the Twenty-five Bosatsu effigy pipe (Hopewell) 466, 466 cornices 288, 288 (Japan) 449, 449 Egyptian art 328–334; Amarna period 331–332, Cottage among Trees (Rembrandt) 151, 151-152 design principles 115-139; artistic awareness of 332; architecture 55, 55-56, 62, 62, 286-287 Counting (Simpson) 190, 190, 523 115; balance 118–119, 121–124, 126; composition 287, 295, 329, 329, 330, 330; contemporary 530, Courbet, Gustave 474; A Burial at Ornans 474, 474 115; emphasis/subordination 126-128; rhythm 530; and daily life themes 62, 62; encaustic 159, Court Ladies Preparing Newly Woven Silk 133-135; scale/proportion 129-132; unity/ 159; furniture 272, 272; glass 268-269, 269; (Hui-Zong, attr.) 62, 62-63, 441 variety 116-117; and visual elements 135-139 and grave robbing 334, 334; map 325; painting Courtyard (Kaprow) 506, 506 Diamond Sutra (woodblock, China) 179, 179, 439 330-331, 331; proportion 130, 130; pyramids 55, crafts. See arts of ritual and daily life digital technology 114, 199; and architecture 55-56; and Roman Empire 348, 348; sculpture Craftsman Workshop: library table 279, 279 **309,** 309–310, **310**; and designers 283; and 252-253, 253, 329, 329-330, 330, 332, 332; and

Golden Gate Bridge (San Francisco) 304, 304 Flack, Audrey: Wheel of Fortune (Vanitas) 16, 17, social order themes 55-56; Tutankhamun tomb golden section/golden rectangle 131, 131-132, 342 332-334, **333, 334**; wood 272, **272** 136, 510 A Goldsmith in His Shop (Christus) 164, 164-165, The Flatiron (Steichen) 206, 206-207 Eiffel, Gustave: Eiffel Tower 300, 300, 316, 496 Flavin, Dan: Untitled (to Karin and Walther) 261, 261 18th-century art: academies 405; map 406; Goldsworthy, Andy: Reconstructed Icicles, Floris, Frans (workshop of): Portrait of Michelangelo Neoclassicism 403-410, 404, 407, 409, 410, 472; Dumfriesshire, 1995 259, 259 Buonarroti 375 Rococo era 401-403, 402, 403 Gonzalez-Torres, Felix: Untitled 50, 50, 514 Flow Chart for "The Perfect Ride" (Pastor) 79, 79 Eisenman, Nicole: Untitled 194, 194 Gormley, Antony: Quantum Void III 257, 257-258 flying buttresses 292, 293, 293 Eisenstein, Sergei: Battleship Potemkin 217, 217 Gospel Book of Durrow (Scotland?) 356, 357 foreshortening 108, 108-109 Ejiri in Suruga Province (Hokusai) 74, 74-75, 451 Gothic style 38, 292, 292-293, 293, 359-362, Electric Prisms (Delaunay) 35, 35, 486 forging 270 360-362 form 39 Elgin marbles 341, 341 gouache 167 The Embarkation for Cythera (Watteau) 82-83, 83, formalism 125 La Goulue at the Moulin Rouge (Toulouse-Lautrec) Fossati, Gaspare: Interior of Hagia Sophia 296 402, 402 99, 232, 232-233 Fosso, Samuel: The Chief 101, 101, 529 embroidery 359, **359** Goya, Francisco de 28; Asta su Abuelo 189, 189; Foster, Norman: Millau Viaduct 304, 305 emotional effects of color 96-98 Executions of the Third of May 128, 128, 473; Fountain (Duchamp) 493, 493, 514-515 emphasis 126-128 Saturn Devouring One of His Children 28, 28 Fountain (after Duchamp A. P.) (Levine) 520, 520 Empire (Warhol) 219, 219, 220 Graffiti Archaeology (C. Curtis) 235, 235, 526 Four-headed hamat's a mask (Walkus) 470 Empress Theodora and Retinue (San Vitale) 354, 354 graphic design 226-239; advertising 232-234; Fractal.MGX (WertelOberfell) 283, 283 encaustic 159, 159 and art 236-239; development of 226-227; and Fragonard, Jean-Honoré: The Progress of Love Endless Column (Brancusi) 2, 3 digital technology 233-236, 239; motion and 402-403, 403 L'Enfant Carburateur (Picabia) 492, 492 interactivity 234-236; signs and symbols Francesco di Giorgio Martini (attr.): Architectural English and French Fall in Battle (Bayeux Tapestry) 227-229; typography and layout 230-232 Perspective 105, 105-106 359, 359 Frankenthaler, Helen 170, 504; Mauve District graphite 146-147 engraving 184, 184-185 grave robbing 334, 334 504, 504 entablatures 288, 288 gray-scale values 92, 92 Fred Ott's Sneeze (Edison) 214 entasis 342 Great Friday Mosque (Mali) 285–286, **286**, **417** French Revolution 407, 409 Enthroned Virgin and Child (Constantinople?) Great Mosque (Córdoba) 52, 52, 413, 413-414 fresco secco 159 355, 355 Great Pyramids (Egypt) 55, 55-56, 329, 330 frescoes 159-160, 160, 161, 346, 346, 364, 364, 430, Entombment of Christ (Caravaggio) 391, 391, 393, The Great Sphinx (Giza) 328-329, 329 Great Stupa (Sanchi, India) 428, 429, 429 Essenhigh, Inka: In Bed 93, 93 Friday Mosque (Isfahan) 414, 414-415 The Great Wave at Kanagawa (Hokusai) 451, 451 Friedman, Tom: Untitled 45, 45 etching 184, 188 Greek art 336-344; Archaic period 338, 338; friezes 286, 288 Evening, Honfleur (Seurat) 94-95, 95, 101, 481 architecture 287, 287-288, 288, 295, 340-342, Fuller, Meta Warrick: Talking Skull 65, 65-66 Every Touch (Hodges) 17, 17-18, 517 340-343; and Buddhism 431, 431; ceramics Fuller, R. Buckminster 306, 308; Expo 67 308, 308 Executions of the Third of May (Goya) 128, 128, 473 146, 265, 337, 337, 338, 339; Classical period Fur Traders Descending the Missouri (Bingham) 482, Expo 67 (Fuller) 308, 308 339-343, 340-342; contrapposto 255, 255, 338; 482 export arts 277, 277 drawing 146; Egyptian influence on 337-338, Expressionism 484, 486, 486 Futurism 491, 491 338; Elgin marbles 341, 341; encaustic 159; Hellenistic period 343, 343-344, 431; Late Geometric period 337; map 337; mosaics G 174; painting 338, 339; and proportion 131; The Garden of Earthly Delights (Bosch) 68, 68, 382 fabric architecture 310-311, 311, 313, 313 sculpture 255, 255, 337-339, 338, 339, 341-343, Gas (Hopper) 63, 63, 93 Faezeh (Neshat) 222, 530 341-344 The Gates (Christo & Jeanne-Claude) 263, 263 Fallingwater (Wright) 306 Green, Michael: Wood Innovation and Design Gauguin, Paul 11, 26, 478, 480-481; Te Aa No A Family, Kamathipura, Mumbai ... (Singh) Center 318, 318-319 Areois 94, 480, 480-481 204-205, 205 green architecture 316-319, 316-319 Gehry, Frank O. 8; Guggenheim Museum Bilbao fantasy themes 67-69 Green Light Corridor (Nauman) 512, 513 309, 309-310, 519 Fauvism 256, 484, 484 The Greeting (Viola) 526, 526-527 genre painting 400, 400-401 feather cloaks (Hawaii) 456, 456 Grien, Hans Baldung: The Groom and the Witch Gentileschi, Artemisia 517; artist profile 392, 392; feathered basket (Pomo) 274, 274, 466 108, 108, 383; The Three Ages of Woman, and Judith and Maidservant with the Head of Holofernes female figure (Willendorf) 322, 323 Death 136, 136, 383 390-391, 391; Self-Portrait as the Allegory of feminism 125, 517-518, **518**, 520, 523, 525, **525** groin vaults 291, 291 Painting 392 Feng Mengbo: Long March: Restart 532-533, 533 The Groom and the Witch (Grien) 108, 108, 383 geodesic domes 306, 308, 308 Fertile Land (Pich) 534, 534 Grosse, Katharina: One Floor Up More Highly 171, Georges Pompidou National Center of Art and Fête Champêtre (Titian) 475, 475 Culture (Piano and Rogers) 519, 519 171, 537 fiber arts 274, 274-275, 275. See also specific Grotjahn, Mark: Untitled (Full Color Butterfly 772) Georgia O'Keeffe (Stieglitz) 120 fiber arts Géricault, Théodore: The Raft of the Medusa 82, 82 144, 144 51 Ways of Looking (Group B) (Sikander) 140 ground/figure 85 Gertie the Trained Dinosaur (McCay) 216, 216 Figure Studies (Lippi) 147-148, 148 grounds for surfaces 147, 158, 161, 188 gesso 161 figure/ground 85 Grünewald, Matthias: Isenheim Altarpiece Ghiberti, Lorenzo: Commentaries 369; The Story of figurine of a voluptuous lady (Maya) 243, 381-382, 382 Jacob and Esau 367-368, 368 243-244, 460 Gu Kaizhi (attr.): Admonitions of the Instructress ... Ghirlandaio, Domenico 175 film 213-220; animation 114, 215-216; and art **438**, 438-439 Giacometti, Alberto: The Nose 102, 102 218-220; continuous-motion photography 214; Guanyin (Song) 440-441, 441 Giorgione: The Tempest 377, 377-378 early motion studies 213-214; exploration of Giotto: Arena Chapel frescoes 107, 364, 364 Guerilla Girls 525, 525 the possibilities 214-217; and motion in art 113; Guernica (Picasso) 57-59, 58, 499; first composition Girl Before a Mirror (Picasso) 136, 136, 137-139, origins of 212; stop-motion photography 214. See study 142, 142 138, 487 also video Guggenheim Museum Bilbao (Gehry) 309, 309-310 glass 268-270, 269, 270, 282, 282, 362, 362 fine arts, delineation of 22, 278, 280-281 Gupta, Subodh: Dada 532, 532 Glass Puzzle (Jonas) 516, 516 Fireworks at Ryogoku (Hiroshige) 99, 99, 451 Gursky, Andreas: Shanghai 212, 212 glazes 165 First Communion (Picasso) 29, 29, 30 Guston, Philip: Curtain 191, 191-192 globalization 528-529 Fish (Brancusi) 2, 3 gwandusu (mother-and-child) display figure Gnaw (Antoni) 40, **40** Fisherman's Cottage on the Cliffs at Varengeville (Bamana) 422, 423 Godard, Jean-Luc: Breathless 218, 219 (Monet) 22, 23, 93, 94, 476

Gold Marilyn Monroe (Warhol) 507, 507, 509

Five Words in White Neon (Kosuth) 515, 515

Н Horyu-ji Temple (Japan) 446, 446 International style 303 Haas, Ernst: Peeling Paint on Iron Bench, Kyoto 12, Housepainter III (Hanson) 32, 32, 510 Internet art 223–225, 524, 524, 526 How to Explain Pictures to a Dead Hare (Beuvs) 48, interwar period 495-499, 496-499 Hachiman in the Guise of a Monk (Kaikei) 254, 254, 48, 506 invention themes 67-69 448, 449 hue 92, 92 investment casting 246 Hadid, Zaha: artist profile 312, 312; Burnham Hui-zong (attr.): Court Ladies Preparing Newly Ionic style 287, 287, 347, 348 Pavilion 311, 311, 538 Woven Silk 62, 62-63, 441 iPod ads 233, 233-234 Haghe, Louis: Interior of Hagia Sophia 296 human experience themes 65-67 Ise shrine (Japan) 445, 445 Hagia Sophia (Constantinople/Istanbul) 296, 296, human figure 130-131, 132, 252-255, 253-255, Isenheim Altarpiece (Grünewald) 381-382, 382 297, 353, 353 **257.** 257-258 Ishtar Gate (Babylon) 328, 328 Hairdressing (Utamaro) 36, 37, 451 human-headed winged lion (Assyria) 326, 326 Islamic art 411-417; architecture 52, 52, 285-286, Hammam, Nermine 530; Armed Innocence II humanism 365, 367 286, 296, 296, 297, 297, 298, 412-415, 413-415; 530, 530 Hy-Fi (The Living) 319, 319 arts of daily life 275, 275, 416-417, 417; Hampton, James: Throne of the Third Heaven ... hypostyles 287, 287 ceramics 417, 417; contemporary 531; European 24-25, 25 interest in 256, 473; and iconoclasm 54; Hamzanama (Dasavanta, Shravana, and Madhava illumination 415-416, 416; ink paint 168; map Khurd) 24, 24, 436, 436 412; origins of 411-412; and paper 145; and Han dynasty (China) 437-438, 438 iconoclasm 54 perspective 110-111, 111 handscrolls 62, 62, 110, 110, 447, 447, 448, 448 iconography 40-43, 125 isometric perspective 110, 110-111 haniwa figure of a horse (Japan) 445, 445 icons (Byzantine) 354-355, 355, 535 ivory 275-276, 276, 277, 277, 355, 355 Hansen, Channing 172-173; ALGO 54 1.0 173, 173 Igbo culture 420, 420, 425, 425 Hanson, Duane: Housepainter III 32, 32, 510 ijile masquerade (Igbo) 425, 425 happenings 506, 506 Iktinos 342 The Happiest Man (Ilya and Emilia Kabakov) 260, illumination 356, 357, 435, 435, 436 Jacquette, Yvonne: Three Mile Island, Night I 260-261 i.Mirror (Cao) 224-225, 225, 533 148, 149 hard-edge painting 509, 509-510 implied light 87-89 jade 275, 278, 278 Haring, Keith: Untitled 77-78, 78, 79 implied lines 82-83 Jahangir Receives a Cup from Khusrau (Manohar) 9, Harlem Renaissance 163, 498-499, 499 implied shapes 85-86 9, 94, 168, 436 Harran II (Stella) 509, 509-510 implied space 103-106, 108-111 Jain religion 298, 298, 435, 435 Harvest (Ortega) 536, 536 Imponderabilia (Abramović and Ulay) 513, 513 Jain temple of Dilwara (India) 298, 298, 434 The Harvesters (Bruegel) 384, 384 Impression: Sunrise (Monet) 476 Japanese art 444-452; and aesthetics 47, 47; Hasegawa Tohaku: Pine Wood 450, 450 Impressionism 11, 22, 476-478, 477, 478, 479, architecture 288-289, 289, 445, 445, 446, hatching 89, 89 482-483, 483 446; and art as theme 74, 74-75; Asuka Hatoum, Mona: Dormiente 98, 98, 100, 530; In Bed (Essenhigh) 93, 93 period 446, 446; and asymmetrical balance Untitled (cut-out 4) 156-157, 157 in orbit (Saraceno) 262, 262, 536 123, 123; atmospheric perspective 110; brush Hatshepsut temple (Deir el-Bahri) 330, 330 Inca culture 274-275, 275, 464, 464-465 and ink 123, 123, 154; and Buddhism 446, Haydar 145 Indian art 427-436; architecture 297, 297, 298, 447-448, 449, **449**, 451; ceramics 47, **47**, 265; head (Nok) 418, 418 298, 428, 429, 429, 433, 433-434, 434; and contemporary 534, 534; Edo period 123, 123, head of a king (Yoruba) 32-33, 33, 418, 419, 421 Buddhism 244, 244-245, 428-431, 428-432; 451; European interest in 99, 99; and export head of an Akkadian ruler (Sargon I?) 326, 327 contemporary 204-205, 205, 531, 531-532; and arts 277; graphic design 233; Heian period 446-448, 447, 448; ink paint 451; Kamakura Hei Yiyang (SenseTeam): X Exhibition poster export arts 277; and Hinduism 10, 431, 432-434, 232, 233 432-434, 436; illumination 435, 435, 436; and period 448-449, 449; lacquer 278, 279, Heian period (Japan) 446-448, 447, 448 implied space 104, 104; Indus Valley culture 427, 451; map 426; Momoyama period 450, 450; Heiji Monogatari Emaki (Japan) 448 427-428; ink paint 168; and Jain religion 298, Muromachi period 449, 449; painting 70, 71, Hendrix (Sperber) 95-96, 96 298, 435, 435; map 426; metal 270, 270; Mughal 134, 447-452, **447-452**; and perspective 110; Heringer, Anna: METI Handmade School 315, dynasty 9, 9-10, 24, 24, 297, 297, 435-436, printmaking 36, 37, 74, 74-75, 99, 99, 207, 450, 315-316, 317 531-532; painting 9, 9, 22, 22, 430, 430, 432, 452, 452; and rhythm 134; sculpture 40-41, 41, Hesse, Eva: Contingent 512, 512, 513 436, 531-532; sculpture 10, 10, 242, 242, 244, 254, **254**, 445, **445**, 448, 449; and Shinto 445, Hidden Relief (Sze) 78, 79, 80 244-245, 427, 427, 430, 430, 431, 432, 433, 434, 446; stylization 36, 37; woodcuts 180, 182, 182 Hide and Seek, Kill or Speak (Mutu) 156, 156, 529 532, 532; and stories as themes 60, 60; and jar (Martínez) 266, 266 hide painted with scenes of warfare (Lakota) 467, symbolism 227, 227 Jeanne-Claude: artist profile 264, 264; The Gates 467-468 Indians. See North American peoples 263, 263 hierarchical scale 131 Indus Valley culture 427, 427-428 Jocho: Amida Nyorai 40-41, 41, 288, 446, 448 high relief 242, 242 Industrial Revolution 279, 300, 410, 491 Johns, Jasper 505-506; Numbers in Color 159, 159. Hinduism 10, 431, 432-434, 432-434, 436 industrialization 154, 279, 282, 316, 471, 478 505; Target with Four Faces 505, 505-506 Hiroshige, Ando: Fireworks at Ryogoku 99, 99, 451; Infinity Mirrored Room series (Kusama) 69, 70 Jonas, Joan: Glass Puzzle 516, 516 Riverside Bamboo Market, Kyobashi 99, 99 Infinity Nets [AOWFA] (Kusama) 117, 117 The Joy of Life (Matisse) 484, 484 histories as themes 59-61 Ingres, Jean-Auguste-Dominique 473; Jupiter and Judd, Donald: Untitled (Stack) 511, 511-512 Höch, Hannah 208-209, 492; Cut with the Kitchen Thetis 94, 472, 472-473 The Judgment of Paris (Raphael) 475, 475 Knife Dada ... 208, 208, 492 Inhabitants of the Island of Nuku Hiva (engraving Judith and Maidservant with the Head of Holofernes Hodges, Jim: Every Touch 17, 17-18, 517 after Tilesius) 457, 457 (Gentileschi) 390-391, 391 Hokusai, Katsushika: artist profile 452, 452; Ejiri in ink 151-154, 191 Julia Jackson (Cameron) 202, 203 Suruga Province 74, 74-75, 451; The Great Wave ink stick or ink paint 168, 168-169, 451 The Jungle (Lam) 167, 167 at Kanagawa 451, **451**; Kamado Shogun Kanryaku inkjet prints 179, 195 Jupiter and Thetis (Ingres) 94, 472, 472-473 no Maki 452, 452; Thirty-Six Views of Mt. Fuji Inrush (Pearlman) 157, 157 series 74-75, 451 Inside Out (Serra) 112, 113 Holbein, Hans 382; The Ambassadors 383, 383 installations 40, 40, 49, 49, 259-264, 512, 513, Hollywood Africans (Basquiat) 521, 521-522 515-516 Kabakov, Ilya and Emilia: The Happiest Man 260, Holzer, Jenny: Protect Me From What I Want intaglio 179, 184, 184-185, 187-190 260-261 **522.** 523 intensity 92, 92 kachina doll (Zuni) 469, 469 interactivity in graphic design 235, 235-236, 236 Honeywax (K. Smith) 257, 257 Kahlo, Frida: Self-Portrait with Monkeys 66, 66 Hopper, Edward: Gas 63, 63, 93 Interior (Kiefer) 520-521, 521 Kaikei: Hachiman in the Guise of a Monk 254, 254, Horse and Geometric Symbol (Lascaux cave) 320, 321 Interior of Hagia Sophia (Haghe and Fossati) 448, 449 Horse Galloping (Muybridge) 213, 213-214, 215-216 296, 353 Kalf, Willem: Still Life with Glass Goblet and Horse mask (Amerman) 282, 282 intermediate colors 91 Porcelain Bowl 100, 100, 400

107, 108, 143, 371, 371, 387; Madonna and Child Maharana Amar Singh II, Prince Sangram Singh, Kamado Shogun Kanryaku no Maki (Hokusai) and Courtiers ... (Rajasthan, Mewar) 104, 104, with St. Anne 371-372, 372; Mona Lisa 20-22, 21, 452 452 371, 490; Self-Portrait 143, 151; Star of Bethlehem 168 436 Kamakura period (Japan) 448-449, 449 and Other Plants 142, 142; Study of Human Maman (Bourgeois) 240, 241 Kandariya Mahadeva temple (India) 433, 433, Man Ray (Emmanuel Radnitzky) 212, 492; Champs Proportions According to Vitruvius 131, 131, 371, 434, 434 371; Treatise on Painting 143; The Virgin and St. délicieux, second rayogram 209, 209 Kandinsky, Vasili: Black Lines No. 189 486, 486 Anne with the Christ Child and John the Baptist 88, mandalas 121, 121, 126 Kandors Full Set (Kelley) 13, 13-14 Kano Eitoku (attr.): Cypress Trees 450, 450 89, 371 Mandarin Ducks and Hollyhocks (Lü) 443-444, 444 Letter to Zongfeng Mingben (Zhao) 443, 443 Manet, Edouard: A Bar at the Folies-Bergère 124, Kaprow, Allan: Courtyard 506, 506 Kelley, Mike: Kandors Full Set 13, 13-14 Lever House (Skidmore, Owings, and Merrill) 303, 124, 125, 476; Le Déjeuner sur l'herbe 475, Kensett, John Frederick: Lake George 109, 109-110 303, 314-315, 501 Mannerism 385-387, 385-387 Kent, Rockwell: Workers of the World, Unite! 183, Leviathan Thot (Neto) 538-539, 539 183, 499, 499 Levine, Sherrie: Fountain (after Marcel Duchamp Manohar: Jahangir Receives a Cup from Khusrau 9, 9, 94, 168 kente cloth 9, 9, 421 A. P.) 520, **520** keystones 290, 290 LeWitt, Sol 515; Wall Drawing #122 515, 515-516 Mansart, Jules Hardouin: Hall of Mirrors, Palace Kiefer, Anselm 520-521; Interior 520-521, 521 Leyster, Judith 517; Carousing Couple 400, 400-401 of Versailles 396, 396 Li Cheng (attr.): A Solitary Temple amid Clearing Maori people 456, 456-457 kinetic art 112, 112 Map (Bartholl) 225, 225 Kirchner, Ernst Ludwig: Street, Dresden 486, 486 Peaks 441, 441-442 Lialina, Olia: My Boyfriend Came Back from the War Mapplethorpe, Robert 211; Self-Portrait 211 Kiss (Warhol) 219 Marc, Franz 97 The Kiss (Rodin) 39, 39, 40 224, 524, **524**, 526; Summer 224, **224**, **526** Klee, Paul: Landscape with Yellow Birds 134, Liberty Leading the People (Delacroix) 57, 57, 473 Marcus Aurelius (equestrian statue) 56, 56, library table (Craftsman Workshop) 279, 279 345, 345 135, 497 Klimt, Gustav: Death and Life 122, 122, 126 Lichtenstein, Roy: Blam 509, 509, 510 Marie-Antoinette and Her Children (Vigée-Lebrun) light 86-89, 92, 92 406-407, 407 Kneeling Mother with a Child at Her Breast (Modersohn-Becker) 256, 256 The Lightning Field (De Maria) 514, 514 Mariposa (Milhazes) 169, 169-170, 539 Ligon, Glenn 523; Untitled (I Do Not Always Feel Marquesan people 457, 457 knitting 172-173 Martin, Pierre-Denis: View of the Palace of Versailles Kojin, Haruka: reflectwo 118-119, 119, 534 Colored) 523, 523 Kollwitz, Käthe: artist profile 181, 181; Self-Portrait Limbourg Brothers: Les Très Riches Heures du Duc de Berry 378-379, 379, 384 Martínez, María: artist profile 267, 267; with Hand on Her Forehead 181; The Widow 180. 180 Lin, Maya: artist profile 8, 8; Storm King Wavefield jar 266, **266** Kontrollraum/Control Room (Demand) 537, 537 8, 133, 133, 514; Vietnam Veterans Memorial 7, Marxism 125 masks/masquerades: Africa 48, 48-49, 113, 420, Koons, Jeff: Michael Jackson and Bubbles 246, 7, 8, 511 420, 424, 424-425, 425; Mesoamerica 463, 463; line 77-83 246-247 linear perspective 104-106, 108, 371 North American peoples 469, 469-470, 470; kore/korai and kouros/kourai 338 Tolai people 455, 455 Kosuth, Joseph 515, 522; Five Words in White Neon linguists' staffs (Ghana) 43, 43-44 515, **515**; One and Three Chairs 515 linocuts 183-184, 197-198 mass 83-85, 87-89 lion aquamanile 271, 271, 362 Massaccio: Trinity with the Virgin ... 368, 369 kouros (Greece) 338, 338 Matisse, Henri 256; artist profile 485, 485; The Joy krater (Athens) 337, 337 Lion Hunt (Kalhu) 327, 327 of Life 484, 484; Memory of Oceania 116, 116; Kruger, Barbara: Untitled (Your Gaze Hits the Side Lippi, Filippino: Figure Studies 147-148, 148 of My Face) 237, 237, 518 Lipundja, Samuel: Djalambu 454, 454-455 Music Lesson 38, 38, 39, 484; Piano Lesson 38, LISI House (Team Austria) 317, 317-318 Kuma, Kengo: Teahouse 313, 313, 534 matrix (prints) 178, 195 Kusama, Yayoi 70, 70; Infinity Nets [AOWFA] 117, lithography 179, 190-192, 232 117; Love is Calling 69, 69, 70, 534 The Living 319; Hy-Fi 319, 319 Mausoleum of Galla Placidia (Ravenna) 174, load-bearing construction 285-286, 286, 299, 301 174-175, **354** Kush (kingdom of) 417, 417 Kwakiutl culture 470, 470 logos 228, 228-229 Mauve District (Frankenthaler) 504, 504 logotypes 229, **229** Mayan culture 243, 243-244, 460-462, 461, 462 Long March: Restart (Feng) 532-533, 533 Mayer H und Partner, Jürgen: Metropol Parasol Longshan culture 6, 6 314. 314 lost-wax casting 245, 245-246 meaning 38-45, 125 lacquer 278, 278, 279, 444, 451 medieval art 355-364, 535; and craft 22; early The Lady and the Unicorn tapestry 362, 362 Louis XIV (King of France) 176, 395-396 Lake George (Kensett) 109, 109-110 Love is Calling (Kusama) 69, 69, 70, 534 Middle Ages 355-357, 356, 357; high Middle Ages 357-362, 358-362; late Middle Ages 248, Lam, Wifredo: The Jungle 167, 167 low relief 241, 242 The Lamentation (Giotto) 364, 364 Lü Ji: Mandarin Ducks and Hollyhocks 443-444, 444 248; and linear perspective 105; Renaissance transition **363**, 363–364, **364**; and value of art Lumière brothers 214 Land art 514, 514 Landscape (Sesshu) 449, 449 Luther, Martin 383, 384 22. See also Christianity Luxor temple (Egypt) 286-287, 287, 304, 331 Mediterranean art: Aegean cultures 335, 335-336, Landscape with Yellow Birds (Klee) 134, 135, 497 336; map 322, 325; Mesopotamia 290, 324-328, Lange, Dorothea: Migrant Mother 204, 205, Lysippos: Apoxyomenos 255, 255, 338 499, **499** 325-328; prehistoric 4-6, 5, 6, 107, 146, 320, Laocoön Group (Greece) 343, 343-344, 366, 373 321-324, 323. See also Egyptian art; Greek art; Lascaux cave paintings 107, 320, 321-322 Roman art McCay, Winsor: Gertie the Trained Dinosaur 216, 216 medium (paint) 158 The Last Supper (Leonardo) 106, 106, 107, 107, 108, machinima 225 megaliths 6, 6 143, 371, 371, 387 Machu Picchu (Peru) 464, 464-465 Mehretu, Julie: Untitled 152, 152 The Last Supper (Tintoretto) 387, 387 Maderno, Carlo: St. Peter's Basilica 390 Meketre, tomb of (Egypt) 62, 62, 331 Lawrence, Jacob: artist profile 163, 163; The Migration Series 162, 162, 163, 499; Madhava Khurd: Hamzanama 24, 24, 436, 436 Melanesian people 453, 455, 455 Self-Portrait 163 Madonna and Child with St. Anne (Leonardo) Méliès, Georges: A Trip to the Moon 215, 215 layout 232 371-372, 372 Memory of Oceania (Matisse) 116, 116 Le Brun, Charles: The Battle of the Granicus Madonna Enthroned (Cimabue) 53, 53, 55, 363 Men are working in Town (Muafangejo) 183, 176, 176-177, 396; Hall of Mirrors, Palace of The Madonna of the Meadows (Raphael) 85-86, 183-184 Las Meninas (Velázquez) 170, 396-397, 397, 494 Versailles 396, 396 86, 377 Menkaure and Khamerernebty (Egypt) 252-253, 253, Maestà Altar (Duccio) 363, 363 Le Corbusier: The Modulor 132, 132; Notre-Dame-Maggie's Ponytail (Rothenberg) 37, 37, 521 329.330 du-Haut 132, 132 Léger, Fernand 31, 498; Woman and Child 498, 498 Magnetic Resonance Imaging (MRI) scans 13, 13 Mérode Altarpiece (Campin) 380, 380

Leonardo da Vinci 24, 109, 158, 371-372; artist

profile 143, 143; The Last Supper 106, 106, 107,

Magritte, René: Delusions of Grandeur II 129,

129, 494

Kallikrates 342; Temple of Athena Nike 288,

288, 340

Mes Voeux (Messager) 117, 117 Munch, Edvard: The Scream 97, 97-98, 486 Northern Renaissance art 378-384 Mesoamerican art 458-463; architecture 459, murals (Mayan) 461, 461-462 The Nose (Giacometti) 102, 102 459-461, 460, 461, 464, 464-465; Aztec culture Muromachi period (Japan) 449, 449 Notre Dame cathedral (Chartres) 270, 270, 360-38, 85, **85**, 459, 462–463, **463**; map **458**; Mayan Murray, Elizabeth: The Sun and the Moon 76, 77, 521 362, 360-362 culture 243, 243-244, 460-462, 461, 462; Olmec Musée d'Orsay (Gare d'Orsay) (Paris) 479, 479, 520 Notre Dame cathedral (Reims) 292, 293, 293, 360 museums 44-45, 307, 309, 309-310, 310, 341, 471, culture 48, 48, 248, 248, 276, 459, 459-460, 460; Notre-Dame-du-Haut (Le Corbusier) 132, 132 painting 461, 461-462; pre-Columbian art 458; 479, **479**, 520, 525 nowo masque (Temne) 424, 424-425 sculpture 462, 462 Music Lesson (Matisse) 38, 38, 39, 484 Nubia 417, 417 Mesopotamian art 290, 324-328, 325-328 Mutu, Wangechi: Hide and Seek, Kill or Speak 156, Nude Woman Having Her Hair Combed (Degas) 36, 37 Messager, Annette: Mes Voeux 117, 117 156, 529 Number 1, 1949 (Pollock) 501, 501 metal arts 270, 270-271, 282 Muybridge, Eadweard 214; Horse Galloping 213, Numbers in Color (Johns) 159, 159, 505 metalpoint 147-148 213-214, 215-216 Nut (Sillman) 165, 165-166, 538 Metaphysical Painting 490-491, 491 My Boyfriend Came Back from the War (Lialina) 224, METI Handmade School (Heringer/Roswag) 315, 524, 524, 526 315-316, 317 Mycenaean culture 336, 336 Metropol Parasol (Mayer H. und Partner) 314, 314 Mysteries (Bearden) 155, 155 The Oath of the Horatii (David) 404, 404, 406 Mezzo Fist #1 (Rothenberg) 187, 187 Object (Luncheon in Fur) (Oppenheim) 494, 494 mezzotint 184, 187 objects and art 46, 48-50 Michael Jackson and Bubbles (Koons) 246, 246-247 oculus (domes) 294, 294-295 Ofili, Chris: Prince among Thieves with Flowers Michelangelo Buonarroti 365, 366, 372-376; artist Nanchan Temple (Tang) 440, 440 profile 375, 375; David 211, 372, 373; The Dying Nanna Ziggurat (Ur) 324, 325 146-147, 147, 538 Slave 255, 255, 257, 373; St. Peter's Basilica 376, narthexes 351, 352 oil painting 39, 164, 164-166, 166 376, 390; Sistine Chapel ceiling 63, 159, 373, natural world themes 71-73 O'Keeffe, Georgia: artist profile 120, 120; Deer's 373-374, 374, 393 naturalism 30, 32-33, 36, 37 Skull with Pedernal 119, 119, 121 Middle Ages. See medieval art Nauman, Bruce: Dance or Exercise ... 220, 220, 513; Old St. Peter's (Rome) **351**, 351–352 Miebach, Nathalie: Antarctic Tidal Rhythms Green Light Corridor 512, 513 Old Stone Age (Upper Paleolithic Period) 4-5, 5, 237-238, 238 Navajo culture 46, 46, 47, 48, 469-470, 470 107, 320, 321-322 Migrant Mother (Lange) 204, 205, 499, 499 Navajo Zahadolzha Masker (E. S. Curtis) 470 Oldenburg, Claes: Plantoir 129, 129, 507 The Migration Series (Lawrence) 162, 162, 163, 499 naves 351, 351, 358 Olmec culture 48, 48, 248, 248, 276, 459, 459-460, Milhazes, Beatriz: Mariposa 169, 169-170, 539 Nawa, Kohei: PixCell-Deer#24 534, 534 460 Millau Viaduct (Foster) 304, 305 Nebamun tomb wall painting (Thebes) 330-331, Olowe of Ise: artist profile 273, 273; Olumeye bowl minarets 296, 296 272, 272, 273, 423; Veranda Post with Mounted Ming dynasty (China) 443-444, 444 negative shapes 85 Hunter 273 Minimalism 261, 262, 511, 511-512, 515-516 Neoclassicism 403-410, 404, 407, 409, 410, 472, Olumeye bowl (Olowe of Ise) 272, 272, 273, 423 Minoan culture 335, 335-336 472-473, 482 One and Three Chairs (Kosuth) 515 Miró, Joan: Carnival of the Harlequin 494-495, 495 One Floor Up More Highly (Grosse) 171, 171, 537 Neo-Dada 505 mixing colors 92, 94-95 Neo-Expressionism 520-521, 521 1000 Hands (Universal Everything) 239, 239 Mixtec Culture (Rivera) 160, 161, 495, 495 Neolithic era (New Stone Age) 6, 6, 146, 322-324 I (Sikander) 140, 141, 530 Mo Ti (Chinese philosopher) 200 Nepomuceno, Maria: Untitled 281, 281, 539 one-point linear perspective 105 Moche ceramic art 464, 464 Neshat, Shirin: Faezeh 222, 530; Women without onyeocha ("white man") figure (Igbo) 420, 420 model for the Monument to the Third International Men 222, 222, 530 open palette 94 (Tatlin) 496, 496 Neto, Ernesto: Leviathan Thot 538-539, 539 Oppenheim, Meret: Object (Luncheon in Fur) 494, 494 modeling 87-89, 243-244 Nevelson, Louise 504; Sky Cathedral 503-504, 504 optical color mixture 94-95 Modersohn-Becker, Paula: Kneeling Mother with a New Stone Age (Neolithic era) 6, 6, 9, 146, optical effects of color 94-96 Child at Her Breast 256, 256 322-324 Orange and Yellow (Rothko) 503, 503 The Modulor (Le Corbusier) 132, 132 New Wave (film) 218 orders (Greek architecture) 287, 287 Mogollon culture 468-469, 469 New York School 500, 501, 501, 503, 503-504, 504 ornament from tomb of Queen Amanishakheto mold for casting 245 New Zealand 456, 456-457 (Kush) 417, 417 Momoyama period (Japanese) 450, 450 Ni Zan: The Rongxi Studio 154, 442, 443 Ortega, Damián 534, 536; Harvest 536, 536 Mona Lisa (Leonardo) 20-22, 21, 371, 490 Niépce, Joseph Nicéphore 201 Osorio, Pepón: You're Never Ready 196, 196 Mondrian, Piet 93-94, 496; Trafalgar Square 94, Night Street Chaos (Zynsky) 279-280, 280 Osservanza Master: St. Anthony Abbot Tempted ... 496, 496-497 The Night Watch (Rembrandt) 398, 398, 400 161-162, 162 Monet, Claude 22-23, 476; Autumn Effect at outline 79 19th-century art: American 481-483, 482; Argenteuil 94, 476, 477; Fisherman's Cottage on the Impressionism 11, 22, 476-478, 477, 478, 479, outsider art 26 Cliffs at Varengeville 22, 23, 93, 476 482-483, 483; Manet's effect on 475-476; The Oxbow (Cole) 71, 71, 482, 482 monochromatic color harmonies 93 Neoclassicism 472, 472-473, 482; Postmonotypes 194, 194 Impressionism 478, 480, 480-481; Realism 474, Mont Sainte-Victoire (Cézanne) 480, 481 474, 482; Romanticism 473, 473, 482 Morisot, Berthe 479, 517; Summer's Day 478, 478 nkondi figures 423, 423-424 Pacific cultures 453-457, 454-457 mosaics 174-175, 346, 347, 350, 350, 354, 354, 414, No Title (Not a single ...) (Pettibon) 153, 153-154 Pacific Northwest peoples 470, 470 Nocturne in Blue and Gold (Whistler) 97, 97, 98, 99, Paik, Nam June 220-221, 516; TV Buddha 221, 221, 207, 483 mosque lamp (Dome of the Rock, Jerusalem) 417, 516 Noguchi, Isamu: Red Cube 118, 118 Paine, Roxy: Conjoined 250, 250 motion 111-114, 234, 234-236 Nok culture 418, 418 Painted Fans Mounted on a Screen (Sotatsu) 134, 134 Le Moulin de la Galette (Renoir) 476-478, 477 nonobjective art. See nonrepresentational art painting 158-171; acrylic 169, 169-170; Aegean Mountain Stream (Sargent) 166, 166-167 nonrepresentational art 34-35, 207, 501, 523 cultures 335, 335-336; China 62, 62-63, 72, 72-Mountains Clearing After Rain (Chang) 167-168, 168 North American peoples 466-470; Anasazi culture 73, 110, **110**, **438**, 438–439, **439**, **441**, 441–442, movement, linear 80-82 468, 468; contemporary art 266, 266, 267, 267, 442, 443-444, 444; and collage 154-156; drawing MRI scans 13, 13 282, 282; Eastern Woodlands cultures 258, vs. 153-154; easel vs. non-easel 170-171; Egypt Muafangejo, John: Men are working in Town 183, 258–259, **466**, 466–467, **467**; map **458**; Mogollon 330-331, 331; encaustic 159; fresco 159-160, 160, 183-184 culture 468-469, 469; Navajo culture 46, 46, 47, 161, 430, 430, 432; genre 400, 400-401; Greece Mughal dynasty (India) 9, 9-10, 24, 24, 297, 297, 48, 469-470, 470; Pacific Northwest peoples 470, 338, 339; India 9, 9, 22, 22, 430, 430, 432, 436, 435-436, 531-532 470; Plains culture 467, 467-468; Pomo culture 531-532; Japan 70, 71, 134, 447-452, 447-452; Muhammad, Sultan (attr.): The Ascent of the Prophet 274, 274; pre-Columbian art 458; Pueblo cultures Mesoamerica 461, 461-462; oil 164-166, 165, Muhammad 34, 34, 415 469, 469 166; and photography 204; Postmodern 520-522,

521; Roman 346, 346; tempera 161-162, 162; vocabulary of 158; watermedia 166, 166-168, 167, 168. See also specific periods, movements, and works Pakistani art 531, 531-532 palace altar to King Ovonramwen (Benin) 419, 419 Palace and Temple of the Inscriptions (Mayan) 460-461, 461 Palace Chapel of Charlemagne (Aachen) 356-357, **357** palette, open vs. restricted 94 Palette of Narmer (Hierakonopolis) 329, 329 Palette with a Landscape (Pissarro) 91, 91, 476 Paley, W. Bradford: TextArc of "Alice's Adventures in Wonderland" 235-236, 236 Pantheon (Rome) 294, 294-296, 295, 346, 346 paper 144, 145, 145, 154-157 Parthenon (Athens) 288, **340–342**, 340–343 pastels 150 Pastor, Jennifer: Sequence 6 from Flow Chart for "The Perfect Ride" 79, 79 pattern 101 Paul Revere (Copley) 94, 410, 410 Paxton, Joseph: Crystal Palace 299, 299, 316 Pearlman, Mia: Inrush 157, 157 pediments 288, 288 Peeling Paint on Iron Bench, Kyoto (Haas) 12, 12 pen and ink 151-152 pendant depicting a ruler (Tairona) 465, 465-466 pendentives 296, 296 perception 15 Performance art 513, 513 Persian art: architecture 414, 414-415, 435; fiber arts 275, 275, 416, 417; illumination 436; mosaics 414, 415; stylization 34, 34 The Persistence of Memory (Dalí) 494, 494, 495 Personages series (Bourgeois) 30, 30, 32 perspective: atmospheric 109-110; isometric 110, 110-111; linear 104-106, 105, 108 Pettibon, Raymond: No Title (Not a single ...) 153, 153-154 Phidias 342 Phil (Close) 510, 510 photography 199-210, 212-213, 471, 537, 537; and art 205-210, 212-213; camera obscura 200, 200-201; and collage 208; color vs. black-andwhite 209; Dada 208–209; daguerreotype 201-202; development of 30, 200-203; and digital technology 210, 212, 212-213; film 113, 213-220; and implied light 87-88; and painting 204; and photogravure 190; photojournalism 204-205; pictorialism 206-207; "pure" 208. See also film; video photogravure 184, 190 photojournalism 204-205 Photorealism 510, 510, 520 Piano, Renzo: California Academy of Sciences 316, 317; Georges Pompidou National Center of Art and Culture 519, 519 Piano Lesson (Matisse) 38, 39, 484 Picabia, Francis 492; L'Enfant Carburateur 492, 492 Picasso, Pablo 29, 34, 141-142, 256, 487; artist profile 488, 488; collage 154, 155; Les Demoiselles d'Avignon 487, 487, 489; First Communion 29, 29, 30; Girl Before a Mirror 136, 136, 137-139, 138, 487; Guernica 57-59, 58, 499; Guernica. first composition study 142, 142; Seated Woman Holding a Fan 29, 29, 30, 35, 43, 487; Self-Portrait with Palette 488 Pich, Sopheap 533; Fertile Land 534, 534 pictorialism 206-207

picture plane 103

piers (architecture) 292, 293, 293

Pietà (Bellini) 27, 27-28, 378

pigment 92, 92, 146, 158 Pine Wood (Hasegawa) 450, 450 Pissarro, Camille: Palette with a Landscape 91, PixCell-Deer#24 (Nawa) 534, 534 Plains culture 467, 467-468 planographic process 191 Plantoir (Oldenburg and van Bruggen) 129, 129, 507 plasticity (clay) 265 pointed arch/vault construction 292, 292-293, 293 pointillism 94-95, 95, 149-150, 150, 478 points of view 125 political themes 55–59 Pollock, Jackson 170, 501; artist profile 502, 502; Number 1, 1949 501, 501 Polynesian peoples 455-457, **455-457** Pomo culture 274, **274** Pompeii 346, 346, 347 Pompidou National Center of Art and Culture (Piano and Rogers) 519, 519 Pompidou-Metz (Ban) 310, 310, 534 Pont du Gard (France) 290, 290, 304, 346, 346 Pop art 218-219, **219**, 507, **507**, 509, **509**, 510 Pope Leo X with Two Cardinals (Raphael) 376, 377 porcelain 268, 269, 444 porticoes 294, 295 Portrait of Amilcare, Minerva and Asdrubale Anguissola (Anguissola) 386, 386 Portrait of Michelangelo Buonarroti (workshop of Floris) 375 Portrait of the Artist (Rembrandt) 399 Le Portugais (The Emigrant) (Braque) 489, 489, 490, 522 positive shapes 85 post-and-lintel construction 286-289, 287-289, 295, 298, 299, 301, 433 posters 232, 232-233 Post-Impressionism 478, 480, 480-481 post-Internet art 225 Postminimalism **512–515**, 512–516 Postmodernism 519-527; and advertising 522, 523; architecture 519, 519; and digital technology 524, 524, 526; ideas of 519-520; and identity issues 520-521, **522**, **523**; painting **520**, 520-522 pottery. See ceramics Poussin, Nicolas: The Ashes of Phokion 394, 394, 481 pre-Columbian art 458 primary colors 91 primer (paint) 158 primitivism 256, 256 Prince among Thieves with Flowers (Ofili) 146-147, 147, 538 prints 178-198; and digital technology 179, 195, 233-234; intaglio 179, 184-185, 187-190; Japan 36, 37, 74, 74-75, 99, 99, 207, 451, 452, 452; lithography 179, 190-192, 232; monotype 194; relief 179, 179-180, 182-184, 190; screenprinting 179, 192-193; in sculptures and installations 196-198; vocabulary of 178 Prinzhorn, Hans 26 prism 90, 90 process and art 46-49 Process art 512, 512-513 The Progress of Love (Fragonard) 402-403, 403 proportion 129, 130-132 Protect Me From What I Want (Holzer) 522, 523 Protestant Reformation 383, 384, 386-387 psychoanalytic point of view 125 Pueblo cultures 469, 469 "pure" photography 208 purse cover (Sutton Hoo) 355-356, 356 Puryear, Martin: C.F.A.O. 250-251, 251 Pyke, Matt: video ad 234, 234-235

Pyramid of the Sun (Olmec) 459, 459 pyramids at Giza (Egypt) 55, 55-56, 329, 330

Qaini, Sultan-Ali 145 Qin dynasty (China) 436, 437, 437 Quantum Void III (Gormley) 257, 257-258 Queen Nefertiti (Egypt) 332, 332 quillwork 467, 467 the Our'an 411, 415-416, 416 Qureshi, Imran: Blessings Upon the Land of My Love **531.** 531-532

R

Rae, Fiona: Cute Motion!! 195, 195, 538 The Raft of the Medusa (Géricault) 82, 82 raigo (Japan) 448-449, 449 railroad schedule design (Stern and Tufte) 231, 231 The Raising of the Cross (Rubens) 393, 393 Ram in Thicket (Ur) 325, 325 Rama and Lakshmana ... (Sahibdin) 60, 60, 432 Rand, Paul: logos by 228, 228 Raphael: The Judgment of Paris 475, 475; The Madonna of the Meadows 85-86, 86, 377; Pope Leo X with Two Cardinals 376, 377; The School of Athens 159-160, 160, 377, 377 rapidograph 152 Rasmussen, Merete: Red Twisted Form 281, 281 Rathnasambhava, the Transcendent Buddha of the South (Tibet) 53, 53, 55 Rauschenberg, Robert: artist profile 64, 64; Sor Aqua 64; Theater Piece #1 (with Cage) 64; Windward 63, 63, 65; Winter Pool 505, 505 The Raven and the First Men (Reid) 84, 84, 85 Realism 474, 474, 482 Reconstructed Icicles, Dumfriesshire, 1995 (Goldsworthy) 259, 259 Red Cube (Noguchi) 118, 118 The Red Room-Child (Bourgeois) 261, 261 Red Twisted Form (Rasmussen) 281, 281 Reflection (Suh) 102, 103, 533 reflectwo (Kojin) 118-119, 119, 534 refracted light 90 registration (prints) 182 Reid, Bill: The Raven and the First Men 84, 84, 85 Reims cathedral (France) 292, 293, 293, 360 reinforced concrete construction 305-306, 306, 316 relief prints 179, 179-180, 182-184, 190 relief sculpture 241, 241-242, 242, 332, 332, 341, 367-368, 368, 433 reliquary statue (Sainte-Foy) 359, 359 Rembrandt Harmensz. van Rijn 188, 397-398; artist profile 399, 399; Christ Preaching 188, 188, 398; 398, 398, 400; Portrait of the Artist 399; Sortie of 398, 398, 400

Cottage among Trees 151, 151-152; The Night Watch Captain Banning Cocq's Company of the Civic Guard Rembrandt Signature (Watts) 20, 20 Renaissance art 365-387, 535; architecture 135,

135, 369, 369-370, 376, 376; and audience 23; contrapposto 255, 255, 257, 367, 367; engraving 184-185; fresco 159-160; Greek and Roman revival in 131, 370, 370, 371; and humanism 365, 367; Italy 367-378, 385-387; and linear perspective 105, 105-106, 106, 371; Mannerism 385-387, 385-387; map 366; and metalpoint 147-148; and mosaics 175; Northern 378-384; painting 369, **370**, 370–372, **372**, 373–374, **373–374**, 376, 376-377, 377-387, 379-387; and proportion 131, 131; and Protestant Reformation 383, 384, 386-387; sculpture 255, 255, 257, 367, 367-369, 368, 372, 373; tempera 161–162, 162; transition to 363, 363-364, 364; and value of art 22, 365

Renoir, Pierre-Auguste 477; Le Moulin de la Galette San Vitale (Ravenna) 353, 353-354, 354 17th-century art. See Baroque art 476-478, 477 sand painting (Navajo) 46, 46, 47 sfumato 372 repetition (rhythm) 133-135 Sant'Andrea (Mantua) (Alberti) 135, 135, 368, 369, shades 92 representational art 30, 32-33, 54, 83 369-370 Shah Mosque (Isfahan) 414, 415 restricted palette 94 Saraceno, Tomás: in orbit 262, 262, 536 shamanism 48 Shang dynasty (China) 436, 437 rhythm 133-135 Sargent, John Singer: Mountain Stream 166, rhyton in the shape of a lion's head (Mycenae) Shanghai (Gursky) 212, 212 166-167 336, 336 Sasa (Anatsui) 282, 282, 529 Shanosky, Don: signage system 228, 228 Riace Warrior (Warrior A) (Greece) 339, 339, 344 Sassetta: St. Francis Giving His Mantle to a Poor Man shapes 83-86 ribs (architecture) 292, 293 Shaykhzada: Bahram Gur and the Princess in the **59**, 59–60 Richter, Hans 506 saturation 92 Black Pavilion 416, 416 shell system 284, 301 Riemenschneider, Tilman: Virgin and Child on the Saturn Devouring One of His Children (Goya) 28, 28 Crescent Moon 248, 248 Saville, Jenny 537-538; Rosetta 2 538, 538 Shen Zhou: Autumn Colors among Streams and Rietveld, Gerrit 497; Schroeder House 497, 497 scale 129, 131 Mountains 110, 110, 154, 442 ritual. See arts of ritual and daily life Schmidt, Karsten: video ad 234, 234-235 Sherman, Cindy: Untitled #123 210, 210 ritual mask (Aztec) 463, 463 The School of Athens (Raphael) 159-160, 160, 377, 377 shinmei style shrine (Japan) 445, 445 Schroeder House (Rietveld) 497, 497 ritual wine vessel (jia) (Shang) 436, 437 Shinto 445, 446 The Scream (Munch) 97, 97-98, 486 Rivera, Diego: Mixtec Culture 160, 161, 495, 495 Shiva Nataraja (India) 10, 10, 432 Riverside Bamboo Market, Kyobashi (Hiroshige) screenprinting 179, 192-193 Shonibare, Yinka 529-530; Cake Man 529, 529 scrolling clouds (Chinese art) 33, 33-34 Shravana: Hamzanama 24, 24, 436, 436 Robleto, Dario: Candles Un-burn, Suns Un-shine, Scrovegni Chapel frescoes. See Arena Chapel The Siege of Belgrade (Istanbul) 110-111, 111, 415 Death Un-dies 197, 197 signs and symbols 227-229 sculpture: Aegean cultures 335, 335, 336, 336; ROCI (Rauschenberg Overseas Culture Sikander, Shahzia: I from 51 Ways of Looking Interchange) 64 Africa 254, 254; assemblage 248-252, 249-252, (Group B) 140, 141, 530 rock paintings (Tassili n'Ajjer) 323, 323 505, **505**, 505–506; Baroque **389**, 389–390; silkscreen (screenprinting) 179, 192-193 Rococo era 401-403, 402, 403 carving 246, 248; casting 244-247, 244-247; Sillman, Amy: Nut 165, 165-166, 538 Rodin, Auguste: The Burghers of Calais 253, 253; China 437, 437, 440-441, 441; Constructivist Simpson, Lorna: Counting 190, 190, 523 The Kiss 39, 39, 40 496, 496; contrapposto 255, 255, 257, 338, 339, simultaneous contrast 94 Rogers, Richard: Georges Pompidou National 339, 367, 367, 431; earthworks 73, 73, 258, The Singer in Green (Degas) 150, 150, 476 Center of Art and Culture 519, 519 258-259; Egypt 252-253, 253, 329, 329-330, Singh, Raghubir: A Family, Kamathipura, Mumbai ... Roman art 344-348, 535; architecture 290, 290-330, 332, 332; Futurist 491, 491; Gothic 361, 361; 204-205, 205 291, 293, 294, 294-296, 295, 346-348, 347, 413; Greece 255, 255, 337-339, 338, 339, 341-343, Singing Their Songs (Catlett) 192, 192 encaustic 159, 159; map 344; mosaics 346, 347; 341-344; human figure 252-255, 253-255, 257, Sistine Chapel frescoes (Michelangelo) 63, 159, **373**, 373–374, **374**, 377, 393 painting 346, 346; and political themes 56, 56; 257-258; India 10, 10, 242, 242, 244, 244-245, and Roman Empire 348, 348; sculpture 56, 56, 427, 427, 430, 430, 431, 432, 432-433, 532, 532; The Site (Cooper) 93, 93 255, 255, 345, 345 Six Colorful Inside Jobs (Baldessari) 75, 75 Japan 40-41, 41, 254, 254, 445, 445, 448, 449; Romanesque architecture 291, 291, 292, 357, 357, kinetic 112, 112; Mesoamerica 48, 48, 243, 243skeleton-and-skin system 284-285, 301 358, 358 244, 462, 462; Mesopotamia 326, 326, 327, 327; Skidmore, Owings, and Merrill: Lever House 303, Romanticism 473, 473, 482 modeling 243, 243-244; Pacific cultures 455, 303, 316, 501 The Rongxi Studio (Ni) 154, 442, 443 455, 456; Paleolithic 322, 323; paper 157; relief Sky Cathedral (Nevelson) 503-504, 504 Rosetta 2 (Saville) 538, 538 241, 241-242, 242, 332, 332, 341, 367-368, 368, slip 246 Roswag, Eike: METI Handmade School 315, 433; Renaissance 255, 255, 257, 367, 367-369, Smith, David: Cubi XXI 249, 249, 504 315-316, 317 368, 372, 373; Roman 56, 56, 255, 255, 345, 345; Smith, Kiki: Honeywax 257, 257 Rothenberg, Susan: Maggie's Ponytail 37, 37, 521; Romanesque 359, 359; in the round 241; South Smithson, Robert: Spiral Jetty 73, 73, 258, 259, Mezzo Fist #1 187, 187 America (contemporary) 536, 536, 538-539, 514, 514 Rothko, Mark 503; Orange and Yellow 503, 503 539; space shaped by 102; and time/motion 112, social order themes 55-59 rotundas 296 112-113, 113 Solar Decathlons 317, 317-318 round arch/vault construction 290, 290, 293 Seated Couple (Dogon) 422, 422-423 A Solitary Temple amid Clearing Peaks (Li Cheng, Rousseau, Henri 68-69; The Dream 69, 69 Seated Scribe (Saqqara) 330, 330 attr.) 441, 441-442 Solomon R. Guggenheim Museum (Wright) 307, royal altar to the hand (ikegobo) (Benin) 130, Seated Woman Holding a Fan (Picasso) 29, 29, 30, 130-131, 419 35, 43, 487 310 royal earrings 270, 270-271 Second Life 224-225 Song dynasty (China) 440-442, 441 Rubens, Peter Paul: The Raising of the Cross 393, 393 secondary colors 91 Sor Aqua (Rauschenberg) 64 Ruff, Thomas 212-213; Substratum 12 III 212, Self-Portrait (Lawrence) 163 Sortie of Captain Banning Cocq's Company of the 212 537 Self-Portrait (Leonardo) 143, 151 Civic Guard (Rembrandt) 398, 398, 400 Rural Studio (University of Alabama) 314-315; Self-Portrait (Mapplethorpe) 211 Sotatsu, Tawaraya: Painted Fans Mounted on a Screen Dave's House (£20K House VII) 314, 315 Self-Portrait (van Gogh) 11 134, 134; The Zen Priest Choka 123, 123, 448, 451 Ruscha, Ed: Standard Station 193, 193 Self-Portrait (Vigée-Lebrun) 408 Soundsuit (Cave) 113, 113, 517 Ruskin, John 99 South/Central American art 159, 160, 274-275, Self-Portrait as the Allegory of Painting Ryoan-ji Temple (Kyoto) 73, 73, 258, 448 (Gentileschi) 392 **275**, **458**, **464**, 464–466, **465**, 534, 536, **536** Self-Portrait at Age 28 (Dürer) 186 Southern Cross (Calder) 112, 112 Self-Portrait with Hand on Her Forehead Soviet art 260, 260-261, 496, 496 S space 101-106, 108-111 (Kollwitz) 181 sabi 47 Self-Portrait with Monkeys (Kahlo) 66, 66 space cells 59-60 sacred themes 51-55, 121, 126, 535. See also Self-Portrait with Palette (Picasso) 488 spectral colors 90, 92 specific religions Selve, Georges de 383 Sperber, Devorah: Hendrix 95-96, 96 Sahibdin and workshop: Rama and Lakshmana ... Senefelder, Alois 190-191 Spero, Nancy: Artemis, Acrobats ... 175, 175 60, 60, 432 SenseTeam: X Exhibition poster 232, 233, 533 Sphinx (Giza) 328-329, 329 Saint Francis of Assisi 59-60 serigraphy (screenprinting) 179, 192-193 Spider (Bourgeois) 185, 185 Saint-Denis church (Paris) 359 Serpent Mound (Ohio) 258, 258-259, 466, 466 Spiral Jetty (Smithson) 73, 73, 258, 259, 514, 514 Sainte-Chapelle (Paris) 52, 52, 362 Serra, Richard: Inside Out 112, 113 Spirit Spouse (Ivory Coast) 254, 254, 423 Sainte-Foy church (France) 291, 291, 358, Sesshu Toyo: Landscape 449, 449 St. Anthony Abbot Tempted ... (Osservanza Master) 358-359, 359 Seurat, Georges: Café-concert 149-150, 150, 151; 161-162, 162 San Carlo alle Quattro Fontane (Borromini) Evening, Honfleur 94-95, 95, 101, 481; pointillism St. Francis Giving His Mantle to a Poor Man ... of 94-95, 95, 149-150, 150, 478 (Sassetta) 59, 59-60 390, 390

St. Jerome in His Study (Dürer) 184-185, 185, 382 Surrealism 26, 493-495, 494, 495 Toulouse-Lautrec, Henri de: La Goulue at the Moulin Rouge 99, 232, 232-233 St. Luke Drawing the Virgin (van der Weyden) suspension 304, 304-305 381. 381 sustainability and architecture 316-319, 316-319 Trafalgar Square (Mondrian) 94, 496, 496-497 transepts 351, 352, 358 St. Mark (Donatello) 367, 367, 369 swastika 227, 227 Swoon (Caledonia Curry) 198; Untitled (Kamayurá Tree of Jesse stained glass window (Chartres St. Peter's Basilica (Rome): Bernini 390; Maderno Woman) 197-198, 198 Cathedral, France) 270, 270, 362 390; Michelangelo 376, 376, 390. See also Old St. Sydney Opera House (Utzon) 305, 305-306 Les Très Riches Heures du Duc de Berry (Limbourg Peter's Brothers) 378-379, 379, 384 St. Teresa in Ecstasy (Bernini) 389, 389 symbols 227-229 stained glass 269-270, 270, 362, 362 symmetrical balance 118-119, 126 triadic color harmonies 93-94 Trinity with the Virgin ... (Massaccio) 368, 369 synthetic resin casting 247, 247 Standard Station (Ruscha) 193, 193 Sze, Sarah: Hidden Relief 78, 79, 80 A Trip to the Moon (Méliès) 215, 215 standing figure holding supernatural effigy triptychs 68 (Olmec) 48, 48, 459, 459 Stanford, Leland 213 trompe l'oeil 32 Tschumi, Bernard 341 Star of Bethlehem and Other Plants (Leonardo) Tufte, Edward: railroad schedule design 231, 231 142, 142 tabbed skin bag (Eastern Great Lakes) 467, 467 Tairona culture **465**, 465–466 tunic (Inca) 274-275, 275, 465 The Starry Night (van Gogh) 10, 10, 20, 480, 481 Taj Mahal (India) 297, 297, 298, 435, 435-436 Turner, J. M. W.: The Burning of the Houses of statuette of a women (Cycladic) 335, 335 The Tale of Genji (Japan) 447, 447 Talking Skull (M. W. Fuller) 65, 65–66 Parliament 93, 123, 123-124 steel-frame construction 300, 301-303, 303, 316 Tuscan style 347, 348 The Steerage (Stieglitz) 207, 207 Steichen, Edward J. 208; The Flatiron 206, 206-207 Tang dynasty (China) 439, 439-440, 440 Tutankhamun burial mask (Egypt) 332-333, 333 Tanner, Henry Ossawa: The Banjo Lesson 126, Tutankhamun tomb (Egypt) 332-334, 334 Steinkamp, Jennifer: Dervish 114, 114, 526 126-127, 482, 482 TV Buddha (Paik) 221, 221, 516 stela of the sculptor Userwer (Egypt) 130, 130 tapestries 176, 176-177, 177, 362, 362 Stella, Frank 511; Harran II 509, 509-510 £20K House VII (Dave's House) (Rural Studio) Target with Four Faces (Johns) 505, 505-506 314, 315 stemmed vessel (Chinese) 6, 6, 9, 436 Tatlin, Vladimir 496; model for the Monument to 20th-century art 500, 501; Abstract Expressionism stepped truss system 289, 289 the Third International 496, 496 501, **501**, **503**, 503–504, **504**, 505, 510; Stern, Ani: railroad schedule design 231, 231 tattooing 457, **457** assemblage 248-252, 249-252, 505, 505, 505-Stickley, Gustav (Craftsman Workshop): library table 279, 279 Te Aa No Areois (Gauguin) 94, 480, 480-481 506; avant-garde 483-491, **484**, **486-489**, **491**; Stieglitz, Alfred 120, 208; Georgia O'Keeffe 120; The tea bowl (Japan) 47, 47 and craft 517, 517; Cubism 29, 207, 487, 488, 489-490, 510, 522; Dada 208, 208-209, 492, 492-493, Steerage 207, 207 Teahouse (Kuma) 313, 313, 534 De Stijl 496, 496-497, 497, 498, 519 Team Austria: LISI House 317, 317-318 493, 505, 506; Expressionism 484, 486, 486; Fauvism 484, 484; and feminism 517-518, 518; Still, Untitled (P. White) 177, 177 tempera 161-162, 162 Futurism 491, 491; happenings 506, 506; hard-Still Life on Table: "Gillette" (Braque) 154, 489, 522 The Tempest (Giorgione) 377, 377-378 edge painting 509, 509-510; interwar period Temple of Athena Nike (Kallikrates) 288, 288, 340 Still Life with Compotier, Pitcher, and Fruit (Cézanne) 495-499, 496-499; Metaphysical Painting 490-127, 127-128, 481 Temple of the Feathered Serpent (Olmec) 460, 460 tensile strength 285 491, 491; Minimalism 261, 262, 511, 511-512, Still Life with Glass Goblet and Porcelain Bowl (Kalf) 100, 100, 400 'terra-cotta army" (tomb of First Qin Emperor) 515; New York School 501, 503, 503-504, 504; Photorealism 510, 510, 520; Pop art 218-219, stippling 89, 89 437, 437 tertiary colors 91 219, 507, 507, 509, 509, 510; Postminimalism stirrup vessel (Moche) 464, 464 512-515, 512-516; Surrealism 26, 493-495, 494, Stockholder, Jessica: Untitled 252, 252 tesserae 174 Stonehenge (England) 5-6, **6, 322,** 323 TextArc of "Alice's Adventures in Wonderland" (Paley) 495; video 516, 516. See also Postmodernism Two Horsemen (Greece) 341 Stop 125; Edouard Manet, Une Marchande de 235-236, 236 Consolation 125 textiles 274-275, 275, 529, 529 two-point linear perspective 105 stop-motion photography 214 texture 98, 100-101 typography 230, 230-232 stopped-out areas 189, 193 Theater Piece #1 (Rauschenberg with Cage) 64 stories as themes 59-61 themes: art about art 73-75; daily life 61-63, 65; U Storm King Wavefield (Lin) 8, 133, 133, 514 human experience 65-67; invention and fantasy themes 67-69; natural world 71-73; politics and Ulav: Imponderabilia 513, 513 The Story of Jacob and Esau (Ghiberti) 367-368, 368 Unique Forms of Continuity in Space (Boccioni) 491, social order 55-59; sacred realm 51-55, 121, 126, Street, Dresden (Kirchner) 486, 486 Struth, Thomas: Church of the Frari, Venice 44, 45 535; stories and histories 59-61 Third Tape (Campus) 221, 221-222, 516 unity 116-117 Sts Theodore, Stephen, Clement, and Lawrence Thirteen Deity Inanadakini Mandala (Newar artists at Universal Everything: 1000 Hands 239, 239 (Chartres) 361, 361 Study of Human Proportions According to Vitruvius Untitled (C. White) 88-89, 89 Densatil Monastery) 121, 121, 126 Thirty Are Better than One (Warhol) 20-21, 21, 507 Untitled (cut-out 4) (Hatoum) 156-157, 157 (Leonardo) 131, 131, 371, 371 Untitled (Eisenman) 194, 194 stupas 428, 429, 429 Thornton, David 315 style 36-38 The Three Ages of Woman, and Death (Grien) 136, Untitled (Friedman) 45, 45 Untitled (Full Color Butterfly 772) (Grotjahn) stylized art 33-34 136, 383 subject matter 39 Three Goddesses (Greece) 342, 342-343 144, 144 subordination 126-128 Untitled (Gonzalez-Torres) 50, 50, 514 Three Mile Island, Night I (Jacquette) 148, 149 Substratum 12 III (Ruff) 212, 212, 537 3D printing 283, 283 Untitled (Haring) 77-78, 78, 79 Untitled (I Do Not Always Feel Colored) (Ligon) A Subtlety (Walker) 49, 49–50, 523 three-dimensional space 102 A Sudden Gust of Wind (after Hokusai) (Wall) 74, Throne of the Third Heaven ... (Hampton) 24-25, 25 523, 523 74, 526 Throssel, Richard: Crow Camp, 1910 203, 203 Untitled (Kamayurá Woman) (Swoon) 197-198, 198 Sugiyama, Motosugu: Sumida River, Late Autumn Tibetan art 53, 53, 55, 121, 121, 126 Untitled (Mehretu) 152, 152 Untitled (Mylar) (Donovan) 35, 35, 536 182, 182 Tilesius von Tilenau, Wilhelm Gottlieb 457, 457 Suh, Do Ho: Reflection 102, 103, 533 time and motion 111-114 Untitled (Nepomuceno) 281, 281, 539 Untitled (Stack) (Judd) 511, 511-512 al-Suhraward, Ahmad: Qur'an page 416, 416 Tintoretto: The Last Supper 387, 387 Untitled (Stockholder) 252, 252 Sulaymannama (Istanbul) 110-111, 111 tints 92 Titian: The Annunciation 378, 379; Assumption 44, Untitled (to Karin and Walther) (Flavin) 261, 261 Sullivan, Louis: Wainwright Building 302, 302 Untitled (Your Gaze Hits the Side of My Face) 45, 378, **378**; Fête Champêtre 475, **475**; Venus with Sumida River, Late Autumn (Sugiyama) 182, 182 Summer (Lialina) 224, 224, 526 a Mirror 137, 137, 378, 378 (Kruger) 237, 237, 518 Summer's Day (Morisot) 478, 478 Untitled #123 (Sherman) 210, 210 tomb of First Qin Emperor: "terra-cotta army" The Sun and the Moon (Murray) 76, 77, 521 Upper Paleolithic Period 320, 321-322 Upper Paleolithic Period (Old Stone Age) 4-5, sunken relief 332, 332 Toreador fresco (Knossos) 335, 335-336

torso (Harappa) 427, 427

supports (paint) 158

5, 107

Utamaro, Kitagawa: Hairdressing 36, 37, 451 Utzon, Joern: Sydney Opera House 305, 305-306

V Vajrapani, Guardian of the Buddha, as Hercules (Gandhara) 431, 431 Valdés Leal, Juan de: Vanitas 15, 15-16, 397 value (visual element) 88, 88-89, 92, 92 value of art 19-22, 365 van Bruggen, Coosje: Plantoir 129, 129, 507 van de Velde, Jan 188 van der Weyden, Rogier: St. Luke Drawing the Virgin 381, 381 van Eyck, Jan: Arnolfini Double Portrait 41-43, 42, 380 van Gogh, Vincent 19, 36, 97, 478, 480; artist profile 11, 11; Self-Portrait 11; The Starry Night 10, 10, 20, 480, 481; Wheat Field and Cypress Trees 19, 20, 480, 481 van Ruisdael, Jacob: View of Ootmarsum 401, 401 vanishing point 105, 105 Vanitas (Valdés Leal) 15, 15-16, 397 vanitas theme 15-17, 125, 136, 138, 139 variety 116-117 Various Self Playing Bowling Games (Arcangel) 223, 223 vase (China) 268, 269, 444 vehicles (paint) 158 Velázquez, Diego: Las Meninas 170, 396-397, 397, 494 Venus de Milo 20, 343, 343 Venus with a Mirror (Titian) 137, 137, 378, 378 Veranda Post with Mounted Hunter (Olowe of Ise) 273

Verhoeven, Jeroen: Cinderella table 280, 280 Vermeer, Johannes: Woman Holding a Balance 66-67, 67, 400

Verrocchio, Andrea del 23-24; David 23, 23, 373 Versailles Palace 395, 395–396, 396

video: advertising 233, 234, 234-235; as art 220-223, 516, **516**, **526**, 526–527, 532–533, **533**; and motion in art 113-114

Vietnam Veterans Memorial (Lin) 7, 7, 8, 511 View of Ootmarsum (van Ruisdael) 401, 401 View of the Palace of Versailles (Martin) 394 Vigée-Lebrun, Elisabeth 517; artist profile 408, 408; Marie-Antoinette and Her Children 406-407, 407; Self-Portrait 408

Villa of the Mysteries fresco (Pompeii) 346, 346 Viola, Bill: The Greeting 526, 526-527 Virgin and Child on the Crescent Moon (Riemenschneider) 248, 248

The Virgin and St. Anne with the Christ Child and John the Baptist (Leonardo) 88, 89, 371 Vishnu Dreaming the Universe (Uttar Pradesh) 432, 433 The Vision of Lady Xoc (Mayan) 462, 462 The Visit (Alvarez Bravo) 87-88, 88 visual balance 118 visual texture 100-101

visual unity 117 visual weight 118-119, 122, 122-123 Vitruvius 131, 366 volutes (columns) 287 Von Siegen, Ludwig 187

W

wabi 47 Wainwright Building (Sullivan) 302, 302 Walker, Kara: A Subtlety 49, 49-50, 523 Walkus, George 470 Wall, Jeff: A Sudden Gust of Wind (after Hokusai) 73, 74, 526 Wall Drawing #122 (LeWitt) 515, 515-516 Walter, Marie-Thérèse 136, 139 Wang Jian: White Clouds over Xiao and Xiang 72, 72-73, 442 Warhol, Andy 218-219, 220, 520; artist profile 508, 508; Black Bean 237, 237, 507; Brillo Boxes 535, 535; Campbell's Soup series 237, 237; Empire 219, 219, 220; Gold Marilyn Monroe 507, 507, 509; Kiss 219; Thirty Are Better than One 20-21, 21, 507 warm colors 91 Warrior A (Riace Warrior) (Greece) 339, 339, 344 washes 152, 166 watercolor 158, 166, 166-167 watermedia 166-168 Watteau, Jean-Antoine: The Embarkation for Cythera 82-83, 83, 402, 402 Watts, Robert: Rembrandt Signature 20, 20 WertelOberfell: Fractal.MGX 283, 283 Weston, Edward: Cabbage Leaf 27, 28, 43

Wheat Field and Cypress Trees (van Gogh) 19, 20, Wheel of Fortune (Vanitas) (Flack) 16, 17, 136, 510 Wheeler, Doug: D-N SF 12 PG VI 14 87, 87 Whistler, James Abbott McNeill: Nocturne in Blue and Gold 97, 97, 98, 99, 207, 483 White, Charles: Untitled 88-89, 89 White, Pae: Still, Untitled 177, 177 White Clouds over Xiao and Xiang (Wang Jian) 72, 72-73, 442

Whitehorse, Emmi: Chanter 84, 84, 85 Whiteread, Rachel: Daylight 247, 247, 538

The Widow (Kollwitz) 180, 180 Windward (Rauschenberg) 63, 63, 65 Winter Pool (Rauschenberg) 505, 505 Winters, Terry: Color and Information 527, 527 Wojnarowicz, David 523; Americans can't deal with death 522, 523 Wolff Olins: AOL wordmark 229, 229 Woman and Child (Léger) 498, 498 Woman Bathing (Cassatt) 189, 189-190, 483 Woman Holding a Balance (Vermeer) 66-67, 67, 400 Woman IV (de Kooning) 503, 503 Woman with Packages (Bourgeois) 30, 30, 33, 35 Women and Cattle (Algeria) 323, 323 The Women of Algiers (Delacroix) 473, 473 Women without Men (Neshat) 222, 222, 530 wood arts 271-273, 272, 273, 280, 280 wood engraving 182-183 wood in architecture 318, 318-319 Wood Innovation and Design Center (Green) 318, 318-319 woodcuts 179-180, 182, 197-198, 451 wordmarks 229, 229 Workers of the World, Unite! (Kent) 183, 183, 499. 499 Wright, Frank Lloyd: artist profile 307, 307; Fallingwater 306, 306; Solomon R. Guggenheim Museum 307, 310

X Exhibition poster (SenseTeam) 232, 233, 533

yin-yang symbol 227, 227 "Yogi" seal (Mohenjo-daro) 427, 427 Yoruba culture 32-33, 33, 272, 272, 273, 273, 276, 276, 419, 420, 421, 421-422 Young Woman with a Gold Pectoral (Egypt) 159, 159 You're Never Ready (Osorio) 196, 196 Yuan dynasty (China) 442-443, 443

Z

Zen Buddhism 47, 313, 449 The Zen Priest Choka (Sotatsu) 123, 123, 448, 451 Zhang Yanyuan 158 Zhao Mengfu 72; Letter to Zongfeng Mingben 443, 443 Zhou dynasty (China) 436 ziggurats 324, 325 Zynsky, Toots: Night Street Chaos 279-280, 280